Architecture and Allied Design: An Environmental Design Perspective

Architecture and Allied Design: An Environmental Design Perspective

Second Edition

Anthony C. Antoniades, AIA, AICP

University of Texas at Arlington

KENDALL/HUNT PUBLISHING COMPANY
2460 Kerper Boulevard P.O. Box 539 Dubuque, Iowa 52004-0539

Cover Design, John Maruszczak.

Axonometric on front cover, condominium in Saronis, Greece.
Anthony C. Antoniades, architect.

Villa Natassa on back cover, holiday bungalow in Corfu,
Greece. Anthony C. Antoniades, architect.

Copyright © 1980, 1986 by Kendall/Hunt Publishing Company

Library of Congress Card Number: 86-81124

ISBN 0-8403-3919-4

Printed in the United States of America
10 9 8 7 6 5 4 3

To Tassia and Costas, my parents and to my students everywhere.

Contents

Figures

Tables

Foreword

Architecture is an integral part of our lives. It affects our everyday experiences and actions. In its most simple and direct form, it shelters, protects and comforts us; while in its most sublime and poetic aspects, it expresses our highest cultural aspirations and touches our soul and spirit. Architecture encompasses the great monuments of all ages, tombs, palaces and temples, symbols of power and authority as well as the modest villages and hamlets built by and cared for by those who inhabit them.

The forces which shape architectural decisions in today's dynamic world are ever more varied and complex. It becomes easy to avoid or to forget the human factor in our equations. Aldo Van Eyck, the distinguished Dutch architect, cautions us to include the concerns of those who use our buildings and our cities when making design decisions. To paraphrase Van Eyck, "If one adds people to SPACE and TIME, one gets PLACE and OCCASION." A challenge to architects to create buildings and places which support, enhance and celebrate man's activities both profane and spiritual.

Cities, buildings and landscapes are now and have always been the result of cultural and economic forces. In the final accounting, a community gets the physical environment it hopes for, demands and probably deserves. It is encumbent upon architects to be advocates for those cultural forces which support the design and planning of responsive buildings and of lively, vibrant cities. Unfortunately, too much has been built purely for short range gain and there is much room for enlightened self-interest and good deeds. We depend, to a great extent, upon the public domain to control and manage the overall quality of the physical environment, the fabric of our cities. Unfortunately, there has often been a lack of vision or will to demand quality from all participants and to make progressive plans for the future.

Individual buildings, no matter how elegant and persuasive, are not sufficient in themselves. Like people, they have to be part of a community, part of a large and satisfying whole. To come close to this goal is a herculean task. It engages architects, landscape architects, planners and other design professionals in a creative search . . . an endless journey.

Along the route there is a need to confront and understand both private and public values. Challenging questions have to be asked. "Internationalism or regionalism in a search for roots? Is it "Zeitgeist" or is it fashion? Technology as a tool or as an expression of our time? Romantic memories or Utopian visions? Housing as market economy or housing the less affluent? Cities for pedestrians or ever more highways?" These are just a few of the aesthetic, technological, socio-cultural, economic and political issues which occupy us all.

Professor Antoniades has written a comprehensive book on Architecture, full of information and insights. It is a fitting companion for the journey that faces clients as well as professionals, students as well as experienced architects.

George Anselevicius, FAIA
Dean of the School of Architecture and Planning
University of New Mexico

Preface

"Architecture is a direct expression of existence, of
human presence in the world"

Juhani Pallasmaa

Our time is very exciting for the study of architecture;
yet, it is also a time for caution from the dangers of mis-
guidance and mis-orientation.

The intensive debate that sparkled in the mid 70's with
the proclamation of Post-Modernism and the subsequent
influence exerted both in education as well as in practice,
generated a climate of negation of values that were taken
for granted up to the very recent past. This climate gen-
erated in the process a substantial body of realized work
exemplified by landmarks of the kind such as the AT and
T headquarters in New York by Philip Johnson and the
Portland Public Service building by Michael Graves,
which became in another sense landmarks of controversy
and polarization.

A new wave for concern and the study of history came
about and the practice of design gave itself a new license
for historicist eclecticism. All this was facilitated by many
schools of architecture in America that established
summer programs abroad and the relative facility of our
students to travel and experience historical environments
in other countries. Several publishing houses were also in-
fluential in the propagation of the "new" concerns and for
reasons fit to their own interests promoted writers, archi-
tects and treatizes of historical-historicist orientation. The
result was the abrupt generation of a body of theory, proj-
ects, architectural "stars", "writers" and "critics" that did
not exist a decade ago.

The role of architectural mass media (magazines) was
also most significant in the process. Their emphasis on
color glossies, the extraordinary quality and the emphasis
on drawing became the means for the communication of
proposals and realized products to prospect converts, fol-
lowers and consumers.

Among the earliest converts to historicist-post mod-
ernity were many architectural instructors in the United
States; contrary to the European case one may start a
teaching career in this country at a much younger age, at
a time when he may not yet have substantial personal ex-
perience from the practice of his craft.

xvii

This educational paradox which, in its exceptions, produced nonetheless several extraordinary teachers of architecture, may on occasion cause great harm for the misorientation of students just entering the field; this can be especially harmful if the instructor is over-anxious because of his or her youth to join the so-call "avant garde" and the fashions of the time. Such anxiety on the part of such instructor may make him by-pass the body of the foundation of the essentials. An eclectic disposition, the naive and unsubstantiated promotion of fashionable idols in the introductory teaching of architecture will most probably deprive the student from acquiring knowledge of the premordially fundamentals, thus helping him become in time a "hero" in his own merit. On the contrary, such attitude may create (and has already created) fanatic followers, depriving the profession from original thinkers who could develop in the future into designers of essential worth and all-inclusive relevancy.

The first edition of this book occurred at a time when the wave of "Post-modernism" was at its full upward trend. The coming of the second edition is a proof that the eternal values of architecture introduced and elaborated here can withstand the tides of fashion and the turmoil of the times.

It is with great satisfaction that we have contributed and participated in the debate of our time and have re-assured ourselves once more on the strength of the humanist argument and the observance of the essentials. Because architecture is already back, yet further enriched to the values of sanity appreciated by most human beings; to human scale, concern for comprehensivity, environmental and intellectual sensitivity. Back to the track of a well-conceived appreciation and use of history, away from the shallow results of formal or historicist immediacy.

The recent strong suggestions coming from Scandinavia and voiced by people such as Juhani Pallasmaa, Aarno Ruusuvuori, and Göran Schildt, along with the strong influence exerted on the international debate, either through the strength of Scandinavia's extraordinary architectural heritage (Asplund, Aalto, the Saarinens, Jacobsen) or the occasional symposia on architecture that take place there, represent at the moment the strong antidote to Post-Modern Historicism and a promise for an international return to architectural values that affect humanity and users across the board, rather than values of temporariness and idiosyncratic whim of an "inner" circle of peers and followers.

It is also encouraging that several of the most influential publishing houses in architecture seem to be ready to promote architects of essence either through publication of biographies or actual work. As a landmark in this respect could be considered the recent publication of the first volume of the Aalto biography by Göran Schildt by Rizzoli; a turning point of the trend away from Post-Modern whims and back to values of architectural eternity and the poetics of meaningful creativity.

It is the writer's belief that the environmentally inclusivist approach to architecture will prevail, that fashions will always come and go, always, of course, leaving something which if further elaborated by well meaning, environmentally educated architects, will help create an evolutionary architecture, index of the positive aspects of the civilization of the time.

It is with these intensions and these hopes in mind, and with the responsibility of someone who has seen, practiced and taught that I offer this enriched edition for publication.

Anthony C. Antoniades
Arlington, Texas

Acknowledgments

I would like to express my gratitude to Don P. Schlegel, for he provided the initial incentive to prepare this material and present it to the students of the University of New Mexico in Albuquerque. I will always recall with nostalgia the large blackboard in the auditorium of the Anthropology Building at the University of New Mexico. The quality of the quick sketches on this board were never surpassed by the subsequent attempts for sketching on transparencies for overhead projectors and mechanically reproduced handouts.

Several other people, teachers, and colleagues, deserve my gratitude, for they taught me, challenged me, and tried to help me "see." These people were Panagiotis Michelis, my professor of Aesthetics in Athens; Victor F-Christ Janer, my design professor at Columbia University; Percival Goodman and Harry Anthony, also at Columbia; and Nathaniel Lichfield in England. Great credit is also due to the time I spent in Paul Rudolph's office in New York; I had the chance to observe the master at work and to develop insight into the methodology of "simultaneity."

I want to further acknowledge the importance of my association with some very concerned architects and teachers. I should mention here Bob Walters, Dr. Baimbridge Bunting, Michel Pillet, and Jane Abrams from New Mexico; George Wright and Dr. Ernest Buckley from Texas; Theodore Panzaris, Dr. Constantine Xanthopoulos and Dr. Nicholas Cholevas from Greece; Kazuhiro Ishii from Japan; Ricardo Legorreta from Mexico; and Zvi Hecker from Israel. Finally, but not least, I would like to acknowledge the importance of Hal Box, FAIA, Dean of Architecture, the University of Texas at Austin. When Hal was Dean of the school of Architecture and Environmental Design at the University of Texas at Arlington, he made it possible for me to further develop this material.

Many of my past freshman students on this campus, now practicing architects for several years, were the primary challengers in the making of this volume. I gratefully acknowledge the help of the following students at the University of Texas at Arlington who read the manuscript at its very early stages and offered suggestions for improvement. These people are Marianne Andrews, Penelope Hudson, Larry Joe, Susan Long, Alice Love, Charles Northington, Kathleen Payne, Kathie Robinson, Jaynne

Seeburger, Linda Ann Smith, Marsha Schwob, and Denice Thedford. Acknowledgment for initial proofreading and support is also due to my lab assistants, Eddie Brooks, Donald Harrington, David Browning, and Aaron Farmer.

Finally, but not least, I would like to acknowledge and express gratitude to the many anonymous colleagues who as reviewers on behalf of the publisher offered criticism and constructive suggestions throughout the evolution of the book. It is supportive and constructive feedback by the peers that makes all the efforts and sacrifices worthwhile.

I am grateful to all these people. Yet none is responsible for the thoughts and interpretations expressed here. The responsibility for the shortcomings of this work is entirely my own.

Anthony C. Antoniades

About the Author

Anthony C. Antoniades is a Professor of Architecture at the University of Texas at Arlington. He was a visiting Professor of Architecture at Washington University in St. Louis, full-time lecturer in Architecture and Planning at the University of New Mexico, and taught urban design studio at the University of London.

Born in Greece, he was educated at the National Technical University in Athens, Columbia University and University of London. A member of the American Institute of Architects the American Institute of Certified Planners and the Greek Society of Architects with professional experience with S.O.M. and Paul Rudolph in New York City, Professor Antoniades maintains his own private practice and has built his own projects in New Mexico, Texas, and in Greece.

Professor Antoniades has authored a great number of articles on architecture and design published in international literature in English, Japanese, and Greek; he is also the author of the books CONTEMPORARY GREEK ARCHITECTURE and POETICS OF ARCHITECTURE, both in Greek.

Professor Antoniades is an extensively traveled researcher, an architectural educator par excellence, with an eye and concern for an inclusive architectural design education. He believes that the needed "Environmental Ethic" and "Environmental Design Approach" will occur when Western potential intermarries with Mediterranean design attitudes and humanity.

Introduction

"The complexity of the world outward is equal to the complexity of the world inward."

George Mantas

"The many variables involved in contemporary . . . decision making simply outrun the capacities of even the finest minds."

Christopher Alexander

What Is Environmental Design?

It is customary in our day to call the disciplines of our inquiry "environmental design disciplines." Those practicing them are often referred to as "environmental designers."

The concern for "environmental design" is nothing more than the state of mind of approaching and performing architecture and its associated design disciplines that deal with the man-made, or built, environment in reciprocal, interrelated ways. In view of this convention, it is important that, prior to our investigation of the separate design disciplines we get as clear an understanding as possible of what is meant by "environmental design," what is meant by "environment" and "design."

The Greek word for environment is *PERIVALON;* it is a composite word. Its exact meaning is "everything that surrounds us." Environment is also considered as "the conditions under which any person or thing lives or is developed; the sum total of influences which modify and determine the development of life or character."[1] The combination of the above notions on the meaning of environment provides the understanding of the term as used in this book: *Environment is everything that surrounds us; it has an influence on our lives and characters.*

The term *design* is very often considered self-explanatory; yet its meaning is more elaborate than the term environment. It means different things to different people. It is usually regarded as "man's intelligent forethought pertaining to the solution of problems that face him." You often hear people saying that they plan to do "this and that." We might say that these people are "designing" in

their minds to do something about the problems confronting them. It is possible that they might have been able to express their idea in a more concrete form by means of a "plan" or "scheme" intended for subsequent execution.[2] Other people might contact certain professionals to prepare the plans or schemes for them. It is customary to consider these professionals "designers." The notion of the *preliminary conception of an idea or the concept of the mind* is the key ingredient of a design. A prepared plan, scheme, or descriptive document could express an idea, but it would not be the idea itself. We could therefore say that design deals with man's forethoughts pertaining to the creation of situations or things that will improve certain situations, or the performance of things he previously used. A design, now, is one out of many possible designs; man selects the one that offers the optimum solution to his problems. Optimum solution will permit him to live a more relaxed life, both physically and mentally, within the constraints of the new situation he has created or with the use of the new thing.

It is possible that man may design and build something for himself; he may design something and have others build it for him; he may commission others to design and build it for him; or, finally, he may find something already designed and built by others that he will purchase for his use. In any one of the above possibilities, design is concerned with ideas, creation, betterment of a situation, optimization of external influences, and, finally, improvement of life through the use of the design creations. In consumer societies these designs are referred to as "design products."

Environmental design, therefore, within the context of the above background, is that design that deals with man's forethoughts, concepts, and ideas about the betterment of situations regarding him and of everything that surrounds him. This definition makes evident the difficulty of the task of environmental designers.

To some people, the very concept of a design discipline that is able to deal with everything that surrounds us might sound superficial. They might argue that it would be impossible to produce a person, the environmental designer, who is able to solve all the problems pertaining to the harmonious development of everything that surrounds man. It could be further argued that it would be difficult and unfair to ask that there be an individual who will have the knowledge and expertise to solve all the problems that face man and his surroundings. These arguments would be right if we were to expect to create such an individual. Even if one's whole life were devoted to education in all the known fields that deal with the environment, it would be impossible to complete one's education within his lifetime. But an environmental designer is not expected to be a master of all trades. The term "environmental designer" has been adopted recently to distinguish certain professionals who

are experts within their own fields, yet who possess an educated awareness of the interrelationships pertaining to other design fields. Moreover, these individuals possess a belief that there is need for a multifaceted and coordinated approach to the problems that face us, be they ecological, physical, psychological, or economic.

A first step toward environmental design is the trend followed by ever-increasing numbers of people, especially young people, who place themselves on the side of the environment; they care about it, and they support "environmental issues." We call them, and they call themselves, "environmentalists." Any individual who is concerned about the man-environment situation is an environmentalist. The next step is to become deeply involved, acquire an educated awareness, and develop the vocabulary of the interrelationships of the various environmental professions. This puts one well on the way toward becoming an environmental designer.

The final step to becoming an environmental designer is to become environmentally sensitive. One must become aware of the issues of our time that have caused environmental imbalances and that have brought the concept of environmental design into existence. These issues indicate the pivotal points that must be treated with sensitivity by designers so as to avoid negative effects of the environmental creation of any specific discipline.

The model of a design that is environmentally relevant must take into consideration the requirements of the specific discipline narrowly considered, as well as its relationship to the environmentally relevant criteria that are general and those that depend on the occasional situation, that is, the occasional set of environmental constraints.

The Spheres of Environmental Design

The definition of environmental design demonstrates the enormous task of environmental designers. We speak, however, about the young discipline of environmental design in very timid terms at present. Many people might even question that it exists, or that it will ever develop into a major discipline. This book is based on the belief that such a discipline is absolutely necessary and that it will evolve in time into one of the most important disciplines for the future development of civilization. Yet, obviously, today many people may be confronted with doubts, and the introductory reader may rightly have initial questions pertaining to the possibility of offering responsible knowledge on environmental design, this immense inquiry of design. In response to these doubts we should argue that the task for the development of the discipline is immense.

The university is the most inclusive environmental educator we know today. Within this there are fragmented environmental concerns. The real environmental designer today would be the Yellow Pages of the telephone directory! All professionals, all specialists, all industries, all intellectuals, theoreticians, doers, and thinkers, are the

TABLE 1. SPHERES OF ENVIRONMENTAL DESIGN

From nothingness . **To God**

Genesis chemistry physics, etc.

1	2	3		4		5		6		7 N	
Object	Furniture	Individual buildings	Landscape	Urban design	Landscape	Town or urban planning	Landscape or rural planning	Regional planning	Rural planning	National planning	Space planning	Universal planning

Part one Part two

Architects and planners

Small scale architecture Large scale architecture

Interiors

Politics religion philosophy

God!

environmental designers. We must not fool ourselves that there is a single person that deserves to be called "environmental designer." The environmental designers are *all* the "designers" together, *all* the people of mankind.

It is only current civilization fashion that has grouped a few professions under the all-inclusive term of "environmental design." This fashion concerns environment within the concept of closed inquiries.

So, if from the Yellow Pages we exclude all other "environmental professions," keeping only those that deal with the traditional building trades, we have what our civilization at present calls environmental design. This includes spheres of design that are smaller, equal to, or larger than the scale of man. The spheres of this environmental design are (1) object design, (2) furniture design, (3) interior design, (4) individual building design (understood for the purposes of this book to be the sphere of architecture), (5) landscape design, (6) urban design, (7) urban planning, and (8) regional planning. Professionals who operate in any one of these spheres are currently referred to as environmental designers. Some of these spheres of design are very old ones indeed, such as the sphere that deals with individual buildings. Numerous professionals with differing inclinations may find tasks within the individual design spheres, and different time scales are involved in the creation of the product of each design sphere.

Through the process of exclusion of all other trades and disciplines, it will be easier to tackle the immense present inquiry. Surely the design of aircrafts and spacecrafts comes immediately to mind when one studies environmental design. Yet you will find discussed here only the fields of design about which the writer feels comfortable and qualified to write. The common denominators which relate the separate spheres discussed here are man and the environmental issues pertinent to the occasional circumstances. Man, however, is the key factor. At the bottom of the environmental disciplines presented here, as well as in all other disciplines, there is man.

The reader should be aware that every designer's concern, every design methodology, and every design practice should always commence with man in mind. If this has been done then one certainly is on the right track to interrelating the various disciplines among themselves and producing a human-oriented, relevant design product.

This book will introduce you to the spheres of environmental design previously indicated, as also shown in Tables 1 and 2. Part 1 introduces the vocabulary and concepts of environmental design through the lens of the environmental design discipline of architecture. This is done for two purposes. One is methodological and has to do with the process of learning in general, while the other is applied. In the process of learning, the easiest things to comprehend are those that, from the point of view of logical deduction, are not very near nor very far, neither very small nor very great.[3] Architecture belongs to the sphere of environmental design that is not very small, as furniture design is, for instance; nor is it too large, as regional planning.

TABLE 2. THE DOMAINS OF ARCHITECTS AND OTHER DESIGNERS

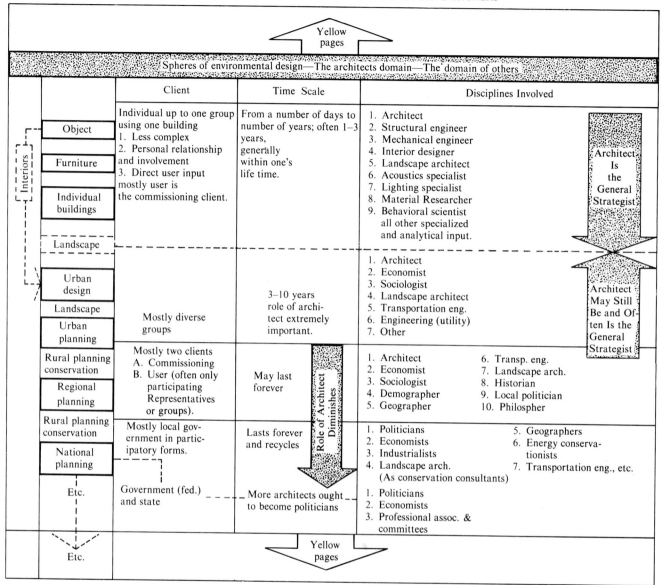

From the applied point of view, the product of architecture is of large enough scale to permit man to move in it and about it. These two possibilities (to live inside and outside) give a total personal experience that allows man to study an environment in depth and become aware of the basics more easily.[4]

The second part of the study is devoted to all other environmental design disciplines; i.e., landscape or exterior architecture, interior design or interior architecture, urban design, urban planning, and regional planning. National planning and more comprehensive spheres of planning are beyond the scope of the closed physical environmental fragments with which we are dealing in this book.

It is very important now to understand the need for the interrelated concern of the various disciplines presented here. It is necessary because mankind has seen enough "magnificent" buildings that have nothing to do with their surroundings. Very often new creations of urban design and its components, such as highways, etc., destroyed historical and social environments. Many products of landscape architecture, such as large open spaces, etc., became traps for crime and psychosocial alienation. Many interiors and their furnishings have been totally nonresponsive to users' needs. And, finally, many previous prototypes of urban and regional planning have been the reasons for people's anxieties and stimulators of waste. It is important, therefore, to present the issues of our time that have created the general environmental decadence we experience today, and which, in turn, have brought about the need for interrelated design consideration. Following this discussion, we'll continue our study with the introduction and study of architecture.

Environmental Balance

"Everything that surrounds us." This includes the natural as well as the man-made. Some of the things that surround us are close to us, other things are farther away. Certain elements of our surroundings are extremely close to use. Even our thoughts are part of our surroundings; they come from our inner worlds; they are products of our minds. Yet, sometimes they fill the air; we sense it. A common expression in most languages is "Where are your thoughts flying?" The aura of an individual's mind surrounds him; his thoughts affect his personality, his looks, his immediate environment, and finally, his relationship with others. The environment, natural or man-made, very close or very remote, starts in our hearts and minds and ends in the endless spheres of the cosmos.

Several previous civilizations experienced flourishing peaks of environmental harmony. The Golden Age of Greece is considered one of them. The Italian Renaissance is another. Many people in history—poets, philosophers, politicians—were critical of practices that would harm the environmental balance. They advocated the opposite. Aristotle, Leonardo da Vinci, and Thomas More are representative of people who we could call "influential environmental comprehensivists" of the past. Buckminster Fuller was a good recent example of a man with similar anxieties who made considerable contributions to the man-environment issues.

In the past, environmental balance evolved out of an environmental imbalance. And the same thing can happen today.

With the exception of very few countries, the current state of the world presents a general picture of environmental imbalance. Fortunately, we are in a period of awareness of this existing imbalance. Many people in many parts of the earth have become sensitive to issues that brought about this awareness and made germane the need for environmental design concepts. The next step to becoming aware of the issues[5] that cause a problem is to solve the problem itself. We can therefore say that we are slowly but surely on the path toward the solutions to the current environmental problems and we will once again attain a peak of environmental flourishing. The period that will be experienced by the coming generations will perhaps be shorter in duration than the period of the Italian Renaissance, the last positive environmental peak experienced by mankind; this will happen because things evolve much faster today than they did in the past. But, if everything goes well, the coming new environmental era will cover a much larger geographic area than the one covered by the Renaissance.

The issues that caused the environmental problems of today are many and general. The most important ones had to do with man's difficulty in adjusting from a rural to an industrial life. They are furthered by his subsequent difficulties in adjusting from the industrial to the postindustrial and, currently, to the electronic life. The first environmental problems in the industrial world were observed in England, and they were related to the unhygienic situation of the housing settlements near the pollution-promoting industrial plants. The slums of industrial England brought to the surface the first cases of nineteenth-century environmental misery: industrial laws insensitive to working conditions and to children's and women's employment. A series of fatal industrial accidents and increased mortality rate of the teenage labor force were the results of the lack of proper legislation. The situation was observed by the medical people of Great Britain first[6] and was brought to the attention of the public by them, as well as by some social thinkers, the most celebrated of whom was Engels. They recommended altering the total industrial environment, both physically and socially. These first British environmentalists stirred the waters. The government passed legislation aimed at the improvement of the environment of industrial areas and slums.

The changes did not come about overnight. The slum became at first more hygienic through the introduction of sanitation laws and public utilities. It was then developed into the "industrial estate," a preplanned industrial-residential development; and it finally was totally replaced by the hygienic, and in most respects human, environment of the neighborhoods of the British "new towns." Many environmental movements occurred with the passing of time. The Garden City movement asked that the "environment of town" integrate urban development with open space and separate, through careful design, the industrial from the living areas. Britain and the story of its awakening on the hazardous environmental issues is the fundamental historic reference on the subject.

The most recent lessons to be learned from England prove that even the worst environmental mistakes can be corrected and that environments can be purified through proper legislation, collective environmental ethic, and time. London regained its clear sky following the passage of environmentally sensitive legislation that prohibited the burning of coal in fireplaces. The famous "London smog" caused by the burning coal now belongs to the past. England has also been able to repurify the water of the Thames River. Environmental legislation that banned cargo boats in the river and controlled the discharge of industrial wastes has made it possible for the river to regain its clear water and its fish.

The most important handicap to environmental balance is caused by the relativity of interpretations given by various men or nations to the concept of freedom. In some countries one may experience concepts of freedom that

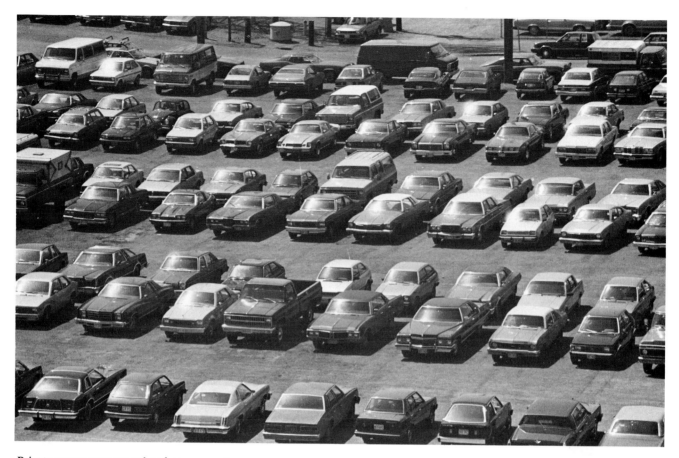

Private motor cars; sprawl and energy waste

How much fuel will they consume in their lives? (Left, photo by Craig Kuhner; right, photo by Richard Scherr.)

tolerate no restrictions whatsoever on the individual. In excess cases of *laissez faire,* when one may act as one wishes and where the free market economy and motivations for unrestrained profit prevail, one experiences the worst cases of environmental imbalance. This happens because the environmental resources are looked upon as commodities for profit, and they are exploited accordingly without regard for the natural environmental processes on the plant, animal, and human habitat. Plant and animal ecologies are often sacrificed to extinction through profit-motivated acts that are presented as acts of "improvement" and "development." Many such cases are presented in recent environmental literature and are widely known. Such cases point up the insensitive attitude of man toward the ecological processes of nature, which require

The place of the motor car in less technological cultures: an object for display rather than urban space waster. (Puebla, Mexico)

An alternative use of the motor car. (Photo by Richard Scherr.)

respect for all aspects of the natural environment if environmental balance is to be achieved. Jungles and forests, rivers and lakes, water and earth have been disturbed by man's acts of thoughtless exploitation. The natural environment became "God's own junkyard"[7] and very few were thinking that it would perhaps be better to "build into the junkyard and look into the forest than to destroy the forest in order to build in it."[8]

The most recently noticeable environmental issue is known as "the energy issue." Shortage of scarce fuels brought about the awareness of, and turned man's attention to energy. It became an element of national and international concern in the early 1970s and has since become a global environmental issue.

The energy crisis was brought about by a number of factors, the most important of which were: (a) the unplanned exploitation of scarce fuel resources, (b) man's ever-increasing use of private modes of transport (private motor cars instead of rapid transit), (c) the inability to utilize sources of energy other than oil, (d) forms of urban settlement that are insensitive to energy savings (unplanned decentralization, sprawl, scattering), (e) the lack of an energy ethic, and (f) the total lack of an environmental ethic.

The energy issue gave a tremendous impetus to people's concern for environmental design. The year 1973 was celebrated globally as the "environmental year." Conferences, exhibitions, lectures, and media presentations brought the theme of environment to public attention. Legislation focusing on environmental issues was initiated in many countries. The United States government initiated the Environmental Protection Agency and passed

The Scandinavian case: Rural and urban, high density and open space in environmental harmony.

legislation requiring the preparation of Environmental Impact Statements to accompany proposals for any physical development that could cause environmental hazards. This concern needs further emphasis, and it is hoped that the future environmentally sensitive designs of all projects will be self-evident environmental impact statements in themselves. New sources of energy are sought, solar energy being one of the cleanest and most promising. New modes of transport are beginning to emerge and to become acceptable. New forms of urban development, physically more compact and socially more communal, are advocated as less wasteful and more environmentally sound.

The Scandinavian countries are good examples for the study of environmental attitudes. Yet they are not densely populated, and thus the solutions to their environmental

Japanese countryside: The crispy duality of urban-rural continuum.

Immaculate man-made and natural equilibrium in Japan.

problems are easier. Japan could be suggested as a prototype at the present time for densely populated countries. One should consider that the very large population of Japan, which at the present time is half that of the United States, lives in a geographic area the size of California. Further, the bulk of the population lives in urban areas that cover only twenty percent of the total land, with the rest of the land kept in its natural condition. The urbanized parts of the country are linked by the most sophisticated modes of transport, and life takes advantage of all the innovations of twentieth century, remaining at the same time sensitive to the heritage of tradition.

Contrary to the environmental miracle of the densely populated and highly urbanized Japan, one finds a series of problems in most other countries. For instance, the United States, in spite of its declared environmental concern, presently leads the world in environmental waste. It seems unfair that the population of the United States, representing 5% of the population of earth, consumes (wastes) 30% of the total energy resources used on earth daily.[9] We could conclude that thoughtless emphasis on individual as opposed to communal preferences represents a major cause of much of today's environmental decadence.

Causes of Environmental Imbalance

Following is a summary of the factors which have caused the environmental imbalances we see today in many areas of the world.

Primary Causes

1. Disrespect for the ecological process of nature.
2. Thoughtless practices regarding the use of scarce energy resources.
3. Emphasis on individualistic as opposed to communal values.

Secondary Causes

Physical

4. Environmentally unsound methods of physical planning and development.
5. Preferences for sprawling schemes of human settlement.
6. Contamination of the physical environment—air, water, and noise—due to practices insensitive to environmental purity and healthy surroundings.
7. Emphasis on physical solutions without regard for the social, economic, and psychological aspects of life.
8. Disrespect and destruction of the old and historic environments of many urban environments.

Social

9. All problems of social nature such as unemployment, crime, quality of education, birth rates, and overcrowding.
10. Social biases, such as racial and sex discrimination, accompanied by many people's unwillingness to overcome them.
11. Current mobility of population in industrial countries, which creates a constant state of transience, handicapping the development of permanent bonds between man and environment.
12. Anonymity of creators and anonymity of users, by which, in current practices, the contact between creator and user is removed.

Economic

13. Emphasis on monetary concerns rather than on quality of life (or human needs) criteria when considering optimum strategies for environmental development.
14. Profit motivations of private developers and financial institutions accompanied by the lack of environmental controls imposed by government.
15. Promotional processes, public relations, and advertising which often direct the public to environmentally unsound products.

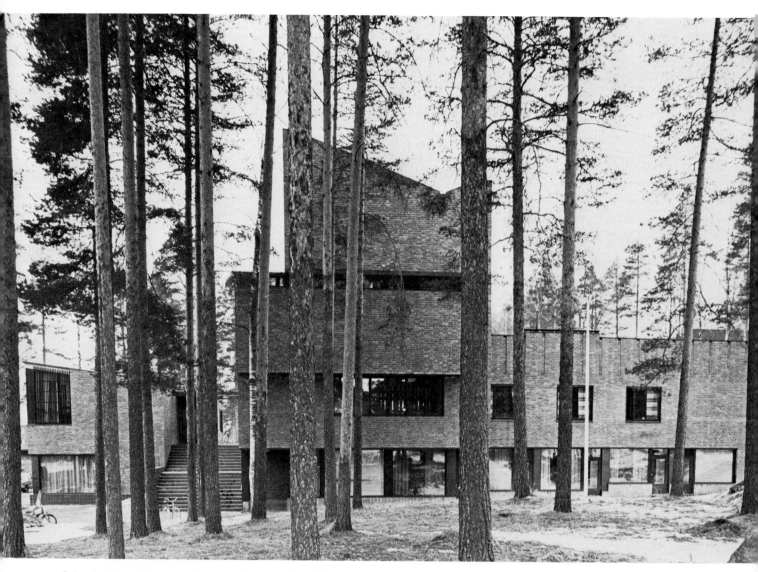

Crisp duality, yet harmony, between the natural and the man-made represents the key quality of this Finnish environment. Alvar Aalto, Town Hall, Säynätsalo, 1952. (Photo by Constantine Xanthopoulos.)

Political

16. The nature of politics, which often encourages fragmented and/or shortsighted solutions designed for political expediency rather than long-range environmental harmony.

17. Occasional corruption of public enterprise in all known systems of government; this often "kills" the soundness of environmentally sound programs by its motivation for personal economic or political gain.

18. Political rather than environmental disposition of most politicians; this occurs because of the current incompatibility between the short-term personal goals of most politicians and the long-range goals one should possess regarding the environment.

Moral

19. Lack of planning, lack of design, lack of energy ethic, lack of environmental ethic, lack of interrelated ways and methods of environmental problem solving.

20. Disrespect for traditional and regional processes; many countries have sacrificed the lessons of their past environments in the name of progress and development.

21. Designers' occasional shortsightedness and their occasional emphasis on isolated environmental issues with no regard for environmental interrelationships. The history of modern architecture has plenty examples to demonstrate the point. The most outstanding case deals with many architects' occasional concern for the creation of forms appealing to the eye that do not necessarily serve the user's needs.

TABLE 3. MATRIX OF ENVIRONMENTALLY SENSITIVE DESIGN

		General issues	Physical	Social	Economic	Political	Psychological	Educational	N . . . Other
	General issues of the time that bring about environmental imbalance.									
	Scale	●	●	●	●	●	●	●	●	●
	Proportions	●	●	●	●	●	●	●	●	●
	Rhythm	●	●	●	●	●	●	●	●	●
	Organization	●	●	●	●	●	●	●	●	●
I.E. Architecture	Order	●	●	●	●	●	●	●	●	●
	Legibility	●	●	●	●	●	●	●	●	●
	Form/cost	●	●	●	●	●	●	●	●	●
	Unity	●	●	●	●	●	●	●	●	●
	⋮	●	●	●	●	●	●	●	●	●
	N . . . Other	●	●	●	●	●	●	●	●	●

Criteria of individual environmental discipline (Narrowly considered)

With "Man in Mind" criteria. Health, safety, strain, physical dimensions, psychological dimensions, cultural connotations, etc.

Matrix of environmentally sensitive design must be prepared prior to starting any design. Matrix will be the tool to check the design decisions and bring them to environmentally relevant context.

Always consider interrelationships with man in mind.

22. Anxiety of many intellectuals, especially young, to invent new movements in art and architecture and to call for innovations without giving previous ideas a chance to mature and test their full potential.

23. Occasional lack of consideration for vital issues, and waste of time and energy on the investigation of details and fragmented approaches to design. Many architects, for instance, do not seem to care about large issues such as "education," "housing," or "urban," in their apparent concern about selecting "styles," "detailing," and "decoration," or the "difference between fun and funny" and other issues of personal, not general, significance.

24. Increasing cynicism of contemporary man, accompanied by a trend toward the total disappearance of romanticism and spiritual disposition. Current art movements have often produced doctrines such as "ugly is beautiful" and have accepted states of decadence as substitutes for expressions of life and joyous harmony.

Educational

25. Lack of environmental education of the public.
26. Inefficient education of environmental professionals regarding the environmental crises of today.
27. Shift from craftsmanship to technology with very little emphasis in scientific education on issues of environmental creation.

The above summary may be expanded, depending upon the situation. Individual environmental imbalances are caused by different sets of causative or causal issues. The environmental critics should identify these issues. The designers should consider them in order to avoid their harmful effects on their designs. Any design, if it is to be truly environmentally sound, should be responsive to the set of criteria that characterizes the unique environmental circumstances. In that sense, successful environmental designs will be achieved only through design efforts that consider the general environmental criteria of the situation as related to the narrow criteria that have to be met by each environmental design discipline. The optimal interrelationship of criteria will be the one that optimizes man's future relationship to the proposed creation.

If the above arguments are accepted, the method of environmental design can be very simple in its general statement. The model of environmental methodology suggested by this book is this: First, it will deal with the individual design discipline and its own inherent design criteria; secondly, it will deal with the investigation of the general environmental criteria; and, thirdly, it will deal with questions pertaining to the relationships of the first two as optimized by the attitude, "with man in mind."

We should expect that responsible environmental designers, responsible critics, and citizens should approve design products *only* if they meet their inherent design requirements, while at the same time meet the criteria that will help avoid environmental imbalances. We should not, for instance, speak only about the "good looks" of a building. We should not speak about the elegance of its detailing alone. Regarding any design, we should mention its good points, if it has any in this respect; but then we should stop and pose a series of questions: "What does it do with the energy it consumes for its heating and cooling requirements?" "What does it do to the people who live in it?" "What does it do to prevent crime?" "What does it do to foster pride in the community and serve the problems of the community at large?" . . . These and other similar questions must be posed by each designer separately in his (or her) process of design. The task of identifying the questions to ask, or the environmental design criteria to satisfy, is difficult and unique to each case. The variables inherent in the solution of the strictly technological, aesthetic, and economic problems are innumerable. The complexity of problems is immense—equally immense outward as inward. But the designer must do his best to identify them and solve them. To do less would be escapism and would be harmful for both man and the design product.

Notes

1. *The Compact Edition of the Oxford English Dictionary,* volume I, Oxford University Press 1971, p. 880.
2. Ibid., p. 698.
3. Russell, p. 2.
4. The validity of the approach of presenting architecture first has been tested over a period of time through the teaching of the subject at the university level. It is recommended for didactic purposes.
5. For further background on environmental issues, refer to "Environmental Quality Reports." A good summary is presented in *The Fourth Annual Report of the Council on Environmental Quality.* U.S. Government publications, Washington, D.C. 1973.
6. Reference to medical reports on which F. Engels based many of his arguments.
7. This is the title of a synonymous book by Peter Blake.
8. Statement accredited to Hal Box, dean of two schools of environmental design. He mentioned it occasionally when criticizing student projects which lacked respect for trees and plant life.
9. It is also important to remind the reader that Sweden, a country that experiences the same standard of living as the United States, spends only 40% of the energy consumed in the United States. See *AIA Memo,* Aug. 31, 1976.

Selected Readings

Blake, Peter. *God's Own Junkyard.*
Fathy, Hassan. *Architecture for the Poor.*
Harrington, Michael. *The Accidental Century.*
McHarg, Ian. *Design with Nature.*

PART 1
Architecture

1
Introduction to Architecture

"The sun never knew how great it was until it struck the side of a building. Just so, one must think of architecture. . . ."

Louis Kahn[1]

What Is Architecture?

It was the first day of classes in an old school of architecture somewhere in the Mediterranean.[2] The first-year students were excited; after all, they had survived the difficult admissions test. They were "in," the ones privileged to become "architects." . . . The old professor walked in. He was admitted in silence and admiration. All were seated.

"What is Architecture?" was the old man's first question. Some ventured to answer. The old man wrote his students' input on the blackboard.

"Architecture is to be an architect."
"Architecture is to design buildings."
"Architecture is to draw plans."
"Architecture is to think and write about architecture."
. . . and many other such things. The whole hour was spent analyzing the written statements, trying to understand them clearly:

" 'to draw plans,' now what do you mean?"
" 'to design buildings,' what is design? What are buildings? . . ."
"What do these words mean?"

Two blackboards were filled with the professor's questions, "What do you mean?" "What does this mean?" . . . The old, respected, supposedly "wise man" knew nothing! Simple words used by everyone, words everyone thought he knew appeared to be incomprehensible to him. Where did he want to take it? After all, what is architecture? If he did not know, who would know?

. . . Three blackboards were filled with chalk, one with the students' answers, the other two with the professor's doubts. The bell rang.

"You may be dismissed," the old professor said. "We'll continue this discussion when you are at the end of your third year of architecture studies." The professor died before the students reached the end of their third year.

The author was one of the students in that class. His response written on the blackboard was, "Architecture is a lot of things." Since then he has expanded this sentence. In the two words, *lot* and *things,* he found a better understanding of his initial notion. Other activities followed. Reading, work, practice, travel, and argument all helped. He was lucky. There was good truth in his generalization.

Architecture is a discipline, a profession, and a *state of mind.* Architecture is a cultural index. It takes different forms in different civilizations and political settings. It deals with the process and the final creation of man-made environments in ways that are functional, economic to build, and emotionally appealing to the user and the independent viewer or appreciator.

Architecture is a discipline aimed at synthesizing, organizing, and creating order out of nothingness or unrelated parts. Architecture is the remedy to chaos or monotony. Architecture requires "poetic disposition"; it is a poetic act.[3]

Architecture is many things in one. Some things tangible, others intangible. Some things visible, others invisible. Where all things, tangible and intangible, visible and invisible, are in balanced harmony among themselves and with the rest of the world, constituting a useful and mind-elevating whole, then this whole is "architecture."

Architecture safeguards life, health, and property, and promotes public welfare.[4] Architecture is, unfortunately, at present, a drop in the ocean of reality;[5] but, "architecture can wait thousands of years, because its presence in this world is indestructible."[6] If the various disciplines that "create" physical entities harmonize in a useful, appealing, and mind-elevating way, they constitute "architecture." All other names are but professional inventions. Yet some of these creations are "bigger" than others. Architecture, therefore, varies in scale of magnitude. It depends on the actual physical size of the creation, on the number of the "many things" that were put together, on the time it took to put them together, and on the size of the group using the creation or the created environment.

There are two basic **scales, or spheres, of architecture** depending upon its magnitude:

1. Small- or intimate-scale architecture, which refers to one-user up to one-family relationships or to one-building-requirement relationships. (This is regarded by most practitioners as "architecture.")
2. Large-scale architecture, which deals with more-than-one-building relationships. (This is usually called "urban design.")

Both basic scales of architectural magnitude are, for practical purposes, further broken down to such specialized concerns as interior involvement and exterior issues. Interior design and landscape architecture are such creative tasks. They represent recent professional refinements in the technologically advanced countries, while they were an integral part of the total task of creation in some older civilizations such as the Japanese, the vernacular of many Mediterranean cultures, and the works of some of the most influential architects of the 20th century.

Architecture deals with solutions to the complex system of relationships that are involved in the performance of any one of its creations. It is, in that sense, **a system-solving discipline.** The major interrelationships to be satisfied in any architectural work are the following:

1. Specific work of architecture (any scale); old, external world relationships; i.e., location of a creation (building) in relation to its surroundings, social milieus, and economic milieus.
2. Specific work of architecture in relation to its functional requirements. No conflict of function has been the doctrine in the past.
3. Specific work of architecture in relation to its self-generated form. (The form of a new work of architecture represents the new entity that is added to the environment and that has a positive or negative effect.)
4. Specific work of architecture in relationship to the "economy of its design."

A Work of Architecture = Response to Environmental Constraints + Function + Form + Economy.

Because of the complexity of the factors in the above formula, architecture is very complex and difficult to achieve. The difficulties, though, enhance the architect's ultimate satisfaction with a meaningful creation. Pier Luigi Nervi, the Italian structural engineer who perhaps grasped the meaning of architecture better than many good architects, wrote the following on the difficulties and gratifications of architecture: "No other creative act is so long and difficult, because no other expressive language (words, sounds, colors, and sculptural form) is as rebellious as the architectural one, formed as it is by limitations and ties of functional, statical, and constructional nature."[7] To overcome the difficulties is to reach the point where function, form, economy, and all other environmental constraints are brought together in an "equilibrated compromise, and harmonize spontaneously with one another in a play of forms and volumes capable of expressing the architectural idea. . . ."[8]

During the evolution of architecture there have been architects and movements that emphasized one component of architecture at the expense of the others. Those who emphasized form were called *formalists*. Those who emphasized function were called *functionalists*. The emphasis on the component of economy also led to functionalism. The emphasis on "all other environmental constraints," a syndrome of the early 1970s, led to what has been labeled *process-oriented architecture,* which in turn led to extremes of total *de-architectural*[9] stands. A genuine concern for architecture does not leave room for "isms." An architect should avoid these biased approaches; he or she should be interested instead in what Nervi called "equilibrated compromise."

The major expectation of architecture, therefore, should be to fulfill all the factors of the formula of total architecture, to be able to transcend triviality, to move emotionally, and to lift the spirit to levels that enhance the essence and meaning of life for mankind. This should be architecture; and the goal should be an uplifting act for mankind. The incomparable satisfaction connected with every creative act and the soul-uplifting feeling of having offered a work in the making of civilization are the great rewards of architects.[10]

It has taken some people a number of years to really grasp and define the meaning of architecture. It has taken many good architects a great deal of time to come up with their own understandings, to develop in time and contribute to the evolution of the architecture of their era with their works. The examples we have today indicate that all good architects were products of a continuous effort, constant concern for their discipline, and constant dialogue about the issues of architecture and the problems of mankind.

There is a lot more to becoming and being an architect than "drawing the plans" for a building. Yes, one has to know how to draw, ideally to sketch and draw well; that helps enormously. One must know the language of architecture which is based on the making of sound and appropriate statements; one must learn, therefore, the principles and the elements of design. Then one must learn how to build proposals and make conceptions reality. One must know, therefore, about structures, the mechanical equipment of buildings, and the materials and methods of construction. The architect should also know a lot about the uses of the buildings. He (or she) should be able to design for uses indoors as well as outdoors and should design in contextual harmony and respect with the deserving aspects of the surroundings. He should learn about current issues and consider them in the design. Finally he should always bear in mind that he is not alone, but a being in society; and therefore, his creations should serve the needs of society, not his private ones.

It has become clear that architecture is not just "form, function, and economy" as it was previously understood, but it is that, *plus* "response to everything else." This makes it a more comprehensive and clearly a more demanding affair. The architect hopefully learns all these things in his formal study of architecture, or he may pick them up through many years of informal learning through apprenticeship. This, of course, is very difficult in an era of professional and design specialization; apprenticeships in our days lack the comprehensive involvement and comprehensive training that architects received in the past by working with great masters who had relatively small offices and comprehensive control of what they were doing.

In any manner of learning, however, the goal is to learn, to learn well and use it right. Learning, however, should not only consist of acquiring information and applying it blindly; it should consist also of dialogue regarding the *appropriateness* of what has been acquired and how it ought to be applied. In very general terms, what is "good" and what is "bad" are questions that should always be asked, and attempts should be made, constant attempts, to reason and answer. It is for this reason that any creative person should, prior to anything else, get a healthy base and attitude toward the "poetics," or as it is more commonly known, "the aesthetics," of his discipline. This will cultivate in him an inquiring attitude (*aporia:* wondering) and will hopefully help him design solutions that are closer to what is "good." (In the past aesthetics was also called *kalologia,* "to talk about what is good.") This, in a sense, places an immense task on the shoulders of architects, as opposed to other creative artists, because their works, if not "good," may have enormous negative effects on the welfare of mankind. Aesthetics represents the broader base

of architecture as a creative and poetic act and, as such, it has to be considered as the foundation for any further learning of the elements of the language or the state of the art.

. . . The old professor would perhaps still shake his head, even after all the efforts. He would still ask his old students to give further explanations to all these things: "Tangible," "intangible," "interior," "exterior," "language of architecture," "principles of design," "user needs," "technological considerations," "environmental constraints," "aesthetics." . . . etc, etc. . . .

. . . I will attempt to analyze these things in this book, hoping that I will never lose touch with my strong conviction that architecture is, above everything else, "a poetic act" . . . And . . . if anything goes wrong, if any trivia gets in between I'll ask you to leave me alone, so that I might return to my train of thought—close my eyes, and get back to *poetry* again, where I feel *I am* (and at the same time I am absent). In poetry, where everything *is,* where things are all together and alone, "inseparable in their division and by design recombination."[11]

Notes

1. Louis Isadore Kahn, *Architecture,* Tulane University School of Architecture, New Orleans, 1972. (No page numbers).
2. This refers to the author's first experience as a student of architecture.
3. References and analytical discussion of the above statement can be found in the writings of Vitruvius, Renaissance writers such as Leon Batista Alberti, Filarete, Vasari, Palladio, and the twentieth century writers, Geoffrey Scott, Berenson, Frank Lloyd Wright, Le Corbusier, Gropius, Mies Van der Rohe, Giedion, Rasmussen, Gauldie, and others. Also refer to Antoniades, 1973 (l).
4. Conception of architecture according to Architectural Law and Rules of United States. Specific reference: *Architectural Law and Rules and Regulations,* New Mexico Board of Examiners for Architects, June, 1971, p. 78.
5. Antoniades, 1975 (l).
6. Louis Kahn, op. cit.
7. Nervi, 1965, p. 108.
8. Ibid.
9. Huxtable, 1976 (2), p. 52.
10. Read Chapter I of Gauldie, 1972.
11. Adapted from Yiannis Ritsos, 1975, p. 32.

Selected Readings

Gauldie. *Architecture.*
Giedion. *Space, Time and Architecture.*
Gropius. *The Scope of Total Architecture.*
Rasmussen. *Experiencing Architecture.*

2
Architecture and Aesthetics

"The state of the Art of Architecture in 1971 was one of lively confusion . . . what makes architecture in definition and practice? . . . The debate is style vs. antistyle, process vs. product. . . . Others reject architectural form of any kind. . . . And in New Haven, a true sign of the times, a symbol of rebellion and revolution has been rehabilitated. Yale's Art and Architecture Building by Paul Rudolph, which burned mysteriously two years ago after bitter criticism, and rejected as an artist's work, was reopened to students after renovation. They announced that they proposed to live with the building as "a statement of the human spirit and a manifestation of an ideal of human culture." It looks as if architecture may be coming back in style."

Ada Louise Huxtable[1]

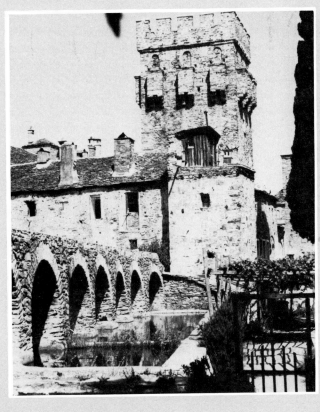

The architectural editorial was indicative of the state of architecture in the early 1970s in the United States. It was indeed in a state of confusion and doubt.[2]

During the mid-seventies the confusion became even worse. The dialectic between socio-economic-energy dynamics and professional pragmatism created further gaps between architecture and the way it was conceived by various architects, architectural critics, and architectural educators.[3] In the late seventies the confusion reached its highest peak. The almost simultaneous circulation of a number of books by writers such as Brent Brolin, Charles Jencks, Ray Smith, and Peter Blake (all of which succeeded an earlier Italian book by Bruno Zevi[4]) challenged what modern architecture of the twentieth century had been doing till then, assured everybody of the death of the Modern movement, and proclaimed a new era, the era of Post-modern architecture.[5] The dialogue burned on in practice and in schools. Many pointed to the real reasons for the creation of Modern Architecture early in the century (i.e., masses, new technology, new materials, etc.), and to the artificiality of Post-modernism, as it lacked the substantial dynamics that would call for its making. Others became fervent supporters of Post-modernism for the new freedom, the new formality, and the eclecticism it permitted. Two years after Post-modernism was introduced, the student magazine *Crit* offered the most comprehensive arguments against it.[6] It cautioned students and architects and called for what one could label a "back to discipline trend, away from the traps of fashion."

Yet much of the commercial architectural press worldwide went on publishing ideas and giving awards to proposals done by some architects, that under any normal circumstances would be classified as inhuman, masochistic, and even perhaps, lunatic. Although intellectual debate is prerequisite to evolution, much to the dismay of some people, a lot of the publicized architecture, and much of the "elitist" architectural writing of our day has been "ego" oriented. Much of it has been committed in the name of approaching "architecture as an art," "architecture for the users," etc., while in fact, it has been the camouflage for self-centered, self-serving incentives. The concept of "architecture as an art" seems to have faded away, and much of the fashionable architectural writing of our day has created meaningless, incomprehensible jargon that confuses the issues—and thus confuses students and the public. Architectural criticism became petty, often commercially and promotionally biased, and in too many cases, shallow.[7] Many architects, professional organizations, and even schools were searching for "terms" and design gimmicks. Yet very few of these things were helpful.

The result of all this was that architecture slipped from the hands of architects. Important tasks of architecture were cheapened, and certain architectural terms, such as "aesthetics," "art," and "society," lost their meaning. They became just a few additional meaningless words to expand the vocabularies of the commodity promoters and profit-oriented developers. "Architecture as an art" meant nothing for most people. "Why should I pay an architect to draw me some plans?" . . . would be the immediate concern of a person intending to develop a certain moderate-size building. ". . . If I can draw the plans, or pay a 'designer' to do it, why should I have to use an architect?" There were a few corporate or individual clients who supported architecture as an "art," but they were often motivated by tax incentives rather than "art" purposes.

Architecture as an art does exist in many parts of the world, but especially in the twentieth-century United States one experiences good architecture as just a drop in the ocean of environmental reality. Much of the best U.S. architecture and many of the best U.S. architects are unknown. Architecture worth mentioning is the exception. It is done primarily by people who have approached architecture as a vocation. These people are products of disciplined training and vocation; they understand the issues that underlie the trends. These are the people who have not forgotten the meaning of aesthetics; their primary role is the creation of appealing spaces in which people can live. These good architects have not forgotten that aesthetics deals with knowledge, and art deals with action. They have not forgotten that aesthetics philosophizes on the "virtuous" and formulates criticism for the evolution of art.[8]

There is a definite need to reeducate the architect, and to return to the roots again.[9] Aesthetics should cease to mean "looks"[10] or "elevations." Art should become an art again. If not, then architects should quit architecture and become contractors, profit-oriented developers, "designers," and draftsmen. . . . One often hears architects say such things as, "I did this for aesthetic reasons; this color is not good for the aesthetics of the building; . . . beautification; . . . it is out of style; . . . it is not good aesthetics." But these are meaningless, shallow statements. One should start from scratch and try in all seriousness; *the effort will bear fruit.*

Let us then go back to the roots. If one is to become an architect, he must make a meaningful beginning. If one is to remain a consumer, he must get a better idea of what he is consuming. One needs to start learning why he does what he does, and why he wants what he wants.

. . . After all, Ada Louise Huxtable may not have been wrong when she wrote, "It looks as if architecture may be coming back into style."

What Is Aesthetics?

Aesthetics is concerned with what is "good" (in Greek, *kalon*), what is art, what are its origins and evolution, what is and what should be its role in the social life.[11] Architectural aesthetics refers to all of the above with reference to architecture. The term *aesthetics* derives from the Greek word *aesthetiki*. Aesthetiki comes from the verb *aesthanome* which means "to feel." This term, therefore, may be somehow misleading as aesthetics not only preoccupies itself with the feelings evoked by a certain work of art (i.e., visual-mental-sensual feelings), but with the total inquiry of "what is good," in physical as well as social terms. This is why *kalologia* (the inquiry into what is good) would be a more appropriate term than the one-dimensional term *aesthetics* that was borrowed from the Greek language and introduced in the Western world by the German philosopher Alexander Gottlieb Baumgarten some two hundred years ago.[12] In any event, one should try to understand the concerns of architectural aesthetics as comprehensively as possible.

According to the way conventional aesthetics has come to us during the last two hundred years, through the concerns of European and American aesthetes, the inquiry may be presented as having four basic general aspects: the physical, which deals with the "feeling evocation" aspect of the term; the historical, which concerns itself with the evolution of the art; the social, which concerns itself with the role of the work of architecture in society; and the critical, which makes statements regarding what is "good," how good it is, and why. Everything dealt with in this book is part of the aesthetic inquiry. In the lines that follow, we pay introductory attention to the four basic aspects of architectural aesthetics, giving particular focus to the social dimension since it has been generally disregarded by many architectural treatises of the last two decades.

Aesthetic Inquiry

Evocation of Feelings

A major area of aesthetic inquiry concerns itself with feelings; visual, mental, and sensual. It tries to understand the feelings that are created by certain works of art and why. Why, for instance, do certain relationships between the physical dimensions of the elevation of a building create a feeling of security and stability while others do not? Why is a certain physical configuration accepted as serene by one individual and not by another? Why do some works evoke the feelings of fear, anxiety, indifference, etc., etc., while others do not? Why does a certain work make some people smile or laugh, while it might inhibit others and even disgust them? In the attempt to learn these "whys," aesthetics learns from the works being viewed. It

accumulates knowledge and organizes it in general ways that are useful in the creation of future works. In this sense, aesthetics has an analytical dimension, a dimension that also characterizes science.

In the process of Aesthetic argument, one encounters the "ideas" and "concepts" that were fundamental in the creation of a work: aesthetics, therefore, deals with ideas and concepts as well as with descriptive attempts to solve visual, mental, and sensual issues. Aesthetics presupposes sensitivity to feelings as related to a total matrix of experiential reality.[13] Moreover, it requires the ability to rationalize about the evocation of feelings and to articulate conclusions in ways that can be understood by others, the artists and the audience. We could safely say that "any philosophic discussion pertaining to matters of Art is Aesthetics."[14]

Criticism

This, however, has to be done within a framework of critical attitude. Criticism lies in the heart of aesthetics. And criticism based on sound aesthetic foundations is the prerequisite to artistic evolution. Aesthetics and criticism are the divine foundations of any art.

To be an aesthete on a specific art, one first must have knowledge of the art. To be an artist one does not necessarily need to be an aesthete; many artists do not feel they should have to articulate the "whys" of their decisions, or the motivations of their creations. Matisse said characteristically, "You begin painting well when your hand escapes from your head."[15] And Braque said that "the only important thing in art is that which cannot be explained."[16] These notions are often heard, but one should not forget that both Matisse and Braque were geniuses, and therefore, their aphorisms may only be applicable to geniuses.

Many subscribe to the notion that truth varies, and one could argue that even geniuses use their minds in aesthetic argument, even if they don't realize it. Their work of art is the conscious or unconscious dialogue among the various theses they take during their creative artistic processes. Many geniuses, as for example Picasso, have loathed conventional criticism of their works by others, yet they accepted well-intended criticism by people whose qualifications and opinions they respected. Picasso had a highly developed play of aesthetic argument with Braque. The result of this honest dialogue was the making of Cubism, an important art form of the twentieth century that perhaps would never have evolved if the two painters had not had these intellectual arguments and encounters of aesthetics. So, even in the case of the geniuses,[17] we experience the importance of the influence of aesthetics.

Of course, most people are not born geniuses. Many people, though, are born with creative charismata; we call them talented people. But talent will stay at an infantile level if not cultivated with aesthetic argument and persistent hard work. Aesthetics helps talented people to develop their talents. Aesthetics can also help people who are not talented in a field. These people will have to work much harder than the talented ones, but at the end they will overcome their initial handicaps through their involvement and persistence. It is possible that talented people who loathe aesthetics and do not persist may lose or never develop their talents; while it is possible and common for people without any talent at all to become successful servants of their art.

It is possible that great artists are also extremely articulate aesthetes. These people would be the best teachers a student could seek.

The didactic purpose of aesthetics is to provide the foundation for the development of artists in one art or another. Aesthetics gives the architect the "intellectual tools" of his art; this learning comes about through philosophic discussions pertaining to architecture.

Historical Foundations

Some of these discussions deal with the architecture of previous generations. The history of architecture is, therefore, part of the aesthetic inquiry. The same is true with the study of contemporary works, the study of works of important architects, and the constant consideration of the relationships between architecture and the other arts and between architecture and its allied design disciplines.

The first aesthetes of mankind were the early philosophers. The aesthetic dictum of the Ancient Greek was, "ΦΙΟΣΟΦΟΥΜΕΝ ΓΑΡ ΜΕΤ' ΕΥΤΕΛΕΙΑΣ ΚΑΙ ΦΙΛΟΚΑΛΟΥΜΕΝ ΑΝΕΥ ΜΑΛΑΚΙΑΣ."[18] This means, "We philosophize with modesty and pursue the arts without being soft." Architecture attracted numerous aesthetic treatises.[19]

There is an abundance of bibliography pertaining to architectural aesthetics today. Most of the good contemporary works were written in the early twentieth century.[20] As architecture develops, as its relationship to society and technology broadens, so does the aesthetic inquiry. A recent architectural aesthete who expanded this inquiry to include technological considerations is Reyner Banham.[21] An architectural aesthete who enlarged his dialectic to include urbanization concerns is Vincent Scully.[22] The aesthete who focused his attention on issues of environmental psychology and performance criteria for buildings is James Marston Fitch.[23] It is the author's opinion that these people and their theories represent the keys to more recent developments in architectual thinking. If one were to look, for instance, for the foundations of "American Postmodern," he would certainly have to give credit to these men.

The nonarchitectural aesthetes who are extremely important to the architect, although very difficult to follow at the beginning, are philosophers such as Gaston Bachelard who wrote on "the poetics of space"; Jean Paul Sartre who wrote the general treatise, *Essays in Aesthetics,* which dealt with the creative process;[24] Albert Camus whose work, *Critical and Lyrical Essays* partly dealt with the meaning of space to people; and musician Igor Stravinsky whose work, *Poetics of Music* is a first-class reference for the aesthetic issues of traditional vs. contemporary elements of architecture.[25] Indispensable readings for the development of a comprehensive aesthetic vocabulary are the works of social anthropologists who have dealt with the issues of perception and meaning in different cultures.[26] The Norwegian professor, Christian Norberg-Schulz has approached aesthetics from the "meaning" point of view. His works provide a good introduction to aesthetic issues as related to people who belong to different groups and cultures.[27] One should mention, also, the geographer Yi-Fu-Tuan who studies the concept of "topophilia," man's love for place, and who has investigated in depth the mental prerequisites of aesthetics.[28]

Aesthetics pertain to the philosophic discussions on matters of art. Yet architecture is a man-serving art. Man is part of society. Aesthetics, therefore, should consider first the relationships that exist among society, art, and the art of architecture. Panagiotis Michelis, in his book, *Architecture as Art,* developed some very good arguments, in the author's opinion, on the above issues.[29] The analysis that follows on the issues of society, art, and the art of architecture represents the author's endorsement and an adaptation of Michelis' argument to suit the introductory nature of the present study.

The Social Aspect of Aesthetic Inquiry

It is axiomatic that creations of man are products of his needs, physical or mental. Works of man usually *serve* man. But man lives in society; his works should serve himself and society if he is to live in peace within the larger context. Man's works usually aim at satisfying him. Some people, in some societies, get greater satisfaction by creating products for their own personal needs. Other people, in other societies, tend to derive greater satisfaction in creating products for the satisfaction of others. Almost all people feel satisfaction when others compliment and admire the products they produce. Many men want society to be aware of their works; they feel the need for expression and recognition. To communicate with society is a deeper reason for creative work. It has been argued for these reasons that "the need for communication is *ephemeral,* while the reason, the motivation, is eternal. "We come and go, but society stays." It has also been argued that "the more individualistic a work of art, the more antithetical it is to the communal interest and vice versa."[30] One may not necessarily agree with that. Yet one would agree,

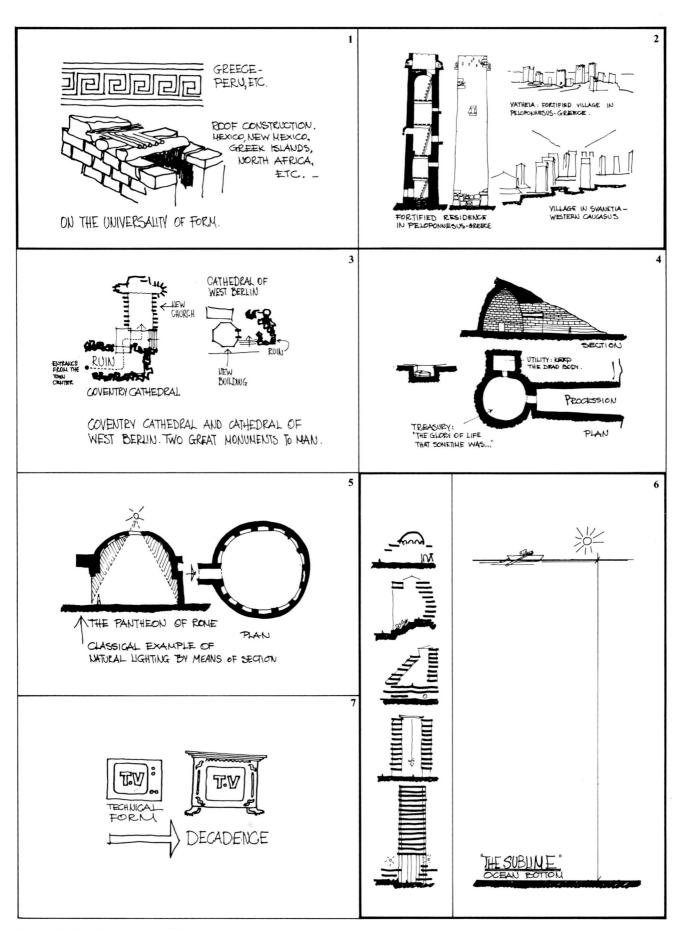

Figure 1. Aesthetic concepts (1)

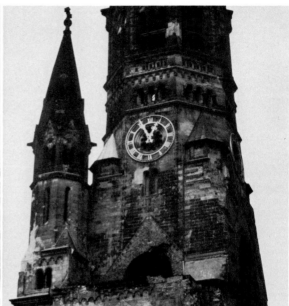

Cathedral of West Berlin. Egon Eiermann, Architect. (Photos by Hasan Tariq.)

however, that a work of architecture should not be conceived as separate from the communal spheres of environmental design such as urban design and urban planning. Architecture and urban design, when balanced, create equilibrium between personal (or individual) needs and communal (or collective) needs of a certain communal order.

Small-scale architecture (architecture of individual buildings) and large-scale architecture (urban design, urban planning), considering both individual and collective needs, create and maintain peaceful co-existence among the members of society. Most works of architecture and its allied design fields serve man in practical ways; they also appeal to man's viewing delight. There are other endeavors, such as painting, music, singing, and even architecture, that do not serve practical purposes; they may not even serve monetary interests. However, they do arouse the interest and appreciation of society. Such nonutilitarian works have the strength to arouse the emotions; they have the power to move people above the everyday human triviality, above the narrow limits of their egos, and to make them feel communal feelings. This is, one could suggest, the greatest purpose of art, and this is why the greatest expression of architecture is to be found in the works that wake one's soul and that make "brothers out of strangers."[31] This happens with the playing of the ancient "tragedies" when all people applaud a virtuous deed.[32]

Among the architectural works of this century that generally cause superior effects on the people who experience them, one could single out the cathedrals in Coventry, England, and in West Berlin. The quoted passage from the travel diary of a Greek architect who was living in self-exile during the years of a dictatorship at home (1967–74) communicates the strength of the new cathedral of West Berlin designed by architect Egon Eiermann.

". . . the Cathedral of West Berlin. A ruin; yet a ruin that was maintained by the architects. Next to that, an indifferent, octagonal, new edifice . . . A fugue by Johann Sebastian Bach was playing on the organ. . . . I walked into the opened cathedral. There were very few tourists in West Berlin at that time . . . I went inside. . . . There was a dictatorship at home. I had not gone back in years. I didn't think I would ever go back. I thought of the other dictatorships in Germany. . . . I got lost in my thoughts, and the music of Bach. . . . My tears dropped to the floor. Now I recall how the floor was made: some crystal glasses inbedded into the glazed tile. . . . I saw my tear shining on the glass. The church was empty; just me and Bach. I left the tears going. Sparkling constellations returned from the floor hitting my eyes. . . ."

Some time later this architect wrote to an art historian friend about the church and his experience. "I thought you would understand. I want to tell you about architecture and its effect on man," and he mentioned his tears on the shining floor. He said he didn't know the name of the architect then, the textbooks he had read did not include the cathedral of West Berlin; yet he was sure he was experiencing a superior work of architecture. His letter went on like this:

"That architect, if he designed thinking of people crying in the cathedral, thinking of Johann Sebastian Bach, thinking of the ruin, and thinking of people's cruelties in Berlin, then this architect, in my opinion, must be one of the greatest architects of the world . . . and this Cathedral, the ruin and the New Edifice, is—*The Guernica of architecture*—the disaster of Guernica and the flower on the left corner of the painting—the ruin and the shining crystals in some secret corner of the temple. Flowers, cries, honesty, hopes, catharsis. . . ."[33]

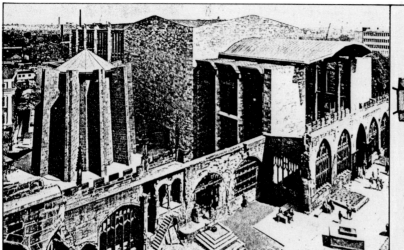

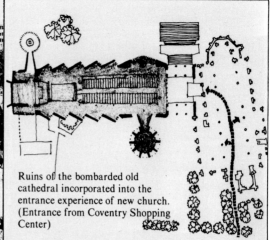

Ruins of the bombarded old cathedral incorporated into the entrance experience of new church. (Entrance from Coventry Shopping Center)

Coventry Cathedral
Sir Basil Spence, Architect, 1951–1962.

Figure 2. Coventry Cathedral

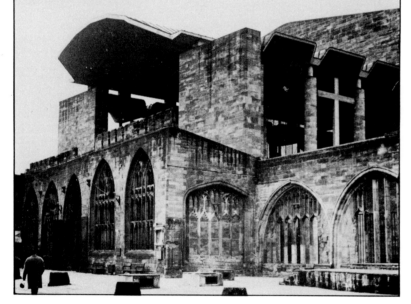

Cathedral of St. Michael's in Coventry. The entrance experience is an anathema to war. Sir Basil Spence, Architect, 1951–1962.

Works with that power can be called "works of art." What they serve is not the practical, ephemeral purpose of a society, but rather society's eternal values. Works of art, therefore, express *"ideas."* "Hope," "catharsis," "condemnation of past cruelties," "man's self-criticism" . . . These are, in the mind of this author, some of the ideas conveyed by the cathedral of West Berlin. To understand the *idea* of a work of art is not an easy thing. In order to feel *aesthetic emotion* in a work of art, we have to try to get into its spirit. Then, as Michelis said, quoting Socrates, "we will fall in love-unity with it."[34] . . . The work of art attracts us as a magnet attracts an iron ring. This attracts all other rings around it until a pyramid of rings is created, at the top of which is the inspiration of the poet[35] . . . the creator, the painter, the musician, the architect.

Ideally, works of art should be formulated in such ways that, by *viewing* them, it is possible to understand the works' spiritual contexts. It is only then that a work of the art of architecture is liberated from the need of the purpose it serves. It goes beyond the practical need and becomes the manifestation of some spiritual need, the spiritual need it expresses.

Art is considered to be the *universal language* of our global amalgam. Art is the only human thing. In some future times, when more layers of sophistication will have been imposed upon us and cause us to completely forget and be completely unable to see our primitive humanity, art will remind us that we still have some positive values, that we are still good, that we are still human. And if we say that we think this is necessary, if we think that our

Outdoor sculpture in San Francisco. Broken concrete elements and water: the destruction of the great earthquake and the life that continues.

progressing alienation from ourselves and our fellow human beings is occurring now, then we have a responsibility as architects to see our profession as our art again. We must perform for society what we alone can perform, and offer our work to the world; so worked out, and painfully formulated as work of spiritual art, that it will finally make us all feel in unity again. It will cause us to react again and joyously exclaim that the work of architecture has touched our inner, primitive, human chords.

. . . Architecture then should be a tool for people, a means to the brotherly union of the human race, an incentive for catharsis . . . in a world that we are losing. This should be the position of architecture as an art, and this should be the relationship of architecture to society.

But how can architects meet these goals? Sometimes people ask, "But does it all have to be *architectural,* does it all have to be good? Some works are just for utility. Not everything can be a monument." An architect should then reply, "Yes, everything can be given the *blow* of art; everything architects do ought to be given the spirit of life, the spirit of creation." Bad works have been created when their creators failed to do this, when they failed to assume their responsibility to their art.

Creating Aesthetic Architecture

The architect's main concern should be to create works that transcend the trivial and become works of art. Most works of architecture, like most other works of man, fulfill some utilitarian need. In that respect some basic questions have to be answered: How can works of architecture be made to transcend utility and rise to spiritual spheres? When will a work created to meet a utilitarian need become the cause for aesthetic pleasure, and thus have a value of its own—this value which will express spirituality and foster the "common union" among people expected from works of art? Is it possible to achieve these ends with any kind of work, or are there some works in which the creation of aesthetic pleasure is easier?

The glory of El Greco; from the interior of Santo Tome mural on the Adobes of Toledo.

Paraportiani, Mykonos. The poetry of a people.

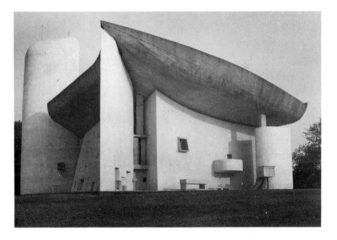

Ronchamp Le Corbusier, The poetry of a man, 1954.

It must be stated now that *the creation of aesthetic pleasure rests with the blow of life that the creator puts into his creation.* This *blow* could be called the process of the formulation of a work. Based upon the kind of process involved, we can distinguish three very basic forms of man's creation:

1. The very utilitarian
2. The technical form which is a direct result of certain scientific rules and is undeniable
3. The artistic form[36]

All three may be *works of art,* **but we must always know what we should expect from each.**

Utilitarian Forms

The history of art, archaeology, and man teach us about man's early utilitarian works. The tools he used to kill animals and other people in order to eat and protect himself were among his earliest works. At first they were characterized by temporariness, minimum adjustability to the

Japan's message of peace. Kenzo Tange's pavilion in Osaka, 1970.

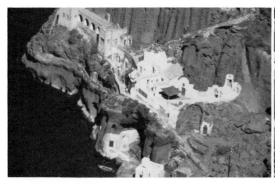

Cave habitation satisfied the early utility of shelter. In time the caves acquired entrances and painted elevations. Finally memories of other forms found their way on the rocks through vernacular ingenuity. Ancient pediments on contemporary troglodytic dwellings in Santorini, Greece. The cave transcended its utility.

form of the human body, and a very limited radius of action. Man spent a lot of energy in order to use his first tool and often failed to kill the animal at which he was aiming. These primitive utilitarian creations of man, his first tools, became works of art only when man felt the need to keep them instead of throwing them away after they had fulfilled their primary purpose. He began to carve on them symbols of the animals he intended to kill, and he made his tools and his weapons elements of his household, decorations for the walls of his home. He kept them as relics, to remind him of his youth, his first lion killing, or the weapon with which he had protected his family and religion. In the Middle Ages, the utility of the hunting tool became secondary. It was assumed that an arrow worked, so more emphasis was put on the colors, the lines carved or painted on it, and the mannerisms and virtuosity with which certain tools were used. Ceremony was attached to the use of elements of utility. Ceremonies became part of life.[37]

A utilitarian work of man, therefore, may evolve and in later stages become a work of art, with values beyond the ones for which it was once created.

When appreciating an artifact, we must ask ourselves: Is it strictly utilitarian? Does it really serve the utility (the need) for which it was built (e.g., could the stone be properly handled by the primitive hunter)? And if so, does it transcend this purely utilitarian need? Does it foster other feelings upon sight? Does it evoke man's respect for reasons beyond the purely functional ones? If that is true, this specific work of man is an *artifact,* that is, a utilitarian object into which was blown the love of its creator. It is a simple person's work of art, even though it has as its primary purpose, serving man.

Thus, even in the process of creating a purely utilitarian form, a work of art may be generated, and that should be the aim of every creator.

As with any artifact, with any work of architecture, there should be no justification that "because it is utilitarian it cannot be a work of art." Many corporate architectural firms in the United States have built completely utilitarian buildings (for example, observatories, power plants, etc.) which transcend the strictly utilitarian purposes. They have gone beyond the initial purpose of "need" and have created "architecture."

Technical Forms

We call technical forms those which are based upon certain scientific laws—the law of gravity, certain lunar radiations, the form of the satellites, or the uniforms of astronauts. They are stricly based upon natural facts and mathematics. These forms can be the only ones we see and nothing else. If they evolve, it is not because of any artistic motivations of a designer; rather they evolve because existing forms are incomplete. When a technical form has reached its peak, it works as an absolute solution to the natural constraints (e.g., radiation) that define the need for it. Beyond that point there is decadence. This happened recently when television manufacturers promoted television sets in engraved wooden boxes. Such woods as mahogany and elaborate decorations are "unnecessary cosmetics" for the well-developed television set.

Should a technical form become a work of art? The author believes not, because a great technical work has powers similar to those of art. A technical work unites all people in their admiration for what this work performs: admiration for the "unexplained miracles" of television, admiration for the astronaut's uniform, admiration for the "little instrument" that magnifies things a thousand times beyond our limited eyesight capability. This admiration is felt the same by all people; all people are united in front of a technical work.

The negative is also possible. A technical work may create a gap among people. It may create hate. It may create wars.

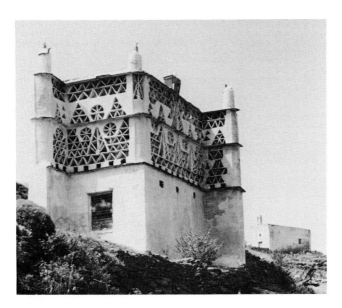

Free-standing rural structures devoted solely to the "adoration and sheltering of the pigeons" in the island of Tinos-Greece c. 1300 to today (left).

The "pigeonhole" rural vernacular as integrated decoration to the residential architecture of the island of Tinos elevates the otherwise simple cubic masses to statements of higher art.

Thus, the potential danger of a technical work is in its definite distinction from the humanistic aspect of art: art should promote peace rather than war, love rather than hate. War and hate may unfortunately occur through the use of technical forms. But people who create technical forms, many of which have inherent distructive potentials, enjoy the respect of all people. We all respect scientists and scientific designers, because we do not understand what they are doing. We do not understand their mathematical and scientific experiments; and we are glad to place them above ourselves, accept them as superior beings, and make them happy.

Scientists are happy, because although people do not understand how they do what they do, people are prepared to accept their work.

Artists are often unhappy. If John Doe does not understand Picasso's "Guernica," Picasso "must be crazy." This is the dilemma of the artist—constant frustration on one hand, continual effort for betterment and appreciation on the other.

Artistic Forms

We have already referred to the artistic qualities of music, theatre, painting, and architecture. We could also discuss those of dance, prose, and the cinema. What is essential here is for us to understand how architecture differs from the other forms of artistic expression.

Music and dance and, more recently, cinema are the arts that readily bring aesthetic delight,[38] common union, common soul, and catharsis. These things are difficult to achieve with painting, and sculpture, and even more difficult with architecture.

Of all artistic expressions, architecture expands to the greatest degree beyond the spiritual, for it must be spiritual even when it serves the most utilitarian purpose. The difference between architecture and the other art lies here. Unlike the other works of art, a work of architecture must combine all three aspects into one creation. Architecture must be utilitarian, technical, *and* artistic. Only when the three exist in harmony, should one be satisfied and, therefore, speak about the existence of a work of architecture.

Of course, man went through periods when he created works to shelter himself which were not works of "architecture." The cave was not. But the fortified houses of Kaukase and Mani in Greece and in Italy are architecture. One wonders about and admires the person who created such an edifice for the protection of his family.[39] This man's love for his family has the power to move one, to make a person react positively. The man is admired for the ingenious creation of his residence.

The same is true with the tomb. A utilitarian hole in the ground (Mycenae), a necessary thing in which to bury the dead, becomes, in later years, a *ceremonial procession* and a *place*. The tomb of Atreus, its street, and its majestic treasury are symbolic statements of "the glory of a life that sometime was." To the right or the left, in contrast, lies the purely utilitarian place for the dead. . . .

. . . So this chapter concludes with the following statement: only when the utilitarian form and the technical form are subordinate to the artistic in a functional and harmonious way, can a creation be considered a work of architecture.

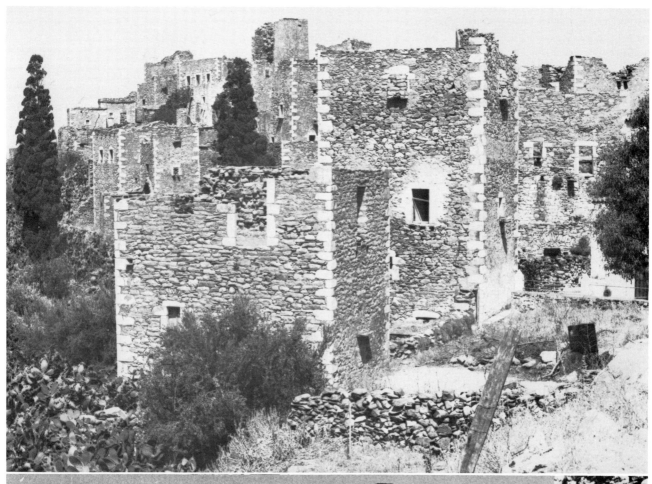

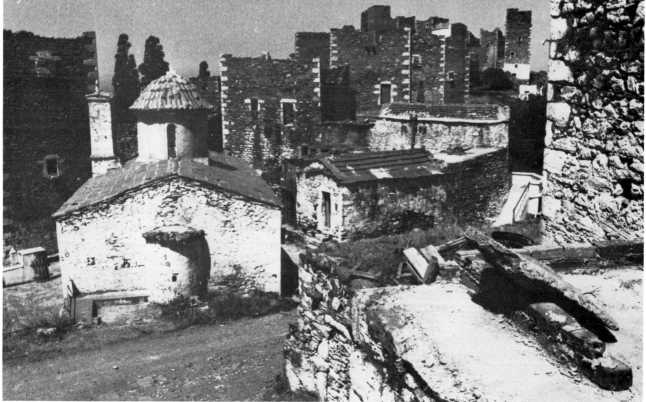

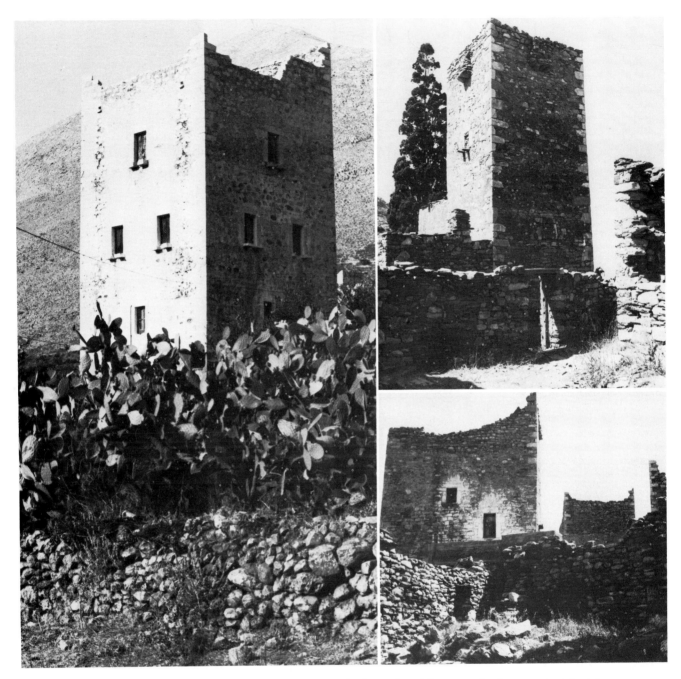

Vatheia-Mani, Peloponnese Greece. Fortified residences. Form evolved out of need for protection from constant feudal disputes and clan fighting.

If this is the case, if this is a work of architecture, then *man* moves, stays by, uses, or looks at it, and, in union with other people, reacts. He is at peace with the work, because the work satisfies his natural needs, his environment-adjusting capabilities, and his spiritual needs. . . . It has been said that architecture is a spiritual art and architects are its highest priests. Thus architecture is not the "drawing of some plans." . . . Architecture is achieved not only by means of plan, not only by means of volume, not only by means of *voids* vs. *solids,* not only by means of light and time experience, not only by the proportions of the edifice and their relationships to man. . . . But by all of these elements combined, all at the same time and in a way that gives integrity, wholeness, and harmony to the work of which these elements represent parts. Then the work will move; it will move the user and also the person who looks at it. It will give a glimpse of eternity, and a vision which will remain with the person forever.

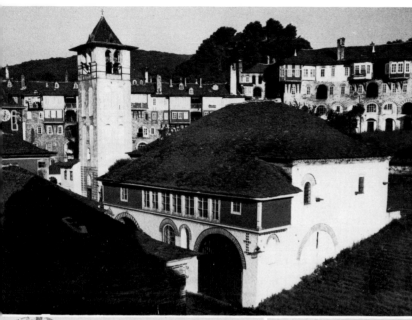

Monastery of Vatopedi (*top left*). Monastery of Megisti Lavra (*top right*). Stavronikita monastery (*bottom left*). Tower and residential quarters of Vatopedi Monastery (*bottom right*).

Notes

1. Huxtable, 1972, p. 26.
2. The "doubts" of this era were articulated by James Marston Fitch in 1970. This happened prior to Huxtable's editorial in the *New York Times*. See Fitch, 1970, p. 87.
3. A study of the professional and educational literature of the mid-seventies provides concrete evidence for the points made. Refer to *A.I.A. Memo* and *A.I.A. Journal,* 1974, 1975; and to Antoniades, 1973 (1); and Antoniades, 1973 (2).
4. English text entitled "The Modern Language of Architecture," Bruno Zevi 1978.
5. Refer to Brolin, 1976; Jencks, 1978; Smith, 1977; and Blake, 1977.
6. See, for instance, Laine, 1978.
7. It is widely known that some of the recent critical books on architecture were produced in very off-hand ways. It has been rumored that a four-day visit generated a book on a characteristic automobile city, while a quick visit to Houston by one of New York's most prominent architectural critics generated some "trend-creating" editorials.
8. Michelis, 1965, p. ia.
9. Antoniades, op. cit.
10. On the misapprehension of "aesthetics" refer to Fitch, 1970, p. 86.
11. See Varnalis Costas "Aesthetika—Kritika," Kedros, Athens 1958, p. 11.
12. Van De Ven Cornelis T.M. "Concerning the Idea of Space: The Rise of a New Fundamental in German Architectural Theory and in the Modern Movements until 1930." Ph.D. dissertation 1974, University Microfilm International, p. 4.
13. Ibid, p. 86.
14. Michelis, op. cit., p. ia.
15. O'Brian, p. 267. It was perhaps Picasso's attitude that made his friend, Cocteau state, "Genius, like electricity, is not to be analyzed. You have it, or you don't have it."
16. O'Brian, p. 7.
17. Jean Cocteau, "Le Rappel a l'Ordre" in Phelps, 1970, p. 83. Also refer to O'Brian, p. 267.
18. Stated by Pericles in his "Epitafios."
19. Refer to works by: Vasari, Filarete, Alberti, Palladio, Vitruvious, and Leonardo da Vinci.
20. Refer to works by: Berenson, Scott, Michelis, and Papanoutsos.
21. See Banham, 1969.
22. See Scully, 1971.
23. See Fitch, 1970 and 1971.
24. See on Alberto Giacometti and Calder in Sartre, 1963.
25. Also refer to Antoniades, 1971.
26. As such original readings may be difficult for the young student of architecture, the simplified secondary references of Christian Norberg-Schulz, 1969, and Yi-fu-Tuan, 1974, can be used.
27. Norberg-Schulz, 1973, and Jencks, 1969.
28. Yi-fu-Tuan, 1974.
29. Michelis *E Architoctonike os Techni* ("Architecture as Art") only in Greek. Athens edition, 1965. The student of aesthetics is also advised to refer to Michelis 1949, 1958, 1959, 1962, 1966, 1969, 1971, 1972, and to the total work of Michelis in *Aesthetic Theorems* (in French) and *Aesthetica Theorimata* (in Greek), Athens, 1965, 1971, 1972. See also Michelis 1974 and Bonta 1977 pp. 235–38.
30. Michelis, 1965 (1), p. 1.
31. Fitch, 1970, p. 101.
32. For classification and analysis of the various "aesthetic spheres," refer to Papanoutsos, 1964.
33. Antoniades, unpublished sketchbook, West Berlin, Summer, 1968.
34. Michelis, 1965 (1).
35. Ibid.
36. Discussion of the various forms of the works of man can be found in most art history and introductory aesthetic treatises. Specific reference is made here to Michelis, 1965 (1), pp. 7–9.
37. Huizinga, 1954 and 1962.
38. Fitch, 1970, p. 101.
39. For further information regarding the function-social dynamics/form relationship of the fortified residence of Mani in Peloponnese, Greece, see Fermor, 1971, pp. 125–135.

3
Design Concepts

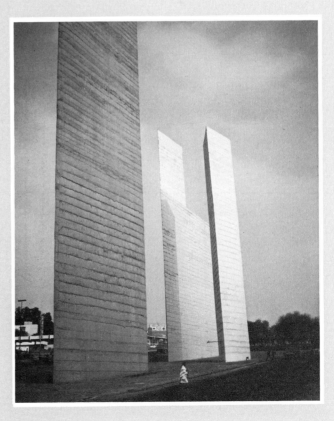

The aesthetic vocabulary of architecture consists of the following concepts: (1) synthesis, (2) organization, (3) order/hierarchy, (4) dominance-exarsis-punctuation, (5) imageability, (6) legibility, (7) identity, (8) diversity, (9) scale, (10) proportions, (11) rhythm, (12) unity, (13) meaning, (14) intention, and (15) morality.[1] Very special connotations of the above terms constitute the basis of all architectural design, as well as the basis of almost all creative arts. These concepts are the "intellectual tools" of designers; the quality of any design is dependent on them. Rationalization pertaining to each one of these "intellectual design tools" can explain the basic reasons for the appeal or lack of it in a particular work of art. No aesthetic analysis and no design can be successful without a good understanding of these basic concepts. The understanding of these concepts should be the fundamental preoccupation of all students of architecture and all architects. A detailed examination of the concepts is carried out here for the use of the student and the layman.

Synthesis

A primary concept is that of synthesis. In the English language one often uses the word *composition.* Its meaning is exactly the same as that of synthesis. Synthesis is a combination of two Greek words, *syn* and *thesis: syn*—together, adding, or plus; and *thesis*—thesis, situation, position, entity, statement. The word *synthesis,* therefore, means "to put together" certain elements . . . in a way that a new thesis is stated, a new position is created, a new work is generated. A work of architecture, then is a work of synthesis in which elements are put together in such a way as to constitute an entity, to create a new thesis or a new statement. In the case of elements which have been put together but do not constitute a new statement, or a new meaningful entity, one may not speak of a work of *SYNTHESIS.*

Composition (from the French *composer*—put together) means exactly the same as synthesis. The elements to be put together in a work of architecture (as, of course, in any other form of art) may be completely unrelated even totally antithetical; yet if they are to become architecture (painting, dance, or music), they have to be put together in complementary ways through a rationale that will accommodate them in a cooperative way. This rationale in most arts is based on prerogatives of the artists. This is spoken of as "poetic license." In architecture, which is among others a functional art, this rationale is enforced by the "program" to be served or by the needs of the user(s) who will live in the work to be produced. The rationale of architectural synthesis is largely dependent on the architect's personality and on his ability to restrain himself within frameworks of possibilities ranging from the very loose to the very controlled (tight). To become more precise, the architect has to set for himself "the rules of the game." He may spend, for instance, all of his life trying to find the optimum combination for putting the elements of his SYNTHESIS together, or he may decide that he would prefer to spend one week instead. The decision between the life-time period of effort and the one-week period of effort (or an attempt for synthesis) is purely dependent upon the artist. In the case of architecture, this decision is often dictated by the deadline for the submission of the project. The utilitarian element of architecture helps the architect to set a deadline; this helps the architect to work within certain "game rules," and thus makes the task easier.

If such **rules of the game** were not imposed by reality or by the architect himself, then the work of synthesis might last forever, as there could always be a better possibility of putting the elements under consideration together. If that were the case, the architect would produce one unfinished work in his life, and it would never be built. The good architect, therefore, must not only be able to put elements together in order to create a meaningful new whole, but he must very early in his process of design be able to set the rules by which he will produce his work of art. These rules (time, materials to be used, formality vs. informality, etc.) are set more easily by experienced architects. These rules of the game, especially the limitation of the time to be spent in design, may become such that they affect the work in a negative way.

A very short time schedule may produce an inferior solution to the extent that it may force the architect to copy some of his previous works. In such a case, therefore, we would not be able to speak about a work of architecture as the element of a "new thesis" or a "new statement." We may agree, therefore, that the works which are products of minimum time spent on the design stage are not works of architecture. As such they must be challenged, and the architects in consideration should be aesthetically, artistically, and professionally questioned. One should dismiss such practices as unworthy of architecture.

The ability to set one's own rules of the game depends upon experience; the statement of such rules and the architect's consistency in them represent the **discipline** of the art. Discipline is the ability to exclude all other possibilities and work within the possibilities of the game rules one has set. Life after all has an infinite number of possibilities. A disciplined life is a life which is pursued on the basis of certain predetermined rules. In painting we have the case of Joseph Albers. He explored possibilities for interaction of color (color combinations), yet he did it through the fundamental concern that his forms would be only squares within squares within squares. The same high level of discipline is shown by Mies van der Rohe. He worked out his works of synthesis in a way that all he had to do was to follow the rules of his game. These rules were 90° coordinates and limited combinations of materials—steel, glass, and marble.

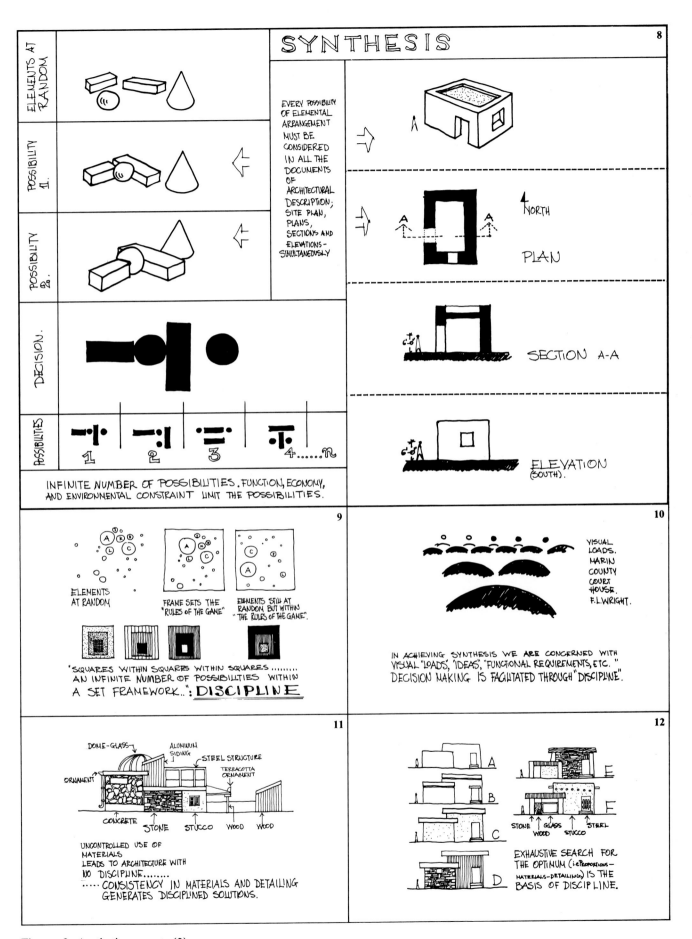

SYNTHESIS

ELEMENTS AT RANDOM

POSSIBILITY 1

POSSIBILITY 2

DECISION

POSSIBILITIES

1 2 3 4......n

INFINITE NUMBER OF POSSIBILITIES. FUNCTION, ECONOMY, AND ENVIRONMENTAL CONSTRAINT LIMIT THE POSSIBILITIES.

EVERY POSSIBILITY OF ELEMENTAL ARRANGEMENT MUST BE CONSIDERED IN ALL THE DOCUMENTS OF ARCHITECTURAL DESCRIPTION; SITE PLAN, PLANS, SECTIONS AND ELEVATIONS—SIMULTANEOUSLY

A

NORTH

PLAN

SECTION A-A

ELEVATION (SOUTH).

9

ELEMENTS AT RANDOM

FRAME SETS THE "RULES OF THE GAME"

ELEMENTS STILL AT RANDOM, BUT WITHIN "THE RULES OF THE GAME".

"SQUARES WITHIN SQUARES WITHIN SQUARES........ AN INFINITE NUMBER OF POSSIBILITIES WITHIN A SET FRAMEWORK..": DISCIPLINE

10

VISUAL LOADS. MARIN COUNTY COURT HOUSE. F.L.WRIGHT.

IN ACHIEVING SYNTHESIS WE ARE CONCERNED WITH VISUAL "LOADS", "IDEAS", "FUNCTIONAL REQUIREMENTS, ETC." DECISION MAKING IS FACILITATED THROUGH "DISCIPLINE".

11

DOME-GLASS ALUMINUM SIDING

STEEL STRUCTURE

TERRACOTTA ORNAMENT

ORNAMENT

CONCRETE STONE STUCCO WOOD WOOD

UNCONTROLLED USE OF MATERIALS LEADS TO ARCHITECTURE WITH NO DISCIPLINE........CONSISTENCY IN MATERIALS AND DETAILING GENERATES DISCIPLINED SOLUTIONS.

12

A

B

C

D

E

F

STONE GLASS STEEL
WOOD STUCCO

EXHAUSTIVE SEARCH FOR THE OPTIMUM (i.e.PROPORTIONS— MATERIALS-DETAILING) IS THE BASIS OF DISCIPLINE.

Figure 3. Aesthetic concepts (2)

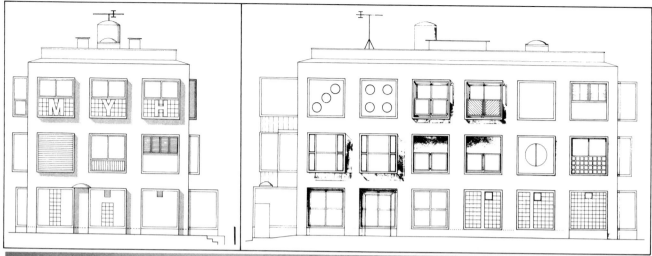

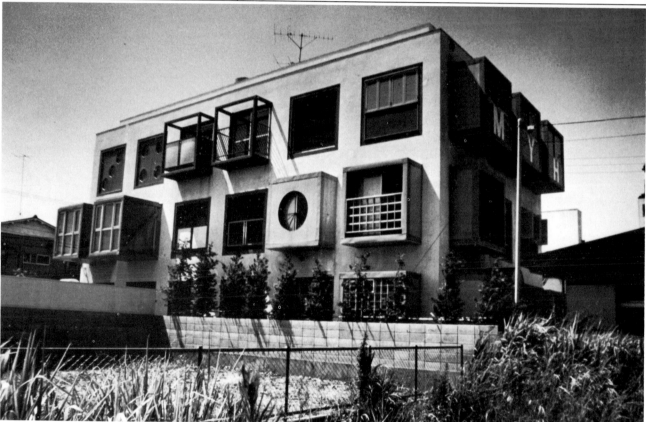

The rules of the game are "tight"; the game itself is diverse. "54 Windows" or "Tokyo Boogie Woogie," Kazuhiro Ishii, Architect, 1975. (Drawings by Kazuhiro Ishii.)

Discipline and the ability to perform depend upon the personality of the artist. Various artists may go through life with one set of rules, as for instance Joseph Albers, Mies van der Rohe, and S.O.M.; others will experiment by setting different rules of the game at different stages of their lives. Some examples of those would be Frank Lloyd Wright (prairie period, Late Guggenheim period, etc.), Le Corbusier (use of concrete, sculptural approach to architecture, urban concern), and Paul Rudolph (spatial discipline, "New Freedom" discipline, "modular design and systems" discipline). Both cases of discipline, the strict or static and the evolving or free, should be acceptable, although one might suggest that the second category could provide more opportunity for innovation, while the former could become stagnant and boring.

Many people have argued, and one would easily agree, that periods of architectural eclecticism (i.e., nineteenth-century Beaux-arts, twentieth-century Postmodernism)

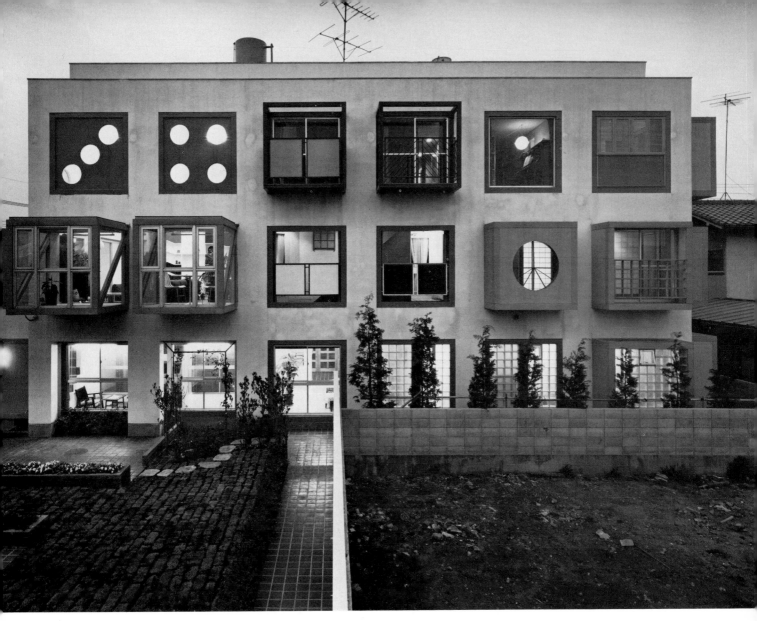

"54 Windows" or "Tokyo Boogie Woogie," south elevation at night. Kazuhiro Ishii, Architect, 1975. (Photo by Tohru Waki.)

have lacked real architectural discipline, or rather that their discipline was of an inferior level. The success of eclectic architects is dependent upon their ability to select and copy architectural styles of other times and other places (often ancient Greek, Roman, Egyptian, or Gothic) which were created under different sets of circumstances (different materials, different technologies, different life styles). If synthesis suggests the notion of "something new," then certainly to copy does not fulfill this notion. If discipline represents a necessary quality in performing a "synthesis," the disciplined architect should avoid the trap of imitation.

The discipline of the architect is therefore the fundamental quality in performing a work of synthesis, because it makes synthesis a realistic possibility. The amount of discipline to be exercised, however, is a completely different quality an architect possesses. This quality is called **measure.** One may live a *disciplined* life (i.e., no drinking of alcohol, not eating certain types of food, etc.), but the

issue of *how much discipline* is what we will call "measure." The ancient Greeks believed that measure was the top quality of a work of art. They used to say, "*Pan metron Ariston*"; "it is top virtue to create works that have measure." To determine the appropriate measure is a most difficult thing. Yet measure is present if there is not excess of anything and if the rules of the game as set by the architect have been conscientiously retained.

If all these prerequisites exist, *rules of the game, discipline,* and *measure,* then a work of synthesis may eventually be achieved.

In the process, however, a number of other concepts must be used. These "tools" are examined in the pages that follow. It appears therefore, that the concept of SYNTHESIS is fundamental, while the others are subordinate concepts but necessary for the achievement of the fundamental one. The process of utilizing all the concepts in making a work of synthesis is what we refer to as the "process of design" or simply "design."

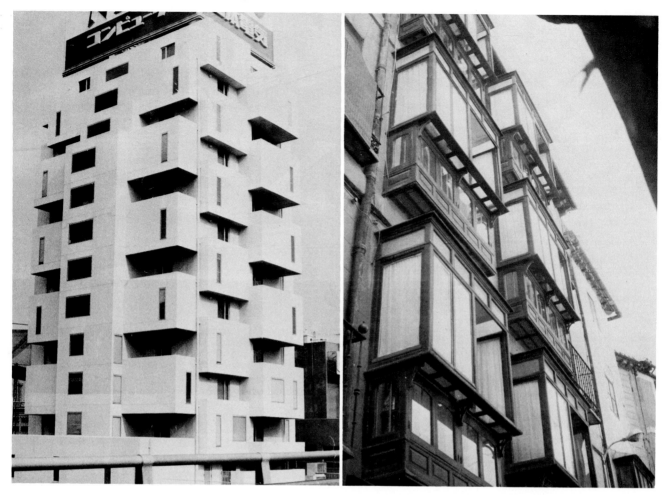

Left, discipline of systematic construction. Apartment building in Osaka, Japan. Right, discipline due to a life style pattern. Balconies for the ladies of a Toledo apartment, Spain.

Summary

To *synthesize* is to create a new reality out of many parts.

The process of making a synthesis is called "design;" and "design process" represents nothing but the mechanics, or the steps on the road called *process,* that one has to follow in making a design. "Synthesis" is superior to "design," however; "design" does not necessarily imply that the work is a synthesis, that is, the creation of a *new reality,* a *new thesis,* by putting parts synthetically together. This is why the term "designer" is often regarded with reservation and skepticism.

Architecture must seek synthesis. When this is not achieved, the design in concern is not a work of architecture.

Abstract patterns,[2] therefore, cannot become works of architecture, as they obey certain other demands of design and may not necessarily permit the satisfaction of certain needs. For example, a work of decorative art, a work of two-dimensional synthesis in itself, a work concerned only with the balance of certain shapes and loads of colors in two dimensions,[3] has very little chance to be used as a stimulant for the creation of architecture.

However, the simpler a work of two-dimensional design becomes, say it becomes a "square" by Joseph Albers, the better are its chances of becoming some stimulant for a work. A square in three dimensions may suggest a universal space, in other words a free space, in the interior of which many things may happen and flexibility may be achieved. This work of design, then (e.g., the squares of Albers), may be easily used.

Of course, part of the education of architects is the development of imagination through exercises opposite in character. Exercises of trying to impose a function into a form (e.g., taking a painting and trying to generate a work of three dimensions out of it) are legitimate and desirable.

SYNTHESIS should be the primary concern of the architect. It is achieved through exhaustive investigation of all possibilities for putting things together. If the putting together of things architecturally were only two-dimensional, only in plan, then synthesis would be easier. But architecture deals with space, it deals with the three dimensions. It is exactly here that things get complicated.

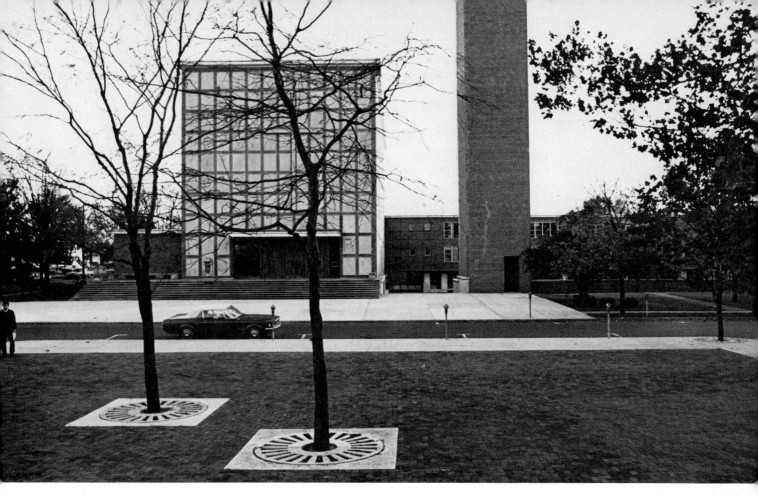

Disciplined works often appear simple, but they are clear as the clear water. First Christian Church, Columbus, Indiana. Eliel Saarinen, Architect, 1940. (Photo by Craig Kuhner.)

Everything that comes to mind and use of everything that is available. The other extreme of discipline. Floating community of artists in Sausalito, California.

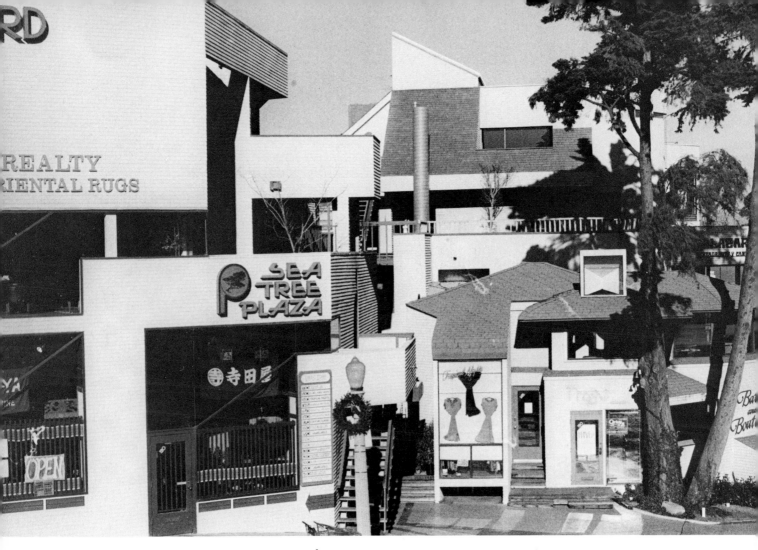

Multiplicity of materials and excessive articulation of the building's mass renders construction difficult, may result to bad joinery and eventually may result to unsuccessful construction. The visual chaos has often negative practical side effects. An early aged building, victim of problems due to lack of discipline regarding the above basics. LaJolla, California.

Synthesis assumes possibilities, and possibilities could be very easily traced through the use of a computer.[4] Due to the element of the third dimension, however, all possibilities increase to an exponential power, and beyond that it is not a matter of numbers alone. The intuition which is fundamental in dealing with space is excluded when we use the machine; it is still feasible that architectural synthesis stays within the limits of the human computer, the human mind.

Organization

Fundamental steps in the process of synthesizing are the steps of *organizing* and *establishing order* of things. If the elements of a synthesis are organized properly in an undeniable, interrelated way, then the work of architecture possesses the qualities of healthy organisms. In such cases there is no competition among functions: each function supports the others and all functions operate together to enhance the architectural concept. We can safely say that "organization," as used in architecture, is a quality

of the specific synthesis. Through the process of "organizing,"[5] the composer creates sets of elements that bear similar characteristics. The "sets" eventually find their places in the finished synthesis. The characteristics of the sets may be functional, activity, technological, formal, or material.

We will argue that organizations that evolve out of "activity" considerations have better chances to result in spatially appealing solutions. This may become clear if we consider a simple problem of architectural design. Assume that the elements to be put together, thus creating a work of synthesis, are the following:

1. Bedroom	10. Bedroom
2. Bathroom I	11. Study/Den
3. Kitchen	12. Master Bedroom
4. Living room	13. Bathroom II
5. Storage room	14. Recreation room
6. Bedroom	15. Bedroom
7. Utility room	16. Bedroom, etc.
8. Guest room	17. Entry, etc.
9. Greenery	18. Dining

The elements may have names, as those above, and the names may be very specific; e.g., master bedroom or den, thus denoting a very specific connotation that is determined and prefixed onto their exact use pending on the interpretations of the culture (i.e., "den" has meaning only in the United States). On the other hand, these elements may be set more loosely, such as *space for sleeping I, space for sleeping II,* etc. (instead of Bedroom I, II, etc.). In that case the elements to be used for composition may be interpreted by the architect as to his prerogatives and talents and the users' life style requirements.

Spaces that have been given definite names are already preconceived; however, referring to spaces in the very early design stages as descriptions of activities, may allow for new interpretations to be made by the architect for the best performance of these specific activities in space.[6] The elements of the problem as set above seem to be thrown at random. This random picture may be the result of the very preliminary confrontation with the client. Although there is a chance that some of these elements may already have been grouped and organized in the client's mind, it is the architect's responsibility to demand that these elements be conceived initially at random and be stated as loosely as possible so that he may exercise his trained responsibility of creating the organizational settings and the new entities himself.

Some of the items to be composed have the same name. Others connote that similar functions occur within them. The architect has to single out these similarities and create a new set of groups for the elements he is eventually to synthesize. Exercising this step, the composer ends up with a new chart describing the elements of the problem in groups as follows:

I	Bedroom I Bedroom II Bedroom III Bedroom IV	III	Mechanical Storage	V	Entry Greenery
II	Kitchen Utility Dining	IV	Study/Den Living room Recreation room Dining maybe	VI	Bathroom I Bathroom II Bathroom III

Thus the number of the elements of the problem is reduced. If we assume that the ultimate group arrangement has been achieved—this will be the case in which the groupings are justified by *functional, activity, operational, building economy, life style,* and *site considerations*—then we may safely say that the work of synthesizing will become easier. This, of course, is because the elements to put together are not as numerous as they were before. In this simple problem of architectural design, the 18 elements the architect had to compose initially have now become 6. If we assume that the ultimate

solution is to be one, then we see that for the first case one would need combinations of the scale of 18, while now one needs combinations of the scale of 6.

The process of organizing unrelated elements into groups is the first step in the process of synthesis. It represents the attempt to expedite the process of synthesis and make the work realistic. Yet things are not so simple. The site and other environmental considerations of "exterior" and "interior" nature complicate the things. Is it true, for instance, that all bedrooms should go together and create one organizational set, or could it be that this is not true and necessary? The answer is to be found when one carefully considers the interrelationships of all the factors of design, such as function, economy, activity, life style, etc.

The arguments favoring the grouping of all bedrooms together may be easily stated as orientation or noise avoidance. Life style considerations, however, may suggest that one of the similar elements should become an entity in itself (e.g., the bedroom to be used for guests, or the bedroom to be used by the eldest son), and may suggest that this element ought to be excluded from the group. A life style consideration may be based on the belief that the son will stay home more if he is given more individual freedom, if he is given a private entrance, if he is given a parking space of his own. Guests may appreciate the same freedom. There is no reason for the unknown life styles of future guests to be forced into the same patterns as those of the host. Of course, one assumes that "in Rome one acts as the Romans," but this is not always the case nor the desire of the contemporary client. Therefore, if it is the client's desire or the natural conclusion between client and architect that the guest must have his freedom, then the guest bedroom may become a "group" of its own.

Thus we see that there are no absolute criteria for helping the architect to proceed in organizing (grouping) the initially unrelated elements of his problem. The more personal the client becomes (the more specific he is about his requirements, life style, and economic reality) the more difficult and complex, yet more real, the problem becomes.

If the client is unknown, then there is great uncertainty as to what path should be followed in setting the groups of elements to be organized. In the case of public housing or a speculative house there is no way the architect can have concrete ideas of what the specific user requirements and specific life styles will be. The architect then bases his judgement on generalizations, experience from previous projects, and research evidence. He utilizes a lot of assumptions in guiding himself in the process of organizing. In cases such as the above, the nature of the problem is "uncertainty."

One might say that for problems of such uncertain nature the architect should definitely take a stand and "keep his personality out." He should offer neutral answers, and offer physical elements that he knows are appreciated by *all* human beings. In achieving this neutral stand the architect should organize only the *big idea* elements of his problem and offer in his organization the "small things" that he knows are appreciated by all human beings (e.g., street furniture on which to relax, generally good views, protection from disturbing winds, etc.). The architect should not get involved with design details that might infringe on unknown personal preferences. His design task should stop at the point where "uncertainty" begins.

The architect should offer a "cell" or a certain "space" in which each need of the family can be met. He should avoid becoming an advocate of "assumed" needs (needs, user behavior, and life styles about which he probably has minimal knowledge). We see, therefore, that if the architect really philosophizes about his role as an "organizer," and if he gets into the real "guts" of this step of the design process, he will eventually see that, due to the knowledge of the client and the relationship he has with him at this stage, he may not be able to come up with definite solutions. His input depends on the nature of the problem. Through serious inquiry, however, the architect not only expedites the process of his *synthesis,* but he becomes realistic, challenging his client and himself.

If the architect has gone thoroughly through the process of organizing the elements of his problem, and if the other aspects to be examined later are also taken thoroughly into consideration, then his end work will possess the quality of a "living whole." The process of "organizing" is not only a step in the design process, but it is also a quality of the work of architecture. If organization exists, then the building would have good chances to stand as an "organism" (all parts holding rationally together and working as a whole). It is this kind of architecture that should be called "organic" architecture, instead of the "organic architecture" that is conceived in terms of visual resemblance to parts of living organisms.

Forms in plans and elevations that remind one of living organisms (with elements such as biological parts and amoebas, etc.), are often labeled as works of organic architecture. It is not the appearance, but the working associations of the elements of the work that should be the criteria for the use of the term "organic." In that respect, a very sharp-edged and rectilinear building based on "cubic" lessons of three-dimensional synthesis may be a work of "organic" architecture, while a work that visually resembles an organism may have nothing to do with the proper use of the term.[7]

The architect must possess knowledge of the total package of architectural interrelationships in his task for organizing. The requirements—technical, spatial, functional, economic, and environmental—must be well mastered by him. This was done in the past through the traditional models of architectural education. Unfortunately this is not the general case today. Some people have suggested, and one would easily agree with them, that most important in the making of the total architect is the study of the history of living modern architecture which examines and researches projects similar to the one being produced in order to gain the necessary knowledge of the life style and peculiar user-needs issues otherwise unknown. It is, however, this aspect on which the architect needs more input. Happily enough, current architects gain enough knowledge through the assistance, expertise, and findings of environmental psychologists. The task of organizing currently takes place at the stage of architectural programming, and it is examined in detail in a later chapter of this book.

Summary

Organization is desirable because it:

1. promotes design economy, as similar functions share similar services.
2. makes the design process progress faster.
3. makes the edifice more functional.
4. makes the edifice more comprehensible to the user.
5. results in less conflict during creation of the building (makes construction easier).

Organization depends on the requirements of the user, yet it may influence the building's pattern of use. The role of the architect should be to create "organizations" that will not frustrate the users, but on the contrary, will inspire them, make them more creative, and make them happy.

Organization is a complex task; in order to facilitate it, we establish hierarchies among the elements that need to be organized. In so doing we deal with concerns for "order" which is another design tool assisting the architect in his synthesis.

Order

"First things first and everything in place."[8] . . . If this has been achieved in a plan—that is, if the elements that compose it are properly organized so that first things come first, etc.—then we may say that this plan is "orderly" arranged. *Order,* therefore, is the quality of a work of architecture which tells the user or the observer that there are not inequities in the organization of the elements and that, therefore, an equilibrium, or balance, is at hand.[9] This equilibrium may be sought by the designer in terms of function, of activity, or of form. The elements of the work of architecture and, for purposes of simplicity let us say here, the elements of a plan in an ideal synthesis must be related in such an orderly way that minimal "conflicts" are apparent—or even better, that hopefully no conflicts exist.

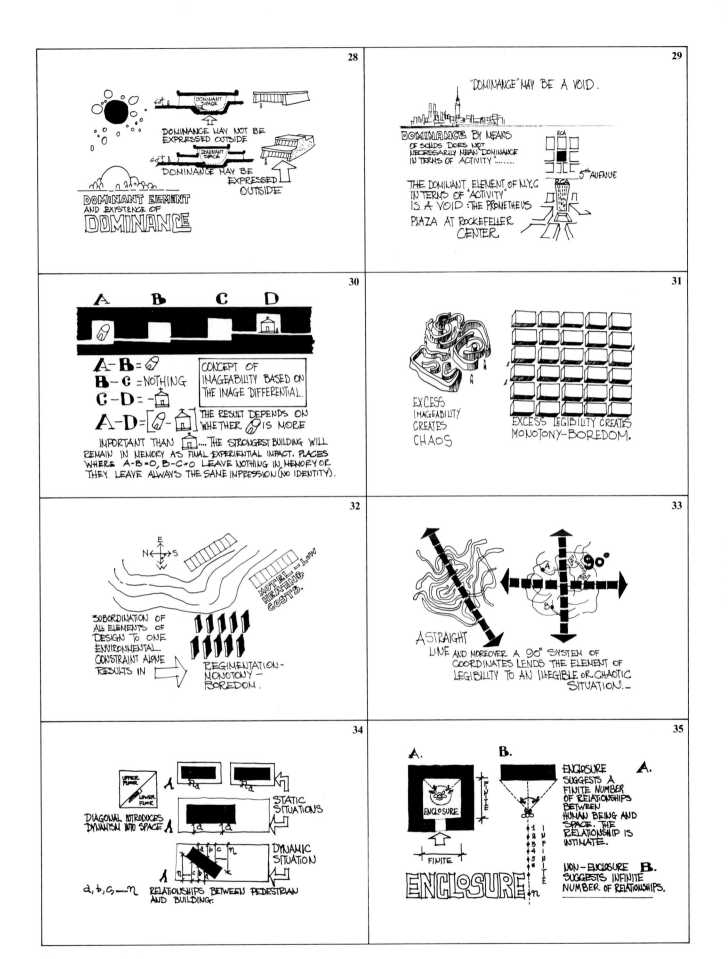

Figure 4. Aesthetic concepts (3)

In the effort to achieve order the designer simplifies his task of synthesis. As soon as the elements of organization have been identified and set together in groups of similarities, the task of setting rules and identifying the relationships that exist between the elements or the groups of elements and the environmental constraints can be carried out. The task of establishing "order" is in order.

Elements of the plan having varying relationships to the environmental constraints (such as a group of elements to be used for sleeping purposes: bedroom I, bedroom II, bedroom III) demand that special importance be placed on the relationship that exists between the site, the orientation, and the placing of this grouping on the site. The bedrooms need to be warm at night, thus the architectural solution should achieve placement of bedrooms on such part of the site where they will be exposed to the sun for most of the afternoon. If the sun privilege was given to another group of spaces where the sun was not really needed that much or even needed at all, then we would say that there have been inequities in the plan, as allocations and locations have not been determined in an "ordered" way according to the priority of needs.

Order, therefore, evolves only after the designer goes through careful analytical consideration of the relationships of internal function and environmental constraints, and formulates a statement of priorities. The architect then tries to come up with a solution that demonstrates that first priorities came first and that the various requirements were satisfied in equitable ways.

The dictionary definition of order is "a situation in which equilibrium, balance, peace, or eventually no conflict exists." It would follow, then, that an architect has achieved order when a work is synthesized in such a way as to have the elements of its organization related among themselves in nonconflicting ways. The realization of this situation, however, is almost impossible. It depends on the scale of magnitude of an architectural work. The more the elements to be composed, the greater is the possibility for conflict. Order, therefore, presents the most difficult task for the architect. It is exactly here that the human computer may be helped by the mechanical. Ordinary computers may set the requirements that ought to be satisfied by the various elements of a plan (i.e., environmental constraints, functional and economic requirements). Then the computer might identify groups that could present conflicting interests in site placement, thus informing the designer about the difficulties or the potential impossibilities he may encounter in the design process.

The simple example that follows may make clear the difficulty stated here, that is, the difficulty of producing an orderly plan. Let us assume that there exists a conflict between orientation and view, and that the site is not ample. If, for instance, the view is toward the southwest and the best orientation for the bedrooms is also southwest, then it is definite that one of the two groups of the plan, bedrooms or living room and day spaces usually requiring view, must be sacrificed. It is clear that the designer must give the advantage of this southwestern portion of the site to one of the two uses, thus creating an inferior situation for the other, and thus coming up with a weak plan. Of course, this conflict could be worked out by means of section; a smart section and possibly a second-level solution might place one group on top of the other and solve the problem. This, however, is impossible in cases where city codes do not permit second floors and where the density is very high (as in public housing cases). An equitable solution may never be implemented. Should such a plan be out of order, should it be a solution of compromise? A compromise can be avoided if the statement comes strong from the program and if the program says that sun for the bedrooms is more important than the view for the living rooms which might be considered a luxury. There must always, therefore, be a section in the program where definite priorities are established between spaces or groups of spaces of the architectural organization to be composed and the environmental (site, orientation, wind, etc.) and economic constraints. Order will be achieved only when these briefly stated priorities have been satisfied by the ultimate physical expression of the design.

Le Corbusier said, "Standards are necessary for order in human effort."[10] We can expand on this and say that standards are necessary for order in architectural efforts. These standards should respond to man's need for "spiritual order"[11] as well as to functional requirements. "Spiritual order" is difficult to achieve, while functional order can be dealt with more easily.

There are certain rules that may be followed by the composer for purposes of successful design, at least in its basic functional purposes. The argument is set as follows: the environmental constraints are many and if only one of them is singled out as the most important and to which all groups of the architectural organization are to conform, then the resulting order of the solution will be one of total uniformity, visual similarity, repetition, and regimentation. Examples of this may be seen in designs of institutional buildings whose sole design criterion was one and dominant; e.g., a motel owner may have as his sole consideration the most economic way of construction and a building that will be the most economic in terms of thermal insulation. These two considerations probably complement each other, and they can both be accommodated by total emphasis on the orientation of the motel. A linear southwestern exposure will satisfy both concerns: equitable exposure of all rooms to sun for the second half of the day, thus cutting costs for heating; and repetition in the construction process to cut costs there. The result

will be one of regimentation and one direction. Army barracks, school buildings, and public housing are among the typical examples of modern architecture where this phenomenon may be identified; that is, regimentation, monotony, and boredom due to nonexistence or order of priorities, or emphasis on only one priority.

We might, therefore, state here that the architect must definitely try to establish criteria and establish priorities of importance for these criteria without excessively emphasizing one alone. If the latter is to happen, we will have works where there is no order and where there is visual and functional monotony. Standards are necessary for order in architectural efforts.

Summary

The effort to establish hierarchies among the elements of an organization results in establishing *order* in architecture. *First things first and everything in its place.*

The architect establishes order. He (or she) orders the unrelated elements after he has organized the related elements. The issue is how much order he contributes and if that order is based on variety (and how much) or monotony (and how much). The concept of *rhythm,* to be discussed later, is associated with the quality of order. Excess order can produce "monotony" as well as "chaos."

In the simplicity of the organization and order system rest the simplicity and economy of design.

Dominance

Related to the concept of order is dominance. If the existence of the situation "first things first . . . , etc." represents a quality of a work, then the question is, "which thing is to come first," or "how many," "why," or "where." There may be elements or groups of elements of an architectural organization that are definitely more important than others. The importance again may be assigned in terms of function, activity, economy, form, etc. *Dominance* exists in a work of synthesis if the most important element or group of elements is located in a dominant and prominent position of the plan; or if it represents the focal point of the whole composition; or if it acts as a point of rest, relaxation, or as a summarizing element for all the other groups that are around. Such an element or group of elements may not be visually apparent to the outside observer. It may be an interior space. Dominant elements may be apparent in all descriptive documents of a three-dimensional work; that is, a dominant element may be so in plan, in section, and in elevation. Then one may safely speak about "dominance" as a quality (and it may be well stated, thus being positive, or badly, being negative) of the work of architecture. But it is possible for a dominant element to be apparent only in terms of plan and section or in plan alone.

Since these possibilities exist, we may speak of three different types of dominance. The second and third may be purely functional, while the third may be more expressional and further satisfy symbolic considerations. The element of dominance, therefore, is important for a design, because, if it exists, it not only serves functional issues, but it may provide the catalyst for further intellectual expression. The dome of Hagia Sophia, for example, is the most dominant of all the elements of the edifice. It not only satisfies the functional requirement of sheltering a large group of people and covering the open plan of the temple; it not only performs the function of providing natural light; beyond all, it symbolizes the center of everything, the sky, the only visible connotation of the unknown universe. In that sense a dominant element *punctuates* the landscape, and a dominant building represents a place of activity *climax*. Climax and punctuation are further qualifications of dominance.

Dominance in architecture may be achieved through "solids" or "voids." To the outside observer the dominant element of the Hagia Sophia is the solid mass of the dome. For the person inside the church the dominant element of the composition is the space (void) under the dome. In large-scale architecture or, as we now call it, "urban design," the dominant elements for the pedestrian are often voids rather than solids. The dominant element of the urban composition of Venice is the void of the Piazza San Marco, while for the observer on the Grand Canal it is the tower of the campanile and pillars with the Lion of Venice. A good contemporary example of urban design where dominance is achieved through "void" is that of Rockefeller Center in New York City. The dominant element of the center is not the tall RCA skyscraper, but the Prometheus ice skating rink.

One might speak of dominance in terms of "life," or "activity," and of dominance in terms of "vision." The life-dominant element in New York City may be said to be the ice skating rink of the Rockefeller Center, while the visually dominant element of the lower part of Manhattan is the Empire State Building. If both dominances, "life" and "visual," overlap, then we might say that a totally dominant architectural expression is at hand. But this does not often happen, and very often dominance is achieved in one way alone. For architectural design purposes it should be logically preferable if the designers achieve the situation where dominance is totally expressed. It should be the job of the critic to investigate and make certain that such qualities have been achieved and are properties of the place.

Dominance in architecture achieves more than just simplifying the work of synthesis or determining order and priorities. Dominance may be achieved through placing proper emphases on landmarks or proper urban "punctuations." These are extremely important for the functional organization of the broader urban landscape and

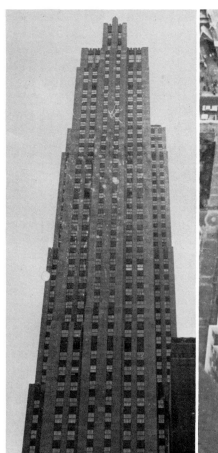

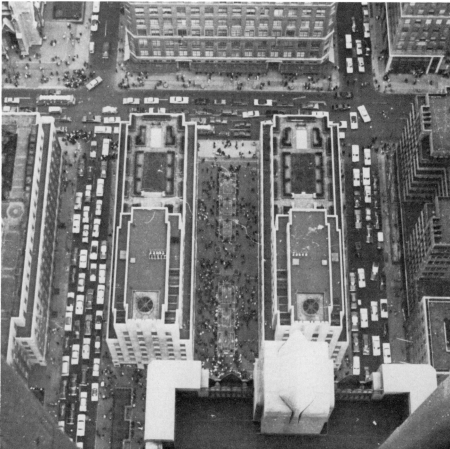

Rockefeller Center in New York City. The dominant element from the activity point of view is the void. 1930–1933 Reinhart, Hofmeister, Morris, Corbett, Harmon and MacMurray, Hood and Fouilhoux, 1931–1940.

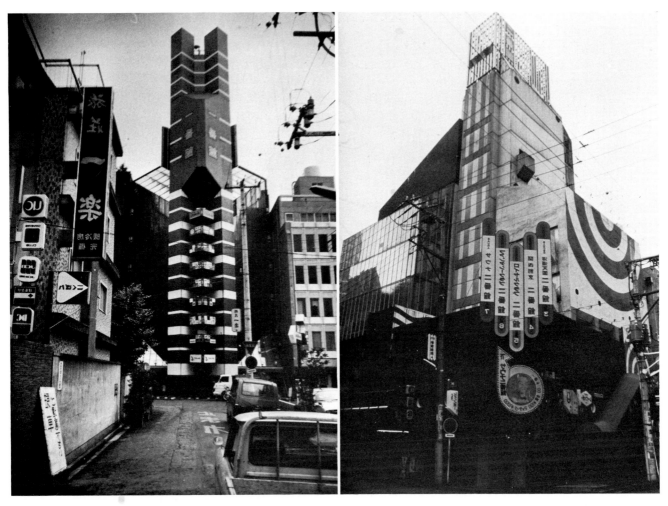

Image generators in Sinzuku, Tokyo, Japan. Ichi-ban-kan (*left*), and Ni-ban-kan (*right*). Minoru Takeyama, Architect, 1970.

they make the concepts of imageability, legibility, and clarity urban possibilities. These terms which represent new concepts, new tools, and new words for the vocabulary of the large-scale architect are investigated further, and they are largely enhanced by the existence of the element of dominance in both small-scale and large-scale spheres of architectural design.

Imageability

The term imageability was introduced to the vocabulary of the design professions by Kevin Lynch in 1964. It was used for urban design purposes and it referred to the ability an environment possesses to create an image.[12] If an environment has the ability to stamp an impression in your mind which you will carry the rest of your life, then it is said that this environment possesses a strong degree of *imageability*. It has been argued and it is taken as basis

for theory here, that imageability, in principle, is a good quality for an environment to possess. However, imageability can be positive or negative. There is also the issue of "how much imageability," that is, how much capacity should an environment have, and how many single or individual images are necessary to constitute the optimum aggregate imageability of an environment?

Let us say that the environment under consideration may be analyzed into a series of important and dominant visual experiences represented by the sum of:

$$\text{Total image} = A + B + C + D \ldots + n$$

The things the designer must know and control in his process of design are the following: how many elements will there be from A to n, that is, what should be the exact number of n? How close together should the elements be?

Should the distances between A, B, C. . . . n be the same? Should they differ? And if so, how much, what rules should be followed, and why? These are not simple questions to answer, and, of course, right now there is not a body of formal research on the images of many cities which would permit us to get answers. It is necessary, however, to state that in the process of an environment's creating an image in our minds, the most important elements are "time" and the "speed." Length of time and speed of travel are the basic determinants of our perception of an environment. If the time from A to B (where A and B are different physical statements in the environment) is very short, then the registration of the experience in our mind is incomplete or wrong or not well digested. One could suggest that the experience we get from A and B is nothing but the difference between A and B. If A is bigger than B, if A is a plaza with the cathedral and B is an equal plaza without a cathedral, the differential between A and B is the cathedral. If we have enough time and progress at an appropriate speed in going from A to B, then we are able to perform this calculation in our mind and keep it there, or keep it in our sketchbook, and remember the difference. If we do not have substantial time, this calculation may not be done right or it might never take place. Thus it will leave no memory with us, and memory of our environment is nothing else but what the environment teaches us. There is, therefore, a fear that if the time intervals between A, B, . . . n are too short, if the speed while moving between A, B, . . . n is too great, if the A, B, . . . n are all different or all the same, the learning the environment will have for us may not be positive, because the calculations may never take place; or if they do take place they might yield a wrong result. We make mistakes in our calculations only when we get confused by some things. Thus one might say that wrong imageability, positive or negative, may be the result of a confused environment.

If the aggregate of all the individual environmental lessons (A . . . n) is clear, then we might say that there is a definite positive imageability. If the aggregate is confused due to excess change of images, with all factors of the summation being different, then we may say that this imageability is negative. We might relate it to *chaos* (excess sequence of images, as control of succession in time intervals between the various elements of the environmental summation was lost due to very high speeds of movement). If the aggregate is not confused, but it is a summation of environmental elements and time intervals that are equal among themselves, one may be speaking of an environment that has a strong imageability which, however, is of the class of boredom or *monotony*.

Imageability, therefore, must be controlled. The real difficulty is in controlling the time intervals and generating meaningful design differentials, as with the example of the two equal plazas with the church in one of them.

What should the C be? How far should it be from B, and in what characteristics should it be different from B and A?

These are abstract theoretical questions, yet there is no scientific answer at this moment, nor will there probably ever be. A, B, and C, etc., are spaces, yet they have three dimensions and they all have potential for different activities—activities not in terms of the area capacity of the space (i.e., all space may accommodate similar urban audiences), but in terms of program. An urban program may suggest that A will be an assembly hall, while B a circulation node. The program, therefore, may provide the adequate differential and thus enhance or change an existing imageability. Imageability, therefore, is a quality of an environment, positive or negative, possibly chaotic or monotonous. The answer to the question about the optimum imageability is to be found in the very difficult concept of the "measure" of design and in the discipline of the designer.

Imageability was introduced for urban design purposes. Very little has been written about imageability in architecture; yet the concept is there. The elements from A to n are the various elements or groups of elements of an architectural composition. One might suggest that such elements here may be sought in the specific architectural detail, and that the materials and the differentials among them may suggest the final image of the edifice. This image we have so far called *texture*. We might, therefore, say that the texture we have known in architecture so far is the "equivalent" of *imageability* as used for urban design purposes. We have often been told to control our materials, not to use all the material we know, but to seek complementary combinations in well-defined and proportioned intervals.

The materials of a building and the sequences among them constitute what we might now start to call the imageability of a building. It may be well defined, it may be chaotic and confused, or it could be nonstimulating and monotonous as we have seen in urban design.

Legibility

Legibility is the second term Kevin Lynch introduced[13] to the vocabulary of architecture. It means that an environment is not confusing, it is easy to "read," it is useful in directing your whereabouts. An environment is legible if it makes it easy for you to find places that you never visited before. The classical example to illustrate legibility is the following: visit a friend in his new house; find his house with minimum information, then successfully find your way out. An environment or urban layout in which it is difficult for you to find your way around is said to be an illegible environment. Urban legibility is also related to the concepts of chaos and monotony. Typical examples of illegible environments are mazes. In mythology

Figure 5. Knossos, Palace of Minos, Crete

such a place was the Labyrinth, the place inside of which the Minotaur was living. In order for Theseus to find his way out, he had to be helped by the daughter of King Minos who was sitting at the entrance of the complex. By using an unrolled string he was able to find his way out of the Labyrinth. *Chaos* is a case of excess illegibility. *Monotony,* on the contrary, is a case of excess legibility. A grid system without dominant elements and with low imageability may be very legible, yet it may be completely unappealing and unexciting. Legibility, therefore, is a quality of design control, but it must not be the only design control. Excess legibility must be avoided as well as excess illegibility.

Legibility can be easily seen in examples of small-scale architecture. It represents the property of the plan. An architect may very easily find his way around a well-organized, properly ordered plan of another architect without asking information about the location of the various spaces of the plan. Legibility is enhanced by dominance, and the latter may work for the success of the former.

A rule of thumb the designer must know is that legibility can be achieved by the simple action of cutting a straight line through an illegible environment. The illegible and chaotic pattern of medieval Paris eventually became "legible" by the straight lines of the boulevards opened by Haussmann. In theory, an illegible system will easily become legible if it can be analyzed into a ninety-degree system of coordinates. This has often been practiced and it has opened up situations previously regarded as impossible.

Identity

If a certain environment possesses a unique character then we say it has identity. An environment may be unique due to the use of certain unique "forms" that are to be found in this environment and nowhere else, or it may be unique due to a certain activity or a certain sequence of activities that are performed in this environment and nowhere else. Special land uses often give identity to towns.

We might say that the physical element that offers identity to the city of Athens is the hill of Acropolis with the Parthenon, while the identity of Athens in terms of special land use is the section of Plaka on the foothills of Acropolis. The concept of "identity" is directly related to "imageability," as it is the memory of a strong image that stays with people and makes them identify a certain environment, or identify *with* it. Identity caused by a special land use, is much stronger, as people often participate in the activities of that use and thus identify with the environment. An environment, therefore, has identity not only when it has the ability to make you remember its uniqueness and thus identify it, but also when it has the ability to make you identify with it through your participation in its uses. Environments or buildings with identity become sources of pride for their users. It is therefore fundamental that architects try to create works that possess identity. The Hyatt Regency Hotels all have identity, for example; it is the unique quality of their flamboyant multistory interior universal spaces.

Diversity

Diversity refers to activities, to forms, to masses, to feelings. It is directly related to the concepts of imageability, chaos, monotony, identity. Diversity must be controlled so as to permit a good differential of images, thus permitting imageability. Excess visual or activity diversity may lead to chaos. No diversity at all results in monotony. Diversity requires "measure" if it is to be a positive quality of a design. Diversity is dangerous if it relates to the materials used for the construction of an edifice, however. Diversity is a desirable design quality, but is should be found in the spatial experiences provided by the interior of an edifice rather than in its exterior characteristics. Diversity, if not controlled, can easily disturb the "unity" of a work.

With the examination of the concept of diversity we conclude the first basic group of the concepts of design, the intellectual tools of the designer. We must now examine the very important working concepts and tools of scale, proportions, and rhythm in order to get a clear understanding of the design issues that are directly related to the man-environment dialectic.

Scale[14]

"It is out of human scale," or "This building has no scale," represent exclamations often made by critical observers of architectural works. The second exclamation uses the term *scale* in a way that assumes it to mean "human scale." *Human* is the element which, according to the lines of most architectural traditions, usually derived from the academic schools of nineteenth-century France and Germany, represents the qualifying adjective

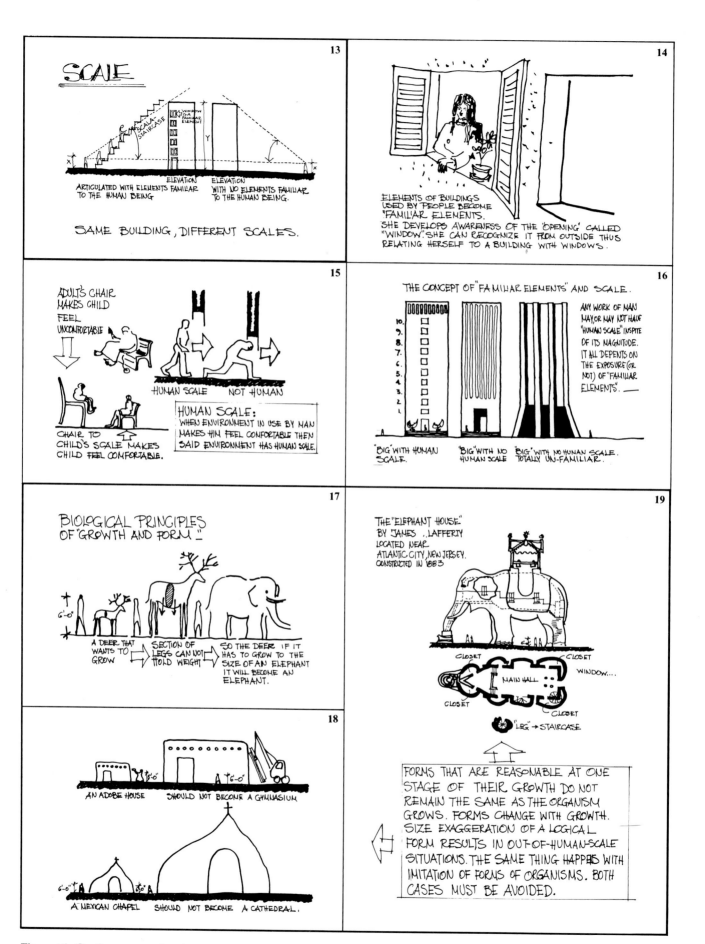

Figure 6. On the concept of scale

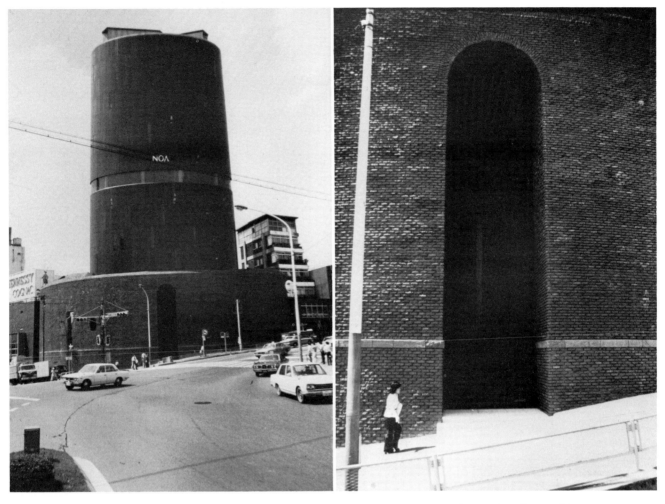

Absence of elements familiar to the human being. Out-of-human scale building. NOA building, Tokyo, Japan 1974.

of proper scale. *Human scale,* however, represents but one type of scale and should necessarily be associated with "scale" in general. To proceed into the discussion of the concept of scale, however, certain assumptions have to be stated as to the importance of the human being, the "observer" who makes statements about scale. In that respect a method of understanding has to be followed which will assume the importance of the human being, that is, one would have to start from the concept of "human scale."

Etymological Interpretation of Scale

The word "scale" draws its origin from the Latin word *scala* (in French, *eschelle*). *Scala* means "staircase" or "ladder"; that is, it denotes the instrument one uses to **reach someplace.** It is important to note the boldfaced words, as they probably represent the key to the understanding of the concept of scale in physical terms in architecture.

The Greek language uses the word ΚΛΙΜΑΞ for "scale." ΚΛΙΜΑΞ has the same meaning as the Latin word *scala,* that is, ΚΛΙΜΑΞ means staircase, or ladder, too.

Here, therefore, we have an etymological overlapping of the first meaning of the word "scale" as used in its origins of Latin and Greek. So scale derives its origin from the earlier words for staircase and ladder, which as we said denoted (and still denote) the instruments, or the building elements one uses to reach somewhere—to "reach somewhere with the purpose of grasping something," or "to reach somewhere with the purpose of seeing and understanding a thing."

We may interpret, therefore, from this analysis that "scale" as used in architecture may also refer to the design tool one may use in order to "reach" a building in order to "grasp" a building. "Reaching" a building or "grasping" a building, metaphorically used, can mean "to understand a building." And as with the case of the staircase, one has to go step by step, pace by pace in order to reach the top, to grasp the goal. It may also be assumed that with "scale" in architecture one has to follow a "step by step" process by which he can reach the top, to "reach" and "understand" the building, to make the image of the

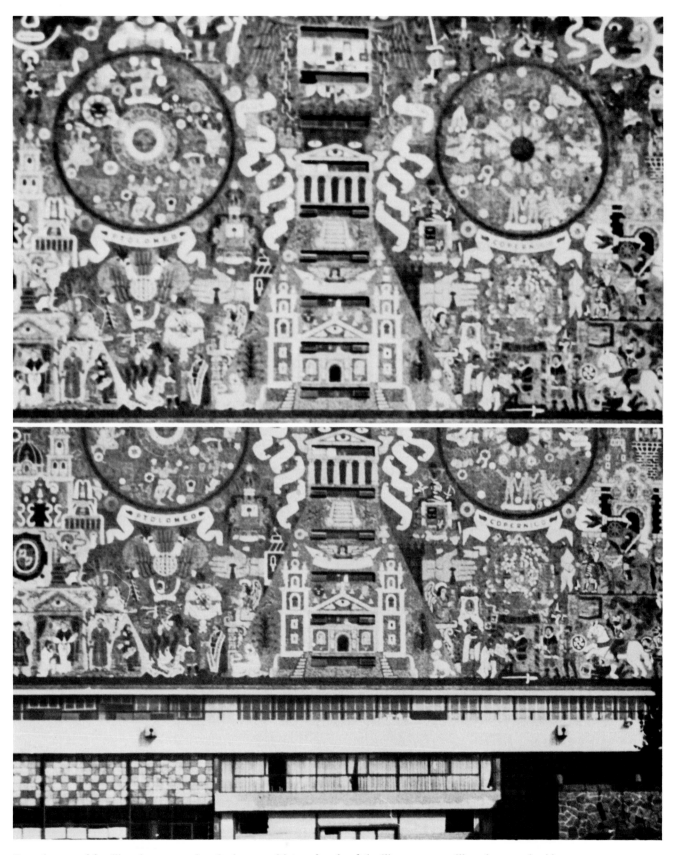

Top, absence of familiar elements makes the large multistory facade of the library appear like a large embroidery, not a building. Bottom, the appearance of familiar elements, such as entrance height, start to give an idea of the size of the building.

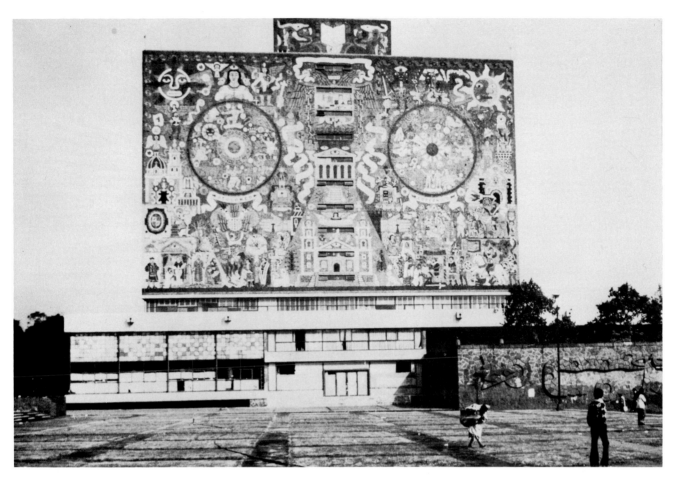

Familiar elements and people permit the viewer to relate to the large volume of the library. Main Library, National University, Mexico City. Juan O'Gorman, Architect-muralist, and Gustavo Saavedra, Juan Martinez de Velasco, Architects, 1956.

building his own property, to be a conqueror—that is, to comprehend the building in a visual sense, from its foundation to its top, through an intellectual process of step-by-step comprehension, in a nonthreatening way.

This is what is done in architecture. A building will have scale if there are elements of it which can be (metaphorically) used as steps, through which the observer will intellectually reach, grasp, or comprehend the building. The "steps" in that sense are the elements of a building that are known to the observer, the elements with which he is familiar and whose dimensions he knows in relation to himself. An opening in a wall may have any desired dimensions, but an "opening" does not represent a term denoting an architectural element familiar to the human being. But openings such as "windows" or "doors" do, and so they can be safely considered as the elements of a building that are familiar to a person. By taking these known elements into consideration, and by relating himself to the building as a whole through these intermediate

familiar elements the person becomes a visual "conqueror" of the magnitude, importance, and modesty or not of the building in concern; that is, he "reaches" or "grasps" the building.

In that case we may say that the building has a human scale, since it permits, through its elements, an intellectual appreciation of its importance. This appreciation is the result of visual comparison between the human being and the building through the use of the known-to-the-human-being elements of the building.

This process of explanation of the concept of "scale" may tell us that if the familiar elements are absent, then the process of the grasping of the building takes other dimensions, creates other feelings, and may create confusions about the importance, magnitude, and context of the building . . . all of this, because the elements necessary for the process of laddering, escalating, "reaching," and "grasping" the building are absent. Then it becomes apparent that a different process for "reaching" the building

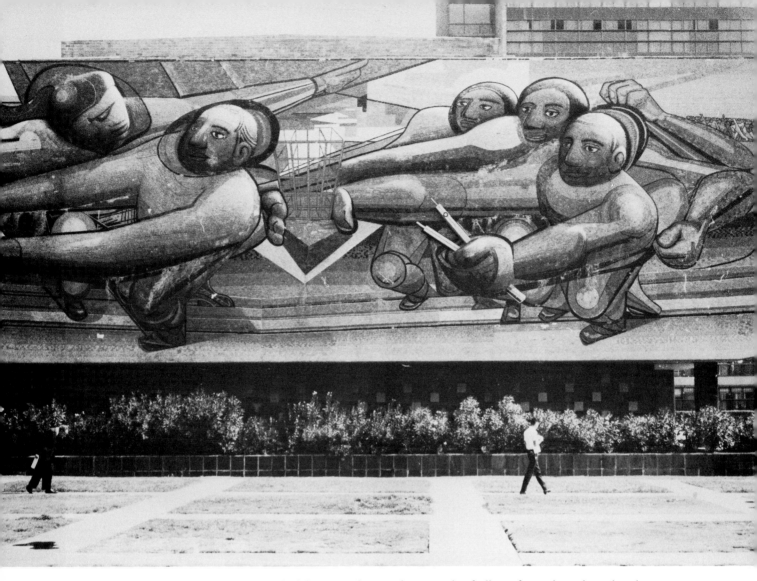

Buildings conceived as billboards or murals lack human scale, sometimes creating feelings of uneasiness, but other times creating grandiose feelings or the feeling of the sublime. Administration building, National University, Mexico City. Architects: Salvador Ortega, Mario Pani, Enrique del Moral, Mexico City, 1951–1953.

On the concept of scale. Set designs are usually out of human scale.

is necessary, a different intellectual preparation. The scale of the building is there, but it's different. Not only that, but a building may have different scales, depending on whether it possesses the necessary elements throughout all its visible parts (elevations that are familiar to the human being). For the same reason, buildings of similar bulk may have completely different scales.

Scale is not related to size. A building large in size may possess human scale if it possesses adequate articulation of elements familiar to the human being, through which he can relate his size to that of the building.

Referring to the issues of scale and size, architects should remember the lessons of biology. D'Arcy Thompson, in his monumental work *On Growth and Form*, suggested that if an organism grows, that is, if it changes size, its form must change. A deer with exaggerated proportions will cease being a deer; its form will change and will eventually take the form of . . . an elephant.[15] The legs of the deer won't be able to support the exaggerated

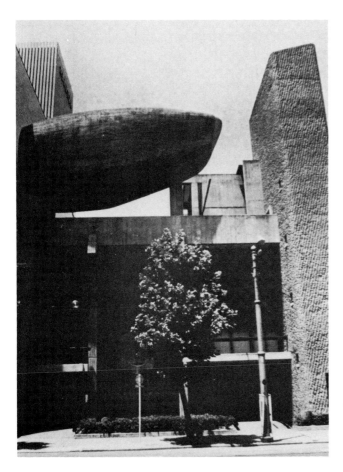

Exaggerated "pebbles." Out-of-human scale buildings.
Kyoto, Japan.

weight of the grown body of the elephant-size deer. Thus the proportions of the legs will change; they will take the proportions of the legs of the elephant. In fact, the deer will *become* an elephant.

The same is true with buildings. A Mexican chapel cannot grow to the size of a cathedral and still keep the proportions and form of the chapel. It will have to take a new form, new structural articulation. The form of the cathedral is dictated by the methods of construction that are different from the methods of construction[16] of the modest chapel. If the form grows in size and retains its previous proportions, that is, if it remains the same, the new building type will be out of scale.

Scale as Feeling Manipulator

Scale does not only denote a physical process. It is not concerned with physical relationships alone (the relationship of the human being to the building through the consideration of known, familiar, architectural elements). Scale also has "spiritual" connotations. It may denote the spiritual relationship that is generated between the architectural work and the observer in the process of the visual understanding. The understanding of the "spiritual" interpretation of scale is very important, because it allows that certain possibly apparent physical disproportions become negligible. The spiritual element of scale may have an integrity of its own. When considered alone, without the consideration of physical relationships (that is, when "scale" is considered in the intellectual spheres alone), it may generate the creation of certain distinct psychological conditions for the individual observer which can be described as feelings—such as the feelings of the "sublime," "humbleness," "modesty," "arrogance," etc.

Various periods of architecture have tried to create these feelings; the "sublime," for instance, is very often generated upon the view of religious works. This feeling represents nothing else but an attempted spiritual interpretation of "scale." The spiritual element of scale is very often achieved by disregarding the incorporation of familiar physical elements in the work of architecture. In the Gothic cathedral, man, through darkness and light, and not through comparing himself to any familiar elements, grasps the meaning of the edifice; through a psychological process he reaches the "Unknown." The feeling of "sublime" is generated, and the spiritual element of this particular architectural scale is glorified.

Vernacular architecture generates feelings of modesty and humbleness. The architecture of the Indian pueblos in New Mexico and the architecture of the Greek islands are examples of this case. The relationships that exist between the edifices, the elements of these edifices, and the observer have a definite human character—the character and the dimensions of a land-respecting people who build everything with their own hands in a way that is measured by humble and modest needs and potentials—the humble, human needs to rest and relax, to see the sun, and to derive pleasure from a refreshing breeze and a nearby stream. "Scale," however, must not be considered as only a spiritual *or* a physical relationship. For design purposes, both aspects of scale must be taken into consideration, and efforts toward achieving both aspects must be made.

It must be understood that the spiritual interpretation of architecture (the psychological result caused by the view of the physical entity) and the physical entity itself are interdependent; the latter may manipulate the first. That is, through proper attention to the element of scale, considering the building as a physical entity, the spiritual entity may be created; and a vice versa consideration is also necessary. This tells us that, depending on the feelings a designer wants to create, the physical elements of a building can be manipulated.

If that is understood, then it must be accepted that *scale* does not necessarily imply "human scale", any type of scale can be used, provided it is conscientiously done, if the intention exists to create certain different experiences and feelings.

Absence of familiar elements and inclusion of iconography in exaggerated size can create environments that lack human scale. Project in private development—Chandeloupe les Vignes in France.

Exaggerated size of familiar elements results to environments that have no human scale. "Foot sculpture" in Chandeloupe les Vignes in France.

Environmental cavities of unfamiliar dimensions may significantly affect the scale of buildings. Tristan Tzara house in Paris. Adolf Loos, Architect.

Absence of "familiar elements" creates buildings that have non-human scale. James Stirling, Architect.

Manipulation of scale can generate feelings of monumentality, state domination and individual annihilation. Such case was frequent in the architecture developed by Fascism. Palazzo della Civilta Italica. E. B. La Padula. EUR, Rome, 1939.

From the Byker Wall Housing project by Ralph Erskine in Newcastle Upon Tyne in England. Duality in scale as a means to create different feelings to the viewer. 1968–present.

The "out-of-human-scale," is desirable here. The feeling of sublime through scale manipulation in the symbolic entrance to Satellite City in Mexico City. Luis Barragan, Architect, and Mathias Goeritz, Collaborator on the Sculpture, 1957.

The history of architecture contains a number of examples in which scale can be seen in its total and its great variety of applications—both in buildings that express one scale alone, and in buildings that result from a number of different scale considerations. The duality of scales can be seen in modern stadiums. A human scale exists in the interior space, since there the building is broken into parts that are functional for individuals. In this case the part is a step on which a person can sit comfortably to watch the game; that is, the interior of the building is composed of familiar elements through which people may reach and comprehend the building. (The stadium represents the most characteristic actual example to illustrate the currently attempted interpretation of scale, both metaphorically and actually.) The exterior, on the other hand, is oriented toward the appreciation of the building by the masses while they are approaching the building. No details are emphasized. The building exists as a volume, big enough on a big plaza to attract crowds from far away. The purpose is different, so the scale can be different from the one inside. The exterior is designed for the masses.

There is a current school of thought which accepts and utilizes juxtaposition of scales[17] in architecture. A building may have two different scales, present one character on one side, another character on the other. Robert Venturi has created such ambiguous buildings for "esoteric" as well as functional reasons.[18] It is important that this license be permitted to architects today, especially in view of the fact that walking and motor car use each create different conditions for visual appreciation and visual perception.

Proportions

Some of the concepts described here may be characterized as "stronger" than others. This differentiation derives from the fact that in applying these concepts, certain kinds of comparisons are involved—either comparisons among the elements of buildings, or between the elements of buildings and the human being. The concepts that require comparisons with man may be classified as "stronger" than those that do not. . . . The reason is that it is more difficult to make objective statements when the personal element, or "ego," is involved than when it is not. In this respect, the concept of scale, so far examined, may be regarded as a stronger concept than proportion.

Scale is a "dialogue" between human and object, while *proportions* denotes only a dry concept of physical relationships between the parts of a building. In a strictly architectural sense, the concept of proportions represents a geometric concept that results from the comparison of physical (linear) dimensions.[19] The proportions of a building are "there," even though a human being may not

be around to estimate or appreciate them. The proportions are there because the building is there—that is, because the relationship of its width and height, or the total dimensions to the dimensions of the elements of the edifice, are there.

Architects have long been aware of this concept and have also inquired further. The concept of proportions was very conscientiously used during various periods, and "proper" proportions were defined (e.g., the golden section or divine proportion, the Modulor series of proportions by Le Corbusier),[20] so as to make buildings appealing to observers—that is, appealing through the proper relationships of the elements of the building among themselves, and the building as a whole.

The proportions of a work of architecture are found in plan, section, and elevation. In terms of **plan,** the proportions are necessary for the function. There are certain proportions that may be immediately excluded, as they might not permit a functional accommodation. For example, the width of a room may not be sufficient for the accommodation of a certain set of furniture, or the accommodation of a particular activity. A different width may change the situation altogether. Proportions change the "tension" and "movement" in spaces.[21]

The functional consideration is also important for the purposes of **section,** but it is not really as strong as it is in plan. The view and the height of the human being are the determinant factors of the proportions of a section. These proportions determine the volume of light to be permitted to enter the interior space and are thus fundamental in controlling the quality of the space per se.

Since the proportions of the sections are essentially functional from the spatial point of view, the same may be expected to be true for the proportions of the elevations. This, however, is not the case. The proportions of the **elevation** serve no utilitarian function. Their function is purely expressionistic of the structure, purely arbitrary; they often have very little to do with the proportions of the section and, of course, are only minimally related to the proportions of the plan.

In spite of this, it is in the elevations where proportion is taken seriously by many architects and many students of architecture.[22] The proportions of the plan and of the sections are not often regarded with the religious attitude that characterizes the concern over the proportions of elevations. There is an explanation, of course, for this phenomenon. It is extremely difficult for the "user" to become aware of the proportions of the plan; it is also very difficult to perceive the proportions of the section, since we often experience fragments of the section and not the section of the building as a whole. The elevation, however, can be experienced in its totality, even in cases of very narrow streets and extremely limited vistas. It seems logical, therefore, that it would be easy for a designer to be taken

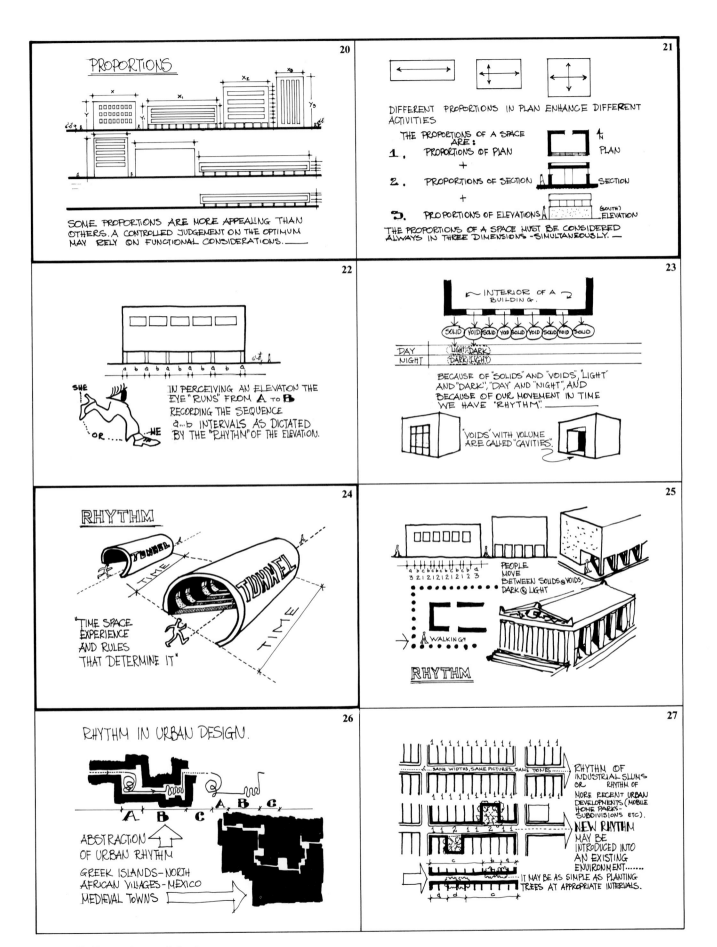

Figure 7. Proportions and rhythm

Marin County Court House. Frank Lloyd Wright, Architect, 1959.

over by the visual possibilities of his elevations and to disregard the proportions of the plan and sections. This, of course, is not an attitude one should have, and the explanation provided above should not be an excuse for partial consideration of proportions with emphasis only on the proportions of elevations.

The proportions of elevations, however, will provide examples for the discussion of the theory that follows with the purpose of explaining certain fundamental design concepts.

Proportions deal with **visual loads.** Visual loads are carried to the ground by means of voids. The visual bulk of the solid volume of an edifice is more comfortably supported by the voids defined by the bays between the columns than by the columns themselves. The voids in concern perform the role of a base, which, of course, is not real; it is only a visual base which supports the bulk of the building it carries. It appears, therefore, that the proportions of the visual base in concern are essential for creating the feeling of security that the building will be supported and not collapse. Other proportions than the "right" ones might not, of course, generate such a feeling, although, of course, the edifice might still be excellent structurally. This is the case with many recent buildings. It is often argued that structural proportioning is right for visual load purposes too, yet this is not true. One has only to point to the works of Pier Luigi Nervi which make it clear that the structural engineer can provide much more than just static arrangements and calculations. Nervi's work has solved the problems of the statics of buildings by means of psychologically sound proportioning.

There are numerous examples of rational visual-load proportioning in the history of architecture. The Temple of Aphaea on the island of Aegina in Greece is a classic case. The proportions of the visual loads of the second floor are lighter than those of the first floor, the latter playing the role of base for the former. The same is true for the courthouse of the Marin County Civic Center designed by Frank Lloyd Wright. The proportions of the arches change progressively, and the lower strip of voids supports with its strength the two upper strips. The apparent structural irrationality of the elevation (The lower arches support the two upper strips in a structurally weak manner.) is disregarded by the strong rationality of the proper proportioning of the elements of the facade for visual purposes.

The second important consideration related to the proportions of elevations has to do with the total perception experience which may be static or dynamic. An elevation may express minimum relationships of the elements of a building, or on the contrary, the opposite might be true.

The degree of expression, however, represents the prerogative of the designer. As soon as the designer has committed himself and the work is built, the relative expression of the building will be the stimuli for the observer. The elevation is perceived in time as the eye "runs" from one part of the elevation to the other,[23] that is, as the eye compares the expressed parts of the elevation among themselves, or as the eye acts as an immediate calculator of relationships. It may be suggested that it is this process of instant calculations in which the concept of **dynamism** of elevations may be found. For the purposes of further discussion, it could be stated here completely arbitrarily that a calculation of one relationship, i.e., $\frac{x}{y}$, may denote a static building, while an aggregate of such calculations may denote a dynamic building. It appears, therefore, that the designer must exhaustively investigate the possibilities in proportioning his elevations and, through training and practice, establish his own vocabulary of "static" and "dynamic" and express them effectively.

The question of proportions in elevation has been recently negated by a number of architects. Some buildings have been created for purely proportional purposes and they have generated situations where **life** was completely removed from the streets. Well-proportioned walls have replaced series of street stores and other street activities just for the purpose of creating a visual base or a visually appealing result. The results, however, have often been of another nature and negative. Discouragement of people on street levels has fostered crime and generated situations where nobody will stay around to see the "well-proportioned buildings." An architect must not, therefore, forget the damage that can result in urban design or "large-scale architecture" projects if primary concern is given to proportions and not to the quality of life. This should be first, with all other concerns secondary.

At this point it appears necessary to challenge an understanding of the concept of proportions in "urban-scale terms" and use it as an introduction to the concept of rhythm with which *urban proportion* is strongly related.

The proportions of an urban environment are analyzed in similar ways as those of a building. The proportions of a building are appreciated almost instantaneously (This is not true, actually; further discussion will clarify the matter later.) as the eye runs from one part of the building to another; in urban environments, however, instead of the "moving eye," it is the moving man which in time becomes aware of distances and dimensions and compares them (among themselves), thus getting the experience of urban proportions. Thus we say that in urban settings we find

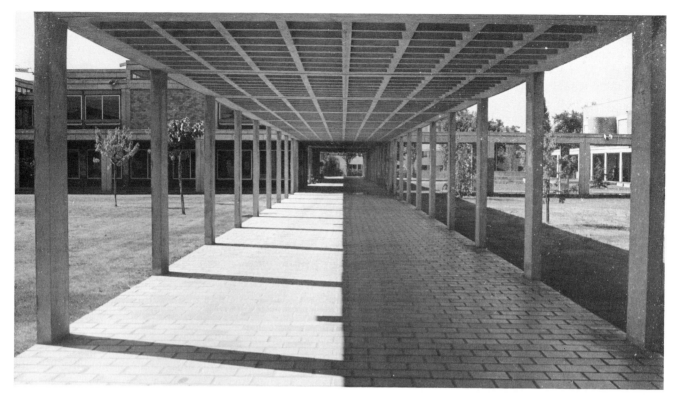

Rhythm as achieved by means of natural lighting and structure can emphasize the movement and create ceremonial tendencies for the approach. Main Approach axis, University of Toulouse-Le Mirail, in France. Candilis-Josic-Woods, Architects.

four dimensions instead of the three that usually constitute our understanding of small-scale architecture. Generally speaking, in urban terms we have the following types of dimensions and dimensional entities:

1. Linear dimensions; they pertain to the linear time experiences accommodated by the linear elements of urban plans, as for example, pedestrian walks.
2. Surface dimensions; these are the elements of two dimensions of a plan; they are "areas" occupied by various land uses and corresponding activities.
3. Volume dimensions (three dimensions); the bulk of built-up urban environment; urban solids are seen as aggregates of buildings, density areas.
4. Time dimension—the fourth dimension; the time it takes to appreciate the various parts of a plan, or the time it takes for a space experience to be accomplished.

This consideration of the fourth dimension makes the perception of urban environmental proportions unique and it brings us to a good point for the examination of the concept of "rhythm." We will see "rhythm" in urban terms first, as it is much easier to explain the concept as related to urban design. We will try to see the implication of the concept for small-scale architecture purposes in the subsequent part of the discussion.

Rhythm[24]

Rhythm connotes a space-time experience, and it is related to the proportioning of an urban environment in all respects. Rhythm is a function of the proportions of a space. The environmental awareness permitted by a certain environment is also related to the velocity of one's movement. Rhythm, therefore, is a function of spatial proportions, movement time, and velocity of movement.

The linear, area, and volume proportions of an urban space and the relationships among them, that is, the urban proportions, dictate that a certain experience is derived by the person moving in such space in time. The total amount of time spent in movement is an aggregate of time intervals spent moving between the details of urban space. Rhythm is then the aggregate of the rules that determine space-time experiences. The rhythm of an environment A, B, C, D, E may be the following: time spent to appreciate or purely become visually aware of activities or visual stimulation of space A, plus time spent moving from A to B, plus time spent to experience activity B, plus time spent moving from B to C, etc., until the whole environment has been appreciated.

Rhythm represents the "rules of the game of movement." The time spent going from A to B may be completely different from the time spent going from B to C, etc. The designer sets the rules of the game through his

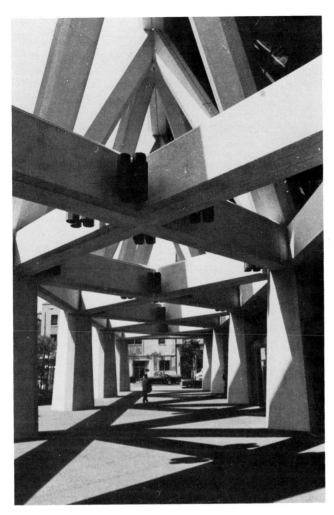

Hit by light and dark; the sharp rhythm under the canopy of the Transamerica Building in San Francisco. William Pereira, Architect, 1973.

processional elements that take us from space A to space B, or, as we might also say, from tone A to tone B. The relationships that exist between the tones, their similarity if it exists, and the amount of their repetition in conjunction with the relationships that exist between the intervals are the elements that determine rhythm. The goal is to compose harmony as opposed to the possibilities of monotomy or chaos.

An urban rhythm would be monotonous if there was an excess amount of repetition between tones and intervals. The question, therefore, is again an issue of "measure," and the designer must always ask himself, "How much of A to B, and how many A's and B's?" Monotonous rhythms in large-scale architecture result when there is emphasis in only one factor of design constraints, and disregard for all others. Structural economy, for instance, may be one of the reasons to produce monotonous rhythmic situations. Sometimes the strongest reasons for rhythmic monotonies are based on excess emphasis of social constraints. Attitudes in design where social equitability is taken as the primary criterion lead to monotonous urban scenes; classical examples are the sequences of the industrial slums of Europe and the urban design seen in socialist town planning of communist countries. The final experience of a "monotonic" environment is one of low stimulation and boredom.

The opposite may result if there is very little control or if there are no rules to determine the relationships that exist between tones and intervals. The tones may bear no similarities and the intervals may be totally unrelated; the human being, therefore, must be constantly alert to capture every tone that passes by, to experience every interval that follows. There is great chance that many of the tones and intervals will be missed if one is not alert and that the individual will have no chance to learn from the environment what he could have learned if some well-measured repetition was at hand. An environment which is based on excess and constant succession of tones and intervals provides a rhythmic experience of uncontrolled polyphony, what we might label here as an experience of *chaos*.

Urban chaos offers every tone possible with no coherence among the tones. The observer often disregards all "tones" that do not appeal to him and relates directly to the tones of his personal preference—thus the specialization of highly sophisticated contemporary urban chaotic situations.

An appealing rhythmic urban experience, monotony, and chaos constitute the three possibilities of total urban aesthetics. Rhythm is the quality that permits total experience, because it is the only aspect of design that relates to the fourth dimension. Rhythm may be spoken of in the purely life style, "rhythm of life," or "activity" sense; or it may refer to purely geometric and abstract relationships of urban plans. The pure geometry of a plan may suggest monotony, chaos, or an optimum.

designs. Thus the linear, area, and volume relationships as determined by the design set the symphony which is experienced in time, and it is called *urban space*. An environment suggests a certain time-space experience, that is, a certain rhythm. It encourages certain movement or a certain type of life (since life is an aggregate of time intervals and the respective experiences); while, on the other hand, it may be life or certain life patterns that suggest to the designer the rhythm which he ought to incorporate into his design. An environment may be an expression of the rhythm of a certain life style. The "rules of the game" that suggest the rhythm of an environment are fundamental for the creation of stimulating (or not) situations.

Rhythm in architecture may be explained in similar terms as rhythm in music. We might speak about "tones," similar or different, as well as "intervals" between the tones. When mentioning "tones," we may refer to the urban areas where activities take place; while as "intervals" we may refer to the time spent in the linear or

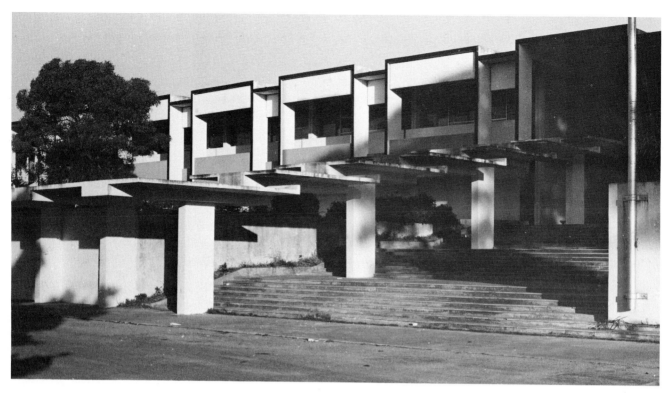

Multi-directional rhythms can create dynamic environments and suggest movement. High school in Sarasota Florida, Paul Rudolph, Architect.

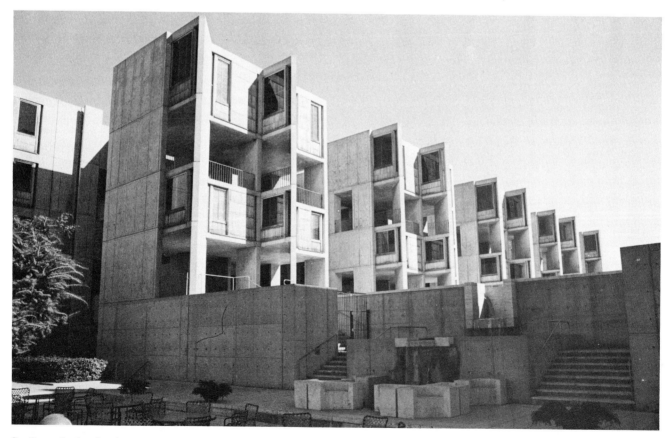

Studious rhythm has been incorporated in some of the greatest buildings throughout history. Salk Institute, La Jolla, California, Louis Kahn, Architect, 1966.

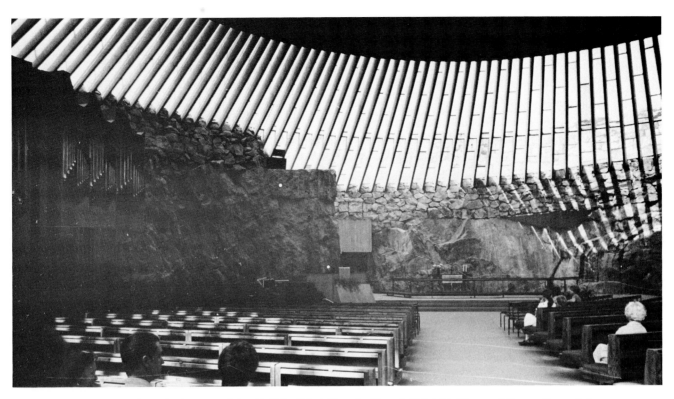

Rhythm in architecture through elements of detail. Taivallahti Church. Church Helsinki, Timo and Tuomo Suomalainen

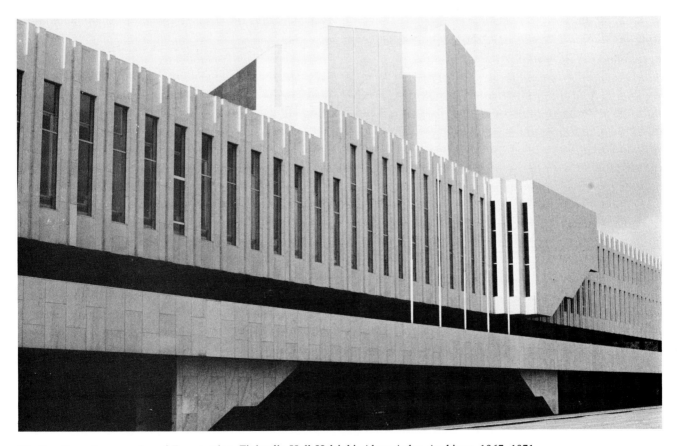

Rhythm through expression of Fenestration. Finlandia Hall-Helsinki, Alvar Aalto, Architect, 1967–1971.

Lack of well-established rhythm may cause "monotony," which in turn may become the reason for boredom and allienation. Housing in New Town Kutiky, New Bratislava, Czechoslovakia. (Photo by Craig Kuhner.)

Excess repetition, Monotony, chaos, or the chaos of monotony? (Kazuhiro Ishii.)

70

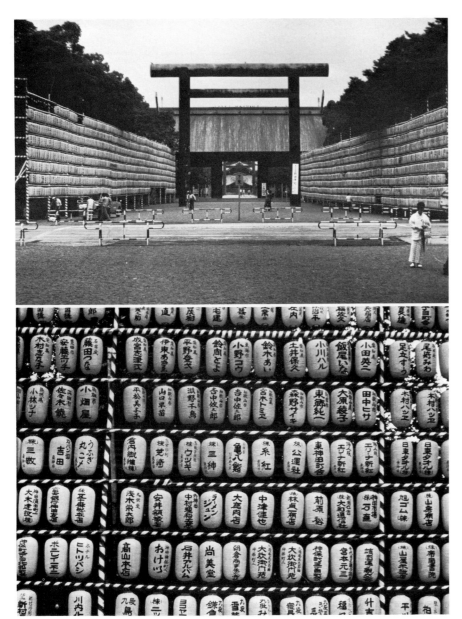

Monument to the unknown soldier.
Tokyo, Japan.

Having dealt with the concept of "rhythm" in urban terms, it may now be easier to understand it in terms of small-scale architecture. It is more difficult to understand this concept in buildings, because the time spent in the total experience of a building is usually much less than the time spent in an urban movement experience. The rhythm of an edifice is basically experienced in terms of plan. It is the plan, its various areas, that may be equated to the "tones" of an urban space example; and the connections between these areas are the corridors or the elements of circulation that permit movement. The rhythm of a building, however, has often been misunderstood in the past as being the rhythm suggested by the elevations. This is the aspect of the concept that is most difficult to understand. When we view an elevation, a picture registers in our minds instantaneously. Yet "instantaneously"

is only a word to be used for communication purposes. There is still time involved, and it is the time it takes for the light to come through our eyes and register the pattern in our minds. During this very short time interval our eyes run from one end of the elevation to the other and perceive the building by means of solid-vs.-void sequences, or by means of dark-vs.-light sequences. The solid/void relationships or the dark/light relationships have already been set by the process of proportioning the building. Thus they indirectly set the "rhythmic" theme, that is, the *time-shape appreciation* experience in which we indulge when perceiving an architectural elevation. In a similar manner, as in urban space rhythmic experiences, we may have monotony or chaos.

Rhythm through modular construction can successfully integrate buildings, to terrains of peculiar irregularity. School of St. John the Theologian. Patmos Greece, Michalis Photiades, Architect, 1970.

The use of modular building system does not have to result to monotonous rhythm. The pleasant case of the Nakagin Towers in Tokyo. Kisho Kurokawa, Architect.

Effort to eliminate the problem of monotony caused by the excess repetition of earlier curtain wall buildings. The "sky" has been articulated by means of color coding indicative of the functions inside thus creating pleasant vertical rhythm. Oak Leaf Towers in Houston. Cesar Pelli, Architect, 1982.

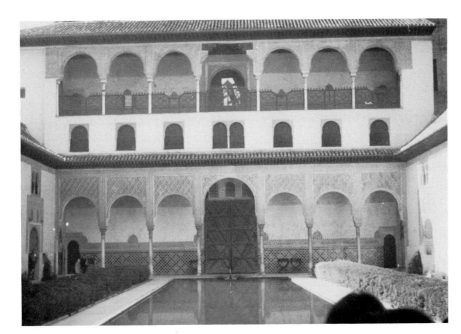

Monotony or chaos can be avoided if excess repetition or excess diversity are avoided both horizontally and vertically. Detail from the Alhambra, Spain, 10th Century.

Measure in design represents the only way to control the situations at hand. It is only through training and practice that it may be achieved and through which urban and architectural rhythms can be expressed in their optimum possibilities.

Unity

Unity represents the "checking" consideration for a work of art. It is the quality that exists when all previous concepts operate within a balanced equilibrium holding the work together as a total whole. If some parts of a design do not "hold" together, if there is emphasis of one design aspect over another, if it seems that the building possesses elements of conflicting qualities that are unfit and disobedient to the total spirit of the composition, then we say that the building lacks unity. Absence of unity is a disturbing aesthetic situation. It is often found in the works of undisciplined artists. Besides the aesthetic burdens, it burdens the construction economically. In empirical terms unity means coordination; when all elements of architecture are coordinated among themselves, we have design economy and construction savings.

Unity is the last to be considered, yet the most comprehensive, intellectual tool of designers. Unity and the design concepts that preceed it deal with physical issues, or physical issues as related to man and to his visible dimensions. But the creations of man also have certain other dimensions; there are the invisible dimensions that rest in the hidden part of each creator's mind. Works of art are more than anything else products of these hidden design considerations. The "meaning" of a work, the "intention" of a work, and the "morality" that dictated the meaning and permitted the intention represent the final considerations when dealing with works of art.

Morality

Perhaps "morality" of a work of art is the easiest concept to understand—yet the most "touchy" to talk about, and the most difficult to master. *Morality* in architecture refers to the very basic issue of morality and decency as understood by society and as purported by various groups' codes of ethics. Morality is obviously circumstantial and it underlies the architect's response to the occasional crises that confront mankind. In that sense "morality" is directly related to the success of a design from today's environmental standpoint.

Designers are sooner or later forced to take stands on physical, economic, social, psychological, and political issues. How would you respond as an architect in the event your country came to be ruled by a dictator? Would you become a collaborator in furthering oppression[25] in your country's environments? How would you respond in the event of a social crisis? What attitude would you take toward an architectural program (e.g., competition) if your social values were totally antithetical to its values? How would you act in the event of an environmental crisis such as the energy crisis which is pertinent today?

The history of modern architecture is full of cases of contrasting moralities. It was implied by Philip Johnson that Mies van der Rohe flirted with Hitler in the hope of commissions, and that the reason he left Nazi Germany was not his concern for the oppressive regime, but because "Hitler liked pitched roofs."[26] Philip Johnson himself would represent a great case study on the issue of morality in architecture. He has stated that architecture does not influence the moral life of the people;[27] and also that he wouldn't give a damn about designing something for Harlem. "Give me to design the palace for the Vice President!" he exclaimed.

Such theses represent the factors that have alienated architecture from society and brought negative criticism to architecture by social as well as architectural critics.[28]

One obviously may claim ignorance, for instance, that he did not know the hidden oppressive practices of a totalitarian regime. Should his collaboration be dismissed then as innocent? Well, it is just exactly here that justice is left in the hands of posterity, for it is this writer's belief that all morality is circumstantial and that one should have all the facts before making definitive judgments. As the critic should have all the facts, so should architects. Again, it is the author's opinion that a "moral" architect tries to do the best he can to collect *all* the facts of the situation of his project. If he is certain that all facts are at hand, he should then consider them and decide whether to undertake the commission. If he does not carry out this process, he could commit an "immoral" crime, perhaps unknowingly.

Most crimes are committed in the functional aspects of architecture, and they are often due to the challenges of form. There are numerous contemporary buildings of ordinary functions that possess no windows in areas where people work. The fact that sun and light are sources of life makes windowless rooms devoted to the most usual working activities, works of architectural crime.[29] All too often such decisions are made for the sake of an elevation or a form.

It is again the conviction of many people, including the author, that it is immoral to talk about or, even worse, give architectural awards to projects that tolerate certain criminal functional compromises in order to enhance their form. It is unfortunate that most of the architectural awards are given with disregard to the architectural and environmental morality of projects. Such award practices should be eliminated, and architects who are not concerned for the environmental relevance and morality of their work should withdraw from the practice of architecture.

Architectural morality should be a virtue of all architects. One should also not confuse architectural morality with "professional ethics."[30] The latter is sometimes in conflict with the former. "Professional ethics" in the United States, for instance, has often tolerated architecturally immoral acts, as with the case of windowless working areas. The morality of a work will be looked upon by the future critic.

For works that are built today, that is, in a period of awakening on the issues of energy, the critic will probably ask, "Was it moral that grand interior enclosures of air-conditioned environments were created in times when mankind realized it was on the threshold of an energy crisis?" The architect would reply, "It was not my intention to commit such an 'immoral' act, as at the time I was designing this project there was not an energy issue, and I was totally unaware of its implications for the future survival of mankind. . . ." "I only wanted to convey to future generations the '*meaning*' of our civilization, that we could indeed create such great air-conditioned enclosures and offer to man comfortable environments . . . much better than his natural surroundings. My architecture was *intended* to *mean* 'a glory of mankind over nature. . . .' " This could be an acceptable answer—perhaps arrogant, but acceptable. It was meant "to mean something," its intentions were honest, it was therefore not an immoral act under the specific circumstances of civilization. To "plead guilty" is not the solution with architecture, however.

The architect is not like other artists. His works are works on the surface of the earth; that is, each architectural work, no matter how small in scale or how individualistic, occupies a spot on a public space. Very often it is done with public money, both in socialist and capitalist environments. Architecture, therefore, must be responsible to public issues; it must be moral; its intentions must be good ones and its meaning must focus on mankind.

There are numerous unknown architects whose anonymity is perhaps due to the excessive degree of their morality—a morality that goes beyond the narrow spheres of "architectural morality"; their morality is deeply rooted in the cosmotheory of their existence. Pikionis and Victor F-Christ Janer are such individuals the author has encountered. Not all students or architects are so lucky as to find such great paradigms in life. The student, in most cases, must settle for the paradigms conveyed to him through books. These paradigms are often manipulated by the vanity of the writer or the critic, so the student must be inquiring and cautious.

The best way to formulate opinions about an architect and his work is to become a judge yourself. Study and visit the works of the architects you have been told by books to admire. From the author's own experience he can say that he was astonished by the lack of depth he experienced when he visited the building of Minoru Takeyama in Sinjuku, Tokyo, which made the cover of the very influential book by Charles Jencks, *The Language of Postmodern Architecture*.

Be aware that pleasing forms do not necessarily assure morality. The opposite is also possible. All nonpleasing forms do not necessarily reveal moral deficiency of a designer. The viewer or the critic may become a judge himself only when he has all evidence at hand.

Of the contemporary architects that have appealed to many critics for the pleasing forms they have produced, one could single out Philip Johnson.[31] Yet one could hardly recommend him as a paradigm of environmental morality. An environmentally relevant architect should serve architecture in Harlem as well as in the nation's capital.[32] He should also try to come up with some solutions to the big problems that face the environment.

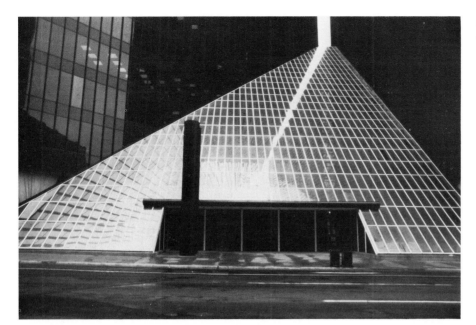

The Pennzoil Building, Houston,
Texas. Philip Johnson,
Architect, 1976.

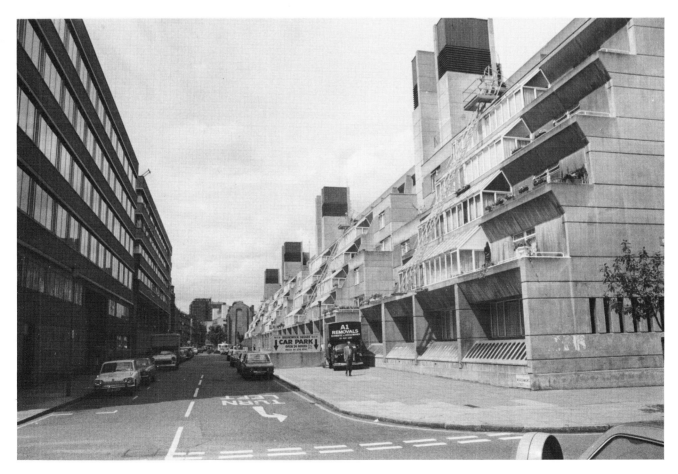

Environmental rhythm in the urban scale as achieved through the expression of architectural elements (i.e., circulation, mechanical towers, etc.). Bluemsburry Housing, Pattrick Hodgkinson, Architect, London, England, 1975.

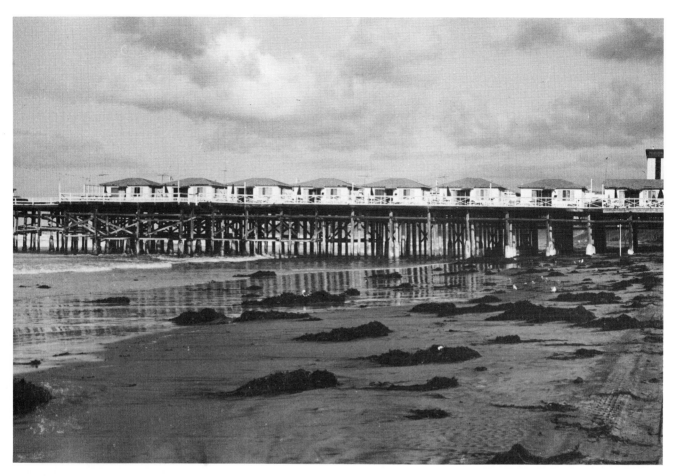

Rhythm as achieved by articulation of individual functional elements and the element of structure. Crystal Motel Pier, Mission Beach, San Diego, California.

The attitudes of British architect, James Stirling toward design and general issues point to another case of the "form-morality" relationship. The critic, viewer, or student should be extremely cautious in his evaluation. Stirling's architecture has been justified by him and his recent critics as one of extreme sensitivity to social and public issues, public money, and the cost approach.[33] It is true that his preoccupation with costs helped him develop unique structural and functional solutions that eventually produced distinctive and pleasing buildings possessing structural logic and a massing expression reflective of the building program. He took stands on crucial issues, such as the irrelevancy of the individualistic house in the postwar situation in England, and he expressed attitudes regarding the waste of circulation in the "free plan" situation. Yet in spite of all his claims of concern for resolving the above issues, much of his architecture has not pleased most of its users[34] nor the British public at large; and, contrary to his "claims" of concern for real issues, his architecture appears to be one of form and form alone.

His (or her) own morality, therefore, is not something a designer can talk about or insist that he possesses. It is a quality that the honest and competent designer will blow into his design; and it will stay with it forever. Most often, moral works remain unnoticed. They serve their users in all respects and do not disturb the environment in which they are located. On the contrary, they enhance it. The Ghirardelli Square and Cannery Shopping Center in San Francisco are very good examples of moral acts of environmentally relevant architecture. The same is true with Quincy Market in Boston.

There are numerous examples of morality to be studied in the traditional architectures of many peoples. As for a contemporary case of a nationwide concern, one could easily point to Finland. The reciprocal respect between architecture and nature in Finland is such that one should not hesitate for a minute to call it the most moral and environmentally relevant architecture in the world today. It is not an architecture of one man, although much of the credit could justly go to Alvar Aalto; but it is an architecture of a nation of *morally* concerned architects. This

nation that institutionalized the protection of the trunks of trees with rubber bumpers should be regarded as a model. Its architects and its people deserve the credit.

Architectural works possessing no meaning, with unclear intentions,[35] with no moral concern should rank low in our esteem. Perhaps they should be totally dismissed.

Notes

1. The references on the basic concepts of design are very few. The existing ones are rather antinquated, yet because they talk about "universal principles" of design, they are always relevant and to the point. The notes and original references on the sections that follow are exhaustive. For comprehensive reference, see Banham, 1967. Explanations and occasional theoretical suggestions are offered here without further references, as the interpretations pertaining to the various concepts have been strictly developed by the author. As major references for this chapter, refer to all selected bibliography of the chapter.
2. For concepts on abstraction and abstract patterns, refer to Arnheim, 1971, p. 173.
3. For principles of two-dimensional design, refer to Wong, 1972, general reference.
4. For input here refer to Negroponte, 1970, p. 41.
5. It takes place during the architectural programming stage. For the techniques of the process, refer to Peña, problem seeking.
6. This was recognized by the Greater London Council. In 1969 they came up with a report for housing ("Houses for People") suggesting minimum areas for the performance of certain activities, rather than suggesting minimum dimensions for a certain qualified space.
7. Such misconception has been widespread in the United States and has often been due to misinterpretation of statements made by Frank Lloyd Wright. Paolo Soleri still refers to "organic" architecture on the basis of resemblance to organs of living organisms.
8. A widespread Greek proverb.
9. Do not confuse "order" with the concept of "orders in architecture" which in the classical sense is referred to a specific combination of column-base, column, capital, and entablature vocabulary according to a prescribed formula. For "orders in architecture" also see Gauldie, 1972, p. 113. For further argument on "order" refer to Gauldie, 1972, pp. 26, 35. Also to Fletcher 1975, p. 1052.
10. Le Corbusier, 1972, p. 125.
11. Ibid., p. 126.
12. Lynch, 1963, p. 9.
13. Ibid. (legibility), p. 2, 3, 10.
14. For further discussion on scale, refer to Rasmussen, 1974, p. 104. Also Gauldie, p. 30; and Michelis, 1965.
15. Thompson D'Arcy, 1917.
16. Antoniades, 1971 (1).
17. The advocate of this approach is Robert Venturi. See Venturi, 1968, pp. 38–46.
18. A good example is the town hall for a town in Ohio designed by Venturi. It has one "scale" on the plaza for the masses and another scale on the side of the building approached by the employees. Venturi, 1968, p. 125.
19. For further theory on proportions, refer to Rasmussen, 1974, p. 104; Michelis, 1965; Arnheim, 1971, p. 49.
20. Refer to Le Corbusier, 1968. General reference.
21. Arnheim, 1971, p. 403.
22. The whole theoretical work of Colin Rowe focuses on the two-dimensional issues of proportions on plan and elevation. His well-known theses on "transparency," "wall and superwall," etc., have been, in the author's mind, totally wrong. The concern of architecture should not be limited to the proportions of elevations, or the proportions of the plan alone. It should encompass the whole spectrum of three dimensions. For the theses of Colin Rowe, refer to Rowe and Slutzky.
23. The concept of the "running eye" was first introduced by Borissavliévitch, 1926, pp. 41–42.
24. For further input on rhythm, refer to Rasmussen, 1974, p. 127; Gauldie, op. cit., p. 30.
25. For the issue of "oppression" as referred to, see Tzonis, 1972, pp. 11, 13.
26. Cook and Klotz, 1973, p. 37.
27. Ibid., p. 37.
28. Ibid. The "morality" of architecture is touched upon by Ruskin and is further questioned by the environmental psychologists.
29. Ibid. There are obviously working activities that do not necessitate light and where windowless rooms would be a functional necessity.
30. Do not confuse morality with "professional ethics." Professional ethics are sometimes contradictory to the larger concept of architectural morality.
31. Many other important contemporary architects have been criticized that their work lacks moral and social content. Among them Richard Meier, the "most polished" of the United States architects, protested such criticisms and suggested that: . . . "formal ideas are not *a priori* antisocial. In fact, it is only formal ideas which elevate architecture from mere building, and make it, whether one likes it or not, a cultural artifact—a work of art." See Richard Pommer "The New Architectural Supremacists," in *Artforum*, Oct. 1976, p. 42.
32. Johnson in Cook and Klotz, *Conversations with Architects*, 1973, p. 37.
33. Jacobus, 1975, p. 17.
34. Ibid., p. 19.
35. For further reading on intentions in architecture refer to Norberg-Schulz, 1965.

Selected Readings

Banham: *Theory and Design in the First Machine Age*
Giedion: *Space, Time, and Architecture*
Michelis: *E Architectonike os Techni* (only in Greek)
Rasmussen: *Experiencing Architecture*
Sartre: *Essays in Aesthetics*
Thompson D'Arcy: *On Growth and Form*

4
Concise History of Architecture

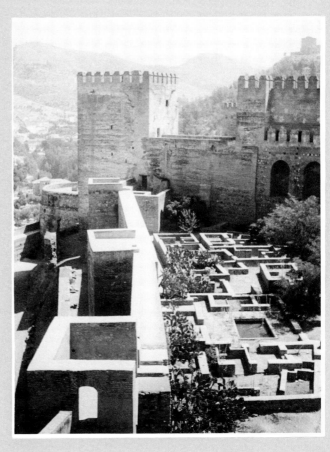

A Framework for Inclusive Appreciation of History

Man-made environments have not always been built and shaped by "architects," nor even by people specially trained in the arts of building. In fact, most architecture has been done by untrained people, by people referred to collectively as the "unknown architects."[1] The "official" history of architecture, however, is to its greatest extent the history of works done by trained architects, people versed in theory, geometry, painting, sculpture, mathematics, and related subjects. This is largely due to the fact that scholars have felt more comfortable when they could base their cases on existing written evidence, rather than deal subjectively with environments that did not have the backing of theoretical treatises, emperial or papal seals, and other documents. Furthermore, the architecture of many people whose languages were incomprehensible to the scholars has been generally neglected, thus its mention in history has been insignificant, if not totally omitted. The history of architecture as generally presented by architectural scholars has been, therefore, the history of the monumental, the powerful, and the stately or religious building. This attitude has created rather one-sided ideas about what architecture is and what the role of the architect should be. It is our responsibility here to point out this one-sidedness of history and to stress that the discipline of today's environmental designers should be based on a comprehensive, all-inclusive perception of environmental evolution that includes all the works of man, be they monumental and official, or vernacular and produced by untrained architects. This must be the case, because studies of both can contribute to the solid betterment of today's architects. References to the lessons of vernacular prototypes will be made constantly throughout the chapters of this book, while the accepted knowledge regarding the history of architecture as researched and written by the scholars will be introduced here.

The Dawn of Architecture

The story of ancient architects has been well researched and it makes for fascinating reading.[2] It offers a glimpse of aspects of the profession that have been consistent through the ages. The number of significant architects whose work is still alive is very large and well recorded.[3] The architect's position in ancient societies was exceptional, always near those of the influential, the clergy, the politicians, and the monarchs of the time. They were men of thought, of knowledge, and of the abilities to direct others on how to build and to coordinate. With the understanding that it should not be regarded as disrespectful that we do not mention all of those recognized by history, we will exercise strict selective license here and present a very few for the purposes of this introduction.[4]

Ancient Egypt and Greece have left us their great monuments but also the evidence of mankind's earliest architects. Imhotep was the best known of the many Egyptian architects.[5] He possessed great knowledge and was highly respected by the Egyptian notables, the clergy, and the Pharaohs. He was responsible for a good number of innovations in pyramid and mastaba design and he designed many of them. He was a master of geometry and excelled in many fields that incorporated astronomy and mathematics. He pursued architecture in both applied and theoretical manners. He produced a book, thus starting the pattern of architect-theoreticians that was to continue through history.

The greatness of Egypt was succeeded by two subsequent civilizations, the Cretan (or Minoan) and the Mycenaean. Both developed in Greece and both developed architectures of exemplary significance.[7]

Cretan architecture had its peak about 2000 B.C. and its recorded champions were King Minos and his architect Daedalus, both legendary figures in the political and creative fields. Daedalus has been credited with the construction of the Palace of Knossos, the epitome of Cretan architectural space-making and civilization. The study of this palace is of extraordinary significance for the environmental designer of today, as it is the oldest surviving example of architecture that integrates all of the arts, and because it is a work that responded to innumerable constraints—including environmental, functional, and symbolic.[8] The palace has a very complex organization achieved by such simple means as clear circulation, well-proportioned rectangular rooms, load-bearing walls, and post-and-beam construction. It is appropriately oriented; it responds to the strong climate of the area through the use of sun-shading spaces (porticos); it achieves cross-ventilation through the use of patios and clerestories; it is well drained and sanitary (a respect in which many subsequent yet celebrated architectures were notoriously inefficient i.e., the Palace of Versailles in the seventeenth century); it integrates other arts, such as painting and sculpture; and it integrates interior with exterior in a most functional and joyous way. Knossos, uncovered by Sir Arthur Evans between 1899 and 1932, has been called by those who have studied it "the Paris of Ancient Greece".[9] It was indeed the center of a great civilization that produced works of unsurpassed beauty, rationality, and ceremony. It displays qualities that recent architects have tried hard to achieve. It is one of the earliest masterpieces of comprehensive, totally efficient architecture, yet one that does not display the monumentality nor the inhumanity of many subsequent and more celebrated civilizations.

Mycenaean architecture did not display the refinement and craftmanship of Cretan architecture.[10] It was more primitive and vernacular. Its buildings and towns (Mycenae, Tiryns, Argos, etc.) were built on irregular sites,

Figure 8. Concise history of architecture. A visual summary

	EGYPT	CRETE	MYCENAE	CLASSICAL GREECE	HELLENISTIC PERIOD / CLASSICAL ORDERS	ROME — INNOVATIONS	ROME — PANTHEON	ROME — TRAJAN'S MARKET	ROME — PALATIAL VILLAS
SELECTED BUILDINGS	c. 2000 B.C. PYRAMID OF CHEOPS	c. 2000 B.C. PALACE OF KNOSSOS	c. 1525 B.C. TOMB OF ATREUS / MEGARON	447–432 B.C. THE PARTHENON	4TH CENTURY B.C. PLAN OF MILETUS / DORIC, IONIC, CORINTHIAN	HIGHWAY, CAMP	120–125 A.D. PANTHEON	106 A.D. TRAJAN'S MARKET	126 A.D. HADRIAN'S VILLA
AESTHETICS, SPACE, BIG-IDEA AND MAJOR PROBLEM SOLVED	THE AESTHETICS OF ABSOLUTE GEOMETRIC SHAPES, MASSIVE CONSTRUCTION AND ASSEMBLIES OF BUILDINGS FOR RELIGIOUS AND CEREMONIAL PURPOSES. THE MASS CULTURE IN ARCHITECTURE AT ITS BEST 2600 B.C.	THE AESTHETICS OF "TOTAL" ARCHITECTURE. ENVIRONMENTAL ADJUSTABILITY-FUNCTION STRUCTURAL-PROCESSIONAL EFFICIENCY. ENERGY CONSCIOUS LAYOUT. USE OF COLOR AND SKYLIGHTING IN THE INTERIOR SPACE. EARLIEST PERIOD 2000 B.C.	ELEVATION OF THE "UTILITARIAN" TO SPIRITUAL LEVELS. CONSTRUCTIONAL EFFICIENCY WITH PROCESSIONAL UPLIFTING. TOMB OF ATREUS 1325 B.C. MEGARON: ARCHETYPE FROM TIRYNS	THE SUMMARY OF THE CONCEPT OF "BEAUTY" ACCORDING TO THE GREEKS. THE KEY MONUMENT OF CLASSICAL PERICLEAN 447–452 B.C.	THE AESTHETICS OF EFFICIENCY AND EXPEDIENCY IN LAYOUT. / THE THREE MAJOR ORDERS OF CLASSICAL GREEK ARCHITECTURE. RECORDED SOURCES OF INFLUENCE AND	THE AESTHETICS OF CONSTRUCTION. RATIONAL-UTILITARIAN AND EXPEDIENCY CONSTRAINTS. FURTHER EVOLUTION	DYNAMIC SPATIAL EXPERIENCE. INTERIOR SPACE AS A LARGE CAVITY WITH NATURAL LIGHTING THROUGH THE TOP OF THE DOME	PLAN FORMALITY AS AN ORGANIZER OF A LARGER URBAN CONTEXT. CONCAVE FACADE AND ELABORATE SECTION. PIONEERING EXAMPLE OF MULTI-LEVEL MULTI-USE STRUCTURE IN DENSE URBAN SURROUNDINGS	THE AESTHETICS OF LARGE COMPLEX BUILDINGS CONSTRUCTED OVER TIME ON IRREGULAR TERRAINS. GEOMETRIES AND CREATION OF TENSION JOINTS CAUSED THROUGH TOPOGRAPHIC ADJUSTABILITY
SITE PLANNING AND CONTEXT	BUILDINGS ORGANIZED ALONG CEREMONIAL AXIS	FOLLOWING THE TERRAIN. FREE ORGANIZATION ALONG MAXIMUM UTILIZATION OF TOPOGRAPHY AND ORIENTATION CONSTRAINTS		SITE PLANNING STRATEGY UTILIZING "POINTS OF ENTRY TO PUBLIC SPACES AND TURNING BUILDINGS ACCORDINGLY FOR MAXIMUM VISUAL IMPACT	GRID SYSTEM OF SQUARE OR RECTANGULAR PROPORTIONS FOLLOWING CONTOURS	MEANS TO CONQUER THE SITES AND EXPAND THE ROMAN EMPIRE. UTILITARIAN WORKS OF URBAN AND REGIONAL SIGNIFICANCE WHICH HELPED IT TO MATURE	INDIVIDUAL BUILDING AS PART OF A TIGHT URBAN CONTEXT	THE INDIVIDUAL BUILDING AS AN INTEGRATED PART OF A CONTINUOUS URBAN SUPERSTRUCTURE	PICTURESQUE "VISUAL" RESULT OF THE WHOLE THROUGH THE "COLLISION" OF INTEGRAL IDENTIFIABLE GEOMETRIES
ENERGY, ORIENTATION, TOPOGRAPHY, RECYCLING	HIGHLY EFFICIENT ARCHITECTURE RESPONDING TO CLIMATE AND ORIENTATION. BEST EXAMPLES IN DOMESTIC ARCHITECTURE OF EGYPT	MOST EFFICIENT/ENERGY CONSCIOUS ARCHITECTURE OF THE PAST. RESPONSIVE RESPONSIBLE. CROSS VENTILATION, CONTROL OF GLARE. A MUST FOR FURTHER STUDY	ENERGY EFFICIENT USE OF MASSIVE CONSTRUCTIONAL ELEMENTS (i.e. CYCLOPEAN) WALLS. ALSO SOLAR? ORIENTATION	ENERGY SAVINGS THROUGH THE USE OF RECYCLED MATERIALS. ORIENTATION EAST-WEST FOR SYMBOLIC PURPOSES	ENERGY SAVINGS THROUGH BEST ORIENTATION AND ECONOMIC EXPLOITATION OF TOPOGRAPHY	ENERGY SAVINGS THROUGH LOGICAL USE OF CONSTRUCTION METHODS AND TECHNIQUES. THERE IS ENOUGH EVIDENCE TO SUGGEST THAT ENERGY EFFICIENCY WAS AMONG THE CENTRAL CONSIDERATIONS OF ANCIENT ARCHITECTS.	INCORPORATION OF SALVAGE MATERIALS FOR CONSTRUCTION. APPROPRIATE STRUCTURE FOR ENCLOSED SPACE	ENERGY SAVINGS THROUGH HIGH DENSITY AND TIGHT URBAN CONSTRUCTION	ENERGY SAVINGS EVEN FOR THE PALACES OF THE RICH THROUGH LARGE SITE PLANNING AND ORIENTATION
ART, COLOR, SCULPTURE	INTEGRATION OF BUILDINGS WITH SCULPTURES AND WALL FRESCOES	SENSITIVE USE OF VIBRANT COLORS. LARGE WALL FRESCOES TOTALLY INTEGRATED WITH ARCHITECTURE		SCULPTURAL WORLD INTEGRATED TO ARCHITECTURE AND SHAPING EVENTS OF HISTORY. PARTHENON WAS INITIALLY PAINTED		THE ROMAN ENVIRONMENT WAS OFTEN OVERLOADED WITH WORKS OF ART (SCULPTURES AND PAINTINGS) THAT WERE OFTEN HIGHLY DECORATIVE, PREFABRICATED (e.g. SCULPTURES) AND EXCESSIVE.			
THEORY	NO EVIDENCE	NO EVIDENCE	NO EVIDENCE	ARCHITECT HAD WRITTEN BOOKS	HIPPODAMUS THEORETICIAN				
ARCHITECTS AND PROFESSION	IMHOTEP. THE MAJOR ARCHITECT OF EGYPT. FIRST ARCHITECTURAL WRITER	DAEDALUS. ACCOMPLISHED ARCHITECT AND INVENTOR		IKTINOS AND CALLIKRATES. IKTINOS WROTE ON ARCHITECTURE. RESEARCH HAS REVEALED THE NAMES OF OVER 100 ARCHITECTS WHO WORKED DURING THE ABOVE PERIODS.	HIPPODAMUS. EVOLVED THROUGH THE WORKS OF MANY ARCHITECTS		APOLLODORUS OF DAMASCUS 106 A.D.		HADRIAN AND STAFF OF ARCHITECTS AND MASONS. RESEARCH HAS REVEALED THE NAMES OF MANY ACCOMPLISHED ROMAN ARCHITECTS. SEVERAL EMPERORS WERE ALSO TRAINED ARCHITECTS, MOST NOTABLY THE EMPEROR HADRIAN.

VITRUVIUS: MAJOR AUTHORITY ON THE THEORETICAL AND ARCHITECTURAL TREATISE "ON ARCHITECTURE" — LATE FIRST CENTURY B.C. DISCOVERED AND ISSUED AT ROME IN 1486.

Figure 9. Concise history of architecture. A visual summary and issues involved

usually inaccessible for purposes of defense.[11] The fortifications followed the contours of the terrain and demonstrated constructive rationality, functional simplicity, and invention (the "ekforic" system). The unknown architects of the Kingdom of Agamemnon created, through the use of load-bearing walls and posts and beams, the most primordial space-enclosing prototype, the MEGARON, which has persisted as a dominant architectural form ever since.

Simple rooms, palaces, and temples were built on this archetype. The Mycenaeans were also masters of geometry, the use of massive materials, and the achievement of sophisticated enclosures such as the connoid enclosures for the tombs for their royalty. The Tomb of Agamemnon, known as the "Treasury of Atreus," is the most magnificent example of their architecture in which constructive inventiveness (achieving a connoid enclosure through the use of masonry laid on top of each other in concentric circles), ceremonial access, and utility coexist harmoniously. We know nothing of the architects of this period, only of the kings and notables who commissioned the projects. It is the first time in history where the real creators are overshadowed by the patrons who took the credit.[12]

Classical Antiquity—from Greece to Rome

Galloping down the road of centuries, we encounter the period of Classical Antiquity.[13] Here we will focus on the events and construction in Greece, especially Athens, around 500 B.C.

The architects of Greece were many, but Iktinos will always remain as the most celebrated of the time.[14] He was a writer,[15] like Imhotep, but he is better remembered as one of the founders of the earliest architectural partnership, the firm of Iktinos and Kallikrates, the makers of the Parthenon. Iktinos has often been regarded as the designer of the "firm," the man with the artistic and creative impulses, while Kallikrates has been thought of as the more "engineeringly" inclined, the more practical and pragmatic member of the duo. A diversity of talent and expertise was required for the achievement of architectural works of significance, just as it is indeed today. The cooperation of many artistic disciplines was also important and was practiced then as it is today. The main coordinator, and the person who had total responsibility for all the construction on the Acropolis of Athens, was Feidias, a sculptor and friend of Pericles, the head of the Athenean State who commissioned the projects that have marked that particular era of history as the "Golden Age."

Politics and the architecture done by architects have always gone hand in hand. As the various states of antiquity expanded, as there was a need for the construction of new projects and new cities, the role of architecture changed and specialization evolved. A person most important in the history of architecture and one who first approached the solution of more complex environmental problems, including the design and layout of new towns, was Hippodamus. During the Hellenistic period, he was the person responsible for the design and layout of many Greek towns, the most famous of which were the new towns of Miletus and Priene.[16] The design of both towns is based on the grid system, a rectangular grid of streets that define rectangular city blocks of varying proportions according to the topography. When the terrain was flat, the grid was square; but when the terrain had a slope the grid would have rectilinear dimensions with the longer dimension of the rectangle following the contour of the slope. This was necessary so that the construction would be more economic. Hippodamus, however, was not just a simple surveyor. He designed cities and had ideas about how to make these cities physically, socially, and economically viable. He had concerns and concrete proposals for the optimum population size of cities, the optimum size of neighborhoods, the relationships between private and public buildings, and the relationships of built-up to open space. He was careful that these considerations were satisfied by his physical designs. Hippodamus was very much respected by his contemporaries, and Aristotle, one of the great philosophers of all times, considered Hippodamus a political philosopher more than anything else.[17] The grid system of Hippodamus, also known as the Hippodamean system, was later adopted by the Romans for the layout of their military camps,[18] which evolved in time into large towns. The same system was transplanted in the United States where many of the early colonial and mercantile towns,[19] such as Savannah, New Orleans, and Philadelphia, displayed grid-system layouts of varying proportioning and refinement. The grid system is easily laid out and creates environments that can be navigated easily. Because it fostered expediency and economy, it became the favorite town planning system.

As the centuries moved on, approaching the time of Christ, the role of architects changed. The architects of Greece's Golden Age were followed by generations of apprentices who tested the principles and inventions of the great masters, and it was usually the clients who were recognized for architectural achievements. A very important such client was Alexander the Great. He was responsible for the establishment of numerous new towns and prestigious buildings throughout the areas he conquered. Most famous of all was the town of Alexandria in Egypt. It was done by his favorite architect, Dinokrates, and run by his generals in the years to come.

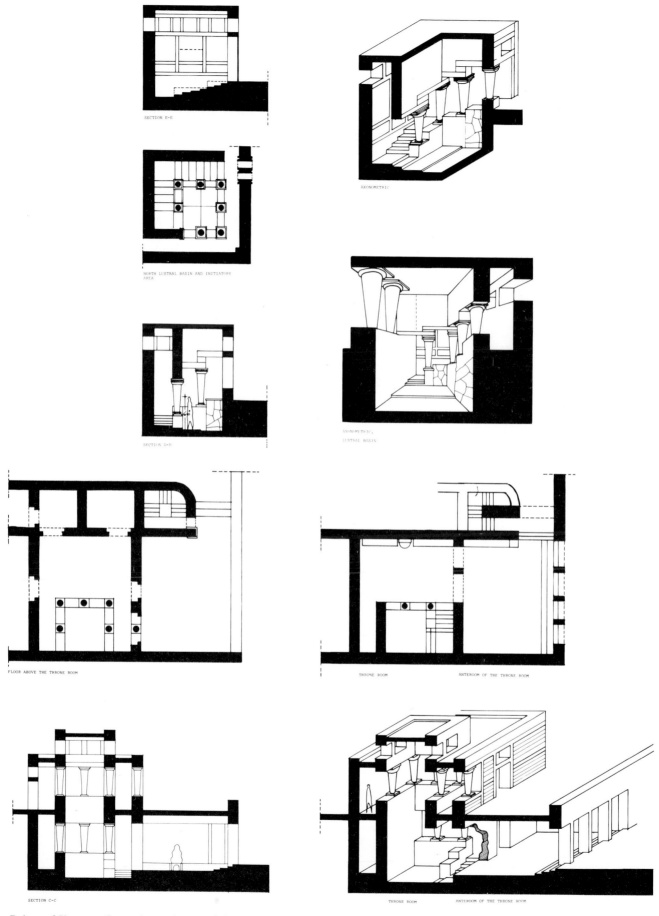

Palace of Knossos, Crete: A case in one of the earliest and most successful efforts for the creation of spatial continuity and ceremonial experience of space.

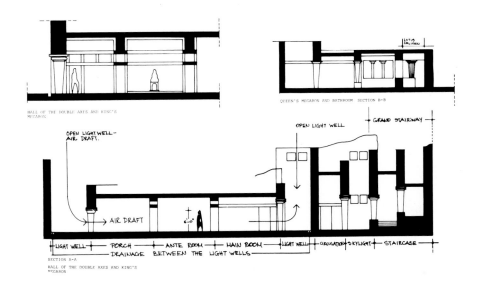

HALL OF THE DOUBLE AXES AND KING'S
MEGARON

QUEEN'S MEGARON AND BATHROOM. SECTION B-B.

OPEN LIGHT WELL-
AIR DRAFT.

OPEN LIGHT WELL

GRAND STAIRWAY

AIR DRAFT

6'-0"

├ LIGHT WELL ┼ PORCH ┼ ANTE ROOM ┼ MAIN ROOM ┼ LIGHT WELL ┼ CIRCULATION ┼ SKYLIGHT ┼ STAIRCASE ┤
─ DRAINAGE BETWEEN THE LIGHT WELLS ─

SECTION A-A
HALL OF THE DOUBLE AXES AND KING'S
MEGARON

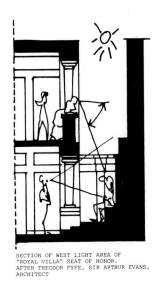

SECTION OF WEST LIGHT AREA OF
"ROYAL VILLA" SEAT OF HONOR.
AFTER THEODOR FYFE, SIR ARTHUR EVANS,
ARCHITECT

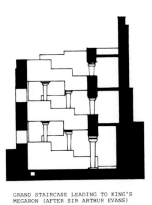

GRAND STAIRCASE LEADING TO KING'S
MEGARON (AFTER SIR ARTHUR EVANS)

Palace of Knossos, Crete. Ceremony in the experience and use of space by means of light (above) and circulation below (great staircase).

85

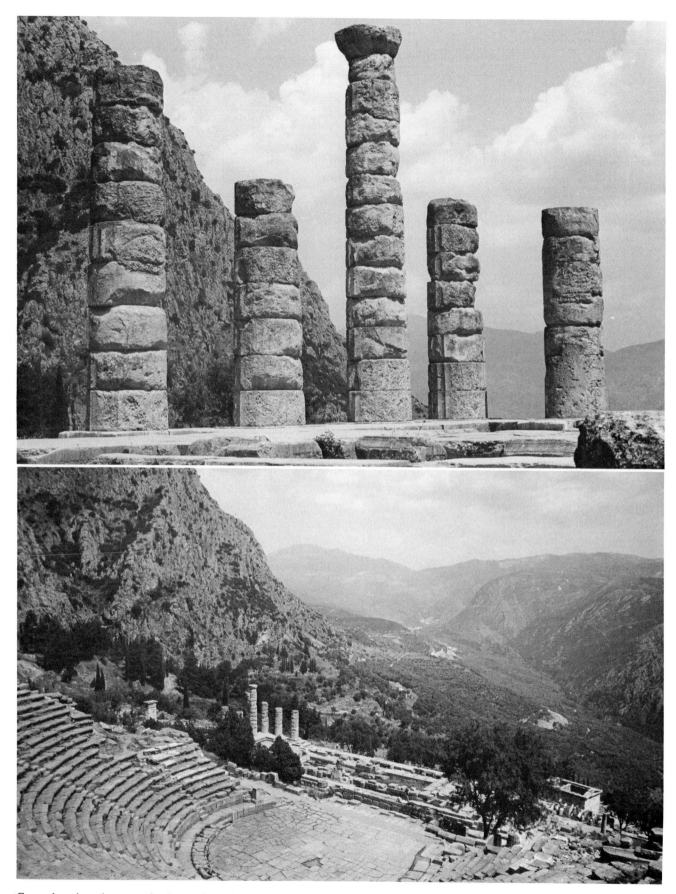

General setting, theater and columns from the Temple of Apollo in Delphi, Greece.

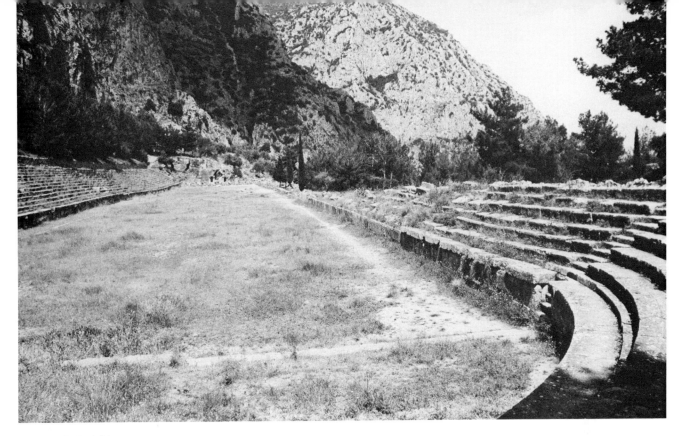

Stadium in Delphi.

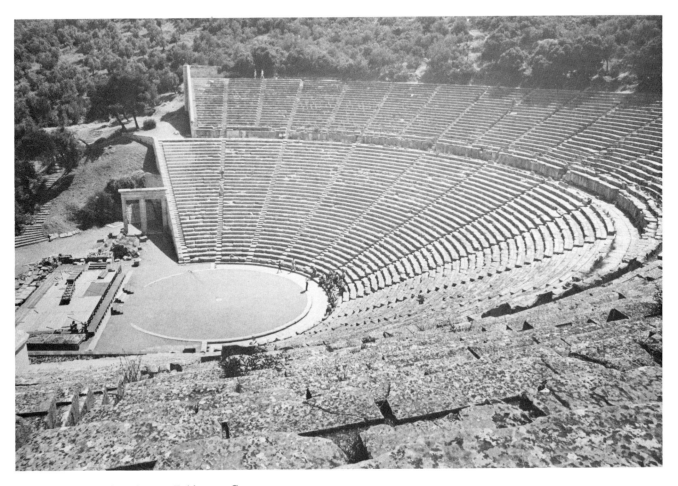

Outdoor Theater of Epidaurus. Epidaurus, Greece.

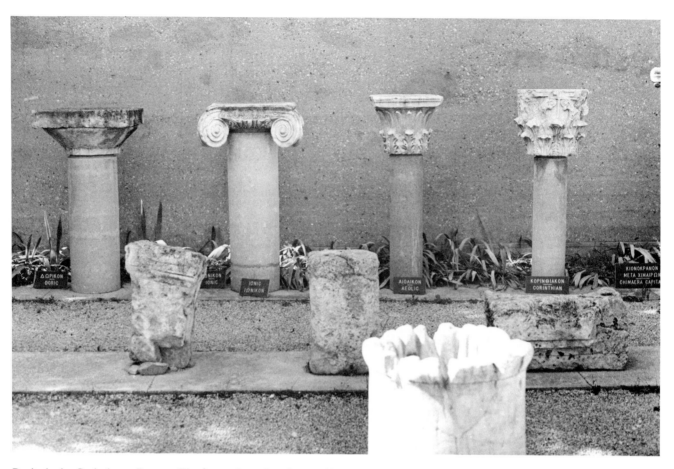

Doric, Ionic, Corinthean, Roman. The four orders of ancient architecture can be seen throughout the Mediterranean Basin. Display from Ancient Corinth, Greece.

Roman Times

Other architects were not so well treated by history, especially the architects of the Roman Empire.[20] Although some of them are known, they were generally overshadowed by the Emperors who commissioned their work. This was the case with Nero. He aspired to be an architect[21] and has been credited by history as the architect of New Rome. Scholastic scrutiny has shown, however, that he employed architects such as Severus and Celer, another team of specialists, who designed and built for him the Palace Domus Aurea.[22] Roman architecture was for some time a continuation of the Greek. In fact, many Roman architects had Greek names. They developed expertise in the structural and engineering aspects of architecture. They developed new materials and techniques such as bricks, the arch, and reinforced concrete. They built large public buildings, such as forums, baths, palaces, stadiums, aqueducts, and roads.[23] Many structures were built to accommodate crowds and permit assemblies. The history of Roman architecture is a celebrated one, not only for the structures it achieved but for its architects and theoreticians. Vitruvius, the first of the great Roman theoreticians, wrote the treatise *Ten Books on Architecture* in 25 B.C., starting a tradition of theoretical discourse that reached its peak in Italy many centuries later during the Italian Renaissance.

Among the most celebrated Roman buildings are the Pantheon of Rome, the Colosseum, Trajan's Forum, and Hadrian's villa at Tivoli. The first two represent individual masterpieces excelling in their structural significance; for example, the display of a combination of orders (Colosseum), the creation of an impressive interior cavity (Pantheon), and the use of methods of recycling (use of materials from other buildings, the Pantheon). The last two are examples of enormous assemblies of varied buildings that developed over time into what appear today as total compositions. In the cases of Trajan's Forum and Hadrian's villa,[24] the various parts of their plans, with symmetrical and rectilinear layouts (classical parts), were expanded through adjacent constructions that had to follow the contours of irregular terrains, thus resulting in joints of irregular shaping and asymmetrical wholes. Substantial understandings of the growth of these constructions over long periods of time and the topographic adjustability that ultimately shaped these Roman works have not been achieved by the many historicists who have occasionally looked to Rome for Prototypes.

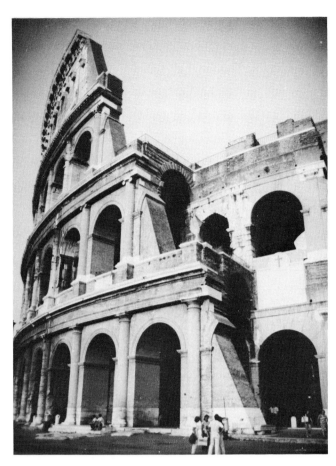

The Colosseum, Rome, 70–80 A.D.

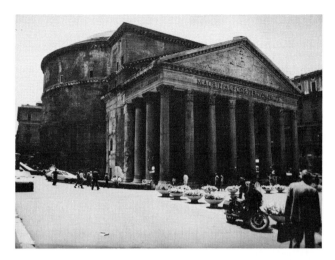

The Pantheon of Rome, 120–124 A.D.

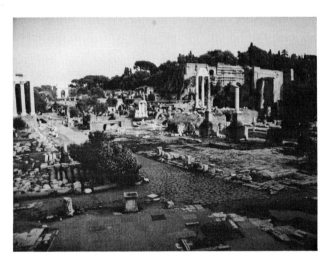

Forum Romanum. Rome.

Roman architecture has been greatly admired in the West, although one should be very conscientious in pointing out that the Roman buildings were not all designed for humane and moral purposes. Careful study of Roman writings reveals that many of the buildings were the scenes of such unworthy acts as bloody shows,[25] treachery, assassinations, state-ordered suicides, persecutions, prostitution, usury, and intrigue. Although such activities were more or less present in many historic periods, one should bear in mind that Rome excelled in this respect; thus one should be cautious when looking to Rome for lessons.

The Great Space Making Era of Byzantium

The Roman Empire became extremely large, and the time came to split it into the East and the West. The Eastern Roman Empire became known as *Byzantine*. Its center was Constantinople (today Istanbul), a town built by the Emperor Constantine, a Christian and subsequently a saint of the Christian Orthodox Church.[26] Constantinople survived as the capital of the nation for more than one thousand years. The new, Christian, God and the new empire developed a new architecture. In fact, the God

of the Christians had given them specific rules outlining the shape, dimensions, and materials for the construction of their temples.[27] The Christian architects had God-prescribed archetypes on which to build. The temple built by King Solomon was the prototype for the early Christian basilicas, and they evolved in time into more complex organizations to eventually produce one of the most extraordinary space enclosures of all time, the cruciform Byzantine church. The two Byzantine architects, Anthemios and Isidoros—the second most important partnership in architectural history—developed, designed, and built Haghia Sophia[28] (the Great Church of the Holy Wisdom), the first project to demonstrate interior three-dimensional continuity by using multiple interior levels, interlocking volumes of air, and the animation of light in the interior space through clerestory windows. The two architects, who were experts in geometry and mathematics and wrote books on the subjects, made models for

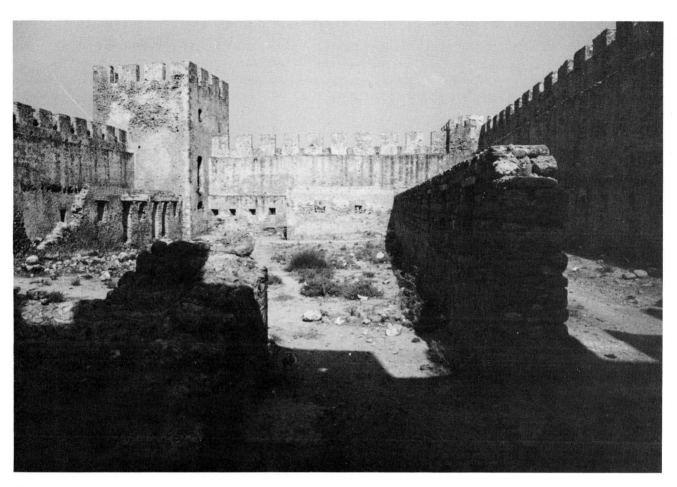

Venacular Medieval Architecture. Fortification posts by the Crusaders built all over the Mediterranean. Paradigm from Southern Crete.

their buildings. They passed on their expertise and model-making habits to "Isidoros the Younger" (nephew of Isidoros) who made a model of the final dome of the church in scale 1:1, and tested its strength a number of times by loading and rebuilding it after it collapsed. It is unfortunate that Byzantine architecture has not been paid its due attention by the general architectural public in the West. It is well known that the Byzantines had enormous influence in the East, particularly in China and Japan,[30] and that they exerted great influence on Moslem architecture, which frequently used and even recycled such Byzantine prototypes as the Temple of Haghia Sophia.

European Middle-Ages: Moslem-"Carolingian"-Romanesque-Gothic

During the Byzantine period the Western Roman Empire was undergoing important political and territorial transformations. The Western world was enlarging, and many of the Roman generals who were sent to conquer new lands and build the famous Roman highways and aquedects along the various paths of Europe decided that they preferred living where they had been sent and that they would not return to Rome. The conquest and decentralization thus weakened the center and the Empire. New nations developed in the centuries that followed. This period lasted approximately one thousand years and is known as "the Middle Ages." It is a complex and complicated period for the purposes of a summarizing introduction. It was a time of wars, constant territorial changes, feudalism, religious fanaticism, nationalism, and persecution. Through it all evolved the composition and image of most of the Europe we know today. Architectural historians have divided this very large period into a number of major eras, all corresponding to prevailing sociopolitical events and identified with the dominant ruling personalities. It will be enough for us here to deal with the European architecture of the Middle Ages as it was characterized by the creation of four major architectural directions.

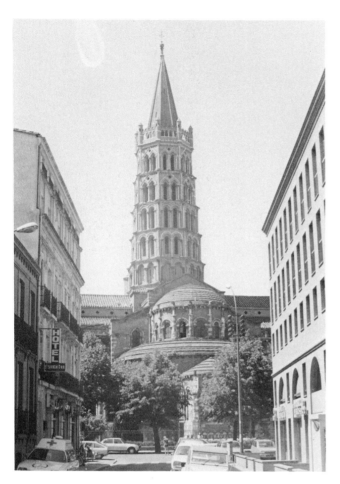

The first period includes the Moslem conquest of part of Europe and the flourishing of Moslem architecture,[31] particularly in Spain. This architecture is characterized by highly skilled craftsmanship, the integration of interior and exterior, an emphasis on landscaping, and the utilization of elements that address all the human senses. The Koran makes very frequent reference to the outdoors, to the gardens of delight, and the seven heavens with the constellations;[32] thus Moslem architecture created exquisite gardens and experiences for the outdoors, while the embroidery-like decoration on the ceilings of their interiors were certainly efforts to recreate through matter the metaphor of the seventh heaven with the constellations. The Gardens of Generalife in Alhambra, Granada,[33] and the Temenos in Cordoba represent the best samples of Moslem architecture that flourished in Europe during the Middle Ages.

The second period of the European Middle Ages has been associated with the reign of Charlemagne, and the period is called the "Carolingian." The most representative building of the period is the Monastery of St. Gallen in Switzerland.[34] The third period developed the "Romanesque" style, typified by the rebuilding of the Monastery of Cluny in Burgundy (981). The last period created the "Gothic" style.

Layers of historical examples in the european towns.
Medieval Cathedral of St. Severin in Toulouse, France.

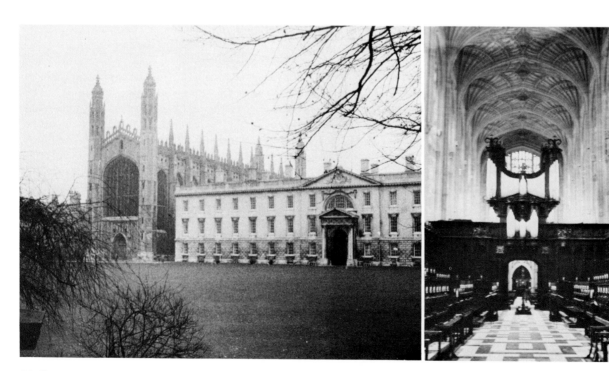

Medieval Architects created walls of religious and institutional significance. Kings College, Cambridge, England.

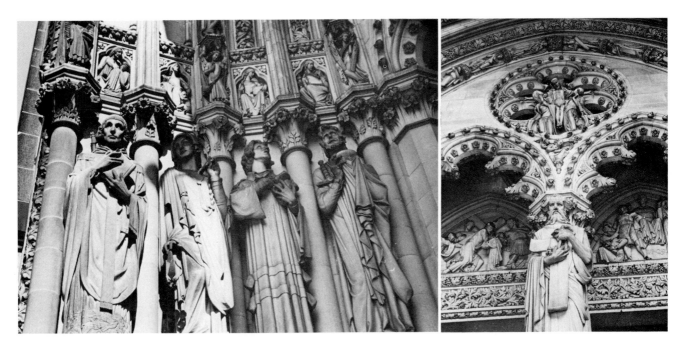

The extraordinary dynamism of Medieval Architecture; revelation of life through extraction of mass from the lifeless masonry. Figures of saints form medieval church displayed in the cloisters in New York City.

St. Etienne Cathedral, Vienna.

Medieval European architecture is extraordinary for many respects beyond the structural, symbolic, and constructural qualities for which it has been praised. The Carolingian and Romanesque periods are of particular significance, as they provide prototypes of monastic and urban architecture that could be conceived to be historic precedents of architectural ecologies; that is, they are self-sufficient, self-contained, socially and economically balanced units existing in cooperative harmony with their surroundings. The many monastic structures of Europe built during the medieval times, and the Byzantine monasteries in Mount Athos built at approximately the same time (963 A.C.) are among the least recognized precedents of environmentally relevant architectures of the past.[35] The attention of historians has focused instead on individual buildings of the Gothic period, the churches and major cathedrals of Central and Northern Europe.[36] The fascination of the historian is certainly justified if one considers the spirituality, and craftmanship, the structural competence, and the feeling of sublime observed and experienced when in these buildings. Gothic, as is true of other medieval architectures as well, was achieved by both well-known builder-masons[37] of the time and by crews of wandering masons who traveled from one feudal estate to another, spotting Europe with works, fortifications, castles, and especially churches of grandeur.[38] Many of the

The Cathedral in Uppsala-Sweden.

builders of these times, especially those of the major monuments, are known today.[39] Yet there are castles, utilitarian buildings, individual houses, and small chapels in England, France, and Central and Northern Europe, whose space, construction, and detailing speak the same medieval language and whose builders remain unknown. All of these buildings are testimonies to the artistic, structural, sculptural, and spatial genius of their creators. The art and the secrets of architecture were transmitted from one generation of architects to the next through a well-established pattern of training and apprenticeship which lasted for many years.[40] These traveling builders moved around Europe building one cathedral after another, developing as time went on, refinement upon refinement. A "vertical" spirituality prevailed in the works of these builders. The massiveness of their masonry, the mastery of their craftmanship, and their structural inventiveness created projects that have served and will always serve as testimonies to the genius of the unknown builder who makes his living by his art and his craftmanship.

Church in Uppsala-Sweden.

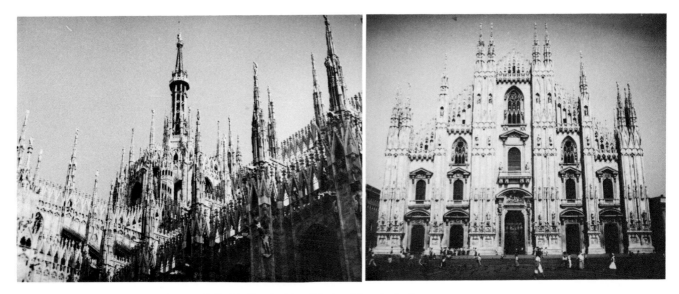

The Duomo of Milan. The Ultimate of Gothic "embroidery" in its rising to the heavens.

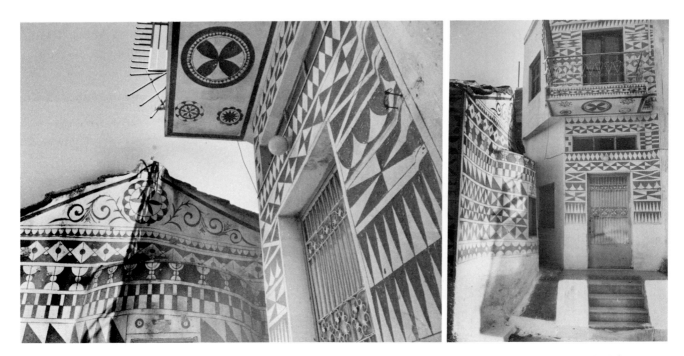

Centuries old tradition that commenced with the wandering medieval masons. Scrafito on 10th Century Church on the left. Same technique in recent house in Pyrghi, Chios to the right.

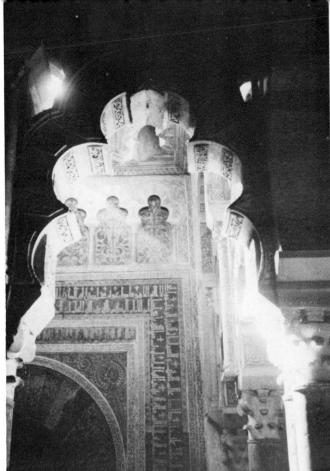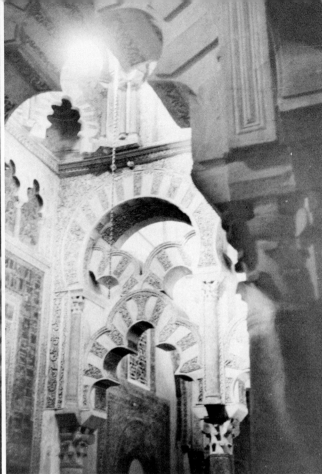

Organic integration of natural lighting and decoration. Moslem architecture in Cordoba, Spain.

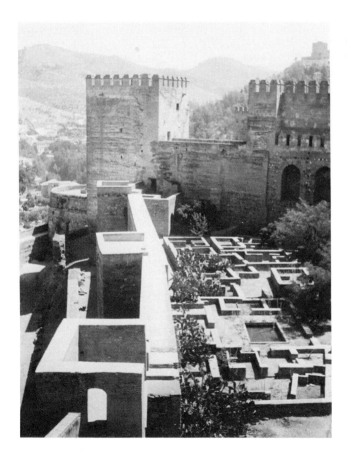

Fortification walls of Alhambra. A large scale architectural ecology. Outstanding example of comprehensive Moslem architectural ingenuity. 10th Century A.D.

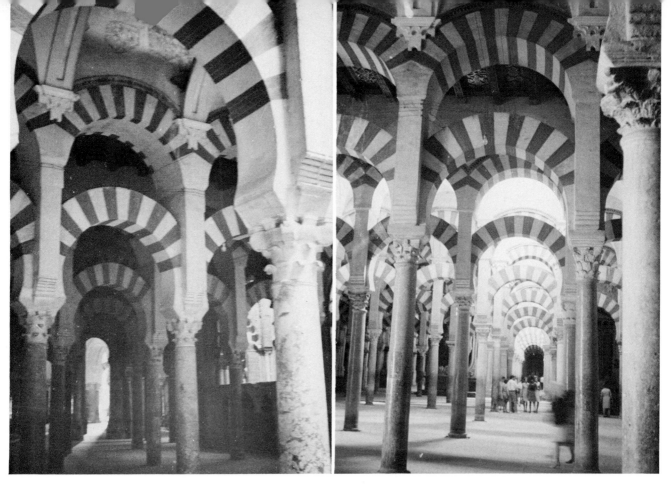

A forest of columns. Moslem Temenos in Cordoba, Spain. 8th–10th century A.D.

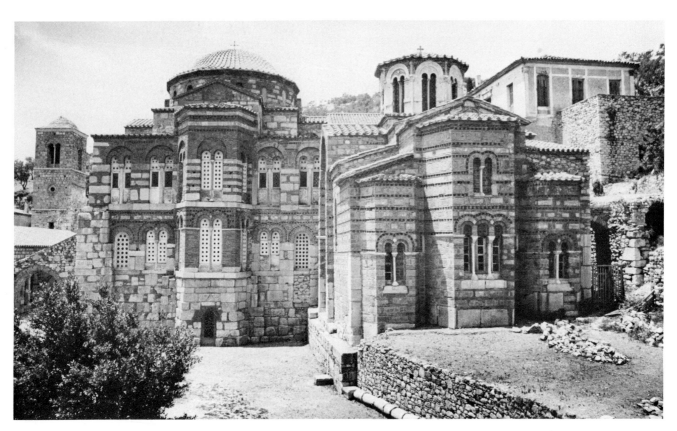

Embroidery like brick craftsmanship in Byzantine Architecture. East elevation of Osios Loukas Monastery, 9th century.
Osios Loukas, Greece.

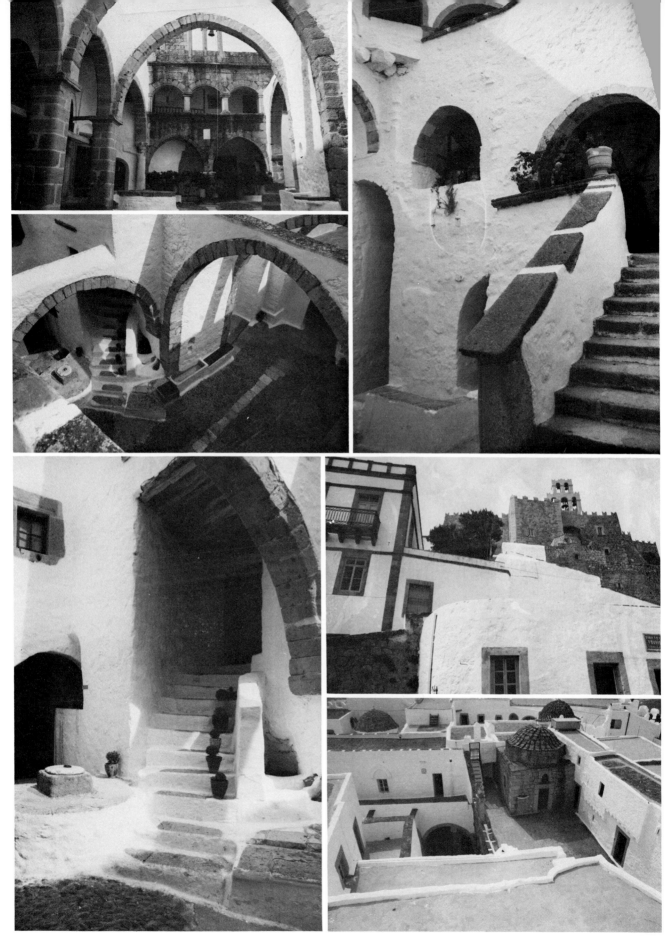

The Byzantine architects created works of extraordinary complexity, spatial and textural appeal. Sequences from the Monastery of St. John the Theologian. Patmos-Greece.

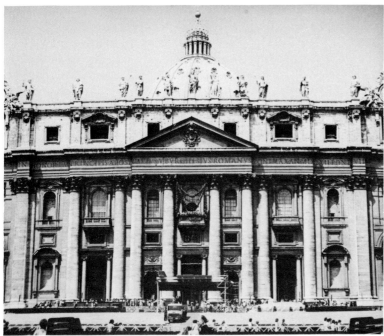

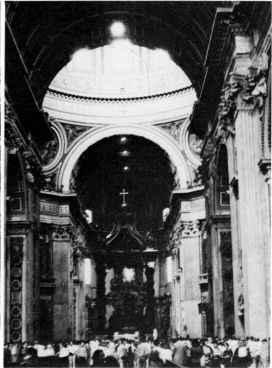

St. Peter, Rome, 1506–1620. The work of many
architects under the direction of many Popes.

The Renaissance: From Italy
and France to 20th Century

As the history of civilization is the story of a continuous
dialectic and as one era develops its own principles and
philosophies on the bases of the principles and philoso-
phies of previous eras, so it is with the history of archi-
tecture. The empirical "doers" of the Middle Ages (which
also included a period of persecution, the Dark Ages), who
created the masterpieces of artistic and religious devotion,
were succeeded in the fourteenth century by what we could
call "Multi-talented and theoretically inclined architects"
of the Italian Renaissance. It was the first time since Vi-
truvius and Filarete that architects, artists, and art his-
torians—such as Leon Batista Alberti, Vasari, Leonardo
da Vinci, and Andrea Palladio—wrote theoretical works
and manuals on architecture and built projects as case
studies, often on the basis of precedent and theoretical in-
vestigation.[41] Not only did their writings influence their
contemporaries and subsequent generations, but their built
works were occasionally regarded as prototypes, often re-
ferred to and very frequently copied by architects of sub-
sequent centuries. During this period there were artists
such as Rafael, Leonardo da Vinci, and Michaelangelo
who frequently performed as architects, as well as many
others such as Bramante and Brunelleschi who became
architectural creators par excellence. The last two men

created substantial buildings and also developed profes-
sional inventive genius. Filippo Brunelleschi, in partic-
ular, was concerned about improving his ways of getting
commissions as well as performing works of art.[42] His pro-
ject for the Church of Santa Maria del Fiore in Florence
provides a case study in both professional and artistic ge-
nius. Other architects, and frequently artist-sculptor-ar-
chitects, produced exceedingly influential buildings during
the *quattrocento* (the fifteenth-century period of the
Italian Renaissance) and the years that succeeded it. Most
notable among them are Francesco Borromini and Ber-
nini, who along with their predecessors created a series of
evolutions referred to as "Mannerism," "Baroque," "Eu-
ropean Mannerism," etc.

In summary, the architecture of the Italian Renais-
sance was characterized by the revival of the character-
istics of classical Greek architecture—symmetry of
facades, concern for appealing proportioning, and elabo-
ration on the various orders of previous architecture. It
was generally an architecture of urban context. It was fre-
quently commissioned by the economic, political, and re-
ligious notables, such as the Medicis, the Farneses, and
the various Popes.

Exceptional to this rule was the work of Palladio; his
work was mainly rural. He built a series of villas, most of
them near his native town Vicenza,[43] although his port-
folio also included buildings in high urban context such

Scala di Spagna (Spanish Steps), Rome (1721–1725).

Piazza Navona, Rome, with fountain, 1647–1652.
Church of St. Agnese.

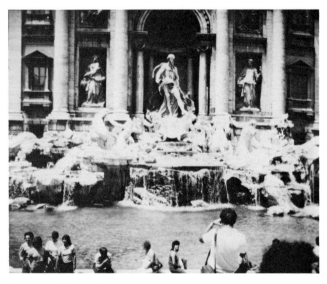

Fontana di Trevi, Rome (1732–1762).

Baroque Church in Brindisi, Italy.

as the churches of S. Giorgio Maggiore and the Redentore in Venice. Palladio's work was exceedingly influential[44] and it came into vogue in periods of architectural history when eclecticism prevailed. Thomas Jefferson is thus far the most notable case on an architect greatly influenced by Palladio, and his house, "Monticello," is the most famous American building designed after the principles of the Palladian villas.[45]

The Mannerist and Baroque movements were two of the major creative manifestations of the Renaissance developed by architects who sought originality as opposed to direct reference to classical and Roman precedents. Such references, however, took place during and following the Renaissance.[46] Mannerism represented a stylistic refinement of the "High Renaissance." Facades were regarded carefully, and the "manner" in which a building's exterior was proportioned, articulated, detailed, and decorated was of great significance. Projects such as the Laurentian Library by Michaelangelo and the Santa Maria del Fiore in Florence completed by Brunelleschi are good examples of mannerist buildings. Refinements of such distinction deserve much deeper study and investigation than this brief introduction can offer. Only through systematic historical investigation and site visitation can one fully understand these achievements.

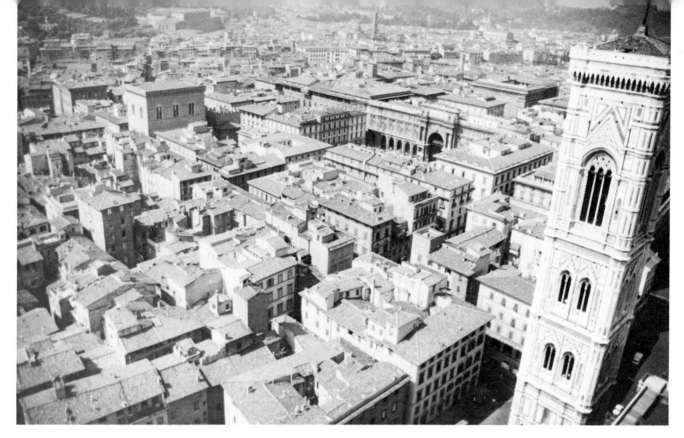

View of Florence and Giotto tower from the top of the Dome of Brunelleschi, Santa Maria del Fiore, Florence.

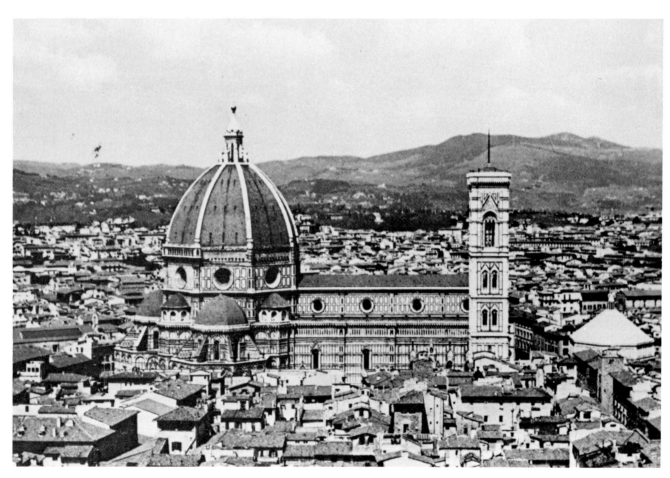

Santa Maria del Fiore with the Dome of Brunelleschi, dominating the city of Florence.

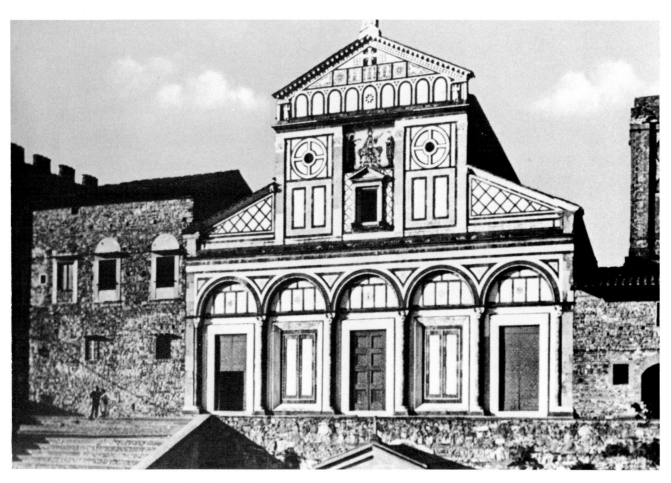

St. Miniato al Monte in Florence. Architect unknown. C. 11th century.

Baroque architecture, however, is easier to comprehend.[47] It displays three-dimensional interior continuity through the use of interlocking volumes of air and clerestories to provide interior lighting, similar to the Byzantine style. It is different, however, in that the proportions of the interiors tend to emphasize the vertical dimension and that architectural elements such as columns, capitals, pediments (often broken), and parapets are uniquely decorated and frequently painted. The master architects of the baroque era were Bernini and Borromini.[48]

In summary, one could say that High Renaissance architecture, especially the domestic, is mostly an architecture of facade; while baroque architecture is generally an architecture of space and urban adjustability, imaginative inventiveness, and ceremony (stairways, processions, etc.), as many baroque buildings are part of urban complexes. It is not surprising that of the architectures of the Italian Renaissance, the mannerism and the baroque have attracted the attention of many scholars and have frequently been referred to for the precedents they set. These architectures were generally urban, and they dealt with problems of context and space-making that were as pertinent then as they are today.

The period between the Italian Renaissance and the seventeenth century in France was one of refinement and evolution of architecture. Other countries and civilizations developed architectures during the same periods that were equally, if not more important, and yet they went substantially unnoticed. The architectures of the Orient, for example, did not concern Western scholars in the deserving weight.[49] The same was true for the architectures developed by the Moslems and the native Americans. There were certainly isolationist, religious, territorial, and communication considerations that could be blamed for these oversights. The secrets of Chinese and Japanese landscaping, the beautiful simplicity and lightness of Japanese construction, and the extraordinary discipline and craftsmanship of Asian temples[50] were left substantially unscrutinized, to be discovered much later by individual travelers and visiting architects who drew from their effect. The architectures of Mexico, Central America, and the North American Indians was likewise neglected. Yet history has been precise and thorough in its treatment of European architectural developments.

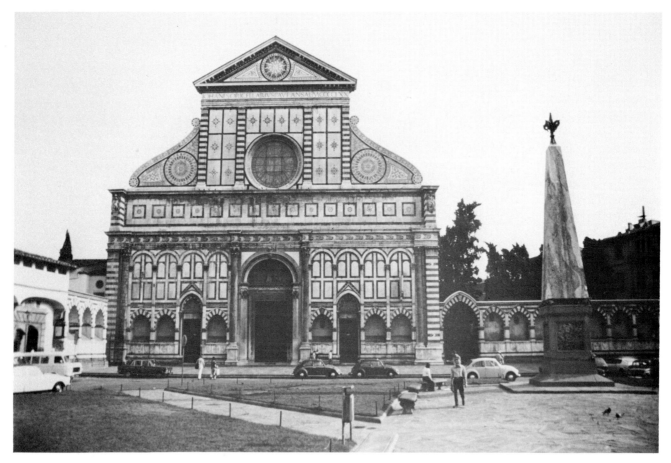

Santa Maria Novella in Florence. New facade by Leon Batista Alberti. (Completed between 1948–70.)

Italy, as we have seen, produced during the Renaissance individual works and architect-artist-theoriticians of great significance; the "Renaissance men," people who were problem-solvers, creators of originality and great competence. We could say that the Popes and the private clients favored individual personalities who had the ability to carry on the task of creation. They preferred "task-oriented" architects. In France, however, things were different. The French kings were responsible for much of what happened in architecture. Commencing with the reign of Charles V (1364–80), architecture became totally dependent upon the monarchs who supported it and who shaped with their preferences the stylistic directions it would take. The architects became, in a sense, bureaucratic entities working for a central organization established by the king known as the "Royal Building Administration."[51] This administration operated for more than three centuries, going through a series of transformations. Run by top architects who had been appointed by the monarch, it was responsible for the construction and supervision of many stately buildings. It was within this administration that issues regarding the need for architectural education were raised. After a series of evolutionary stages which included the writing of books by the top administration architectural officials, and with the advent of Louis XIV, the Royal Academy of Architecture was established in 1611. It was succeeded by the Ecole des Beaux-Arts in 1733.[52] The school was founded initially for the training of the French architects of the Building Administration.[53]

The Ecole des Beaux-Arts considered architecture as an art. It emphasized the aesthetics of classical antiquity, the Roman orders, the works of famous architects of the past and present, and the study of existing theoretical treatises. All of the great French architects commemorated in the history textbooks were in one way or another associated with the Royal Building Administration, the kings of France, the Royal Academy, and the Ecole des Beaux-Arts. The Palaces of Versailles, The Louvre and its

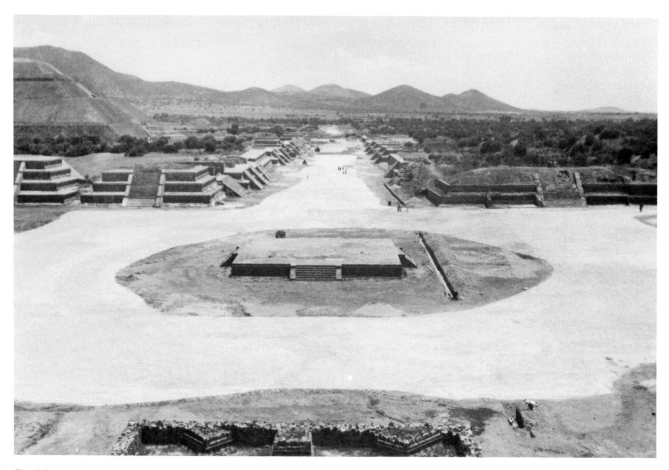

Teotichuacan, Mexico.

expansion, and the great series of French mansions known as "Hotels" were done by architects of the Administration; and these architects only infrequently, and rather late, operated as free agents.[54] This was a time when architect-administrators were looking to the past for their learning, and they were trained as a group through the collective system of the Academy. The individuality that characterized the Renaissance architect was not to be found. Although the French Revolution brought about the end of monarchy in France, architecture continued to be monumental and eclectic, serving the up-and-coming bourgeoisie and the industrial barons of subsequent centuries. The Ecole des Beaux-Arts survived its founders and became the major bastion, archives, and historic depository for the selection, revival, and construction of buildings of the past in light of the needs materials, and technologies of the time. The Ecole served as an institution of identity for the profession, and it was revered by all aspiring architects of the world in the nineteenth century, many of whom went to France for their architectural education.[55]

The twentieth century brought new materials—reinforced concrete, steel, glass—and new demands for less monumental works, housing, factories, hospitals, community buildings, and public works for the masses. The architecture of the twentieth century responded to new needs—technological, sociological—and reacted to the eclectic-elitist approach of nineteenth-century Beaux Arts architecture.

The champions of this new dialogue were architects such as Le Corbusier, Gropius, Mies van der Rohe, Frank Lloyd Wright, Alvar Aalto, and their followers, and they pretty much spoke for architecture till our day. Architects of the current generation are questioning many things, however, and there is much uncertainty and debate. As seen through the works of the avant-garde, the architecture of today is characterized by works of historic references, eclectic revival, material and technological search, symbolism, and ambiguity. The most important developments in the evolution of architecture in the twentieth century and the current state of the art are discussed in the chapter that follows.

Notes

1. There are numerous books on the subject. One may refer to Rudofsky, *Architecture Without Architects;* Sibyl Moholy Nagy, *Prodigious Builders;* and Myron Goldfinger, *Villages in the Sun.*
2. See for instance Coulton, 1977; Kostof, 1977.
3. I.e., "The names of over a hundred Greek architects are known from the period c. 650–50 B.C." Coulton, 1977, p. 15.
4. For comprehensive study one should refer to Kostof and Coulton, op. cit.
5. Kostof, ibid., p. 3.
6. The title of the book, according to the legend, was *The Book of Foundation for Temples.* See Kostof, ibid., p. 6.
7. For comprehensive references see Marinatos, 1960; Graham, 1962; and Scully, 1979.
8. Original reference for the above: Sir Arthur Evans "The Palace of Minos at Knossos" Vol. I, II, London 1921.
9. Knossos was called so by poet George Seferis. See Ioanna Tsatsou, "My Brother George Seferis"—were original correspondence of Seferis.
10. For more about this architecture see Marinatos, op. cit.
11. One could refer to Homer's *Iliad* as primary reference for the topic.
12. This has happened repeatedly in history. Persian and early Jewish architectures are similar cases. See Kostof, op. cit., p. 5, and Rykwert, 1972.
13. There is an abundance of primary bibliography on this period. Classic architectural references are the books by Choisy and Fletcher (1975). Most gratifying reading has been provided by Vincent Scully, 1979.
14. Coulton, op. cit., p. 26.
15. Kostof, op. cit., p. 17.
16. For general references on above subjects see Mumford 1966 and Benevolo 1980, pp. 110–117.
17. Aristotle.
18. See Benevolo, op. cit., p. 222; 223.
19. Original scholastic references on the above subjects: Reps 1969 and 1979.
20. Kostof, op. cit., p. 17.
21. Refer to Nero's biography by Romain Rolan.
22. Kostof, op. cit., p. 39.
23. For detailing and constructural aspects of Roman architecture refer to Choisy, op. cit., and Fletcher.
24. For a good analysis on the developmental and functional aspects of Hadrian's villa refer to Thorndike, p. 54.
25. It is interesting to note Seneca's concern about the anti-aesthetic nature of cutting slaves' throats with razor blades during intermission in a cold-blooded manner, while the same philosopher made no objection to the regular bloodshed of gladiator fighting in the Colosseum. See Seneca's *Letters.*
26. Constantine the Great also built the Temple of the Holy Sepulchre in Bethlehem, Kostof, p. 51.
27. See Rykwert, 1972, and the Bible, Exodus 25–31 and 35–40.
28. For primary references on Hagia Sophia see E. Antoniades, *Ekfrasis: Haghia Sophia,* 1905; P. Michelis, *Haghia Sophia* and *Aesthetic Approach to Byzantine Art.*

29. Downey, 1976, pp. 112, 113; Michelis, 1976, p. 12.
30. The Japanese are more familiar with the Byzantines, and there is a substantial amount of literature by Japanese scholars on the connection between Byzantium and the East and the related influences.
31. See Hoage, 1963 and 1975.
32. See the Koran.
33. See Grabar, 1978.
34. For an excellent expanded introduction to the European Middle Ages see Risebero, 1979, pp. 36–85.
35. See Antoniades, 1979, (2), pp. 9–20.
36. See Otto Simpson, 1974; Harvey John, 1972; general reference on "The Medieval Architect," p. 69.
37. Case in point, John James, *The Contractors of Chartres.*
38. Risebero, op. cit., pp. 55, 63–64; also Lancaster, p. 16.
39. For additional general information see Kostof, 1977, pp. 59–93.
40. See Lancaster, op. cit., pp. 16–32, for variation of the Gothic in England. See also Harvey, 1972, pp. 90–91, for education and professionalism of Medieval architects.
41. For further specifics on these topics refer to Ettligner in Kostof's 1977, pp. 96–158.
42. See Fanelli, 1980, pp. 10–11.
43. See Palladio (exhibition catalog) and Ackerman, 1966.
44. See Farber, *Palladio's Architecture and Its Influence: A Photographic Guide;* also Whitehill and Nichols, 1976.
45. See on Vincent Scully, 1970, pp. 164–68 and Adams, 1983.
46. Fletcher, 1975, p. 788; Pevsner, 1976, pp. 111–40.
47. For an outstanding analysis of baroque architecture and its spatial principles see Portoguese.
48. For more see Fletcher, 1975, pp. 846–51.
49. It also must be noted that the situation has been more evident in architectural studios, where one rarely encounters references to prototypes of these civilization.
50. I.e., Vassiliou, 1971.
51. Rosenfeld in Kostof, 1977, p. 161.
52. Chafee in Drextler, 1977, p. 61. For detailed chronology of the evolution of the Beaux-Arts and its educational methods see Rosenfeld, ibid, p. 173.
53. Rosenfeld, ibid, p. 177.
54. See Rosenfeld and Drextler.
55. The educational system of the Beaux Arts was also followed by many countries and many schools that were headed by Beaux Arts graduates; i.e., Berkeley in the United States. See Draper in Kostof, 1977, p. 229.
56. The visual charts of this chapter were prepared by the author through reference to the bibliographic sources of the chapter with particular reference to the Selected Readings.

Selected Readings

Risebero, Bill, *The Story of Western Architecture*
Stierlin, Henri, *Encyclopedia of World Architecture*
Lancaster, Osbert, *A Cartoon History of Architecture*
Kostof, Spiro K., *The Architect; Chapters in the History of the Profession*
Fletcher, Banister, Sir, *A History of Architecture*

5

The Fathers of Contemporary Architecture

"For whatever profession, your inner devotion to the tasks you have set yourself must be so deep that you can never be deflected from your aim. However often the thread may be torn out of your hands, you must develop enough patience to wind it up again and again. Act as if you were going to live forever and cast your plans way ahead. By this I mean that you must feel responsible without time limitation, and consideration whether you may or may not be around to see the results should never enter your thoughts. If your contribution has been vital, there will always be somebody to pick up where you left off, and that will be your claim to immortality. . . ."

Walter Gropius,[1] letter to a group of students, 14 January 1964.

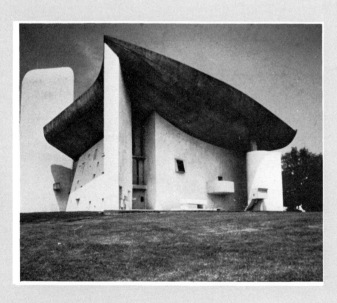

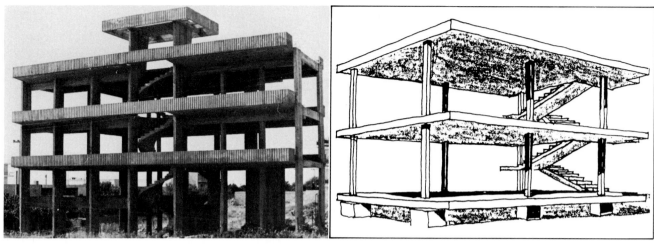

Typical reinforced concrete skeleton in Greece. Reinforced concrete frame. The Dom-ino house by Le Corbusier.

A lot has already been written about the "fathers" of modern architecture, either by themselves or by their biographers and critics. Le Corbusier, Frank Lloyd Wright, Gropius, and Mies van der Rohe have been officially accepted as the four great makers[2] of twentieth-century architecture. On the other hand, relatively little attention has been paid and relatively little is known about the people who influenced them,[3] people such as William Morris, August Perret, Peter Behrens, and Louis Sullivan. It is important to speak about people who were great, because they are for civilization as light is for darkness, so we'll speak about some of them here. In addition to the great forefathers, though, attention will be drawn to some contemporary names; it is important to know the names of people of our own time who will probably be considered "great"[4] in the years to come.[5]

The selection and presentation of the contemporary architects is based strictly upon the author's judgment, and the presentation is tailored to fit the didactic purposes of this book. It is focused on the principles and general attitudes of these people toward architecture, the environmental relevance of their works, and their thinking on the education of the architect. There is no discussion of scholastic issues of the above inquiry in this section, because they are adequately covered in the various references on the history of modern architecture. In many instances the arguments presented here will suggest what others have already suggested, yet there will be a summary of the didactics of their statements and the writer's personal conclusions.

"Besides the complex work of a modern architect, who must be everywhere and who is confronted with a thousand tasks, I cultivate, in peace of mind, a taste for art. I know that this world is defeated by the younger generation who think they can, in this way, defeat the monster of academism. But if I agreed that my hands were sullied by the trash of past centuries I would still rather wash them than cut them off. Moreover, the past centuries do not soil our hands, on the contrary they replenish them.

To devote yourself to art is to become your own judge, your own master; you are faced with a blank sheet and what you write on it is the true product of your own personality. You are full conscious of your personality. You show your true self and you recognize what you really are, neither more nor less. This means that you offer yourself faithfully to the judgment of the public without trusting to chance, blaming it for failure, and ignoring it in success."

Le Corbusier[6]

"We must always say what we see, but above all and more difficult, we must always see what we see."

Le Corbusier[7]

Le Corbusier

Le Corbusier has been presented by his biographers and by himself, in his writings and his work, as the rebel architect of the century.[8] He fought from the very early days of his life against all academic conventionality and against all established frozen thinking on the architecture of his time.[9] This architecture was following academic traditions and was reviving dead and unreasonable works of previous eras not fit for the production processes and labor skills of the industrial era. The man possessed strong and inquiring character, a strong eye in recording and understanding the reasons that formulated the form of what was upon sight. More than anything else, he possessed a strong background in the fine arts, painting, and sculpture. His life was an endless process of hard work, of pursuing architecture as a professional who was more interested in the evolution of the art than in the monetary return. He practiced and wrote on architecture simultaneously. His writing focused on his work and it was the tool that made his works known and clients receptive to his ideas. Young students and architects were influenced by Le Corbusier's sketches and written statements first,[10] and by his actual works later if they were able to travel to see the great master's works. A lot of the architectural forms in the world today are stamped with Le Corbusier's influence. One may

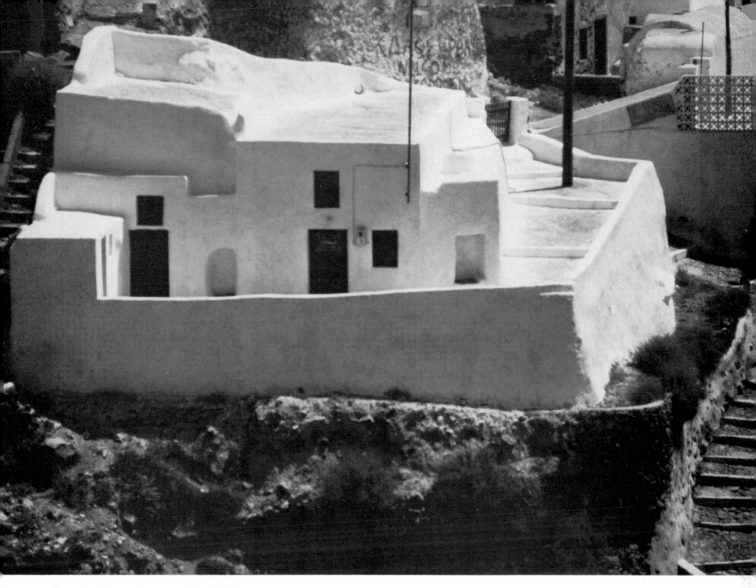

The plasticity and spaces of the Mediterranean area
were early lessons for Le Corbusier.

easily speak, not about individual architects alone, but about whole countries whose national contemporary architecture was influenced by the dogmas and form approaches of Le Corbusier. Japan's post-World War II architecture was strongly influenced by Le Corbusier.[11] Latin America, India, and many European nations experienced similar phenomena. For the young architect of today, especially the European architect, Le Corbusier is a state of mind. He ought to be admired not for his work as much as for his attitude toward architecture. This attitude is considered most relevant and is discussed in what follows. The attitude deals with a process of learning for the architect. Following Le Corbusier's example, the young architect learns that for the purpose of his education he must do the following:

1. *Travel:* in order to see works of other architects and other civilizations. He should try through exhaustive sketching to understand the "whys."
2. *Paint and Sculpt:* so that through the process of immediate creation he gets the feeling of offering something new in the world. Le Corbusier strongly believed

that architects should be "doers." The quotation at the beginning of this section on Le Corbusier sums up the master's attitude toward architecture as an art, and its relationship to other art and to professionalism.

3. *Educate:* educate oneself first, educate the client at the same time. Always explain one's thinking and always keep the client intellectually alert if you want to have your visions and beliefs implemented.
4. *Build:* be not a traveler, a painter, a sculptor, a writer, or an academic alone, but build; because to *build* is the ultimate goal of architecture and the thing which society asks as a service from the architect.

Le Corbusier's life was unique, as one would assume from the statements above which suggest what Le Corbusier did throughout his life. He traveled extensively in his youth. His early sketches suggest the great impact those travels had upon his later works. He often expressed his gratitude to the lessons he learned from those early trips, and he often spoke to his apprentices about the influence

107

Houses at Pessac. Le Corbusier. Mid nineteen twenties.

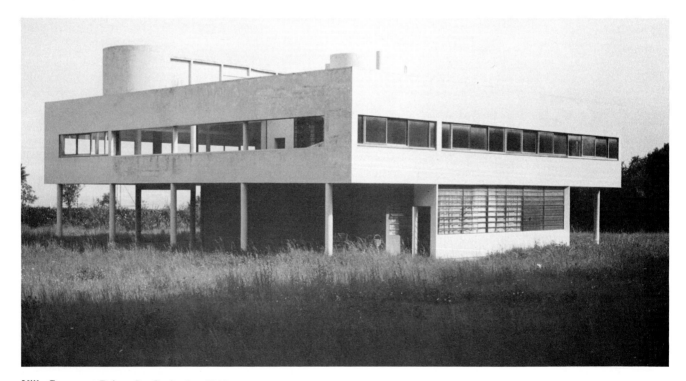

Villa Savoye at Poissy. Le Corbusier, 1929–1931.

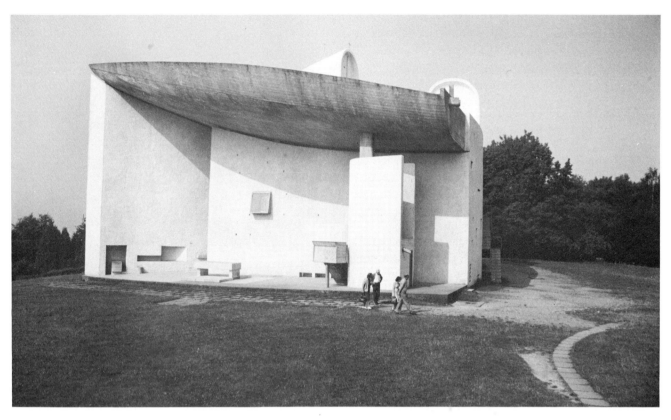

Chapel of Notre-Dame-Du-haut Le Corbusier, 1950–1953.

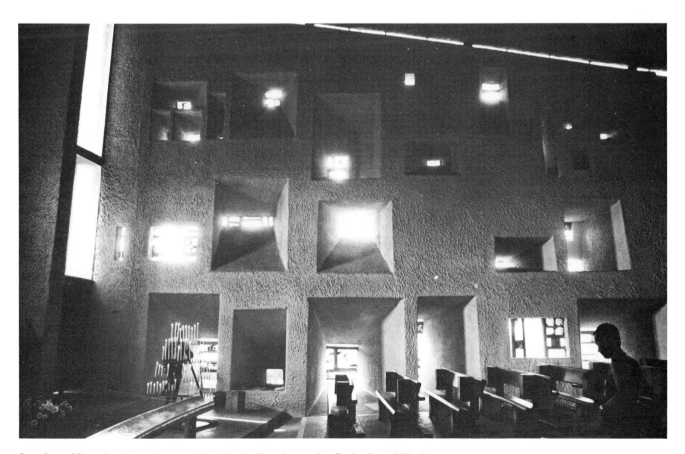

Interior sublimation through normal lighting in Ronchamp. Le Corbusier. 1950–53.

of his trips and of the influence exerted on him by certain foreign environments. The houses of Skyros, for instance, inspired in him the concept of the maisonete units of the Marseilles Block. He also spoke of the influence he experienced during his 21-day visit to the monasteries of Mount Athos when designing La Tourette.[12] He made it well-known that it was on the Island of Santorini where he got his first idea about architecture—modern architecture.

Le Corbusier loved to talk to students. He spoke in a poetic manner, similarly as he wrote about architecture. From the beginning of his career his speeches were poems full of human compassion. It might appear contradictory that he ultimately expressed the concept of the house as a machine for living. Yet this conceptualization of the house as a machine for living was well worked out by him. Unfortunately, though, it was misinterpreted by many. Le Corbusier was a prolific architect and thinker. Because of that, some early disciples grasped his essence, but others did not. Those who did not lost touch with man and built monuments to formal exercise. Some of his early Japanese imitators were the most noncreative and depressing ones.[13]

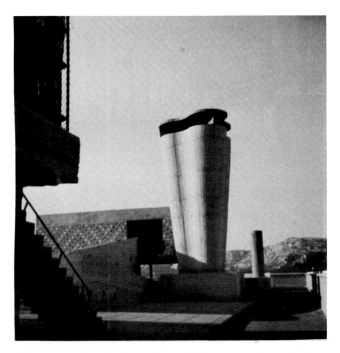

Chimneys and roof exits, sculptural elements on the roof of the Marseilles block, Le Corbusier.

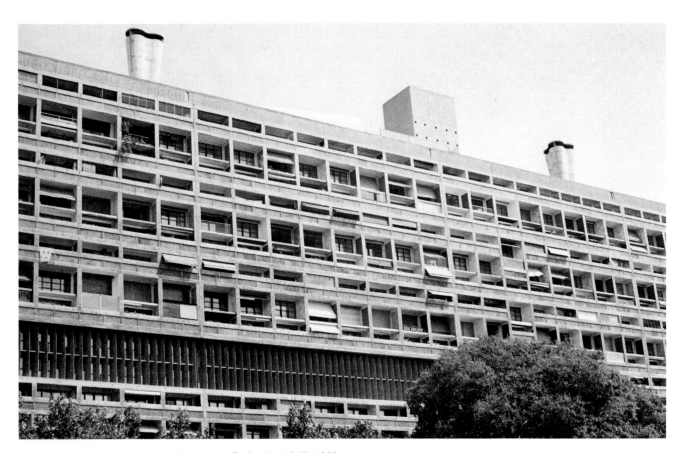

Unité d'Habitation, Marseilles, France, Le Corbusier, 1947–1952.

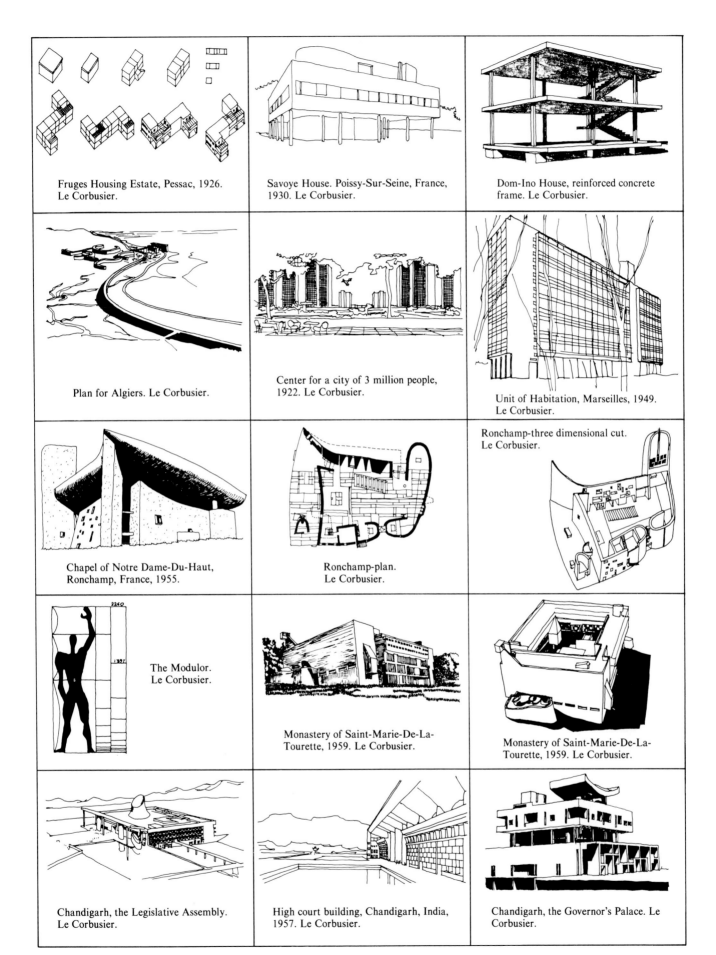

Fruges Housing Estate, Pessac, 1926. Le Corbusier.

Savoye House. Poissy-Sur-Seine, France, 1930. Le Corbusier.

Dom-Ino House, reinforced concrete frame. Le Corbusier.

Plan for Algiers. Le Corbusier.

Center for a city of 3 million people, 1922. Le Corbusier.

Unit of Habitation, Marseilles, 1949. Le Corbusier.

Chapel of Notre Dame-Du-Haut, Ronchamp, France, 1955.

Ronchamp-plan. Le Corbusier.

Ronchamp-three dimensional cut. Le Corbusier.

The Modulor. Le Corbusier.

Monastery of Saint-Marie-De-La-Tourette, 1959. Le Corbusier.

Monastery of Saint-Marie-De-La-Tourette, 1959. Le Corbusier.

Chandigarh, the Legislative Assembly. Le Corbusier.

High court building, Chandigarh, India, 1957. Le Corbusier.

Chandigarh, the Governor's Palace. Le Corbusier.

Figure 10. Le Corbusier buildings and proposals

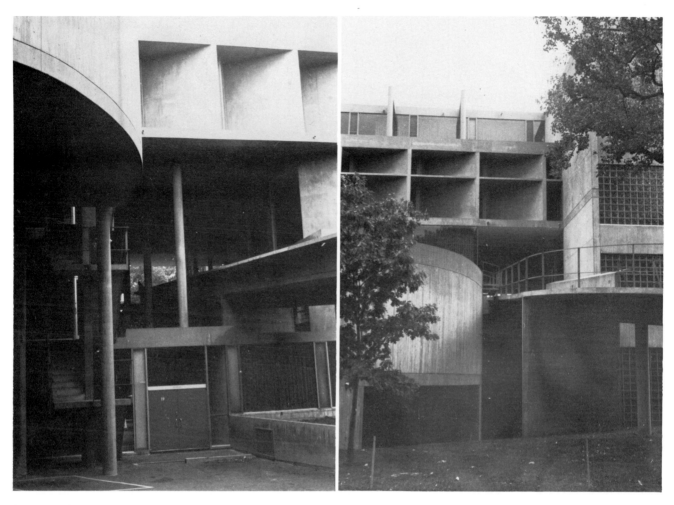

Carpenter Center. The only building Le Corbusier built in the United States. An ultra-honest 20th century building in the midst of red brick 18th century surroundings of Harvard University campus, 1961–1964.

Le Corbusier's spirit developed as a reaction to the revivals of old styles (Neo-Gothic, neoclassic), and as a reaction to the directions Art Nouveau was taking at the time. Le Corbusier disagreed that the new art should imitate plant forms, using inappropriate materials such as steel and glass. With the death of Art Nouveau, which was in a way a step forward, as it served to expose and fight academic neoclassisism, Le Corbusier gave birth to the movement of the "New Spirit."

L'esprit nouveau—this movement was about the due aesthetics of the new industrial era. Le Corbusier exclaimed, "A great epoch has begun. There exists a new spirit!"[14] The major points of this new spirit stayed with him throughout his life; they were the following:

—honesty of material expression.
—honesty in structural expression.
—avoidance of ornament.
—freedom and flexibility of plan.

It should be mentioned that the major predecessors and applied advocates of this movement were August Perret (French) and Peter Behrens (German). Le Corbusier worked with and learned from both of them, yet neither of them came out as strong as he did in stating their ideas in public and attempting to explain the reasoning of their concepts to the people.

The study of the "New Spirit" would be the study of the whole *oeuvre* of Le Corbusier; and every student of architecture should undertake it. It is not an easy task, but is a must for every architect. Such study should include the reading of the original writings of Le Corbusier as well as the study and personal inspection of his buildings. Some of the most important works of Le Corbusier which are especially appropriate for study by the contemporary student are the following:

1. Pessac, housing for workers near Bordeaux, France. It is important because it recently became a case study on space-behavior issues and indicated that Le Corbusier was a master in this respect.
2. Ville Savoye, Poissy, France. Concept of *pilots* raising the building off the ground with concrete supporting

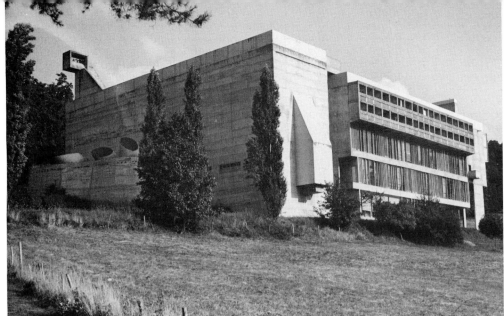

Monastery of Saint-Marie-De-La Tourette, 1959–1960. Le Corbusier.

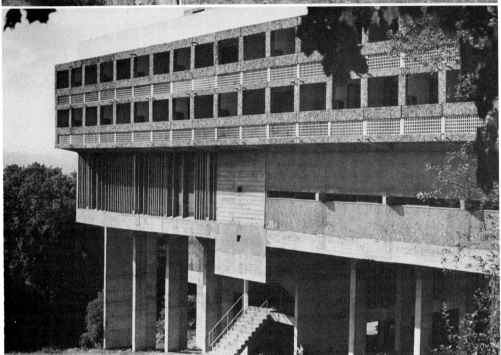

columns. Many of the subsequent urban theories of Le Corbusier were developed around the principles of this project. The "pilotis" proposal was based on good intentions; it was believed that it would leave the ground free for the play of children and would not obstruct the continuity of nature. Unfortunately the concept was not successful in high-density urban environments, especially in the United States. The pilotis generated "no man's" surroundings. The lifting of the building one floor up and the taking of people off of the ground encouraged an increase in crime and the neglect of public areas.

3. The "Modulor." This was Le Corbusier's theory on scale and proportions. An idealized human figure invented by Le Corbusier lent its proportions as the canon of design to subsequent projects.

4. Theories of Urbanism: Very high densities, acceptance of motor cars, ground-floor open spaces. Le Corbusier's urban theories[15] were detrimental for some countries. Many of the projects that were created based on his theories were not handled right and gave birth to alienating environments, since the people were taken away from the ground, and since the scale and proportions of built-up areas vs. open space had been lost.

5. Marseilles Block. High-density residential. It introduced continuity of space through the use of mezzanine units. It also provided apartment units with very narrow elevations so that more people would get maximum benefit of the view. Perhaps the most influential apartment prototype on a global basis.

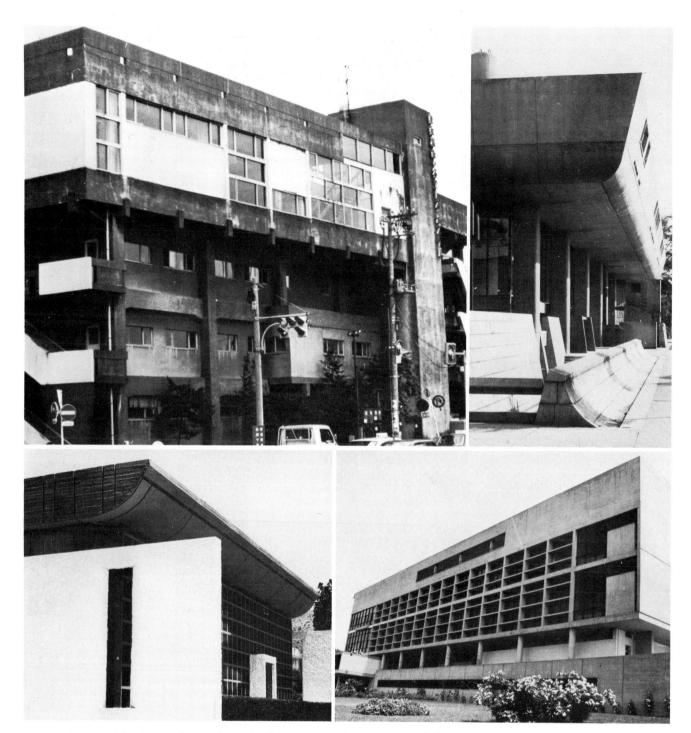

Top left, Youth hotel in Tokyo, Japan. *Top right*, Tokyo Metropolitan Festival Hall. Kunio Mayekawa, Architect, 1961. *Bottom left*, City Hall in Vouliagmeni, Greece, 1965. Elias Papayannopoulos, Architect. *Bottom right*, University of Thessaloniki campus. Fines-Papaioannou, Architects, 1963.

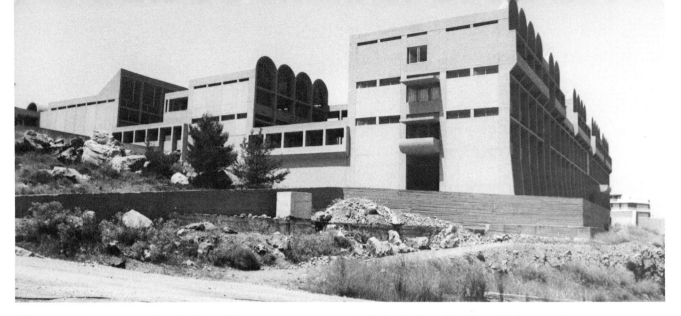

Influence and evolution on the principles of the modern movement: Le Corbusier brutality, Team 10 plan organization, Mount Athos precedent; School of Theology University of Athens. Competition winning entry by Calyvitis and Leonardos, Architects, 1970.

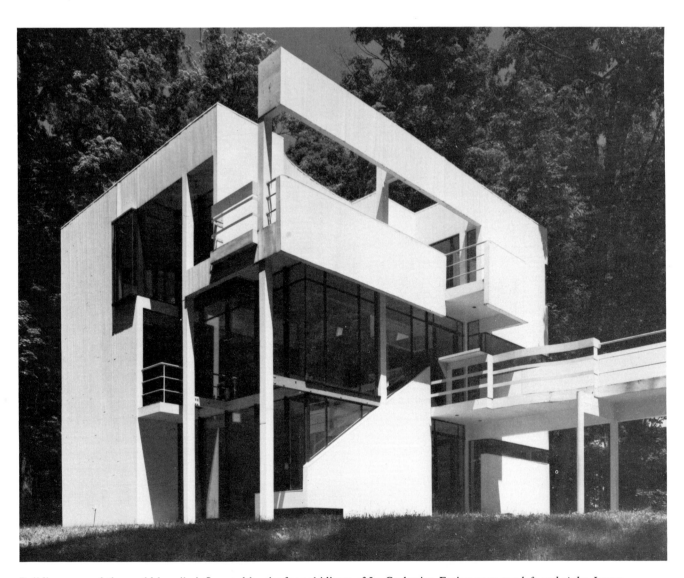

Buildings around the world heavily influenced by the formal idioms of Le Corbusier, Facing page *top left and right*, Japan; *bottom left and right*, Greece; This page *top,* Greece, and *bottom,* United States (Bottom photo by Craig Kuhner.)

115

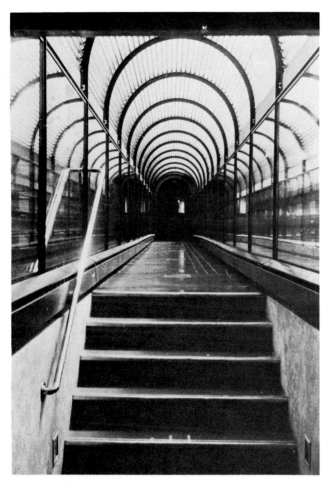

Most of the things we do today were suggested by Wright. Pioneering use of plastic tubes in corridor of Johnson Wax Foundation Building. Frank Lloyd Wright, Architect, 1936.

Chicago Auditorium, entrance. Louis Sullivan, Architect, 1886–1890.

6. Plastic Works: The chapel of Notre Dame du Haut, Ronchamp, France. In this project Le Corbusier demonstrated successful use of natural light. Approach to design is through sections. This work has been characterized by many as one of Le Corbusier's most successful.

7. La Tourette Monastery, France. A great case study of a design that coordinates functional requirements for large groups (church-chapel) with functional requirements for individuals (cells). It is a balanced building, structurally and formally sound, and highly appealing to look at.

8. Large-scale architecture: Plan of Chandigarh. (The concept of Chandigarh's design is discussed in the urban design section of this book.) Le Corbusier was the architect of the Government Center of the town.

9. Writings and sketches of Le Corbusier. He produced a bulk of written work consisting of approximately 44 volumes.

This grand master was born 6 October 1887 in Switzerland. He had artistic parental roots and a strong inclination for the arts. He died 5 October 1957 while swimming in the Mediterannean which he loved. He can now be studied and researched[16] around the globe where he left samples of his work and in the "Center Le Corbusier" in Zurich, Switzerland.

Frank Lloyd Wright

Wright's childhood play experiences seem to have led to his later decision to become an architect. His mother gave him toys such as cubes, pyramids, spheres, and other structural components. The concepts of "sets," "systems," and "wholes" became early notions in this child's perception of the world.[17]

Wright's formal education was never in architecture. As was also the case with some other great architects such as Le Corbusier and Mies van der Rohe, Wright never took the architecture courses of academia.[18] There were

Early houses by Frank Lloyd Wright in Oak Park, Illinois. Some of the early houses were done for clients of Louis Sullivan.

very few such courses in the nineteenth century, so, of course, most architects did not study in professional schools. We could say they became architects the hard way. Such things were possible in those days. In 1887 Wright worked with the firm of Dankmar Adler and Louis Sullivan. Through this association Sullivan became Wright's master. Sullivan had popularized the rationalistic doctrine, "Form follows function," which had been introduced by Horatio Greenough. This doctrine considered the form that resulted from function as the fundamental condition of good architecture and beauty.[19] Sullivan previously had written of his architectural attitudes in his book, *New Democratic Architecture,* and Wright obviously became aware of them soon.[20] The principles furthered in the master's study expressed that form would develop naturally out of structure, material, and function.

According to Wright's confessions, Japanese architecture and prints in the Japanese pavilion in the Chicago Exhibition in 1873 had a tremendous influence on him.[21]

Peter Blake, who wrote the first biography of Wright, identified five distinctive periods in the architect's work.[22] There was, however, a sixth period—the Japanese one—which, according to my findings, was more fundamental than all others. It supports the actual influence of the Orient on the architect's later works. After all, Wright himself had admitted that his work was in the deeper philosophical sense, Oriental. Wright built more than one building in Japan.[23] While only the Imperial Hotel in Tokyo became well known, the existence of numerous other buildings was silenced. This revelation poses new questions and requires restudy of the "making" of Frank Lloyd

Wright. With this necessary parenthesis, Wright's work went through six distinctive periods:

1. Early years with Sullivan in Chicago.
2. Prairie Style Period
3. Japanese Period
4. The 1930s Period of Masterpieces
5. Broadacre City Period
6. Late, back to Ornament Period

Whether the Prairie period came before or after the Japanese, and whether the similarity of principles to be found in both architectures was coincidental, must remain academic issues, perhaps to be cleared up by future students of Wright's work. In spite of this issue, each period demonstrated well-identified characteristics that should be mentioned here, but further studied[24] and understood by all students of architecture.

Wright's Six Periods

1. During the early years with Sullivan, Wright designed numerous residential buildings in Chicago and its suburbs (Oak Park, Riverdale, Forest Hills, etc.). *Form follows function* was the generic principle of this early architecture, but emphasis was put on what was later to become an integral concept[25] of interrelationships between form and function. These relationships were expressed in black wood posts and beams, deep roof overhangs, white plaster panels between the darkened framework, relationship of house to nature, open space, and sliding screens.

The beginnings of the Prairie Period.
Winslow House. Oak Park, Illinois.
Frank Lloyd Wright. 1894.

2. Wright's "prairie" architecture was his response to the balance between the dominant lines of the landscape, the horizontal of the prairie and the perpendicular of tall prairie trees, and it emphasized the horizontal. The total resulted in the triad: horizontal, vertical, horizontal. The characteristics of this architecture were low roof planes, ribbon windows, terraces extending out of the house and thus making house and landscape one, and a fireplace as the heart of the house. Open spaces, water, fire, and earth seemed to become obsessions with Wright and they were integrated into functional and formal wholes. Most of the prairie houses were built in Chicago and in Buffalo, New York.

During the same period he designed a number of nonresidential buildings such as the Unity Church in Oak Park (1906) and the Larkin Building in Buffalo. The Unity Church was important for its use of concrete poured in place and the universal space of its interior. Wright regarded this building as the one where he first consciously expressed his "new" ideas of building.[26] The Larkin Building featured the use of universal space as well, and it also emphasized with its silo-like vertical expression the mechanical systems of the building. The architectural expression of verticality that became an obsession with architects during the 1950s–60s was first stated by Wright.

3. The Japanese period included works that were built in Japan. Wright built the Imperial Hotel in the heart of Tokyo. It was destroyed by fire and replaced by an unworthy monstrosity. It has recently been learned that Wright also built a number of residential buildings in Japan. They were not publicized until their recent mention in a Japanese publication as a matter of general information.[27] The hotel in Tokyo furthered Wright's notion on integral architecture and demonstrated once again the architect's genius in conceiving, as a whole, functional as well as structural and mechanical problems. The radiant floor-heating system was an architectural innovation first used in Tokyo's Imperial Hotel.[28]

4. The 1930s has been considered the period of Wright's masterpieces.[29] The Kaufmann house, also known as "Fallingwater," in Bear Run, Pennsylvania, was Wright's most successful statement of integral architecture whereby interior, building masses, and exterior became one. The house is in total harmony with the landscape in spite of its cantilevered technical forms. Appropriate use of reinforced concrete, extensive use of glass, and appropriate activity and spatial planning represent the main features of this successful work. His second masterpiece was the Johnson's Wax Building in Racine, Wisconsin. In this building the architect demonstrated his structural genius. It was only after he built a mushroom-looking column to a scale of one to one and loaded it with sacks of cement that he was able to convince the code-enforcing engineers to grant him a permit to build the pioneering building. This building is also important for its ingenious use of transparent materials that permitted a handsome total appearance during night illumination. The building also possesses interior details and furniture designed by Wright. Third in the list of masterpieces is Taliesin West, Wright's school in Arizona. "Taliesin" was a concept for an "architectural greenhouse" rather than an architecture. The

Verticality of trees vs. the horizontality of the structure. Another Prairie house by Frank Lloyd Wright.

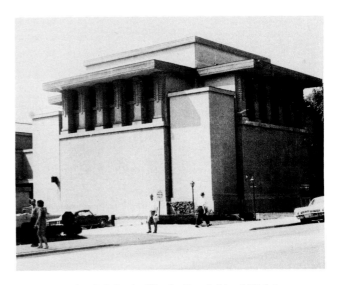

Unity Temple, Oak Park, Illinois. Frank Lloyd Wright. 1905–1906

communal life style of the students the relationships of master with students, and the curriculum and artistic activities of the members were reflected in the plan of the complex. Studios, halls for music and theatrical performances, living spaces, and the outdoors were all integrated into one coherent whole. The building becomes one with the landscape through the extensive use of the desert stone that is the material of the surroundings. All elements of indoors and outdoors are stated in accordance with the master's theories. The selection of construction materials (desert stone, wood, canvas), the site planning, the selection of surface materials for the exterior grounds (hard vs. soft elements of landscaping), and the multiangled and well-controlled design of the approach to the building make this yet another of Wright's lessons to future generations of architects.

The "Usonian House" was a residential house advocacy rather than a specific house. Although Wright built and exhibited a prototype, "Usonian houses" were built throughout the United States. Through this type Wright attempted universalization of the prairie style, simplifaction of the earlier forms, and avoidance of ornament. The aim of this residential advocacy was the creation of a universal American democratic residence.[30]

5. Broadacre City Period, 1933. This period was filled with Wright's urban concerns. According to many students of the architect, these concerns developed as side effects of the drop in his business during the Depression years.[31] The Broadacre City was publicized a lot and became the subject of numerous articles, most of which portrayed Wright as an individualistic agrarian, negator, and hater of cities.[32]

These early criticisms were grounded on the anti-urban characteristics of Broadacre City, low densities, and deemphasis of social contact. Broadacre City recommended growth and self-production.

Although Wright's responses to his critics and his fiery temperament did not permit further modification of his belief in decentralization as stated in Broadacre, his urban works that followed showed him to be an extremely talented architect when dealing with urban situations. He demonstrated an innovative grasp of urban reality. Unlike his low-density Broadacre City which he never reconsidered conceptually and formally, even when it had become reality in the case of never-ending suburbia, his later urban projects introduced advanced concepts of urban design and urban integration. Such was the case with the concept of the "three-dimensionality of the street," suggested by the Guggenheim Museum, the Morris Shop in San Francisco, and the notable urban jewel, Anderton Court Center in Beverly Hills.[33] These concepts became the preoccupation of many European planners during the decades of the 60s and 70s, and then became realities in many high-density projects, but they were never credited to Wright conceptually.[34] On the contrary, Wright's duality as an architect and planner was never recognized and his only planning theory, Broadacre City, received nothing but attack. My argument is that Wright was an extremely good urban designer when he dealt with urban situations, and had he been given the chance to plan whole sections of towns and even whole towns, he would have been successful, and perhaps even better than Le Corbusier ever managed to be.

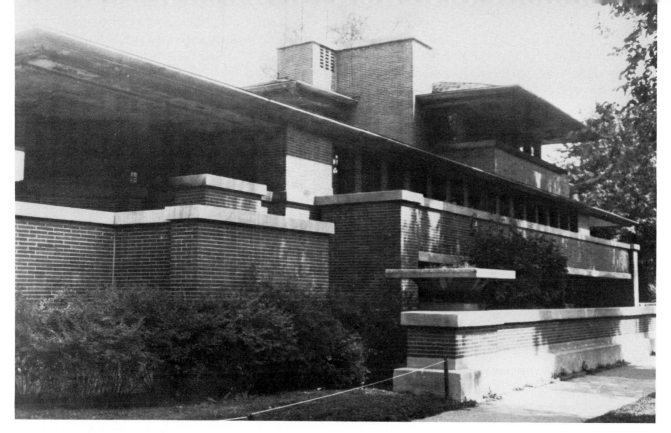

The Robie House. Wright's Prairie masterpiece, Chicago, Illinois. 1907

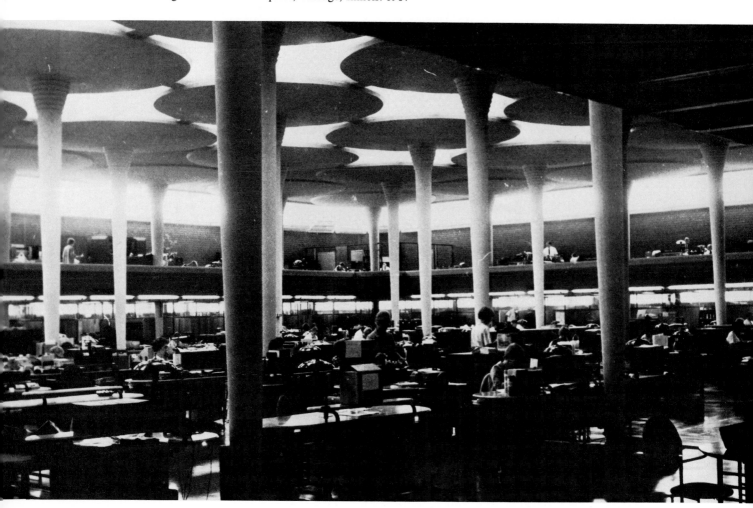

A forest of "mushrooms." The main office space of Johnson Wax, Racine, Wisconsin. Frank Lloyd Wright. 1936

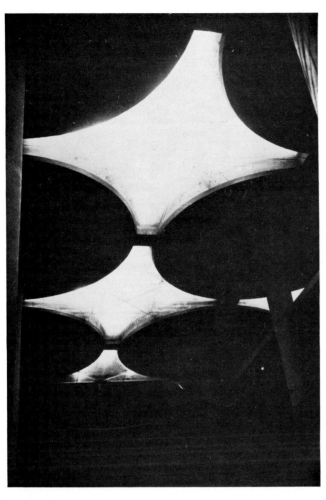

The sky and the forest, or a constellation of heavens. Beauty and spirituality of the work environment. Main office space, Johnson Wax Co., Administration Building, Racine, Wisconsin. Frank Lloyd Wright, 1936.

6. In the first three periods of his career Wright made extensive use of ornament, an influence of Louis Sullivan. He abandoned ornamentation during the period of his masterpieces, but them assumed it again in his last period.[35] An outstanding work where ornament was reintroduced is the Marin County Civic Center. There is an absolute need for the use of ornament in this building, especially on the roof. The roof becomes visible from the adjacent hills, on which the great complex crawls. These hills are occupied by the employees of the building for eating their lunches and relaxing. Ornament was introduced but in a functional manner rather than in purely visual ways as with the ornamentation of elevations in the past.[36] If the roof of the building had not been designed, one would have to constantly face the unappealing sight of mechanical equipment, asphalt, and gravel disorder.

Frank Lloyd Wright was a legendary architect. His works, as well as his writings and speeches, are monuments to the formulation of twentieth-century architecture. He saw architecture in its totality. He created works that became one with nature, even when he did so through the use of daring structural solutions, as was the case with the Kaufmann house in Bear Run. He claimed he was not influenced by the European movement in architecture. He did not deny that he was touched by the Orient. In any event, he always expressed his convictions in his uniquely independent way. If he could still be heard he would once again say, "After all, who built it? Who put these thoughts into buildings? Laotse nor anyone had consciously built it. . . . Well then, no matter what you say, I can still go along with head up."[37]

Use of prefabricated concrete element; Dr. Storer's house by Frank Lloyd Wright in Hollywood, California.

An embroidery-like roof for the visual joy of those who relax on the hill. Marin County Courthouse, California. Frank Lloyd Wright, 1959.

Detail of the roof edge. Marin County Courthouse.

Play between tree and wall. Anderton Court Center, Rodeo Drive, Beverly Hills, California. Frank Lloyd Wright, 1955.

Gropius and the Bauhaus

"Gropius" and the "Bauhaus" represent in the minds of many architects one and the same thing. From the writer's point of view, they connote a spiritual concept more than anything else. Walter Gropius and the Bauhaus, that is, the group and design school he founded, were for modern architecture and contemporary civilization more fundamental than all other influential architects, industrial designers, and movements combined.[38] Both Gropius and the Bauhaus had not a building dogma, but an *idea:* "To build not only houses, but first and foremost a community, because great things are always carried forward by the community. . . ."[39] "Unity in diversity" was the motto of the Gropius-founded school.

Bauhaus was the name of a school of architecture which was, in fact, the first school of environmental design of the century. *Bauhaus* also is the name of the specific building where the school was housed in its Dessau period. *Bauhaus,* finally, connotes the name of a political and active group founded and headed by Gropius through three distinctive periods of evolution: impact, persecution, and finally eviction from its motherland at the time when Fascism was taking over in Germany.[40]

The Bauhaus as a cultural and political group was founded and operated in the Republic of Weimar from 1919 to 1925. During these years the young members of the group probed the basic issues of traditional vs. contemporary values; challenged the prevailing neo-Gothic–neoclassic revivals;[41] attacked the antiquated practices of nineteenth-century construction; and argued instead for the use of modern materials such as steel, glass, and reinforced concrete, and for the need for response to

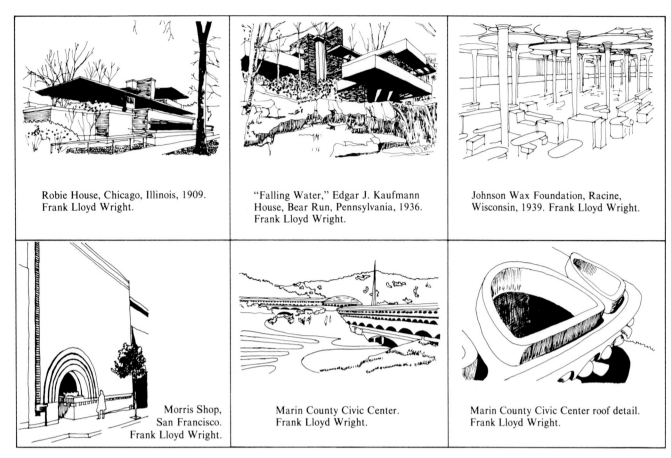

Robie House, Chicago, Illinois, 1909.
Frank Lloyd Wright.

"Falling Water," Edgar J. Kaufmann
House, Bear Run, Pennsylvania, 1936.
Frank Lloyd Wright.

Johnson Wax Foundation, Racine,
Wisconsin, 1939. Frank Lloyd Wright.

Morris Shop,
San Francisco.
Frank Lloyd Wright.

Marin County Civic Center.
Frank Lloyd Wright.

Marin County Civic Center roof detail.
Frank Lloyd Wright.

Figure 11. Frank Lloyd Wright buildings

mass housing, standardization, and mass production.[42] They also advocated the need for community projects through team design effort including specialization[43] of the individual members, instead of the arrogant solutions promoted by individual architects who could not possess the skills to solve the complicated projects of the twentieth Century. In summary, the group questioned the then prevailing nationalist approaches of Germany[44] which tended to capitalize on the past and ignore the essence of the problems of the new technological era. The Bauhaus group, instead, demanded innovations for the buildings of the future. Obviously such probes generated polemic outbursts from conservative factions of the Republic of Weimar, especially from representatives of the building industry of the time[45] who saw their profits cut because their skills and building methods were being jeopardized by the potential of future implementation of innovative ideas. The Bauhaus was finally evicted from Weimar, and by then (1925) any person belonging to the group was considered a "lunatic." In later days "Bauhaus" was considered a title of honor.[46]

The second period of the Bauhaus is associated with the town of Dessau. It lasted from 1925 to 1932. The school of Bauhaus was housed in the synonymous building which was an actual summary of the architectural vocabulary advocated by Gropius and his disciples. In line with the earlier Gropius projects such as the Fagus factory and the Werkbund Exposition, the building of the Bauhaus in Dessau demonstrated articulation of masses, separation of the glass "skin" from the skeleton, and well-established structural order. The building was resolved in an undeniably functional way (e.g., studios getting the northern light, thus glass skin was used on the north side of the building). The functional organization was based on the revolutionary concept of architectural education that was taking place inside. Different disciplines such as painting, theory of color, theory of design, photography, construction, set design, furniture design, planning, and others were operating under the same roof. Learning therefore was acquired through actual interaction in addition to the traditional methods of theory and practice that were desirable and at hand. Constant student and faculty interaction was achieved by including faculty quarters on the same site as the school. The Bauhaus school of architecture operated as a commune for learning.

In 1932 the group moved to Berlin in the hope that they would be better off there promoting their ideas at a time when Germany seemed to be seeking progressive ideas and

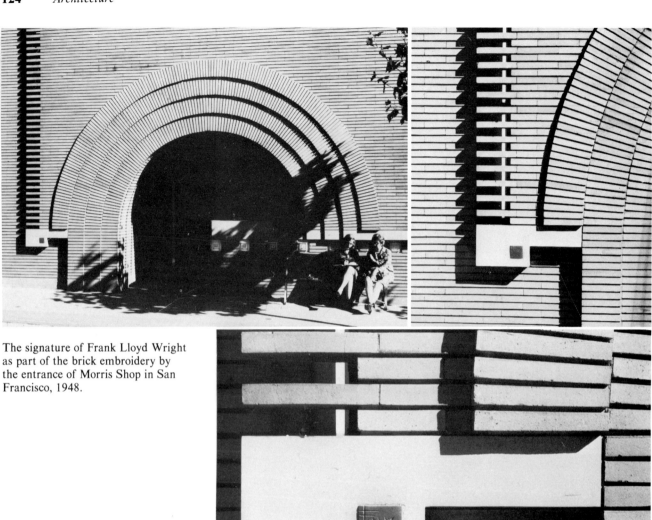

The signature of Frank Lloyd Wright as part of the brick embroidery by the entrance of Morris Shop in San Francisco, 1948.

innovations. But alas! These young artists and intellectuals were fooled; the promises and advocacies of the Hitler supporters were nothing but fat rhetoric, deeply rooted in an ill-conceived antiquated nationalism that was blinding the German people and making it difficult for *truth* to exist.[47] Forecasting the disaster that was to come, Gropius and his group suffered the consequences of eviction on the accusation of being Bolsheviks; they closed their buildings in Berlin in 1933 and left.

The search for a new home started. Some of the members of the Bauhaus were invited to other countries. In 1934 Gropius accepted invitation to establish himself in Greece as a professor of design at the National Technical University in Athens.[48] This came about due to the initiative of Jan Despo (Yannis Despotopoulos), a student of Gropius and a professor of architecture in Greece. Unfortunately, the Hitleric Embassy in Athens did not issue a visa for Gropius to go to Greece. Some other countries were more influential in that respect, and finally Gropius and some other leading members of the Bauhaus group found their ways to the United States. László Moholy-Nagy, Mies van der Rohe, and Walter Gropius came to the East Coast. They all stayed at Harvard first; then Mies moved to I.I.T. in Chicago, and Gropius with many of the others remained at Harvard to head the School of Design. Bauhaus had found its new home. Harvard University became the point where European architecture was transplanted to the United States. A great number of the most

TABLE 4. BAUHAUS—DIAGRAM OF CONCERNS

Bauhaus

Important teachers	Fame	Specialty	USA	Diagram of concerns
Albers	●	Color	Yale	
Arndt		Practical man teaching		
Bayer		Design graphics—Communications		
Breuer	●	Furniture—architecture	Practice	
Gropius	●	Founder teaching—architecture	Harvard	
Hilberseimer		Planning housing		
Itten		Color		
Kandinsky	●	Painting—color		
Klee	●	Aesthetics synthesis—color		
Moholy Nagy		Photography—movie making	Harvard	
Mies	●	Most celebrated architect	I.I.T	
Schelmmer		Set design		

prominent U.S. architects of the three decades that followed were students of Gropius.[49] Some of the lessons of the Bauhaus were also furthered in Chicago, yet the Chicago-educated architect had the "stylized" influence of Mies van der Rohe. World architecture, and American architecture in particular, developed as a dialectic of the Bauhaus concepts promoted at Harvard, the Miesien concepts promoted at I.I.T., the native influence of Frank Lloyd Wright, and the distant influences of Le Corbusier as they were coming from Europe.[50]

One can only wonder what would have happened to Gropius, and to the Bauhaus as a whole, had Gropius gotten his visa for Greece. The whole course of American architecture since then would perhaps have been very different, since Greece would have affected Gropius differently than technological America.

The greatest influences of the Bauhaus have been recorded in Greece, in Israel, and in Japan. Greece, during the period of 1933–36, built a great number of schools which bear the stamp of Bauhaus morphology with some buildings possessing striking similarities to certain Bauhaus buildings of the Dessau Era.[51] Many of the "Bauhaus" buildings in Japan are now renovated and preserved as worthy samples of a great era of architecture.[52]

The Bauhaus morphology and ideas were introduced in Israel by Arieh Sharon, a student at the Bauhaus and subsequently an influential architect and planner in his country.[53] Some of his earliest housing co-operatives in Tel Aviv indicate that the student had surpassed his teacher as a designer. Tel Aviv is a showcase for the spread of the Bauhaus style out of Germany and of the subsequent adaptations of a style through user additions.

Walter Gropius, Albers, Arndt, Bayer, Breuer, Hilberseimer, Itten, Kandinsky, Klee, Moholy-Nagy, Mies van der Rohe, and Schelmmer must be kept in the memory of all architects and regarded as the fathers of modern architecture.

The story of the Bauhaus has been repeatedly written. Most of the members of the group wrote extensively[54] about their theories and design attitudes. All in all, they tried to develop designers trained in multifaceted design skills, yet ready to collaborate with others and work as teams to create the demanding projects of a technological era. Practical training and on-site education were considered necessary. Walter Gropius never stopped emphasizing that the acquisition of skills and practical education should go hand in hand with social conscience and theoretical awareness.[55]

United States Embassy, Athens, Greece. Walter Gropius, and "The Architects Collaborative," 1960.

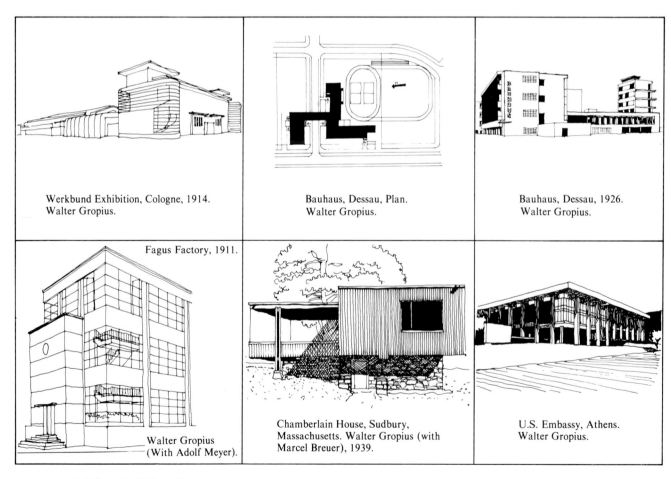

Werkbund Exhibition, Cologne, 1914. Walter Gropius.

Bauhaus, Dessau, Plan. Walter Gropius.

Bauhaus, Dessau, 1926. Walter Gropius.

Fagus Factory, 1911. Walter Gropius (With Adolf Meyer).

Chamberlain House, Sudbury, Massachusetts. Walter Gropius (with Marcel Breuer), 1939.

U.S. Embassy, Athens. Walter Gropius.

Figure 12. Buildings by Walter Gropius

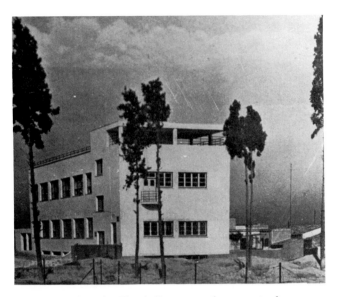

School in Athens by Yannis Despotopoulos, an actual student of the Bauhaus. (Photo courtesy of "Ta nea scholika Ktiria," Technikon Epimeleterion, Athens, 1938.)

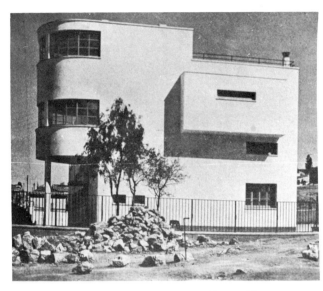

School in Athens. C. Panagiotakos, Architect. (Photo courtesy of "Ta nea scholika Ktiria," Technikon Epimeleterion, Athens, 1938.)

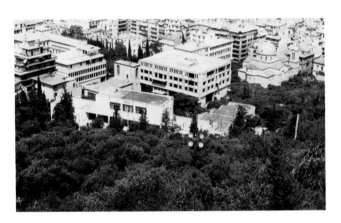

School on Lycabettus. Dimitris Pikionis, Architect, 1938.

Private residence in Athens, Stamos Papadakis, Architect, 1936.

Housing in Tel Aviv.

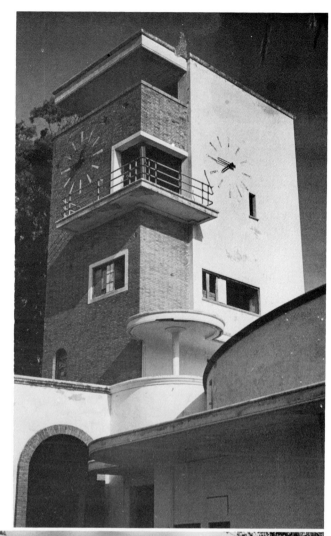

The influence of Bauhaus in Japan. An International idiom has prevailed, Ginza, Tokyo.

The influence of the Bauhaus in Leros, Greece—The Town Hall/ Market Place complex as built by the Italians during the mid 1930's.

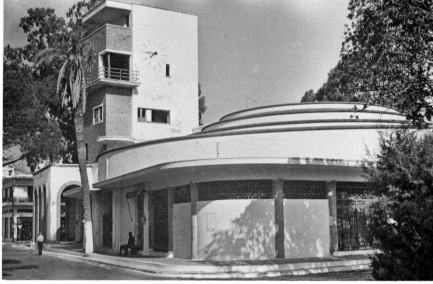

Tel Aviv; international style as affected by user adaptation.

International style residence in Athens, Greece.

School on Lycabettus. Dimitris Pikionis, Architect.

High density educational facility in Thessaloniki, Greece.

School in Greece. (Courtesy of "Ta nea scholika Ktiria," Technikon Epimeleterion, Athens, 1938.)

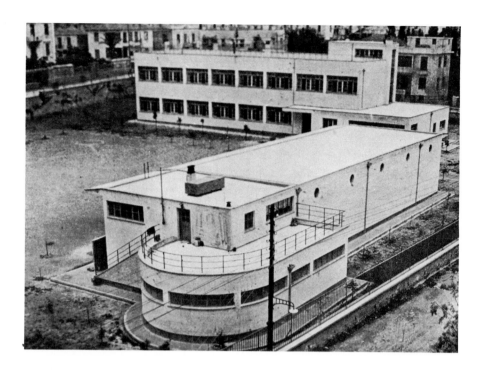

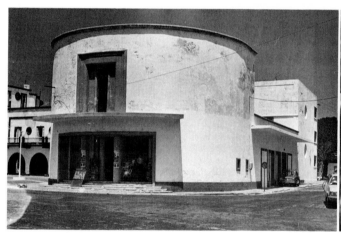

Theater section of Hotel "Roma" in the Greek Island of Leros. The expansion of international style by unknown Italian Architects in the mid 1930's. The variation of the international style known as "Italian Rationalism."

Gropius himself did not build a great number of buildings, nor did he build any great buildings. In fact, he was attacked occasionally by some critics who referred to him as an architect who lacked a "delicate aesthetic."[56] But Gropius' greatness was in his design methodology, his approach to architectural education, and his whole philosophy about architecture in general. His design methodology was pragmatic, emphasizing functional rather than spatial solutions. Space became the concern of some Bauhaus students in later years after they had been exposed to the theories and the works of Wright. Paul Rudolph developed into the most celebrated student of Walter Gropius—an architect who understood the Wrightian concepts of space, observed the spatial attitudes of Le Corbusier, and finally became "Paul Rudolph." Walter Gropius remained a great teacher, a great stimulator for collaboration and team work. As an architect he designd several housing prototypes, but his best projects were the Housing Building Exhibition in Berlin, the Werkbund Exposition in Paris, and the U.S. Embassy in Athens, which he designed in association with "the Architects Collaborative" which he had founded in the United States.

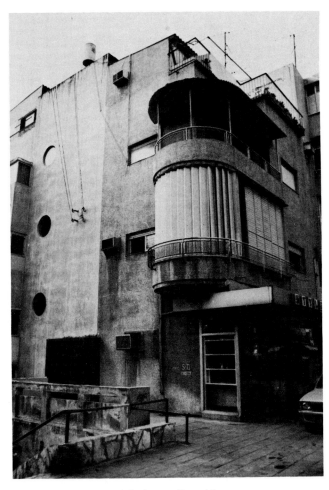

Tel Aviv. International Style as affected by user adaptations.

Mies van der Rohe

Looking at modern architecture in retrospect, one realizes that Wright and Mies exercised the strongest influence on spatial issues for the generations that followed. Le Corbusier had undeniable influence on numerous urban design schemes of modern planning as well as in aspects of reinforced concrete expression. Gropius' influence was mostly on the process of design and architectural education. Wright and Mies have remained, in my opinion, the two poles that inspired and taught architectural space concepts and architectural technology to the architects that followed. I have argued elsewhere that the successful architectural spaces of the decade, 1960s–1970s, could be conceived as oscillations between the poles of the Wrightian concept of three-dimensional continuity on one hand and Miesian straightforwardness in terms of plan, structural clarity, and statement boldness on the other.[57] Architects who demonstrated exceptional understanding of

spatial treatment, such as Rudolph Schindler and Paul Rudolph, were most certainly influenced by Wright; while the whole mainstream of corporate U.S. architecture, as well as the curtain-wall office building architecture of Europe, was most certainly influenced by Mies van der Rohe.

Mies could be thought of as the real master builder of modern architecture. His charm with his structural and detail perfectionism infatuated the corporate clientele of the United States. Upon his arrival in North America he taught initially at Harvard (under Gropius), but then found his own place for the teaching of architecture at the Illinois Institute of Technology. The plan of this campus and the designs for some of the campus buildings were done by Mies. Mies's spatial concept focused on open plans that permitted two-dimensional continuity. The first paradigm of Miesian space was created for a 1929 exhibition in Barcelona. The German Pavilion, built by him, became known as "the Barcelona Pavilion." Space was enclosed by means of linear and vertial elements, vertical and horizontal planes, and by spot steel columns. The pavilion was demolished after the exhibition, but it served well its purpose of establishing the Miesian spatial vocabulary which pushed to the side the fragmented, compartmentalized interiors of 19th-century architecture. The Miesian buildings were achieved by means of steel, glass, and expensive finishes extremely well detailed. Drama and diversity were not the concerns of Mies van der Rohe. He wanted solid buildings, expressions of one strong idea—clear and sharp as shiny razor blades. He was emphatic about this attitude. One will always remember how he summarized his credo with the statement, "I do not want to be interesting, I want to be good."[58] And "to be good" was exactly what corporate clients wanted from their architects in the U.S. It was not accidental that the precision detailing of the Miesian buildings earned him fame and appealed to clients who were interested in buildings "that would not leak," as opposed to "great ideas" that could not get built or, if so, would leak. . . .[59] Mies van der Rohe taught large numbers of students at I.I.T. Most of them swear to Mies's name and the Miesian concepts of architecture. I.I.T. produced many Mies van der Rohe disciples.

The energy crisis was not an issue in Mies's days. Curtain-wall skyscrapers filled the United States and Europe. The amount of energy needed to air-condition these fixed-glass buildings was enormous, and therefore the Miesian "goodness" eventually produced the worst architecture from the energy point of view, and without Mies knowing it or ever thinking of it. Vincent Scully was a prophet when he wrote that "Mies van der Rohe's classicizing limitation of himself to a few simple shapes, to 'almost nothing,' was at first a virtue; but it had certain dangerous restrictions in it, since it answered all problems by ignoring most."[60] Mies certainly ignored the energy issue.

Reflections in downtown Chicago. Mies van der Rohe.

Mies van der Rohe has been either beloved or hated as an architect. His buildings have been either adored or damned. Some of his most recent critics, after looking at the fate and performance of some of his projects in retrospect, have crucified him.[61] In any event, the student should not dismiss Mies van der Rohe, as he represents a unique case of a man with a most strong discipline.

His persistence on his principles of purity and the application of those principles in his buildings have made him a legendary figure striving for a perfection that could be found, if ever, on the absoluteness of divine. The pursuit of purity became a concern of followers of Mies van der Rohe, with Philip Johnson representing a notable example. Some, like Eero Saarinen, managed occasionally to create more humane interpretations of the Miesian concept; others, like S.O.M., remained Miesian for many years; and yet others, like Kevin Roche and John Dinkeloo, managed to extend the Miesian principles of two-dimensional continuity to three dimensions. Miesian principles dominated the architecture of the technologically advanced world for at least two decades, especially between the late forties and late sixties. The early seventies experienced the construction of "all glass" skyscrapers (reflective glass) in the prototypes conceived by Mies at the beginning of the century. The time had come for the disciples to be able to construct the visions of the master. This was ironic, as a generation of architects was becoming aware of the energy crisis, thus realizing the obsolescence of glass and fixed-window solutions.

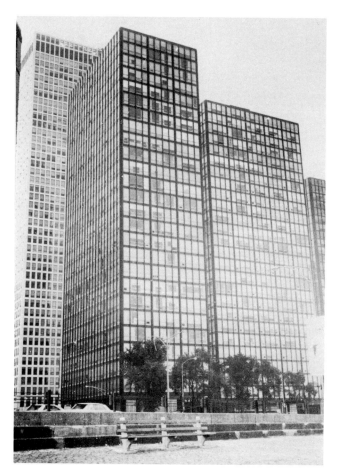

Lake Shore Drive apartments. Chicago, Illinois. Mies van der Rohe.

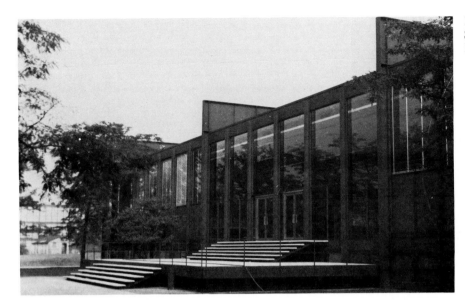

Illinois Institute of Technology, School of Architecture. Mies van der Rohe 1950–1956.

Model of a project by a student of Mies at the Illinois Institute of Technology.

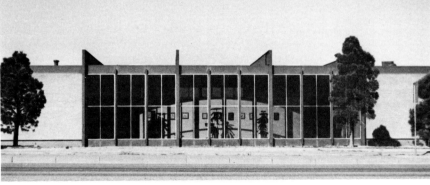

Church in Albuquerque, New Mexico, by a student of Mies van der Rohe.

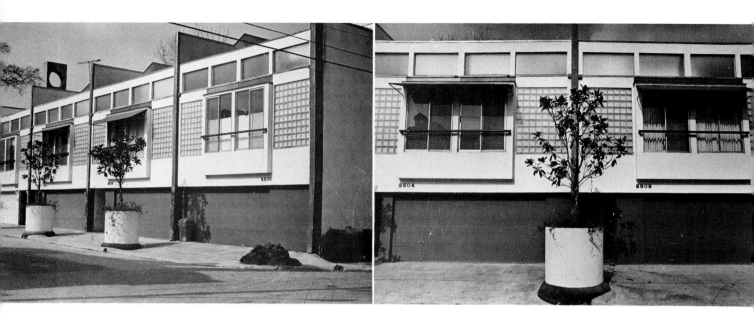

Adherence to the universal principles of Mies van der Rohe could produce and did produce works of spirited individualistic excellence as evidenced through the works of several designers.

Ironic encounter between ivy and immaculate corner articulation of a Mies van der Rohe building on IIT campus.

Mies van der Rohe was the teacher who taught discipline, functional absolutism, two-dimensional balance, proportional appeal, and detail perfection. For the engineer who finally embraced architecture in a unique master builder's way, he did extremely well in all the above respects. He would have done much better for himself and civilization if the energy issue and the environmental performance of his buildings had become his concerns. He might have resolved many of our current environmental problems bequeathed to us through his energy-insensitive and glare-producing glass skyscrapers. Any current Miesian derivation that is insensitive to the energy and building performance issues of today should fail as environmentally detrimental.

The Status of Contemporary Architecture

The Bauhaus taught architecture, "team design," concern for mass production, industrialization of design, simplicity, use of modern materials. . . . The critics gave the architecture that evolved names: "Bauhaus," "International Style."[62] Frank Lloyd Wright taught space. . . . Then they spoke of the "Prairie Style," the "Usonian Style." Le Corbusier, the same. He offered "Architecture"; he taught space, creativity, urban design. They spoke of "Le Corbusier"; they called him names; brutalist, functionalist, formalist, etc., etc. Clients were expecting from their architects an . . . "ism." In the past it was neo-Gothic(ism), neoclassic(ism). After the "Great Ones," clients were asking for Frank Lloyd Wright(ism), Le Corbusier(ism), Bauhaus(ism) . . . International Style.

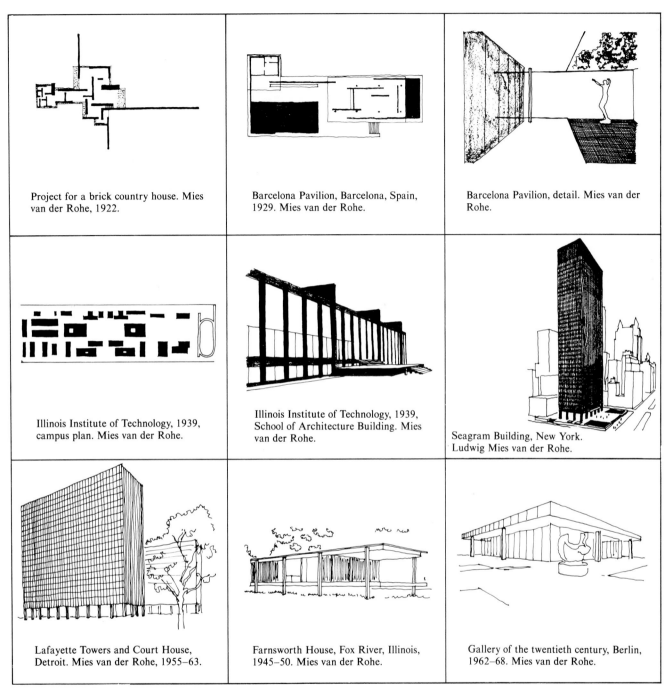

Project for a brick country house. Mies van der Rohe, 1922.

Barcelona Pavilion, Barcelona, Spain, 1929. Mies van der Rohe.

Barcelona Pavilion, detail. Mies van der Rohe.

Illinois Institute of Technology, 1939, campus plan. Mies van der Rohe.

Illinois Institute of Technology, 1939, School of Architecture Building. Mies van der Rohe.

Seagram Building, New York. Ludwig Mies van der Rohe.

Lafayette Towers and Court House, Detroit. Mies van der Rohe, 1955–63.

Farnsworth House, Fox River, Illinois, 1945–50. Mies van der Rohe.

Gallery of the twentieth century, Berlin, 1962–68. Mies van der Rohe.

Figure 13. Buildings by Mies van der Rohe

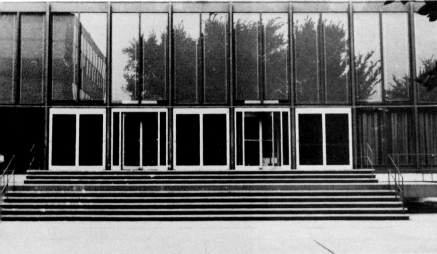

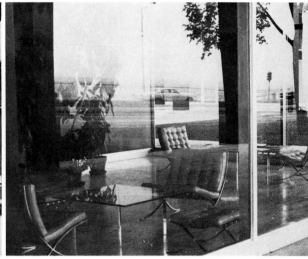

Building influenced by the Miesian morphology. A source of glare at IIT.

Interior-exterior continuity. The "Barcelona" chair.

Many of the works of the early masters of twentieth century were not sensitive to the larger context of their surroundings. Rietveld, the Schröder house in Utrecht. 1924.

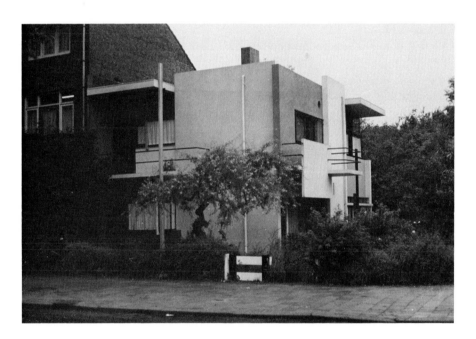

Well, then, what would be a healthy attitude toward these "isms?" What is architecture today? How can one speak about today's architects? What should architecture be tomorrow? The answers must be convincing. I believe the answer should be lengthy, as follows:

. . . The child learns to count. One, two, three, . . ., etc. Parents and relatives are happy. . . . It is exactly at the point of admiration where a great deal of the fallacies of our civilization, architecture included, are to be found. The child knows how to count, but the child does not know why he is counting nor the meaning of one, two, three. He finds that out later while playing with his mates. When he gets his toys in hand, if they happen to be three, and he says "three"; he knows then what he says.

Some mathematicians have pointed out that there is a substantial period of time between the unconscious knowledge of counting and the conscious experience of understanding the meaning of the numbers. So now, preschool and kindergarten mathematics instruction attempts to assure that the concepts of what numbers mean are acquired before number names and their proper order are taught. The children are given toys and games to manipulate. They see, they count, they learn. Their words, one, two, three, . . ., have meaning.

The point here is that a great number of our hang-ups today originated in childhood experiences when we learned how to say words before we had their concepts. It took us time to learn concepts. Mankind has been resentful of all things it was unable to understand, due either to a limited vocabulary or religious and political doctrines imposed upon people through the communication of traditional practices and learning through imitation.

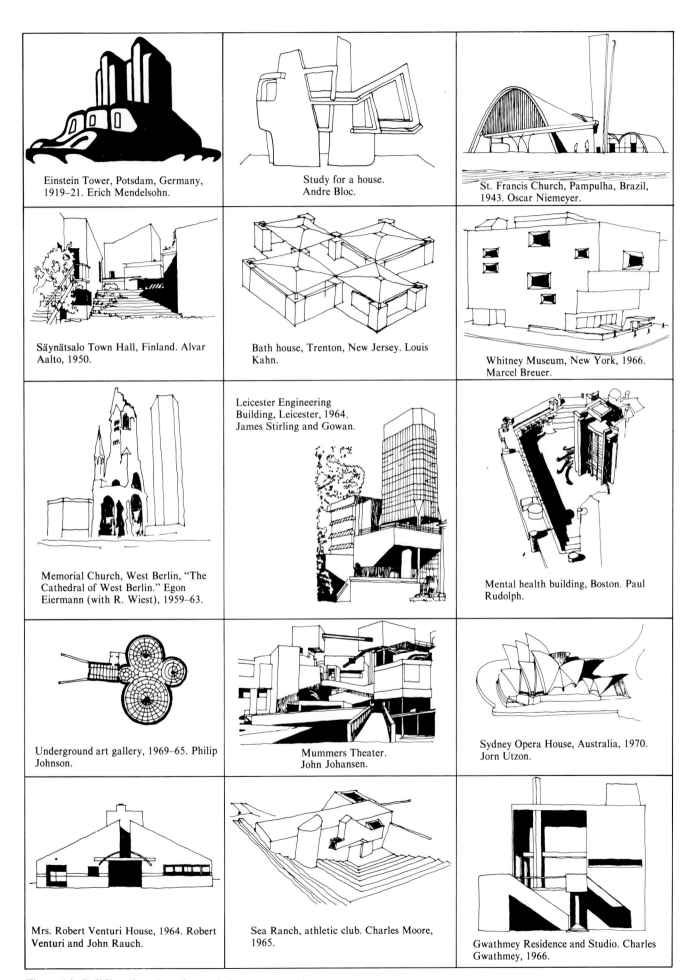

Einstein Tower, Potsdam, Germany, 1919–21. Erich Mendelsohn.

Study for a house. Andre Bloc.

St. Francis Church, Pampulha, Brazil, 1943. Oscar Niemeyer.

Säynätsalo Town Hall, Finland. Alvar Aalto, 1950.

Bath house, Trenton, New Jersey. Louis Kahn.

Whitney Museum, New York, 1966. Marcel Breuer.

Memorial Church, West Berlin, "The Cathedral of West Berlin." Egon Eiermann (with R. Wiest), 1959–63.

Leicester Engineering Building, Leicester, 1964. James Stirling and Gowan.

Mental health building, Boston. Paul Rudolph.

Underground art gallery, 1969–65. Philip Johnson.

Mummers Theater. John Johansen.

Sydney Opera House, Australia, 1970. Jorn Utzon.

Mrs. Robert Venturi House, 1964. Robert Venturi and John Rauch.

Sea Ranch, athletic club. Charles Moore, 1965.

Gwathmey Residence and Studio. Charles Gwathmey, 1966.

Figure 14. Buildings by selected twentieth century architects

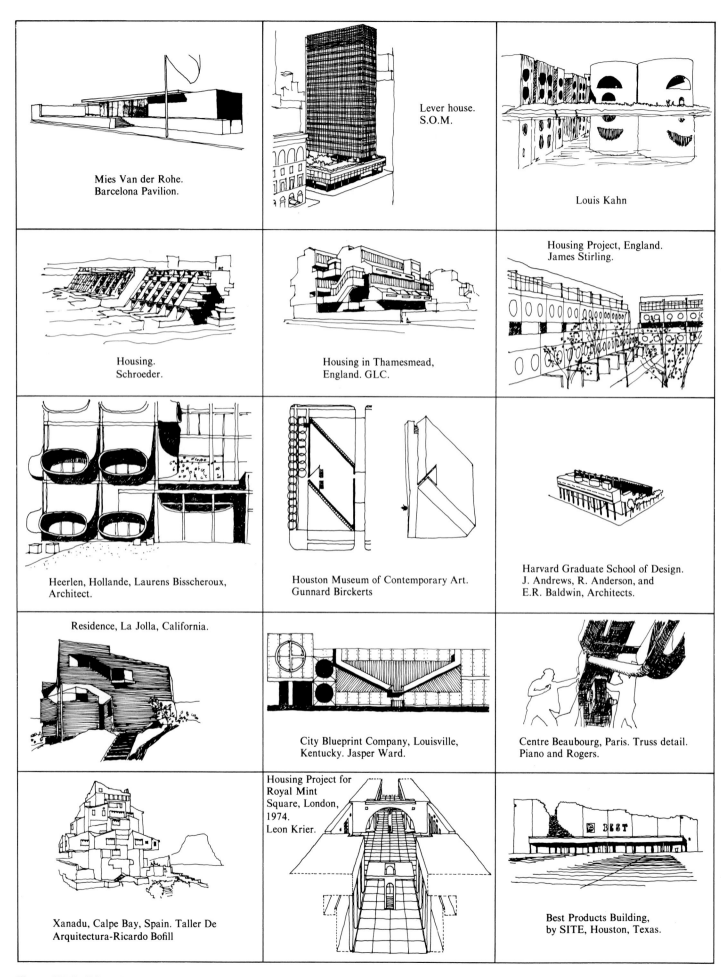

Mies Van der Rohe.
Barcelona Pavilion.

Lever house.
S.O.M.

Louis Kahn

Housing.
Schroeder.

Housing in Thamesmead,
England. GLC.

Housing Project, England.
James Stirling.

Heerlen, Hollande, Laurens Bisscheroux,
Architect.

Houston Museum of Contemporary Art.
Gunnard Birckerts

Harvard Graduate School of Design.
J. Andrews, R. Anderson, and
E.R. Baldwin, Architects.

Residence, La Jolla, California.

City Blueprint Company, Louisville,
Kentucky. Jasper Ward.

Centre Beaubourg, Paris. Truss detail.
Piano and Rogers.

Xanadu, Calpe Bay, Spain. Taller De
Arquitectura-Ricardo Bofill

Housing Project for
Royal Mint
Square, London,
1974.
Leon Krier.

Best Products Building,
by SITE, Houston, Texas.

Figure 15. Buildings by selected twentieth century architects

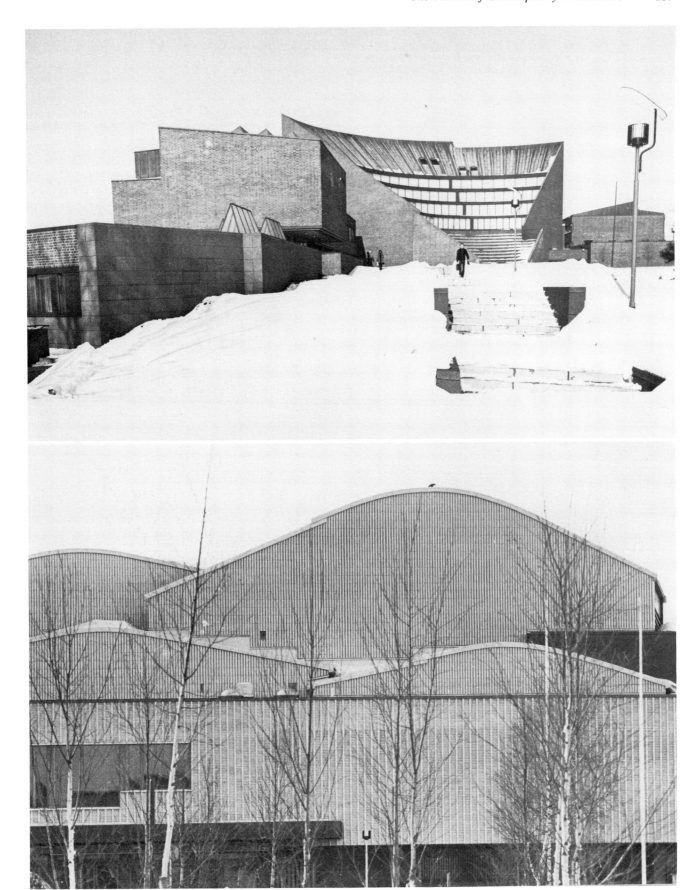

The poetry of Alvar Aalto. Institute of Technology at Otaniemi, Finland, 1961–1964. (top) Detail from the center for concerts and exhibitions at Rovaniemi, 1965. (Photos by Constantine Xanthopoulos.) (bottom)

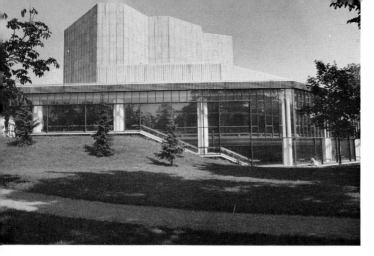

National Theater of Finland in Helsinki. Timo Penttilä, Architect, 1964–1967.

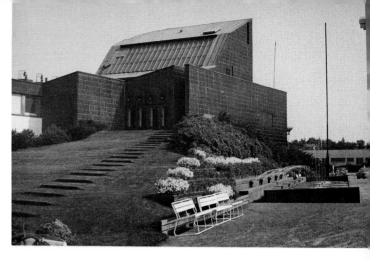

Seinäjoki Town Hall. Alvar Aalto, Architect, 1963–1965.

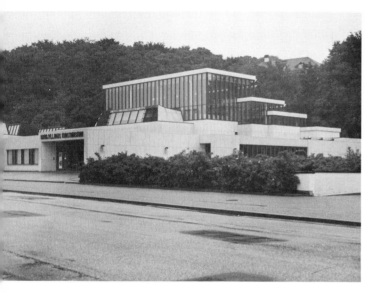

Aalborg Museum of Contemporary Art. Alvar Aalto, Architect. Aalborg, Denmark (designed 1958) built, 1969–1973.

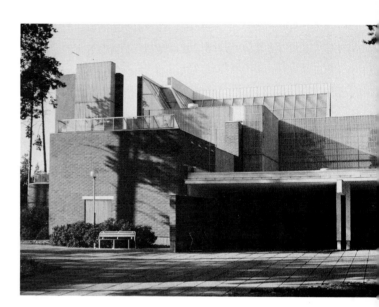

Puolivälinkankaan Church in Oulu, Finland, Juha Leiviskä, Architect, 1971.

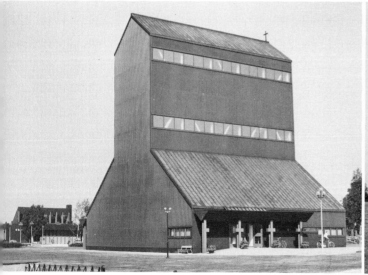

Happaranda Church, Happaranda, Sweden.

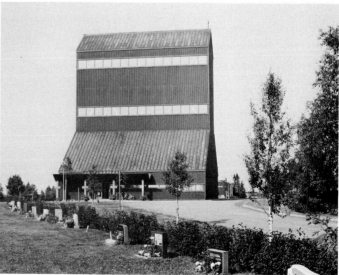

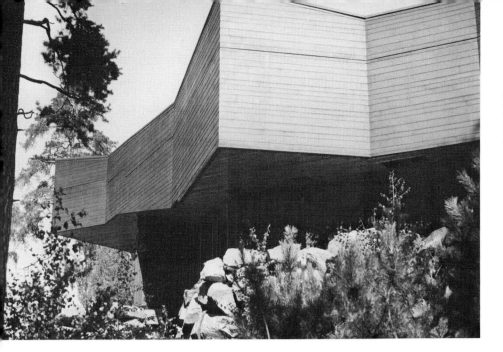

"Dipoli" Student Union Building by
Reima Pietilä, and Raili Paatelainen
in the University of Otaniemi,
Finland, 1964–1966.

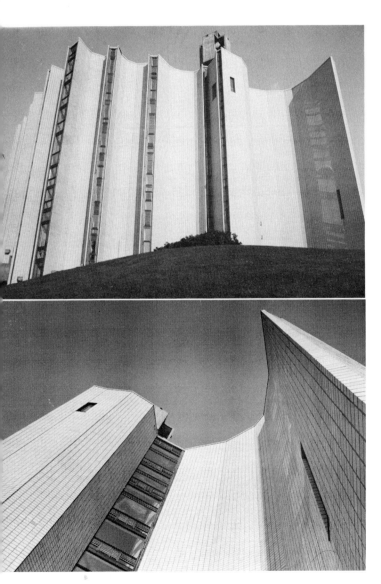

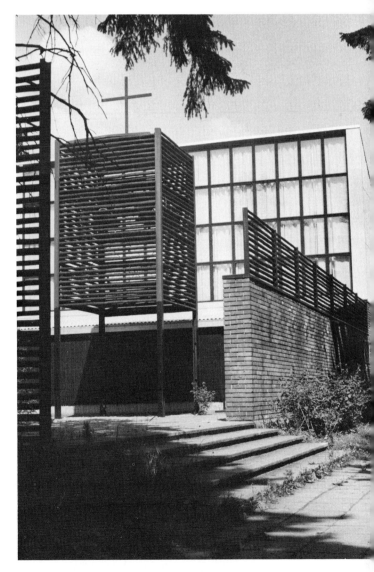

Caleva Church. Economy and constructural ingenuity in
the service of spirituality and architecture. Reima
Pietilä and Raili Paatelainen. Tampere, Finland,
1964–1966.

Chapel in Otaniemi. Otaniemi Technical University.
Kaija & Heikki Siren, Architects, 1956–1957.

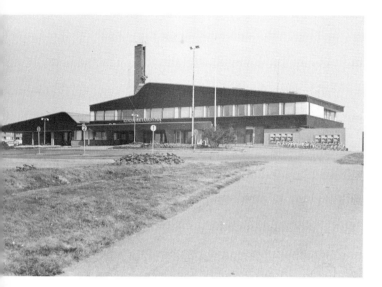

Bus Station in Rovaniemi

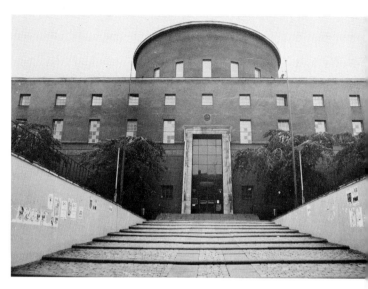

Stockholm Public Library—Gunnar Asplund, Architect, 1920–1928.

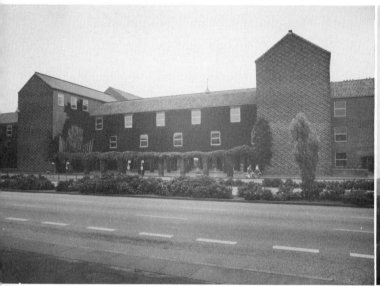

Åhrus University. One of the landmark cases in the Danish-Swedish-Finnish architectural evolution. Kay Fisker, C. F. Möller and Poul Stegmann, Architects.

So most people today, when it comes to architecture, already have a verbal knowledge about it; they have heard about and have learned to prefer one "style" over another, yet they have not learned what these styles imply, why they were created, what they were meant to solve, what materials they utilized, and under what circumstances they were used. So, the greatest enemies of architectural progress are the "style" preferences or the stubborn positions and preconceptions people have about architecture and its "ought to be" form. Some good architects have tried to fight this attitude. Le Corbusier said, "Architecture has

nothing to do with the various 'styles.' Styles are to architecture what a feather is on a woman's head; it is sometimes pretty, though not always, and never is anything more."[63] Unlike Le Corbusier, most other architects did not undertake polemic campaigns against "styles," nor did they undertake campaigns, and rarely did they play the role that modern mathematicians attempt today. Most recent architects have seen themselves more as professionals, less as public educators. Yet it is at this level where the future of architecture lies. The truths about environment, urban planning, and large- and small-scale architecture have to be presented in convincing ways to the

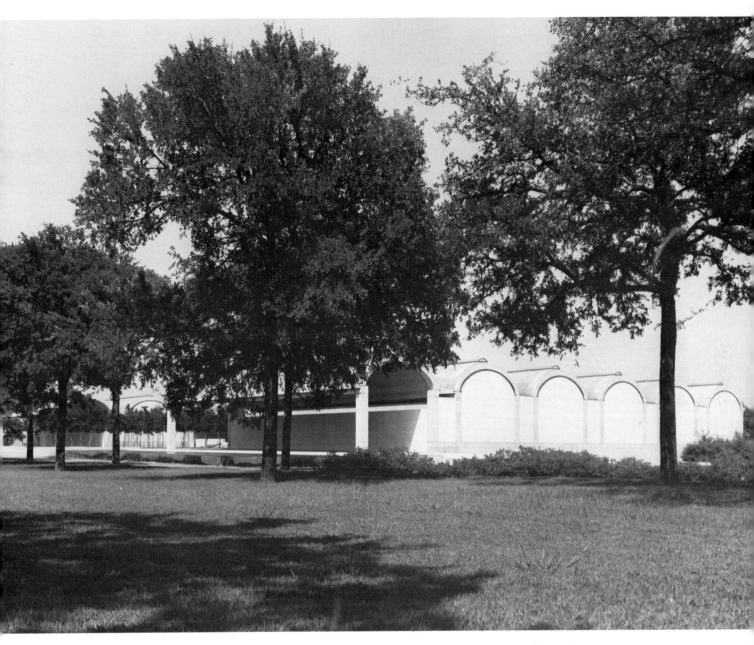

The Kimbell Art Museum at Fort Worth, Texas. Louis Kahn, Architect, 1972. (Photo by Tommy Stewart.)

youth as very early experiences in their lives. Scientific museums have performed this role for science, but they have done very little to expose the public to matters of architecture and aesthetics. The first enemy is in ourselves; the inquiring attitude we had toward the meaning of things might have been suppressed by uninspired educational systems. Many people have committed themselves to work and terminologies without having seen or totally experienced the objects and the significance of the words they used.

A "style" therefore, should never be taken for granted. One should understand it, see if it fits his life style, his budget, the reality he lives in. We must know ourselves first and confess it to our architect; we need to help him (or her) find out more about us. He will find our real style, the style that will fit us and our needs. It will be our own, unique and only, style. . . .

The architecture founded by the fathers of twentieth-century architecture and their followers was called "modern architecture," and their movement was called "the modern movement." It capitalized on simplicity,

The "sensual functionalism" of Ralph Erskine. Stockholm University Library, above. Exterior and interior of same wall in Stockholm University, Student Union building, below. Architecture addressing all the senses in a most comprehensive way, where the formal and the sensual have an undeniable functional justification.

avoidance of ornament, concern for the massing of the building, proportional appeal of the elevations, and often excessive use of glass—especially in the case of Mies van der Rohe. This architecture that influenced the world, had many handicaps; nonetheless, most notably: very little attention was paid to the user, his needs, his preferences, that is, to issues of individual and psychological importance which we will examine in later chapters.

Some students of the evolution of modern architecture became extremely critical in the early and mid 1970s. Brent Brolin, Peter Blake, and Charles Jencks were among the most vocal critics of the modern movement. Charles Jencks in his book, *The Language of Post-Modern Architecture,* suggested clearly that we are now beyond the era of the modern movement and moving toward what he called "Post-Modern." What Jencks argued at first was to

a great extent true. Yet the study of subsequent writings by Jencks and others could point out that Post-Modernism was another movement with less than all-inclusive results. In fact, *post-modernism* as a term came to include advocacies and efforts ranging from historical revival, historic eclecticism, and historicist attitudes to schizophrenic, illogical approaches of collage and architecture of frequently irrelevant elitism. Events such as the architectural exhibition in the Bienale of Venice in 1980 (Strada Novissima), which subsequently moved to Paris, San Francisco, and Tokyo, summarized the various directions of the Post-Modern avant-garde. The writings of some of the gurus of the movement relating to the above exhibition testified to the manipulative nature and commission-hunting motivation of the proponents of Post-Modernism rather than to their concern for genuine solutions to problems. One could say that the main concern

Architectural tour de-forces in American cities. From gigantic crystalline glass sculptures to monumental restatements of historical prototypes. The case of Dallas, Texas. Clockwise, Hotel Regency Hyatt by Welton Becket and Associates, the Dallas City Hall by I. M. Pei, and The Chapel of Thanksgiving Square by Philip Johnson.

Big ideas can produce urban buildings through simplicity of means. Shopping center with sports facilities in Mexico City. Juan Sordo Madaleno, Architect, 1978.

Maximum results through economy of means is the architecture of Ricardo Legorreta. IBM Warehouse, Mexico City, 1978.

of the interventionist activities, the creation of Post-Modern news, and the continual staging of events and exhibitions was exactly what Charles Jencks was pointing at; afterall, "How can you get the top ten architects to get the top ten jobs and be commissioned by the top ten patrons?"[64] It should not be denied however, that in spite of the questionable foundations of the movement, architectural debate sparkled while a series of controversial works were built that would have never been built otherwise. Furthermore, some younger architects who had been educated as modernists and who permitted themselves some post-modern license, created projects of discipline yet with formal, visual, and user appeal. The most important project in the controversial sense were the highly criticized

building in Portland by Michael Graves and the AT & T building in New York by Philip Johnson. Many regional works of minor followers displayed similar design attitudes of historic eclectic reference; they were collage assemblies of forms that developed out of structural and material constraints of the past, they have displayed an applied decorativeness, and they approached the levels of set design.[65] *Eclecticism,* that is, the license to select and borrow from the past (from the Greek verb ΕΚΛΕΓΟ, "to select"), which was the key characteristic of the Ecole des Beaux-Arts, was revived. To copy from the past became acceptable.[65] A published statement by Philip Johnson that he "could *not* not copy" was perhaps the most telling evidence of the state of referential (plagiaristic?) license that architects gave to themselves in the late seventies-early eighties period. Post-modernists of the eclectic neo-neo-classicist, historicist, or even the "schizophrenic technocratic," kind sprang up in America and Europe, and Japan followed with gusto. Among the most prominent Europen post-modernists, representatives of varying inclinations, one could point out Lucien Kroll, Ricardo Bofill, Aldo Rossi, and the Krier Brothers. Americans Robert Venturi, Robert Stern, Michael Graves, Thomas Gordon Smith, Eric Owen Moss, Philip Johnson, the Taft Architects, Frank Gehry, and numerous others would qualify; as would Arata Isozaki and Kazuhiro Ishii in Japan. There are certainly several cases of post modern creativity that could qualify as exceptional under any "label," Post-Modern or otherwise. Charles Moore is probably one of the key figures in this respect; his architecture is highly inventive, pleasant, and humanely and environmentally relevant.

Hotel Camino Real, Mexico City. Ricardo Legorreta, Architect.

The work of "arquitectonica" (composed by Bernardo Fort-Brescia, Hervin Romney and Laurinda Spear) as well as the work of Charles M. Correa in India represent Post-Modern examples of the synthesis that may evolve through combination of the lessons and discipline of modernism, derviational license and inclusion of color as applied earlier by "poetic" architects such as Luis Barragan and Ricardo Legorreta. Several other young architects, both, European and American (especially from California), have combined Post-Modernism with Modernist synthetic discipline to create exceptionally appealing projects.

Post-modernism like any other movement has its positive and negative effects. It is this writer's belief that although post-modernism will not be a lasting influence, it will have a significant impact for at least a generation. This should be especially true in architectural education as there is a rather large number of instructors with post-modern training, especially of the historicist Beaux-Arts nature, currently teaching design in many schools, particularly in America. This is considered by this writer to be an adverse circumstance due to the doctrinaire attitudes and "cult" nature of historicism. A young architect should not try to become "post-modern", or anything else for that matter, through the process of formal imitation; he should rather evolve organically to whatever he is destined to become, looking not only at form but at all the parameters that influence architecture and design. This presupposes discipline, openness to all points of view including post-modernism, attempts to master and personally evaluate all possibilities and expressional directions, devotion to one's vocation, and study in many more fields than earlier architects had to pursue. It was exactly this different course of discipline that was followed by those good architects who succeeded the founders of the modern movement and produced the evolved architecture of our day. It will always be the unfailing course of attitude that will produce evolution. Great architects took the tools of Le Corbusier, Gropius, Mies, etc., learned their doctrines, and often became infatuated with them; but in the process they solved their problems "uniquely," they found themselves.

147

Barrio Gaudí. Low-cost housing in
Reus, Spain. Ricardo Bofill, Taller de
Arquitectura.

Complexity through the use of
extremely simple structural system.
Bario Gaudí, Reus, Spain. Ricardo
Bofill, Taller de Arquitectura.

Low-cost housing. Barrio, Gaudí,
Reus, Spain, 1964–1966.

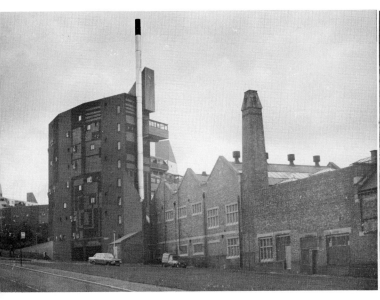
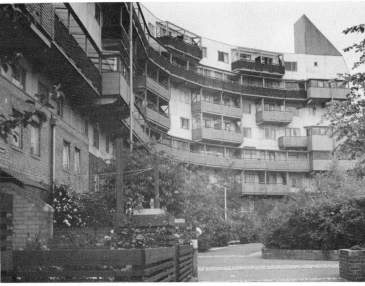

The Byker Wall. A project of comprehensive architecture summarizing multiplicity of considerations such as "recycling," "environmental," "materials," "historic reference," "privacy," "individuality," "play of scales," etc. Ralph Erskine, Architect. Newcastle upon Tyne, England, 1968–present.

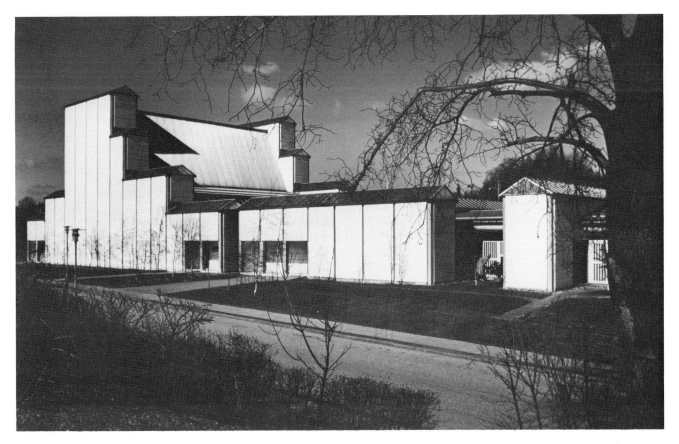

Great works of architecture will always prove the superiority of the basic rules and principles of the all-inclusivist approach to our art over the ephemeral appeal of fashionable visions. Bagsvaerd Church near Copenhagen. Jørn Utzon, Architect. Photo by Martin Price.

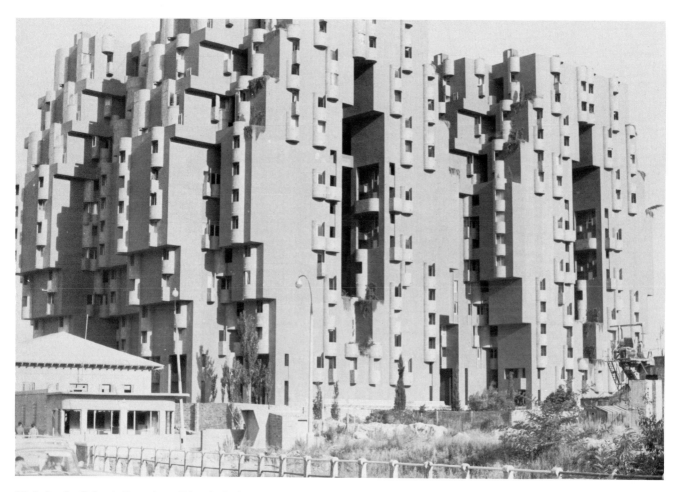

High density living in Barcelona. Ricardo Bofill, 1975.

The men who shaped architecture during and after the passing of the four celebrated great ones, were problem solving individualists of perseverance, hard work, and courage. Many of them came to the attention of the broader public late. Top among them were the late Eero Saarinen and Alvar Aalto. They were concerned for the definition of their problems and the unique response to the circumstances rather than to "style" dictates. Their works fit no style. Their projects are never alike. Their answers are circumstantial acts resolved with religious devotion. One should certainly distinguish the figure of Alvar Aalto, for he alone, unlike most other influential architects of the century who were aggressive public speakers, remained a private person[68] totally devoted in his vocation. His devotion to his art created a great number of buildings of the highest degree of excellence. Aalto's works were works

of Aalto and his very small group of collaborators and apprentices.[69] In that sense, Aalto has proved to modern times that sophisticated and complex architecture can still be done by small practitioners; it can still produce art and retain human scale for buildings and the profession alike.

Some people expect, and it is also the author's belief, that Alvar Aalto will have a more lasting influence on architecture than anyone else. His buildings, most of them for public use, are easily accessible throughout his native Finland. There is almost no major town in Finland that does not have a major Aalto project just a few blocks from its central train station.[70] Students can visit these projects easily, while they'll find it more difficult to visit the projects of other masters such as Le Corbusier and Wright which are in remote locations throughout the world and in the United States.

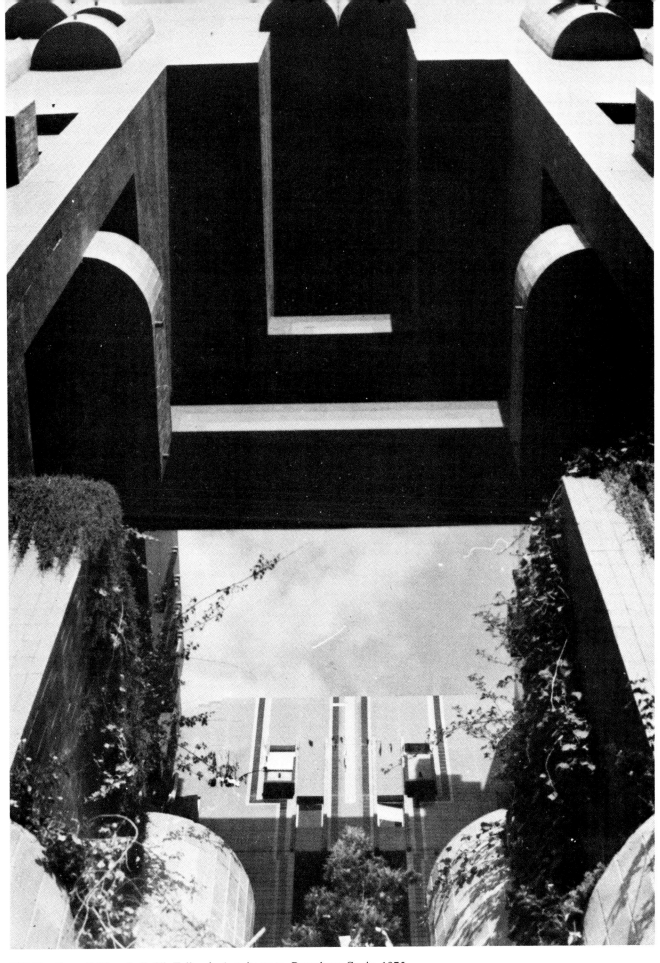

"Walden Seven," Ricardo Bofill, Taller de Arquitectura, Barcelona, Spain, 1975.

Pompidou Center, Paris. Piano and
Rogers, Architects. 1977

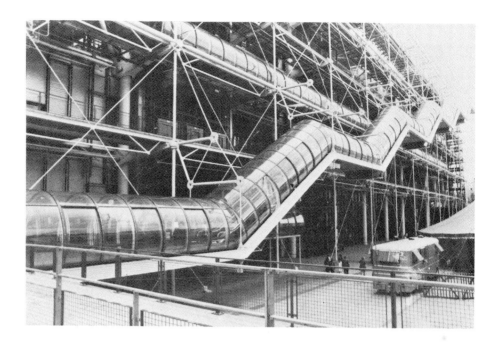

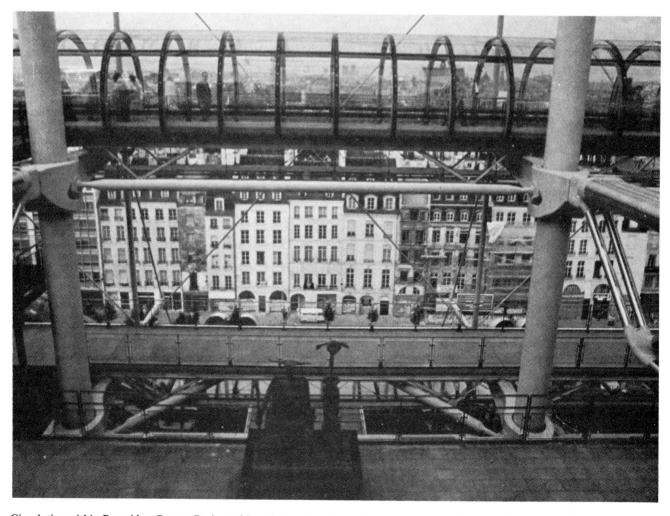

Circulation within Pompidou Center, Paris, and its relationship with existing environment. Piano and Rogers, Architects,
1977.

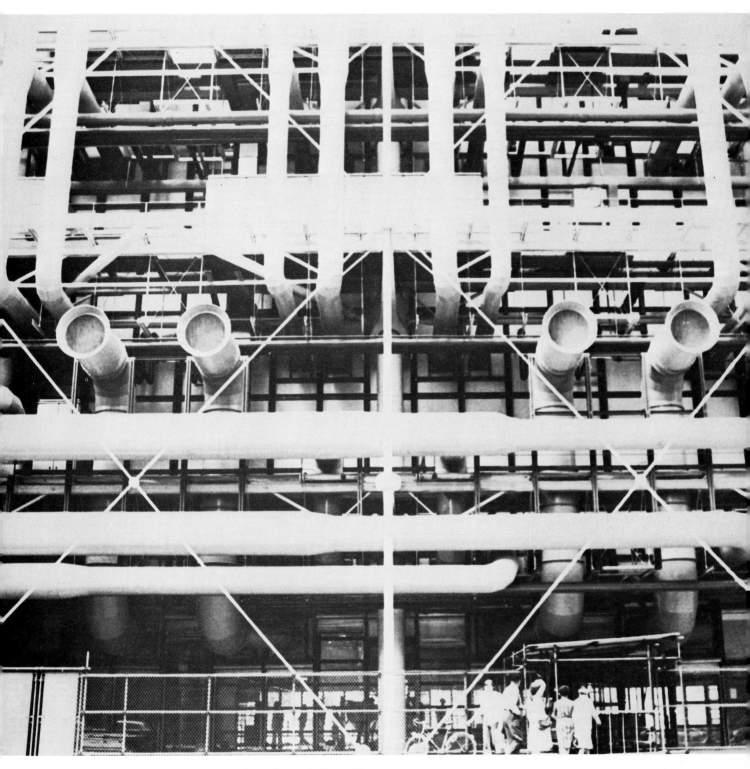

Mechanical diagram-like facade of Pompidou Center in Paris. Piano and Rogers, Architects, 1977.

Mummers Theater, Oklahoma City.
Building form is result of the emphasis
and expression of mechanical systems.
John Johansen, Architect, 1970.

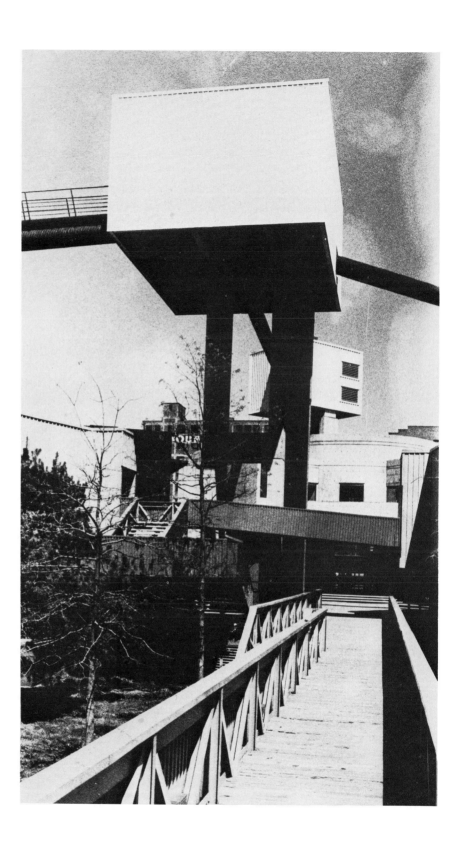

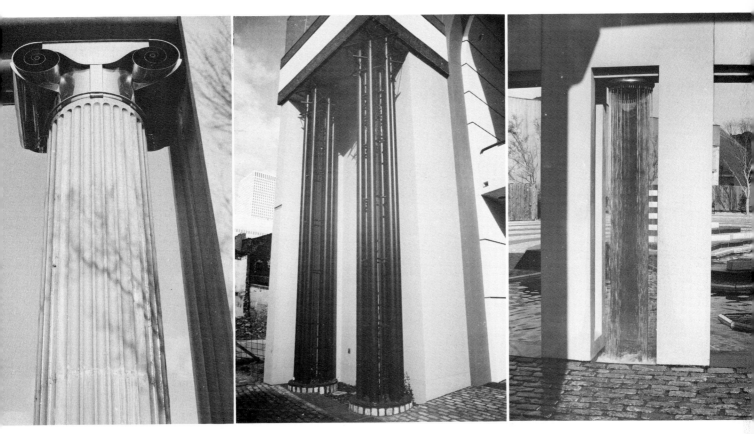

Neo-Neo Ionian, New-Neo-Corinthian, Water/stainless steel original: Columns of Post-Modern ingenuity. Piazza d'Italia, New Orleans. Charles Moore and Perez Associates, Inc., 1980.

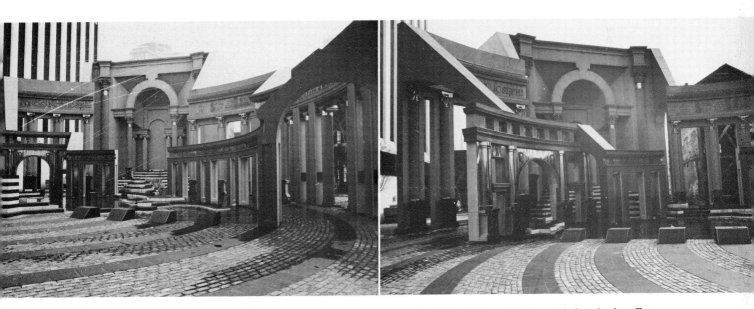

Piazza d'Italia, New Orleans. Juxtaposition of Modern (office building to the left) with historicist Post-Modern in the effort to create an urban place for a specific ethnic group. Project designer Charles Moore, Architect Perez & Associates, New Orleans, 1978.

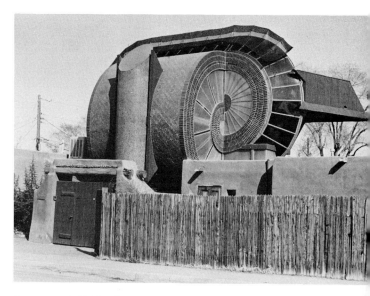

The Spiller House in Venice, California. Frank Gehry, Architect.

Irreverant individuality. Individuals pad on top of Adobe House in Albuquerque, New Mexico, mid-nineteen seventies.

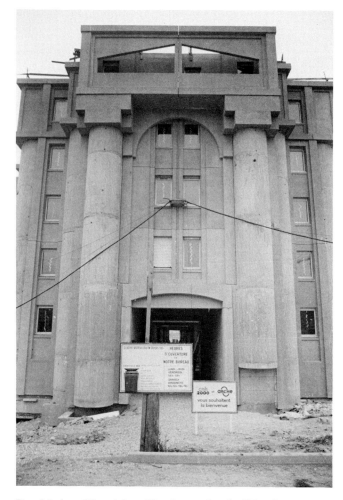

Post-modern license and imagination in encounter with the limits of orthodoxy and the laws of nature. The "Petal House". Eric Owen Moss, Architect. Los Angeles (1982).

Post-Modern Historicism. Housing project by Ricardo Bofill in The French New Town St. Quentin-en-Yveline. Completed in 1982.

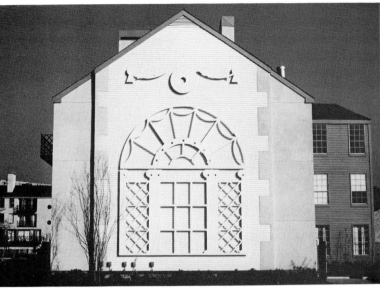

Pop-Historicist. Applied Decoration on side elevation of Regency Condominiums in Houston, Texas. Robert Venturi, Denise Scott Brown, 1982.

Municipal library at San Juan Capistrano. Historicist inventiveness in dialogue with historic context. Michael Graves, Architect, 1983.

Sensitivity in contextual relationships can produce strong results despite stylistic choices. Combination of Post-modern classicism with "high tech" detailing in the new state gallery and chamber theater in Stuttgard, Germany. James Stirling and Michael Wilford, Architects, 1983. (Photo by Guido Porto).

Post-modern Vernacular. Me & Me fast food restaurant, Berkeley, California. Daniel Solomon, Architect, 1979.

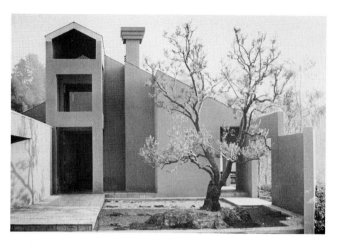

Archetypal, comprehensive architecture. Case of the possibility for successful integration of multiplicity of design parameters, intellectual as well as realistic concerns. Nilsen House, Beverley Hills, California. Eugene Kupper, Architect, 1978.

In Finland one will witness not only the genius of Aalto, but also the greatness of many of his colleagues. Finland is a living "gallery" of the most relevant, comprehensive architecture built today; a gallery that demonstrates the creative possibilities open to man as he solves architectural problems by addressing as many design parameters as possible—environmental structural, material, psychological, symbolic, and form. As a rule these are all addressed by the well-known and the lesser-known architects in this country. Architects such as Aarno Ruusuvuori, Timo Penttilä, Juha Leiviskä, Kristian Gullichsen, Timo and Tuomo Suomalainen, Kaija and Heikki Siren, Reima Pietilä, Kirmo Mikkola, and Cari Virta are some of the many whose outstanding work can stand as evidence to the collective genius of contemporary Finnish architecture.[71] It is an architecture which is not an isolated phenomenon, but the result of a progressive evolution of influences that started in Denmark, influenced Sweden, and then through the figure of Gunnar Asplund, the most important Swedish architect of the century, was transmitted and crystalized in Finland via Alvar Aalto, a friend, admirer, and to a great extent a disciple of Asplund.[72] The story of Scandinavian architecture has not yet been written in its totality. Certain existing studies on individual architects and their works point out that there is still much to be learned about the architecture of this century, the events and movements that have shaped it, its dominant

personalities, and the education and profession of its architects. Although the story of what one could call "the Danish-Swedish-Finnish architectural connection"[73] has not been written, one can certainly find numerous imitators of Scandinavian originals over most of the world who, almost as a rule, have given no footnote, as to the sources of their inspiration.

. . . Aalto, the late Eero Saarinen, John Utzon and Ralph Erskine . . . and there are so many others, all these "unknown" good, circumstantial architects of today.

There are people like this in every country. . . . One could only name here a few who deserve credit well beyond the credit that has been given to some well-known few. Hassan Fathy, Dimitris Pikionis, Aris Constantinides, Takis Zenetos, Ricardo Legorreta, Luis Barragán, Kazuo Shinohara from abroad. Alexander Kouzmanoff, Victor F-Chist Janer, O'Neal Ford, and Fay Jones, in the United States. All these architects are of differing expressive directions, yet they are distinguished by devotion to the basic discipline of their art which produces a "human" architecture.

Then, of course, there are some well-known good architects of our time: Robert Venturi, Charles Moore, and Antoine Predock lead in exploring relevant practice. Romaldo Giurgola, Gunnar Birkerts, and James Stirling all search and perform in quality large-scale work. Philip Johnson, Kenzo Tange, and I.M. Pei, the elders of the time, are men of experience with some undeniable masterpieces in their backgrounds, and they have made undeniable contributions to the architecture of the last two decades.

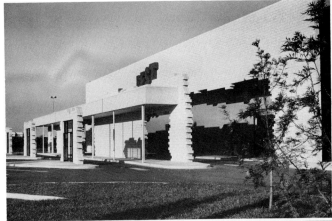

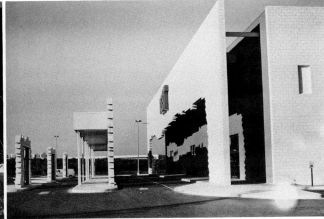

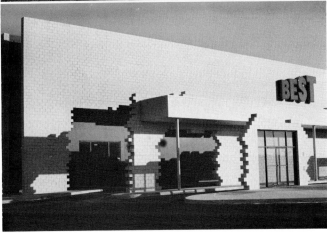

Best Products building in Miami, Florida. Incorporation of humor and attitudes of the oxymoron. Is the broken building the best building for the Best Products? Product promotions and Post-Modernism have co-existed happily in the works of the architects of SITE, Miami, 1978.

John Portman, a controversial figure early in his career, has evolved into one of the most important architectural personalities in the United States. His impact as an architect developer of large downtown revitalization projects has been enormous. His projects are full of life, and the interior spaces of some of his hotels will certainly acquire distinguished place in the history of this century's architecture. Portman was regarded by many in the past with scepticism because of his iconoclastic direction to perform as architect-developer. In the mind of this author, John Portman is perhaps this country's architectural genius of the time. He is doing what the major advocates of Post-Modernism would perhaps be doing if they had the chance to put their hands on large-scale projects such as the ones he has been initiating and creating from scratch.

Closely involved with the processes and techniques of development, that is, developing large-scale projects as packages, are the architects of the Taller de Arquitectura in Barcelona, Spain. Ricardo Bofill is the head and conceptual, architectural brain of this most prolific European group. He has initiated and produced works of undeniable conceptual strength and metaphysical appeal, although he failed consistently in his historicist projects.

Then last, but not least, Louis Kahn: what music in one's ears; the last existentialist, yet more of a classicist, a most formal stylist; most esoteric, yet most unorthodox, and perhaps the most difficult-to-comprehend architect of our age. . . . One must become aware and try to understand the work and the "isms" of all these people.

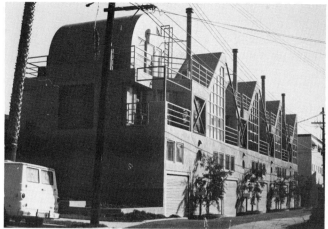

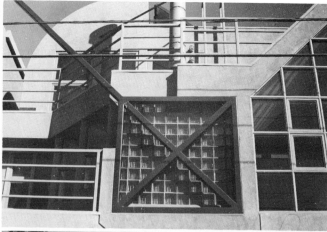

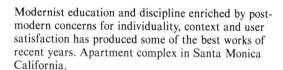

Modernist education and discipline enriched by post-modern concerns for individuality, context and user satisfaction has produced some of the best works of recent years. Apartment complex in Santa Monica California.

The above list of architects is certainly cautiously selective. I do indeed feel that students should be extremely cautious from the sirens of post-modern historicism. Anyone who exclaimed ironically "is that it?" upon entering the patio of Muuratsalo, Summer house of Alvar and Elissa Aalto, does not deserve to be pointed out as a prototype and idol for the young inspite the magnitude of his current fame. One's attitude, sincerity, respect and open mindedness regarding the works of others is also an indication of his attitude toward clients and architecture in general.

. . . So if you were a client, what architect would you select? If you are a student, which "idol" might you follow, what architect would you like to become? . . . Let's let Albert Camus help us find our answer. He would perhaps say this to us: "For me, the highest luxury has always coincided with a certain bareness. I love the bare interiors of houses in Spain and North Africa. The place where I prefer to live and work (and, something more rare, where I would not mind dying) is a hotel bedroom. . . ."[74] . . . Perhaps he has suggested an answer. Perhaps he would say it in more direct terms, "Look at your reality, the reality of your circumstances, and try hard to find the bedroom that suits you . . . for death, or for life. . . ."

A villa north of San Diego. Tom Grondona, Architect. 1979. Photo: Courtesy of Tom Grondona.

Post-modern/modernity: "Basic design" exercises turned into reality. Simplicity and economy of means will produce positive results despite the trends of fashion. Interior court, Spear House, Miami (*left*), and condominiums in Houston (*right*—photo by Todd Hamilton) by "Arquitectonica".

Mix of materials and surface treatment along the lines of set-design techniques characterize many of the early projects of the post-modern Avant-garde. YWCA building in Houston, Texas. Taft Architects, 1981.

The popularization of post-modern imagery. Typical shopping center of "Modern" vocabulary converted "post-modern" through plywood columns and "classical" axiality. Six Flag's shopping mall. Arlington, Texas.

Notes

1. Walter Gropius. Letter to a group of students, 14 January 1964.
2. See "Four Great Makers of Modern Architecture," Columbia University monograph, 1970.
3. Notable introductory reference in this respect is the work of Nikolaus Pevsner, *Pioneers of Modern Design*. The reader may refer to the first chapter in order to follow the theories of art from Morris to Gropius, pp. 19–39. For August Perret, Peter Behrens, Louis Sullivan, refer to general bibliography as well as to Banham *Theory and Design in the First Machine Age;* Giedion, 1967; Jencks, 1973 and 1974; and Sullivan, 1956.
4. Breunig, 1972, p. 18.
5. Some of the architects were deified and accepted with respect by their compatriots and critics while living. Others, like most artists, suffered a lot. Alvar Aalto, Kenzo Tange, Le Corbusier, and Frank Lloyd Wright were appreciated in their lifetimes. For Alvar Aalto and the respectful attitudes of his compatriots toward him, see McQuade, 1976, p. 121.
6. Le Corbusier. "A Talk to Students" in *Four Great Makers of Modern Architecture*.
7. Ibid. Also in Le Corbusier, 1972, p. 9, "Eyes which do not see."
8. Choay, 1960, p. 9.
9. Furneaux, 1972, p. 2. No further specific references will be given in the text pertaining to biographical information or to attitudes and theories of the architects in consideration. The reader is encouraged to refer to the study of the selected Bibliography. Selective references for the arguments that follow will be made only as necessary.
10. Choay, op. cit., p. 9.
11. Antoniades, 1975 (4), pp. 22–29.
12. Le Corbusier, 1972.
13. Antoniades, op. cit.
14. Le Corbusier, op. cit., 1972; also Furneaux, 1972, p. 23.
15. Le Corbusier, 1971.
16. For immediate study of Le Corbusier, refer to the following selected references in Bibliography: Choay, 1960; Furneaux, 1972; Jencks, 1974; Le Corbusier, 1972, etc.
17. George Collins in *Four Great Makers of Modern Architecture*.
18. For biographical information, refer to Scully, 1969; Peter Blake, 1965; and Twombly, 1973.
19. Bush Brown, 1960, p. 27. Also refer to Fitch *American Building*, p. 270; and to DeZurko, 1957, p. 4. De Zurko's work is the most informative on the origins of functionalist theory.
20. Peter Blake, 1965.
21. Frank Lloyd Wright, *The Natural House*, 1954.
22. Peter Blake, 1965.
23. Japan National Tourist Agency. *Japan*. Tokyo, 1975; also Antoniades, 1975 (4), p. 28.
24. The study of Wright's philosophy and architectural principles may start with Wright's general work, *A Testament* Beyond this early reading, the following references are recommended: Blake, 1965; Scully, 1969; Wright, 1970; and Wright, 1954.
25. Wright, 1954, p. 54.
26. Wright, 1970, p. 2.
27. *Japan,* op. cit., and Antoniades, 1975 (4), p. 28.
28. Wright, 1954, p. 220.
29. Blake, 1965.
30. Wright, 1954, p. 208.
31. For the story of Broadacre City, refer to Wright, *The Living City,* as well as to Collins, 1963, pp. 55–75.
32. Major critic of Wright in this respect was the urbanist, Katerina Bauer. For quick evaluation of Broadacre City, refer to Paul and Percival Goodman, 1960, p. 88.
33. Anderton Court Center was one of the late works of Wright. It has never been published or studied at length. An unpublished academic paper of this urban masterpiece was prepared by Antoniades in 1966.
34. Bakema often used the terminology on urban three-dimensionality ("three-dimensionality of the street"), but never gave credit to Wright. Reference to Bakema's lecture to students of architecture at Columbia University, Spring, 1967.
35. Collins. *Four Great Makers of Modern Architecture*.
36. For early arguments on ornament, ornamentation, and the ornament vs. nonornament issues, refer to Pevsner, 1972, pp. 19, 28; to Wright, 1954, pp. 55, 56, 57; to Bush-Brown, 1960, pp. 13, 15, 20, 22, etc.: Scully in *Perspecta V,* (No date) and Brolin, 1976, 1980.
37. Adaptation from Wright, 1954, p. 223.
38. The huge volume of the work of Walter Gropius and his contributions as a designer, architectural educator and critic have been presented by James Marston Fitch in a comprehensive little volume. This work represents, in the author's opinion, the best introduction and the highest tribute to Walter Gropius. For further general introduction, see Fitch, 1960, p. 7. Also refer to Fitch, 1966, "A Utopia Revisited," in *Columbia University Forum*.
39. Gropius, 1943, and Gropius, 1974.
40. Refer to the following general references on the Bauhaus: Bayer, Gropius, and Ise Gropius, *Bauhaus 1919–1928*, Charles T. Branford Company, Boston, 1952; on the courses taught at the Bauhaus and Bauhaus teaching in the United States. Also, Wingler, 1969, *The Bauhaus*. This is the most comprehensive reference and includes original texts by the teachers of the Bauhaus, drawings, and manifestos, as well as a complete bibliography and a list of students.
41. On the story of the Bauhaus, see Wingler, ibid. Also, Bayer, ibid. On the Bauhaus in Weimar, see Eckardt, 1963, p. 230. See also Peter Gay, 1976, pp. 111–172.
42. See Gropius, 1943. Also Pevsner, 1972, p. 38.
43. On team design, see Gropius, 1943. Also Gropius, 1968, p. 53.
44. On the story of the Bauhaus (The Nationalistic Issues).
45. Ibid. See also Gay, op. cit.
46. Ibid.
47. To get an idea of the prevailing situation, refer to Speer, 1970.
48. According to letter of Jan Despo (Yannis Despotopoulos) to the author.
49. Students who acquired subsequent fame were Paul Rudolph, Philip Johnson, I.M. Pei, E. Barnes, etc.
50. Although Le Corbusier visited the United States and designed the Carpenter Center at Harvard University, he remained a secondary influence for the architecture of this country. The Bauhaus was the most important European influence on United States architecture right after the Second World War. Le Corbusier's influence was to come later, during the early and mid seventies.
51. Antoniades, 1979, pp. 36–43.
52. Author's testimonial.
53. See Sharon, 1976.
54. For complete bibliography, refer to Wingler, 1969.

55. Gropius, 1943.
56. Hitchock, Henry-Russell, 1932, p. 60.
57. Antoniades, 1975 (3).
58. Refer to Blaser, 1965; also to general references on Mies van der Rohe.
59. In that respect, one could mention the contrast between Mies and Rudolph Schindler. The latter was apparently notorious for his poor construction details. See the story on the leaking of the La Jolla apartments in Gebhard, 1971.
60. Scully, 1974, p. 34.
61. See Blake, 1977, for example.
62. Hitchcock, 1966. General reference.
63. Pawley, 1970, pp. 9–19.
64. Jencks, 1982, p. 33.
65. For a rather comprehensive analysis of the various directions in California* see Tigerman, 1983, pp. 11–29. For a comprehensive critical polemic concerning the directions and attitudes of Post-Modernism see Aldo-Van-Eyck, 1981, pp. 25–29.
66. Johnson in Smith College Museum of Art, 1981, p. 35.
67. Gebhard, 1971.
68. McQuade, 1976, p. 122. Also refer to Karl Fleig, 1971. For the evolution of Alvar Aalto see Heinonen, 1978, pp. 20–27. See also Aalto, 1978. For an advanced analysis of Aalto see Porphyrios 1982.
69. Ibid., p. 121.
70. See Antoniades, 1981, pp. 88–111.
71. Ibid.
72. On the influence of Asplund on Aalto, see Wrede.
73. Exceptional in this respect is Leonardo Benevolo with referred to Scandinavia in his book "The Modern Movement." See Benevolo, 1967, pp. 607–613. Outstanding protagonists in this respect were architects such as the Danish Möller, Sven Markecius, Peter Celsing, Asplund, Aalto, etc. with the exception of Aalto, and recently Asplund, the others have been largely overshadowed by other architects of the non-Scandinavian pantheon.
74. Camus, 1968. Also Yi-fu-Tuan, 1974; James Marston Fitch, 1960; and Antoniades, 1975 (2).

Selected Readings

Aalto, Alvar. *Sketches*
Columbia University. *Four Great Makers of Modern Architecture*
Cook and Klotz. *Conversation with Architects*
Gropius. *The New Architecture and the Bauhaus*
Le Corbusier. "A Talk to Students" in *Four Great Makers of Modern Architecture*
Wright, Frank Lloyd. *A Testament*

6

Architecture for Man and Society

"The oppressive environment is an environment within which, first and foremost, man oppresses man. The development of the man-made environment is interconnected with man's development as a freedom-seeking being, rather than as a being in search of rationality."

Alexander Tzonis[1]

A fundamental component of the environment is man. The collective entity of man is society. All social issues derive from the state of the social environment. Since architecture becomes part of the environment, it has a social impact, and it should be responsive to human beings, both as individuals and as groups. Architects need to understand the needs, the attitudes, the psychology, and the behavior of both individuals and groups.

Architects, as well as other professionals, are members of society themselves. They have individual characteristics, such as their personal attitudes, cultural background, psychology, etc. The primary responsibility of architects should be to moderate their own personal attitudes and values and attempt to reconcile them with those of the people for whom they work. They must become the people themselves if they want their work to evolve as a result of people's need,[2] to serve and to be meaningful to people. Architects should defend the inherent demands of their discipline, such as the various technical and professional components and standards; but they should utilize them within the framework of the needs of the client or the "people" for whom they design. Society expects from architects the strictly professional services they have been trained to master[3] and should also expect that their work will enhance the social environment and the quality of life in it. Architects should never manipulate social needs for the expression of their own egos. They should suppress their egos and resolve their design problems through the reality of the social context of the occasional environmental circumstances.

In order to play the above role, architects should do the following three things: (1) They should operate within a concept of ethic that includes all aspects of their professional ethic narrowly considered,[4] as well as all the aspects of environmental responsibility. Attempts to justify designs on the basis of certain narrow professional criteria (e.g., the very little time spent in the design process, due to excessive office overhead and limited fee, did not permit complete programming and user input), with the exclusion of social criteria, should be dismissed as unethical.

(2) Architects should acquire knowledge on the needs of their clients; the client who offers them the commission (i.e., a developer-commissioning client) and the client who will use the product of the design. In most cases there may be a conflict between the needs and expectations of the commissioning client and the needs of the user client. The first may want more profit out of a design, while the second will want comfort. Architects should do their best to satisfy both of them, but they should never compromise on the needs of the user client. In this sense, the primary responsibility of architects should focus on the needs and expectations of the user client, since this client is the one who will live in the space.

(3) The third thing architects should do is analyze their problems as deeply as possible in order to define them appropriately, thus avoiding vain solutions that are socially inappropriate and irrelevant to the needs of the specific users.

In order to achieve these desirable ends, architects must train themselves in all the above respects. The specific professional issues, narrowly considered (i.e., architectural practice, insurances, liabilities, architect-client-contractor relationships, etc.), are rather complex for an introductory inquiry and are of no pertinent interest to the general reader who will be the user of architecture, anyhow. The user issues, though, have to be examined here, because it is very important that designers and users have a mutual understanding of the terms and concepts involved if they are to collaborate in the design process.

If architects are to understand the users and their needs, they'll have to be able to take input from them (user input); thus, the collaboration.

The third thing that will be investigated here pertains to the issues of awareness on architectural analysis, such as architectural programming, which both architects and the public should understand as the prerequisite to user, and therefore socially, meaningful design.

Space-Behavior Issues

"The really total saturating environments are invisible. The ones we notice are quite fragmentary and insignificant compared to the ones we don't see."

Marshal McLuhan[5]

"There seems to be some evidence that a new type of man is appearing."

Pierre Bertaux[6]

Author's note: The reader should excuse me for presenting the chapter that follows in the first person and for the references to some personal experiences. This has been done because, I believe, it will convey in the best possible way some very important points regarding the issues presented.

I copied this chapter from my academic diary. The students had just finished one of their biweekly assignments, and I was about to introduce them to a new series of lectures on the social responsibility of the architect. The theory on the subject was complex and diversified. I believed that the methods and objectives of many professional architects on one hand and many environment/behavioral scientists on the other had not always proven themselves in actuality. I was also aware that if I were to take the approach of attacking the traditional practice of

Top left, public beach in San Sebastian, Spain. *Top right,* people in San Sebastian, Spain. *Bottom right,* children in London. (*Bottom left* photo by United Press International.)

architecture and accuse the architects of being irresponsible to human needs and user requirements—much the same as some of the early environmental psychology researchers did—I would not be rendering a service to architecture. I believed this would be unfair, as I was convinced that early modern architecture had played its fair role in the development of twentieth-century civilization.

After all, the great pioneers of twentieth-century architecture were, according to my beliefs, real environmental designers; sometimes they failed, but they were honest and tried hard to alleviate the misery of industrial slums. They tried to offer hygienic shelter; they thought of the welfare of the many, not the limited palatial habitation of the few. Prefabrication and industrialization played their fair roles, while the new materials of the twentieth century (steel, glass, reinforced concrete) premitted straightforward solutions of unprecedented utility and expression. The client of early twentieth-century architects was not the "individual," but an "idea." The clients were the people of the working classes; and their needs were the needs of all those people considered in a collective way.

Human scale exercise by freshman students at the University of Texas at Arlington.

To my students I was a learned teacher. To my younger colleagues, I was an angry architect. I believed I was a relevant environmental critic. I could "buy" the argument for research on human behavior, yet I was not ready to accept the great generalizations of many behavioral scientists. I was also absolutely convinced of the need for architectural programming, but was certain that many things were going wrong. Often there was programming for programming's sake and the public's money was being wasted. I would have to dramatize the situation if there was to be an impact in the minds of my students. And I had to be as open and as explicit as I could. I had to convey that their main responsibility should be respect for the human beings for whom they were to design . . . *respect* in all the possible interpretations of the term. I had started them, though with an easy approach, to "respect"; the exercise they had just completed called for making cut-outs of their own bodies in one-to-one scale. The cut-outs had arrived, some 340 of them. We put them in the large "Jury Room" of the school. In fact, we put some of them in the corridors leading to the Jury Room. Some art instructors got excited by the multicolored paper cut-outs with upraised arms that looked as if Le Corbusier's Modulor had left its Marseille entrance, picked up friends from all over, and come to Arlington.

Someone had called the television station; I knew it, but the students did not. It was too late for an announcement. I had already told the class we were going to meet in the Jury Room instead of the large auditorium where we usually meet. They started coming in and sitting on the floor. A young girl looked around. I looked around at the cut-outs, trying to distinguish her figure. "My grandmother says you are crazy," she told me. I smiled and thanked her for telling me what her grandmother thought about me. Unlike my general practice of never lecturing from notes, that day I read straight from my diary. I've copied for this book exactly what I read to the students that day.

Physical vs. Hidden Dimensions of Architecture

I brought the class here today so that we might remember this occasion in the future.

I want to summarize first the message of this beautiful day, so that those of you who would like to leave may do so at ease.

1. We are here to suggest that what we say today will probably be forgotten by most of you in the years to come.
2. We are here to suggest that in the years to come these cut-outs of the human-scale figures of yourselves will most probably be the most important exercise you had in your study of architecture.

Freshman students attending lecture on the dimensions of architecture. (Photo by "Shorthorn.")

3. We are here to suggest that you will manipulate visible as well as invisible dimensions in the creation of your architecture.

4. We are here to suggest that the visible dimensions you will manipulate in the creation of your architecture are the physical dimensions of the human body, and that if the result of this manipulation is inappropriate, the human body will suffer. The brain, the intellect, the psyche will be distressed; that is, the invisible dimensions will be in jeopardy.

5. We are here to suggest that the silent cut-outs are the best clients you could ever expect to find, as far as the human body's physical dimensions and human proportioning goes.

6. We are here to suggest that the group there (pointing to the cut-outs) is the group from which you have to start, and the group here (pointing to the audience) is where you have to go.

It would be easy to satisfy this group here (pointing to the cut-outs). See, they all stand alright. They occupy so many square feet. They are quiet. And now yourselves? How comfortable do you feel? Where do you sit? On the floor? Are you here? Where is your mind? Can you hear me? Does the person next to you make you feel comfortable, or would you like to move a bit away? Why are the cut-outs comfortable, and you are not? Silly question; you are not comfortable, because *you* are human beings. And

as such, you are different. Look at the beautiful colors you decided to give to your dolls; in a way these colorful dolls are reflections of yourselves. We have chrome, blue, red, black, white, yellow, green; all the colors are here and you selected them. But your dolls stand, and are replicas of yourselves. Of course, only one replica—a stiff one, a position fixed in time. There are infinite other positions, but all positions involve the joints of the body. This is why the dimensions from the ground to the joints are important. The angle may change, but the dimension doesn't change; it changes only in time. As we grow older, everything changes.

The lesson that you are going to forget is related to just these basic dimensions—your height, your knees, your butt, the length of your arms, the reach of your extended arm. You can build your adobe with your own resources as far as you can reach with your extended arm. The adobe that was built by you, using no aids but you, your body's dimensions (and of course strength and energy) has *your scale;* it is yours, done by you, and for your own needs.

But then say that for one reason or another, say because you wanted to build a church for the many, or a kiva for the community, you got a scaffolding and some tools for digging, some extra help from the outside, others of the community to help. You made a building using other

resources, and help from others. You made a bigger building, spending more than your individual strength and energy. The community became involved. And if one of you had control over the decisions, or if the tradition took care of the thinking, then your church or your kiva would have a bench for you to sit, an arrangement responding to the viewing facility of the audience, ceiling height to make the group feel comfortable, that is, it would be a building that would not oppress, but on the contrary make one feel "at home."

Here is a *public building,* done by the many, according to the directions of one (the architect, the first builder), or acccording to the directions of tradition. This last thing, tradition, might have dictated the order of the jobs to be done; it might have required some ceremonials in between, just to relax the working crowd and pay tribute to the gods or superstitions. You made a public building that comforts you. Then this public building, although larger in size than your adobe, has human scale. As with your hand-built adobe house for yourself, so it may happen that the group-built church or kiva may comfort your physical dimensions and delight your mind. Here is human scale. But we spoke of scale before. That was some time ago and from another perspective.

. . . How much chance do we have today to build our own adobe? How comfortable do we feel in the houses we occupy? How relaxed are we inside the public institutions and commercial buildings that our civilization builds today? I doubt if we are often relaxed. Worst of all, how many of us like the houses in which we live? Do a small experiment. How much time do you spend at home? That is, how much time does your apartment or house keep you inside for living, for enjoyment and productive purposes? Many of the problems we have are due to *unrelaxing* surroundings. The problems are not just physical, but they are largely and primarily so. The height of the walls, the sills of the windows, the height of the fence—all are related to privacy, to safety, and to visual pleasure. How is visual pleasure compromised for privacy and, beyond that, for safety?

You will forget even the exact dimensions of your own body. You'll find it difficult to remember. Perhaps your height you will never forget, but what about the distance from ground to knee, from ground to your butt? The most difficult thing for an architect to design is his *own* drafting board, you know!

And now let us move on to something a little bit more complex. Let us assume that you will not forget your physical dimensions, in spite of what I claim to prophesize. Let us assume that you built your own house. Let us assume that you measured all your clients one by one, the parents, the children, each member of the community, and you built tailored houses, and tailored buildings for them. But would that be all? Here now comes the complexity. It is the complexity that is "beyond the physical"

Lab project on students' awareness of their own physical dimensions.

aspects of architecture. The brain, the preferences, the images, the connotations, the "schemata" of each individual user will all be at work either in the use or in the experience of a work of architecture. There are things about which most of us know very little now. How much do we know about "silence." John Cage has told us that, of all the things going on all the time in any environment, the one that was never programmed or intended is silence. Things are very complex, and they become more complicated every day.

Let us take the complexity out; let us leave our intellectual snobbery aside; let us admit our ignorance, and say from now on that for us, the architects, the great unknown to start with will be the *user* of our works. Foremost and primarily, you work for the user and civilization. Your client is the user, not the commissioning client, the developer, the contractor, the financier, or whoever, who first wants monetary profits out of the project you'll design for him. *Your client is the user of the project.* And here will be your dilemma, in fact, the dilemma of modern architecture. Your real client will be less concrete than these silent dummies are. Your client is an unknown client. We build for the unknown user, the unknown man. If you don't, others will; and they know much less than you, and they care less.

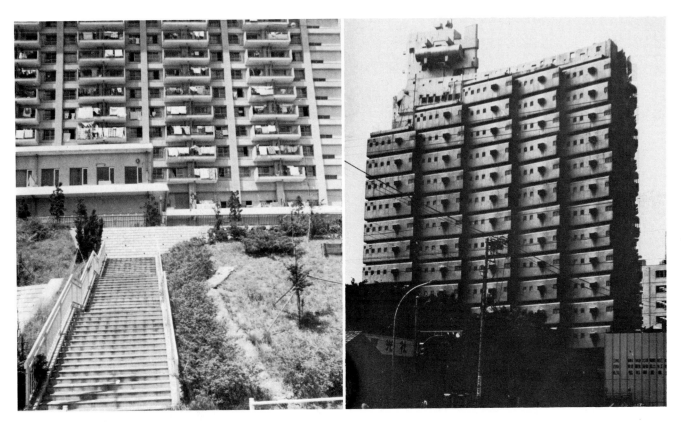

The problem of modern architecture; its dilemma and its anathema; great "architecture" for the "unknown" users; Senri New Town, 1961–1968. "Sky apartment complex"—Japan. Yoji Watanabe, Architect, 1970.

So you are different; you care. You've learned the physical aspects of your vocation, I now assume, and you know the impossibility of coping personally with these unknown users, but you've tried to do something about it. And, this is what the relevant architects of the past tried to do, *just do something about it*. The environmentally relevant architect of today must go a few steps further. He must honor his sincere, analytical, and honest psychoenvironmental colleagues. He must get exposed to their concerns as they must get to know the architect. The environmental psychologist, and the M.D. (who, by the way, is absent today from environmental literature) represent the architect's chances to learn about his unknown clientele in a scientific way. Long-range research, multifaceted research devoid of specialized jargon, will teach the architect the hidden dimensions of human beings. A lot has been written so far, but much of it is rhetoric. Most that has been found hibernates in serious student papers and university research files; we have a lot of them in our own files. Architects today are in many cases at war with environmental psychologists, because many psychologists don't understand the architects, and many architects don't understand the psychologists. The best environmental teachers for the architect, thus far, have been the study of architectural history, empirical study through travel and visits to lived-in environments, and intuitive learning about people and groups of clients through exhaustive talks, socializing, and experiences in ethnology and culture.

So now we know that we have to go through all that. The future architect is responsible for the hidden dimensions as well as the physical dimensions of human needs.

—Acceptance of the need for the study of these hidden dimensions is necessary.
—Personal observation, constant review, scientific research, and study of lived-in architecture are all necessary.
—Ability and discipline to suppress the evil of formal supremacy as taught in the academies, as opposed to the experiential supremacy, is necessary.
—Serious study, work, and perseverance are most important.
—Sociologists: get rid of the jargon and make your research understood by the people. (The architects are some of them.)
—Architects: experience is more important than form. Read on previous cases; travel and see; close your eyes and feel, listen to, and touch your buildings.

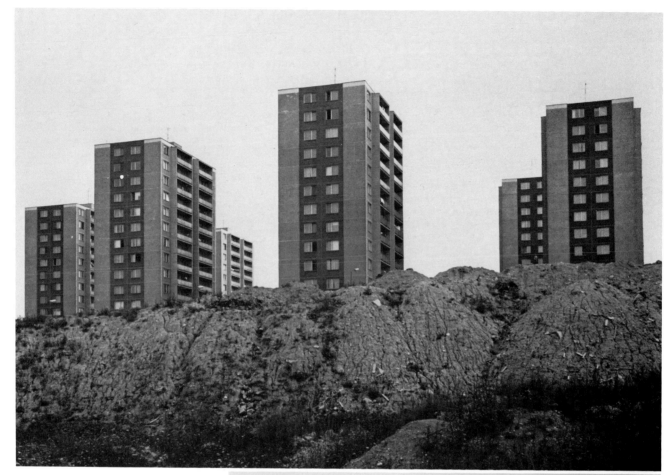

Both free market and controlled
market economies have failed to
produce appealing architecture for the
masses. *Top,* New Town: Kutiky, New
Bratislava, Czechoslovakia; *bottom,*
dormitory at United States University.
(Photos by Craig Kuhner.)

Excess repetition and monotonous rhythm results to
environment of Alienation and appeal of the "deadly".
This is the case of many unsuccessful projects in
Northern Europe and many socialist countries. Housing
by the Kviber Krematorium in Götheborg, Sweden.

—Students: Your task is difficult, and not one-sided. You'll
have to go through the vigorous study of environmental
psychology, even if you are physically and formally in-
clined; you'll have to study the total spectrum of inter-
relationships if you are to understand what it is to build
for human beings—that is, to build for the invisible and
complex intellectual dimensions of the users as well as
for their visible, physical dimensions.

Christian Norberg-Schulz facilitated the problem of
architecture by suggesting the idea that the behavior of
public spaces (where people act with the same "due be-
havior") is a behavior imposed by institutions, like the rules
and regulations of a factory, or the rules of a certain cer-
emonial. I claim that architecture must be returned to the
people. From the World Trade Centers, the Apparel Marts,
the acclaimed museums, and the monumental city halls,
architecture must come to our homes again—and the re-
sponsibility for architecture ought to be given back to con-
cerned architects as is indeed the case in other cultures.

But for that to happen, this lecture that I have claimed
will be forgotten should *not* be forgotten. On the contrary,
I dare boast, it should stay with you forever, and you should
go back to it at any time you begin considering a new pro-
ject or new design commission. I hope it will always re-
mind you that architects are not the only environmental
designers; that man has not only physical dimensions; that
his behavior is affected by the way his environment affects
his physical comfort as well as his psychological comfort.
Your designs, therefore, must make man feel comfortable,
physically and psychologically. Man will feel comfortable
if the environment is tailored to his physical dimensions.
He feels psychologically comfortable if the environment
does not oppress his intellect or his associations with others.
Today we know that certain design standards oppress,

while others stimulate psychological welfare, increase
productivity, and make some activities more pleasant than
ever before.[7] Much of this knowledge of new standards for
design as related to man's psychological and mental wel-
fare we have gained through the research of environ-
mental behavioral scientists.

We know, for instance, that man enjoys privacy.[8] This
is the design quality that gives one: the option to be left
alone if he so desires, invisible and unobstructed by out-
siders, while at the same time he can see outside, enjoy
the view, and survey his surroundings. We know that man,
like many other living species, enjoys the feeling of com-
mand over a territory which he considers his own. "Ter-
ritoriality" has been found to be one of the ingredients of
human happiness or vice versa. We have also learned that
man feels comfortable if he feels his territory is secured[9]
and not violated by others. Designs that encourage the
protection of the users' territories are more successful than
designs where the territories are vulnerable to intruders
or other users. We are also sure that man feels comfort-
able only when his very personal territory, the invisible
space bubble that each individual carries with him, is not
obstructed by other individuals and their respective "bub-
bles." Our personal "bubble" is very important for our
psychological welfare and behavioral euphoria. Designs
must permit us to keep our personal "bubbles" intact.

We know quite a bit already about patterns of distri-
bution in various spaces, under different plans and fur-
niture arrangements. There is already a bulk of research
we can consult so as to decide on optimum plan arrange-
ments. Original research has indicated that some plans
encourage the involvement of people while others do not.
On occasions when involvement is desirable, we should
seek "involver" plans as well as involver arrangements.[10]

You should not forget that we already know more than
many of the architects of the past, and that we should de-
sign for the defense of our private and communal terri-
tories, which will make us feel secure in the best sense of
the word. Extensive research in this area[11] has indicated
that some of the early solutions of the pioneering archi-
tects of the twentieth century did not help defend public
territories, that they stimulated an increase in crime in
public open spaces rather than achieving peaceful sur-
roundings.

Finally, don't forget that "care" alone is not enough.
In order to be able to express your "care" in your designs,
you have to be prepared to go through the rigorous dis-
cipline of analysis, research, and the mastery of the meth-
odologies of programming. Because programming is the
task that helps you seek and define your occasional design
problem, it helps you identify the problem's parameters
and prepares the foundations for your meaningful and en-
vironmentally relevant answers. Through good program-
ming you will respond to the space/people issues in the

best way. Programming should not just be a sophisticated technique of larger practices, it should be a universal process in all design spheres.

The first thing you ought to do when trying to resolve a problem is to determine the type of your problem. This will help you realize your ability to solve it. Problems are of four major types, and each type has its own uniqueness and its own limitations.[12] Avoid trying to solve the problem if it belongs to the category of the *impossible*. Traditional types of buildings of well-known performance and function expectations are *simple problems*. There are many prototypes, many successful such buildings which you can study, visit, experience, learn, and take off from for your own creation. New, innovative, perhaps never-built-before buildings belong to the *complex* and *metaproblem* categories of problems. With these, therefore, be prepared to investigate a lot, stay free, keep your mind open, collaborate with as many environmental colleagues as possible, hypothesize and question your hypotheses, and try to define the difficult problems.

After you determine the type of your problem, try to find its parameters and define them. But don't do this based on your own intuition or your own value judgments alone. That would not take into consideration the users. Programming involves the client and the environmentally relevant architect. The ideal programming team should include the commissioning client, the user client, and the architect. If the user client is not included he must be identified and brought into the programming group by the architect.

There are at least fifty programming methodologies currently identified for the purpose of programming theory. All methodologies have been developed by practicing firms and represent theoretical suggestions that have been tested in practice.

The methodology developed by C.R.S. is a very clear, well argued, and adequately presented approach. It can well serve our introductory purposes. It can be used as the basis for the further challenging and understanding of other methodologies.[13] The C.R.S. *Problem Seeking* methodology involves the following five steps: (1) Goals, (2) Facts, (3) Concepts, (4) Needs, and (5) Problem statement. (Inexperience in the building type requires that an information background be established through research. This is most important in compound, complex, and metaproblem types of problems.) All five steps are considered in the light of the interrelationships to form, function, economy, and time.

Goals are stated by the client, while the architect tries to guide the client to state his goals in terms of form, function, economy, and time.

Facts are collected by the programming team. The team collects, organizes, and analyzes facts.

Concepts are discovered by the programmer and brought to the attention of the client. The programmer provides the analysis to bring out concepts and to stimulate the decision, but it is the client who makes the decision.

Needs are quantitative in terms of space requirements, budget, and quality. The proposed space requirements and the expected level of quality must be tested against the proposed budget at this stage of programming.

Problem statement is the link between problem definition and problem solving, between programming and design. It is stated in qualitative terms in a way that will bring out the essence and uniqueness of the project at hand. According to C.R.S. there should be no less than four such statements, dealing with form, function, economy, and time.

Care for people and good programming will help you relate your design to the fourth and most difficult component of the formula of the environmentally relevant work of architecture—This is the formula of **Form + Function + Economy + Everything Else.** Educated care for people and good programming are the guarantees of the "Everything Else" component.

Some of you might want to specialize in programming techniques and methodologies. Others might prefer specialties in environmental psychology and space/behavior issues. All of you must become good and sensitive. Never forget the "human being" and never sacrifice him for the sake of an "elegant methodology" or an "elegant research" conclusion. Just try to always stay "with man in mind"; this will make you good and sensitive. Good and sensitive programmers and behavior-environmental analysts are fundamental members of environmentally relevant architectural teams. Good and sensitive programming and behavioral input are the fundamental prerequisites to user-responsive architecture.

In order to achieve all this you must look at your profession with a moral eye. It must become your vocation, and you will be its priest. I don't think one could give you a better suggestion on how to go about that than Le Corbusier. One month before he died he summarized the moral philosophy of his life, ". . . act, act in a spirit of modesty, with exactitude, with precision. The only possible atmosphere in which to carry on creative work is one in which these qualities prevail: regularity, modesty, continuity, preseverance. . . ."[14]

. . . Take your cut-out with you. I think it will be a nice, meaningful sculpture for your living room. At least, keep a picture; in the years to come it might remind you of today.

Thank you all! Oct. 13, 1975

Two weeks after that talk the particular young lady once again approached me in the lecture hall and wanted to talk to me. "You know," she said, "I'd like to apologize for the other day. I explained to my grandmother the meaning of the cut-outs. She thinks you are all right." I smiled again and thanked her once more.

The unknown client.

Students attending lecture on the dimensions of architecture. (Photo by Ed Brooks.)

Space-Behavior Theory

The best way to demonstrate a responsible attitude toward human beings and their future environment is by demonstrating an early "active care" and an eagerness for learning about the space/behavioral needs of environment users. This can be encouraged through appropriate early training. The "user" and "behavioral" aspects of environmental design should become early preoccupations of young students and environmentally concerned citizens. "Care" can be expressed through constructive action, even when one is not yet a qualified environmental designer. Behavioral concepts can be presented in lectures, but due to the uniqueness of their concerns for

human beings, interaction, participation, and original observation, they can be best taught through lab discussions, lab exercises, original field research, and real environmental problems.

This method has been tested and it can be recommended as most appropriate for this part of our inquiry. It has been also found that the necessary introductory theory on space/behavior issues that follows is usually understood more easily if its presentation is combined with lab exercises. This approach encourages interaction and reinforces learning through personal experience.

The product of the design professions has recently been challenged by criticisms from representatives of the psychological and environmental behavior sciences.[15] These

criticisms have been fair to a great extent. In some respects, however, they have been totally unfair. Concerns pertaining to the relationship that exists between design product and user input were stated during the last decade in a series of publications, the compendium of which may be labeled as the challenge of the input of environmental and behavioral sciences into the design professions. The majority of this written work was produced by nonarchitectural professionals, yet the subject matter was directly related to criticism of the design practices of the architect.[16] There is only one exception of a notable architectural theoretician sharing similar concerns with the group of environmental-behavioral scientists, and this is the case of the architectural historian and critic, James Marston Fitch.[17] There are also three notable exceptions which suggest concepts for research and constructive design attitudes incorporating the theoreticians' critical probes thus far. Those three studies are *Lived-in Architecture* by Phillippe Boudon,[18] *Defensible Space* by Oscar Newman,[19] and *Environmental Interaction* by David Canter.[20] From the world of architectural practitioners one might point out the published case of C. M. Deasy[21] and the concern of his firm for the applied spheres of behavioral input to design. The firm of C.R.S. in Houston, Texas, represents another notable example of a group involved in the practice and development of theory in "programming."

Except for the noted exceptions, the work of the group in concern has not been influential at large in the general practice of architecture yet; however, it has shaken up the directions of the education of architects today. The group and its theories have generated an intense controversy between architects who were brought up in what might be labeled the "traditional system" of education, and consequently traditional ways of making designs, and architects who want to change the process of education and bring design back to what they believe is an environmentally relevant design process utilizing appropriate user input.[22] According to the environmental psychologist–behavior scientist group, the issue at stake is that all traditional design is wrong and that new directions based on *user behavior* methods should be followed.

It will not help us here to get into an investigation of the various academic arguments. It will be more constructive to isolate the most influential space-behavior theories and concepts and to attempt original research through lab exercises for further grounding of understanding.

Of the most prevalent environmental psychobehaviorist theories, two seem to be the most relevant and influential: the theory of Robert Sommer and the theory of Bechtel. The concepts of both men are easy to comprehend and can be easily tested. One should look at them before any further investigation on the subject.

Sommer's Theory of Territoriality

The most popular of all environmental psychology theories is the theory of *Territoriality* suggested by Robert Sommer. Sommer represents at this moment the hero of the environmental psychology advocacy group and the harshest critic of architects.[23] Sommer has "looked down on" architects, yet has been very influential in making architects bend in his direction and honestly undertake self-evaluation of their works. Architectural educators have taken Sommer seriously; and students, especially those who are exposed in a liberal arts kind of way to architecture, have found his work attractive[24] and his sociological-psychological vocabulary appealing. Together with the concept of territoriality go the concepts of spatial invasion and personal space.

Sommer develops the idea that each person has a varying sphere in which he feels comfortable. The proximity of another may be an intrusion, depending upon distance, illumination, noise level, number of other people in the vicinity, temperature, stress, etc. A summary of Sommer's arguments is as follows: Territoriality is an index of belonging for people. Sommer says, "An alternative form of social organization is territoriality under which individuals know where they belong spatially rather than socially."[25] Territoriality is a compound of the concept of territory and the efforts to define or protect it. "Territory is an area rendered distinctive by its owner in a particular way, and defended by its owner."[26] The major issues pertaining to territory are personalization and defense. Territoriality when accompanied by personalization and defense adds up to a situation of dominance of a territory. Dominance of a territory, that is, territoriality, diminishes aggression.

This is stated as a fact by Sommer, and he further sees in this situation the potential for maintaining social order. "When everyone possesses an individual territory, the reasons for one man to dominate another disappear."[27] Sommer also argues the opposite, that the built-up space may become a protector of our territorial needs. Examples to support that statement may be found in the study of the history of architecture; the monasteries of Mount Athos, the feudal castles of Europe, and the fortified houses of Italy and Greece are typical proofs of the psychologist's argument. In further summary of Sommer's very important and influential theory, we find the following:

1. Space can increase confidence in territorial respects. Solids and voids and our uses interact to establish positive or negative territorial attitudes (positive: when relationship is intimate and secure).
2. In this case, *we* and *space* become one, inseparable. This particular space is ours; it is *us*! We are one; we belong. Space and its design can promote belonging.
3. Spaces can promote indifference, universality; e.g., commercial spaces, railroad stations.

Territoriality. Defending his territory as well as protected by it. (Photo by Wolfgang Stübler.)

Territoriality within a public institution. Different color boxes, made by freshman students and placed in their classroom for the purpose of assignment return by lab instructors.

4. But with different treatment, spaces may promote unity. When a territory is communal, although not ours (no association to property rights), we feel at home in it. Communal public spaces are the great urban spaces; e.g., stadiums, auditoriums, etc.

5. And there are spaces that can make us feel beyond space, make us conquerors; the space is ours in a victorious way (i.e., the form stimulates in us feelings of superiority).

Different spaces, types of spaces, and designs promote different degrees of territoriality. The variety (optimum) of these possibilities is what makes a successful environment; they permit territorial choices. The following examples of spaces and situations promote territorial feelings in urban conditions:

1. Streets; they enhance feelings of territoriality especially to children.
2. Organized personal spaces (e.g., booths in bars and restaurants).
3. Street details and street furniture which permit people to establish personal space (i.e., adequate benches, etc.).
4. Fences, walls, street graphics, and building details that enhance territorial associations.
5. Adequate outdoors which might satisfy peoples' tendency to increase their personal space (for picnics, etc.).
6. Spaces for mass activities and public ceremonies (e.g., from demonstrations to rock festivals).
7. Sidewalks.
8. Any protected building certainly enhances feelings of territoriality although it may alienate nonusers.

Total Environmental Conscience. Area allocated for the necessities of dogs in park in Tampere Finland. The ultimate of concern for territoriality and "Satisfaction" going beyond the care for humans alone.

Protection and territoriality are closely related; yet the incorporation of protective elements may cause positive or negative situations, depending upon the degree of protection (maximum–minimum). An ultimate negative result may be crime.

Lack of appropriate elements that allow territorial choices makes people improvise in their use of space.

Lack of social spaces makes for inferior environments.

Spatial Invasion is the intrusion of personal space. "The best way to learn the location of invisible boundaries is to keep walking until somebody complains. *Personal space refers to an area with invisible boundaries surrounding a person's body into which intruders may not come.*"[28]

Privacy (there is no word for privacy in Greek) is the state in which the physical environment or its details permit one to exercise his desire to be left alone.

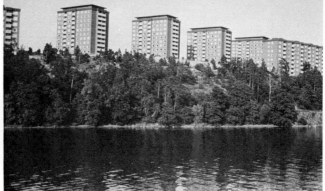

Environment of repetitious rhythm.

Student Housing. Medical School, University of Louvain-Brussells. Lucien Kroll, Architect, 1977.

Iviron Monastery, Mount Athos, Greece.

From the deadly dehumanization of the repetitive high density habitat to the chaotic case of Lucien Kroll's individualization efforts in Brussells. The monasteries of Mount Athos and the Case of Ponte-Vechio suggest that large scale construction can certainly accommodate individual expression while guaranteeing territorial dominance and high density. The Project of Ralph Erskine in Newcastle Upon Tyne represents one of the exceptional successful applications of the above possibility in recent times.

179

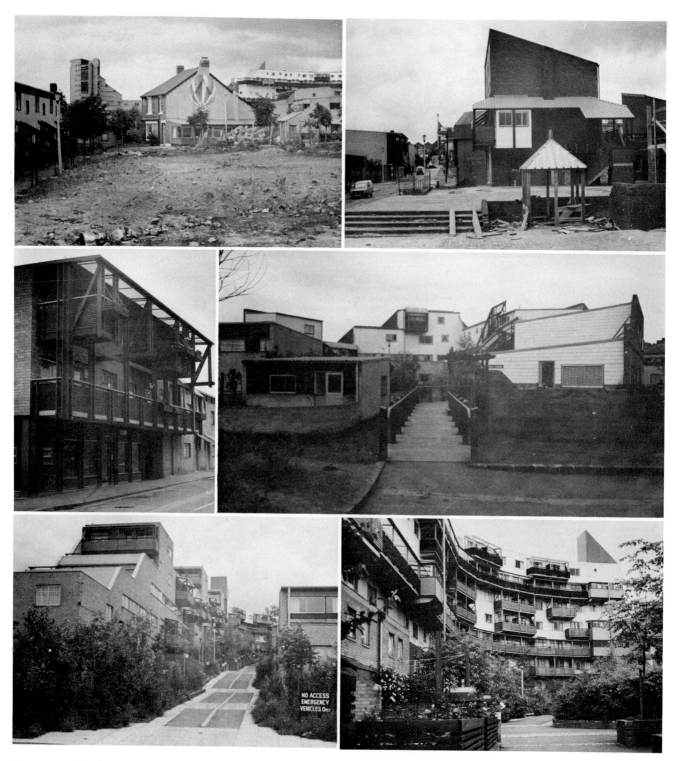

Fragments of environmental sensitivity and inclusivist design from the "Byker Wall" development in Newcastle Upon Tyne, England. On-going design process, with branch office of the architect located in rehabilitated older structure (top left). Ralph Erskine, architect.

Ponte-Vechio, Florence

Personal territories and privacy in low-cost housing in Spain. Barrio Gaudi, Barcelona. Ricardo Bofill, Architect, 1964–1968.

Privacy and territoriality are important. In his early book, *Personal Space,* Sommer introduced the theoretical concepts, often using a polemic language against architects and other designers. He was more positive and constructive in his second study, *Design Awareness.*[29] This work, though, was another statement of his own personal theory; it did very little to generate design applications. It is too general, leaving a lot of questions about how spaces and building types should be evaluated.[30] Sommer's work is fundamental, but it should be remembered that it is still a repetition of concepts and terms taught to architects for generations through courses on the history of architecture and through the study of lived-in, existing situations. This has been especially true in European schools of architecture. U.S. schools have neglected the study of *lived-in* architecture, and thus, one may see the light of Sommer's argument. It is exactly here that the theory of Bechtel assumes primacy and deserves our attention.

Bechtel's Theory—The Empirical Approach

Robert Bechtel is a member of the profession of environmental psychologists. He is the first representative of this field to arrive at conclusions which can help designers to design better, human-responding environments. Bechtel did not deny that the major concern of the designer ought to be the user, and that user needs[31] and input are necessary, but he made clear the realization that because of professional competition, it is usually impossible to exchange information pertaining to user need requirements and their relationships to physical and spatial concepts. So the answer, according to Bechtel, and as endorsed by this writer, lies in the very simple concept of experience. Through *experience* each designer compiles his own file of information, and then he uses it appropriately. Another way of having such relevant information at hand may be by means of banks of environmental-behavior *research.*

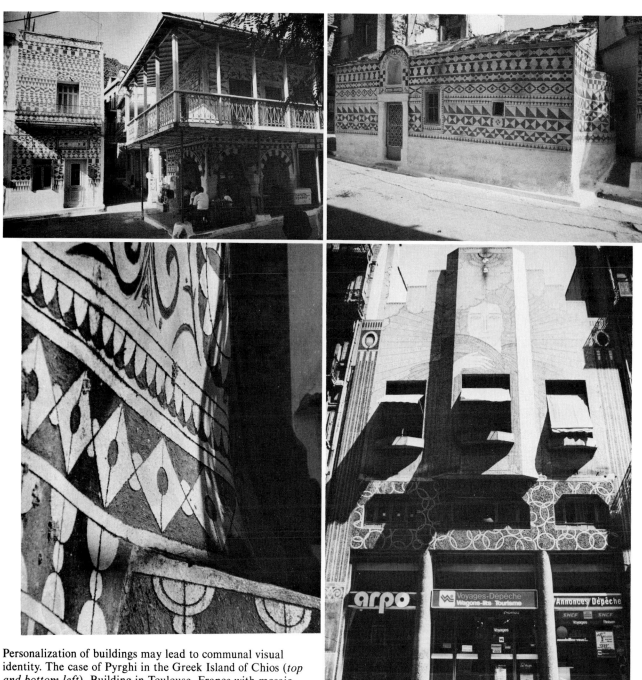

Personalization of buildings may lead to communal visual identity. The case of Pyrghi in the Greek Island of Chios (*top and bottom left*). Building in Toulouse, France with mosaic mural on the facade (*bottom right*).

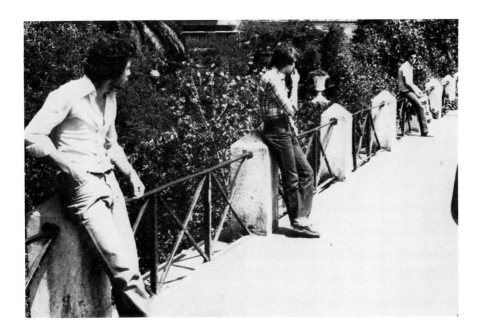

People utilizing environmental details.

Patterns of distribution of people in public spaces indicate people's need to increase their personal space.

These banks may be within universities or appropriate branches of the profession—architectural, planning, and behavioral institutes.[32] This research will provide information on the following basic issues from which the designer wants to gain knowledge for the purposes of practical application:

1. What does the building communicate? What messages should it emphasize?
2. The building has to be analyzed in terms of what kind of behavior it inhibits.
3. The building must be rated in terms of its success. Does it work exactly as expected? If not, where did it fail and why?

In this way, either through keeping one's own file or by using the information provided by data banks, Bechtel suggests a period of "New Medievalism" based on *observation* and *intuitive interpretation* which are needed in the design process. Bechtel believes the scientific approach has failed, and that a more systematic, intuitive approach is now necessary. He suggested data banks for design information purposes. He suggested, however, that "scientific" methodology, which as has already been argued, and as is suggested by Sommer's own statements pertaining to short- vs. long-range research,[33] has the time element working against it—not to mention the element of "inhibition" which prevents the collection of absolutely reliable information.

Design of park benches providing options for seating (group, two persons, one person). Ippolytos Papaeliopoulos, Architect. Zapeion Park, Athens, Greece.

France and England are ahead in these efforts. England in highly qualitative and "scientific," while France in rather "intuitive." The work of Boudon, *Lived-in Architecture,*[34] has given answers to the issues of user-behavior about which Bechtel requires knowledge. This was done through the study of "Pessac," the early industrial workers' housing settlement designed by Le Corbusier. The author believes the study of lived-in architecture is the best way of educating oneself about the relationships that exist between users and environment. Works of acclaimed modern architecture, prototypes in aesthetics terms, should be the ones to be studied first. Bechtel's argument has proved that architects have not failed; it has also proved that architectural education practices well established in the past ought to become fashionable once again, especially since they are the only ones that produced appealing designs in the past.

The environmental psychologists and behavioral scientists' period, 1960–1970 (and of course to today), was not a waste of time.[35] It was a time of architectural challenge and one that introduced the need for user-input, human beings, and behavior issues. Some architects were perhaps offended by what might have appeared to them to be an intrusion to their profession by outsiders. Many architects have spoken of environmental psychologists as pseudo-scientists, while many environmental psychologists have spoken of many architects as pseudo-designers.

The conflict between the scientific and empirical approaches to design will continue. Perhaps it should, as the one could be a challenge to the other, and thus encourage evolution through the dialectic of competition. Bechtel is clearly on the side of the empiricists. This point of view is perhaps best summarized by the "gut" quotation of architect Richard Neutra. He wrote:

". . . I should like to do away with the implication that the designer in his functioning can be wholly governed by scientific attitude or methods, or should aspire to be a scientist himself. He sometimes accomplishes his most important work in fractions of a second, as fast as a human brain can live time. He must continue to rely on intuitive insight, often telescoped . . . into an instant, just as the physician who practices the art of medicine must often act . . . on the spur of the moment in order to answer the emergencies of life. Neither can have the laborious slowness on which the scientist prides himself. Obviously, art, the art of design, which is a part of the art of living, cannot be replaced by science or technology."[36]

The student has a responsibility to investigate both approaches, the scientific and the empirical. There will be times when he'll feel the need for each one. There will be times when one or a combination of the two is necessary. My own point of view is that the environmentally relevant architect of the future must be trained in both the scientific approach and the empirical space-behavior approach. Both investigations will enrich him and prepare him for his future contributions.

7

The Technology of Architecture

"The equilibrium and harmony that reign over technology, the objectivity that one is forced to assume in its presence, the modesty that its unplumbed mysteries demand of us, constitute such an elegant lesson that it cannot but have profound repercussions on all intellectual and moral manifestations and even on the life of society."

Pier Luigi Nervi[1]

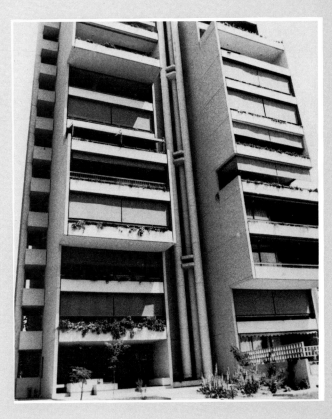

Architecture is a creative art that uses technology for peaceful purposes and the benefit of mankind. In that sense, architecture exploits the advantages of technology in positive ways. Those steps of architecture that use technology distinctively deal with the "structural," "mechanical," "lighting," "acoustics," and "general environmental comfort considerations" of buildings. All materials used in the construction of an architectural work, all the building and mechanical systems, as well as all techniques utilizing technological innovations for the betterment of architecture, belong to the general concern of building technology.

In advanced countries with high technology it is to be expected that building technology will be exceptionally sophisticated. The availability and constant evolution of building materials, mechanical and energy-saving systems, etc., make it extremely difficult for "individual" architects to keep up an in-depth awareness of the innovations involved. Specialization solves the above problem. There are architects who specialize in aspects of building technology and, therefore, occupy respective positions in the "group practice" of architecture, while the general practitioners are aware of the general issues of building technology so as to be able to converse with their specialist colleagues.

Yet "building technology" is a vast field. Architecture would not really exist today if it were not for highly specialized engineers who play the role of advisors to the architect ("individual" or "group") on structural, mechanical, lighting, acoustics, and other technological matters. The architect who is a specialist in building technology is, in fact, another general architect who is more responsibly educated and trained in matters of technology. If he (or she) is available in a group he will be helpful in setting responsible grounds for communication between the architectural team and the actual technologists, the consulting engineers for specific projects. It must become very clear that the studies pertaining to structural, mechanical, and other environmental comfort issues of the design ought to be the tasks of specialized engineers. These engineers are "professionals" fundamentally related to architecture, and they ought to be brought into the process of design at its very early stages in order to discuss the total project with the architect from the beginning. The actual "safety" of a building as well as its actual "costs" are highly dependent on the organic involvement of the design consultant in the design process.

In spite of the above imperative, it is extremely important that architects develop through their education and practical training a high degree of understanding of the tasks of each one of their consultants. This is important if they are to use the consultants' advice for the benefit of the solution and if they are to use occasional "tips" to architectural advantage. Good schools of architecture place strong emphasis on the building technology education of their students. In-depth understanding of the technological principles does not necessarily mean that the architect must be mathematically or engineeringly inclined.[2] On the contrary, good architects have a good intuitive grasp of the mechanical laws of technology and they are appreciated by their technologist colleagues. Building technologists are better known as *engineers*. We'll use the term engineer from now on. The most important engineers with whom architects collaborate are the structural and mechanical engineers. Engineers of secondary collaboration frequency are other, more specialized, experts such as "lighting" and "acoustics" engineers. Because of the significance of the former group of engineers, it is necessary that the reader be introduced to the basic vocabulary involved in structural and mechanical engineering. The sections that follow will deal in the most elementary ways with issues of structural, environmental comfort, building systems, and "energy" vocabularies; while in the suggested readings one will find references for further reading on lighting, acoustics, "systems building," "building materials," and "energy" as related to architecture. In the examination that follows, priority is given to the concept and issues of "structures," because structural considerations are fundamental for the safety and economy, as well as for the healthy existence of a building.

Structures

". . . The old teacher of architecture came in and gave his first sketch problem. He drew an orthogonal wall on the blackboard. He gave its dimensions, length to height; then he drew a human figure next to the wall. He stated the problem in capital letters: 'LOCATE AN APPEALING OPENING ON THE WALL. . . . NO QUESTIONS WILL BE ALLOWED. ALL PARAMETERS OF THE PROBLEM HAVE BEEN GIVEN. YOU HAVE FOUR HOURS TO COMPLETE THE PROBLEM. HANG YOUR PROJECT ON THE EXHIBITION BOARDS AS SOON AS YOU ARE FINISHED.' . . . Most of the students started turning in their projects after the first thirty minutes. Others took their rapidographs and made ink drawings. The whole exercise was finished by the end of the first hour. It was the professor's turn. He didn't say a word. He walked around the classroom, stopped in front of each project, took a quick look, then tore each one to pieces. . . . The audience started to murmur. What was the crazy man doing? All the drawings, the inked ones included, were torn to pieces. . . . The professor went back, lighted his pipe, and said, 'Never make an opening in a wall before you know the material of the wall and before you consider its strength to hold together. Different materials permit different openings, with differing proportions. This was your first lesson on structures.' . . . and he left the room. . . ."

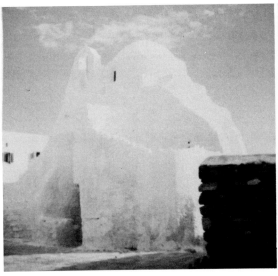
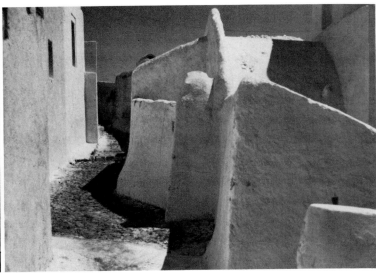

Structures of the "Amoeba" type cannot afford large openings, but they often have very pleasing sculptural presence. Paraportiani Church in Mykonos, and street sequence in Santorini, Greece.

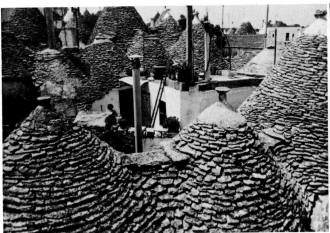
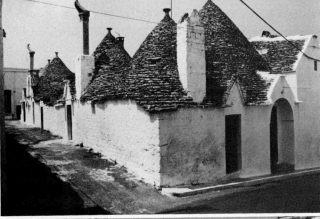
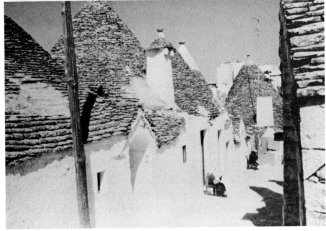

"Amoeba" structures in Alberobello, Italy. Load bearing walls carrying masonry cones, composed out of masonry concentric circles.

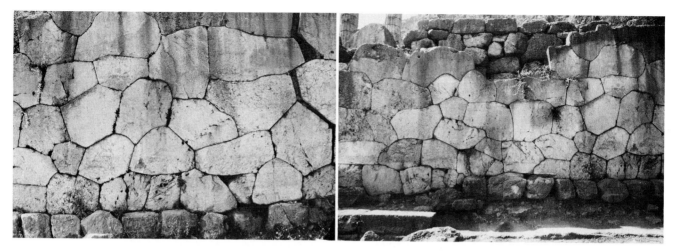

Foundation wall of the Temple of Apollo in Delphi. Meticulous masonry joinery with inscriptions on the surface. The genious of ancient architecture.

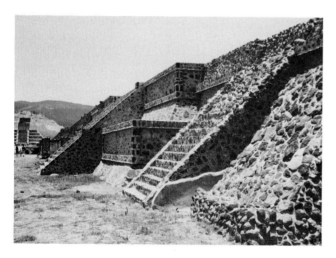

Masonry pyramidal structures along the ceremonial axis of Teotichuacan in Mexico.

Many people use the term *structure* synonymously with *building* or *edifice*. You will hear them refer to a building as "this structure" instead of "this building."[3] Such use of the word *structure* is not always correct; the word has a specific meaning when it is used in architectural context. *"Structure"* is that part of an edifice which does the job of bearing all, live and dead, loads to the ground. Sometimes, though, the whole building envelope is necessary for structural purposes, and in *those* instances *structure* is synonymous with *building*. We have the primitive or Amoeba structures, the Fish-type structures,[4] advanced structures such as the Shells, the Membranes, the Pneumatic, and the Tensile structures. The most common structures are the Fish-principled structures.

Primitive structures[5] are like the **amoeba**. They are modest, self-bearing structures that collapse once an external force takes over; this force can be time or an earthquake. An amoeba splits into two or three divisions without any resistance when it is attacked by external forces. Each particle of an amoeba is necessary for the amoeba's totality; as soon as a particle is removed or destroyed due to some external force, the amoeba splits. In the case of an "amoeba" structure, the building collapses. The terms *structure* and *building* may be used synonymously when discussing amoeba structures; this is justified because all particles of the building are vitally necessary for the support of the building and the carrying of the loads to the ground.

Adobe and masonry structures are primitive, or amoeba-type structures. Each adobe is necessary for the support of the others; each particle of the building is necessary for the support of the building. Now, it does not mean in reality that if we omit certain "adobes" in order to create an opening, a window or an entrance, the building will collapse. In fact, it will not collapse, because we intermarry the structure with materials other than adobes— materials that are stronger than adobes and that can carry the load of the adobes above them, distribute it to the other parts of the structure and, through them, to the ground. The openings, though, must be as narrow and as modest as possible. The reason for the small openings of Greek island and American Indian architecture is structural.

The primitive structures are often called *self-bearing* or *load-bearing* structures. A single masonry wall on the landscape is a self-bearing wall. Layers of masonry walls forming concentric circles of diminishing radii create a masonry cone, perhaps for a grainary or a tipi. Each particle of earth on the interior of a cave is necessary for the

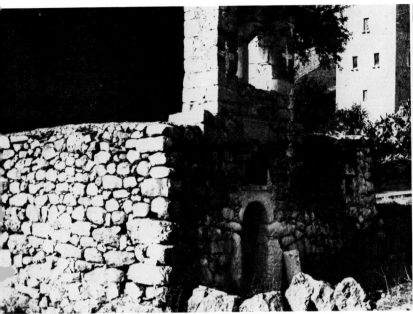

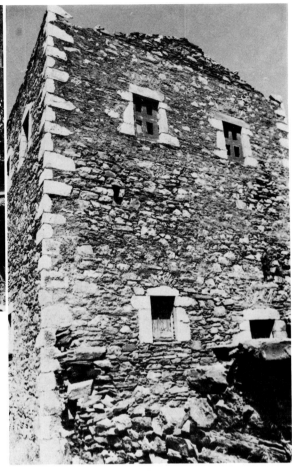

"Amoeba" structures are most pleasing as they are constructed particle by particle (stone by stone, or adobe by adobe) through human resources. Masonry structures, residences and family chapel in Mani, Peloponnese-Greece.

support of the whole cave. Four self-bearing walls put together at 90° in combination with some strong wooden beams supported by two out of the four walls create the most primitive man-made enclosure, the ancient "megaron." The "adobes" of the Indians and the masonry dwellings of the Greek Islands, Italian hill towns, North African towns, and Mexican villages are but restatements of the primitive structure of the "megaron."

Primitive structures are economic structures, as their materials are extracted from the immediate vicinity. They seem as if they grew out of the ground. You can build small, modest environments this way, yet you cannot go larger; you cannot create large openings; you cannot support large functions.

Most advanced and more often used structures are the **fish** type of structures. A fish exists as a combination of flesh and bones. What the fisherman catches is the fish you see, but what make the fish are flesh and bones. The bone skeleton that you see in a fish X-ray is what holds the flesh together and makes the fish. The fish type of structures have "flesh" and a "skeleton" made of "bones."

You take the flesh out and the bones stay; the flesh cannot support the fish, only the bones can. Then you start studying the "bones." You see that there is a central spine, then cantilevered bones left and right. The bones become strong at their junctions with the spine. This is because they have to support themselves at the spine as well as to carry to the strong spine their weight and the weight of the flesh they support. Bones that carry more flesh are even stronger than the others. You can distinguish a heavy bone, a "reinforced member," by the head of the fish. Then you also see a heavy joint, another reinforced member, by the tail. Just like the fish in principle are the advanced linear structures which form most of the moderate-size buildings we build today. There is a "skeleton" inside, which you may or you may not see, depending on the architectural expression of the structure (Some buildings express the structure, others do not.[6]), and there is a "flesh." The "skeleton" or "structure" is what supports the building. "Flesh" are the walls, partitions, skin, all dead and live loads.

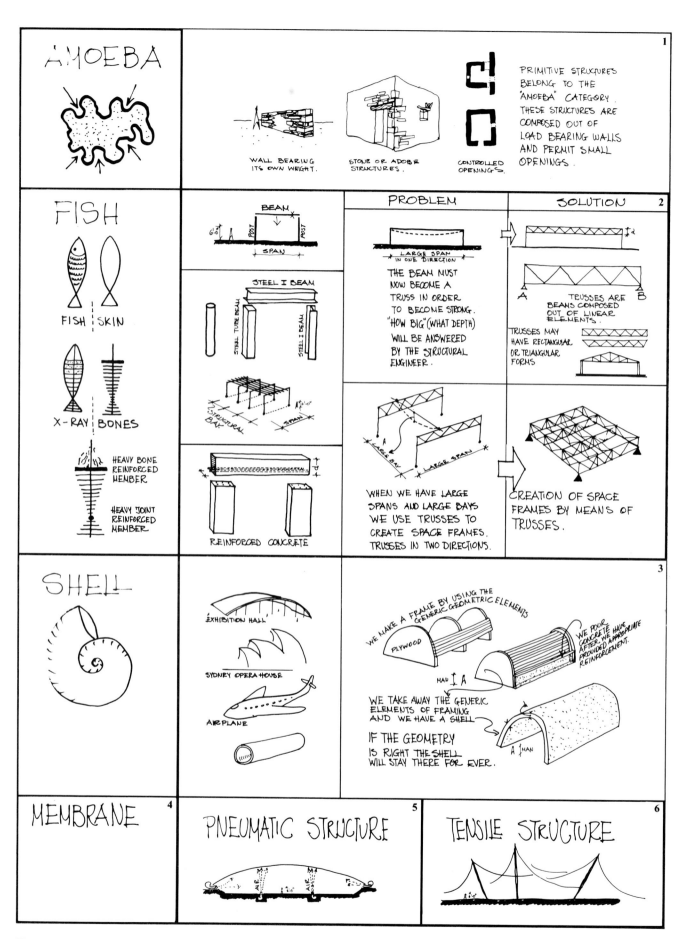

Figure 17. Types of structures

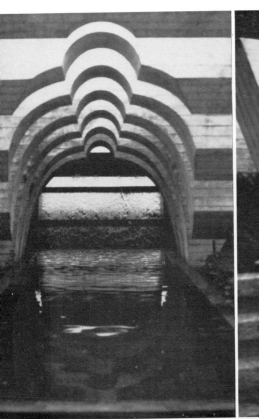

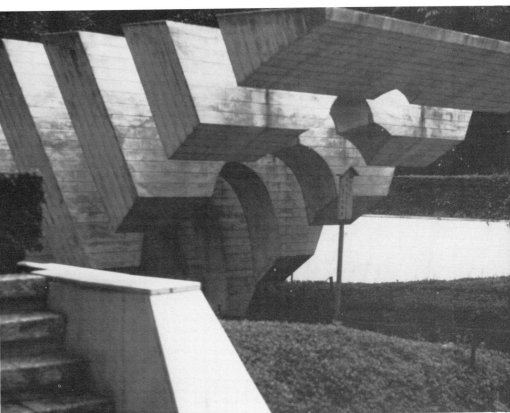

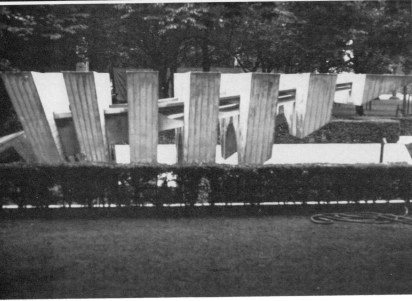

"Flying masses of concrete." Sculpture in Tokyo.

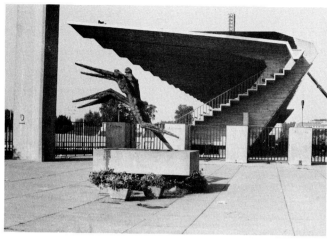
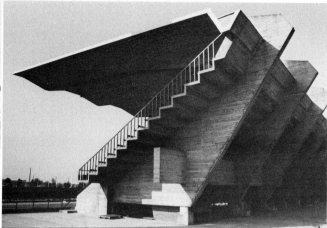

Olympic Stadium in Tampere, Finland. Timo Penttilä, Architect.

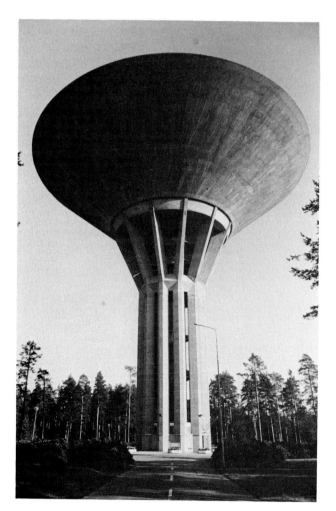

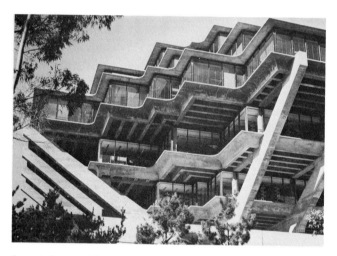

Inverted pyramid structure of Library at the University of Southern California in San Diego. The wrong geometry for an earthquake-prone environment, it requires extraordinary foundation "gymnastics" for its support. Yet the monolithic quality of reinforced concrete makes it possible. William Pereira, Architect.

"Beauty" can be achieved in many ways. Here is the beauty of the expression of pure form as required by structural and material constraints. Water Tower, Oulu, Finland.

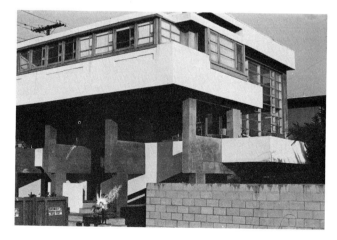

The monolithic quality of reinforced concrete can permit the creation of architecture that has the sculptural quality of "mass" vocabulary. Lowell House, Newport Beach. Rudolph Schindler, Architect.

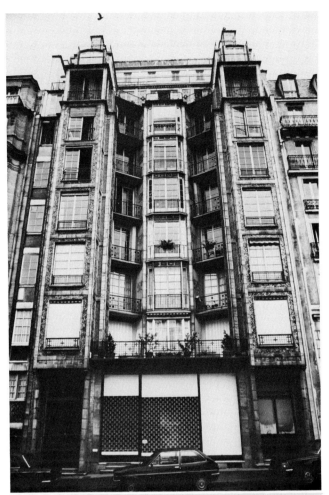

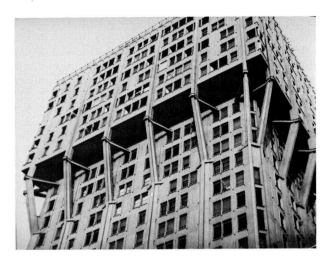

Structural expressionism whereby the illogically heavier upper part of the building is rendered logical through the finger-like expression and the appropriate articulation of the columns. High rise building, "Torre Velasca," in Milan, Italy. Studio B.B.P.R., 1957.

The most common skeletons of buildings are composed out of one-dimensional elements; the vertical ones called "posts," and the horizontal ones called "beams." **Post and beam**[7] structures, often called *post and lintel,* belong to the "fish" category, and they are the structures that have been most used by mankind.[8]

The most critical element of any structure is its capacity to cover spaces. Therefore, the span of a post and beam situation is fundamental. By repeating posts and beams following the rules of a certain structural "game," you can create a three-dimensional skeleton. The distance between each post and beam in the plan is called a *bay.* The distance between the two posts of a post and beam situation is called a *span.* The selection of span and the decision of the bay are the most critical decisions from the safety, economic, and functional points of view. These decisions must be made very early in close collaboration between architect and structural engineer. Selection of appropriate structural materials will permit appropriate spans and bays. Design attempts to integrate the structural bays with the functional requirements will result in functionally-structurally coordinated plans, which are economical and create clear interiors devoid of the handicaps of intruding columns (posts) and disturbing beams.

Posts and beams can be achieved by means of various materials such as steel, reinforced concrete, and wood. Most commonly used today are steel and reinforced concrete. Yet each material has different load-resisting properties. In this respect the "depth" of the beam is most critical. When spans become large, the depth of the beams must become very great. It is possible to create strong beams that are able to accommodate large spans with less weight than solid beams through the use of "trusses."[9] A

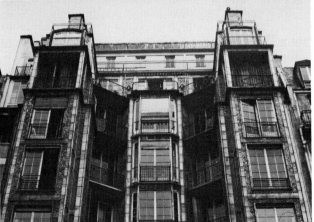

Early and eventually commonest application of reinforced concrete. Expression of the "skeleton" through post and beam poured in place process. Apartment house in Paris. August Perret, Architect, 1903.

Wooden truss expressed in the elevation of commercial exhibition building in Albuquerque, New Mexico.

Generic element of Kenzo Tange's space frame for the Japanese pavilion at Expo '70, Osaka, Japan.

Sainsbury Gallery, Norwich England. Foster Associates, 1978.

Open spiral column, Osaka, Japan, 1970.

truss is a beam composed of linear elements. Trusses may have rectangular or triangular forms. They can help us to accommodate large spans in one direction. With the use of trusses we can cover large spaces.

When we have functional requirements for large spans in two directions, we make use of **space frames**[10] A space frame is generated by trusses running in two directions.[11] It is a two-directional truss system. A space frame has total structural coherence within itself. It can be lifted with a crane and supported on four columns (posts), thus sheltering a much larger space than a simple truss or a simple post and beam could. Large assembly halls, exhibition halls, and industrial buildings, are achieved by means of space frames.[12] The depth of a space frame is often such that functional activities may find their place there.[13]

Space frames operate best when the area they cover is square, but they can cover areas that are proportioned up to a ratio of 2 to 1, never more than that.

A space frame is, in a sense, a **rigid plate,** a "plate" whose particles hold it so tightly together that you could lift it up and it would not break. A small piece of plywood is a rigid plate, although if it is large enough it bends as you lift it up. The same may happen with a sheet of paper. But if you fold the paper it becomes rigid. In this case you have a folded plate. Space frames, plates, folded plates, and shells, are two-dimensional structures with advanced structural properties.[14] We have seen already that a space frame, that is, a two-dimensional structure, can be lifted up and supported by four posts, thus creating a three-dimensional enclosure.

Of the two-dimensional structures, **shells** are the most important, as they have the capacity to cover extremely large spaces using extremely thin and light materials.

Shells exist because of their geometry. Their form is the absolute factor of their existence. Shells are made of plates or sheets, or out of plastic materials such as reinforced concrete poured appropriately into appropriately built forms having the appropriate geometric shape. Shells are carrying surfaces that are stiff and curved, sometimes in one direction (cylinder, cone), sometimes in two directions in the same sense (sphere, ellipsoid), and sometimes in two directions in an opposing sense (anti-clastic or saddle-shaped hyperboloids).[15]

The sizes of shells can vary, but the proportions and geometry of each shell must always remain the same.

Shells can cover large spaces. The design of shells requires extremely sophisticated calculations, yet the conception of shells can be well disciplined by any person who is strongly inclined to geometrical conceptions. An architect who has used shells successfully is the Mexican, Felix Candela.[16] An engineer who has designed extremely appealing shells and created sublime enclosures is the Italian, Pier Luigi Nervi.[17] A shell structure and a building whose basic structure is a shell are synonymous. In shells the structural system and the building envelope form a single unit. The same is true with membrane structures.

Membranes are *unstiff,* flat or curved carrying surfaces. The ability of membranes to resist in two directions is negligible.[18] For all practical purposes, membranes should be considered as structures resisting basically in one direction. As such, they cannot be substituted for shells. Ship sails are membranes. The efficiency of membranes pertains only to the *value* of their *weight* and *volume* which affect the cost of buildings.

Architecture where form and structure overlap. The Lycabettus Theater in Athens, Takis Zenetos, Architect. Athens, Greece, 1965. (Photo courtesy of Takis Zenetos.)

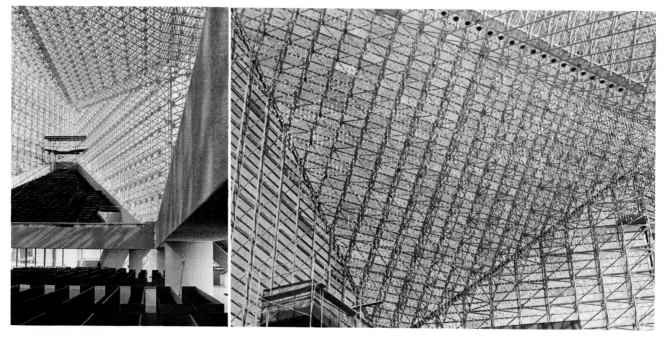

Constellation of stars through the possibilities offered by contemporary building technology and appropriate structural design. Crystal Cathedral at Los Angeles. Philip Johnson and John Burgee Architects, 1979.

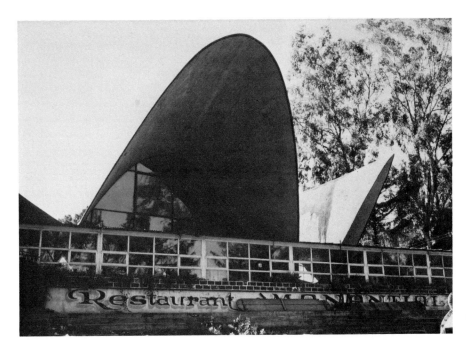

Shell. A restaurant by Félix Candela in Xochimilco, Mexico, 1958.

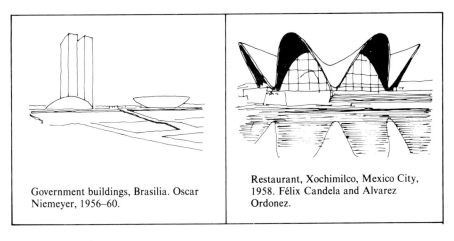

Government buildings, Brasilia. Oscar Niemeyer, 1956–60.

Restaurant, Xochimilco, Mexico City, 1958. Félix Candela and Alvarez Ordonez.

Many shells were constructed in the decade 1950–60. Central and South America produced significant achievements in this respect.

Most structures used by man carry their loads to the ground, and thus work with the law of gravity. Membranes are often used for the creation of **pneumatic structures**[19] (also known as inflatables), which work, in a sense, on principles opposite to the law of gravity. Streams of air constantly pumped from the ground up are able to inflate thin, light membranes, keeping them in place, and thus creating balloon-type enclosures. Pneumatic structures are very light, and can cover extremely large spaces and accommodate solutions for temporary installations, exhibitions, and other types of buildings which do not have permanent functional requirements. Shells, membranes, and pneumatic structures cannot support multistory functions.

The last category of basic structures includes the tensile ones. **Tensile structures**[20] have been with man for years. The first tent man built was a tensile structure. Driving a post into the ground and then attaching cables from the top of the post to the ground demonstrates the principle of the basic tensile structure.[21] If other cables or threads are woven around the initial cables, an enclosure is created, a tensile enclosure. A suspended bridge is a tensile structure that has secondary cables suspending from the initially tended cables. The suspended cables hold the bridge deck. Tensile structures can cover extremely large spaces. They can bear their own weight and very minimal additional loads, such as a load of workers, a suspended deck, or a roof skin. Tensile structures are extremely vulnerable to wind; which has a tendency to get underneath, inflate them, and in instances of bad design, "unroot" and destroy them. The wind direction is the most important environmental consideration in the design of tensile structures.[22] There have been certain outstanding applications of tensile structures, especially in stadium designs. The Yoyogi Stadium in Tokyo, the early masterpiece of Kenzo Tange, is a tensile structure. The Olympic Stadium at

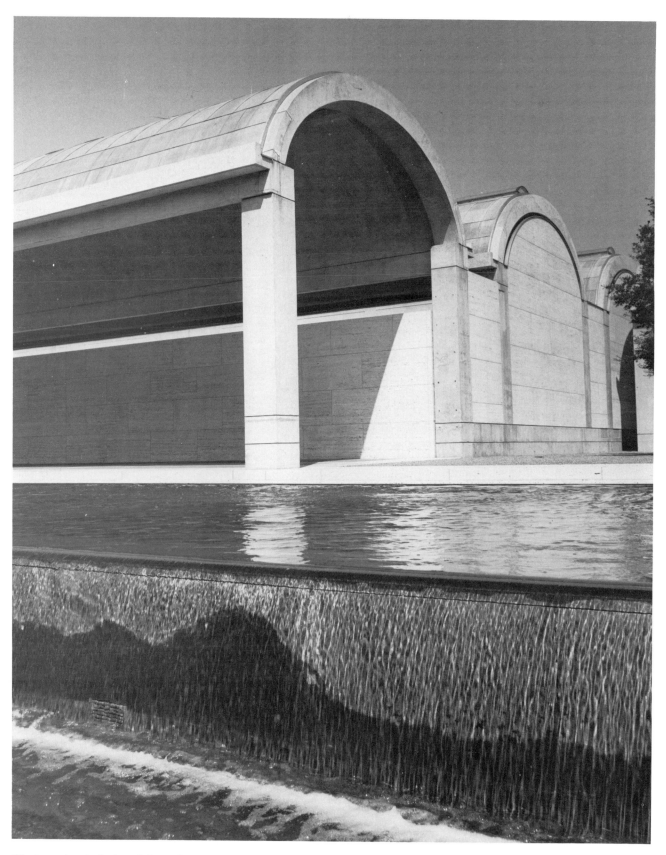

Clarity and articulation of the various structural elements as achieved by means of different textures and expression of the joints. The Kimbell Art Museum, Fort Worth, Texas. Louis Kahn, Architect, 1972. (Photo by Tommy Stewart.)

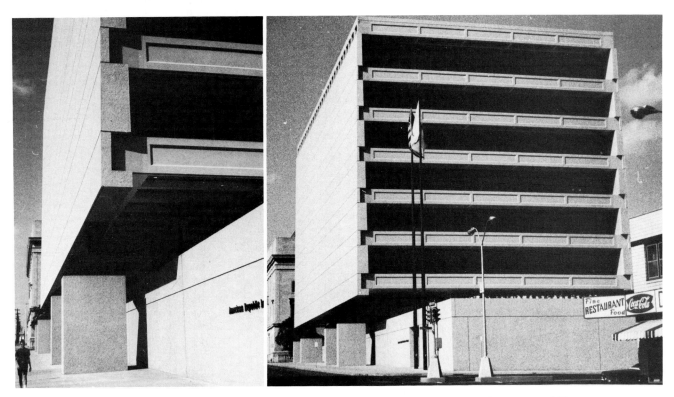

Sincere articulation and expression of structural elements. Office building by S.O.M. in Des Moines, Iowa, 1965.

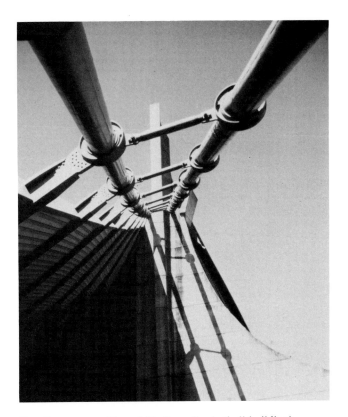

Tensile structure. Yoyogi Stadium (basketball building), Tokyo, Japan. Kenzo Tange, Architect. Design by Kenzo Tange and URTEC, 1964.

Munich is another outstanding example. It was designed and calculated by Frei Otto, who is at present the predominant advocate and foremost world expert on tensile structures.

Selecting Appropriate Structural Systems

As has been mentioned, most critical in the design process is the early selection of the structural system. This is done in collaboration with the structural engineer who is working on the problem. Architects must possess strong knowledge of the issues involved in order to be able to evaluate the engineer's suggestions and be as creative and helpful as possible. Good engineers listen to good architects and vice-versa. Only through well-conceived collaboration will the best product evolve. In considering the selection of a structural system, architects and engineers cover issues pertaining to safety, costs, efficiency, energy consumption, stresses, and general appropriateness.[23] Discussion of the above issues is necessary for their further clarification.

In deciding what structural system to use one must consider the **safety** factors provided. Savings in materials and in a structural system with fewer safety hazards does not necessarily mean that we are talking about a better structural system. Prior to making structural decisions on the grounds of safety, we must consider the following components: labor, knowledge in dealing with particular structural systems, available materials, space characteristics.

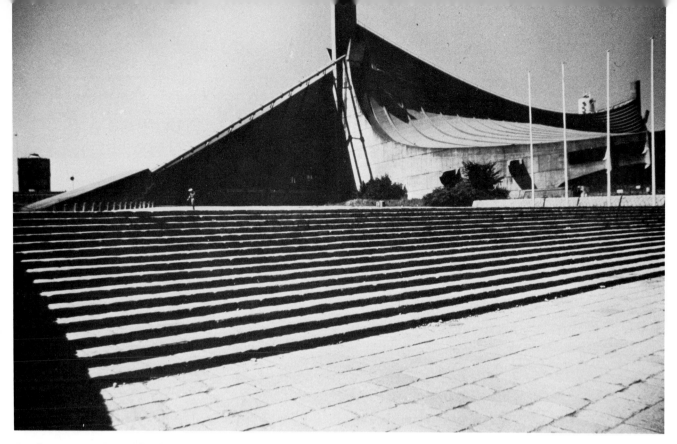

Tensile structure, Yoyogi Stadium (indoor pool building), Tokyo, Japan. Kenzo Tange, Architect. Design by Kenzo Tange and URTEC, 1964.

Costs present the most decisive factor in the selection of a structural system. New and more innovative structural systems are more expensive than traditional systems.

Efficiency is a very important consideration in judging which structural systems and materials to use. The efficiency of a structural system pertains to the *value* of its *weight* and *volume*.

Total **energy consumption** for the solution of a specific building task is the best measuring stick for a relative comparison. Here, all structural systems can be compared, and it makes no difference if they are substances or substance-less effects. Not only are the prices of all building materials dependent upon the energy expended in their preparation, and not only should such factors as man-hours and erection time be included in the energy consideration, but the materials themselves, on the basis of modern knowledge of physics, can be thought of as forms of energy and thus evaluated.

A structure identical in function to another but which requires a smaller expense of energy has, in the long run, a better chance of being the more economical.

In addition, there are some strictly structural considerations that deal specifically with the predominant type of suffering (stresses under load) a certain structure must withstand. Some structures are better than others in resisting the stresses they experience under the application of various forces, and therefore, they might be more appropriate for a certain use than others. Decisions on the **stress and load resistance appropriateness** of a structure are based on a good understanding of the issues of basic stresses and load application. Engineers are absolutely aware of the various stresses and forces involved; in fact, they calculate their values and assign the detailed design of the various structural members to resist these stresses and forces. Though architects might never have to do any calculations of stresses in practice, and many believe they shouldn't, they must have a good knowledge of the vocabulary and concepts involved. The section that follows attempts to build an understanding of the three basic stresses. Following that is a discussion of the peculiar issue of seismic forces (lateral forces) which deserves special attention.

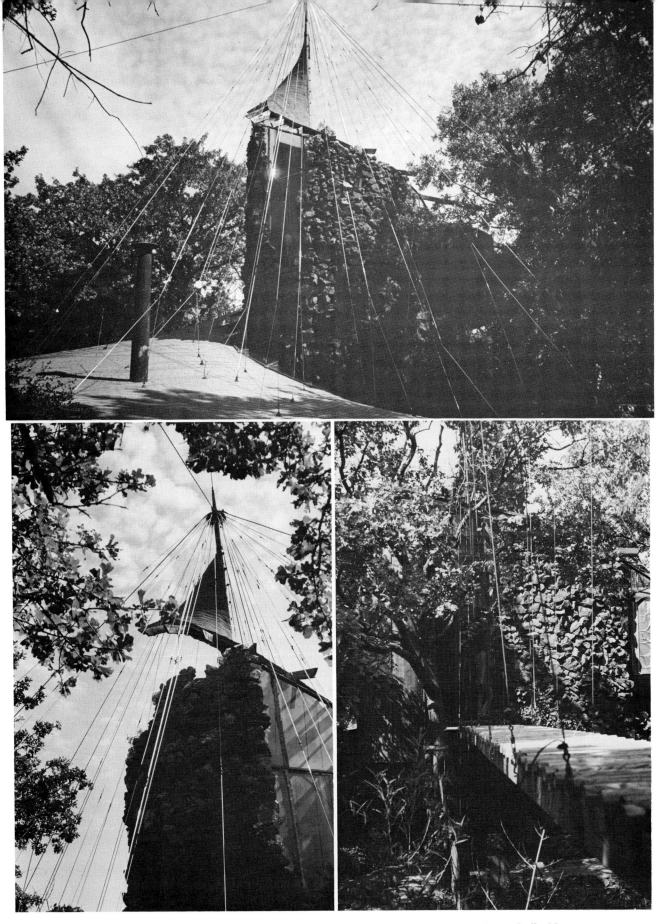

Suspended house with suspended bridge operating on the principles of tension. Bavinger House. Bruce Goff—Norman, Oklahoma, 1949.

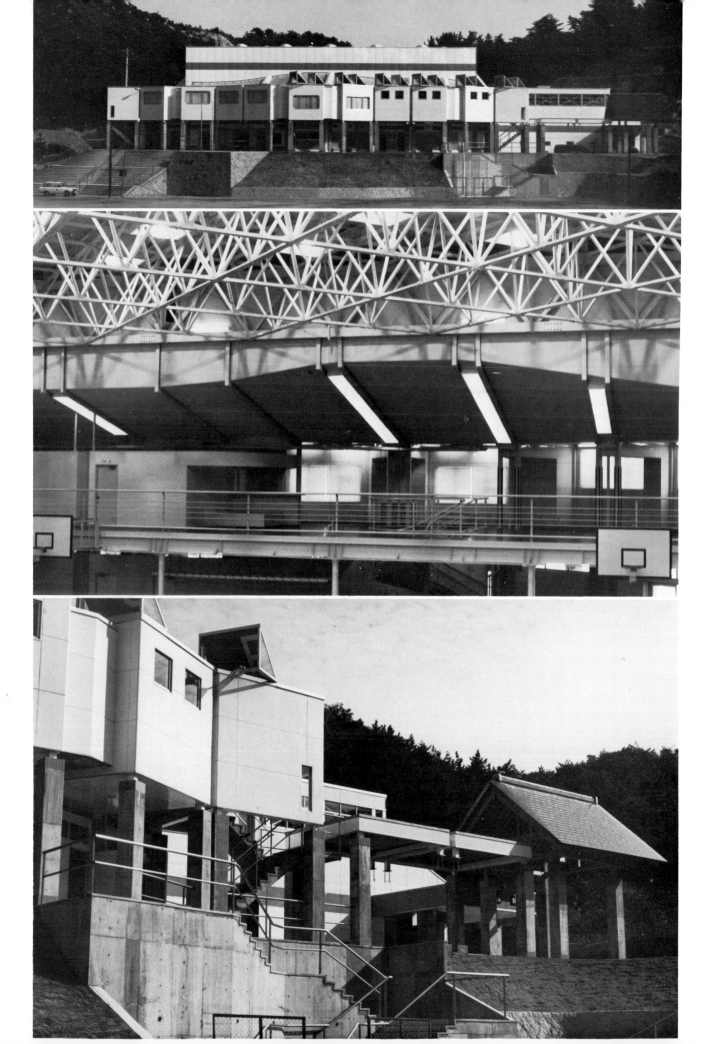

←—Combination of more than one structural system is necessary for the efficient and economic realization of multifunctional buildings with diverse spatial requirements. Separation of the various areas according to use and structural system creates successful buildings possessing integral structural quality. The post and beam for the curved colonade and space frame for the basketball courts in Kazuhiro Ishii's Naoshima Gym. A case where the masterful structural manipulation can even give license to the designer to even incorporate "structural wit." Notice for instance, the "missing column" in bottom picture, 1979. (Photos by Kazuhiro Ishii.) 1979.

Stresses

Any material is composed of particles of matter. Each material has a certain "nature" as well as certain "properties." Due to the nature and properties of the material, the particles that compose it—those millions and trillions of particles—stay positioned adjacent to each other at certain distances that are characteristic for that particular material. There are certain "inherent forces" that keep the particles in place. Under natural conditions the particles stay at ease, undisturbed. They retain their natural distance, holding together "tenderly" or "tightly"; "tenderly" if the material is porous, "tightly" if the material is "solid." In this natural state the material suffers no stress.

If we somehow get inside of the material and we put our hands in there and start pushing the two particles in concern toward each other, that is, if we start "compressing" them toward each other, the particles are going to resist our compressing push—because they will want to come back to their initial position, the one in which they felt "at ease." The particles, therefore, push back on our hands as strongly as we push them. They suffer by our hands, and our hands that applied the horizontal compressing force to them suffer from the resistance of the particles in return. Stresses of similar nature suffered by particles are called *compressive stresses,* and the general state of affairs is called *compression.*

The opposite may also happen. If we try to pull apart the particles of the material, that is, if we "tend" these particles away from each other, we put them under the stress of *tension.* Tension is the resistance of the particles to separate. Exactly what happens with the two particles we isolate happens with all the particles of any material. Now, compression and tension are two situations of "stress" under the application of horizontal forces.

There is also the possibility of a vertical force. If we put our hands above the two particles and try to push them vertically in opposing directions, we tend to displace the one particle from the other in the same way as if we were cutting them with a pair of shears. This type of stress the particles suffer is called, indeed, *shear.*

Elements of every structure suffer basically from these three primary stresses: tension, compression, and shear. But as we said, different materials have different "natures" and different properties. Some materials are stronger in tension than others, while others are stronger in compression, and others in shear. The structural elements resist the stresses through their materials, as well as through their basic configuration, such as the depth of their section.

If structural members demonstrate weaknesses in tension, compression, or shear, we either substitute them with materials that have stronger capacities in resisting those forces, or we reinforce the weak parts of their suffering section with materials that are strong in resisting the damaging forces. This is exactly what happens in the case of a reinforced concrete beam. If the beam were to be of concrete alone, it would break and collapse under certain forces. As illustrated in drawing #9, the particles on the top surface of the beam come close to each other suffering from compression. This happens because under load, the top length of the beam becomes shorter. But cement performs well in compression. The bottom surface, however, becomes elongated (look, simple geometry), which means the particles are forced apart from each other. The bottom particles are experiencing tension. If the removal of the particles exceeds a certain limit, the bottom part of the beam will break. As you can also see in the drawing, the length of the beam that runs along the middle axis (called the neutral axis) stays the same as the initial length of the beam prior to its loading. The crack of the beam starts exactly below this axis.

In order to take care of the crack, and in order to avoid the collapsing of the beams, we reinforce the bottom part of the beam with steel, a material strong in tension. The marriage of concrete and steel (reinforcing bars), gives us reinforced concrete. Concrete and steel are calculated by structural engineers to act collaboratively.

Structural systems must resist compression, tension, shear, and bending. *Bending* is a state in which a structural member "bends" under stress.

Linear compression members, compression-loaded surfaces, and compression-loaded spatial systems should be made out of compression-resistant materials.

Tension-resistant materials, such as linear cables, can be used for tension-suffering membranes and cable nets, as well as for tension-loaded space frames.

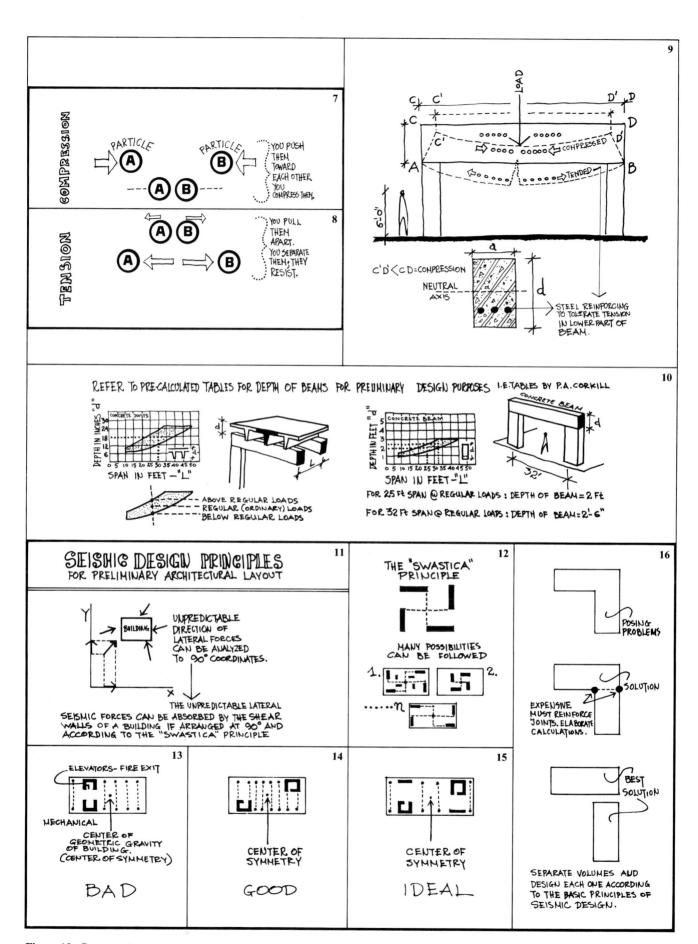

Figure 18. Structural concepts

Primitive "amoeba" structures should be avoided in environments vulnerable to earthquakes. Village of Oia, Island of Santorini, Greece.

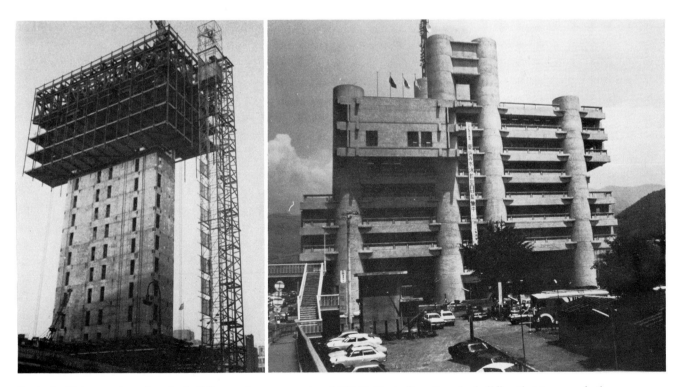

Typical, efficient anti-earthquake building, under construction, 1969 (*left*). Anti-earthquake building that transcends the strictly diagrammatic anti-earthquake design requirements; by elaborating on them it becomes a work of art (*right*). Yamanachi Press and Broadcasting Center, Kofu, Japan. Kenzo Tange, Architect, 1966.

Bending-resistant materials are good for beams, plates, and rigid frames.

Structural systems have limitations. It is not possible to span as much as one pleases. Compression-stressed systems have lower span limits than tension systems. The limiting spans of tension-stressed systems are today about five to ten times greater than those of compression systems.

Architects need to have an idea about the spans they can achieve with the various structural systems. In addition to the advice they must get from their structural consultants, they ought to be able to formulate their own opinions for preliminary design purposes. The task of structural system selection and selection of span for basic loads, in the case of noncomplicated projects, is rather easy; it is accomplished through the use of tables that are available. These tables have been prepared by structural engineers covering series of calculations, span and load assumptions. Tables such as those prepared by Philip Corkill and included in the book, *Architectural Structures* by Henry Cowan, are very helpful to the student.

Seismic Design

Most important for the safety of buildings is seismic design, also known as "lateral forces design." It is a design to counteract the effects of earthquakes. "Seismic" comes from the Greek word *seismos* which means earthquake. The use of a Greek word for antiearthquake design is very appropriate, as Greece is a country that has suffered great damage from earth tremors. Other areas that frequently suffer from earthquake impact are Japan, the west coast of South America, and the west coast of North America, notably the state of California. Many other countries have occasionally suffered from earthquakes, sometimes with catastrophic results, collapse of buildings, and the loss of thousands of human lives. Earthquake disasters that have hit the earth during the twentieth century have taken place in Skopia, Yugoslavia, in Agadir, North Africa,[25] and in Guatemala; the last earthquake in Guatemala claimed the lives of more than twenty thousand people and completely demolished a number of villages. Prestigious buildings in Guatemala City which had been built on the basis of antiearthquake design did not suffer any structural damages, however.

Earthquake damage can be avoided through: land use planning[26] that prohibits the erection of buildings in regions with high earthquake possibilities;[27] construction of artificial bodies of water that "trigger" earthquake occurrence;[28] enforcement of building codes that require that building structures take into consideration the seismic impact;[29] and through appropriate architectural design, especially in the arrangement of the plan of the building.[30]

Good land use planning may completely prevent earthquake disasters. Unfortunately, land use planning does not often take such issues into consideration. It is also unfortunate that those countries that need such planning the most do not have it, leaving totally unprotected large numbers of their population who build (and sometimes rebuild) their settlements in the earthquake region. It is ironic that many earthquake-stricken regions are very productive, thus attracting population.[31] Government care, regional planning, antiearthquake land use planning, and construction of large works of engineering such as artificial lakes should be the first measures responsible countries take in order to avoid earthquake disasters.

Code requirements pertaining to seismic design are most vitally necessary and must be enforced, by all means. Most building codes of the most advanced countries are constantly modified to meet seismic consideration requirements. Those codes require that buildings have a certain earthquake resistance. This resistance can be calculated on the basis of the locality requirements; each locality belongs to an earthquake zone classification given by the codes. In the United States, for instance, the resistance of a building is dependent on the earthquake zone ($Z = 0, 1, 2, 3, 4$) and the earthquake coefficient (K), which is dependent on the earthquake zone and the volume of the building. The actual earthquake resistance calculation may become very elaborate; it all depends on the earthquake zone.

Earthquake zone zero ($Z = 0$), poses no problem at all, as there are no expectations of structural damages due to earthquakes in this zone.[32] The earthquake zone for Texas is zero, ($Z = 0$). The earthquake zone for California, northern Colorado, and some parts of the east coast of the United States is 2–4 (maximum problem). The Japanese and the Greeks have developed a substantial amount of theory regarding earthquake-resistant design. Sophisticated seismic forces design must be performed by highly qualified specialists.

Architects can contribute greatly in designing earthquake-resistant buildings if they understand the basic principles of seismic forces. For architectural purposes, seismic forces are considered to be lateral (horizontal) forces of unpredictable direction. There are of course certain vertical forces generated during an earthquake, but the architect is concerned *first* for the horizontal forces; these forces can easily be dealt with through the plan arrangement, while the vertical forces can be taken care of later by the sophisticated structural antiearthquake calculations.

As the horizontal forces have unpredictable directions, they can be dealt with by the resistance of structural elements acting at 90°, thus eliminating the multidirectional

. . . yet all rules have exceptions! New Orleans.

or utility cores of the building. Architects can design antiearthquake buildings by means of symmetrical plans (symmetry with regard to the geometric center of gravity of the plan), symmetrical distribution of loads, and use of the best earthquake-resisting materials—such as reinforced concrete poured in place. Buildings of odd shapes, such as buildings with many angles in their plans, require special reinforcement at their angles or at the points of turning of the plan. The seismic design of such buildings is expensive. Simple, symmetric, "boxy" buildings are the most economic ones for earthquake regions.

In summary, the most important tip one could give the student, the young architect, or the client with regard to the structures of buildings is that the most important structural decisions will be the selection of the structural engineer and the commitment to collaboration with the engineer from the very early stages of the project. These decisions will guarantee safety and economy, and will expedite design. Beyond that, the rest will be easy and will depend upon the intuitiveness of the solution, the architect's ability to integrate the functional with the structural decisions, and the appropriate expression of the structure for formal and visual purposes.

Environmental Comfort of Architectural Space

The use of technology in twentieth-century architecture has been a mixed blessing. It has been a blessing that contemporary technology has made it possible to control the environmental conditions of our architectural spaces and render them "comfortable" for habitation. It has been a curse that the so-much-desired technology has wasted scarce resources, such as oil, and has brought mankind to the threshold of environmental crisis which presents at present the most critical issue of all architectural considerations.

It has been unfortunate that most architects and critics of architecture did not pay attention to the implications of technology on architecture much earlier. But such neglect was common to most professions, especially in technocratic societies, which based their growth and prosperity on technology. In this general state of affairs the "moral" issues pertaining to technological applications as related to architecture were neglected. As a result of this neglect, many architects as well as most students remained "uneducated" on the subject.[34]

The initial "miseducation" was then perpetuated by the chronic processes of a building industry that remains, as a rule, traditional, due to its capital vested interests on technologies of past years. It has been observed that there is a forty-year gap between the introduction of a technological innovation in building and the time of its implementation.[35] This is due to labor unions' attitudes,

probability of impact loads. To do this, the earthquake-resistant part of the structure of a building must be symmetrically located in the plan following the "swastika"[33] principle of design. The structural elements that can withstand these horizontal earthquake impacts are the shear walls of the building. If there is an architectural forethought that will permit location of the structural shear walls in plan in accordance with the "swastika" principle, the architectural solution will be antiearthquake by genesis. Provided the shear walls follow the "swastika" principle, they may be located anywhere in the plan, in the perimeter or on the inside. If the shear walls come very close together, they may become elevator cores, stairwells,

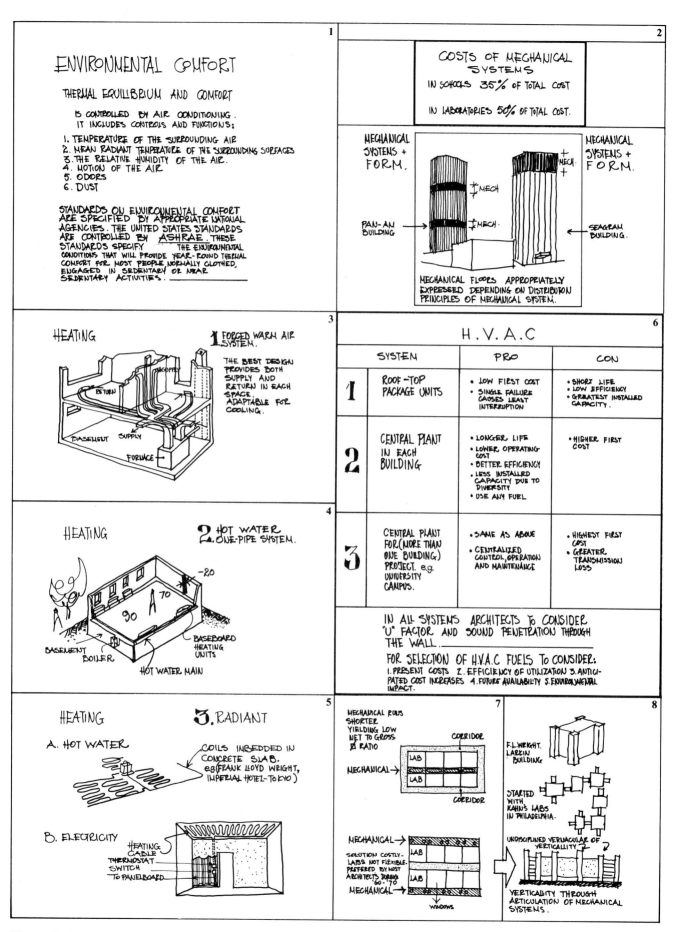

Figure 19. Environmental comfort concepts

public mistrust, time required for the building of social acceptance of innovations, antiquated building codes, and the slow pace of bureaucratic mechanics necessary for the improvement of building codes.

Innovations of today (e.g., inflatables, solar heating, etc.) can be expected to acquire public acceptance in the next forty years. Building methods in practice today were conceived and suggested for modern use by Le Corbusier and the Bauhaus people forty years ago. Current "technologies" responsive to the issues of energy conservation[36] will become publicly accepted in the years to come. Yet current architects must prepare themselves for the "energy conserving" technological future.

A new technological morality is necessary for architects and public.[37] It must be based on energy conservation considerations. The "energy ethic" must become the touchstone for all environmental designers, public, students, and technologists. As the architect prepares himself (or herself) for the new era, he ought to be totally aware of what is available at present and how it can best be used, as well as of what is coming up in the future.

The raw technologies we deal with today and the new technologies we will deal with in the future are basically concerned with the environmental comfort of our spaces— thermal, visual, and acoustical comfort.

In-depth understandings of the basic concepts are necessary if architects are to perform wisely and meet the future successfully. Unlike most of the early historians and critics of architecture who neglected a total appraisal of architecture[38] (that is, they neglected the interior, the structural, the mechanical, the lighting, and the acoustical comfort of buildings), young architects must do the opposite. As the subject of environmental control of architectural space is so vast (vital, but very specialized for such an introduction), it would only be appropriate to touch on the issues here in the most elementary way.[39] Students should study these issues in depth during the years of their education; while, when they are in practice as architects, they will have appropriate consultants to undertake the specialized studies for them. In the sections that follow the reader is introduced to issues of environmental control, lighting, and "systems building" which integrates all structural, environmental comfort, material, and construction considerations.

Environmental Control

Environmental control is the aspect of design that is concerned with the appropriate location (in plan and in section) of the mechanical systems necessary to heat, ventilate, and cool a space in such a way as to encourage its functioning and make it comfortable for those who live in it. Environmental control systems often require

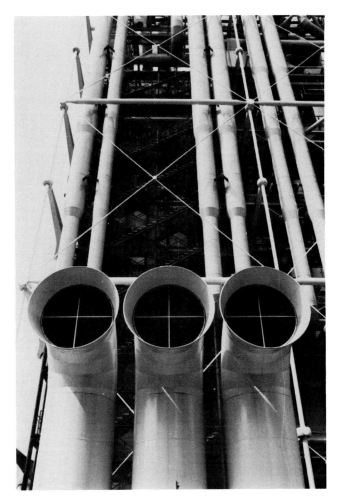

Architecture expressive of its mechanical systems. Center Pompidou, Paris. Piano and Rogers, Architects, 1977.

30%–50% of the costs of a building, thus their coordinated design is fundamental.[40] This type of design is concerned with two major categories of problem solving; control through the use of materials, and control through the use of mechanical systems and equipment. The properties of materials, their behavior in terms of environmental constraints such as thermal constraints (heat losses vs. heat gains), and the appropriate selection of materials are dealt with first. The second concern of environmental control of buildings deals with the selection, calculation, and coordination of H.V.A.C. systems; that refers to heating, ventilating, and cooling, the necessary operations of a total air-conditioning system.[41]

Heating is the maintenance of a space at a temperature above that of its surroundings.

Ventilation is the supplying of atmospheric air and the removal of inside air in sufficient amounts to provide satisfactory living conditions.

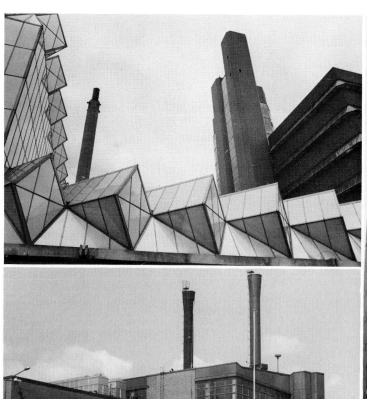

Mechanical systems as integral part of the architectural expression. Leicester University, engineering building (detail) by James Stirling and James Gowan (*top left*), and Byker wall housing in Newcastle Upon Tyne by Ralph Erskine (*right*), mechanical plant, University of Otaniemi, Alvar Aalto (*bottom left*).

Cooling is the process through which the temperature inside a space is controlled on a level below that of its surroundings.

The study of early heating systems (fireplaces and stoves) has revealed that modern heating systems (central heating—air, steam with hot water as medium, gravity warm air systems, and forced air systems) are more efficient, more easily maintained, cleaner, and less dangerous than the early systems. The energy consideration came into the picture late. It is this issue that concerns modern technology the most; and the most predominant current response to the energy issue is the use of solar energy. If the energy issue is resolved, then "air conditioning" will be a highly desirable situation in all respects. "Air conditioning," which is taken for granted as the top element of environmental comfort in advanced countries, is the creation and maintenance of an atmosphere having such conditions of temperature, humidity, air circulation, and air

purity as to produce the desired effects upon the occupants of that space or upon the materials that are handled or stored there. Air conditioning was first developed for industrial uses.[42] Its first use was for the storage of cotton supplies that required special environmental conditions.

Different spaces have different "conditioning" requirements depending upon their uses. Air conditioning makes it possible to differentially control the environmental conditions of different spaces within the same building. Architects must design buildings in such ways that there are transitional conditioning situations between the interior and the exterior. Abrupt transitions from the interior temperature to the exterior may be harmful to health. Secondary areas in plan facilitating the transition from indoors to outdoors are desirable. These transitional areas ought to have temperatures preparing the user to go from indoors to outdoors and vice versa.

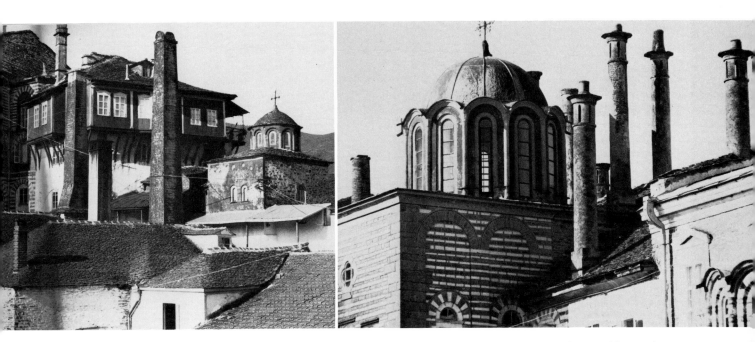

Monastic architecture of Mount Athos, Greece. The "mechanical systems" (chimneys) are integral parts of the architectural expression.

Mummers Theater, Oklahoma City, by Architect John Johansen. The form of the building is an absolute expression of its mechanical equipment.

Air conditioning systems must also be selected so as to economize in energy, strength of equipment, and the length of necessary ducts. The architectural solution must consider advantages and disadvantages of centralized and decentralized systems.[43]

Mechanical systems may affect the form of architecture. They may be exposed or they may be hidden. Frank Lloyd Wright was the first to use the mechanical systems as a means of formal expression. By articulating the vertical shafts of his Larkin Building he introduced a morphology of verticality in modern architecture. Verticality due to articulating of mechanical equipment was also used successfully by Louis Kahn in his Medical Research Laboratories in Philadelphia.[44] Many other architects did the same, especially during the decade 1960–1970. Total articulation of mechanical systems is obviously to be experienced in industrial plants and power plants in particular, where all the necessary machinery is exposed.[45] One experiences analogous architectural expression in many newer buildings. The forms of such buildings really evolved out of the diagram of their mechanical runs, vertical and horizontal, as well as out of the articulation of mechanical rooms, cooling towers, etc.

Reyner Banham, the first major architectural critic who introduced the concern for an aesthetic appraisal of buildings on the basis of their mechanical systems, pointed to Queen Elizabeth Hall as the top example in that respect.[46] One could now point to buildings that are even more successful (more honest) in that respect, such as the Mummers Theater of architect John Johansen in Oklahoma City, the "sky apartment house" of Watanabe in Sinjuku Ward in Tokyo, and the Centre Pompidou in Paris done by the architects, Piano and Rogers. (The latter has, in fact, a whole elevation which is nothing else but the blow-up in scale 1:1 of its mechanical diagram.) Truthful articulation of the mechanical systems, expressed sincerely without fear, yields an economic architecture, since it avoids the additional costs for extra building envelopes.

Mechanical systems must be integrated with the functional and structural requirements of the edifice, and they must be worked out in close collaboration with the mechanical consultants.[47]

Lighting

Lighting is another factor of environmental comfort in interior spaces. There are two types of lighting: natural and artificial. Architects tend to prefer natural lighting,[48] and they have often mastered its treatment. They accepted the necessity for the use of artificial lighting only after pressures of overpopulation and business concentration (downtown development, high-densities) made unavoidable the use of high-rise buildings and the use of spaces

The mechanical elements can become pivotal points for the articulation of the building masses. Apartment house in Kifisia, Athens, Greece. Tombazis and Associates, Architects, 1975.

where natural lighting was impossible to reach.[49] Today light is considered to be just as much an architectural element as bricks and mortar.

Natural lighting is controlled through design coordination of "the plan" and "the sections" of a building. Yet "the section" is more important than "the plan" in design with natural lighting. Proper sections may bring natural light even into high-rise buildings with extremely wide plans. "Proper" sections are achieved utilizing "skylights," "clerestories," and variations of "openings" at varying elevations.

Traditional environments have used light successfully. Proper lighting, in combination with building mass articulation, casts shadows which create rhythm on the elevations, thus making the outdoor strolling experience pleasant. If natural lighting is not properly treated, however, it may cause problems. One of the problems treated most successfully by traditional architecture is "glare."

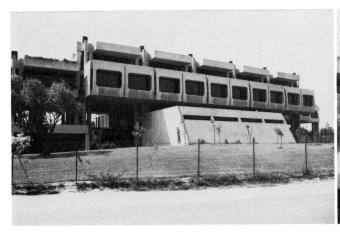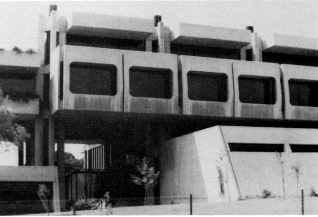

Orderly arrangement and expression of integrated structural and mechanical elements can give order and honest expression to a building. AGET (cement corporation) headquarters in Athens, Greece. Tombazis and Associates, Architects, 1975.

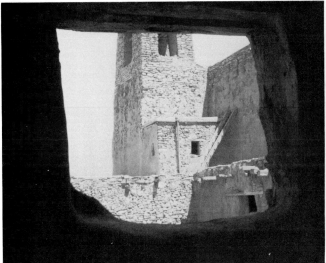

Control of glare in Acoma, New Mexico.

Control of glare in Troglodytic habitations. Santorini, Greece.

Glare is the basic discomfort resulting from bad lighting.[50] It is caused by:

1. Close proximity of light sources to the user, or
2. Abrupt contrast between two light situations without transition.

Traditional architecture has controlled glare through the breaking of building masses. We can avoid glare through appropriate plan and section design. A "porch" or a covered veranda may take good care of the glare problem and provide a transition between indoors and outdoors.

Architects must consider natural and artificial lighting and the advantages and disadvantages of each. Specific input on the subject must be obtained from the lighting consultant.[51]

Advantages of Natural Lighting

1. It wastes no energy; it is costless.
2. It has effect on the psychology of man, because it enhances in him identity with the time of day, the season, and the locality.
3. It permits clarity of form.
4. It permits variation of tones in time.
5. It gives birth to architecture. Great works of architecture have been achieved through the "life" and "drama" possibilities of natural lighting situations.

Disadvantages of Natural Lighting

1. Costs to get natural light into interior space, especially if the necessary architectural "sections" are elaborate.

Natural lighting brought into buildings by means of patios or skylighted walks (corridors) creates dynamic, animated interiors. Building in Puebla, Mexico.

2. Inflexibility; unpredictability. There are sunny and cloudy days, so an abundance natural lighting is not guaranteed.
3. Sky glare.
4. "Plan" restriction (beyond 50-foot width of plan) necessitates definite use of artificial lighting.
5. It is not appropriate for all types of productive activities.

Advantages of Artificial Lighting

1. Twenty-four-hour light; constant output.
2. May be controlled (on-off).
3. Intensity may be controlled and promote particular "moods."
4. Type and intensity may be controlled to facilitate specific productive purposes.
5. May be used as anticrime device.

Disadvantages of Artificial Lighting

1. Excessive use affects energy consumption.
2. It costs money.
3. It requires fixtures.
4. It is vulnerable to incorrect use.

The lighting problem for the architect consists of dealing with six major issues: (1) aesthetics, (2) functional considerations, (3) constructural considerations, (4) types of light distribution, (5) types of lamps, and (6) lighting jargon.

I. Aesthetic Considerations of Lighting

Lighting is directly related to the perception of rhythm in buildings, as well as to the evocation of "special moods" or "atmosphere."

1. Rhythm of Buildings. Natural lighting in daytime creates shading tones on the elevations and masses of a building that accent the rhythm. At night this is

218

achieved through the use of artificial lighting. Artificial lighting at night may provide "continuity to a scene which by day might appear fragmented."[52] It may produce different rhythm and "abstraction." This abstraction is similar to the abstraction created in daytime when environmental details are covered by snow. Good artificial lighting creates the desirable abstraction every night, while the natural abstraction and continuity due to snow is often infrequent, and in some localities nonexistent.

2. Special "moods." Different areas have different lighting requirements, and different lighting situations in the interiors enhance different functions and stimulate different use.

II. Functional Considerations[53]

The major functional considerations that must be taken into account when making lighting decisions are the following:

1. Purpose of building.
2. Purpose of space.
3. Groups using space with varied illumination requirements.
4. Size of space.
5. Time of day space used.

III. Constructional Considerations

The major constructional considerations regarding lighting have to do with the lighting fixtures to be used and their attachment to the various members of the building. There are usually mounted light fixtures, suspended light fixtures, and integrated building fixtures. Their coordination and actual relationship to the building structure is achieved through the study of "reflected ceiling plans." These are drawings of what one sees when turning the head up and looking at the ceiling.

IV. Types of Light Distribution

The activity, the task to be performed, and the mood to be created have affect on the type of light distribution. Distribution may be direct, semi-direct, general diffusing, semi-indirect, or indirect.

V. Types of Lamps and VI. Lighting Jargon

Architects must also be aware of the properties of the various types of lamps (i.e., incandescent, fluorescent, high-intensity) and must understand "lighting jargon." Lighting experts and interior designers who deal with artificial lighting perhaps more intensively than architects on a day to day basis use terms such as "downlight," "uplight," "wall-washer," "up-down," etc. These terms are usually self-explanatory.

Of the great architects of the twentieth century, Le Corbusier probably mastered the use of natural lighting to the greatest degree, and the Chapel of Ronchamp is the masterpiece of his genius in the use of natural light.[54] Frank Lloyd Wright, on the other hand, developed superb interior spaces demonstrating combinations of natural and artificial lighting. The reflected ceiling plan of his Morris Shop in San Francisco is a masterpiece of integrated lighting design. Other modern architects who placed tremendous emphasis on lighting, and even designed their own lighting fixtures, are Alvar Aalto and Erich Mendelsohn. The latter not only integrated lighting with the structural and mechanical design, he also made sketches of his buildings at night in considering their night illumination. These sketches capture the strength of "architectural abstraction" as achieved by means of artificial lighting at night.

Systems Building

When all aspects of building technology are integrated, when a system is found to achieve this integration, and when the system develops techniques and methods for construction in a systematic way, we are confronted with the case of a "systems building."

Systems building and prefabrication represent the natural methods of building because of recently generated demands brought about by: the increase in building volume, increases in the "gross national incomes" of advanced nations, and changes in the labor force from generalized to specialized.[55] Systems building is an inclusive term and it is dependent on *prefabrication*. It may be prefabrication of elements or prefabrication of total units. Prefabrication utilizes techniques of the assembly line, so familiar to the specialization of the twentieth century. Yet prefabrication does not represent a recent innovation. Its history goes back to Greek antiquity. The columns of the Parthenon were built of prefabricated elements, which were lifted into place and secured vertically by means of melted lead. In more recent times prefabrication was advocated for buildings by Leonardo da Vinci in 1516. He planned a utopian city on the Loire to consist of knock-down serial houses. Only the foundations were to be built *in situ* (on the site).

In 1851 Sir Joseph Paxton constructed "the Crystal Palace" for the Great Exhibition in London, England.[56] It was dismantled in 1854 and reerected in Sydenham. This historically interesting building was destroyed by fire in 1935. The great Crystal Palace was built in the extraordinarily short period of nine days! Without prefabrication this could not have been achieved.

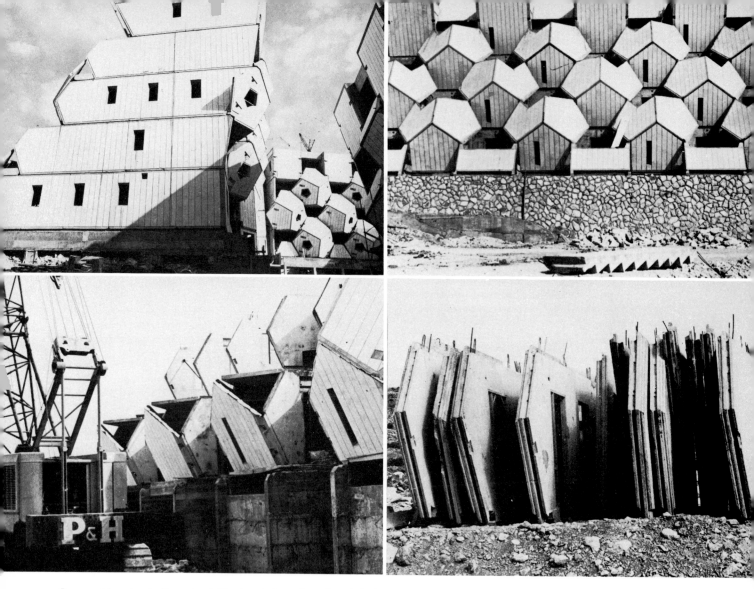

Low-cost housing in Ramot neighborhood, Jerusalem, Israel. Zvi Hecker, Architect, 1976.
Prefabricated panels for polyhedric housing in Jerusalem. Zvi Hecker, Architect, 1976.

In 1854, four knock-down timber houses at the Paris International Exhibition were shipped to Australia and reassembled in Sydney.[57]

Prefabrication may be of varying types depending upon the circumstances. Prefabrication may be on site if there is enough room on the site for it. There may be factories that produce prefabricated elements and supply substantially large geographic areas with their products. (The supply radii may extend up to 125 miles at times.)

Most of the present-day building volume in the world is carried out through prefabrication. Socialist countries, which attempt to resolve housing and construction problems in massive ways, depend heavily on prefabrication. Eighty percent of the construction volume in the U.S.S.R. is done by prefabrication; sixty percent in Sweden; and forty percent in the United Kingdom. Among the non-socialist countries, France and Switzerland hold leading positions.[58] Worldwide, rough structure prefabrication is 40%, and detailing prefabrication is 60% of the total.

In prefabrication it is important to consider *planning, construction,* and *production* as a unit, not as separate processes.[59] The design of a prefabricated element must include all aspects of the element, from each small detail to the whole.

There are three major classes of systems: the skeletal, the panel, and the cellular.[60] A system is *skeletal* when it uses linear prefabricated elements. *Panel* systems use two-dimensional prefabricated elements for the construction of enclosures.

Cellular systems use prefabricated three-dimensional building shells that are brought to site, lifted by crane, and secured in place. An early case study in the potential of the cellular idea was "the Habitat" in Montreal by architect Moshe Safdie.[61] Prior to Safdie, Louis Kahn experimented with cellular systems buildings, while the Japanese architect Kisho Kurokawa most successfully erected the Twin Towers of Nagagin, which, in this author's judgement, is one of the best examples of the use of cellular systems building.

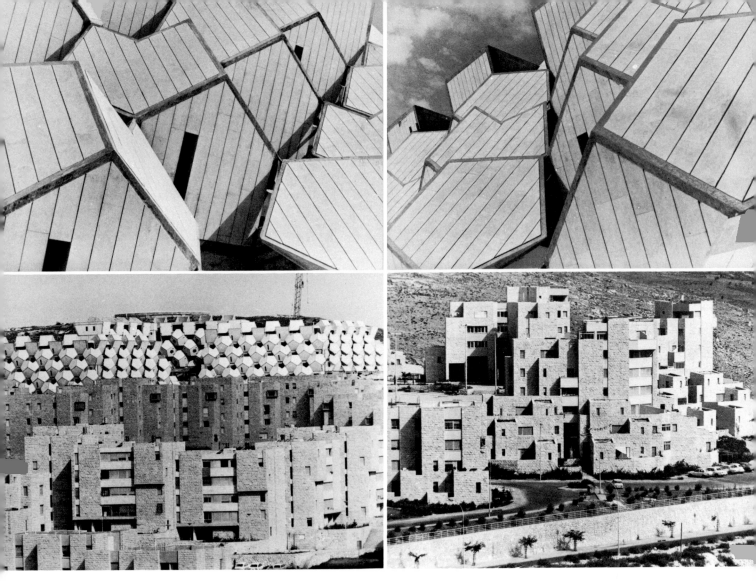

Systems building and prefabrication can bring costs of extraordinary proposals down. The section of the polyhedric habitation designed by Zvi Hecker for the Ramot neighborhood in Israel was realized within the same budget as its neighboring conventional housing.

Most systems today, especially the skeletal and panel ones, are not resistant to earthquakes. This is due to their multiplicity of joints. Systems also pose problems as far as the creation of "universal interior enclosures," although they are apt to permit the creation of substantial exterior cavities in the urban landscape. An architect who has been dealing for some time with the issues of "grand enclosures" achieved by means of systems building is Israeli architect Zvi Hecker. His "Synagogue" in the desert of Israel is a good example of the possibility.[62] Hecker has also designed housing using polyhedric forms and prefabrication. He managed to produce extraordinary results within the same budget as ordinary housing.

Thus far in its evolution, systems building has not produced appealing environments. This is unfortunately true both in socialistic and capitalistic worlds.

The question on systems building, at present, is not one of formal results. It is rather a question of energy. Will systems buildings conserve energy or not? The answer is very complex; it must take into account extremely sophisticated research on the costs and benefits of each new system produced as related to energy.[63] Systems building indeed saves energy in terms of labor force and time spent in construction; but does it really save energy when it demands the manufacture of new materials? This is where the answer lies; and it is an answer that must come from other experts and the research they will conduct in the years to come.

Architects, especially those educated in the past, will have to wait, repose a little, perhaps draw from past experience, perhaps look to past civilizations and use their principles as energy didactics. Using technology without first considering the issues of energy is an unworthy practice for the architect. Technology must not be used with closed eyes.

The author's personal stand on the energy issue is based on *the concept of repose and the study of energy civilizations of the past.* This concept could have substantial consequences for energy-responsive architecture in the future if it were widely accepted. For this reason, it is argued further in the chapter that follows.

Notes

1. Nervi, 1965, p. 96.
2. Salvadori-Heller, 1963, p. 8.
3. Here I take issue with prominant structural engineer, Mario Salvadori. His concept on the purpose of structures equates "building" to "structure." He sees "structures" as enclosing and defining space, rather than bearing loads to the ground. Salvadori states, "Only in rare cases is resistance to loads the primary purpose of a structure: loads are usually a necessary and unavoidable evil." Salvadori-Heller, 1963, p. 12.
4. The structural metaphors, *amoeba* and *fish,* are introduced here for explanation purposes.
5. For discussion on historic evaluation of structures, refer to Cowan, 1966, pp. 3–6; also Salvadori, pp. 4–5.
6. For aesthetic arguments of the expressive potential of structures, refer to Michelis, 1963.
7. For introductory discussion on moments and stresses of post and beam, see Cowan, 1971, p. 5.
8. The simple, logical, and economic post and beam has been used from the days of the Greek megaron to today's high-rise office, commercial, and residential construction. Sophisticated structural systems utilizing the arch, used in Persian, Roman, and Gothic architecture, produced but a small number of buildings, usually religious and utilitarian ones. Refer to "Choice of Structure" in Cowan, 1971, p. 15.
9. See Cowan, 1966, p. 48; also Cowan, 1971, p. 21; and Salvadori-Heller, 1963, pp. 108–19.
10. A "space frame" is a multiplanar, continuous framework which acts simultaneously in three dimensions to resist all applied forces. Rapp, 1964, p. 4.
11. There are numerous sophisticated distinctions between space frame types. Space frame types are often referred to as "grid systems," and a common space frame type is the "grid" framework. A grid framework can be described as a continuous monolithic plane system usually symmetrically tied together by a series of longitudinal and transverse members to resist all applied forces acting normal to the system's plane. Rapp, 1964, p. 2. Also general reference to Fischer, 1964, pp. 2–20.
12. Mies van der Rohe proposed space frames for his large assembly hall projects. Outstanding space frames have been designed by S.O.M. for the Air Force Academy in Colorado Springs, Colorado; by I.M. Pei and Associates, Architects, and Ammann and Whitney, Structural Engineers, for the multiairlines terminal at New York International Airport; and by Kenzo Tange and URTEC, for the National Pavilion of Japan, in Osaka, Expo '72.
13. Living capsules have been attached in Kenzo Tange's space frame in Japan. Living accommodations was also provided for in the space frame proposal of Yona Friedman.
14. For basic introduction refer to Salvadori-Heller, 1963, pp. 222–42; Cowan, 1971, pp. 329, 339; and Fischer, 1964, pp. 26, 72.
15. Refer to Salvadori, 1963, pp. 294–357.
16. Refer to Felix Candela, 1964, p. 45.
17. General reference to Pier Luigi Nervi, 1965, p. 102.
18. For Membranes, see Salvadori, 1963, p. 272.
19. Ibid., p. 276.
20. Basic reference on the subject, Frei, Otto, 1962.
21. Ibid., pp. 147, 155.
22. Ibid., p. 32.
23. The issue of appropriateness belongs to the general issue of "optional structures." For further argument, see Salvadori, 1963, p. 74.
24. No specific references are provided for the discussion that follows. For the time being the reader is encouraged to concentrate on chapter as presented here. Structural engineering references might confuse intuitive understanding of the concepts explained here.
25. For history on Agadir earthquake, refer to Despeycroux, 1960, p. 521. For other earthquake disasters, refer to Science Council of Japan, 1960, pp. 359, 457.
26. Certain earthquake zones are kept as open space for recreation purposes.
27. Greece has limited the height of buildings for antiearthquake purposes. The method of antiearthquake calculations developed in Greece by Prof. A. Roussopoulos focuses on building heights of up to eight stories. See Moliotis, pp. 23A–1, 23A–3. Japan also has developed considerable antiearthquake theory and has imposed restrictions on building heights.
28. Greece has created artificial lakes for the purpose of "triggering" earthquake occurrence.
29. Refer to *Uniform Building Code.*
30. Most important in that respect is the total design concept.
31. The population of the Greek island of Thera represents a case study in that respect.
32. $Z = 0$ does not necessarily mean that earthquakes will never happen there. It just means that no structural damages are expected to occur due to the low intensity of a possible earthquake.
33. The "swastika principle" of antiearthquake design is credited to structural engineer, Prof. G. Koroneos; lectures on seismic design, Spring, 1963; National Technical University, Athens, Greece. It is astonishing that very little has been written on antiearthquake design pertaining to layout of buildings with regard to seismic considerations.
34. Banham, 1969, p. 13.
35. Ibid., 27.
36. Notable case here is the experimentation on solar energy. Pioneering work was started by progressive individuals in the states of Arizona and New Mexico in the mid-50s. See Cook, 1974. Several institutions launched experimental programs in the early 70s.
37. In the mid-70s, the "new morality" focused on acceptance of energy-conserving principles, recycling, and restoration of old buildings. The motto in the United States was, "Let's invest in conservation of energy instead of waste," *A.I.A. Journal,* March, 1975, p. 19. Public education was also at the heart of the concern. See *A.I.A. Journal,* September, 1975, p. 40.
38. Banham, op. cit., p. 14.
39. Basic specialized reference for the student of architecture: McGuinness and Stein, *Mechanical and Electrical Equipment of Buildings.*
40. Ibid.; also "Energy Management" in *A.I.A. Journal,* September, 1975, p. 11.
41. Basic reference for discussion that follows: McGuinness and Stein, op. cit.

42. For an historic overview of the evaluation of environmental control systems, refer to Banham, op. cit., pp. 29–70.
43. Refer to op. cit. for details.
44. For a discussion of relationships between mechanical systems and form, refer to Banham, op. cit.
45. For further reading on the above issues, refer to Hasselman, 1975, p. 48.
46. Op. cit., pp. 258–264.
47. For further general reading, refer to Banham, ibid., "Readings in Environmental Technology," p. 290.
48. Basic reference for natural lighting: Lynes, 1968. Also Kohler-Luckhart, 1959, pp. 109–43; and Hopkinson and Kay, 1969, pp. 42–68.
49. For artificial lighting, refer to Kohler-Luckhardt, 1959, pp. 147–219; and Hopkinson and Kay, ibid., pp. 68–120.
50. Hopkinson and Collins, 1970, p. 80.
51. Boud, 1973. General reference covering the advantages and disadvantages of various lighting situations.
52. Larson, 1964, p. 13.
53. For further discussions on design considerations for lighting, refer to all above references, as well as to McGuinnes and Stein, section on lighting.
54. Larson considers Le Corbusier's Chapel at Ronchamp as the classical example of natural lighting in modern architecture. Larson, 1964, p. x.
55. Schmid-Testa, 1969, pp. 6, 8.
56. Ibid., p. 12.
57. Ibid., p. 12.
58. Percentages based on ibid., p. 14.
59. Ibid., p. 16.
60. Major reference on systems building: Schmid-Testa, 1969. Also refer to evolving reference by Kurt Braudle, 1974. For further reading on systems building in the United States, refer to *Building Systems Planning Manual,* 1971.
61. Safdie, 1970, p. 59.
62. Hazelton, 1974, pp. 33–34. Also Hecker, 1972, general reference; and Hecker, 1969, general reference.
63. Dietz, 1969, pp. 13–17.

Selected Readings

Banham: *The Architecture of the Well-Tempered Environment*
Nervi: *On the Design Process* and *Is Architecture Moving Toward Unchangeable Forms?*
Salvadori: *Structure in Architecture*

8

Designing
for Energy
Conservation

". . . The sun is the only hope for our long-range
future. . . . The Island of Skyros: beautiful, simple,
efficient, people live long lives, a little society that is
people-oriented, not automobile-oriented. Most of the
energy needed is provided by windmills. But ladies there
have no washing machines, no dryers, no dishwashers,
no television, no gadgets of any kind, and no
refrigeration. When they wash their hair, the sun dries
it. You might say that this is a primitive way of life.
The question is, will Americans accept such a way of
life today? I am afraid the answer is no!"

Dr. Harry Anthony[2]

"Houston . . . correctly perceived and publicized as
freeway city, mobile city, space city, and speculator
city. . . . Houston's web of freeways is the consummate
example of the twentieth-century phenomenon known as
the commercial strip . . . gas stations, drive-ins, and
displays meant to catch the eye and fancy at 60 miles
an hour. . . . Gertrude Stein said of Oakland that there
was no *there*, there. One might say of Houston that one
never gets there. . . . Houston is *the* City of the second
half of the twentieth century."

Ada Louise Huxtable[3]

We have already mentioned that one of the major factors responsible for the current concern for environmental design is our inadequate handling of energy in the past. Man has wasted scarce resources (such as oil); he did not properly use other available resources (such as coal); and he didn't undertake fruitful research toward utilization of ample and inexhaustible sources of energy (such as solar energy). Man in general lost control of energy. The concern for energy conservation and the thinking about alternative sources of energy has come about only recently. It was in the early 1970s that a general awareness of the imminent energy crisis was established. Designers, especially architects, urban designers, and city planners, should be concerned for everything that has anything to do with energy. Moreover, if they are to develop designs that will be environmentally relevant they should develop new approaches to design, disciplined by their "energy ethic."

In the midst of the "energy crisis" concerns on energy got all out of proportion. As a result, "energy" was presented by many as a scientific concern, and some very simple facts about energy-sensitive design were forgotten or not presented appropriately. It is true that chemistry and physics are fundamental as far as research and alternative sources of energy are concerned. But it is also true that environmentally relevant designs from the energy point of view should not necessarily be the results of scientific efforts and scientific research alone. "Energy-relevant" lessons can be learned empirically through the study of environmentally relevant traditional architecture. In fact, it is the author's strong belief that the generic answers to energy-sensitive environmental design are hidden in the many successful traditional environments that have been overlooked in the search. . . . We will focus on these neglected issues here in order to come up with some fundamental principles on which to base future designs.

"The energy ethic" stated in architectural terms could simply consist of new attitudes toward "heat losses" and "heat gains"; "technological sophistication"; and the adoption of new standards for the environmental control of buildings, architectural form, and materials. All of the above may or may not enhance the conservation of energy. Of these broad factors, which are sufficiently covered in general and specialized literature, the subfactors pertaining to architectural form are of generic importance, especially when one makes the assumption that "materials" and "technological sophistication" can be easily controlled by the discriminating designer. This logic brings us to the fundamental fact that it is the *basic design* of a work of architecture that reveals whether or not the building is an "ethical" statement regarding energy.

The same logic also demands our attention to the ever present considerations for "space" creation, which was and should always be the task of architects. Space should transcend "shelter" requirements and be qualitative enough so as to stimulate efficient function, comfort, interaction, and psychological appeal for the users. The components of the "space"-achieving process considered abstractly are physical as well as human.[4] The physical components of space[5] are the three dimensions, which finally determine the architectural mass as well as the sequence of solids and voids which control the quality of the interior through the established rhythm of lighting. The human component depends on the users of the space who, through their life styles (and needs), cultural connotations, or certain appreciations of "schemata,"[6] create feedback to the three-dimensional entity designed by the architect and give respective meaning to it.[7] It appears, therefore, that architecture that sets conservation of energy as its task must seek to satisfy both three-dimensional and human requirements.

In requestioning their "energy ethic," architects must go way beyond their current concerns, which are mostly technological and encyclopedic in nature[8] (e.g., concern for various solar heating systems). Architects must get back into the basics of design as far as design principles go. They will have to return to some of the preoccupations of their early architectural education and training. They must once again ask questions about controlling the solids and the voids, controlling the massing qualities of their works (dynamic vs. static massing), and controlling their attitudes toward the making of interior spaces that respond to energy-conserving demands. Similar concerns need to be developed for large-scale architecture, that is, for urban design and planning.

Discovering Principles of Energy-Relevant Architecture in New Mexico

The study of the "typology" and "principles" of the "spaces" and "places"[9] in many vernacular architectures reveals lessons that enhance our appreciation and respect for the energy ethic as it relates to architecture. We will concentrate here on the case of New Mexico, since there is sufficient research evidence at present to support our arguments and thus develop some principles for energy-sensitive environmental design.

In most primitive architectures fire was the natural energy used by man. The only suffering ecology was the neighboring forest and the recycled manure. Yet, man had to pay the price himself. He spent energy from his within. His survival depended on the burning of the resources of his own body and his own hard work. Toil and fatigue combined with the discomfort caused by the moisture and dampness of his early troglodytic pattern of living were

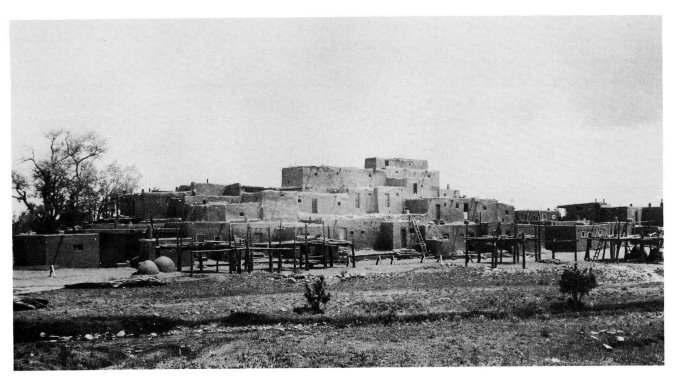

Taos Pueblo, New Mexico.

the price he paid for the high degree of his (unconscious) natural-energy-conservative living. In that early era, New Mexico offered three types of habitation: caves, cave cliff dwellings, and subterranean and cliff kivas.[10]

The cliff "dwellings" were an advancement over the earliest cave dwellings in that their entrances were protected by man-made walls or by structures that were blended into the cliff and the occasional cave in it composing the back part of the building. These dwellings were achieved by means of earth extraction and by treating the added parts in a "mass"-articulating manner. The element of "mass" is fundamental. Its achievement was perhaps accidental from the energy conservation standpoint. One could easily suggest that there were structural reasons first, that the properties of masonry and earth as building materials required a "massive" approach. But "mass" is the thing that must be retained by today's designers if building within the energy ethic is to be achieved. The "massive" articulation of the cave or cliff dwelling gave it a tremendous ability to absorb, store, and retard transmission of the heat that was applied to it during the day; and after sunset the radiation of that heat into the space helped to temper the chill of the evening.[11]

The kivas were ceremonial spaces, mostly subterranean, achieved by means of extraction. Absolute control of natural lighting, ventilation through a diligent section, and symmetry were their basic physical characteristics.

In all instances the physical components that became distinctly evident are:

1. "massiveness" with distinct articulation,
2. superiority of solids over voids,
3. proximity and high densities,
4. symmetry in the plans and sections, especially of ceremonial spaces, and
5. use of transitional spaces in combination with light, temporary structures and light-diffusing textures for the alleviation of glare.

Massiveness: Articulation and Breaking-down of Mass

We may regard "mass" and "massiveness" as the key to energy-relevant design in New Mexico. In later days the mass of the cliff edge or the mass of the man-made masonry wall was replaced by the mass of free-standing natural formations to which man attached his edifice. I have distinguished several examples of these types, and there is a photograph of what I have called a rural "pavilion". This small desert edifice represents perhaps a unique case of visual balance, a combination of natural and man-made, a *pas de deux* between a free-standing rock and architecture. Such dwellings of the rural "pavilion" type were perhaps built that way primarily for purposes of construction economy (since the rock helped

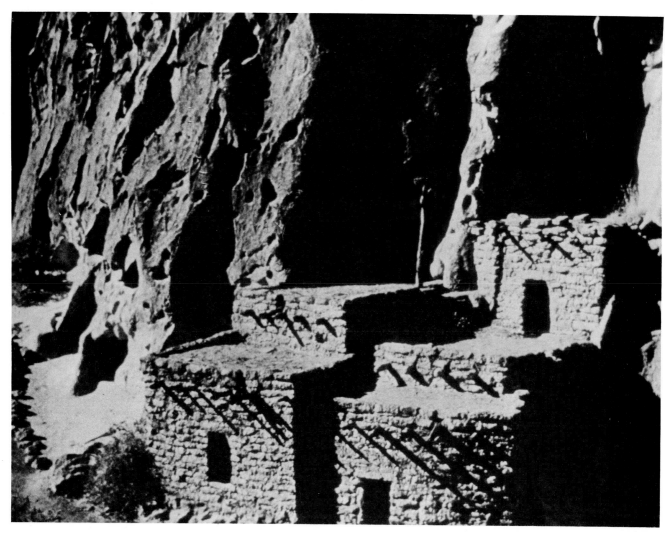

American Indian dwellings by the rocks of Bandelier, New Mexico.

eliminate the cost of one wall), yet even if economy was the only consideration, it can still be argued that conservation of energy was a side effect. Energy this time was the human energy that was saved by avoiding the building of the fourth wall. The early architects of Portugal and Greece provided us with numerous other examples of this free-standing type of rock-edifice composite.

The next type of "massiveness" is to be seen in the strictly man-made habitat of New Mexico. All the pueblos of the Indian civilizations demonstrate the qualitative advantages of the mass. Through proximity, sharing of walls, and use of masonry and earth, the early pueblos in Chaco Canyon, Bandelier, and Taos achieved energy economics, both natural and human. The natural energy resource conservation is the same as with of the cave dwellings and the subterranean kivas. Additionally, the pueblos accommodate extensive use of wood burning and incorporate fireplaces and chimneys which radiate heat to the interior environment after the heat source has been extinguished and during the chill of the night.

Mass articulation also fosters the creation of pleasant work areas protected from the direct sun and freshened by prevailing breezes. These work areas are provided through the "human scaling"[12] of the total mass of the pueblo and articulation of the total volume.

The "volume" of the energy-conserving "mass" of the New Mexico architecture is broken down into well-articulated parts, thus creating a "free" or "sculptural" total composition. The "sculptural" quality is due to the constantly changing shade patterns generated by the moving sun which eventually animate the building. This *dynamism* (movement of shadows on the surface) creates pleasing spaces between the masses and creates work corners and, through the variety of the mass breakdown (in

Pueblo Bonito, Chaco Canyon. View and structural considerations.

volume and in plan), offers choices of exterior areas for doing productive work during the heat of the day. A side effect of the mass scaling of the pueblos is that it breaks down glare, which would be unbearable if the mass were concentrated in one "static" volume. Contemporary architecture has a lot to learn in this respect as well.

Solids Versus Voids

Directly associated with the "massiveness" of New Mexico architecture is the supremacy of its solids over its voids. New Mexico pueblos demonstrate a discipline of small openings (voids). These openings are appropriate for materials weak in tension, such as stone and adobe; at the same time they are important for heat loss and gain purposes and they protect interiors from direct sun penetration during the bright days throughout the year. The small openings in combination with the masssive walls help to maintain the comfort level during the chill of night. Characteristic examples of the supremacy of solids over voids

seen in the "sections" of New Mexico churches. The opening in each of these structures is uniquely placed above the altar, letting direct sunbeams hit the cross during the mass. On other occasions, especially in residential architecture, small voids are placed appropriately to frame special views or catch prevailing breezes and direct them into the interior. The supremacy of solids over voids has been well understood as a discipline in New Mexico design. It represents a quality of most vernacular works in the state as well as of many contemporary works, residential and institutional, which have distilled the lessons of tradition and have used traditional and regional principles in intuitive contemporary ways. There are, however, certain unfortunate cases of new buildings, especially commercial and office structures, which deviate from this very logical design practice.

Proximity and High Densities

Thus far, we have discussed "massiveness" and mass articulation as well as the supremacy of solids over voids. The third element, which is at present of maximum importance in terms of energy conservation, is the element of "proximity." The cave dwellings and the pueblos represent cases of urban habitat of very high densities. In the past these densities were achieved for purposes of protection; the whole town became a fortification machine operated by its inhabitants. Yet the centralization achieved through this proximity reduced tremendously the lines of communication among the people, facilitated the division of urban labor, and offered an everlasting performance of urban theater for those who lived in it. Nowadays, we have lost proximity. Uncontrolled growth and sprawl have lengthened the lines of communication among human beings. We now have incredibly high mileages of pipelines, electricity networks, and channels of transportation, all consuming the scarce resources of energy our planet possesses. Our entertainment is costly to get; the ceremonial of societal living has been lost; our human energy (fatigue) as well as energy in the resource sense is wasted in the seeking of pleasures which have been dispersed in a dispersed environment.

Sprawl lies at the heart of the energy crisis, and sprawl is the broader issue that architects and planners ought to attack foremostly and primarily. Taos, Bandelier, and Chaco Canyon ought to become models for teaching the principles of energy-conserving urban design. But proximity and high density are directly related to people's attitudes toward living under these conditions. The human factor is an extremely important consideration here; it represents the key element of this type of energy-conserving design. Discussion of the "human factor" and "human components" of space is now in order.

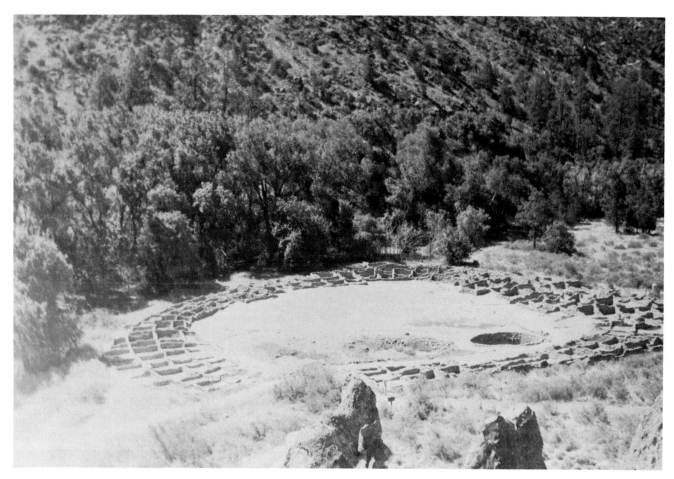

The ruins of Tyuoni, communal Indian habitation in Bandelier, New Mexico.

Symmetry

More than any other consideration that affects design (and thus the conservation of energy) is the "human factor"[13] with its level of connotations[14] or "appreciation of schemata."[15] Humans respond to the spaces determined by architects (feedback and meaning), and accept the spaces to the extent that they respond to their physical, activity, and psychological needs. In communities with homogenous human factors, one witnesses homogeneity in architecture and urban design. This is true for traditional New Mexico as well as for a good many other cultures such as the Greek, the North African, Southern Italian, and others. In communities with a "complex human factor" (diversified life styles, cultural inequities, etc.), there is diversification and heterogeneity in architecture. In extreme cases of heterogeneity, such as the United States, one observes environmental extremes; and the development of a sound energy-conserving architecture may be impossible if this heterogeneity is not worked out first through the channels of education, gigantic government programs, and civilization incentives. New Mexico, which teaches the principles of a sound energy-conserving architecture, also demonstrates the homogeneity of its early people's attitudes toward space, high densities, and environmental images (e.g., the inhabitants' love for adobe construction).

The early inhabitants of New Mexico had collective preferences, collective symbols and "schemata," and commonly accepted life styles. Of the human component, life style, and perhaps even better, "the ceremony of life,"[16] had a direct effect on architecture and urban form which came to demonstrate the people's respect for conservation and care for energy. Life style and collective preferences expressed architecturally created the high density and proximity of the pueblos, as well as the distinctive geometry of equitability for the kivas and ceremonial places. The forms of certain functional areas (kivas, rooms, hogans) were symmetrical (circles, semicircles, octagons, squares);[17] while the form of the total urban unit also followed the rules of compact symmetry as much as it was

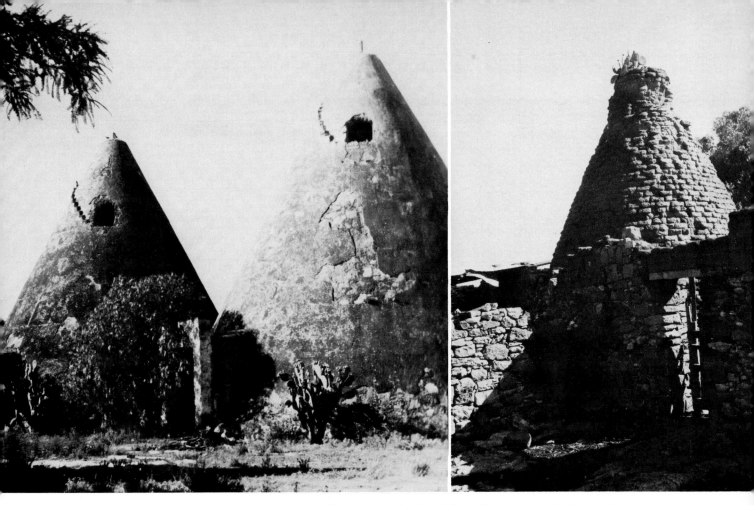

Conoid grainaries in Santa Monica, Zacatecas, Mexico. The circular principle of the utilitarian grainaries became the generator of the circular kitchen prototype in the adjacent village of Santa Monica. Santa Monica, Zacatecas, Mexico.

permitted by the topography and the general environmental constraints. Symmetry and geometry of absolute shapes can be well justified in subterranean architecture, because the general environmental constraints (sun, wind, view, rain, topography, etc.) are left outside, bearing no effect on the shape of the building. Absolute symmetry would be undesirable for purposes above-ground, where environmental constraints operate. Different types of buildings, as well as different functions carried out in each building, have different environmental requirements which affect the various parts of buildings differently. Symmetry of subterranean architecture, apart from the equipotentiality it offers for user participation, also offers equity in enjoying heating or ventilation, and it is economic beyond description. Symmetry (circles, squares), therefore, should stay with us and, if nothing else, should at least be one of our concerns in checking out our energy-saving schemes. It is very possible that there is a good chance for strong symmetrical spaces in a good number of the multifunctional buildings we design today, such as large hotels, shopping centers, community and university buildings, etc. If nothing else, a good, strong, geometrically well-balanced space will help us to distribute the heat sources and

the cooling devices appropriately and offer economical equity of comfort to the users of the interior. The interior, by the way, can feature ground arrangements and circulation patterns that are "free" of symmetry if diverse functions are to occur in it.

Treatment of Glare

The sun's brightness and the extreme differences between day and night temperatures are the key environmental problems for the architecture of New Mexico. Brightness causes the discomfort of "glare" which, to a good extent, is moderated by mass articulation which has already been discussed. Sun-absorbing textures (beige-colored stucco) and glare-controlling transitional areas in the plan represent the other two major means of glare control. Glare is not directly related to natural resource waste, but it is related to human energy control and human comfort. The problem of glare is treated through considering the location of transitional areas in the plan. These areas, such as porticos (covered walkways around patios or entranceways) permit a sequential and harmonic variation of light transition, eliminating abruptness which is

Antiglare wood shelters in Taos Pueblo, New Mexico.

the basis of the glare problem. Glare is also caused by direct contact of the sun with the grounds surrounding a building. Especially when the surrounding landscaping is "hard," glare may be very severe. Untreated building surroundings may produce environments that are not conducive to outdoor living and outdoor working. Treating the problem of glare in the outdoors is the most energy-conserving act man ever performs in the shaping of his environment. The New Mexican Indians of the Taos pueblo construct temporary shelters out of rough logs, thus creating shaded areas on the ground which are cooler than the surroundings and allow outdoor living and working during the summertime. Abundant air-conditioning would be necessary for cooling enclosed work areas, but here comfort is provided by inexpensively created shadows in combination with the prevailing breeze.

Conclusions

It is perhaps not accidental that energy awareness is highly developed in New Mexico in the twentieth century. A lot of early energy experimentation and research started in that state[18] and the neighboring state of Arizona. In fact, some of the earliest works of energy-sensitive modern architecture were built in New Mexico.[19]

Yet, in spite all that, it is absolutely doubtful that individual schemes of solar energy self-sufficiency (houses, domes, etc.) are the solution for the energy issue at large. The cause of the energy shortage—at least as experienced in countries such as the United States which are highly dependent on automobiles—is *urban sprawl*. Solarly heated dwellings require low densities so that their solar collectors will collect the sun. They are, therefore, causes of further urban sprawl. The total environment will benefit only if scientific, empirical, and experimental ingenuity serve to develop a responsible and "space"-oriented architecture.

Man need not go back to the troglodytic habitation of the cave, but he should go back and look at technologically less sophisticated civilizations and use their principles as bases for new designs. The designer should be cautious, however, because the lessons to be drawn through further and more elaborate study of traditional architecture are not necessarily going to provide universal solutions to the energy problem. What this chapter claims is

that the apparent consistent universality of the regional architecture of New Mexico produced in the past what is today understood as energy-efficient architecture and urban organization. In this sense, it is argued that a certain formal and spatial universality will have to evolve in other regions with similar sets of environmental constraints if architecture is to become truly energy-relevant. This universality will not exclude individual expression or the use of new materials; it will rather incorporate certain universal principles of design that are sensitive to the question of energy, and some of the principles will be as simple as a "glass versus no glass" attitude. Such attitudes, scientifically justified through the sound advice of appropriate consultants, will produce the "ethical"[20] or energy-conserving work which will be not only responsive to the needs of the current users, but also responsible to future generations.

And, as for New Mexico, the region of our current concentration, it is rather clear that the formal vocabulary of ethical, energy-conserving architecture is that of massiveness, mass breakdown, superiority of solids over voids, proximity and high density, abundant use of shading, and sun-diffusing texturing.

Hypotheses for Environmentally Meaningful Design

". . . while not clinging to elements from any one particular society, we make use of all of them in order to distinguish those principles of social life which may be applied to reform our own customs and not those of customs foreign to our own. . . . Our own society is the only one which we can transform and yet not destroy, since the changes which we should introduce would come from within."

Claude Levi-Strauss[21]

Many of the "traditional" environments in the Mediterranean basin and the Central American plateaus have existed for generations. They appear to be environmentally sound, and they are attractive; they attract our attention for study as well as simply for visiting. An empirical inquiry into the structures of these environments, which we will refer to from now on as "parallel environments,"[22]

reveals certain common characteristics in their physical, social, and economic lives. These similarities can be considered as hypotheses for environmentally meaningful design. The key similarities will be discussed here in order to help prepare the way for the development of a vocabulary of environmentally relevant architecture.

In the past, most people of the environments we refer to here did not plan; at least they did not plan as far as we know. They acted, though, in laissez-faire ways; surely they did not plan in the manner and scale we do today. The Greek islands were not planned; Athens and the Parthenon were not planned; neither the Italian hill towns, nor the Portuguese fishing villages were ever planned. Although planning was unknown in the environments we discuss here, it does not mean that the laissez-faire attitude was universal. At the time of the European Middle Ages and during the Renaissance when most of the "parallel environments" saw their birth, some great cities were developed in Europe in planned ways. Great kings even associated their names with the building of planned towns. The central part of Copenhagen was designed by a king. The Zäringen towns were designed by a king.

With the above exceptions in mind, one could say that the architectural examples of the parallel environments were results of unplanned efforts. They were, in other words, the results of isolated solutions to individual problems of building; and the physical world thus evolved was an aggregate of details. The details had nothing to do with notions about planned wholes.

With these thoughts in mind then, we can safely say that *vernacular* architecture is a laissez-faire architecture that developed through tradition. It accepted traditional ways of solving problems and was in return accepted by the respective societies who created totals out of details. The builder's identity was forgotten; the architect remained unknown. We often give credit for the design of these environments to "the people." The words "architecture" and "people" become synonymous; we assume that each inhabitant designed and built his own building. That is how we justify our academic ignorance resulting from the lack of written evidence as to who, or what family of builders, came by and built a certain traditional environment.

There were indeed families of wandering masons who traveled from one feudal estate to another and built the great castles and cathedrals of Europe that we admire today. These families of traveling architects may have left their "seals" somewhere in the foundations of feudal castles, Gothic cathedrals, and houses on the Island of Hydra. But still, this is only a suggestion and it hardly makes for an academic argument. Thus we can only study and compare the similarities of the architectural forms created by "the wandering masons," the "unknown architect," "the

people," or the "architecture without architects" as Rudofsky has called it. The important thing for us today is to accept that the "vernacular" architecture, "the architecture of the unknown architect," or the "architecture of the folk," may very possibly have been an architecture of "architects," professional architects of times gone by, yet unknown to us.

Their's was a highly sophisticated architecture that has much to offer us today. We receive environmental lessons if we happen to be architects studying them; we get "euphoria" if we happen to be observers, inhabitants, or passers by. In conclusion, these environments offer lessons for the architect and aesthetic enthusiasm for the rest. The didactics of these environments, considering the "whole" first and the "details" second, were the following:

THE WHOLE: It could be called, *"large-scale architecture,"* or *"the broader physical milieu,"* or *"urban design sphere of physical environment."* It is this man-made environment which includes private and public, is organized by means of channels of movement, has dynamic and static places in which to be, and is composed of a succession of solids vs. voids, (buildings vs. streets and plazas). This whole is always a response to certain social-cultural and economic constraints. Both, physical environment and social-economic-cultural dynamics, have reciprocal relationships.

As you can see, this is a large framework of understanding of the "whole"; it is a comprehensive framework. In terms of this whole, the parallel environments show the following common similarities.

Street Sequences

Streets are the major channels of movement in the parallel environments. A street is a place to be, to relax, to play, to talk to neighbors; that is, the street is a place to socialize. The street is, in fact, the place where the highest degree of social life and life ceremonial takes place.

The movement along the street is facilitated by special treatment of the corners. The cut corners represent visual statements of intersections or directions.

The street is a continuous visual experience by means of different widths, dynamic corridors, and static openings.

The street accommodates people and provides access to high-density forms of housing. Streets protect people from the strong sun; they cut the glare and produce variety of tones in natural lighting.

The streets are used for public as well as private purposes. There is a total mixture of uses. Merchandise is exhibited on the streets, citizens sit, children play, passersby stroll.

The street sequences of the parallel environments offer what I would call "the camera probe of urban design." There are views, vistas, limited vistas, and glimpses of views, plants, architectural details, sculptural perspectives which would make you "click" the camera, take a picture, keep the memory forever.

Along the streets of the parallel environments you'll find a scarcity of "green"; but wherever you find it, it will be treated in a respectful, holy way. A sacred love prevails for whatever is scarce.

People and animals move about the street. Architectural details are treated appropriately. Steps are narrow where private stairs meet the public street; corners are cut to facilitate and direct intersectional movement.

There is tremendous emphasis on details. Benches, fountains, planters, and chimneys are all well thought out and handmade, their forms developed in time.

The maximum is achieved through minimal means. Respect for what is there is demonstrated throughout the environments. The shade of an existing tree is exploited. Breezes are used to advantage. Every new decision is complementary to previous ones.

Topography

The parallel environments demonstrate similarities in the economy of means. This is most evident in their consistency in the use of topography. As a rule, buildings follow the contours of the land and obey to a continuous system of building, thus creating high-density situations. The continuous system of building was necessary for the initial need of fortification, but it had a side effect economies in construction. Another advantage of continuous building has to do with the conservation of land. Densed towns were built on hills and irregular topography; valleys and prairie land were kept for agricultural purposes. High-density, fortified-like towns are found in many of the environments compared. Cuenka in Spain, Mount Athos in Greece, and Mesa Verde in Colorado represent typical examples of these principles.

Family Structure

Other similar environmental forms have evolved out of similarities in social structure and life style and have to do with the correlation between the family structure and the urban form. Continuous patterns of physical development are logical formal results of the growth of an extended family. As families have grown, so have their houses, in a linear way.

Utilitarian Architecture

Utilitarian edifices often developed forms that appealed to people visually, and with the process of time these forms became part of life. The form of such a structure subsequently imitated in residential architecture generated new uses for the form. Such instances have been observed in the granaries of Mexico and in the "pigeonholed" structures of Greece. The form of the granaries of Santa Monica in Zacatecas, Mexico, inspired the forms of the kitchens of the residences of the neighboring village, while the pigeonholed farm structures of the island of Mykonos in Greece found a place in the more urban architecture of the island. A utilitarian structure for the use of pigeons evolved into a residential structure for the use of humans.

Other Common and Appealing Similarities

Other appealing similarities of the parallel environments are observable in social, economic, and formal issues. Among these similarities, the most important are:

1. *Social Life:* Ceremonial of life and life style habits have found their places in the streets and plazas. In fact, such activities have reciprocated the creation of appropriate physical areas where the activities may take place.
2. *Privacy:* There are two extremes as far as privacy goes. There is no privacy at all in some environments, such as the Greek islands or the Mexican villages; or there is privacy totally enhanced by physical solutions. In many Greek islands one's house is everybody's house, and "one's business" is "everybody's business" (thus the institutionalization of "gossip"). In African villages the privacy of the residence, especially the female quarters of the house, have created introverted forms of construction, fortifying privacy, and literally cutting off external life from life inside the house.
3. *Use of Materials:* Normally the materials used are extracted from the locality. Economy and textural continuity are the results of such practices.
4. *Similarity in Certain Functional Details:* T-shaped windows or T-shaped entrances are often found in the parallel environments. The need to enter the house while carrying a load of wood or a provision has generated the T form.
5. *Economy of Construction:* Human intuition, improvisation, use of natural protective elements, and the use of existing materials assembled from previous eras represent common characteristics of the concern for "economizing" in the process of environmental creation.
6. *Simplicity* of basic forms and *complexity* evolving out of the repetition of simple elements represent key characteristics of the parallel environments. The best examples of this are seen in the island of Skyros in Greece and Taos Pueblo in New Mexico. The total forms are extremely complicated wholes with very apparent sculptural qualities, yet the generic elements of this complexity, the individual residences, are extremely simple in their conception and construction.

7. *Simple massing:* The individual space possesses extremely simple massing; it is usually a cube demonstrating economy of interior space, and characterized by a variety of levels and built-in furniture.

8. *Element of the Accidental:* This is always present in the never ending, ever changing, organic urban forms of the studied environments.

9. *Treatment of Glare:* Glare is always faced as a problem. It is resolved in most cases either by breaking down the masses that cast shadows, which in turn cuts down the glare, or through the use of appropriate colors, such as beige stucco in the case of the Indian pueblos in New Mexico; the earthy colors absorb rather than reflect the light.

10. *Concern for Environmental Comfort:* This is achieved by the exploitation of existing breezes, slowing of heat absorption through the use of thick walls, and the heat-reflective coloring of the total environment.

11. *Inclusion of Non-Utilitarian Architecture:* The "metaphysical," "unknown," and "beyond our understanding" elements of life have buildings devoted just to them. The church, the shrine, the ikonostasis, the religious or pagan symbols are ever present in the parallel environments. The total environment is approached by its inhabitants in a spiritual way. The ultimate expression of the spiritual disposition takes place during annual or seasonal ceremonials. They are devoted to concepts of life and death, and they are serious as well as light-hearted. Formal religious, paganistic, and festive entertainment are all present in the parallel environments we have seen.

Closing Thoughts

. . . What have we learned from all this?

What have architects done to meet man's needs—to please man's spirit? Ask yourself. . . . Why would you select a Greek island, an Italian hilltown, a Mexican village, or an Indian village for your holidays, for your relaxation? Why select one of these parallel environments and not Jersey City? It is, after all, near New York. . . . I think we all know why when we make decisions for our summer holidays. . . . I can suggest a simple reason: places that attract us for our holidays are *attractive* places. Perhaps some of their "attractiveness" secrets ought to stay with us, and even become properties of our own architectural works. . . . Yes, I know, we must not imitate, just follow the principles. . . . The first principle of an "attractive" environment is *human scale*. Yet in our everyday lives we are surrounded by physical worlds which are alien to us. The office buildings, the skyscrapers, they are nothing but physical expressions of a socioeconomic superiority much bigger than most of us . . . the alien highway and the speeds on it. Both diminish our capacity for perception of the detail; we have no sense of where we

are. The landscape moves so quickly. With the speeds we go we cannot really see what is next to us; we drive through nonexistent environments.

. . . The geographic areas in which we spend our daily lives enlarge, but our environmental awareness shrinks. The only sphere in which we have some chance for human-to-human, or human-to-nature contact is the pedestrian one. Pedestrian life occurs in the neighborhood. Yet even there we are trapped.

. . . Past environments were experiences in choice. Spatial, activity, and ceremonial *diversity* were found in all of the parallel environments. No sophisticated technologies, no glittering materials, no aesthetic debate, no dilettante critics; just diversity and human scale. No hard answers, no tough solutions. Yet today, what a paradox! There is diversity, but in the industrial product. There is variety, but in the cleaning detergent; there is choice, but there is excess of it. Diversity, variety, and choice have gone into the supermarket, into the goods we consume. They have become the diseases of our century. We do not know how to decide what to select. The "future shock" that Alvin Tofler described in his book is with us today, and in the United States it is more evident than anywhere else. We live in a state of inability to decide, to select, to choose for ourselves; we live in shock because we have so many choices.

. . . Our environment causes an antithetical shock, the lack of environmental choice. There is a lack of places to be, and of physical choices. The industrial product and the diversification process have created uniformity of the very physical milieu where man lives. Yet, the non-durability of the man-made industrial product—from the toy to the motor car or the fountain pen—has transformed our physical environment into an industrial waste can. The pollution of our environment is with us, it is right in our *heads;* that is where it all happens.

. . . Maybe Oldenburgh's sculpture of a "screw" will very well immortalize for future generations the sickness of our minds, while the distant memory of a modest candle in the dark interior of a modest church someplace in the Mediterranean might make us think of poetry again. Think of the spiritual attitude in life, the attitude that modern man has lost. This might make us cry; then within our tears we might find again what we have lost. IT IS BETTER TO BUILD AGAIN FOLLOWING THE PRINCIPLES OF THE PARALLEL ENVIRONMENTS we have lost, than to let our present "technological" environment eradicate us from the face of the earth.

It is difficult to be pessimistic about the future when one sees the lessons of the parallel environments. It is important that we learn all we can from them.

Notes

1. First published in a different version in Antoniades, 1976, pp. 10–13.
2. Dr. Harry Anthony paper at the "National Issues Conference" on Conservation of Energy by Design. University of California-Riverside, October 2, 1973, pp. 7, 8.
3. Huxtable, 1976 (1), pp. D–1 and D–35.
4. See Norberg-Schulz. "Space is understood as a two-way process, a real interaction. 'Architectural space' is a concrete physical aspect of this process." *Existence, Space, and Architecture,* Praeger, 1971, p. 37.
5. For well-covered theory of the physical component of space and related design concepts, such as scale, rhythm, proportions, etc., refer to articles "Interior Volume" and "Exterior Volume," *Progressive Architecture,* June, 1965, pp. 155, 166. Also basic reference on the subject, S. Rasmussen, *Experiencing Architecture.*
6. Landmark reference for the study of above concepts which also suggests attitudes toward dealing with space: Paul Baker, *Integration of Abilities: Exercises for Creative Growth,* Trinity University Press, 1972.
7. See Norberg-Schulz, *Meaning in Architecture,* C. Jenks and G. Baird, eds., 1969.
8. This refers to concern for information on specific energy-saving devices (such as solar heating equipment currently popularized through magazines), yet not genuine concern for fundamental design principles which might affect energy conservation. E.g., *Popular Science,* March, 1975, p. 74.
9. Distinction is made here between *space* and *place:* space connoting "enclosure," "focal point," "end in itself;" place connoting "an end and a beginning," "a terminal and a distribution point." "Place" is referring to urban design cases. See K. Lynch, *The Image of the City,* 1960, p. 72. Also C. Norberg-Schulz, *Existence, Space, and Architecture,* op. cit., p. 39.
10. Kittridge, A. Wing, *Bandelier,* National Park Service, Historical Handbook Series, No. 23, Washington, D.C., 1955, reprint, 1961, p. 4.
11. R. Banham, *The Architecture of the Well-Tempered Environment,* Architectural Press, 1969, p. 23.

12. For discussion on the "scale" issue of the pueblos, see A. C. Antoniades, "Traditional vs. Contemporary Elements in Architecture," in *New Mexico Architecture,* November–December, 1971.
13. For information on the "people" of New Mexico (Indian, Spanish, and Anglo), refer to A. Paul Theil, *New Mexico, Dancing-Ground of the Sun,* Historical Society of New Mexico and School of American Research, Santa Fe, 1954, p. 10.
14. "Level of connotations" terminology was originated by the "semiologists." Refer to L. Straus, Piaget, etc.
15. *Schemata,* Greek term meaning "shape of things," was introduced to Anglo-Saxon architectural literature by C. Norberg-Schulz.
16. Characteristic activities of this ceremonial are witnessed in the Indian dances and the Mexican festivities (e.g., annual Fiesta in Santa Fe, religious ceremonies, etc.).
17. "Squares" is referring to the almost absolute square pattern of the individual rooms of the pueblo of Kuaua at Coronado National Monument. See A. Paul Theil, *New Mexico, Dancing-Ground of Sun,* Historical Society of New Mexico and School of American Research, Santa Fe, 1954, p. 31.
18. A good part of the development in this direction is reported by Jeffrey Cook, "The Varied and Early Solar Energy Applications of Northern New Mexico," *A.I.A. Journal,* August, 1974, p. 37.
19. Ibid., "Solar Building" by Stanley and Wright in Albuquerque, p. 38.
20. The first time the author heard the term "ethical" used to refer to energy-responsible architecture was by Texas architect, Frank Moreland, in a lecture pertaining to global issues of energy, University of Texas at Arlington, Spring, 1975.
21. Leach, Edmund, *Claude Levi-Strauss,* 1974.
22. Basic references for further study on the issues of parallel environments are the following: Rapoport, *House and Culture;* Goldfinger, M., *Villages in the Sun;* and Rudofsky, *Architecture Without Architects.*

Selected Readings

The book on the energy ethic has not yet been written. For the vernacular environments see note 22 above.

9

The Economics
of Architectural
Space and
Aesthetics

"Firmness, Commodity, Delight."

Vitruvius

"I believe that everyone should live in one big empty
space. . . . If you live in New York your closet should
be at the very least in New Jersey."

Andy Warhol

Architecture is a *commodity*. Without consideration for "space," there is no architecture. The economics of architecture and the concern for spatial creation should be considered simultaneously. Because of this, our discussion of the economic aspects of architecture is laced with the vocabulary of space. This was not the case in the past, and the issues of architecture and economics were considered separately.

Between the "Form follows function" of Louis Sullivan and the "New Eclectic License," in a sense, the New Freedom that underlines Post-Modern Architecture, lies thoughtless triviality and the "ugliest" physical reality in the world.[1]

"How many are the architects today who still consider their primary preoccupation to be the making of 'spaces' for people to live in? How many are the architects who mumble daily the word 'space', 'space', 'space', time and again, who have dreams of spaces to come, dreams of models of the projects on which they are working, dreams of the variations of light . . . of the sounds of their buildings? How many have nightmares and wake up to a reverberant ceiling of a yet unbuilt project still lying on the drawing boards? The list of question marks could go on forever. . . . Yes, but 'on money'. . . . Yes, 'Now you talk architecture'; the money, mortgages, interim financing, the whole package. . . ."[2]

If architects continue thinking that way they had better leave the concern for "space" to Andy Warhol.[3] Yet "space" *was*, and had better become *again*, the primary concern of all architects.

. . . If now the conceptualization and periodically developed directions of architecture represent an evolving dialectic between the currents of "functionalism" and "freedom" (all fads included here, be they conscious or unconscious), the conceptualization of "space" today, as seen in the work of many architects, seems to oscillate from the "absolute nonconcern" to the "nihilistic nothingness."[4] The former (absolute nonconcern) may be due to ignorance, lack of talent, incompetence in visualization, or nonavailability of a design methodology able to challenge the proposed "space" alternatives; while the latter extreme (nihilistic nothingness) is perhaps due to (seemingly sophisticated) oversimplifications of the problem statement of "space." In any event, either extreme of "space" treatment is often justified on the basis of the "*cost of space*," thus posing money in a catalytic way out to "spatial concern" and "spatial incompetence."

For the simplicity of the further argument, we should remind ourselves again, even at the risk of being redundant, that space has three visible dimensions. (One, of

Troglodytic habitation, Santorini, Greece.

course, should always be aware of "time," the fourth dimension of space. For the purposes of the inquiry on space/economics, time is not considered, as it does not have a tangible effect on the realization of space as the visible three dimensions do.) Indeed the three dimensions belong to the edifice we make. They define the quality of an enclosed space, the "*volumes of air inside, atmosphere, and feeling of the people in it*," as well as they define the remaining exterior "universe" for those outside the building. The concept of the edifice as a three-dimensional entity, as determinant (edge) of an interior "space" and an exterior universe, can very well be, for our purposes, a broad definition of the task of architecture. To improve the quality of the interior and enhance the impact of the exterior means undertaking additional tasks and disciplines which in the end further broaden and qualify the definition—and, for that matter, enrich the understanding of architecture (social, psychological, biological concerns,

etc.). Yet the fundamental and very generic concept here, in spite of the degree of qualitative sophistication, is the concept of the three dimensions. All complexities are eventually summarized in the three very old words: "plans," "sections," "elevations." These indeed are the tools of any "designer," but they become tools of an *architect* and produce *architecture* only through toil, suffering, and intellectual challenge. The qualitative differences between sets of plan-section-elevation alternatives eventually make a difference in the spaces created, and sometimes, if exhaustively thought out, they create an appealing optimum that deserves to be called *architecture.*

In situations where "toil" and "creative suffering" are replaced by the drive for quick profit returns, the product suffers. All qualitative arguments about "architecture" are displaced by the predominance of concern for monetary considerations . . . and there goes the architect's responsibility to "space" consideration.

An "ethic of space" is needed for the new breed of architects. This ethic should be based on the belief that space and economics can work together, and that economic considerations should not exclude concerns for space. This new "space" culture will have to come from "within" (starting with values of the existing systems),[5] rather than through reaction and abstract theorizing. To make the New Architecture come into being, architects need to start from scratch. They need to get back to the roots; to remember the discipline of student projects; to remember the requirements for *plans, sections,* and *elevations;* to develop curiosity; and to acquire knowledge on the issue of the "economics of architectural aesthetics" which is presented and argued here. One has to learn about the distinctions and relationships that exist between economics and space. The discussions of these issues would be the aesthetic of the architecture that considers economy, yet does not forget space. Some of the more obvious reasons this investigation is necessary are the following:

1. Surely enough, architectural space costs money.
2. The architecture student and the young practitioner today know very little about the relationships that exist between spatial design decisions and cost.
3. History of architecture as often taught in schools (if it goes any deeper than just presenting slides of "elevations" and distinguishing "styles") has presented to the student as examples of good architecture works that belong economically to the upper cost brackets. No reference is made to lower-cost buildings, nor is their aesthetic importance presented. The student graduates misinformed about this fundamental issue—that is, the relationships that exist between economics and aesthetics. For a number of years he then tries to achieve the "expensive" architecture, the kind he has been taught at school through the glossy illustrations of history manuals and architectural magazines. Often he ends up with unrealistic solutions and with frustrating experiences, till the moment comes when he succumbs to constructional and developers' demands for profit-making, yet uninspiring, architecture. By then he has become a Professional Architect.

4. The professional architect often argues that low budgets cannot produce good architecture;[6] this, of course is a fallacy and an easy way to justify spending a small amount of time in design.
5. There appears to be a correlation between architectural aesthetics and costs, and on that basis one might speak about "spheres" of architectural aesthetics, with each sphere corresponding to respective economics.
6. Contractors often claim that estimating is "their thing." Of course, it is true that in most cases they are more aware than the architects about current costs and about prices. Contractors, however, often base their designs (when they play the role of the architect, and this may be seen happening today in the greater part of the United States) purely on the economics of construction, placing only minimal emphasis on design (theirs is not a design profession), thus offering to the market economic assemblies of materials and spaces, having nothing to do with architecture.

There is a need to give attention to some of the above issues. Attention also should be paid to the general premise that "architectural space costs." There is a need, therefore, to analyze the rationale behind this thinking first, and then to develop the guidelines for the theory on the economics of architectural aesthetics. The reader should also be reminded that such inquiry has not been dealt with in architectural literature in the past.

Costs vs. Benefits. All costs associated with the making of architectural spaces are related to the benefits that are to be enjoyed by the user, the user being the client of the architect. These benefits range from financial returns, which may be of very short run and may represent the basic interest of a speculative developer, to the long-range returns: psychological, happiness, comfortable life, and efficient performance benefits. As it appears with this second category of potential returns, it is difficult to assign monetary value to the "comfortable life" or "happiness" benefit, thus we may safely speak about the "intangible" element which characterizes this kind of long-range benefit. Thus there are *tangible* benefits related directly to the costs of architecture, and there are *intangible* benefits also inherent in the same cost.[7] The latter category is the

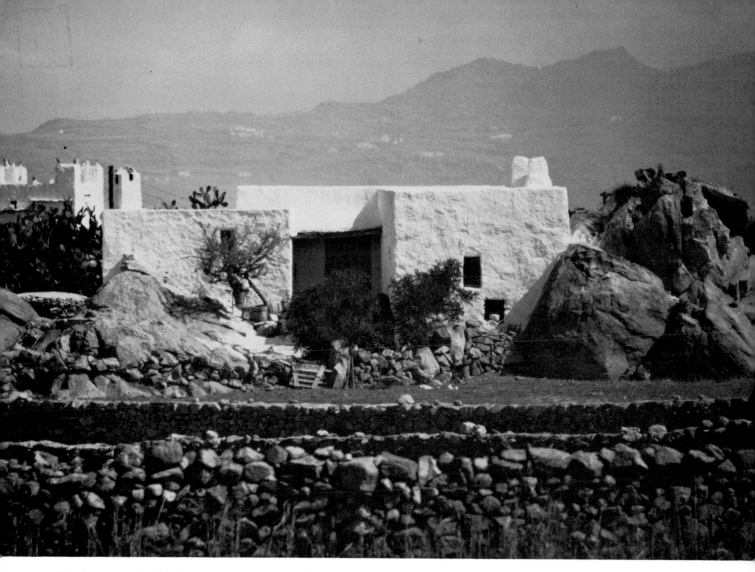

The "economics" of Mediterranean vernacular architecture. Rural dwelling on the island of Mykonos, Greece. (Photo by Chris Ferrante.)

one that makes the investigation of the economic aspects of architecture difficult, and it is exactly here where we should direct attention. So we may now safely say that, as far as user benefits go, the elements that constitute architecture are (some) tangible and (some) intangible. The tangible ones are these elements of "area" and "volume," and they can be quantified through direct reference to the plans, sections, and elevations of a project. These three documents offer direct information to the architect, the professional estimator, or the contractor, to "take off" and come up with the cost estimate. The intangible elements of architecture are not there to be seen by the contractor or the professional estimator; they are hidden or inherent properties of the design. They were, of course, in the mind of the good architect, and they are qualities which will be found later by the users or by an architectural critic. It might be said that the *intangible* elements of architecture are those which only an educated critic would find and

would be able to speak about; yet, in almost all cases, such critics would be unable to set a monetary value on these items. Let us examine some of the space-qualifying elements further.

Tangible vs. Intangible Components of Space[8]

Space becomes meaningful for architecture only when it creates "certain feelings," the ones which are demanded by the function (the user needs) and enhanced by the architectural solution. The dialectic between human beings and physical elements of space (the "fear," "ease," "coziness," or "the sublime") is determined by the success of the architect's concern for the appropriate proportions of the space and the quality of its scale (human vs. non-human scale situations). Proportion and scale are perhaps achieved easily through basic "linear" considerations of the space and can be seen in plans and sections; thus they represent tangible components. Rhythm, on the other hand

The "economics" of primitive architecture. Rural "pavilion" on the way to Acoma.

(and here one regards rhythm as "the time-space experience"), is a far more complicated issue, and most of its costs are intangible. Yet rhythm is the fundamental prerequisite for life and the type of life inside each space we make. Rhythm is related to the plans and to the sections which set the pattern for solids vs. voids succession in the three-dimensional sense, thus controlling the amount of light inside the "guts" of a building. An obvious extension to the above is that natural (as opposed to artificial) lighting may enhance space and may foster certain feelings, some stronger than others. The section in most buildings is more important than the plan as far as natural lighting goes; while the plan, especially a spread out one, may be treated by appropriate location of light fixtures. Special studies will deal with artificial lighting problems.

(A) The question of natural lighting in buildings may suggest sections that demand additional expenditures. The benefits to be derived by the user from the costs allocated for the realization of such sections are intangible. There

are no figures at the moment to suggest the economic benefit to be derived in the long run by a space that provides light-diversified space and spirit-enhancing lighting through the section. Natural lighting, therefore, represents an intangible element for purposes of cost vs. benefit considerations of space. This means that we are unable to measure in monetary terms the benefits which will be enjoyed in the future by our present decision to use the light-enhancing section as opposed to sections that do not offer this possibility.

(B) *Height of space:* The height of space to be used represents another element whose benefit to the user, in the long run, cannot be measured monetarily. The relative height of a space is directly related to man and, together with all other elements of architecture, promotes feelings of comfort or not. An individual may feel comfortable or depressed, cozy or familiar, relaxed, or even afraid, claustrophobic, etc.—depending on the linear relationships that

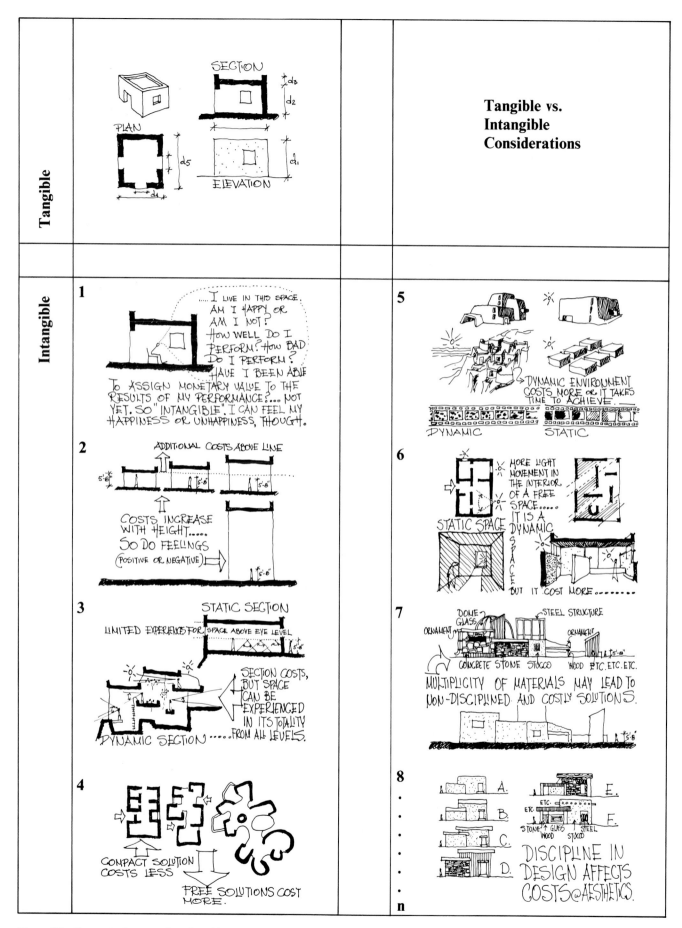

Figure 20. Concept of economics of architectural aesthetics

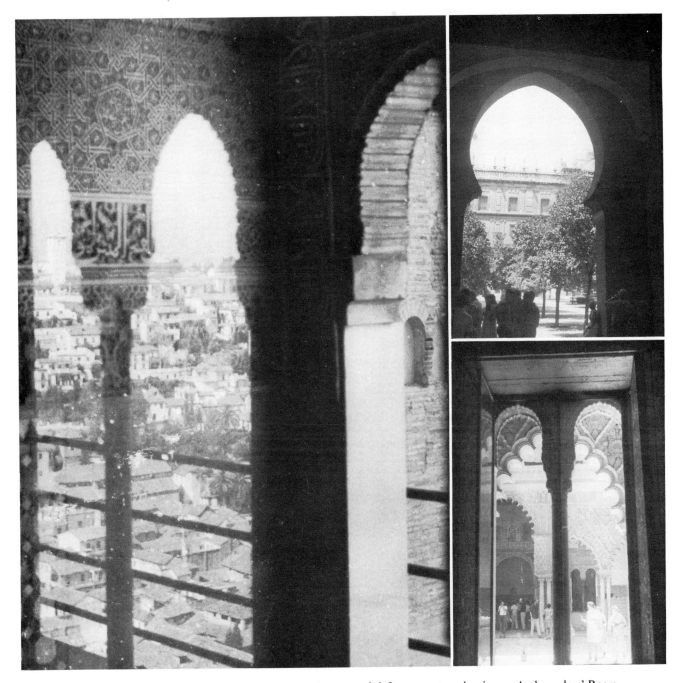

A symbolic photo of architecture which produces an internal space and defines an external universe. Ambassadors' Room, Alhambra, Granada, Spain.

Internal space—external universe.

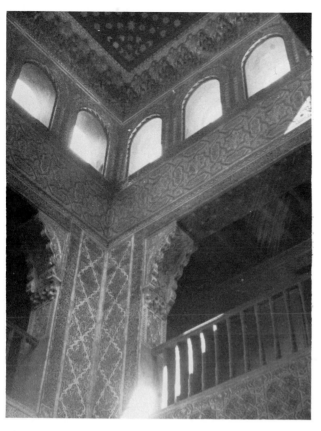

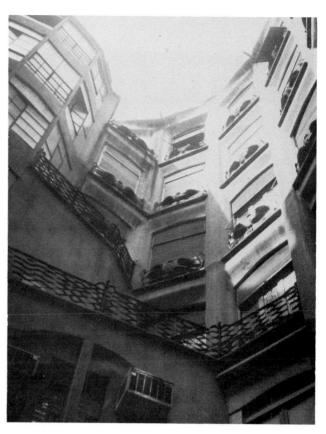

Light and section, the generic elements of interior space. Alhambra, Spain.

Natural light, from generous-on-height, free space. Casa Mila ("La Pedrera"), Antoni Gaudí, Barcelona.

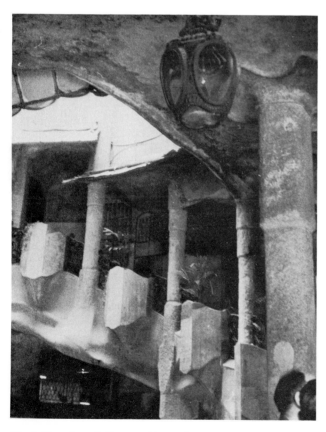

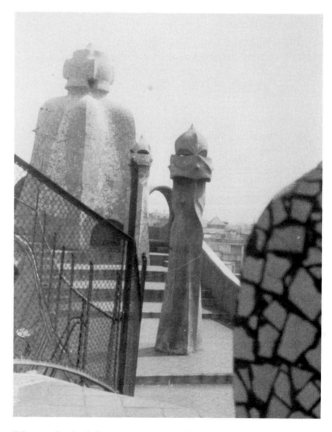

The lobby of spatially magnificent Casa Mila, Antoni Gaudí, Barcelona.

Diamond principle; arrangement of terrace elements. Casa Mila, Antoni Gaudí, 1960–1910.

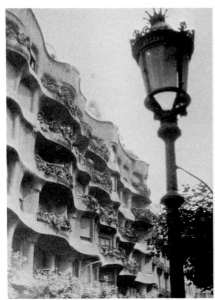 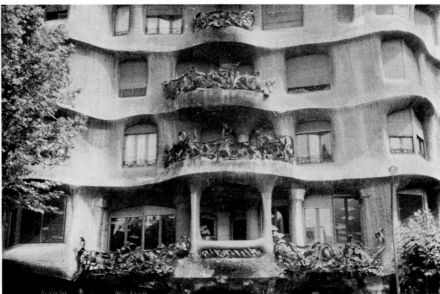

Diamond principle. Casa Mila, Barcelona, Antoni Gaudí, 1906–1910.

exist between the height of the space and himself, as well as on the lighting of the space in which he is. There is a feeling we experience in a low-ceilinged adobe house and a totally different feeling we experience in the lobby of a big hotel, or, to use a contemporary example, the feelings we get in the enclosed, paradiselike lobby of the Ford Foundation Building in New York City. In the first case, the adobe house will probably make most of us feel cozy, comfortable, and at home; the feeling is one of security and individual serenity. In the last case, in the height of the space of the lobby garden, our bodies are but details; we feel ecstatic, we wonder, we feel different.

The feelings we experience in each of these settings are necessary for the architectural success of each edifice. Each edifice enhances the requirements of the client by creating appropriate feelings in the users. The adobe owner expresses his hospitality by having a house that makes his guest feel "at home," comfortable, and secure. The exaggerated height of the Ford Foundation Building lobby implies that the initial expenditures for the creation of the universal space of the lobby will pay in the long run by promoting, through the feelings created by the architecture, the image of the establishment. Other subsequent buildings which create similar "certain feelings" are the Hyatt Regency Hotels in Houston, Atlanta, and San Francisco; but the initial feeling there is "scariness' rather than "sublime."

(C) Continuous spaces and clerestories may cost more than cellular solutions and single-story edifices. In cases of free plan one may suggest the argument that the project will cost less, since there are initial savings in partitions. This would be true if one were not faced with problems of environmental maintenance. The attempt to beat the costs of continuing space may in the long run make continuous space more expensive. Yet continuous space is the kind of space that permits dynamism in the interior of an edifice. In the case of natural lighting, the continuous space is in total movement; this is caused by the constant movement of the sun, and it is permitted by the discontinuity of solids of the edifice. (Discontinuity of solids and continuity of voids is what permits the realization of continuous space.) The dynamism of such space may be demonstrated with the use of lapse photography. A sequence of photos at well-established time intervals may be animated into film where the shadows will constantly move and will perform "dances" of antithesis on the screen. A cellular space does not permit such "dancing." Dynamism is the strength which an architect imposes on his work to animate the space; thus one can suggest that dynamism is a good thing. So we might say here that "dynamism" is a very expensive thing to achieve, since, in this case, it may be achieved by means of open plan and continuous space which, as we have pointed out, are expensive to build and maintain—especially to maintain.

(D) Sculptural articulation of edifices, and elevations emphasizing very distinctive articulation of elements are more costly than static ones. Here we are confronted again with the issues of dynamism, but from the urban townscape point of view. From urban design's concern, one elevation of a building visible to the street or plaza may be

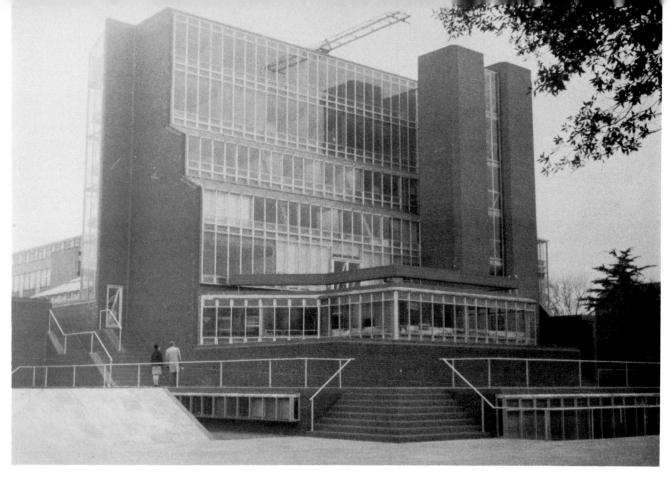

Medallion principle. History faculty building, Cambridge University, England. James Stirling, Architect, 1969.

more stimulating than another. To demonstrate "stimulation" we will again consider an experiment in lapse photography. The sun hitting the various masses of a building distinctive for the articulation of its masses moves in a more dancelike way in the animation of the photographs, while it moves "evenly" and in no dancelike way in the case of a building that is the result of one mass and has one solid elevation. What the layman often condemns as a "box" is this type of building which in our lapse photography experiment would not result in new excitement; it would be what we might call a *static* building. In many cases in hot climates with bright sun, static buildings cause glare and thus are even functionally undesirable. There is a great difference in cost between the box or static building and the building that is articulated in its masses or dynamic from the townscape point of view. All other factors kept the same—material, volume, area—the former building would be much cheaper to build than the latter. The reasons are numerous: less special attention to the layout of the first, less specialized attention to the various joints, and fewer total working hours spent designing and establishing the various grades, both in plan and section. Thus the static building will cost less, while the dynamic will cost more. There is no way to estimate the benefit enjoyed by the community in the long run by the existence of buildings that possess dynamism and, therefore, offer stimulation to the citizens, as opposed to static, nonexciting, nonstimulating buildings.

(E) Different levels in "section." The descriptive document of "section" is the main drawing which tells the final word about the success of an architectural work. (The author is one of very few architects who believe this, and he preaches it in his teaching of design.) The section not only tells us about the lighting of the space and gives meaning to the plan, but it also permits us to get at different levels (if it possesses such levels), thus creating for us more possibilities for the perception of the space, offering us more perspectives, and enhancing the interior visual pleasure. A section possessing levels offers exactly what the "hill" offers the Italian hill town and the Greek islands; it gives meaning to the roofscape, it gives meaning to the chimneys, it gives meaning to every built part of the environment. (It requires coordination, artistic attitude, quality in everything.) A strong section with various levels is the ultimate exploiter of the visual experiences that can be offered by the interior of a space. Plan alone does not constitute architecture, because it never gives us the real feeling of the space. Plan and section and, to go one step further, *section with levels considered together* do it; they do it to the extent that the section is for some architects even more important than the plan. Some architects start their design process with the consideration of "section."

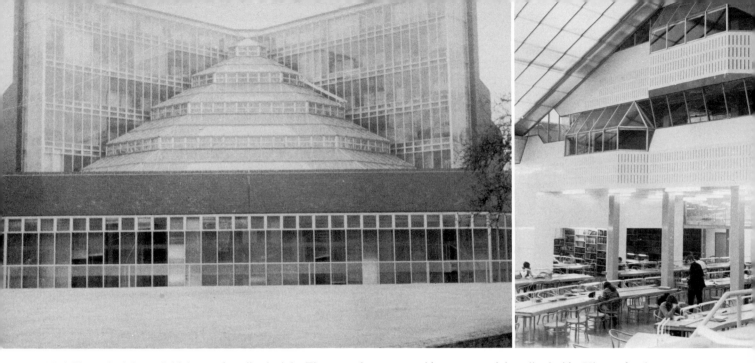

Medallion principle; or "chicken and egg" principle. The neutral masses outside create spatial quality inside. History faculty building, Cambridge, England. James Stirling, Architect.

The reality implication and the righteousness of this approach to design is, in my mind, the following: man stands up more of the time and has more understanding of height and the relationships of elements of space to his eye-level. He spends less time lying down and is, therefore, less aware of relationships in horizontal or in perspective. (We can estimate height more easily than we can estimate distances.) Section is a drawing that relates to the law of gravity. Most people who accept gravity as self-evident reality do not deny the 90° system of coordinates of sections (verticality), while very often they deny this system in plan, and do the best they can to deviate from it.

So, as section is very important and the designer is aware of it, a more interesting section—more levels at the appropriate parts of the plan, light relationships among parts and to the eye level—may produce more expensive solutions than architecture with a section that has minimal variations. The excess costs are usually due to construction complications, flashing, and turning details. Of course, if the section is combined with "clerestories," the expenses of height are added, thus making architecture which possesses "involving" sections more expensive.

(F) Free, noncompact solutions are more expensive than compact solutions. There is not always reason for compact architectural solutions. The life style or the desire for change in life style may suggest that solutions of open plan and site arrangements are more appropriate than compact solutions. This desire, however, is confronted with the implications of the cost of such solutions. Open plans cost more. They require more linear footage for their foundations, while additional expenses must be contributed for thermal insulation of the walls, since there are more exterior walls. In a compact plan the adjacent spaces act as insulators for the others, while in an open plan there is more contact with the exterior. So once more we see that the free plan, which may be valuable for the salvation of a family (e.g., give the son separate quarters with private entry, etc.), the salvation of a marriage, etc., and, therefore, might bring great benefit to the family in the long run, is as a rule more expensive than the compact solution.

(G) Landscaping and exterior walls. In many cases the landscaping or certain exterior walls which might define exterior patios or other features of the site are seen only in the model, because they are omitted in the realization of the project (maybe to be added sometime in the future). Landscaping *costs,* there is no doubt about it, but the long-run intangible benefits which would be enjoyed are lost forever when landscaping is not done. The community picture is inferior by practices of inferior landscaping; the identity of the owners' edifice suffers; and, of course, the great benefit of privacy is lost when exterior walls are considered luxuries and the additional expenditures for them are never made.

In the presentation above we discussed a few of the economic considerations in architecture. Of course, we did not get into the issues of the materials, durability, and soundness of construction; nor did we enter into the intricate, yet extremely real, issue of financing, which has no small influence on the aesthetics of architectural spaces. Aesthetics, however, is a concern for the architect and should always be. Architects represent a force which, though small, provides the necessary element for balance between economics and aesthetics. Architects and architectural students should be aware of the very basic issues we discuss here. No solution should be attempted without

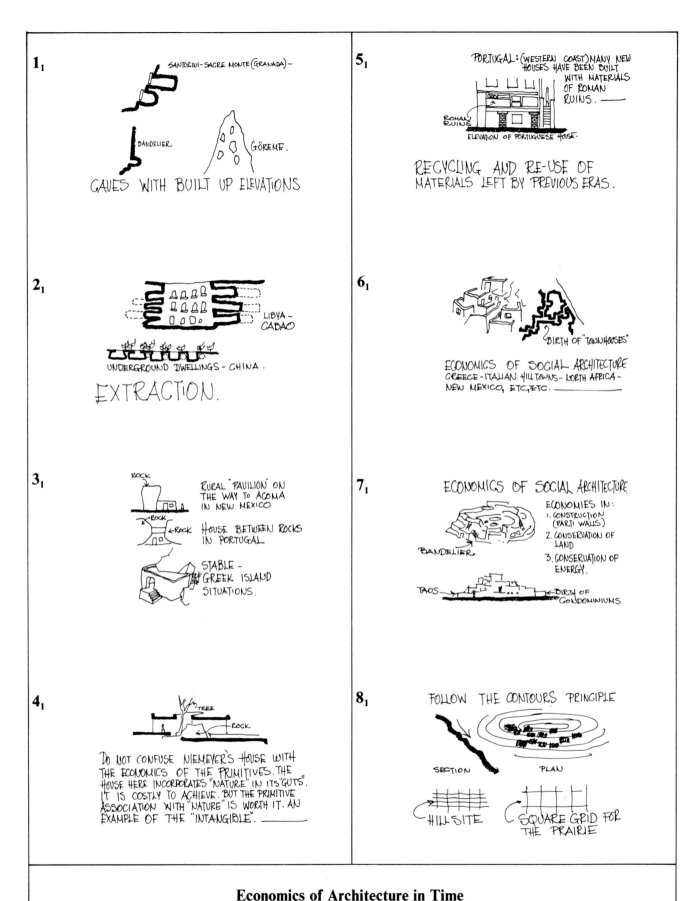

Economics of Architecture in Time

Figure 21. Economics of architecture in time

knowledge of the aesthetic limitations imposed by certain economics. It would be futile to design solely on the basis of absolute aesthetic concepts in a cultural environment where "money concern" may eventually kill aesthetics, while it is architecturally immoral to build "for money" and forget about space, aesthetics, and architecture. One therefore should always bear in mind the relationship that exists between aesthetics and economics. Study of the economics of architectural aesthetics shows us that there are spheres of aesthetics related to different levels of economics, and that there is an optimum aesthetic for each economic bracket.

Spheres of Architectural Aesthetics

Indeed the evolution of man's shelter can be very well traced through the prism of "economy." The whole process of architecture from the cave dwelling to the contemporary technologically achieved and controlled environment can be viewed solely as an economic act—by which man has tried to do what he could in the most efficient way. We can speak of the no-budget cave architecture (no budget in the short run, but long-run negative benefit: unhealthy environment, man dies young). We can speak of the relatively costless architecture that was created through extraction (man-made troglodytic dwellings). We may speak of the popular architecture that utilizes any available natural formation as part of its edifice, thus cutting the costs of one or two walls. And we may speak of the low costs of all vernacular architecture that develops its buildings in time, utilizing the labor and design services of the user, and borrows feeless solutions from the wisdom of tradition. Then the historical survey brings us to the present when the economic morality unfortunately surpasses the architectural.

In an attempt to requestion the issues and to perhaps foster concern for meaningful design, one can suggest that there are today, as perhaps there always were, three very basic spheres of aesthetics from the economic point of view. Instead of calling them "budgetless," "controlled budget" (constraint budget), and "low budget," one could rather approach them as aesthetic spheres one, two, and three.

In the aesthetic sphere one, one may completely and arbitrarily include all the rules of abstract and absolute aesthetics. It is only in this sphere where all desirable elements of architecture may be utilized and exploited—space, light, height, section, levels in the space, open plan, continuity of space, dynamism, best-suited materials, elegant furnishings, fine detailings, etc. It is only in the architecture which knows no economic constraints that such elements may be used, properly investigated, and accordingly utilized. It might be appropriate to call this sphere of architectural aesthetics, the aesthetics of the "*integral diamond*." The building of that sphere is like the big whole

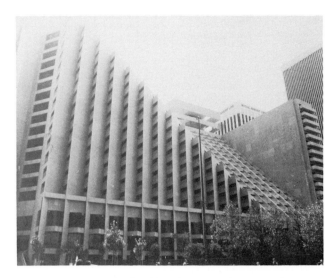

Regency Hyatt Hotel, San Francisco. A rather neutral exterior, 1975.

diamond, that is, the integral, uncut, but pure, rich, and glittering diamond. Great examples of architecture through history and "affluent" architecture of today represent works of this aesthetic category; Hagia Sophia, the Ford Foundation Building, and the Guggenheim Museum belong to this sphere.

In the other spheres of aesthetics, that is, in those where the economic issue is at stake, it will be up to the architect to decide what spatial and emotion-creating elements to use and where. These spheres of architectural aesthetics are usually more difficult. Here the architect must be in constant touch with reality, and he (or she) must exercise selective discipline in deciding which parts of the building ought to be spatially emphasized, and where these well-balanced spatial situations should be located. It is this kind of architecture which can be called the "*necklace*"-principled architecture—a building, or a group of buildings, where the "diamond" has been cut and has been set appropriately in the plan. We have little pieces of the diamond and the chain; the "diamonds" are the more expensive parts of the building complex, while "the chain" is the supporting spaces. Most of the good cases of European and American architecture are of the necklace nature. Architects here, by knowing the economic implications of their design decisions, exercise control in their designs and optimize the intangible potentials of space only at the strategic parts of their buildings. The parts with superior spatial treatment are most logically the areas of buildings assigned to public functions—the entrance halls and lounges, or areas of special ceremonial or symbolic significance.

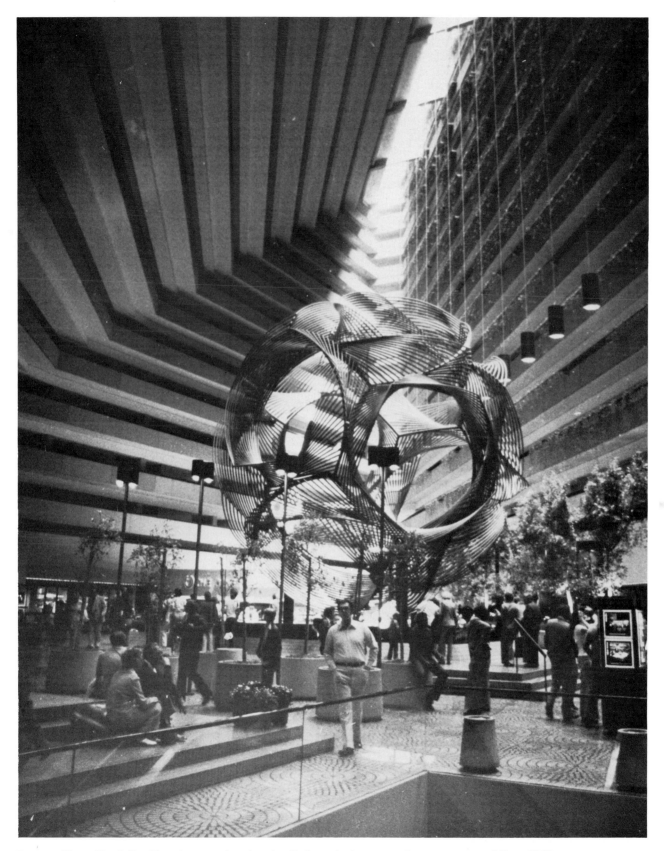

Regency Hyatt Hotel, San Francisco; a unique interior. Perhaps the best case of contemporary sublime, 1975.

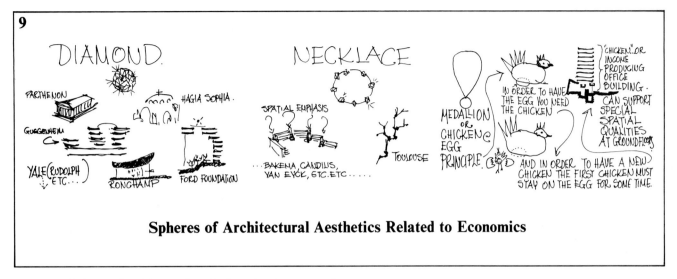

Figure 22. Spheres of architectural aesthetics related to economics

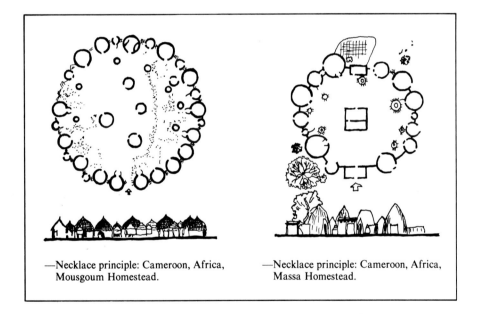

—Necklace principle: Cameroon, Africa, Mousgoum Homestead.

—Necklace principle: Cameroon, Africa, Massa Homestead.

Figure 23. African homesteads

Gems in Architecture
Form Classification

Curvilinear				
Sydney Opera House, Australia	Pilgrimage Chapel, Ronchamp	T.W.A. Terminal, Kennedy Airport	Olympic Stadium, Tokyo	Dulles Airport Terminal, Washington, D.C.
The Coliseum, Rome	S.R. Guggenheim Museum, New York	Kimbell Art Museum, Fort Worth	Kalita Humphreys Theater Center, Dallas	Toronto City Hall, Canada

Rectilinear				
Stepped Pyramid, Saggara, Egypt	Pennzoil Building, Houston	Transamerica Building, San Francisco	International Conference Hall, Kyoto	Baltimore Theater, Maryland
Parthenon, Athens	Bass Residence, Ft. Worth	Larkin Building, Buffalo, N.Y.	Carpenter Center, Cambridge, Mass.	Seagram Building, New York

Figure 24. Gems in architecture

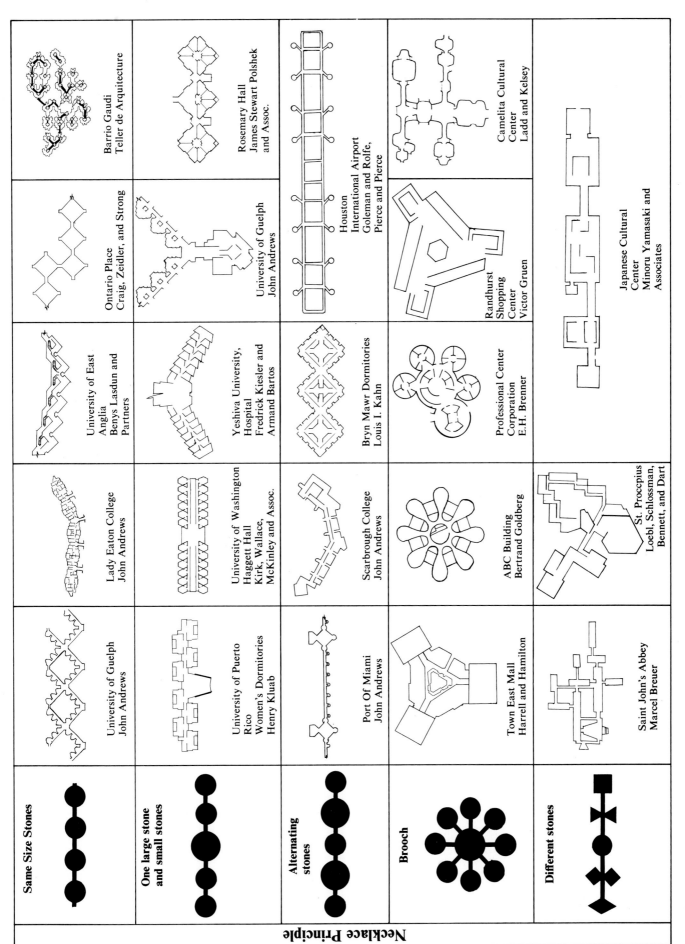

Figure 25. Necklace principle

Necklace Principle					
Same Size Stones	University of Guelph John Andrews	Lady Eaton College John Andrews	University of East Anglia Benys Lasdun and Partners	Ontario Place Craig, Zeidler, and Strong	Barrio Gaudi Teller de Arquitecture
One large stone and small stones	University of Puerto Rico Women's Dormitories Henry Kluab	University of Washington Haggett Hall Kirk, Wallace, McKinley and Assoc.	Yeshiva University, Hospital Fredrik Kiesler and Armand Bartos	University of Guelph John Andrews	Rosemary Hall James Stewart Polshek and Assoc.
Alternating stones	Port Of Miami John Andrews	Scarbrough College John Andrews	Bryn Mawr Dormitories Louis I. Kahn	Houston International Airport Goleman and Rolfe, Pierce and Pierce	
Brooch	Town East Mall Harrell and Hamilton	ABC Building Bertrand Goldberg	Professional Center Corporation E.H. Brenner	Randhurst Shopping Center Victor Gruen	Camelita Cultural Center Ladd and Kelsey
Different stones	Saint John's Abbey Marcel Breuer	St. Procopius Loebl, Schlossman, Bennett, and Dart	Japanese Cultural Center Minoru Yamasaki and Associates		

Necklace principle. East Anglia University. Denis Lasdun, Architect, 1968.

The "necklace"-principled architecture is usually fit for linear buildings, for horizontal expansion. In high-density situations and in vertical morphologies, the "necklace" becomes a special *medallion* with tiny precious stones featured as the climax of the work. The little stone, the little bit of the diamond, the cross or the Star of David, is supported by a neutral and inexpensive chain; but it is still there, making its point. In similar ways, high-rise buildings, where the monetary issue is again at high stake, should have their well-carved or spatial excitement. This can be in the areas where public activities occur and public functions could support qualitative spatial situations. The "necklace" and the "medallion" types of buildings are those for which the architect must be prepared to spend sufficient time in design, investigating a number of designs and constantly getting cost estimates, so that he might eventually achieve the optimum design for the relative economics within which he works. Both above types of architecture belong to the aesthetic sphere number two.

This middle sphere is where the conscientious and talented architect is checked. It is not the first, the no-economic-restriction sphere (Very few will ever have such commissions!), nor the last, the low budget—no-space-concerns sphere (Look around!), but the middle sphere which is the sphere of *discipline* and the one in which we should be trying to achieve excellence.

The last sphere is the worst. It is bad architecture, and it should not be the ambition of anyone.

Postscript

The thoughts suggested here and the point of view presented just "scratch the surface" of one of the most untouched subjects of the architectural profession and of architecture as art. It is the authors' belief that the architect does not need more research or further formal knowledge of cost estimating. The products and materials multiply very quickly; the cost of each building item changes very fast and unevenly. The architect needs a design ethic (which is totally different from the professional ethic as understood by the AIA), and he needs theory and training in design through well-documented examples of the relationships that exist between architectural aesthetics and economics. Research on the subject is now progressing.[9] Further research is needed so that we might soon produce the necessary concrete foundation for a future theory of the economics of architectural aesthetics. Meanwhile, one could suggest that architects stop, look back, and perhaps ask themselves if they are doing what they are doing in a proper manner.

Notes

1. "Ugliest" reality does not, of course, refer to the "architecture" presented by the architectural magazines; that "architecture" represents the "exceptional" reality and an insignificant minority of the total environmental image.
2. Attitudes too familiar to all practitioners currently striving for survival.
3. Andy Warhol, "Secrets of My Life" in *New York* magazine, March 31, 1975, p. 41.
4. "Nihilistic nothingness" is the author's label for what is currently fashionably promoted and termed as "minimal" architecture; e.g., Houston Art Gallery, Pennzoil office complex in Houston, etc.
5. Commendable attitude on the above issues was presented in a recent profile of John Portman in *A.I.A. Journal.* ". . . When I go to Wall Street I put on a Brooks Brothers suit and slick my hair down. I never talk about aesthetics. I talk to them on their own level: business shapes architecture." *A.I.A. Journal,* April, 1975, p. 60.
6. Research project on the "Economics of Architectural Aesthetics: The Dallas/Fort Worth Case," including complete bibliography on subject. University of Texas at Arlington, 1974.
7. The terminology of tangible and intangible as related to costs vs. benefits of physical development is accredited to urban economist, Dr. Nathaniel Lichfield; thus it is introduced to architectural theory here via the theory of urban economics.
8. All sketches by the author. Table A–3 (house between rocks in Portugal) and Table A–5 (Recycling and re-use of materials left by previous eras), from photographs in Portuguese publication, *Architectura Popular em Portugal.*
9. Author's personal research at the University of Texas at Arlington, currently in progress. For general bibliography on the subject, refer to Antoniades, "Economics of Architectural Aesthetics: The Dallas/Fort Worth case."

Selected Readings

The book on the subject has not yet been written. See above references for further research.

10
Creating Architectural Space

The "space" of today has evolved unburdened from the static two-dimensional handicaps of the past. The lessons of Bauhaus functionalism, Miesian "neo-Palladianism,"[1] and Corbusian "plan supremacy"[2] seem to have been digested and to belong in the past. New interpretations are now at hand in three dimensions. Architects have acquired confidence in their role as space makers. A new[3] architecture of spatial dynamism is now being practiced, and there are numerous buildings to prove it. The samples of "didactic" excellence suggest that the spirit of "space" making is currently alive and thriving. This positive trend should be noticed and continued. The fears[4] and processes suggesting the contrary should be eliminated. The struggle for the evolution and improvement of the currently observed spatial excellence is difficult and laborious, but it must be continued by all means.

Here we present a summary of the current state of the evolution of architectural "space." Further discussion will elaborate on these issues:

1. The ambiguity and incomprehensibility of today's great space makers as to their conception and didactics of space support the need for bringing the space issue into focus and indicate the need for systematic theory.

2. The spaces of the recent years suggest a trend toward three-dimensional boldness analogous to the two-dimensional concept of Miesian "goodness," oscillating between the spatial vocabularies of Frank Lloyd Wright and Paul Rudolph.

3. Current directions of architectural education suggest that a new, spatially relevant design process is necessary to guarantee the development of the positive "spatial" trends as opposed to the prevailing two-dimensionality of recent Post-modern collages of historicist iconography.

Toward a Theory of Space

It is perhaps ironic that when most of the great "space makers" of today are confronted in public with questions on space, they either claim ignorance, state a personal doctrine, or become totally incomprehensible. When Philip Johnson was once asked during an interview a question about scale as a major "space" component, he replied, "We don't know what this is, do we?"[5] It also has been noted that I.M. Pei, the advocate and creator of spatial monumentality, professes the doctrine of *simplicity* as his sole didactic answer to "space" questions.[6] This answer can hardly teach the inquiring student, the architectural journalist, or the layman (who *could* just be a developer). Louis Kahn, the most esoteric space maker of recent times, with

his poetic ambiguity, almost always rendered himself incomprehensible for the uninitiated student and the general public.[7] Paul Rudolph, one of the most prolific space makers to day, perhaps fortifies the secrets of the art by being totally metaphoric[8] when he discusses or writes about the "spatial principles" of his schemes. It is my suggestion that the professed ignorance, poetic ambiguity, and metaphoric talk indicate the sacredness of the concept of space in the minds of these great masters.

One is inclined to believe that Le Corbusier's tendency to emphasize the importance of the plan to the neglect of the space-maker section was similarly rooted in the sacredness he vested in the concept and in the word *space*. In spite of his reverence for the ancient Greeks[9] rather than the space-maker Romans, Corbu became an undeniable space maker himself, a Greek and Roman at the same time. The sections of his buildings reveal unsurpassed interior enclosures. In his works at Chandigarh he integrated interior space with exterior universe in highly controlled ways. Ronchamp represents another jewel of spatial excellence. His Shodan House in Ahmedabad, India, was perhaps the first example of the great vocabulary of the "Swiss cheese type"[10] of space making. Perhaps it was Corbu's great ability with the sketches of spatial fragments that always accompanied his ideas that made him neglect, in talks, the importance of his sections and glorify only the plans. Another reason was perhaps that Corbu never taught architecture formally; thus he never tried to analytically systematize and present in applied design terms the secrets of his space-making process. Perhaps it was professional secrecy that kept him from talking, or perhaps it was his attitude that space making was not difficult for the others, because it was never difficult for him as he was born a space maker. Finally, it could have been Corbu's obstinate reaction to the Cubists, who, though nonarchitects, were the first to state an architectural problem and to suggest the time element in the representation or appreciation of space.

The incomprehensibility of space theory as presented by the writings and the few public lectures of the great space makers themselves, and the discrepancy that currently exists between the practice of good architecture and the directions of architectural education make extremely relevant the assessment of the spatial creations of the recent past and the need for a refreshed systematic theory for the future. Those who have built the spaces of the last twenty years received their education and their "feel" for space through the skill-emphasizing methods of the Bauhaus (not in themselves space makers) and architectural theoreticians who emphasized three-dimensional concepts. The student of the previous decade got his education largely by analytical, socio-behaviorally oriented theoreticians who were devoid of skill discipline and who often arrogantly disregarded sketching and design. The

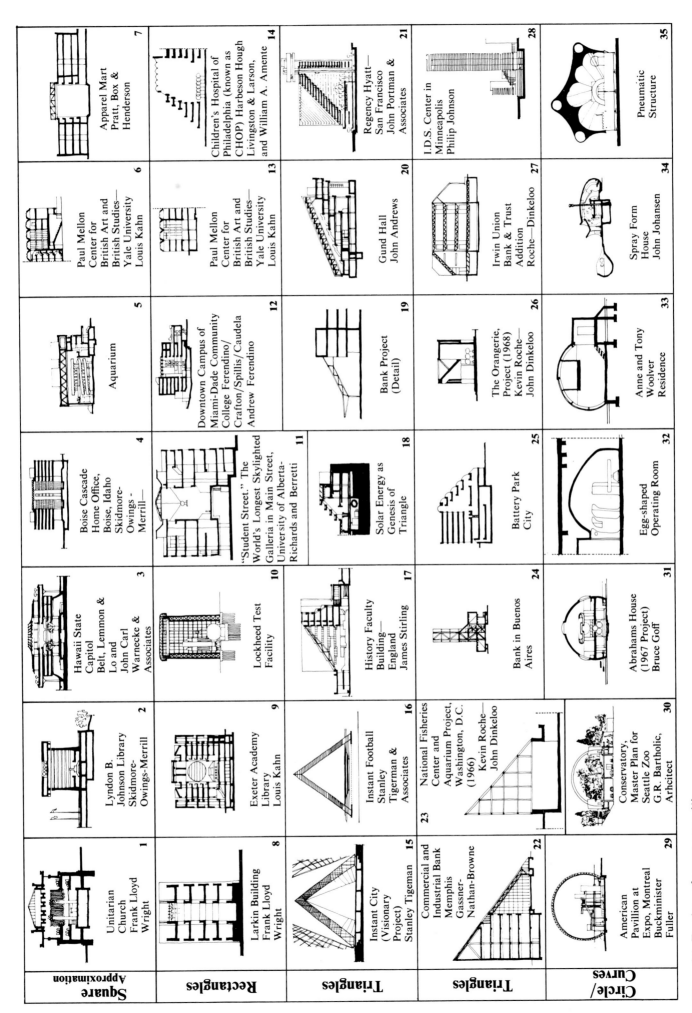

Square Approximation	Rectangles	Triangles	Triangles	Circle/Curves

Square Approximation

1. Unitarian Church Frank Lloyd Wright
2. Lyndon B. Johnson Library Skidmore-Owings-Merrill
3. Hawaii State Capitol Belt, Lemmon & Lo and John Carl Warnecke & Associates
4. Boise Cascade Home Office, Boise, Idaho Skidmore-Owings-Merrill—
5. Aquarium
6. Paul Mellon Center for British Art and British Studies—Yale University Louis Kahn
7. Apparel Mart Pratt, Box & Henderson

Rectangles

8. Larkin Building Frank Lloyd Wright
9. Exeter Academy Library Louis Kahn
10. Lockheed Test Facility
11. "Student Street." The World's Longest Skylighted Galleria in Main Street, University of Alberta-Richards and Berretti
12. Downtown Campus of Miami-Dade Community College Ferendino/Crafton/Spillis/Caudela Andrew Ferendino
13. Paul Mellon Center for British Art and British Studies—Yale University Louis Kahn
14. Children's Hospital of Philadelphia (known as CHOP) Harbeson Hough Livingston & Larson, and William A. Amente

Triangles

15. Instant City (Visionary Project) Stanley Tigerman
16. Instant Football Stanley Tigerman & Associates
17. History Faculty Building—England James Stirling
18. Solar Energy as Genesis of Triangle
19. Bank Project (Detail)
20. Gund Hall John Andrews
21. Regency Hyatt—San Francisco John Portman & Associates

Triangles

22. Commercial and Industrial Bank Memphis Gassner-Nathan-Browne
23. National Fisheries Center and Aquarium Project, Washington, D.C. (1966) Kevin Roche—John Dinkeloo
24. Bank in Buenos Aires
25. Battery Park City
26. The Orangerie, Project (1968) Kevin Roche—John Dinkeloo
27. Irwin Union Bank & Trust Addition Roche—Dinkeloo
28. I.D.S. Center in Minneapolis Philip Johnson

Circle/Curves

29. American Pavilion at Expo, Montreal Buckminister Fuller
30. Conservatory, Master Plan for Seattle Zoo G.R. Bartholic, Arhictect
31. Abrahams House (1967 Project) Bruce Goff
32. Egg-shaped Operating Room
33. Anne and Tony Woolver Residence
34. Spray Form House John Johansen
35. Pneumatic Structure

Figure 26. Typology of recent space (1)

Trapezoids

36 Musee Du XXᴱ Siecle Le Corbusier

37 Guggenheim Museum Frank Lloyd Wright

38 State Health Department Wittenberg, Delaney & Davidson, Inc.

39 North Edge of Metropolitan Museum in New York—Dendur Wing Kevin Roche—John Dimkeloo

40 Boston Public Library Philip Johnson

41 Town East—Dallas, Texas Harrell & Hamilton

42 Galleria Post Oak: Neiman-Marcus Hellmuth, Obate & Kassabaum, Inc.

Challenge To the Square

43 Challenge to the Square

44 Dance Instructional Facility, State Univ. of New York, Purchase, New York Gunnar Birkerts

45 Valley Curtain Project for Colorado Christo

46 Synagogue (Project) Neumann and Hecker

47 Control and Choice 1967: An Environment of Responsive Systems Archigram

48 National Park Headquarters Ronald Giurgola

49 Price House and Clubhouse (1965 Project) Bruce Goff

Combinations Or the Oceanliner Continuity

50 Newport Beach House Rudolph Schindler

51 Marseille Block Apartments LeCorbusier

52 Paul Rudolph's Office, New York City Paul Rudolph

53 Rubin Residence, Martha's Vineyard Peter Anthony Berman

54 Olivetti Complex in Tokyo Kenzo Tange

55 Tougaloo College Library Gunnar Birkerts & Associates

56 Berkeley Art Museum Mario I. Campi & Associates, in Design Partnership with Mario Ciampi Richard Tobasch and Ronald Wagner

Inter Penetration

57 Cross Section through the Center of Cumbernauld New Town Geoffrey Copcutt

58 Forum 303—Arlington Texas-Harrell & Hamilton

59 Brokers Office Booth & Nagle (Chicago)

60 Manhattan Community College Caudill-Rowlett-Scott

61 Columbia New Town—Mall Cope & Lippincott

62 Galleria Houston

63 Mix-use Development in Boston Cambridge Seven

64 The Courts of Justice, Chandigarh Le Corbusier

65 Habitat—Montreal, Canada Roshe Safdie

66 Golden Mile—Singapore Design Partnership of Singapore Architects

67 Habitat Puerto Rico Rosche Safdie

68 Rochester's Southeast Loop Park

69 Park Central Denver Muchow Associates—George Hoover

70 Special Transit Land-Use District for new Second Avenue Subway Raquel Ramat,- Ada Karmi Melamede

Figure 27. Typology of recent space (2)

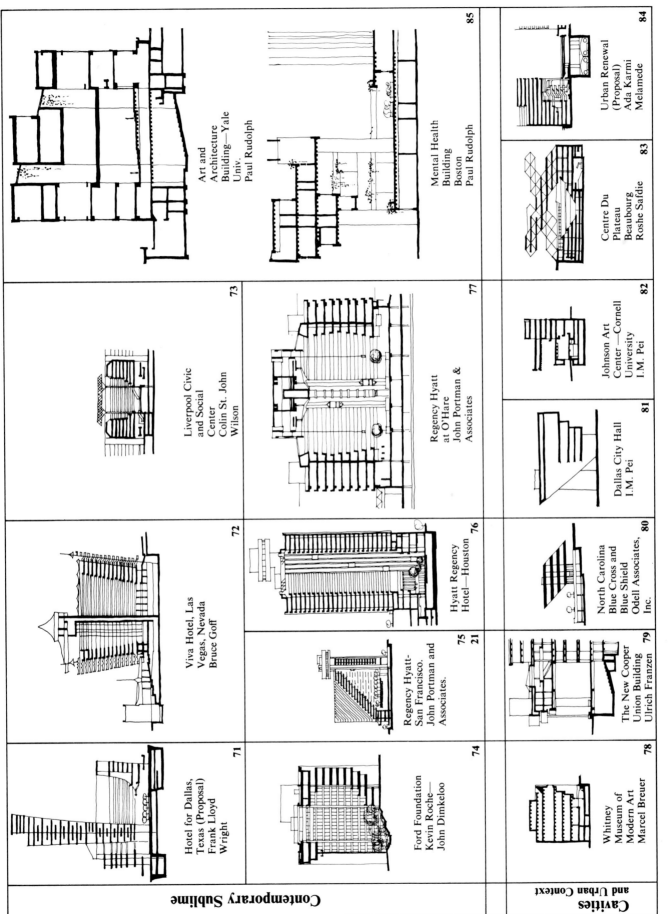

Contemporary Sublime

85 Art and Architecture Building—Yale Univ. Paul Rudolph

 Mental Health Building Boston Paul Rudolph

73 Liverpool Civic and Social Center Colin St. John Wilson

77 Regency Hyatt at O'Hare John Portman & Associates

72 Viva Hotel, Las Vegas, Nevada Bruce Goff

76 Hyatt Regency Hotel—Houston

75 21 Regency Hyatt-San Francisco. John Portman and Associates.

71 Hotel for Dallas, Texas (Proposal) Frank Lloyd Wright

74 Ford Foundation Kevin Roche— John Dimkeloo

Cavities and Urban Context

84 Urban Renewal (Proposal) Ada Karmi Melamede

83 Centre Du Plateau Beaubourg Roshe Safdie

82 Johnson Art Center—Cornell University I.M. Pei

81 Dallas City Hall I.M. Pei

80 North Carolina Blue Cross and Blue Shield Odell Associates, Inc.

79 The New Cooper Union Building Ulrich Franzen

78 Whitney Museum of Modern Art Marcel Breuer

Figure 28. Typology of recent space (3)

current student gets his education largely by historicist oriented "Post-modern" instructors emphasizing far too much drawing (i.e. use of prismacolor pencils etc.) often an end in itself with obvious disregard for the third dimension. It is doubtful, in the author's mind, that the ability in space making that we witness today in the works of the metaBauhaus–metaCorbu architectural generation, will be matched by the architects produced by most schools today.

There is a need to keep the "space" trend going. We must reverse the current trend of spatially undynamic education. The books had better be gotten off the shelves. The drawing rooms need to be occupied again. It is time to term the socio-behavioral and the historicist approaches *inadequate*. We must take with us what we have learned and continue the new tradition of space making. The "spatial" reorientation of architectural education would not have to come about through absolute negation of the socio-psycho-behavioral learning; on the contrary, the education should become more inclusive.

Recent Great Enclosures

"Spaces" of the recent decades are *enclosed* rather than *closed*. Most of the great spaces are for public use, just as they were in previous eras when the spirit of architecture was in the building of enclosures. Contemporary enclosures are mostly disciplined as "universal spaces," vertical or horizontal. The typology and aesthetics of contemporary universal space can now be examined.

Influences

Recent U.S. architecture has been influenced by the currents of three spatial heritages. The first is the heritage of Frank Lloyd Wright, the second is the heritage of Mies van der Rohe, and the third is the amalgamation of both above extremes using as catalyst the disciplines taught at the Bauhaus and the influence of Le Corbusier. The works of Frank Lloyd Wright and his followers can be cited as examples for category one; the works of Paul Rudolph can be presented as representative of the third category; and the great bulk of contemporary U.S. space making can occupy the grand category number two.

The Wrightian heritage is indeed Wright himself. He experimented with space throughout his life. He enclosed space; he hollowed it out; he moved man within it by moving the space accordingly.[11] Wright as a space maker has been compared with the Romans,[12] but unlike the Romans,[13] he never created "static" enclosures. On the occasions he used symmetrically static sections, he was always able to animate them with the movement of people inside. For that purpose he introduced the ramp (Morris

Shop, San Francisco, and Guggenheim Museum, New York). As we witness from the enclosed works of Wright, he worked with almost all possible sectional configurations. Squares, rectangles, triangles, even circles and curves were used in the domes for the Greek Orthodox Church in Minneapolis, for his palace project in Iran that was completed after his death by the Taliesin Fellowship, and for a number of hotels and other unbuilt projects. Wright, however, was never able to achieve with circles and curves the great spatial wholes he achieved through the use of simpler structural geometries such as squares, rectangles, and trapezoids. Wrightian universal spaces that set the trend for today's contemporary U.S. spaces include: the Unitarian Church for the square, the Larkin Building for the rectangle, the Guggenheim Museum for the trapezoid, and the numerous homes of the combinational category. This last category encompasses the houses of Wright and has as forerunner, the Kaufmann House. Yet the smaller houses with their constant interpenetrations and literal *transparencies* were the least influential for the average practice. The bulk of architectural practice that followed concentrated for its didactics rather on Wright's one-dominant-space projects, but the works show the boldness of absolute geometry that was introduced later by the general philosophy and concepts of Mies.

Wright's prolific, never-ending search for spatial vocabulary has been replaced today by the preoccupations of Paul Rudolph. His works can be classified in the third, most complex category of space making. They are works that have digested the Wrightian heritage, have been influenced by the Corbusian examples, and have adopted in three dimensions the Miesian principles of two-dimensional universality.[14] Paul Rudolph is considered the foremost architect of the category of contemporary spaces which have been summarized here under the label of "combination," or "oceanliner continuity." The sections of Rudolph's office in New York (demolished in 1968) and the Hirsch House, also in New York, set the rules of the "combinational" contemporary space explosion in the most clear way. Different ceiling heights, different levels, freestanding bridges, and appropriate natural lighting through the evolving clerestories result in a high degree of transparency which permits a simultaneous perception of different spatial locations[15] and animates the whole interior.

It should be mentioned here that certain works of Rudolph Schindler and some early works by Le Corbusier preceded the work of Paul Rudolph in this spatial vocabulary. It was Rudolph's work, though, that influenced many recent architects much more than Schindler's Lowell House or Corbu's section of the Marseilles Block Apartments. One might also be inclined to refer here to the spaces created by "The New York Five," but they were definite revivals of early Le Corbusier, and the credit should go to him.

The strength of "oceanliner continuity" depends on the interlocking of the volumes of air that are defined by the horizontal and vertical "transparencies." The point of "interlocking" represents the "universal" space of that part of the interior. There are numerous such "interlockings" in these types of architectural sections. The issue of "quality" becomes then an issue of discipline. How many interlockings? Of what configuration? How big? How far apart? These concerns are very difficult to control and master; tremendous time and effort need to be spent in achieving the right space in the design decision-making process. Because of these difficulties, not everybody has succeeded with this combinational vocabulary. Many works appear undisciplined, uncontrolled, and chaotic. Perhaps these difficulties have led other architects to follow the more straightforward vocabulary of Mies. Yet there are cases that indicate this suggestion could be wrong. There were perhaps sincere convictions on strict discipline or even a belief that the emphasis of one big idea is more meritorious than the bombardment of spatial experiences.

Mies said, "I do not want to be interesting, I want to be good!" It was perhaps this statement that summarized the whole range of last decade's professionalism and explains the siding of large firms with Mies rather than with the spatial extremes of Wright and Rudolph. It can be argued that this ideological siding is reinforced by the economic potential of the linear, straightforward simplicity of the Miesian design attitude. The spaces labeled as "contemporary sublime" have been clearly defended by their makers as results of an economic act.[16] (The multiplied savings of the individual activities—for example, the rooms of the Hyatt Regency—have made possible the great internal enclosures, while the demand for the ceremonial and the additional income produced due to the existence of the great enclosure and its facilities make possible the existence of individual spaces.) The old "chicken and egg" question could be asked in studying the relationships between architectural economics and architectural form. Whether or not it was an economic act that originally produced the spaces, the spaces are now there and, as such, they should be evaluated on their effect on man. Squares, rectangles, triangles, and trapezoids represent the key geometric abstractions of the majority of bold architectural sections of the last twenty years. Attempts to break the square and gravitational geometry have been made by certain structural systems advocates abroad.

Psychological Effects

Christian Norberg-Schulz makes a fundamental contribution to the theory of space in his book, *Existence, Space, and Architecture*. He maintains that the appreciation of space does not only depend on the real, undeniable three-dimensional entity of the space, but it also depends on the appreciator's previous experiences, level of connotations, and general appreciation of "*schemata.*" According to Schulz, "space" is a dual intellectual process between three dimensions and human feedback,[17] depending on the specific human's appreciation of the three dimensions. Schulz also realizes the cultural and experiential differences between various individuals, and he suggests that architectural space is really the *public* space, where most humans have subordinated their private preferences and feelings to a common public denominator, perhaps a denominator of an accepted due behavior. To facilitate the study of space, the future evaluator would have to formulate into abstract terms these general common denominators, yet generalizations they will always be. Realizing now this distinction and the limitations that handicap a personal interpretation, the author would like to risk a general introductory evaluation of the spaces he has personally experienced.

The strongest feelings I have experienced in my study of the U.S. architecture were the cases of buildings such as the Ford Foundation Building, the Hyatt Regency Hotels in Houston and San Francisco, and the Great Hall of the Apparel Mart in Dallas, Texas. These cases all evoked feelings of unsurpassed intensity for me. Serenity, admiration, and spiritual contemplation of the human self and the universe were my feelings while in the paradisaic lobby of the Ford Foundation Building, exactly the same as when I was in Hagia Sophia. The two great hotels evoked "the sublime" differently. It was a battle of contradictions. Admiration and wonder were contradicted by feelings of fear and chills. Was it just the heavenly "sublime," or was I experiencing one of its highest forms, "sublime tragedy"— a contradiction between serenity and disaster, with the human being right in the middle of it all? A feeling one might experience sitting in a small boat in the middle of the Pacific Ocean on a calm day and contemplating the relationship between you, the keel of your boat, and the bottom of the ocean. . . . You realize it is just God (nature) and you, and you are at the grace of God.[19] . . . The element of fear is always a part of the sublime tragic experience, and it is ever present death and the desire for

Haghia Sophia. Anthemios and Isidoras, Architects.

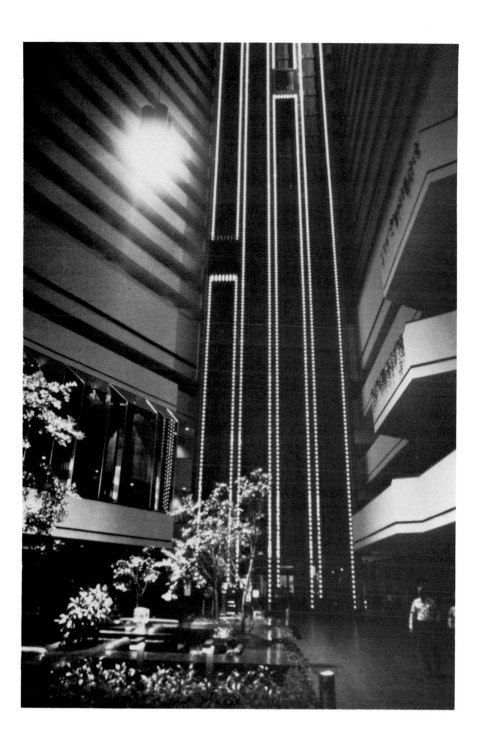

The lobby of Hyatt Regency Hotel in
Houston, Texas. Koetter Tharp and
Cowell, Caudill Rowlett Scott,
Neuhaus and Taylor, Architects.

The feeling of "interior space" as achieved by means of light hitting the interior mass of dwelling in Santorini, Greece.

life that builds the individual up and brings him to terms with the cruel universe, a universe that happened to be serene the day he arrived. I couldn't help but think of the San Francisco earthquake, when at the San Francisco Hyatt, or consider the day when the first attempt at suicide would occur at the Hyatt in Houston.

Feelings of joy, pleasure, and unchallenged easiness filled the many hours and days I spent in Paul Rudolph's office in New York, evidence of the fact that there are spatial treatments that do not challenge one but, on the contrary, make him feel at home. The office of Rudolph in New York, as well as the Hirsch House, are outstanding examples of spatial treatment and human scale. The feelings I've had in the Yale School of Architecture have never reached the heights of those in Rudolph's unpretentious New York office. I have experienced similar neutrality in the interior of Stirling's library at Cambridge. The stimulation from the interior never matched the stimulation brought about by the sculptural quality of the exterior massing. Stirling's library in England, as well as most of the medium universal spaces in the United States (squares-rectangles-triangles), deserve attention for the dynamism they possess by permitting movement of people in their interiors. It is this movement at different levels that permits a visual pleasure, which is a "safe" pleasurable feeling, not the strong feeling of the sublime.

The third aesthetic category I have experienced was in the U.S. Pavilion at Expo in Montreal. It was a feeling of safety, security, and inexplicable pleasure. The man was in the sphere, and the sphere was the world, a nonhostile world, . . . but the poetry of struggle, the poetry of trying

to survive, the contemplation with oneself and the universe was absent. Perhaps it was the old, inexplicable, metaphysical security of roundness[20] which made me feel at home, yet as a home, I would never want to live in it.

With the exception of Hyatt Regency Hotel in San Francisco, no triangular interior space has had any supreme positive or negative effect on me. The fact that no negative psychological effects were apparent has been due, I believe, to the fact of structural clarity and structural and mechanical exposure. This exposure of the "guts" makes one feel safe and secure, never overwhelmed by the weight of nongravitational section.

Structural Characteristics

Most examples achieve their spatial complexity by means of structural order and structural simplicity. The generic structural systems are simple. Space frames and steel trusses are most commonly used. Space frames are used to cover the square and rectangular spaces while trusses of triangular and trapezoid configurations are used for the triangular and the trapezoidal sections of universal spaces. Outstanding cases of decoration of interiors by means of structural and mechanical exposure are the examples of Gund Hall at Harvard University, the History Faculty Building at Cambridge, England, and the University of Alberta Mall. All of these also feature transparent roofing of glass or specially designed synthetics which permit diffused light into the interior spaces. Because of the uniform natural lighting, the interior universal spaces of this type do not have the quality effect of universal spaces that obey to hollowed-out vocabulary such as Louis Kahn's Exeter Building.

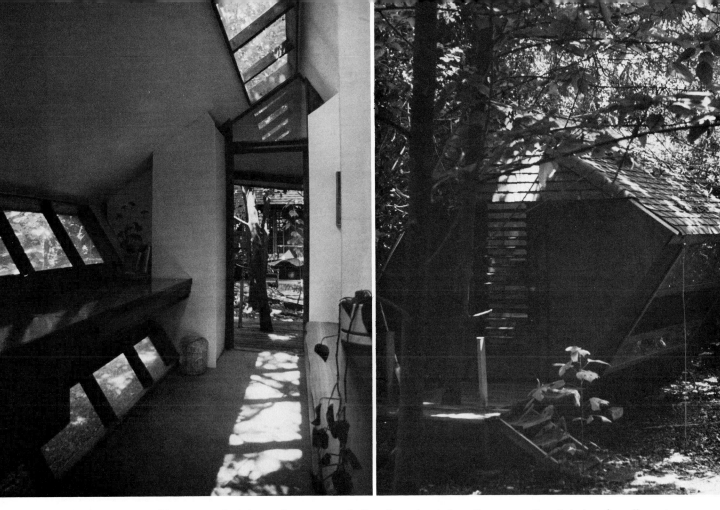

"Maximum" achieved by means of minimum. Larger space feeling through rotation of square section. Interior of small guest cabin in Miami, Florida. Yannis Antoniadis, Architect, 1968 (Photos by Yannis Antoniadis.)

It is clear that no sophisticated structural systems have been used for the universal spaces of the multifunctional buildings of the decade. Architects are satisfied with the old post and beam and its basic variations as ways to enclose space. Shells and more sophisticated structural systems are absent in the large-scale multifunctional examples. There are some basic shell suggestions in the cases of some monofunctional buildings of the circle and curve category. Inflatables and tensile structures presently unfit for multipurpose multistory functions just represent extravagant exceptions.

In conclusion, the most commonly used structural approach is the post and beam. Thus great architectural complexity and interior appeal have been achieved by means of very economic, very well-modulated structural organizations. This simple and logical structural clarity is, in my mind, the key to the feelings of tranquility one has while appreciating most of the great spaces of the study.

An outstanding example of "spatial complexity from within a structural simplicity" is the case of Park Central at Denver, Colorado. This complex demonstrates another important development in the contemporary creation of space—the interpenetration of exterior and interior. Concerns for such urban wholes had been with us for sometime, but it was in the 1970's that some works of significance were realized.

The approach of curving out space, combined with the approach of hollowing space will be the answer to a strong exterior-interior urban integration. Buildings such as the Whitney and the much stronger Cooper Union proposal of Franzen suggested the possibility for this strong architectural-urban space interlocking. Urban space today is not to be the volume-void space that was seen by Giedion, but it is rather going to be the "Swiss cheese" interpenetrated whole as designed by Ada Karmi-Melamede for urban renewal, as seen in Rudolph's Health Center in Boston, and as strongly suggested by Safdie in his proposal for the cultural center in Paris.

The problem of "space" for man's future environment does not seem to be the nonexistence of contemporary paradigm at the building or urban scale, the lack of current talent, the inability to construct, nor the lack of a strong spatial history. The problem is rather the professional inertia of the majority of architects, coupled with their unconcern for space, perhaps a nihilistic attitude toward spatial matters, and, even worse, the lack of an ethic of space.

One feels very uneasy in that respect with the spaces currently created by many of the "postmoderns." Their works often show a total lack of spatial discipline. In most cases the "more is more" dogma of Postmodernism (the other extreme of the Miesien "less in more") has led to the incorporation of excess spatial gimmick which produces chaotic and often torturing spatial experiences. One could point out no better example in illustrating this point than the most publicized of Postmodern buildings, the Ichi-Ban-Kan building in Sinjuku, Tokyo.

The key to designing meaningful and fulfilling spaces rests with design education and architectural studios that emphasize methodologies that will help students to achieve them. The design methodology of "simultaneity" developed by the author would help to do this, and it is offered here as a suggestion.

A Spatially Relevant Design Methodology

Architectural historians and critics have often preoccupied themselves with the tools of architectural communication, and they have often attributed spatial conceptions to innovative communications facilities. Giedion and many others before him attributed, without any hesitation, the development of the Renaissance space to the invention of the perspective.[21] Sometimes these non-designer architectural historians were overly romantic and were fascinated by media whose skills they apparently had not mastered. Therefore, they unfortunately offered undeserved attributes to them. In more recent times Bruno Zevi pointed out the movie camera and suggested its ability to make space appreciation possible in the cubist sense.[22] Indeed, Zevi's point on the use of the movie camera as an architectural tool represents a daily preoccupation of architects and students today. Movies have already found their place in the practice of architecture.[23] But movies are useful only for presentation purposes, for the animation of the motionless; they depend upon a design or a finished product for their usefulness. Movies and moviemaking, therefore, represent just a passive medium, and they are not adequate for the creation of architecture. Yet Zevi's whole outstanding treatise on architectural space has an "appreciator's" tone, rather than a creator's. Of course, "appreciation" and "personal experience" of architectural spaces should represent part of the day-to-day preoccupation of architectural designers, but creation should be the final justification of their existence, and simple moviemaking does not create.

Charles Jencks in his publication, *Modern Movements in Architecture,* points to the axonometrics of James Stirling and gives them the importance of generic significance as tools for the creation of architecture and space. "Stirling's work is rooted in the technique of drafting; the method leads to the form. Without such a technique, sophisticated constructions would be impossible. A whole aesthetic way of life comes from the logic and articulation possible with such a method. . . ."[24] Jencks is right in that the clarity of axonometrics helps communicate the articulation of the construction and helps check the clarity of a work's logic, but he absolutely misses the point when he attributes significance of aesthetic importance to one medium of graphic communication alone. As every architectural designer of caliber knows, the perspectives, plans, sections, elevations, and axonometrics of visual and supreme quality are nothing but tools for presentation purposes, not tools for creative design. The tools of the creative design process are certainly based on the sketching and drafting faculties of designers.[25] Through their love for sketching and their sketching ability, good designers check their design decisions through simultaneous check-ups of plans, sections, elevations, spatial fragments, and models.

In the Bauhaus-Miesian and Corbusian sense, the designer was building his design documents from the plan, up: plans and development of plan first, then sections, then elevations, finally a presentation perspective ("rendering"—awful!). Now all this is dead, or should definitely die. It is clear that the better spaces good architects design today are products of a design discipline. The new design discipline is facilitated by a new concept of the design process called *the concept of simultaneity.* The designer simultaneously checks all his design decisions at any stage of the design decision-making process through all the necessary documents, and he uses all currently available tools in order to describe the design "spatially." Plans, sections, elevations, sketches of spatial fragments, and spatial models are the tools of this process. They are all at hand at every step of the evolution of a design. If the design alternative changes, so do *all* plans, *all* sections, *all* elevations, and the spatial model at the same time—simultaneously. No matter how early the design idea is, the architect checks it through all the documents of its communication.

Unfortunately, many architects have forgotten how to draw. Even worse, the discipline of sketching is suffering in most schools of architecture today. The trend must change. Figurative drawing and freehand drawing must return to the curricula and must be taught by people who know how and love to draw.

As it is clear by now, sketching (correct and to scale) and the use of working models must become inseparable. The ability to create working models as well as the will to cut them, change them immediately, or build them anew from scratch as the alternatives change and the design develops are essential.

This survey of recent grand enclosures has indicated that the good, new space makers of caliber use working models simultaneously as they sketch their sections, and perhaps some elevations below the plan variation they propose. The working model is very feasible today due to the availability of easy-to-cut materials and the X-acto knife. Of all materials, the foam-core board is most easily used, and its thickness makes it almost true to scale when it is used in 2-inch and 4-inch scales. These scales are very good for seeing interior space and checking the natural lighting situation inside.

Unlike the false possibilities of the Renaissance perspective, the passive potentials of movie cameras, the misunderstood possibilities of axonometrics, and the passive "experiential totality"[26] approach of the environmental psychologists, the three traditional tools of communication—plans, sections, elevations, in simultaneous considerations with sketches of spatial fragments and working models, are the ways through which design decisions should be checked.

The creation of "space" during the past decade had been absolutely facilitated by the advent of foam-core board and the X-acto knife.[27] The significance of these design tools should not be ignored. They should be considered as fundamental as "perspective" was for the Florentine Renaissance.

In any good architect's life there is an experience that could be called *the moment of spatial revelation.* In this moment a design is stimulated in his (or her) mind; he finds himself in the interior space of his imagination. Scale, color, texture . . . reality . . . are all there. This fortunate architect needs nothing else to stimulate reality. The space is real in his mind, and it will be real when it is built. This is the reason that only good architects do not need all documents for the communication of a space idea among themselves. A quick and well-proportioned conceptual "section" is enough to stimulate the space. It will tell everything to other architects about the space discussed. The section therefore appears to be, for good architects, the strongest document for the communication of spatial ideas; this is true only for architects who have experienced the space revelation moment. It is absolutely necessary that all architects, as soon as possible in their careers, have this revealing experience. To help the student reach this point, teaching should daily emphasize the necessity of "simultaneity" of the creative space decision-making process. . . .

. . . Hours upon hours have been spent on the evolution of the designs we admire. The spaces we experience, complicated or simple, are not results of divine inspiration or caprices of the moment. Hands and fingernails have been worn out; models upon models have been built, cut,

and rebuilt. A text such as this cannot do the work. It is toil and hard work that will accomplish it. In order to do it and continue the great spatial movement of the recent past, we must inspire again in ourselves an architectural "ethic of space" and work within the bounds of the empirical discipline of *simultaneity,* using our traditional skills, foam-core board, and the Exacto knife as keys to spatial evolution.

Notes

1. Terminology credited to Colin Rowe. See Colin Rowe, "Neoclassicism and Modern Architecture" in Rowe, 1976.
2. This refers to Corbu's concept of *plan generateur* (plan the generator). Bruno Zevi contends that Corbu engendered in his followers "a sort of mystique of the aesthetic of the plan." See Bruno Zevi, *Architecture as Space,* Horizon Press, New York, 1957, p. 46. Also Le Corbusier, *Towards a New Architecture.*
3. Previous architectures of "spatial dynamism," architectures where "the content is in the internal space," are covered mainly and adequately by Bruno Zevi's *Architecture as Space* and Giedion's *Space, Time, and Architecture,* as well as in other periodicals and lecture references that follow.
4. These fears are mostly due to the directions of architectural education and architectural licensing which are analytical or "iconographic", rather than synthetically, inclined.
5. "Interior Volume" in *Progressive Architecture,* June, 1965, p. 155.
6. Ibid., p. 157.
7. Numerous quotations from Louis Kahn's public lectures may support this. The following extract may make the point here:

 > ". . . In the nature of space is the right and the will to exist a certain way.
 > Design must closely follow that will.
 > Therefore a stripe painted horse is not a zebra.
 > Before a railroad station is a building,
 > It wants to be a street.
 > It grows out of the needs of street,
 > Out of the order of movement. . . ."

 from Vincent Scully, Jr., *Louis Kahn,* George Braziller, New York, 1962, p. 113.
8. Refer to discussion on "interiority" vs. "exteriority" in "The Labyrinth," *Architectural Record,* July, 1973, p. 114.
9. Bruno Zevi, op. cit., pp. 143–44.
10. This refers to the architecture achieved through a conscientious sculptural mass extraction by which the final product resembles the "Swiss cheese type" of architecture as mentioned by Victor F. Christ Janer.
11. Op. cit., p. 144.
12. Ibid.
13. Ibid., p. 78.
14. Pointing to the section of his office, Paul Rudolph explained it as a Miesien plan turned upwards.
15. Colin Rowe and Robert Slutzky, "Transparency: Literal and Phenomenal" in Yale *Perspecta 8.*
16. John Portman, *A.I.A. Journal,* April, 1975.
17. C. Norberg-Schulz, *Existence, Space, and Architecture,* Praeger, 1971, p. 37.
18. Ibid., p. 37.

19. P. Michelis, *An Aesthetic Approach to Byzantine Art.* Author's translation of quotation.
20. Gaston Bachelar, *Poetics of Space,* Beacon Press, 1969, p. 232.
21. Giedion, *Space, Time, and Architecture,* op. cit., p. vi.
22. Bruno Zevi, op. cit., p. 59. Also Antoniades, "Film and the Public Relations Stage of Planning Process." Discussion paper series #13, University of London, September, 1969.
23. Antoniades, A., "Film and the Public Relations Stage of the Planning Process." Discussion paper series #13. University of London, September, 1969.
24. Charles Jencks, *Modern Movements in Architecture,* Anchor Books, 1973, p. 267.
25. There is an abundance of testimonial to that effect. Le Corbusier, Mies van der Rohe, and Wright are classical examples. Paul Rudolph has said, "The sketching, I love it." An attitude on sketching as a means of design creation can be extracted in Yukio Futagawa's article, "Paul Rudolph: Drawings," in *Architectural Forum,* June, 1973, p. 51, etc.
26. "Experiential totality" refers to what James Marston Fitch suggests as the crucial aesthetic theory fundamental for architectural aesthetics . . . but Fitch, referring to the aspect of "participation" in the user sense, takes a passive, appreciator's attitude rather than a creator's attitude. See J. M. Fitch, "The Aesthetics of Function" in *People and Buildings,* ed. Robert Gutman, Basic Books, Inc., New York, 1972, p. 4.
27. Testimonials to this can be heard in every creative office in New York and elsewhere in the United States.
28. Sections of space typology sketched by the author are based on publications in architectural literature.

Selected Readings

Bachelard: *Poetics of Space*
Norberg-Schulz: *Existence, Space, and Architecture*
Progressive Architecture: *"Interior Volume"*
Zevi: *Architecture as Space*

11

Concluding
Part One

By now you have had your first basic comprehensive exposure to matters of architecture. The chapters that follow in the second part of the book will be elaborations on the other spheres of environmental design, architecture's allied design disciplines.

It is natural that the more specialized one becomes, the more concerned he becomes for the design of details and the more apt he is to neglect the interrelationships of the basic general concepts that underline all design.

The introductory design concepts of architecture are the same as those of all other design disciplines. Basic design concepts always interplay among themselves. The due expression of their interrelationships in the finished product is the design itself with its respective qualities. One must never forget the basics. All environmental designers must attempt never to forget the fundamental concepts we have touched upon thus far. It is this author's belief that one must not emphasize one aspect of the general points of concern of the first part of the book more than another. The mind that eventually produces integral design is the unbiased mind. Unbiased is the mind that considers all aspects of design (aesthetic, social, technological, etc.) equally, paying equal attention to all aspects in an interrelated manner, and following the priorities set for the solution of each problem. The real architect is not an advocate of a sole consideration (e.g., issues of programming, issues of form, or issues of environmental psychology). He is the objective, creative manipulator of all aspects of architectural concerns, appropriately interrelated through design, adequately presented for the purposes of the various kinds of communications involved (e.g., client communication vs. construction industry communications), and conscientiously searched and worked out with love.

The general rules of thumb that follow are very often forgotten by designers, and it is unfortunately evident in the resulting environmental products. The author believes these rules represent the major "tips" that will ever be given to you by somebody else, and that you will eventually rediscover the truthfulness of the "tips" when experience and confidence in your trade come to you in the years ahead. You should read and reread these rules and try to respond to their demands when you compose or evaluate architectural projects in the future.

Aesthetics

1. Remember that architecture is work in space. Never forget that the product of architecture has three basic physical dimensions and that "time," the fourth dimension, in combination with the other three creates the *rhythm* of the work. The quality of the rhythm is the top attribute of a work of visual and living art. Remember that any space architects make has at any time (a) plans (b) sections (c) elevations, and that the simultaneous consideration of these makes the whole. Any new decision, or any change pertaining to the whole, has a simultaneous effect on all three tools of three-dimensional description (plans, sections, elevations), thus all three must be reconsidered. Thus never forget what has been labeled the concept of *simultaneity* of the design decision-making process.

 Those among the readers who will become architects and will design projects in the future will have to go through the making and drawing of plans, sections, and elevations as many times as they challenge their decisions. This requires tremendous discipline and devotion.

2. Additional to the above process will be the further testing of the visual composite (of plans, sections, and elevations) by means of three-dimensional models and spatial fragments (quick sketches of spatial details and perspectives).

Social Responsibility

1. One should remember that architects' work is for the use of human beings, and that an architect must always try to understand people in order to make their lives better through his (or her) work. First make them feel grateful for the physical environment you design. Design for human comfort. Design for their physical dimensions. Think of their sanity, mental and psychological welfare; but never disregard the physical human dimensions of the space which you'll determine.

2. Design for the *users* and not for yourself.

Technological Implications

1. Introduce structural reality into your designs from the very beginning of the design process. Never forget that there are charts available (e.g., Philip Corkill's, presented in Appendix B of Henry Cowan's book *Architectural Structures*). Use these charts in your design process as soon as you get a feel for the program space requirements.

2. Introduce initial feelings for the integration of the mechanical, electrical, lighting, and other utility systems of your projects. Never leave these items until the end. Think about them and work with them from the very beginning of your design process. Consider the simultaneous operation of *everything* as early as possible. Plan for everything you need to know and get out there and learn it. Get consultants to work with you and to do the detailed calculations for you.

Economic Considerations

1. Develop a general feel for the economics of every project with which you become involved. Study as early as possible similar projects presented by the various "construction calculators" available in the market. Think always of "design economy" as the rational process that suggests the maximum result (in all aspects) achieved by the least means. Think of economics and space simultaneously.

Professional Responsibility

1. Make clear for yourself your contemplated role within the professional context. Do not expect to become a comprehensivist if you have a feel for detail or if you have an inclination for analysis. Make it your ambition to become the best you can become within the alignment of your natural inclination.

Architecture needs (1) competent comprehensivists, (2) competent analysts, and (3) competent fragmentalists. Do not be discouraged if design is not your natural inclination. You may be inclined to be an analyst. Follow your inclination as architecture needs you.

PART 2

Disciplines Allied to Architecture

12

Introduction to the Allied Disciplines

Life takes place indoors and outdoors, not on the *edges*. In a sense, one could conceive of buildings (buildings designed by architects or otherwise) as three-dimensional entities composed of planes, sometimes flat-vertical or horizontal and other times curvilinear, which constitute the *edges* that define the indoors and the outdoors, the territories of life. Of course, there have been occasions when people had some use for these edges, as for instance in the Middle Ages when they had to climb to the top of the defining walls to defend the interior of a castle, or if they were the attackers they had to climb the walls to get inside. The edges of buildings protect interior space from all sorts of enemies, heat and cold, wind and snow, rain and undesirables. They also create with their proportions and relationships, the quality of the interior space. These edges also define the exterior space. There is, therefore, space *inside* the buildings and space *outside* the buildings. If there is to be harmony and if a building is to be a good one, its design should be the result of an integrated concern for the solution of the problems regarding the indoor-outdoor considerations and the interface between the two, which is the building shell.

Part One of this book, deals with issues concerning the design of individual buildings, what is conventionally called *architecture*. In Part Two we devote our attention to what is happening inside the buildings and what major issues and concerns are involved, as well as to what is happening outdoors. A number of environmental design disciplines deal with these large considerations.

The discipline of **Interior Design,** also called Interior Architecture, deals specifically with concerns and design of the interiors of buildings. There are other disciplines, such as those of furniture, object, and product design, which aim at creating artifacts and appliances to be used in interior spaces, that will not be part of our inquiry here.

The discipline of **Landscape Architecture** deals with the outdoors. Its inquiry covers concerns related to the outdoors that is immediately related to buildings, such as the front yard, or to the outdoors defined as the space between buildings, such as public plazas or neighborhood playgrounds, or even to the outdoors of a much larger entity, such as a regional park. Landscape architects perform tasks at all these levels. Their discipline, therefore, is very closely related to the discipline of the architect, as well as to the disciplines of Urban Design, Urban Planning, and Regional Planning.

Urban Design is the discipline that concerns itself with the social scale of environmental design. It solves problems of putting buildings together in various arrangements so as to create a neighborhood or even a whole town. This is the discipline that creates the public urban spaces, generally outdoors and in some occasions indoors, in which we spend most of our urban lives. Its product affects the daily visual experiences of the urban inhabitants and it is responsible for the pride or lack of it felt by a certain population for the neighborhood or town in which it lives.

Urban Planning is an environmental design discipline whose scale of concern is larger than that of Urban Design. It does not necessarily concern itself with physical dimensions, proportions, or scale in the urban space (this is the concern of Urban Design), but it is rather a quantitive and forecasting discipline. It plans for the future development of urban environments as wholes, incorporating the physical, social, economic, psychological, political, cultural, and all other factors of life and human concern in urban areas.

Regional Planning deals with the same considerations as Urban Planning, but it does so within the total continuum to be encountered in a *region,* which is urban and rural and includes natural and human resources. The discipline of Regional Planning closes the range of design disciplines that are currently taught in most schools of architecture and environmental design. This is not to say that there are not other disciplines that are allied to architecture or that should not be called environmental. In a sense, there are some disciplines such as those that deal with certain branches of chemistry, physics, and engineering that deal with the chemistry and properties of materials, air pollution, energy, waste control, etc., that are currently at the heart of environmental problems. These disciplines, however, should represent the concerns of *scientific* study rather than the aesthetic and physio-social direction of the present inquiry.

With these thoughts in mind, we will proceed in the elaboration of the disciplines of Part Two starting with Landscape Architecture. We do this first so that we may complete the inquiry of the issues regarding the edifice in its immediate vicinity—its site and close surroundings. Then we will discuss the aspects of interior architecture, thus completing the sequence, indoor–building shell–outdoors. After that, we will deal with the disciplines of Urban Design, Urban Planning, and Regional Planning, presenting them in this sequence because it conforms to their scale of magnitude and introduces the concepts in a logical and sequential way.

13
Landscape Architecture

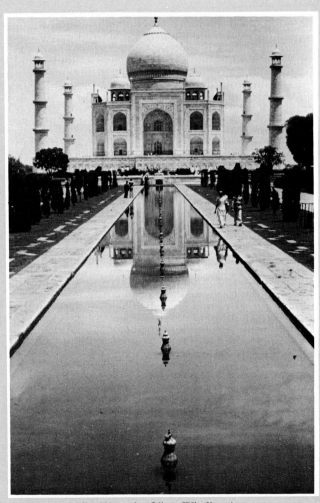

Taj-Mahal, India (Photo by Oliver Windham).

277

Access to Varlaam Monastery. Meteora, Greece.

TABLE 5. FORM AND INTERNAL/EXTERNAL FORCES

Internal forces (constraints)

Internal and external forces (constraints)

The ultimate architectural form in plan, in sections and in elevations, responds to both internal and external forces (constraints)

A

This building can be anywhere—could move anywhere.

B

This building is "undeniable." It is fixed on its site through the recognition and design for the external constraints.

A work of architecture becomes "undeniable" if its form evolves as a logical (or intended) response to the internal and external constraints. The influence of external constraints is evidenced in the site plan and is taken care of by the massing and outlining configuration of the building and the treatment of the exterior grounds. The influence of the *interior constraints is evidenced by the plan and taken care by the general layout where one encounters internal functions (the activity areas and the arrangement of furnitures).*

". . . You've dreamed of your castle on the hilltop surrounded by a splendid lawn. You've long dreamed of this castle from far off, but now it is yours. All you have to do is approach it, get inside it, occupy it. . . . The day before it had rained. The splendid lawn made you all wet . . . and your shoes filled with mud. A functional problem ruined your vision, destroyed your regal entrance. . . . So you built a dry walk on the hillside. No lawn all over the place; some stones, some patio slabs, some concrete aggregate, some wooden trunks would do." This dry, "hard" walk was the result of a conscious act on your part applied to the outdoors, to the site or the terrain of your "castle." It was intended to help you avoid the wet of the earth, to direct you to where you wanted to go, to turn you left and right on your way up the hill, to offer you vistas of varying angles, to make you move, pose, or relax along the course of approaching or entering.

Whatever one does to the outdoors is an act of "dealing with" the outdoors. One can deal with the outdoors by applying new works on the site, by preserving and appropriately utilizing what is there, or by combining the two— the natural and the man-made—in a well-balanced, conscientious manner. These physical works on the outdoors, the man-made (artificial) in combination with the God-made (natural), are usually called works of *landscaping*[1] or, more appropriately from my point of view, works of *exterior architecture.*[2] Works of landscaping are necessary to fix the existence of an edifice on the site, in other words, to make its location undeniable. An entrance is at the end of the entry walk because the entry walk ends there. A building has a certain physiognomy from a certain point of an approaching walk, because the walk is there and the point (e.g., a relaxation point on the walk or a turn of the walk) is exactly where it is.

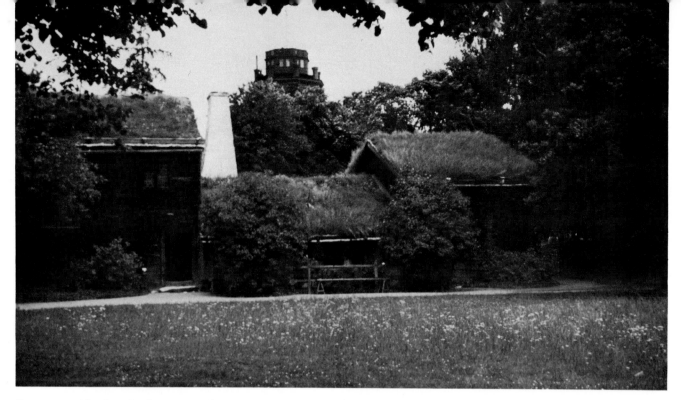

Structure and landscaping into one: typical case of Swedish village. Skansen, Stockholm.

Architectural decisions dealing with the exterior are more dynamic than those dealing with the interior. This is due to the seasonal changes in the external environment. The changes of the interior are mostly changes of temperature and are controlled by man mechanically. As the changes of the outdoors are due to the natural processes of the seasons, man should be aware of them, recognize the God of nature, and act accordingly.

This idea was well summarized by Lawrence Halprin in the notebooks he kept during his early wanderings around the landscapes of the world. He wrote: "We need to design *into* the landscape in a naturalistic way so that communities merge and *become* landscape. Not copy nature, but use her processes to evolve patterns of growth so that communities become part of a landscape."[3]

The wisdom for dealing with the "outdoors" lies in the understanding of nature and natural processes.[4] In order to achieve that, one must have a love for the laws of nature, respect for what takes a natural process years to create, knowledge of the local natural-climatic-topographic characteristics, and a familiarization with the local plant and animal life. In addition, one must possess a poetic disposition,[5] talent, and a mind determined to coordinate the indoor-structural-outdoor sequence. One must recognize the indoors (functions inside the building, location of various rooms, etc.), because from there the outdoors is visible, and outdoor decisions need to be made accordingly. One must recognize the structural entity (massing), because by the way it is approached from the

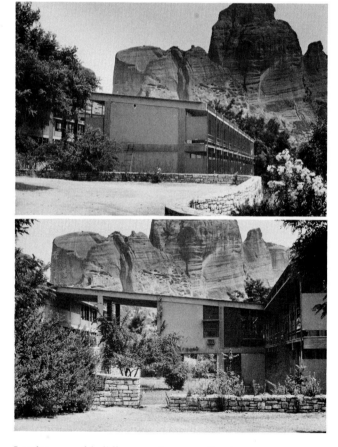

Landscape and building may have equally strong presence yet both may act as elements of a stronger composition. A new landscape where none is subordinate, yet both are necessary for the creation of the new Motel "Xenia" in Kalambaca, Greece. Mid-nineteen sixties. Aris Constantinides, Architect.

280

Earth-covered Hotel Camino Real, Baja, California. The building is the landscape, and the landscape the building. Ricardo Legorreta, Architect. (Photos courtesy of Ricardo Legorreta.)

Architects must develop sensitivity toward the macro and micro landscapes. Texture of rocks and light.

The Palace of Knossos. The duality of strict structural geometry and "free" exterior treatment.

outdoors, its purpose is glorified or defeated (directional decision, entrance tendencies, etc.). One must recognize the outdoors (view, vistas, orientation, etc., etc.), because it is the surrounding universe which is being dealt with, and it is a scarce resource.[6]

Man recognized the importance of "dealing" with the outdoors from very early ages. In the process of history, attitudes and techniques have been refined. Some societies managed to master the design of the outdoors by evolving methods that stimulated the senses of man to high levels of euphoria. Modern man learns from all these examples. In the following pages we will take a look at these civilizations, searching for the principles of exterior design. Then we will summarize the principles and take an introductory look at some important current theories and projects for the making of the contemporary outdoors.

Landscape Architecture Through History[7]

1. There is evidence of conscious, organized landscaping practices since the early periods of the "Fertile Crescent" (Tigris-Euphrates River Valley, Nile River Valley, Indus River Valley). The city park denoted on the first map of the city of Nippur provides evidence of concern for the incorporation of public outdoor spaces in early urban environments. An abundance of the element of water was provided by the two rivers, while the park provided the element of green—water and green, two fundamental elements that are pleasing to man and useful for ecological balance.

2. The Egyptians introduced concern for landscaping into the domestic domain. There is evidence that they transplanted plants from one residence to another. An Egyptian drawing shows workers carrying plants of incense for transplantation.

3. A prime example of ancient landscaping is accredited to Nebuchadnezzar. His treatment of outdoor space was totally integrated with the indoors; plants were placed at varying levels of an indoor patio. It was so wonderful and grandiose that it inspired the ancient

Alhambra, Spain. The Holy Trinity of architecture: interior, building structure, exterior. A strict geometric continuity.

poets to include it in "the Seven Wonders of the World." The idea of Nebuchadnezzar's "Hanging Gardens of Babylon" was later revived in the Moorish complex of Generalife in Granada and in the twentieth century in Ghirardelli Square in San Francisco.

4. In early ancient Greece the architecture of individual buildings was severe and sharp. These buildings represented one pole of the Greek environmental spectrum. The outdoors, however, was free, as God had made it. The dominating outdoors was composed of farmland, olive trees, thyme, pines, great oaks, rocks, and water whenever it was available. After the Golden Age, the loose Greek landscaping practices changed. Instead of the strict demarcation between the natural and the man-made, there evolved an intermingling of the two. Open spaces (soft surfaces) and public spaces (hard surfaces) were conscientiously incorporated into the plans of the Hellenistic "new towns."

5. The plan of Priene shows that organized open spaces surrounded the gymnasium, while "hard" outdoor surfaces covered the public open spaces such as the agora.

Alhambra, Spain.

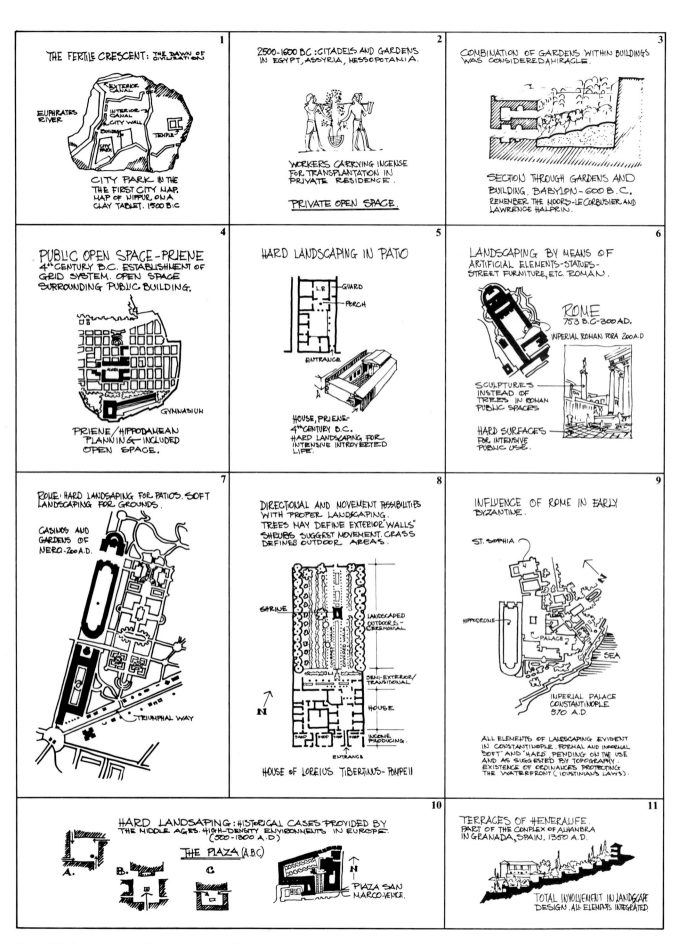

Figure 29. Landscape architecture through history (1)

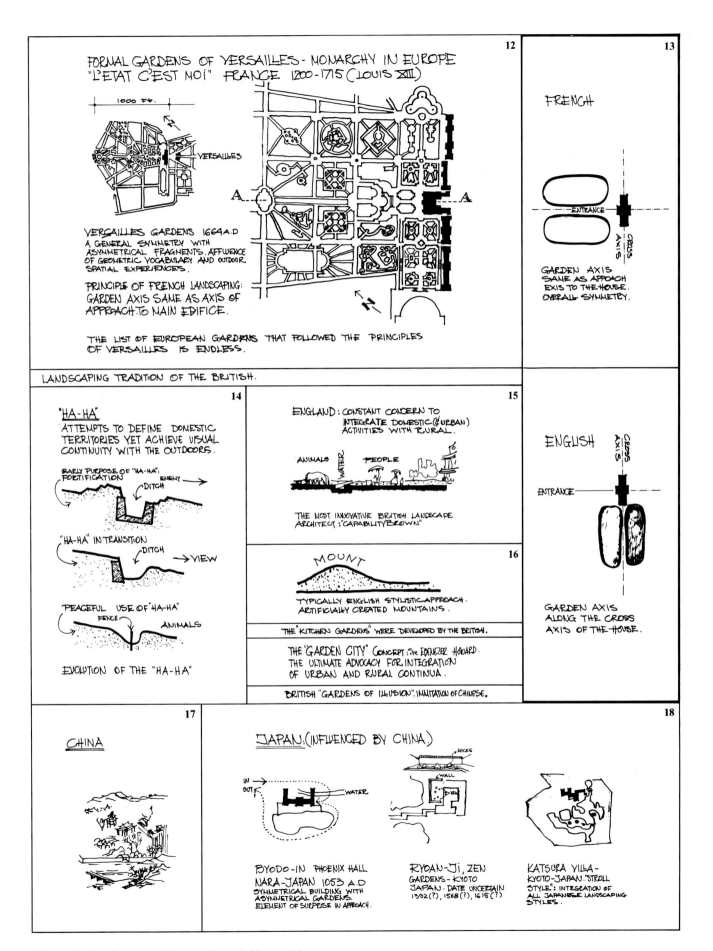

12

FORMAL GARDENS OF VERSAILLES - MONARCHY IN EUROPE
"L'ETAT C'EST MOI" FRANCE 1200-1715 (LOUIS XIV)

1000 Ft.

VERSAILLES

VERSAILLES GARDENS 1664 A.D.
A GENERAL SYMMETRY WITH
ASYMMETRICAL FRAGMENTS. AFFLUENCE
OF GEOMETRIC VOCABULARY AND OUTDOOR
SPATIAL EXPERIENCES.

PRINCIPLE OF FRENCH LANDSCAPING:
GARDEN AXIS SAME AS AXIS OF
APPROACH. TO MAIN EDIFICE.

THE LIST OF EUROPEAN GARDENS THAT FOLLOWED THE PRINCIPLES
OF VERSAILLES IS ENDLESS.

13

FRENCH

ENTRANCE

CROSS AXIS

GARDEN AXIS
SAME AS APPROACH
AXIS TO THE HOUSE.
OVERALL SYMMETRY.

LANDSCAPING TRADITION OF THE BRITISH.

14

"HA-HA"
ATTEMPTS TO DEFINE DOMESTIC
TERRITORIES YET ACHIEVE VISUAL
CONTINUITY WITH THE OUTDOORS.

EARLY PURPOSE OF "HA-HA":
FORTIFICATION ENEMY
 DITCH

"HA-HA" IN TRANSITION
 DITCH VIEW

PEACEFUL USE OF "HA-HA"
 FENCE ANIMALS

EVOLUTION OF THE "HA-HA"

15

ENGLAND: CONSTANT CONCERN TO
INTEGRATE DOMESTIC (& URBAN)
ACTIVITIES WITH RURAL.

ANIMALS WATER PEOPLE TO

THE MOST INNOVATIVE BRITISH LANDSCAPE
ARCHITECT: "CAPABILITY BROWN"

16

MOUNT

TYPICALLY ENGLISH STYLISTIC APPROACH.
ARTIFICIALLY CREATED MOUNTAINS.

THE "KITCHEN GARDENS" WERE DEVELOPED BY THE BRITISH.

THE "GARDEN CITY" CONCEPT: SIR EBENEZER HOWARD.
THE ULTIMATE ADVOCACY FOR INTEGRATION
OF URBAN AND RURAL CONTINUA.

BRITISH "GARDENS OF ILLUSION". IMITATION OF CHINESE.

ENGLISH

CROSS AXIS

ENTRANCE

GARDEN AXIS
ALONG THE CROSS
AXIS OF THE HOUSE.

17

CHINA

18

JAPAN: (INFLUENCED BY CHINA.)

IN
OUT WATER

BYODO-IN PHOENIX HALL
NARA-JAPAN 1053 A.D.
SYMMETRICAL BUILDING WITH
ASYMMETRICAL GARDENS.
ELEMENT OF SURPRISE IN APPROACH.

ROCKS
WALL
ZEN

RYOAN-JI, ZEN
GARDENS - KYOTO
JAPAN. DATE UNCERTAIN
1392(?), 1568(?), 1615(?)

KATSURA VILLA-
KYOTO-JAPAN. "STROLL
STYLE": INTEGRATION OF
ALL JAPANESE LANDSCAPING
STYLES.

Figure 30. Landscape architecture through history (2)

285

6. Marble slabs, that is, hard, land-covering surfaces, were used for the patios of the introverted Greek and Hellenistic houses. The need for maintenance dictated that durable materials (such as stones and marble) were more appropriate for open spaces of intensive use. The dialectic between "hard" and "soft"[8] landscaping continues from the Hellenistic times to our day.

7. The Romans used all kinds of outdoor surfaces and design combinations. "Hard" and "soft," "geometric" and "free" were interrelated as demanded by the use (public or private) and as susggested by the topography (Roman forums, Nero's casinos and gardens, etc.).

8. A choice example of sophisticated architecture in terms of exterior-interior-landscape integration occurred in the house of Loreius Tibertinus in Pompeii. Movement and linearity were emphasized by trees, shrubs, water, and walks. Continuity between indoor and outdoor space was achieved through simple spatial arrangements and logical planning of indoor and outdoor activities.

9. The Byzantines learned from the Romans. The Hagia Sophia, the Palace, and the Hippodromio created a public complex where buildings and outdoors were well integrated on the Greek-Roman prototype.

10. The people of the Middle Ages used "hard" landscaping for their plazas and major streets. "Hard" outdoor surfaces were necessary for the intensive use of the urban congregations in front of the medieval cathedral and the feudal castle. Except for the plaza and the central artery, all medieval streets were covered with mud and misery.

11. In contrast to Christian medieval landscaping was the paradise-like landscaping of the Moors. As they crossed from Africa to Europe, the Moors created as lasting gifts to outdoor civilizations the marvels of Alhambra and Generalife. All elements were used: water, trees, sounds, colorful flowers, hard and soft surfaces, and decoration on buildings for visual relaxation from the strong sun and glare of Andalusia. All senses are stimulated at Alhambra and Generalife; the outdoors is at (everchanging, stimulating) work during all seasons of the year. A free geometry prevails in Moorish outdoors.

12. While the Moors were creating their miracles, Renaissance Europe was on its own way. Geometric rigidity prevailed in French landscaping. The French built great gardens along the main axis of the entrance to the palace. French landscapes demonstrated great imagination and "geometric affluence," but they often resulted in "unreadable" (labyrinthic) situations. Great examples of French landscaping are to be found in the gardens of Versailles designed by Andre Le Notre, the architect of Louis XIV. They are imitated later by most monarchs of Europe. In these schemes, the major axis and all paths lead to the palace. This practice was glorified in Karlsruhe where the palace became not only the center of the garden, but the center of the town as well.

13. The British went through two periods: (a) imitating the geometry of the French but putting the gardens along the cross axis of the house, and (b) imitating the Japanese and Chinese to produce gardens of free form and often arbitrary shapes. Original innovations of British landscaping practices were the "ha-ha" and the "mount," developed by Capability Brown and Dorothy Vernon respectively. The importance of British landscaping is not so much its formal content, but rather its social content. The British permitted the development of *commons* in the hearts of the industrial blocks of their towns (all backyards assembled into an organized whole, a common open space), and later on, through the birth of the "garden city" movement, they created garden cities and new towns whereby urban development was intermarried with the natural (countryside).

14. During the years of colonization the British became acquainted with Chinese gardens, which they called "gardens of illusions."[9] The "illusions" they saw were, in fact, the reality of Chinese landscaping—mountains appearing and reappearing through misty skies, trees, streets, shrines, torii, water, sounds of birds, and lily ponds; all in systheses of "dreams." The Japanese, being closer to the Chinese geographically as well as culturally, learned a great deal from them. The Japanese outdoors is an evolution of the Chinese. From the Japanese, the Europeans learned landscaping practices that had been totally alien to them in the past. The Japanese taught asymmetry and surprise, incorporation of "hard" and "soft," man-made and natural—all from a total experiential angle. The Temple of Byodo-in in Nara is a good example. The Ryoan-ji Zen Temple teaches what could easily be called "outdoor minimalism." The Katsura Imperial Villa puts all lessons and outdoor techniques together to create the "stroll" type of outdoor landscaping, the best example of Japanese landscaping. All styles and techniques of Chinese and previous Japanese eras have been incorporated in Katsura. Westerners have learned a great deal from the Japanese, who are probably the world's greatest masters of coordinated architecture, indoor-structural-outdoor.

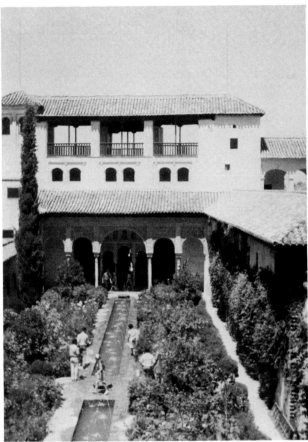

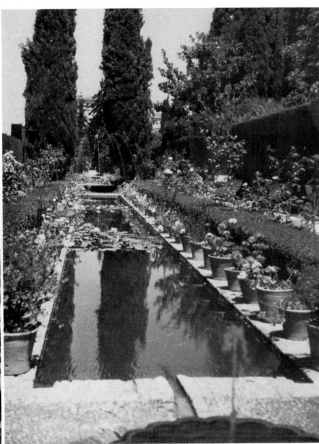

Landscaping elements of Generalife, Spain.

Kyoto International Conference Hall. An antithetical duality: the rolling natural vs. the sharp man-made. Sachio Otani, Architect, 1966.

Outdoor sculpture garden in Kamakura, Japan.

How can you cut an olive tree that it takes three hundred years to reach this size? Masterful landscaping by Ricardo Bofill at "Walden Seven" in Barcelona, 1975.

From the earliest stages of its evolution, the systematic study of architecture for the outdoors considered both micro and macro scales. Perhaps the term, "landscape architecture" has prevailed due to early concerns for the preservation of the great outdoors—the natural landscapes, rather than for small-scale outdoor spaces such as gardens, individual site developments, etc. Famous American landscape architects of the nineteenth century, such as Frederick Law Olmsted, Calvert Vaux, and Charles Eliot, were better known for their large-scale works (regional and national parks) than for their works of moderate scale.[10] These early pioneers were mostly concerned with a macro scale of landscape involvement. Olmsted is considered the founder of landscape architecture in the United States;[11] Calvert Vaux was his partner; and Charles Eliot was the founder of the first metropolitan system of parks.

Concern for small-scale outdoors began in late twentieth century and was mostly associated with the domestic architecture of upper income groups[12] and the architecture of public buildings. Both scales of landscape, macro and micro, demand that the designer be aware of the rules and basic concepts to which the plant ecological units abide. The active landscape architect must have specialized knowledge of numerous ecological processes and know about ecosystem cycles, symbiosis, protection, succession, invasion, favorable climatic conditions, microclimatology, and site details. A keen eye for personal observation is also needed. Beyond these technical faculties, the landscape architect must be able to converse on "architecture" at all levels; moreover, he must be able to grasp the essence of the architectural concept of the building(s) whose grounds he has been called upon to develop. The building architect, on the other hand, must be well educated in general landscape matters so as to be able to collaborate with his landscape colleague.

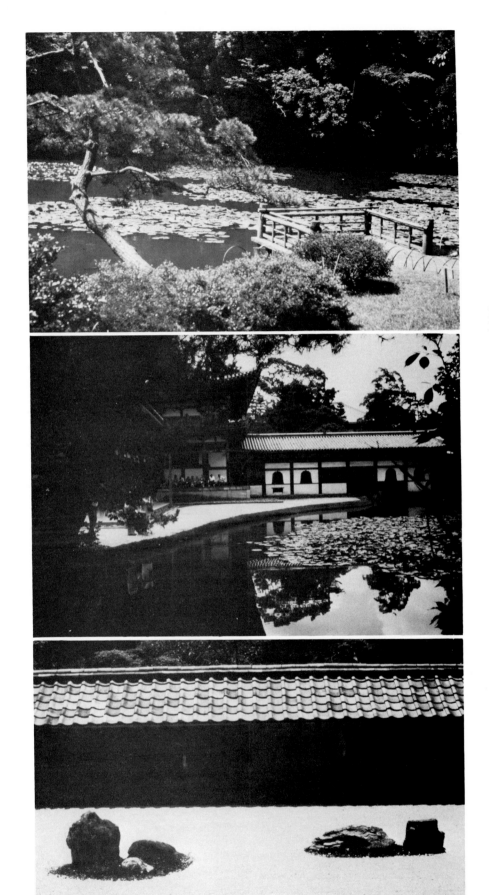

Meinzi Gingu shrine, in Tokyo. The Lake.

Byodo-in Temple, in Nara.

Ryōan-ji, Zen Temple in Kyoto.

Katsura Imperial villa. Structure-landscape relationship.

The fence of Katsura Imperial villa in Kyoto. A gesture of harmony between existing tree and bamboo elements of fence.

Water fountain in Chinese garden.

Sensitive details of Japanese landscaping.

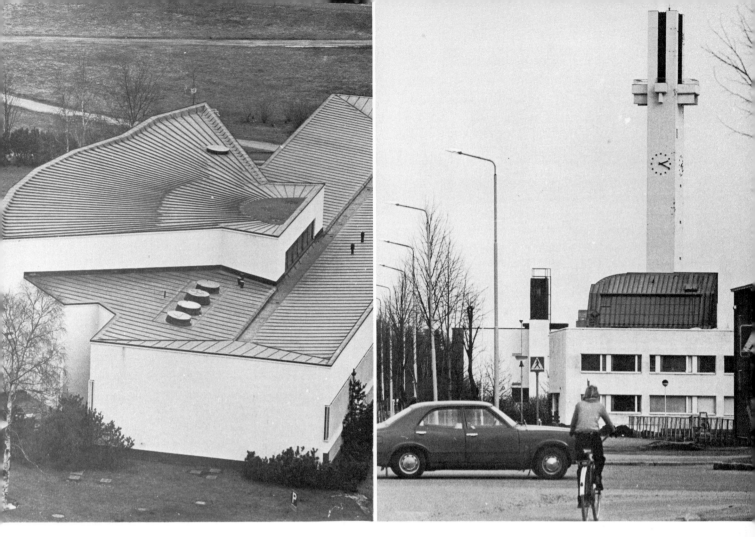

Buildings are also landscaping acts. Offensive buildings become permanent landscape eyesores. Inoffensive and totally considerate buildings represent positive additions to the natural landscape. The total form and roof detailing of the public library at Seinäjoki, Finland, appears like a unique flower to the viewer from the spire of the neighboring church. Both projects by Alvar Aalto, 1958–1960.

Woodland Cemetery in Stockholm. A project of exterior architecture of utmost spirituality. Gunnar Asplund, Architect, 1935–1940.

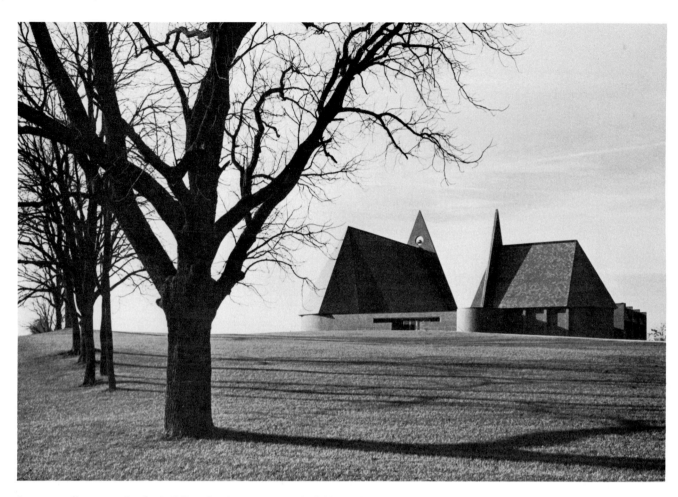

An outstanding example of a building that becomes an undeniable landscape feature, as if it has been there forever. First Baptist Church, Columbus, Indiana. Harry Weese, Architect, 1966. (Photo by Craig Kuhner.) From **INDIANA: THE LANDSCAPE OF MAN** by D. L. Collins.

Sculpture is also a material for the landscape. Sometimes it can be used, other times it may communicate messages, and other times it is there for its beauty alone. (Photo by Craig Kuhner.)

It should be mentioned here that the segregated context of architecture as conceived in some countries such as the United States, and as presented by the American Institute of Architects Handbook of Professional Practice, discourages the creation of a healthy integral architecture. Concern for the outdoors is not regarded as a part of U.S. architects' "basic services,"[13] and the "extra fee" charges for landscaping often guarantees that buildings will be built with no regard for the outdoors. Such practices often make landscaping solutions appear as afterthoughts.

The world architect who approached integration of architecture and landscape in a due way was Frank Lloyd Wright. Classic examples of Wright's integrated buildings are the Kaufmann House ("Fallingwater") in Bear Run, Pennsylvania, and his Taliesin West in Arizona. Another early U.S. architect with great respect for the principles of integration was Richard Neutra. His numerous houses in California can be cited as models of domestic outdoor architecture. In addition to these two pioneers, who did not necessarily call themselves landscape architects, numerous others created works with substantial

Successful landscaping can bring unity to diverse and even unrelated buildings. Landscaping by Garrett Eckbo at the University of New Mexico, 1969.

merits of integral architecture. Among these people, Mies van der Rohe might occupy a predominant position. His glass residences permitted visual marriage between indoors and outdoors. The structural and detailing sharpness of Miesian buildings and their relationship to a free landscape resemble the ancient Greek "building vs. landscaping" prototype.

Among the hot issues confronting architects today is landscape respect and conservation.[14] To what extent can existing landscape be respected? How can architects respect it? What should they know initially so as to create works that are acceptable ecologically, that is, that respect the great, scarce resource of the outdoors? The answers to these questions are unique for each individual case. They require detailed study of the existing conditions and expert advice. Yet there are numerous rules of thumb that can be followed by the general architectural practitioner and by the concerned citizen. Public awareness on issues of landscaping and the outdoors could be extremely beneficial toward the goal of sound civic decisions pertaining to the outdoors.

Some Rules of Thumb

The study of selected landscaping references[15] reveals a number of basic rules of thumb which can be taken into consideration when designing or talking about landscape.

1. One should not work against the topography of the terrain. Contours and drainage patterns should be respected.
2. Capitalize on what is there. Respect existing features (rocks, running water, tree colonies) and glorify them appropriately.
3. Respect existing trees. Do not build where there is unique vegetation. Build in areas possessing no vegetation and orient your building toward green areas. Wisest ecological approach: "Build in the junkyard and look into the forest." Use what is native.
4. Utilize trees as windbreaks. Utilize "free" shade of trees. Utilize seasonal variations of landscapes.
5. Consider landscaping elements that are appealing to all the human senses. Think about the variety of outdoor elements and the variety of plant life on a year-round basis.

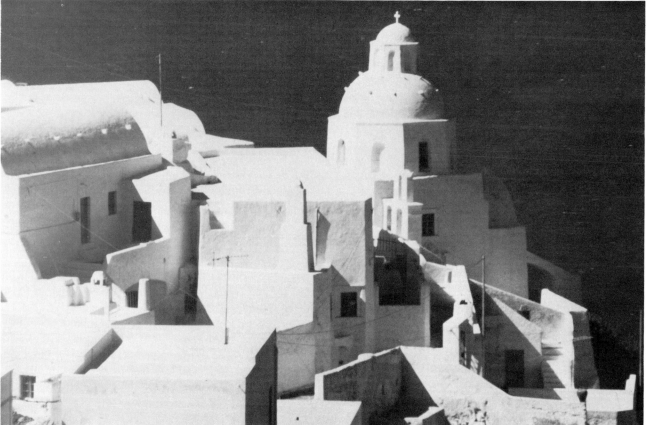

Sculptural articulation of building elements is a must on hilly sites, since the total environment is perceived through three-dimensional movements, up and down the hill. Santorini, Greece.

294

Water and trees integrated into the total architecture of the Kimbell Art Museum, enhancing the processional entrance experience. Louis Kahn, Architect, 1972. (Photo by Tommy Stewart.)

Care for the outdoors. Landscaping can be achieved by modest means if there is enough care.

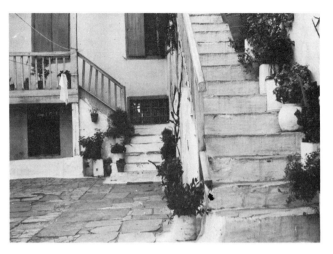

Landscaping achieved by modest means in sophisticated contemporary architecture that respects the regional processes. Detail from private residence in Mexico City. Ricardo Legorreta, Architect, 1978.

Maximum results through modest means. Old Athenian House, Plaka, Athens, Greece.

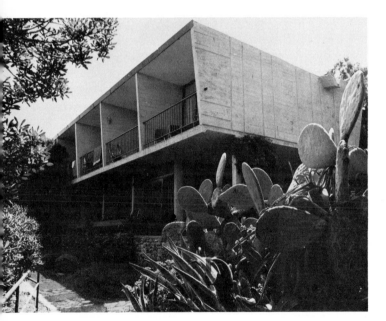

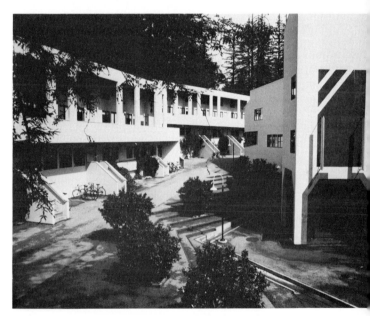

The poetry of man-made and natural. Unpretentious landscaping through the use of native plants. Green-coast resort in Sounion, Greece. Aristomenis Provelengios, Architect, 1963.

When the "natural" is sensitively integrated with the "man made" and when both retain their individual integrity, the result can be very dynamic and the experience rewarding. Cresge College, Santa Cruz campus, Charles Moore, William Turnbull, Architects, 1970.

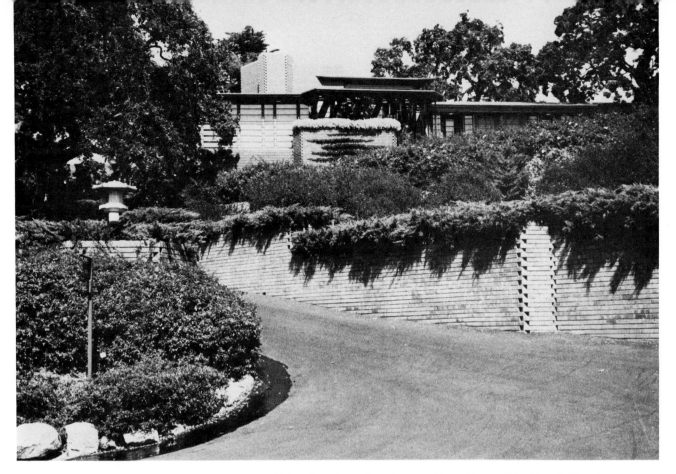

House and landscaping becoming part of nature, as if they have been there forever. Hanna House, Palo Alto, California. Frank Lloyd Wright, Architect, 1937.

6. Terrains are not always flat. Remind your architect that rooftops are important on hilly sites. The sculptural quality of buildings is important; elaborate on it. Avoid landscape solutions that look down onto unattractive roofs.

7. Landscaping must consider surface materials that are appropriate functionally as well as from the maintenance standpoint. In this respect, be aware that there are three basic types of landscape surfaces.[16] Use them and elaborate on them appropriately. Be aware of the following:

 a. *Hard Landscaping:* It incorporates hard surfaces and textures; e.g., patio slabs, concrete-scored areas, tiles, bricks, terra cotta, marble, schisto, wooden platforms, aggregates, etc. Initially costly, it is economic in the long run. It has low maintenance costs and is easy to clean, thus it renders itself to life styles where frequent maintenance is difficult (e.g., the life style of a bachelor). Be extremely careful in proposing hard landscaping, as it may be dangerous to children.

 b. *Soft Landscaping:* It incorporates vegetation and soft textures; e.g., grass carpets, shrubs, sand surfaces, water, etc. Initially inexpensive, but costly in the long run. Maintenance must be frequent and knowledge of gardening, from elementary to very sophisticated, is necessary. It is good for children, safe for infants. Earthy textures (sand, etc.), must be appropriately planned to avoid prevailing winds. Grass "carpets" (lawns) are very good for hot climates, as they cool the surroundings by at least ten percent. Trees are also extremely important because they cut down the velocity of the wind, thus protecting ground areas at least ten times their height.

 c. *Hard-Soft Combinations:* These are balanced combinations of "hard" and "soft." A combination may consist of areas of hard and soft put together "appropriately" or of elements (areal or linear) of hard "appropriately" located in "carpets" or "seas" of soft. (The Japanese garden, typically, is a case of the latter.)

In hard-soft combinations, the elements may be geometric (slabs, etc.) or free in form (natural stones, rocks). The Japanese garden (public, ceremonial, or private) is in most of its stylistic expressions a case of all possible combinations, well and "appropriately" balanced. Symbolism and religious meaning dictate a lot of what is done in Japanese gardens. The "appropriateness" of any combination determines the merit of the respective design.

297

Combination of "soft" and "hard."

Rhythmic experience may be enhanced through care of the paving patterns. Pedestrian walk in Helsinor, Denmark.

The Eleftherios Venizelos monument in Athens, Greece. Where the rolling earth forms transform the monument space to a place for play and relaxation. Panagiotis Vokotopoulos, Architect, 1969.

"Hard" outdoor surfaces. The Italian case.

Strictly "hard," Japan.

←Total integration by giving-in to the forces of landscape. The house is suspended by piles which cause minimum disturbance to the roots of the trees in densely vegetated landscape, Miami, Florida. Yannis Antoniadis, Architect. (Photo by G. Wade Swicord.)

TREES CAN CREATE "EXTERIOR WALLS" THUS THEY CAN DEFINE EXTERIOR SPACE

TWO TREE WALLS CREATE A BOULEVARD

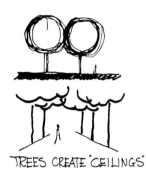

TREES CREATE "CEILINGS"

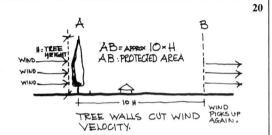

BUSHES CAN DEFINE AN AREA. TREES EMPHASIZE IT.

GRASS DEFINES AREAS SUGGESTING USE.

10% COOLING EFFECT — GRASS "CARPETS" HAVE COOLING EFFECT ON THE ENVIRONMENT.

AB = APPROX 10×H AB: PROTECTED AREA TREE WALLS CUT WIND VELOCITY. WIND PICKS UP AGAIN.

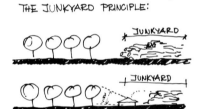

A "LONELY" TREE... CAN TOLERATE THE COMPANION OF "A BENCH" AN "OLIVE" TREE A CYPRESS TREE THE JUNKYARD PRINCIPLE: JUNKYARD JUNKYARD

"PERSONALITY" OF TREES MUST BE RESPECTED.

"BUILD IN THE JUNKYARD AND LOOK IN THE FOREST."

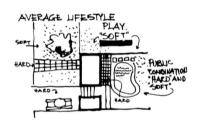
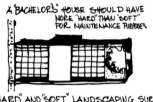
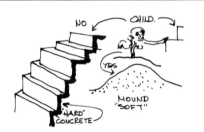

AVERAGE LIFESTYLE PLAY "SOFT" SOFT HARD PUBLIC CONSUMPTION "HARD AND SOFT"

A "BACHELOR'S" HOUSE SHOULD HAVE MORE "HARD" THAN "SOFT" FOR MAINTENANCE PURPOSES

"HARD" AND "SOFT" LANDSCAPING SURFACES DEPEND ON THE USE AND LIFE STYLE.

NO CHILD. YES MOUND "SOFT" "HARD" CONCRETE

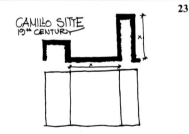

CAMILLO SITTE 19TH CENTURY

...THE MINIMUM DIMENSION OF A SQUARE PLAZA SHOULD BE EQUAL TO THE HEIGHT OF THE PRINCIPAL ADJACENT BUILDING, WHILE ITS MAXIMUM DIMENSION SHOULD NOT EXCEED TWICE THAT HEIGHT UNLESS THE BUILDING'S FORM AND FUNCTION WILL SUPPORT GREATER DIMENSIONS."

A. B. C.

20TH CENTURY. THE 8-10 PRINCIPLE OF YOSHINOBU ASHIHARA.

YOSHINOBU ASHIHARA'S HYPOTHESIS: "...IN THE DESIGN OF EXTERIOR SPACE A SCALE THAT IS ABOUT EIGHT TO TEN TIMES THAT OF INTERIOR SPACE PROVIDES A COMPARABLE ENVIRONMENT... IF 10×10 IS A SATISFACTORY INTERIOR SPACE THEN THE SATISFACTORY EXTERIOR SPACE THAT WOULD COMPLEMENT THIS INTERIOR SPACE SHOULD BE 8-10 TIMES LARGER (A, B or C); IT SHOULD BE 80-120 ft = 6400 sf. THIS EXTERIOR SPACE ALLOWS PEOPLE TO RECOGNIZE FACES.

INTERIOR: 30×60' PERMITS INTIMATE GROUP ACTIVITY. MULTIPLY BY 8 EXTERIOR: 240×480' PERMITS INTIMATE GROUP ACTIVITY OUTDOORS. THIS SHOULD BE THE LARGEST EXTERIOR SPACE WHERE HUMANS CAN RELATE WITH SENSE OF INTIMACY..."

ASHIHARA SUGGESTS THAT THE MODULE FOR THE DESIGN OF EXTERIOR SPACES SHOULD BE 80'

Figure 31. Concepts of landscape architecture

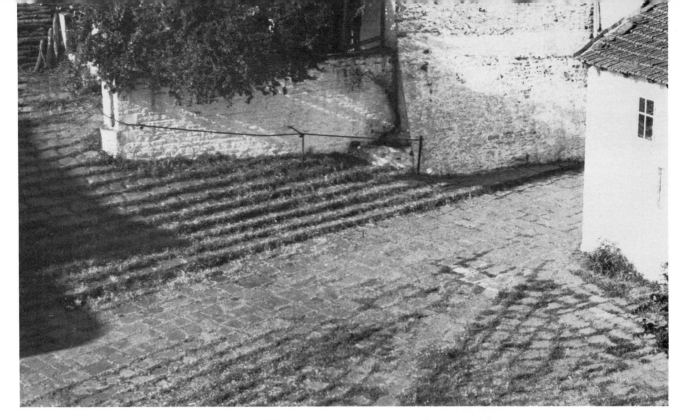

Hard landscaping patterns in interior courtyard of Vatopedi monastery, Mount Athos.

Greenery and lighting have the power to enrich the environment and elevate projects of economic and diagramatic efficiency. University of Toulouse-le Mirail. Candilis-Josic-Woods, Architects.

Integration of natural and man-made Säynätsalo Town Hall, Alvar Aalto, Finland.

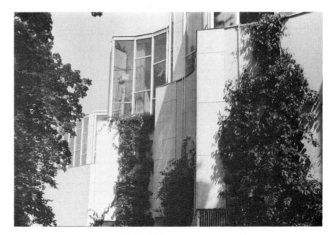

Integration of natural with the man-made. The architecture of Alvar Aalto. Finlandia Hall, Alvar Aalto. Helsinki, 1967–1971.

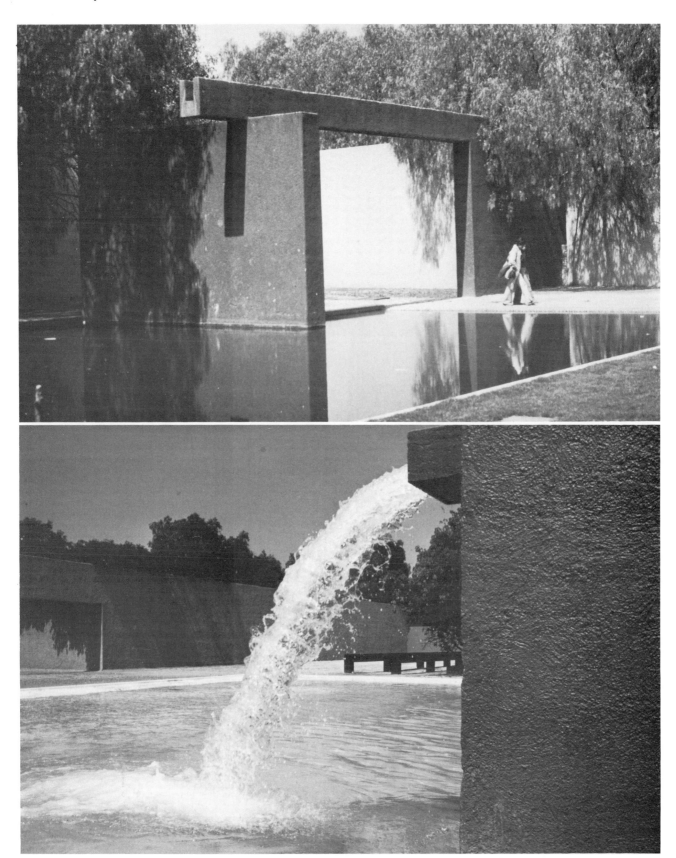

Top, "Fuente de los Amantes"—(Fountain of the Lovers). Subdivision "Los Clubes," Mexico City. Luis Barragán, Architect, 1963–1964. *Bottom,* landscaping for private residence of Mr. & Mrs. Folke Egerstrom with stables in subdivision "Los Clubes," Mexico City. Luis Barragán, Architect, 1967–1968.

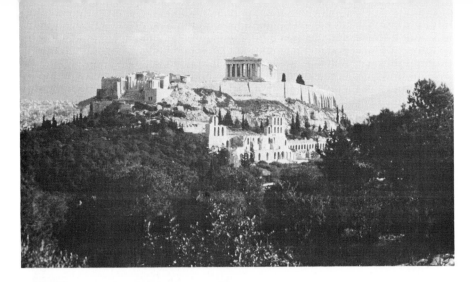

The Acropolis of Athens.

Western edge of the hill of the
Acropolis of Athens.

General Considerations

In any design for the outdoors, utmost attention must be paid to the *movement* and *activity* possibilities of the scheme. Each scheme should enhance movement, utilizing elements fit for the outdoors (natural or artificial—trees, shrubs, outdoor furniture), as well as permit static activities to take place.

We have accepted the idea that the total landscaped area is an integrated whole. This whole should on occasions *invite* people, and at other times it should make them stay at a distance and just look at it. People should feel invited to the areas of the landscape intended for "activities." People should be kept away, at appropriate distances from areas intended for visual pleasure only. Activities in landscape may occur if the unique and intended activities areas are accessible by means of paths,

walks, etc. These elements connect exterior space (the landscape) with interior space (inside the edifice) and vice versa, and eventually become the backbone of the landscape. Paths and walks and their intersections are similar to the circulation backbones (corridors, hallways) of buildings' interiors.

The "backbone" of the landscape is further enhanced by *linear* or *volume* concepts. Shurbs and bushes next to a path may enhance linear direction. Trees may enhance linear and volume if planted in pairs. "Walls" and "ceilings" may be provided by means of trees, while resulting shaded areas on the ground may become protective barriers between different activity areas. There are trees appropriate for emphasizing the "wall" concept (e.g., cypresses), while others are more appropriate for the achievement of "ceiling" (e.g., pine trees), etc.

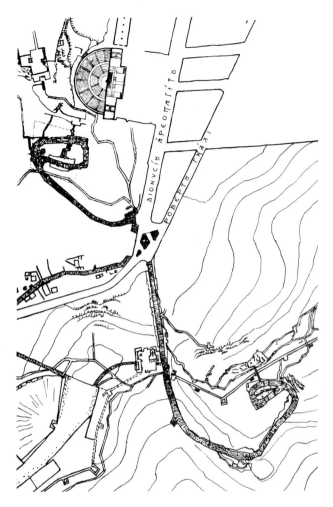

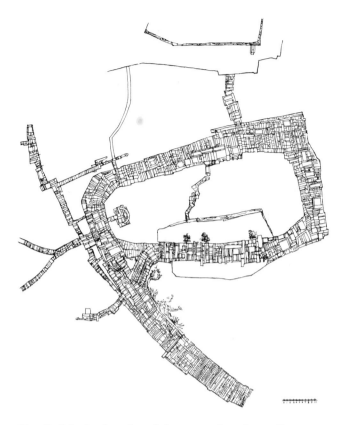

Detail of the landscaping of the approach to Acropolis. Athens, Greece. Dimitris Pikionis, Architect. (After D. Vassiliades, "Odipora stis Morfes ke to efos tou Ellinikou Chorou." Athens, 1973).

The landscaping scheme of the hills of Acropolis, Pnyx and Philopapou, Athens, Greece. Dimitris Pikionis, Architect. (After D. Vassiliades, "Odiporia stis Morfes Ke to efos tou Ellinikou Chorou." Athens 1973.)

Different types of trees have different personalities. A "cypress tree is a cypress tree is a cypress tree," Gertrude Stein perhaps would have said; but an olive tree is different from any other olive tree. Thus, the uniqueness of certain trees may suggest unique treatments.

An olive tree is considered a tree of wisdom by the Greeks. Perhaps this is due to its clockwise wrinkles that connote knowledge acquired through aging, or maybe it is because of the importance given to it by Greek mythology and the people.[17]

One cannot deny the strong significance of outdoor "pictures" and "schemata" in the minds of people; neither can one deny the relativity of landscaping proposals. It is through the outdoors that topophilic attachments are generated, and it is the general configuration of the native landscape that stays with people through their lives.[18] Holy activities may be organized around and under the shade of an olive tree. Village parties and pagan festivals may take place under an empire oak. . . . One should not fail to capitalize on, and do justice to trees that possess personality.

It has been mentioned and must be mentioned again that landscape architecture must be considered a part of the total building process. Even if the "landscaping" is to be left for some later date, due to financial constraint, its design must be considered simultaneously with the design of the building. Only the landscaping decisions will make the building design decisions "undeniable." In this respect, considerations of activity, maintenance, implementation in time, and proximity of building to the "wet outdoors" and roots are fundamental. Let us, therefore, discuss in more detail a few of these "musts."

In designing the total environment, the design team (architect and landscape architect) must consider the following:

1. Activity considerations: Different activities require different landscape approaches. Play, utility, work, family, ceremonial, views.

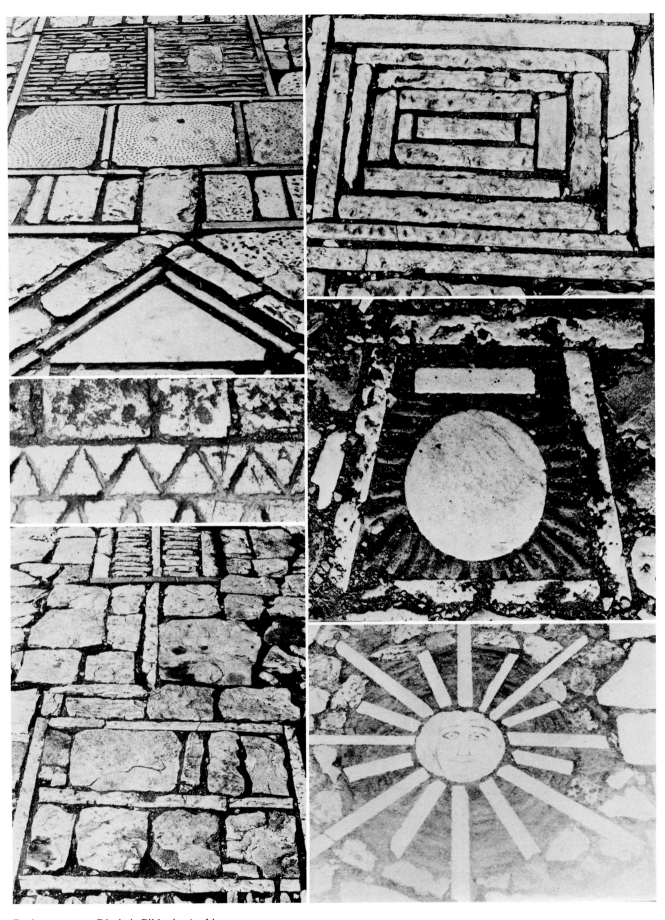

Paving patterns. Dimitris Pikionis, Architect.

Landscaping details at Philopapou. Dimitris Pikionis, Architect.

2. Maintenance considerations: Private vs. public issues, life style.

3. Implementation in time: Knowledge (empirical or otherwise) of what is native, how long it takes to grow, and whether it is evergreen or not.

4. Always check the proximity of the building, and the depth of the building foundation to the depth of plant roots. Close proximity of plants may prove detrimental to the structural resistance of building.

5. Work your landscape plan in terms of total design development: interior–structure–exterior. The building, with its orientation, accesses, etc., will become an undeniable entity on the site only in this integrated case. Make sections and elevations indicating realistic heights of vegetation. Learn all you can about the predominant vegetation (dimensions, bulk, life) of your region and the immediate vicinity. Sketch local plants continuously.

Although the landscape was created before man, man's awareness of it developed empirically and in time. We are still searching in despair yet; as architects for the outdoors we have largely failed. The very few exceptional figures of architectural history who dealt specifically with the landscape were either monarchic architects (e.g., Le Notre: Verseilles) or social thinkers concerned for the outdoors (Ebenezer Howard). The former group of people possessed little technical ability necessary for the creation of great works and useful theory. Frederick Law Olmsted was the first person to undertake prestigious landscape projects in the nineteenth century. His concern for landscaping is especially remarkable considering the fact that there was no lack of open space during his day.[19] He created numerous great parks in the United States, but a great theoretician he was not. For many years the architecture of outdoors was largely a conservation and regional concern.

Landscape architects of today have acquired their poetic skills the hard way; through historical observation, traveling, and sketching.[20] The theoretical anxieties are few. Prominent among them are the theories of Japanese architect Yoshinobu Ashihara who drew his conclusions from the study of Japanese, Italian, and United States examples. Ashihara, though not a landscape architect per se, is largely concerned with the issue of "human" scale in exterior space. His theory of "10" suggests that an exterior space, if it is to have a human scale, must have 8–10 times the size of an indoor space possessing human scale.[21] If, in other words, a human being feels comfortable in an interior space that has an area of say 100 square feet, this person will feel comfortable in an outdoor space having eight to ten times that size, that is, 800–1000 square feet.

Ashihara's theories appear rather doctrinaire, yet they are well tested through his own projects, and they have been verified in numerous historical examples, especially Japanese. In any event they represent plausible beginnings for one's own search.

There are numerous "know how" references, with Garrett Eckbo having, in the author's mind, produced the best one for the consideration of beginners. Lawrence Halprin represents another case of a successful landscape architect in the United States. In other countries, we would mention the works of Gunnar Asplund in Sweden, Luis Barragán in Mexico, and the marvelous work of Dimitrios Pikionis for the landscaping of the hills of Acropolis and Philopapou. Pikionis's designs were conceived with a creative modesty that permitted the holy attitude and greatness of the Parthenon to remain (as it ought to) predominant.

It is unfortunate that our landscapes have been "fornicated" by thoughtless development; and it is perhaps unfortunate that landscape architects are by nature calm, poetic, God-loving people. The opposite might be better. We need forceful and arrogant fighters in order to protect what is being taken by the speculative processes of urbanization, irrelevant industrialization, and thoughtless growth.

Notes

1. For early inclusive definition of "landscape architecture," refer to Hubbard, Henry V.; and Kimball, Theodora, 1967, p. 1.

2. The term "exterior design in architecture" was first used by Yosinobu Ashihara. His book *Exterior Design in Architecture* represents the total builder-architect's sensitive point of view on the design of outdoor spaces.

3. Halprin, Lawrence, 1971, p. 33.

4. See Jan McHarg; as well as ibid., p. 33.

5. Most landscape architects are good-natured, esoteric, religious, and poetic human beings. The author is not aware of any better example of this than the case of Greek architect-landscape architect, Dimitrios Pikionis. For further reference see Antoniades, 1975 (5).

6. For a good argument for the scarcity of landscape resources and conservation of natural resources, refer to Newton, 1971, pp. 654–674.

7. General reference on the history of landscaping is given to Tobey, 1973; Newton, 1971; and Carpenter, Walker, Lanphear, 1975. The latter reference provides a very comprehensive introduction to the history of landscape development and is recommended for further introductory reading. No further specific references will be made in the text that follows.

8: Terminology on "hard" and "soft" landscape surfaces is credited to Garrett Eckbo. Refer to Eckbo 1978.

9. For further reference on Chinese gardens, refer to Keswig, 1979.
10. Barlow, 1972, and Newton, 1971, p. 267, p. 325.
11. Newton, 1971, p. 337.
12. Outstanding for their domestic landscaping are the landscape architects of the state of California. Garrett Eckbo could be pointed to as the dean of California domestic landscape architects.
13. Refer to "Basic Architectural Services" in *A.I.A. Handbook of Professional Practice.*
14. Newton, op. cit., p. 659.
15. Simonds, 1961, general reference; Lynch, 1962, general reference; Carpenter, Walker, Lamphear, 1975, general reference.
16. Eckbo, 1950 and 1978, basic references.
17. Constantinides, 1972.
18. Yi-fu-Tuan, 1974, p. 59, p. 113.
19. Barlow, p. 5.
20. Good example: *Notebooks 1959–1971* by Lawrence Halprin.
21. Ashihara, 1970, p. 47.

Selected Readings

Ashihara: *Exterior Design in Architecture.*
Eckbo: *House Design* The Art of Home Landscape, McGraw Hill, 1978.
Halprin: *Notebooks 1959–1971.*

14
Interior Design

"... I do not like those faces; the heart of those men is far from God; it is the inner man who matters, the heart is the rule for judging. ..."

Jesus Christ

"... serenity and spiritual tranquility prevail in the interior space of this residence ... an internal tranquility."

Aris Constantinides[1]

The total architectural environment is composed of a holy trinity: interior–building mass–exterior. When all elements of the trinity are working as an integral whole, we can safely speak of successful environmental design.

Some climates cause people to spend more time outdoors than indoors and visa versa. As a rule, hot climates have generated outdoor rather than indoor civilizations. Greeks, Southern Italians, North Africans, and Mexicans are people who live outdoors. Scandinavians, Northern Europeans, people of the United States, and inhabitants of other countries with prevailing cold weather and rainfall spend much of their time indoors. It is therefore natural that there are inherent inclinations for some people to prefer outdoor living, and for others to prefer indoor living.

The general attitude in all civilizations, however, is that the indoors has a protective quality, a womblike tenderness; it is the "vase" of human life. The outdoors, on the other hand, has connotations of escape; and it provides opportunities for social contact, for public as opposed to private life.

For many recent civilizations the relationship between indoors and outdoors has changed. The media of communication (the telephone, television, etc.) have brought new dimensions to indoor life in countries with advanced technologies[2] so that there is less need for the outdoors and for direct contact with the outside world than in the past. In some of the same countries there has come about a fear of the outdoors due to increased crime rates. Because of these reasons, advanced countries are experiencing a decadence in their outdoor environments today; while at the same time, they are experiencing the creation of new indoor environments for the performance of activities of private and public nature.[3] Certain indoors flourish, especially the "indoors" of the "have" classes; while other "indoors," such as those to be found in mass housing, are in many cases cells of unhappiness and discomfort. These bad situations are the result of contemporary building practices that design for stereotyped users based on grand assumptions pertaining to life style, individual preferences, and user needs.

The technologically advanced societies are in great need of architecture responsive to "interior" demands. The concern for the balance of the "trinity" needs to be revived. The unknown users must be given the chance to shape their indoors according to their own needs and likes. Older civilizations did not have the problem of twentieth-century urbanites. Those past peoples built their houses themselves, around their own life styles and needs; they were clients, builder-architects, and users.

The problem of uncertainty pertaining to the future user, the lack of specific information pertaining to the future user's life style and specific needs, has created the need for new environmental endeavors. These new endeavors should be exercised by appropriate designers at the time a specific user is known, such as when an apartment has been leased by its future occupants. The task of designing the indoor environment for the known client rests today with the *interior architect* as he (or she) is called in Germany, or *interior designer,* as he is called in the United States.

With this introduction in mind, we may now define interior architecture (interior design) as the sphere of environmental design that properly exploits the interior spaces of a work of architecture by means of color, texture, lighting, furniture, appliance selection, arrangement, and activity grouping[4] so as to make the function of the space efficient, comfortable, psychologically appealing, and sensually and mentally stimulating for the specific users.[5] The interior architect, in attempting to achieve all of the above must have a definite understanding of the architectural space in which he (or she) is working.[6] He must have a strong drive for understanding[7] the needs and mental connotations of the person for whom he is designing. Then he must have technical expertise in color combination, texture, lighting, acoustics, efficiency of materials, economics of detailing, and indoor plant life.[8]

A talented and conscientious interior designer enhances the inherent qualities (if there are any) of an unoccupied architectural space. There are many talented and conscientious interior designers, and they deserve our respect. The architects who collaborate with them and the clients who enjoy the products of their design efforts recognize the tremendous validity and need of their profession.

Yet in spite of the individual cases of good interior design and respect-deserving individuals, there are certain inherent handicaps at present that cause problems within the discipline. Certain practices of interior design are questionable,[9] and certain professional attitudes are unacceptable in their current state. These practices are most noticeable in the United States, in spite of the fact that the United States has demonstrated a great many good examples of humanly successful interior environments. These cases should constitute the beginning for new developments and improvement in the field.

Interior design, like any other sphere of design, should be disciplined. A healthy concept of interior design is that of "interior architecture," which is commonly held in Europe.[10] The concept of "interior decoration" seems to be a detrimental one, because the "decorator" usually acts as a product promoter rather than an educated problem solver for the needs of human beings in interior spaces. A

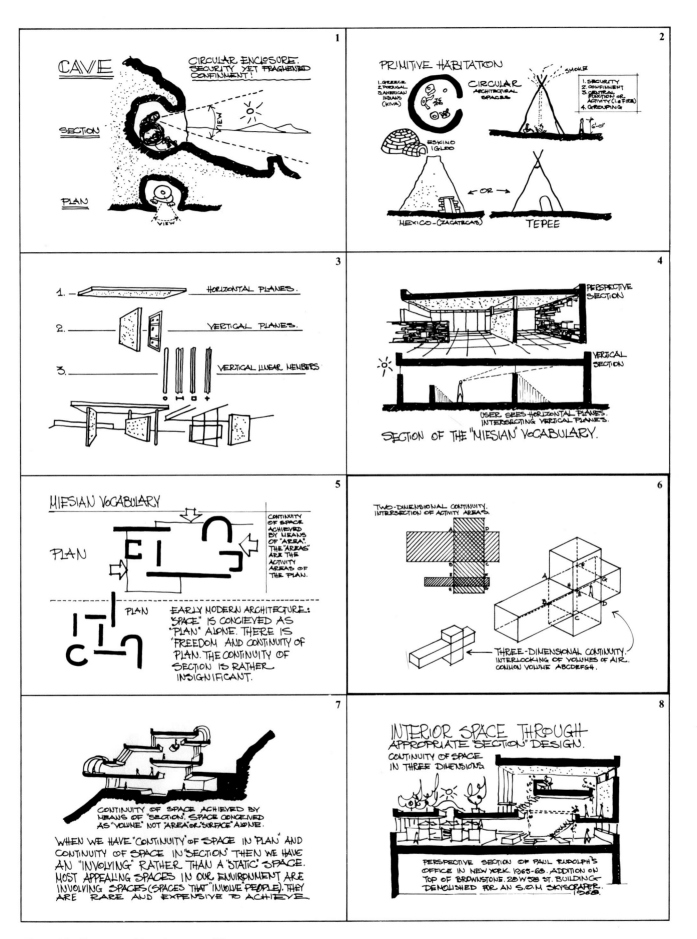

Figure 32. Concepts of interior space (1)

client should hardly trust a "product" or "style" promoter. He should trust a person that speaks to him and shows him ways to meet the needs of his interior habitat. The problems of the profession of interior design in the United States will be resolved if the issues are clarified, and when one does not need to speak of "good interior designers" vs. "decorators," or about "good decorators" and "bad decorators."[11] The literature of interior design is filled, at present, with doubts about term definitions and with professional uncertainties.[12] There is no need for elaboration on these points here. The problems will cease to exist if the designers of interiors become respectful of "space," if they cease practices that make them appear as mere "new material and new fabric" promoters, and if they concentrate their efforts on the areas of design in which they are most qualified to practice. There is a faction of interior designers and decorators who rest on the ambition that "the day will come when they will qualify for the role of the residential architect."[13] One would only hope that if this is to take place, it should happen as a result of a disciplined and environmentally interrelated education that will help these designers to meaningfully qualify for their dreams.

The key answers to all the uncertainties rest with the role of education in this field of design. Most interior designers in the United States today are products of four years of education (in the best cases), compared to the normal six years for architects. The decorators are products of much less exposure to education and a very shallow, nondesign-oriented test; they often work for product promotion. In that sense they become "collaborators" of the getting-rich-quick manufacturers,[14] "pushers" of meaningless antiquated styles, and copiers of irrelevant interiors of the past. In doing all that, they often employ a flamboyant professional behavior and a shallow eloquence inherited from the guru of decoration, the late Oscar Wilde.[15]

The above discussion is not meant to be derogatory or degrading to an environmental discipline that is needed as much as all the others. It is stressed though, because it happens to be the author's strong conviction that interior design must play a very active role in the future in order to shape the immediate environments of man's habitat. This is the right time for an interior designers' primer in the United States, both in education and in practice. Interior designers must work hand in hand with architects, and they must speak "space." This "space" issue is fundamental if the architectural solution is to be enhanced and if the interior is to be an integral part of the total as it ought to be. In this respect, it is extremely important that architects and interior designers have an absolute understanding of the vocabulary of space, and that their interior decisions be cognizant of the inherent properties of given spaces. A well-designed apartment complex, for instance, may possess substantial spatial qualities; it may possess an animated interior created by means of clerestories or different activity levels. A modular store in a shopping center, on the other hand, may possess no spatial qualities at all. Spatial awareness of the vocabulary and cognizance of the spatial properties are fundamental issues, and they are examined in detail in the process of this inquiry.

Evolution of Interior Space[16]

The early spaces mankind used were provided by nature. Through a process of invasion, primitive man evicted the animals and became the occupant of caves. With the use of fire, he tried to keep his caves warm and keep the animals outside. Protection and defense through the control of view were provided by the cave.

In the process man created shelters through extraction. The cavelike atmosphere stayed with man through the troglodytic eons of his existence. The first built-up spaces evolved around the cave prototypes and around the comfort of fire. Primitive tribes built *circular spaces.* These spaces protected the occupants and permitted them to live in groups around fires. These results were achieved by emphasizing a central part of the plan, the point where the fire was. Another central point on the section was given to the chimney on the top of the cave for ventilation and the extraction of the fumes. The equidistant and communal properties of primitive interior spaces have stayed with man since those early days of civilization. Certain public spaces such as churches and assembly halls have kept their circular plans throughout history; and numerous architects have attempted to work on the properties of circular or curvilinear spaces. (The curve is easy to draw in plan, and a nail and a string can simplify drawing the circle.) The third dimension of such spaces posed construction difficulties; man, therefore, looked for easier ways to build his enclosures. The law of gravity made it easy for people to accept as predominant means of construction the post and beam, the vertical and horizontal.

Two-dimensional Continuity

Most interior spaces throughout history, especially spaces destined for private use, evolved by means of vertical and horizontal elements. These elements are either linear or surface. There has been no basic structural evolution in the methods of *enclosing spaces by means of vertical and horizontal elements;* there have been only refinements. One of these refinements is the use of space frames as horizontal elements. The space of the Greek megaron evolved, through the Miesian restatement of the

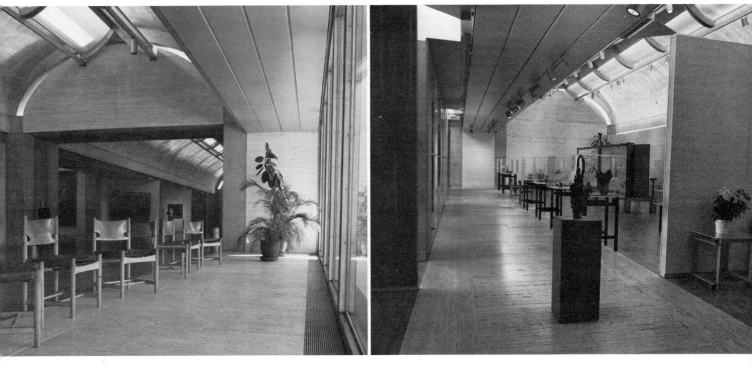

Integrated structural, mechanical, and lighting considerations in the interior space of the Kimbell Art Museum. Louis Kahn, Architect, 1972. (Photo by Tommy Stewart.)

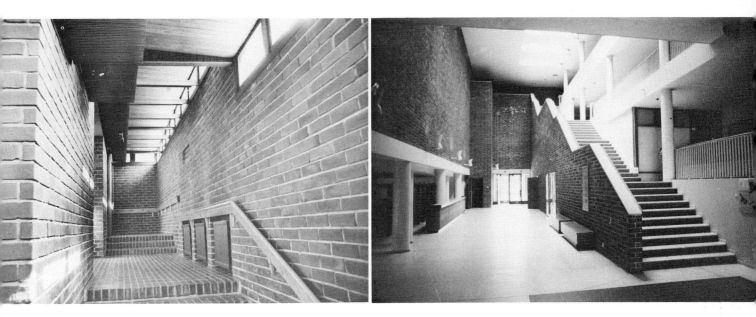

Interior space as enriched through the experience of ceremonial circulation in relationship to animation by means of natural lighting. Examples from the Architecture of Alvar Aalto. Säynätsalo Town Hall, *left*. Jyväskylä Campus Chemistry building, *right*.

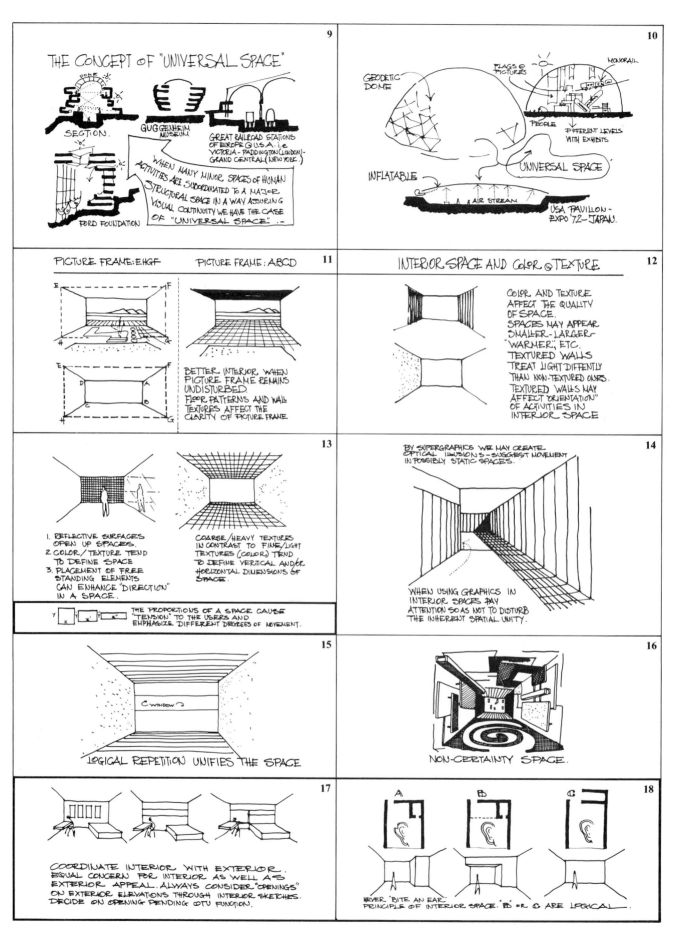

Figure 33. Concepts of interior space (2)

"Barcelona Pavilion," to contemporary exhibition and assembly halls, supermarkets, and residential and industrial structures. The post and beam has permitted the plan to be liberated from the heavy load-bearing walls of the past. The ingenuity of Mies van der Rohe achieved a horizontal as well as a three-dimensional continuity.

The Miesian three-dimensional continuity was weak. It occurred at the spatial junction of vertical and horizontal divisions of transparent surfaces, such as glass. Use of glass permitted the vertical division to end well below the ceiling, so that the eye could wander in three dimensions from one room to another. Ceilings appeared to come from adjacent spaces, pass through, and disappear into the neighboring ones. What Mies achieved was *a first degree of spatial transparency*,[17] that is, a horizontal rather than vertical spatial continuity. The Miesian space is characterized by elemental clarity (each element is structurally and spatially articulated). Since this clarity is justified by structural honesty, it must be respected as a principle; it is vital for the statistic existence of the space.

Textures and surfaces are important; thus considerations of interior nature in spaces of the Miesian vocabulary must not compete with the textural and structural balance of the already achieved space. The corners of the spaces must be left intact or else be reworked so as to create new spaces that obey the Miesian rules. All elevations should be considered in the design of interior spaces, and it is the belief that each one ought to balance in a Mondrian-like fashion if the Miesian structure is to be respected. All Miesian elements—walls, partitions, ceilings, floors—can be conceived as integral frames, as they are indeed ready to accept coloring, texture, and furniture on them. These frames should be respected. Floors when not respected are broken down; they disturb the vertical frames and the view. Clear frames are most advisable.

Excellent applications of interior design that dealt with spaces of the Miesian vocabulary were achieved by S.O.M. The best interior designs of the free Miesian spaces were designs of Mies himself . . . but that was another era of architecture. Mies has left for us the secret of his structural plan—frame clarity and "area," rather than "volume" continuity. It is up to the interior architect to understand this and to create appropriately.

Three-dimensional Continuity

When the Miesian plan is turned sideways, one gets an architectural section possessing the continuity (transparency), that was previously possessed by the plans of Mies. Continuity in plans *and* sections creates *three-dimensional transparencies*,[18] that is, it generates interior spaces with intersecting horizontal and vertical volumes of air. These points of intersection give dynamism to the space and they need to be emphasized. Three-dimensional spatial continuity was developed by Frank Lloyd Wright in some "monotonic" way in his larger projects (Guggenheim Museum, Morris Shop); it was refined by Rudolph Schindler; and it was finally deified by Paul Rudolph. The key understanding of this space lies in the recognition of the point of interlocking of the horizontal and vertical volumes of air. These points can be emphasized by means of vertical elements (plants, banners, etc.) that take the eye and lead it through all the elevations of the interior space.

Since the continuity of such space is total, it should be respected; one should approach the color and texture schemes in a total, coherent way. It would be harmful if such interior spaces were broken down by a multiplicity of color schemes and the integration of numerous materials and colors. Unfortunately, many "decorators" and many interior designers do not understand such things. If there are to be numerous colors and materials, they should be used in the objects, furniture, and appliances inside; the furnishings should be themselves, existing as free objects in the space rather than being attached to the generic architectural space. Supergraphics, for instance, can reemphasize the spatial continuity of such spaces, but they should be studied with the whole space in mind. A pattern of supergraphics that joins only a few of the levels of a total space may "break" the space and thus be undesirable. Acoustics and fire protection are extremely important interior design constraints, especially when dealing with architectural spaces of the vocabulary discussed. The most successful of such spaces have been extremely disciplined in their color and texture schemes; for example, a white interior enhanced by a vertical emphasis of greenery and concentrated appliances or venetian blinds of chrome. The need for color scheme discipline should arise from larger spatial considerations, rather than from misunderstood, fashionable trends and labelings such as "minimalism,"[19] etc. Most successful results have been achieved through the use of primary colors rather than ambiguous color combinations.

It is possible that the inherent integrity of an architectural space can be retained, and even further emphasized, and that the small life-making details can find room and exist within the larger spatial concept. Some of the earlier projects created by the "New York Five" are good examples of color–texture–architectural space coordination of the three-dimensionally continuous spaces.[20] Richard Meier, among them has excelled in the above respect and produces projects of three dimensional continuity of the highest spatial order.

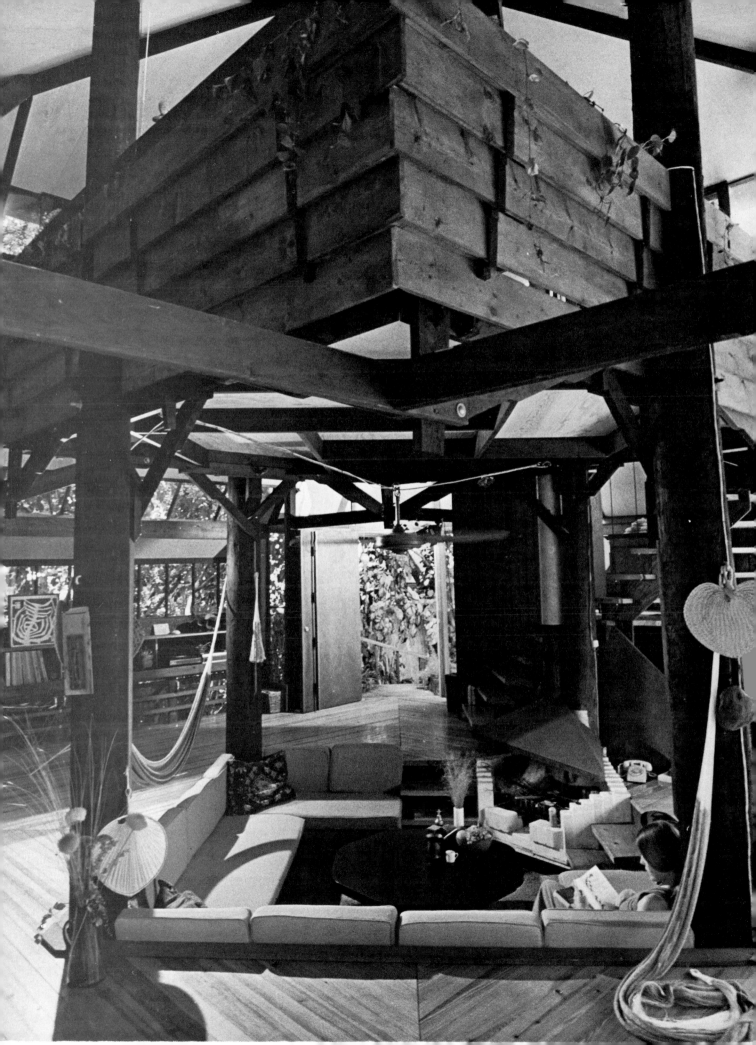

Rational provision of satisfaction elements of necessity results in interior spaces who pocess the element of human scale. Classroom for the instruction of chemistry, University of Jyväskylä, Alvar Aalto, Architect, 1953–1956.

Craftsmanship and knowledge of materials in the service of the exceptional interiors of Finland. Caleva Church, Reima Pietilä and Raili Paatelainen, Tampere, Finland, 1966.

Universal Spaces

When the interlockings of air of three-dimensionally continuous spaces are disciplined to one, we get what is known as a *universal space*. Most such spaces have a predominant vertical continuity which allows for public activities on the ground floor level, and for individual, or private, activities on the spaces of upper levels. Many European railroad stations, Paxton's Crystal Palace, Wright's Guggenheim Museum, and Grand Central Station in New York City are representative of the pioneers of this spatial category. American architecture of the 1960s and 1970s created numerous public spaces that demonstrate unique "universal" spaces. The sections of these buildings include all kinds of basic geometric shapes such as squares, rectangles, trapezoids, triangles, circles,[21] etc.

Many contemporary architects deal with the spatial typology of universal space. In most cases the interior problems of such grand spaces are dealt with by activity planning on the ground floor, and by placing strong emphasis on the vertical interlockings of air by visually accenting them through the use of vertical elements such as elevators, banners, and chandeliers. All these interior spaces demonstrate grandiose scales that have appeared for the first time in the history of architecture. In the minds of the interior designers of these great contemporary spaces, the issue at stake has been *architecture*, rather than

interiors in the narrow sense. Grand feelings, often reaching the aesthetic spheres of the sublime, have been created in these spaces through the proportions and magnitude of the universal space, not through details, textures, and ground floor activities. Interior design of these twentieth-century public indoors is a rather subordinate affair and has been totally controlled by the architects' building around known functions and well-defined needs. The most outstanding examples of this spatial category are the Regency Hyatt Hotels in San Francisco, Houston, and Chicago, as well as the Ford Foundation Building in New York City.

Universal spaces can be different from the ones just discussed above. Large "bubbles" that got stabilized and became covers for public human activities (often at different levels), tensile structures that shelter the seats of large stadiums, and shells that grew to the size of buildings for sheltering exhibitions or individual activities are new types of universal spaces that accommodate private activities within public contexts. These universal spaces require very little interior design if any at all. The spatial physiogomy is so strongly related to the structural entity that adding anything else would be disturbing to the eye and to the great truth such structures state. The most prudent thing one can do in such cases is leave the architectural space alone.

The most integral interior spaces thus far have been created when the architects of the buildings "did the interiors" themselves. Interior designers are needed very desperately today and it is unfortunate that they have little understanding of the architectural integrity of spaces.

← Three-dimensional continuity can make a small building look much larger inside. Interior of small house suspended on piles in Miami, Florida. Yannis Antoniadis, Architect. (Photo by Joachim Schuppe.)

They have fallen into the traps of fashionable promotion, stylistic imitation, and decoration. Many interior design manuals focus on the study of past eras. Instead of teaching the principles of the art, they concentrate on foolish discussion of past details and information. Because of the prevailing interior design fallacies, particularly in the United States, it is important to make a summary of the interiors of past eras in order to look for *principles,* and then to once and for all forget about style memorization and irrelevant imitation.

Historical Overview of Interior Space Treatment[22]

The ancient Greeks did not match the grandeur of the Cretan civilization that produced some splendid murals and interior treatments. The ancient Greeks were extroverted people; they lived outdoors. Their interiors were secondary and claustrophobic.[23] The Romans, on the other hand, elaborated their interiors and created memorable enclosures.[24] The Byzantines went a step further and enhanced the architecturally superior interiors of their temples and public buildings with great murals, frescoes, and mosaics. Hagia Sophia, the lasting example of Byzantine space making, was the predecessor of the Italian Renaissance in interiors, a flourishing period of interior development.

The Italian Renaissance was a period of universal spaces. Beyond the generic architectural space, emphasis was primarily focused on the detail. Highly sophisticated techniques of stuccoing permitted the painting of frescoes in interiors. The clients were Popes and the rich nobility. It could be said that the interior designers of the time were the outstanding painters of the day; Michelangelo, Rafael, Leonardo da Vinci, Titiano, Veroneze, etc. The interior spaces of some buildings were life concerns of the clients and particular artists. Artists were given the commissions on their merit and were allowed to perform with minimal client interference. The people of the Italian Renaissance believed in the abilities of their artists. "Interior space" was usually the creation of one man and his disciples. . . . These were all basic "realities" then. How would one respond to a contemporary client's desire for a Capella Sixtina interior? And who is the interior designer today who would take one interior as a life task? Today a designer might say, "Wallpapers, reproductions of frescoes, something Renaissancelike. . . ." Well, the Renaissance wasn't like that!

The general architectural climate of **the Baroque Period in Europe** was less rational than that of the Italian Renaissance. Buildings possessed much unnecessary detail, some of it appearing to be structural. Taste and ambiguity prevailed in formal expressions. The "arch," for instance, was not completed; and what appeared to be "column" was not necessarily so. Contrary to the structural and exterior inconsistencies, the interiors demonstrated consistency in spatial explosion; horizontal and vertical space interlockings created a dynamic spatial mentality. The European Baroque is an architecture of spatial affluence extremely didactic for the conceptualization of grand architectural space. Inside these dynamic interiors one could find movable furniture made with a high degree of artistry and a concern for details that was the result of decorative affluence rather than concern for function and simplicity. The principles of Baroque spaces have been restated today in many new works. The idea of movable furniture is very valid. Elaborate decorative detailing is not seen (or possible) today, as the labor for it is not available, and because the process of making furniture by machine generates an industrial morphology that minimizes decoration.

The **Rococo** style is regarded as "pleasant,"[25] "often comique,"[26] and by certain aesthetes, "inferior"[27] to previous styles. It incorporated an abundance of decorative detail utilizing many materials and fabrics. The use of many frescoes and "glitter" characterized Rococo interiors.[28] The wealthy, the arrogant, and the extravagant used "Rococo" as the style of their expression. Rococo was the preferred style of French nobility, and it incorporated the waste of artisans' skills and the waste of money. Styles like Louis XIII, XIV, XV, and XVI were developed,[29] all following the trend from "very elaborate" to "less elaborate" to "simple." The Rococo interiors are also known as the interiors of the "Romantique Era." The French Revolution brought an end to those styles in France; though they were influential *enough* for other courts of Europe, especially in England. The British *Elizabethan, Georgian,* and *Victorian* interiors were simply Baroque and Rococo interiors that incorporated new materials, textiles, and glitter, as well as the unique fabrics, stones, and assorted paraphernalia and collectanea the British accumulated from their colonies.[30]

Many uncoordinated contemporary interiors have Rococo characteristics; that is, they appear to be assemblies of materials and fabrics of all sorts arranged in the interior space according to occasionally prevailing rules of fashion. All pleasant eccentricities in contemporary interiors represent nothing else but the rebirth of Rococo today.

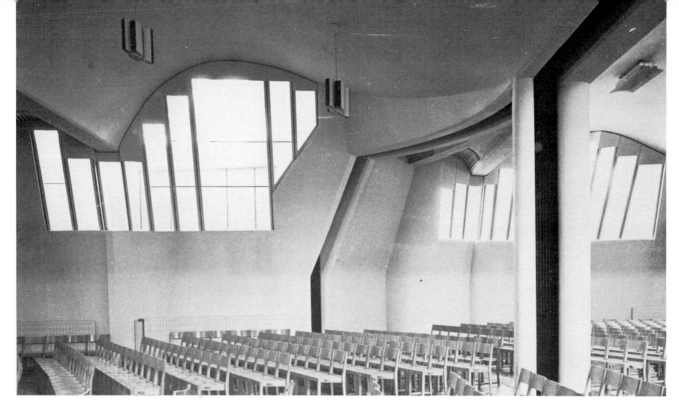

Any act that does not recognize the inherent qualities of architectural space can easily destroy the space. The magnificent interior of the church of Vuoksenniska in Imatra, Finland, by Alvar Aalto. (Photo by Constantine Xanthopoulos.)

All earlier styles of interior treatment were revived in Europe at the beginning of the twentieth century. The movements of *Art Nouveau* and *Art Decoratif* had the light pleasantness of historic imitations. **Art Nouveau** interiors were to be "bright, simple, and spare."[31] They were aimed at functioning with all the economy of a ship's cabin.[32] Art Nouveau's dictum was that all art should be synthesized.[33] In this sense, Art Noveau did not fail in intentions, but it failed in execution. The movement was unable to rid itself of the decorative handicaps of the past and it often created works that imitated romantic forms of the plant world that were unfit for materials such as steel and for industrial production processes.

The **Art Deco** movement similarly created light, simple, spare interiors. It used monochromatic, continuous interiors, chrome, integrated lighting, and continuous strips of graphics that were revived in the late 1960s under the name of "supergraphics." Although the Art Deco period is supposed to have been a period of decoration, it was not so as far as the interior was conceived. Art Deco interiors recognized the total entity of space, and they enhanced it through the continuity achieved by means of texture, color, and graphics. Art Deco was decorative only as far as appliances, people's clothing, and utilitarian objects were concerned.

Both Art Nouveau and Art Deco suffered damages from the attitude of the public toward interiors. The public had been conditioned by certain aesthetes of the late Victorian period. Oscar Wilde, in particular, became the apostle of "the pleasant," "the elegant," and "the stylistic." His influence in creating a decorative attitude toward interior spaces was strong. The "house beautiful" movement started with him,[34] and the snobbish bourgeoisie,[35] although rejecting his life style, accepted his conception of beauty and became in time his decorative disciples.

At the opposite end of the interior aesthetics scale one can see the architects of the twentieth century. Their interests were focused around the new potentials of machines, and they were searching for new aesthetics to fit the industrial processes that would make massive reproduction a reality. In their search for industrial morphology, these architects created interiors that had no historic resemblances; they were original, functional, and appealing. In many cases they were ideal to look at and live with. The greatest interior designers of the twentieth century were architects who concerned themselves with the whole. Frank Lloyd Wright, Alvar Aalto, Mies van der Rohe, the Bauhaus as a whole, Le Corbusier, Gropius, Marcel Breuer, Eero Saarinen, and Charles Eames created interiors that ought to be regarded as case studies for students and aspiring interior designers.

The interiors of Japan are commonly regarded as the inspiration for what could be called *early interior minimalism,* a working minimalism. Paper and wood as used by the Japanese created spaces that, one cannot help but suggest, inspired Mies to develop his vocabulary. Yet we know it didn't . . . as Mies told us, he never went to Japan.

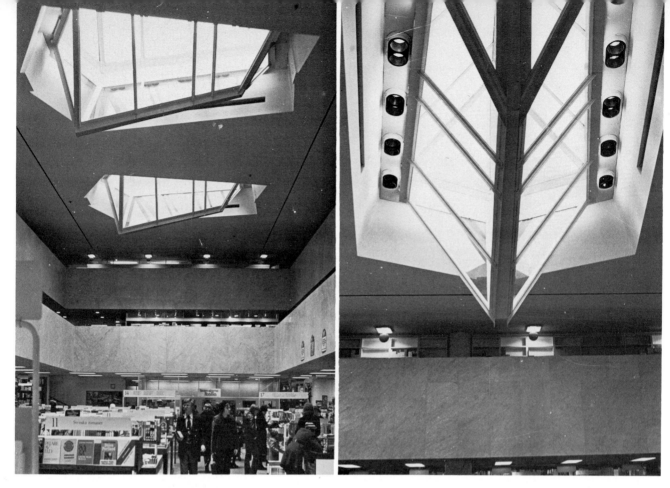

The Academic Bookstore in Helsinki. Alvar Aalto, Architect, 1966–1967 (Photo by Constantine Xanthopoulos.)
Skylight detail combining natural and artificial lighting in Academic Bookstore, Helsinki. Alvar Aalto, Architect. (Photo by Constantine Xanthopoulos.)

Certain other countries have also excelled in interior design. The cold climates of Finland, Denmark, and Sweden dictate that people live indoors. The abundance of forests there has fostered the development of interiors, furniture, and appliances based on wood. Italy, a pioneer in advanced plastic technologies, has addressed itself to modularization of interiors and capsule unit development. Some of today's most advanced interior proposals come from Italy. In the following pages we look further into the work of the pioneers of contemporary interiors.[36]

Contemporary Influences

Scandinavians

The champions of contemporary Finnish and Danish design have been Alvar Aalto and Aarne Jacobsen. They have designed in an integral manner and have created intuitive solutions for lighting fixtures, interior appliances, and interior furniture. Aalto first introduced the principle of "stacking"; he designed furniture that was light and that could be stacked, removed, and stored easily, leaving the space empty—that is, making it flexible for a multiplicity of uses. Aalto used pressured plywood as well as stainless steel and chrome, for some of his appliances and chairs. Jacobsen also created furniture using wood, steel, and leather.

Bauhaus

The concern for mass production was fundamental in the Bauhaus movement. Marcel Breuer was the top furniture designer of the school, while Gropius and Mies van der Rohe involved themselves with interiors. The "Barcelona" chair of Mies van der Rohe is in constant demand today, not so much for its comforting shape as for its visual appeal and detailing clarity.

Le Corbusier

One could say that Le Corbusier's interiors were works in constant process. The lobby of the Swiss Pavilion in the University City of Paris was conceived like a child's room . . . and it still is. He painted his interiors with strong colors. He made "graffiti" on the walls and fixed furniture communicating his ideas on architecture and planning. His interiors, together with all other architectural considerations, were treated as "information" sources for the users.

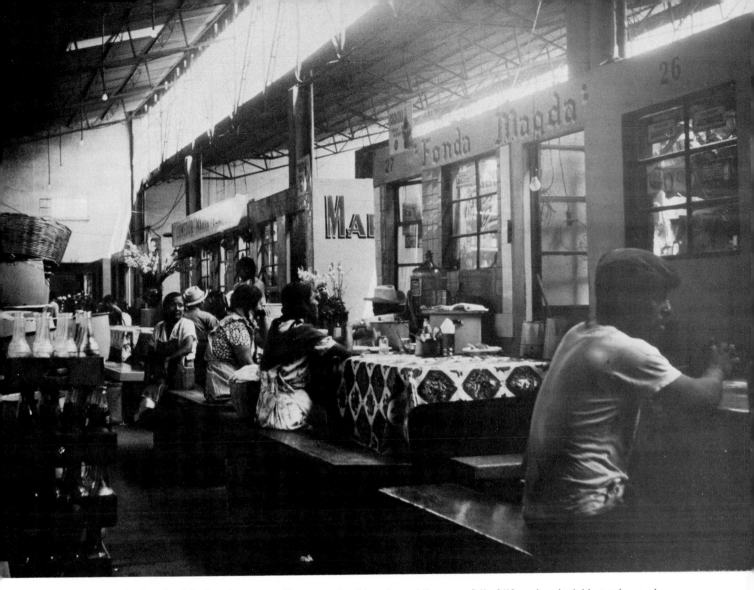

Interior market in Oaxaka, Mexico. An outstanding example of interior public space; full of life and undeniable total appeal.

Frank Lloyd Wright

Frank Lloyd Wright designed his own furniture because he believed in the "integral" or "total" architectural conception and implementation. Of all his works, one should remember the furniture for the Imperial Hotel in Tokyo and the office-table chairs and cabinets for the Johnson Wax factory in Racine, Wisconsin, as well as the chairs and other furniture for Taliesin West in Arizona. Wright, however, is notorious for his inability to create comfortable furniture, especially chairs.

Eero Saarinen and Charles Eames

These two friends produced outstanding interiors. Saarinen created total wholes, such as the red-carpeted interior of the TWA terminal at Kennedy Airport and the lobby of the C.B.S. Tower in Manhattan. In furniture design his chair and dining set represent his best examples. Charles Eames remains the most prolific and human furniture and appliance designer of this century. Many of the patented industrial products we use today are Eames designs. All of Eames's furniture designs are trademarks of ingenuity; they are marvels of formal and color purity, and of his love for people.[37]

Others

Paul Rudolph designed furniture for many of his interiors, but it was very expensive. Philip Johnson used Barcelona chairs and Miesian vocabulary. Ricardo Legorreta is one of the most successful world architects who produce totally coordinated works. He has also been involved with the design and production of furniture. His designs are extremely comfortable, and their forms are appealing. Many young architects in the United States try to design their own furniture; some succeed. Among those who incorporate into their interiors furniture and appliances borrowed from other countries, the Italian vocabulary has been very popular. The "Italian school of interior design" is the most important international movement in interiors today.

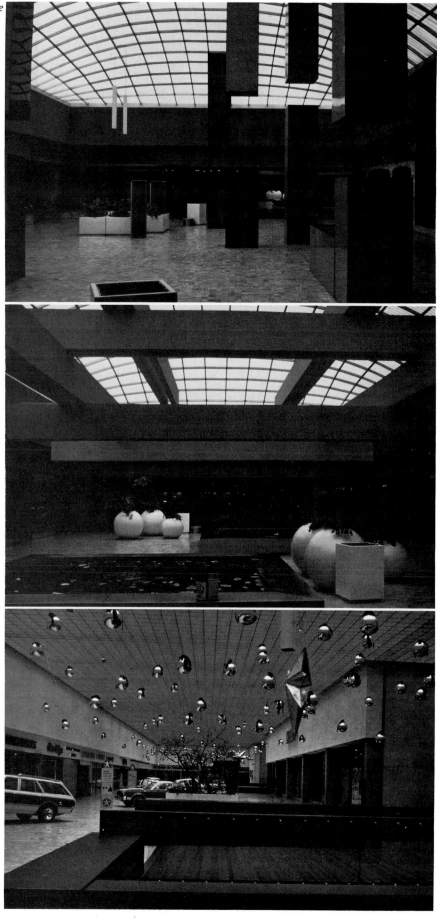

Sequences of interior mall of
shopping center at Satellite City, a
suburb of Mexico City. Juan Sordo
Madaleno, Architect.

IBM warehouse in Mexico City. Treatment of a passageway: the concept of the corridor as a gallery. Lighting and sculpture to divert the feeling of boredom of industrial workers. Ricardo Legorreta, Architect.

Italian School of Interior Design

The Italians have grasped the essence of our times: mobility, absence of performance, lack of specialized labor; and their forms for the new interior landscape reflect these constraints.[38] The need to move suggests light materials and recycled materials. The cost of specialized labor prescribes industrialized techniques of production. The economics and popularization of the industrial object (furniture, video equipment, a matchbox, or a dish) have demanded the use of new synthetics and lightweight plastics. Italian products cover the whole spectrum of indoor human needs and are now to be seen in almost any average Italian home. This very popularized, for Italy, domestic image is still expensive when it's exported, so only the affluent of other countries can afford it at this time.

One of the most important Italian interior designers was Joe Colombo, who died in 1970 at the age of 40. He is remembered for his designs for the total living unit container for multipattern use possibilities. Concerns similar to those of Colombo have motivated Ettore Sottrass, Jr., Alberto Roselli, and Mario Bellini; Bellini is most important for his *Kar-a-sutra* design (car-home for communal mobile living). This project dramatizes the essence of today's "mobile" culture. Robert Magno is most important for his design of such utilitarian objects as forks and spoons.

All the above designers work in close collaboration and enjoy the sponsorship of large corporations such as Olivetti, ANIC-LaneRossi, and others. The great contemporary interior of Italy, however, is not part of a successful total environment. Italian design has been limited to the production of single items for domestic use and the creation of small environments. In Italy, as in some other countries that are advanced in their interiors, isolated objects and microenvironments exist in the midst of urban blight and decay.[39] Perhaps lack of social concern is to blame for that. Thus the "great" Italian interior is just a drop of hope in the ocean of environmental problems.

Italy's problem is not unique. Most countries suffer from schism among the elements of the design trinity (interior–building mass–exterior).

. . . . Interior architecture has a great past. But in-depth understanding and systematic knowledge has not yet been achieved. The awakening of user input the concerns for personal space, territoriality, and, in summary, the anxieties of environmental psychologists for user needs are pretty good signs that interior design will advance to a bright future.

Unfortunately, not all interior designers are vigorously involved in developing understanding and expertise as to the psychological issues of space. Unfortunately, not all designers have a clear undertstanding of their professional identity and their responsibilities. Unfortunately, the ghost of decoration is still at work and thriving. . . . The book of interior design has not been written yet.

Notes

1. Aris Constantinides. *Ta Palia Athenaika Spitia* (The Old Athenian Houses). Athens, 1950, p. 36.
2. On the relationship between environment and new media, refer to Marshall McLuhan, "The Medium is the Message" or "The Invisible Environment" in *The Canadian Architect,* 1966, p. 74.
3. Characteristic country in this respect is the United States. The high crime rate has been one of the major generators of the great number of mechanically controlled interior environments. One may speak of "interior urban design" complexes. Outstanding examples are found in Houston, Texas; e.g., the Galleria, the Greenway Plaza, etc.
4. Definition derived from composite study of a number of currently available treatises on interior design. Basic credits to Friedmann, Pile, Wilson, 1974, p. 143.
5. *A.I.A. Journal,* Vol. X, 1975, p. 19.
6. Alexander, 1972, p. 44.
7. Ibid., p. 216.
8. For detailed information, refer to currently available basic sources of interior design, Friedmann, Pile, and Wilson, op. cit.; Alexander, op. cit.; and Whiton, 1974.
9. Reference can be made to various open letters certain professional "design" organizations published in the early 1970s, which spoke out against the practices and content of some other professional "design" organizations. See *A.I.A. Journal,* 1975.
10. Interior designers in Germany are called "interior architects." Interior design is conceived as further architectural refinement; it is a professional specialization.
11. Harling, 1971, p. 12.
12. McIlhany, 1970, p. 73.
13. Whiton, 1974, p. v.
14. Harling, 1971, p. 12.
15. For the impact of Oscar Wilde on decoration and his public lectures on decoration in the United States and England, refer to Fido, Martin, 1973, p. 65.
16. For further reading refer to Antoniades, 1975 (2), 1975 (3), 1975 (4); also to Zevi, 1957.
17. Use of term "transparency" credited to Colin Rowe. See Rowe.
18. Antoniades, 1975 (2).
19. The author believes that interiors are for the living of human beings. The concept of "minimalism" as used to connote the synonymous art is not appropriate for architectural and interior usage. A "clean, uncluttered form" should not be done for the sake of making a "clean, uncluttered form." Any architectural form should accommodate the needs of life, and if the "life" or "life-style" constraints create such forms, then fine. For arguments on "minimalism" refer to McIlhany, 1970, p. 72.
20. Eisenman, 1975.
21. Antoniades, 1975 (3), p. 41.
22. For major historic reference, see Bruno Zevi.
23. Ibid.
24. Ibid.
25. Papanoutsos, 1956, p. 287.
26. Ibid., p. 297.
27. Ibid., p. 237.
28. For further details, refer to Whiton, p. 682. Also Lancaster, 1964, p. 52.
29. Ibid., pp. 140–81.
30. Lancaster, 1964, pp. 30, 54, and 86.
31. For the history of design from the Victorian era to the present, refer to Ferebee, 1970; for Victorian interior design, p. 21; for Art Nouveau interior design, p. 68; for "modern interior design," p. 86.
32. Ferebee, 1970, p. 68.
33. Ibid., p. 68.
34. Ibid., p. 69.
35. See Fido, Martin, op. cit., p. 65. For Wilde's impact on the bourgeoisie, refer to Pevsner, 1972, p. 27.
36. No specific references are provided here, as the reader may seek general references to numerous sources on the history of modern architecture.
37. For Charles Eames refer to *Design Quarterly 98/99,* pp. 21–29.
38. General reference to Emilio Ambasz, 1972, p. 419.
39. Ibid., p. 419.

Selected Readings

Ambasz: *Italy, the New Domestic Landscape*
Zevi: *Architecture as Space*

15
Urban Design

"When a man is tired of London he is tired of life."

Samuel Johnson

Urban design represents a larger sphere of design magnitude than architecture. It is the intermediate sphere between architecture and urban plannning. As such, it has characteristics of both. It is part, or a part of, architecture; and part, or a part of, urban planning. We know what architecture is; and urban planning will be examined in introductory detail later. Yet for a concrete understanding of what follows on urban design, we need to first consider what planning is. In this manner we will be able to relate urban design to it. Well, what is planning? Perhaps a better answer, however, would be arrived at by thinking about what it is not. . . .

. . . Planning is not architecture; planning is not sociology; planning is not economics; planning is not politics; planning is not psychology; planning is not technology; planning is not engineering; planning is not analysis; planning is not law; planning is not philosophy about planning; planning is not. . . . You name it! Planning is none of these things *alone* . . . but. . . . "Planning is an interconnected series of statements, goals, objectives, plans, and strategies which pertain to optimum relationships between *analysis* and *synthesis* of **all** the factors involved which may have something to say about man's intelligent *forethought* applied to the development of a community as a *whole* in such a way that the community *functions* properly, is economical to arrange and build, and the physical elements (in which all aspects of life—social, economic, and cultural) are beautiful to look at and live with."[1]

Urban design is, therefore, that part of planning which deals with the issues of "beauty" as expressed in its concrete physical entity and as proposed by those physical designers who deal with specific fragments of urban environment. Scholars and urban designers have not been in general agreement in their understandings of urban design, the role of urban designers, and the magnitude of design involvement. There has not been much clarity in urban design. It is therefore necessary to elaborate further on the subject until a more concrete definition of this design sphere and its design tasks is established.

Some people have called urban design *civic design,* referring to the task of designing governmental and administrative centers. This is a fragmented understanding, yet it was justified in times when the only large-scale physical works were done by the nobility and the monarchy, and the sole grand-scale commissions were government, administrative, or religious urban complexes. In recent years the term *urban design* has been substituted for "civic design." Some of the early notions about this new sphere of design involvement emphasized solely physical aspects in their definition, while others gave emphasis to the social issues underlying physical development, and others emphasized the administrative and implementation issues of design. Another group of urban designers has defined their work from the standpoint of people's involvement and sharing of experiences in the urban space.

The definitions of Frederick Gibberd, Harry Anthony, and Frederick Gutheim focus on the physical notions of urban design; they are comprehensive yet specific enough for this introduction. Harry Anthony's definition echoing Frederick Gibberd's notions states: "Urban design is the conscientious four-dimensional arrangement of the physical elements of the urban environment in such a way that it functions properly, is economical to build, and gives pleasure to look at and to live in."[2] Frederick Gutheim defined urban design as "that part of city planning which deals with aesthetics, and which determines the order and form of the city."[3] Supremacy of the social issues is suggested by the definition of Stanley Tankel: "Urban design deals with the spatial community . . . but the spatial community is not a product of mere ideology or an aesthetic; it is the physical expression of basic social needs."[4]

Edmund Bacon and Lawrence Halprin define urban design from the perspective of human interaction and the sharing of experiences in urban space. Bacon states that, "the (urban) designer's problem is not to create facades or architectural mass, but to create an all-encompassing experience, to engender involvement. . . . The City is a people's art, a shared experience, the place where the artist meets the greatest number of potential appreciators."[5] Halprin states almost the same. His concept of urban design demands the ultimate creation of cities which will provide a creative environment for people, that is, an environment with great diversity, allowing freedom of choice, and generating the maximum interaction between people and urban surroundings.[6] Halprin's notion of urban environment is unique, as he wants it to be an arena for creativity[7] and self-expression rather than a deterministic physical set, imposing the patterns of behavior of an era. Yet the terms "creativity" and "self-expression," although they denote desirable situations, are for some people "too esoteric" to grasp, or too ambiguous. Certain designers have been extremely cautious and concerned, especially in view of the fact that "esoteric" approaches to urban design did very little to eliminate the decadence of the total urban picture.

Such concerns brought the American Institute of Architects to produce the document, "Checklist for Cities" which in a sense summarizes the Institute's position on urban design. "Urban Design is the form given to the solution of the city's problems. It is the professional process that finds practical answers to those problems. The answers take physical shape; the shape of the city itself. The best solutions are creative, combining delight and use,

evolving beauty from function. Urban design is neither esoteric nor purely aesthetic."[8] The above definition is too strong to dismiss, as it does not overlook the physical nature of this design sphere nor the need for creativity, the basis of any design work.

It is unfortunate that the professional urban planning organizations in the United States seem to have lost touch with the physical essence of urban design. The contemplated definition of urban design as proposed by the Urban Design Department of the American Institute of Planners is almost totally oriented toward "the process of implementation" rather than the "creation" or "design" of the physical environment. The American Institute of Planners suggest that, "Urban design is the strategic area of interdisciplinary environmental design arts concerned with the implementation of public objectives for the built environment. It involves all levels of physical scale-object design, project design, and city or environmental design. It is process-oriented, user-oriented, framework-based and implementation-focused."[9] It is true that the urban designer-planners are still suffering from the syndrome of sociological advocacies that biased planning decisions and planning practices in the United States during the late sixties and early seventies. Their definition suffers from the syndrome of bureaucratic and administrative compromise.

In considering the above attitudes we can now refine our initial definition and elaborate on it as follows: Urban design is the physically creative element of the city building process. (Note: *Creativity* here refers to "architectural, three-dimensional creation in time.") It is the key to the nature of urban beauty; this "nature" can promote happiness to the citizen and if negative, it may promote unhappiness. The citizens shape their urban spaces and these spaces in turn shape the future generations. Urban spaces must enhance creativity and sharing, and offer freedom of choice. Urban design is a physio-social dialectic in time. Its vocabulary includes all architectural vocabulary examined so far. Design concepts such as scale, proportion, rhythm, containment, enclosure, diversity, imageability, legibility, chaos, and monotony represent the basic intellectual tools of urban designers. Balance of them is a virtue. Chaos or monotony is a handicap. The raw materials of urban design are[10] open spaces and squares, street patterns and pedestrian ways, views, vistas, the topography, individually significant architectural groups of buildings, civic monuments (fountains, statues, murals), street furniture (signs, lamp posts, benches), public indoors and public outdoors.

Urban design is different from architectural design. It is more dynamic in terms of time.[11] It is more general than the design of specific buildings. It organizes its creations so as to accept evolving architectural directions in the years to come. It is economically conscientious, as it involves enormous expenditure of public funds. Finally, it has a realization span much longer than that of architectural design; therefore, it requires that the designers be patient, as it can take decades for their proposals to become reality. The most suitable background for specialization in urban design is the core background of architecture; while the most necessary macrobackground, which should be acquired while studying urban design, is the more comprehensive and more analytical background of planning.

Historical Overview of Urban Design

At the beginning there was no design. Physical development came about in laissez-faire rather than conscientious ways. The traditional notion is that agrarian life evolved first and urban second.[12] Recent speculations suggest the unorthodox but plausible possibility that "urban development" evolved first and "rural development" grew out of the urban.[13] In any event, conscientious physical development of social densities (urban) must have occurred in time as a result of man's need for protection. "Protection" and survival were more important concerns for primitive man than political, economic, or social considerations. The "political," "economic," and "social" could be fast means to an end: the end of survival. The need for physical protection is extremely evident in the early urban concentrations; they incorporated concentrated physical layouts, fortification, and the selection of sites hidden from the sight of invaders.[14] The primitive constraint of protection lasted for many centuries; it flourished in the Middle Ages and was revived in the United States during the twentieth century.[15] Forms of physical decentralization with low densities were sought in the twentieth century as means for protection of urban areas from the atomic bomb.[16]

The concern for the social, political, economic, psychological, and other factors of urban design developed early in history. Greek philosophers, several Anglo-Saxon philosophers of the Middle Ages, and numerous Renaissance men were involved with some of the fundamental issues of urban life. These people were not necessarily concerned with the trivial realities of the day; they inquired rather into the "quality of life" which they saw as the basis of future urban concepts. These men were idealists and non-pragmatists; we call them *utopians*. Plato, Aristotle, Hippodamus, Thomas More, Leonardo da Vinci, and Albrecht Dürer were the first "urban design" utopians of history.[17] Some of them touched urban design as a detail of the larger utopia they were planning. Of these people, only Hippodamus actually became a town designer. His logically controlled geometries (grid system)

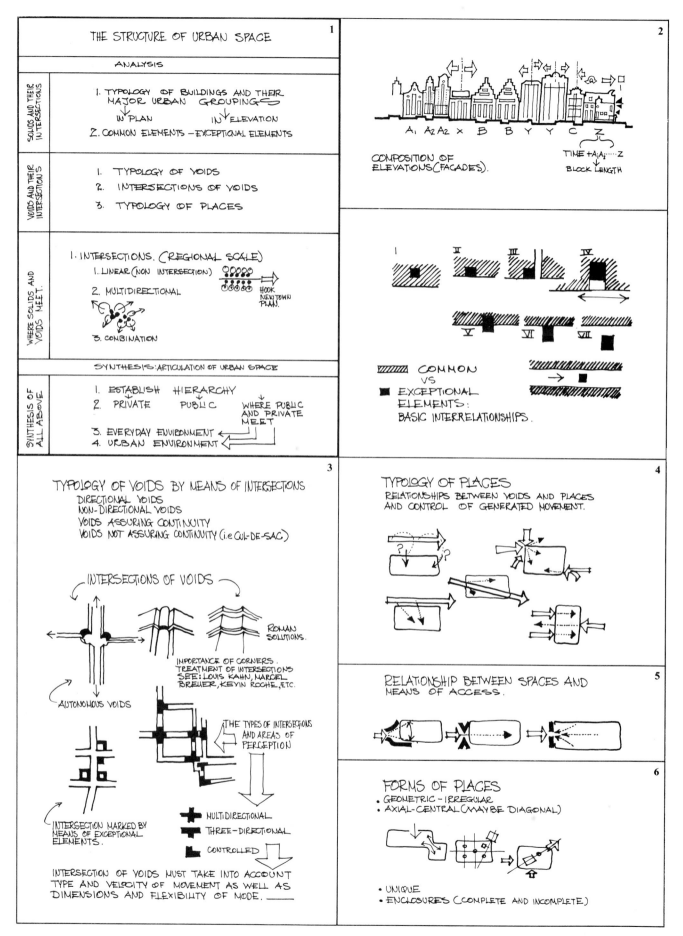

THE STRUCTURE OF URBAN SPACE 1

ANALYSIS

SOLIDS AND THEIR INTERSECTIONS
1. TYPOLOGY OF BUILDINGS AND THEIR MAJOR URBAN GROUPINGS
IN PLAN IN ELEVATION
2. COMMON ELEMENTS — EXCEPTIONAL ELEMENTS

VOIDS AND THEIR INTERSECTIONS
1. TYPOLOGY OF VOIDS
2. INTERSECTIONS OF VOIDS
3. TYPOLOGY OF PLACES

WHERE SOLIDS AND VOIDS MEET
1. INTERSECTIONS. (REGIONAL SCALE)
1. LINEAR (NON INTERSECTION)
HOOK NEWTOWN PLAN.
2. MULTIDIRECTIONAL
3. COMBINATION

SYNTHESIS: ARTICULATION OF URBAN SPACE

SYNTHESIS OF ALL ABOVE
1. ESTABLISH HIERARCHY
2. PRIVATE PUBLIC WHERE PUBLIC AND PRIVATE MEET
3. EVERYDAY ENVIRONMENT
4. URBAN ENVIRONMENT

2

COMPOSITION OF ELEVATIONS (FACADES).
A_1 A_2 A_2 X B B Y Y C Z
TIME $+A_1A_2$ Z
BLOCK LENGTH

I II III IV
V VI VII

▨ COMMON
VS
■ EXCEPTIONAL ELEMENTS:
BASIC INTERRELATIONSHIPS.

3

TYPOLOGY OF VOIDS BY MEANS OF INTERSECTIONS
DIRECTIONAL VOIDS
NON-DIRECTIONAL VOIDS
VOIDS ASSURING CONTINUITY
VOIDS NOT ASSURING CONTINUITY (i.e CUL-DE-SAC)

INTERSECTIONS OF VOIDS

ROMAN SOLUTIONS.

IMPORTANCE OF CORNERS.
TREATMENT OF INTERSECTIONS
SEE: LOUIS KAHN, MARCEL BREUER, KEVIN ROCHE, ETC.

AUTONOMOUS VOIDS

THE TYPES OF INTERSECTIONS AND AREAS OF PERCEPTION

INTERSECTION MARKED BY MEANS OF EXCEPTIONAL ELEMENTS.

➕ MULTIDIRECTIONAL
⬛ THREE-DIRECTIONAL
◼ CONTROLLED

INTERSECTION OF VOIDS MUST TAKE INTO ACCOUNT TYPE AND VELOCITY OF MOVEMENT AS WELL AS DIMENSIONS AND FLEXIBILITY OF MODE.

4

TYPOLOGY OF PLACES
RELATIONSHIPS BETWEEN VOIDS AND PLACES AND CONTROL OF GENERATED MOVEMENT.

5

RELATIONSHIP BETWEEN SPACES AND MEANS OF ACCESS.

6

FORMS OF PLACES
• GEOMETRIC – IRREGULAR
• AXIAL-CENTRAL (MAY BE DIAGONAL)

• UNIQUE
• ENCLOSURES (COMPLETE AND INCOMPLETE)

Figure 34. The structure of urban design

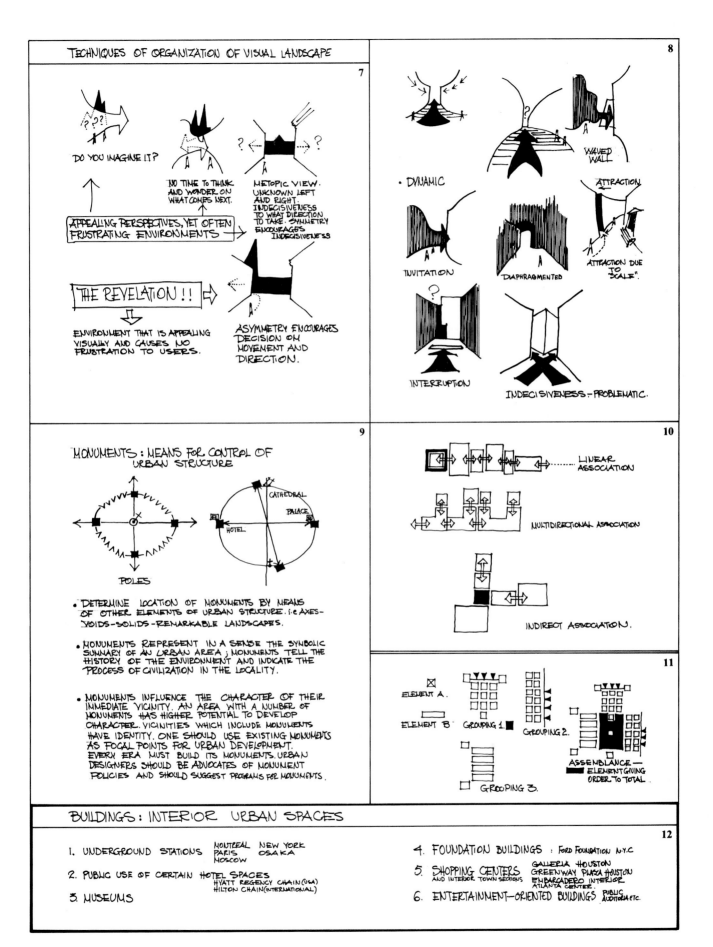

Figure 35. Urban landscape techniques

and his early concerns for diversity of civic activity areas and inclusion of sufficient open space were furthered by his fundamental anxieties on the optimum size of urban areas, both physical and population size.[18] Because of his deep social, demographic, and "community" interests, he was considered by Aristotle as the first "political philosopher"[19] of antiquity. This title suggests that Hippodamus ranked high in the esteem of Aristotle, who was in fact the *real* "political philosopher" of mankind. Aristotle's proclamation that Hippodamus was more of a political philosopher than urban designer is, in a way, the earliest recorded notion in history that "urban design" is much deeper than mere draftsmanship.

Early utopian anxieties about urban design (as well as about planning) were lost in the midst of centuries and the trivialities of the early days of civilization. The works of the day were decided upon by trivial pragmatists, such as the bearers of authority—emperors, kings, feudal lords,[20] religious despots, heads of church, and government parties, totalitarian or liberal.[21] Each one of these decision makers developed urban works that were often biased by personal or clan purposes, or by profit or glamor speculation interests. The imperial and clergy poles of ancient Egypt created urban works that emphasized monumentalism, religious ceremonial, and metaphysical concepts.[22]

The ancient Greeks, free in spirit and dealing with irregular and diverse landscapes, developed "laissez-faire" complexes at first; but in time they developed the most sophisticated, conscientious complexes of antiquity.[23] Besides the Hippodameion system, that is to say the grid system of design developed by Hippodamus, the ancient Greeks developed other systems of conscientious physical design, notably the system of polar coordinates. The determining factor in the design was the human viewpoint.[24] The *polar system* of coordinates took into consideration the *entrance point* to a public space and placed the public buildings accordingly so as to offer the most appealing perspectives to the people entering the public space.[25] Doxiadis has argued that numerous Greek citadels were designed according to the principles of the polar system. One of the most famous cases in this respect was the arrangement of buildings on the Acropolis of Athens.

The Hellenistic towns were all based on the grid system of Hippodamus. This grid system was efficient to lay out, especially on flat sites where it became square. As expediency of construction was a key requirement in times of colonization, it was natural that the adoption of the grid system prevailed. The Romans faced the same problems as the Greek colonizers preceding them. The Roman camp had to be built even faster than a new town; thus the grid

system was immediately utilized. The Romans colonized Europe, and the early Roman camps became the centers of the later developed European capitals.[26] Yet as the Roman generals were building their camps in conscientious, planned ways, the people of the occupied countries were building their own towns around the feudal lords' castles in laissez-faire ways.

All medieval building was the result of laissez-faire processes. As such, it was individualistically oriented with no concern for public utilities, public plazas, drainage systems, organized open space, paved roads, etc.[27] The only public part of the town was the cathedral square and the main street leading to the cathedral or the feudal castle. The laissez-faire medieval towns were concentric for reasons of protection. A side result of this concentricity was that a walk around one of these towns provided, and still provides, ever-changing sequences of perspectives, vanishing points, and appealing surprises; but confusion is often apparent. These towns provide current case studies for lessons on urban diversity, visual appeal, and treatment of urban detail.[28] Yet beyond these positive issues, medieval towns lacked utility infrastructure. They were traps for epidemics, malaria, and fire, and later on they became dangerous to walk in at night. These were times when urban poverty fostered the growth of crime.

The handicaps of the medieval towns aroused the concern of Renaissance thinkers, architects, and planners who advocated conscientious means of physical town development. Among the main Renaissance proposals, one distinguishes the proposal of Leonardo da Vinci who suggested continuous underground passageways as a means of vacating the town in times of epidemic. The sketches of da Vinci are remarkable even today, as they address themselves to some of the current basic problems such as the needs for rapid transit, separation of pedestrian from vehicular traffic, etc. Yet civilization needs pragmatists for the implementation of ideas. Mankind has had many pragmatists, but most of them got their ideas from the utopians and, without giving credit to them, made these ideas reality.

The Zähringen towns of Switzerland were planned new towns.[29] Built on monarchic dictates, they were the first examples of pragmatic planning. Other similar examples were monarchic projects such as the central part of Copenhagen designed by King Christian IV,[30] and the town of Bath in England which was developed on the basis of a total design scheme incorporating a combination of linear and curvilinear urban elements.[31] In Bath was introduced the concept of a relaxed urban rhythm.

Another fundamental urban design development took place in Paris, and it was the first case of the grandiose scheme for urban renewal. Implemented by Napoleon III and proposed by Baron Haussmann, it suggested that huge

boulevards be opened along the "illegible" medieval environment of Paris. The proposal became reality, and an intuitive urban designer (Haussmann) and an intuitive client (Napoleon III) worked effectively together. The early necessity for boulevards was military; they facilitated the movement of the troops of Louis Napoleon about the town. In addition, the straight lines of the boulevards allowed the use of artillery, while the crooked lanes of the medieval pattern of Paris were suited only for pistols and sabers.[32] The innovation in technology that created the powerful artillery brought about an urban innovation. A beneficial urban design side effect, though, was *legibility*;[33] it became easier to "read" the town and to go from one place to another faster. Today these boulevards serve to some extent to alleviate the traffic problems of the center.

The conscientious pre-Industrial-Revolution urban design developments were all brought about either by the kings themselves or by their dictates. In fact, Peter the Great designed the whole plan for St. Petersburg. Conscientious physical developments that did not originate with kings or emperors began to occur in the early years of the Industrial Revolution. The factors that brought about the awakening of the urban conscience for planning were numerous. Among the most important were the following:[34]

1. The deterioration of the conditions of urban life during the nineteenth century and the possibility of an ever-rising standard of living occasioned by the Industrial Revolution led to an increasing emphasis upon the physical as well as the social environment.
2. The unhealthy slums of industrial London aroused the concerns of the medical profession which asked for the creation of a new physical environment based on a concept of hygenic liveability.[35]
3. Socialist philosophers such as Engles and Marx capitalized on the demands of the medical reports and became fierce advocates of the need for new physical order.
4. Fourier, Owen, Guise, Cabet, Soria y Mata, and Tony Garnier emphasized the need for physical solutions to promote a social environment.[36] Most of these advocacies were based on principles of equity, liberty, fraternity, and unity.[37] Camillo Sitte, on the other hand, emphasized purely aesthetic urban considerations. The main features in Sitte's model were continuity in constructed elements, enclosure, diversity, asymmetry, irregularity, and connecting elements that are significant in themselves.[38] Sitte did not prevail. Socially oriented physical designers such as Cabet, Fourier, and Owen were more influential during the early years of conscientious planning. But even so, only Owen survived posterity through his association with Ebenezer Howard.

5. Ebenezer Howard advocated the creation of "Garden Cities" and the marriage of country and urban development. He headed the Garden City Movement[39] in 1892 and constructed two of them in his life, Wellwyn and Lechworth. Howard saw town planning not just as a technique for controlling the layout and design of residential areas (for controlling urban design), but as part of a policy of national, economic, and social objectives.
6. Patrick Geddes, a botanist from Edinburgh, spoke of the need for citizenry education and citizen participation[40] in the design of the physical environment as early as 1910. He was the first advocate of citizens' participation in urban matters. Recent urban planning methodologies emphasizing citizen's participation have not offered Geddes his due credit.[41] It must become clear that by suggesting "constructive citizenship" and "public participation," Patrick Geddes became the first "advocate" planner of the world. The summary of Geddes's theory is put into two words: "constructive citizenship"; through this concern, the essential harmony of all the interests involved in the city are satisfied.[42]
7. Clarence Stein and Henry Wright in the United States advocated the need for creation of "garden cities" in America.[43] They managed to get "Radburn" (New Jersey) off the ground in 1928. Radburn is a fundamental case study of contemporary urban design and is discussed in the next part of this chapter.
8. The Roosevelt Administration in the United States in the 1930s launched the prestigious "New Community Program" and undertook the construction of a great number of new communities[44] on patterns of "relaxed" physical design. These patterns included a good amount of open space and were characterized by relatively low densities.
9. The concerns for reconstruction that naturally developed after the destruction of World Wars I and II, especially World War II, gave impetus to further physical design. . . . During this historic instance, some of the world's leading architects such as Frank Lloyd Wright, Le Corbusier, Gropius, Paul-Percival Goodman (Paul Goodman was a sociologist), and others developed strong proposals for urban physical development.[45] Wright's Broadacre City became an inevitability; it is witnessed today in the sprawled form of U.S. "suburbia." Le Corbusier's ideas to build towns on *pilotis*[46] and keep the ground level free of development were repeatedly used, especially in the United States. The results of this were absolutely unsatisfactory. By raising the people one level above the ground, Le Corbusier's proposals eventually created

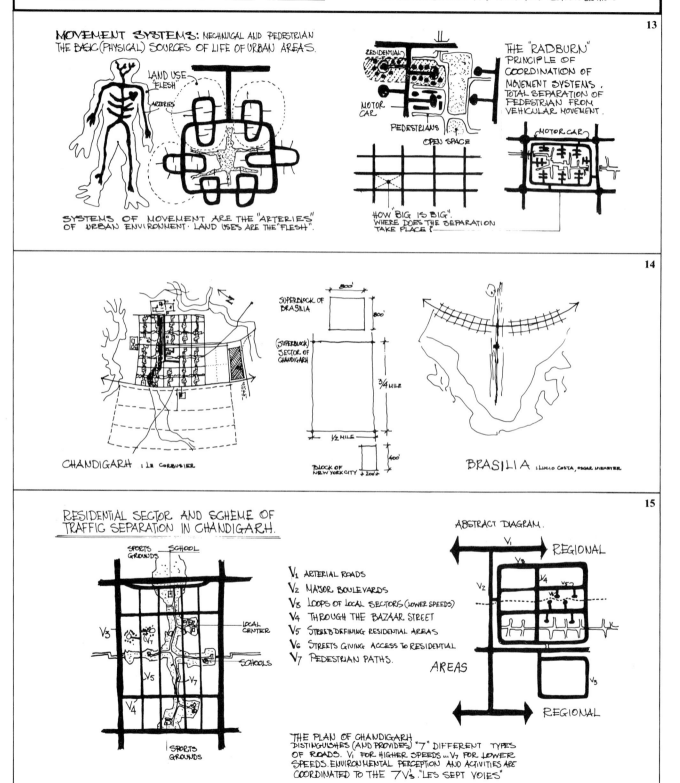

Figure 36. Land uses and systems of movement

"no-man" ground floors, ill-maintained and susceptible to crime.[47] The most important side effect of World War II disasters was the immediate need for the construction of new towns in England, and the process of construction still continues. The British paradigms, theoretical and actual, have been followed by other countries such as Sweden, Finland, Israel, Japan, etc. Some countries such as Brazil, India, and Australia developed new capital towns from scratch. The initial presentation and further study of these contemporary examples is fundamental for any urban designer.

. . . Urban design today exists in the midst of past and present. What is new, is new. The new is an infant, having no history of its own, and it often suffers. What is old, laissez-faire, devoid of cars, and small in size, is looked upon with romantic intentions; it is looked upon as a paradigm for learning. Urban designers today look at the marriage of the two.[48] They build the new and look at the "successful" old for principles and lessons. Many new towns around the world, as well as the physical planning that occurred in the United States during the World War II years, demonstrated practices of segregated land uses. Towns were divided into "good" and "bad" sections. The environments lost their centers. Development occurred in uncontrolled ways, sprawling here and there, wasting energy.

Today people are looking to the past and the future in order to cope with the present. This is a new era of awareness for urban design. The main concerns focus around new concepts of the image of the city, new concepts of physical infrastructure, new concepts of energy conservation, and new concepts of life styles and "freedom of choice." The results of these new concepts can be studied in numerous projects which have recently been built around the world. A survey of the successful urban design creations is necessary; their highlights are pointed out in the discussion that follows.

Successful Urban Design: Case Studies

Radburn, New Jersey

Urban design of the twentieth century went through crippling stages at the beginning. The Garden City Movement in England, which was carried over from the late nineteenth century, created two "garden cities," Wellwyn and Letchworth, but neither demonstrated advanced physical concepts[49] beyond the theoretical stages. The environments of these two early graden cities were reminiscent of English garden planning. The public buildings and mass arrangement of urban solids (sequence of buildings) were much too inferior in comparison with certain historic British prototypes such as Bath.

In view of the physical inferiority of early British "garden cities," the first world example that introduced physical innovations for urban design was "Radburn" in New Jersey. Radburn was the American interpretation of Ebenezer Howard's theories.[50] The design of Radburn demonstrated for the first time the concept of the "superblock," a residential block of substantially enlarged proportions where the motor car stayed at the periphery and where public open space and community facility buildings were located in the middle of the block. The system of pedestrian walks was arranged so as to take people from the residences located in the periphery and bring them into the green open space of the block that acted as the hub of the community. Playgrounds for children and recreation grounds for adults were found in the communal open space. The pedestrian network of the various superblocks was continuous, and separated at different grade levels from the motor car network. In Radburn's design there was no conflict between pedestrians and motorists. A total separation of the two basic systems of movement of the town was achieved by means of grade changes, underground passages for pedestrians at the points where normally there would be intersections of the two systems, and cul-de-sacs for motor cars at points where the motor car network had to feed residential concentrations. In addition to its grade and "finger" principles, the scheme attempted innovations in housing design by changing the meanings of activity areas such as front yard and back yard.

Due to the advent of the economic depression of the 30s, the town was never completed. The principles, though, were clearly stated and extensively repeated in other new towns and urban design developments that followed.

Selected British New Towns[51]

1. The town center of Stevenage, the first of the British twentieth-century new towns, adopted the "Radburn" principle of separation of pedestrians from motor cars. It also paid emphasis to the good articulation of time-space experience of its pedestrian mall. This was achieved through appropriate paving and street furniture design, as well as by a balanced sequence of linear vs. static activities. The use of materials was extensively considered; landmarks were appropriately placed; and street furniture details were devoted to "satisfaction" (relaxation) rather than visual appeal. Stevenage and other earlier new towns suffered from the poor quality design of their residential areas. Attempts to resolve this problem were made at Harlow and other new towns that followed.

2. The residential areas at Harlow were designed with the concept of mixture and diversity in mind. The built-up schemes were results of architectural competitions.

Harlow also attempted a mixture of residential densities. Yet, in spite of the housing consideration, Harlow still suffered from the inherent faults of its land use plan which left large amounts of open space to separate the various neighborhoods, thus disassociating one neighborhood from another. Open space was provided, but the optimum amount and its proportion had not been determined. The Harlow relationship problem of "open space vs. built-up area" remained as the main handicap of almost all the British new towns of the first generation. These problems were identified, and attempts to resolve them were made during the planning of the second generation of new towns that started with the building of Cumbernauld.

3. The plan of Cumbernauld focused on compact physical development, a mixture of uses, and a linear and compact town center. The center was conceived as a building with public spaces indoors rather than the traditional outdoor concept of Stevenage. The indoor emphasis of Cumbernauld center was well justified by the cold climate of Scotland. In pre-Cumbernauld new town planning, land uses were conceived two-dimensionally; that is, one use was put adjacent to another with open space in between. Cumbernauld designers attempted to introduce new concepts of urban order, whereby "uses" occurred in "three dimensions." The pedestrian system of Cumbernauld's center goes from outside to inside, changes grades, spirals up, and moves about the "gut" of the indoor enclosure; it moves people up and down, then gets at the outdoors again. Cumbernauld introduced substantial conceptual innovations. The strong three-dimensional quality of the town center demonstrated a sophisticated architecture from the spatial point of view.

Cumbernauld, however, was just an intermediate step. The town was not compact enough; the industrial districts were located at remote sites of the periphery; and traffic problems were generated during "peak" hours. There was need for more compact development, tighter integration of pedestrian and mechanical systems of movement, and more use of the third dimension in the structure of the town. By the time "Hook" new town was to be studied, the British possessed the experience of two decades of new town building, and some twenty new towns were either built or underway.

4. "Hook" brought about the third generation of British new town development.[52] The plan for "Hook" took care of all the problems identified in the towns that preceded it. With the introduction of light industry such as electronics, the working areas were distributed into the residential areas. The pedestrian system was substantially reduced in length, while the uses were compacted both horizontally and three-dimensionally. "Hook" attempted constant interaction of its inhabitants through the use of

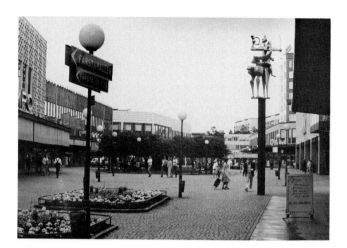

Farsta, New Town, Sweden.

compact physical design, industrial redistribution on an equitable basis throughout the plan, architectural innovation, new concepts of systems building, and new residential designs. "Hook," though, was never built. However, it influenced urban design thinking substantially. Many other new towns that were planned and built in England and elsewhere followed "Hook's" prototype, at least in theoretical conception.

Scandinavian New Towns

1. There are two notable new town examples in Sweden, Vällingby and Farsta. The center of each one of these towns has been conceived as the hub of a total urban experience. The designs of the towns follow the sensitive topography, and they also suggest that it is possible to respect nature and include high-rise construction at the same time. The two towns, however, have received negative town planning criticisms. They are too close to Stockholm, so they fail to become independent, self-contained, and self-sufficient. Because of that, they are just dormitory suburbs.
2. Tapiola is the outstanding example of Finnish new town design. It demonstrates simplicity of architecture, modest expression of its individual buildings, respect for nature, and incorporation of high-density construction in the midst of a rural environment.[53]

Capital New Towns—Brasilia and Chandigarh[54]

Notorious among the grandiose physical developments of the twentieth century are the projects of Brasilia and Chandigarh. They are both capital cities, the first of a nation, the second of a large province. Although numerous capital cities were built in the past, these two are extraordinary in terms of scope, scale, and construction speed.

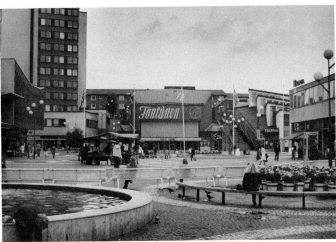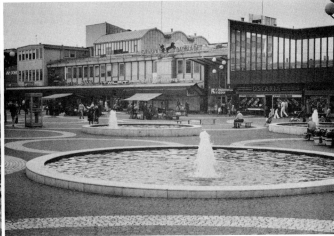

Town Center, Vällingby New Town, Sweden.

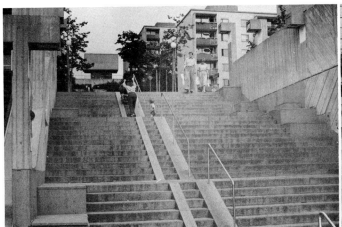

Skärholmen, New Town, Sweden.

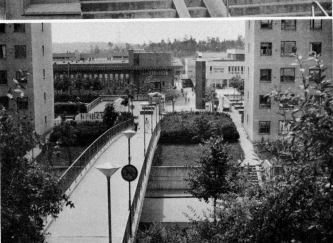

Administrative, Cultural and Religious Center at Seinäjoki, Finland. Alvar Aalto, Architect, 1952–1969.

Toulouse-Le Mirail. New Town in France by Candilis-Josic-Woods.

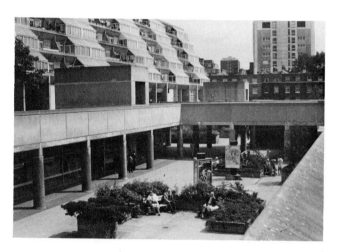

High density housing through the whole-block superstructure approach. Bluemsburry housing. Pattrick Hodgkinson, Architect. London, 1973.

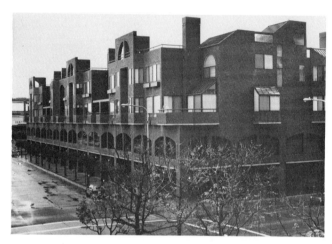

High density housing in San Francisco, California. Happy cases of total architecture can resolve conflicting constraints of real estate requirements, environmental, societal and architectural demands of intellectual as well as realistic considerations, 1980.

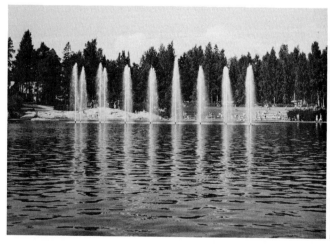

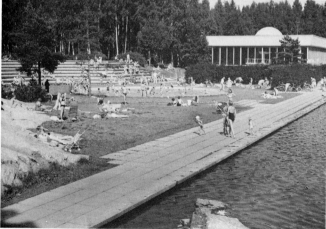

Tapiola, New Town, Tapiola, Finland.

Figure 37. Concepts of urban design (1)

Figure 38. Concepts of urban design (2)

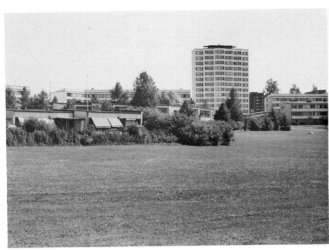

Strategically distributed open space is necessary ingredient of successful urban design. New Neighborhood in Jyväskylä, Finland.

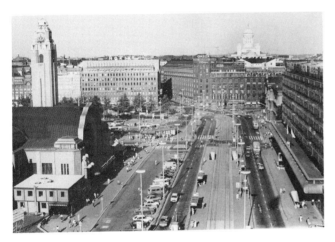

A showcase of "relevant" architecture. Helsinki, Finland.

Physical undertakings of the magnitude of these two towns were never realized before. Because of the uniqueness of these two projects, presentation of their major features of urban design is necessary.

It could be argued that the conceptual roots of each project originated in the theories and philosophies of Le Corbusier. Lucio Costa, the planner, and Oscar Niemeyer, the urban designer and principle architect of Brasilia, were students of Le Corbusier. Le Corbusier himself was the planner and urban designer of Chandigarh.

In both schemes the urban design detail is the "superblock" which Le Corbusier called "the sector." Brasilia's superblock is an 800-foot square. Chandigarh's superblock is larger, ½ × ¾ mile. Brasilia's major plan is monumental and simple; but the quality of containment cannot be found, and this is unfortunate. Human poetry and lyricism are absent from Brasilia. there is only, at present, the lyricism of modern "minimalism," (if one could call lyric the minimal buildings of Niemeyer, especially the buildings by the government plaza with the two assembly halls). The feeling of emptiness is also prevalent in the central area of Chandigarh. The grandiose government complex of this capital is devoid of human scale. There are vast landscaped areas between the buildings, and there is no feeling of containment whatsoever. Criticisms of the Chandigarh design have been made by many. All objective critics agree, though, that if Le Corbusier made errors, they are errors which will be corrected with the passage of time. The open space of today will be the space in which to solve the needs of the city in the future.

Neither Chandigarh nor Brasilia has a connection with history. In the years to come, however, each town will acquire a history. "Topophilic" attachment of the inhabitants will evolve; there will be more people, and more green. There is good chance that, in time, they will be successful. Meanwhile, life will go on in the superblocks.

The superblock of Chandigarh is its major feature at present, possessing balanced integration between urban solids (buildings) and open spaces. there is total separation of pedestrian from vehicular circulation. Chandigarh also possesses the most sophisticated classification of road systems ever designed. Each channel of movement is called a "V." The town has seven V's, that is, its plan provides for seven kinds of roads. They range from the high-speed intercity V1 to the recreational (path for walking) and bicycle road labeled as V7.

Incorporation of building with rapid transit. A possibility of large urban significance. Universal space of hotel in Disneyworld, Florida. Welton Becket, Architect.

Chandigarh is generally accepted as a more advanced urban design achievement than Brasilia. It offers much greater diversity of movement systems; it demonstrates more concern for people than Brasilia, especially in the "sector" quarters; and it integrates open space with the urban environment successfully. All these positive things are achieved through a very simple system of design. The total plan is, in reality, the grid system restated. The scope and expediency of Chandigarh's construction, as well as the unique nature of the commission (A minimal fee was paid to Le Corbusier, and almost no time was spent in the actual design; Le Corbusier designed the grand plan in only four days!),[55] did not allow that an absolutely appealing environment could be designed for the human areas.

The human areas of Chandigarh are better than Brasilia's, but there is still much to be desired. One can suggest that Chandigarh's plan remained at the level of diagrammatic solution. The details need to be further refined. Yet this was to be expected, as we know that Le Corbusier totally rejected Camillo Sitte's concerns for urban design details.[56] The interior spaces of the superblocks ought to have been further designed. The Indian urban designers will have to complete the refinement in the future. In doing so, they will need to provide for a variety of urban activities and reenhance the urban rhythm. In order for the urban designers to do that, they should strive for diversity of urban space, and they should be aware of the typology of urban spaces and the feelings each space creates in its users. As part of this concern, urban designers should be aware of and study the basic notions of imageability, enclosure, direction, decisiveness, decision of movement, invitation, attraction, and others; as well as the typology of

Ghirardelli Square, San Francisco.
Lawrence Halprin, Architect.

voids, intersection of voids, typology of places, and principles of synthesis of urban solids and voids. This can be achieved through the study of traditional and successful contemporary environments. It can be suggested that, although in-depth research of the space-people relationships may provide scientific answers, empirical observation and sketching and taking notes while observing may provide a more expedient means of learning (even perhaps, a more precise way) than statistical inquiry.

Grandiose Urban Redevelopments[57]

There are two major categories of projects as far as urban redevelopment goes. The first occurred as urban renewal, that is, new construction on urban sites that were either destroyed by war or decayed by urban blight. The second occurred through a process of conservation, renovation of existing buildings, and a strong attempt for continuity with the past. The whole world is filled with examples of post-World War II urban renewal. The center of Hiroshima has been rebuilt to a thriving new urban environment. Coventry and West Berlin have seen their whole centers rebuilt. St. Paul's precinct in London and the adjacent project of Barbican have experienced the same. The entire downtown development in Rotterdam, with special emphasis in Lijnbaan, represents a typical case of the renewal that started as early as 1930 all over the globe.

One of the earliest and most grandiose urban projects is Rockefeller Center in New York City. It achieved high-density development, a mixture of uses, separation of traffic, and the inclusion of an outdoor pedestrian mall and an open plaza; Rockefeller Center evolved into one of the most imageable spaces of New York City. It is one of the most memorable urban spaces of modern urban design.

Other important urban design undertakings are the following:

1. The Boston Government Center. It developed around the administrative needs of a great city. Conceived as an assembly of architectural "masterpieces," it suffered for some time from the lack of diversity of uses. This problem was substantially remedied by the opening of the adjacent Quincy Market in 1978, which provides for diversity of activities after office hours.
2. The Embarcadero Center in San Francisco. A private urban development by architect John Portman. It is characterized by diversity of uses, separation of systems of movement, pleasant proportions of exterior spaces, and inclusion of large-scale art in the public spaces. The climax of the design is an urban hotel, the San Francisco Hyatt Regency, with the most extraordinary public interior space twentieth-century architecture has achieved thus far.
3. The Robson Square in Vancouver, British Columbia. It is an exciting three-block development designed by Arthur Erickson, the leading architect of Canada. The whole project has a low profile, including the existing courthouse, waterfalls, plazas, and walkways, as well as a good mixture of uses that make it a very active, but at the same time, very serene and relaxed environment.
4. The Defense redevelopment area in Paris. It was developed in an attempt to decentralize the congestion of office activity in the center of Paris on the concept of a linear regional development along the regional rapid transit system.
5. Sinjuku in Tokyo. This is the most prestigious of all new urban redevelopment projects and is similar in concept and intent to the project of Defence in Paris. Sinjuku today is the most dense part of the densest and largest city in the world. The integration of all kinds of urban uses is horizontal and vertical here. High-density construction, separation of pedestrian and vehicular movement, reclaiming of certain streets from the motor car during certain days of the week, and the distribution of the highest concentration of people in the world to the rest of the metropolitan area and the country occur here and represent the main characteristics of Sinjuku.
6. Umeda Station in Osaka, Japan. With this, Japan has demonstrated the most complicated and grandiose underground urban design development of the century. Urban activities occur on eleven levels below ground, while above-ground activities include all kinds of commercial, office, and transportation uses. Umeda is an underground *wonder;* yet it is not "legible," nor is it a human place to be.
7. In addition to the gargantuan Sinjuku and Umeda, Japan is filled with small urban design renovation schemes, especially in the hearts of many of its traditional areas. Certain streets have been weather-protected with continuous plastic skylights; motor cars have been banned from these streets; and street interiors have been given to pedestrian access and commercial use. These redevelopment projects are usually linear in nature with a beginning and an end. In many instances the beginning is the local subway exit and the end is the neighborhood shrine or some other public building. The most outstanding urban design redevelopment of the above nature is the Asakusa project in the ward of that name in Tokyo. Asakusa belongs to the second category of urban redevelopment, the one that is concerned with conservation, renovation, and continuity with the past.
8. Ghirardelli Square in San Francisco belongs to the same category and is the United States' outstanding example. An old chocolate factory was remodeled, and the resulting three-dimensional design of the total scheme shelters indoor and outdoor uses that attract people at various levels. The total environment of Ghirardelli Square is at work as a great urban symphony. A linear public street connects Ghirardelli with "The Cannery" shopping center. "The Cannery" was an old canning establishment just a few yards from the famous Fisherman's Wharf. The sequence of Ghirardelli Square, The Cannery, and Fisherman's Wharf creates one of the most extraordinary urban design complexes of all times. People are there at all times, and that is what makes an urban place successful.

Renovated old buildings have inherent in them the tie with the past. The element of historic continuity should be respected by all means. In addition to this ethic of respect, renovation of old buildings is efficient ecologically. Therefore, urban designs of the Ghirardelli–Cannery sequence type are most ideal solutions. Many such designs have been prepared for a number of cities around the world. The most prominent examples are to be found in Boston, Denver, and Mexico City. The Plaza de las Tres Culturas in Mexico City demonstrates considerable respect for the past and states the urban design concept of historic continuity in a symbolic way. The Indian, Spanish, and contemporary civilizations of Mexico have been appreciated, retained, and dramatized in one contemporary scheme; the urban designers conserved what was there (Indian ruins, Roman Catholic cathedral) and, by treating the grounds of the contemporary paving modestly, they tied all three civilizations (cultures) together.

To preserve old projects is good; it is ecologically advisable. . . . But to imitate old buildings when new

Quincy Market shopping development, Boston. A most successful and profitable urban design complex by the Boston government center. Thompson Benjamin and Thomas Green, Architects. (Photos by Dimitris Loukopoulos.)

buildings have to be built is not advisable under most circumstances. The urban designer should be alert to issues of historic zoning ordinances, and he should be able to argue on issues of traditional vs. contemporary at all its levels. The Plaza de las Tres Culturas in Mexico City and the development of the Copley Plaza in Boston are good examples of this concern.

Certain recent legislative developments, such as "Bonus Zoning"[58] and "Transfer Development Rights,"[59] in the United States should help to facilitate urban design that is sensitive to conservation and the equitable treatment of resources, physical and historical. Equitability, respect, conservation: all of these are issues of an urban design morality based on the great concern for energy conservation.

Outstanding from that point of view is the ingenious Citycorp Center in New York City designed by Hugh Stubbins and Associates. This masterfully designed project has capitalized on the advantages provided by "bonus zoning." It leaves intact the essence of street-level activities; it permits the existence of a church on one of the most desirable pieces of Manhattan real estate; and it realizes an indoor public concourse, full of life and joyous activity. The project represents a model for urban architecture in the United States, one which is responsive to and a result of the broader urban context (what some theoreticians like to call *contexturalism*). From the strictly theoretical point of view, the Citycorp project can also be considered as the unique United States exercise in *Metabolism*—the Japanese urban design advocacy of the 1960s that aimed at leaving the existing environment intact and, by exploiting wastelands or pockets of available land and using advanced building technology, expanding the city vertically in layers above the existing environment.

Quincy Market shopping development, Boston.

Left, Sinzuku development, Tokyo, Japan. Design by Junzo Sakakura, 1967. *Right,* typical neighborhood shopping street. Asakusa, Tokyo, Japan.

Streets reclaimed for the use of the pedestrians. Mexico City.

The city as a theater—outdoor market, Helsinki, Finland.

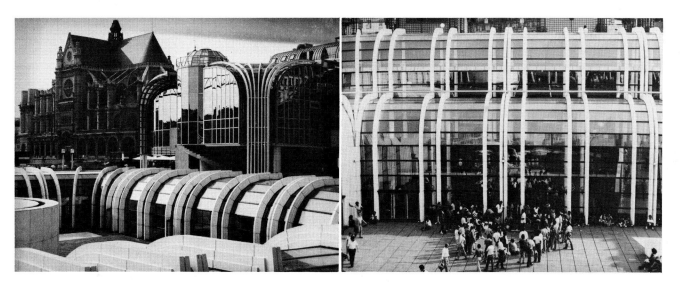

Even flamboyant technological insensitivities may be rendered successful through appropriate planning of activities, permissiveness, and the perception of the building as a set in the theater of the city. Forum of Les Halles, Paris. Claude Vasconi, Architect, 1979–1983.

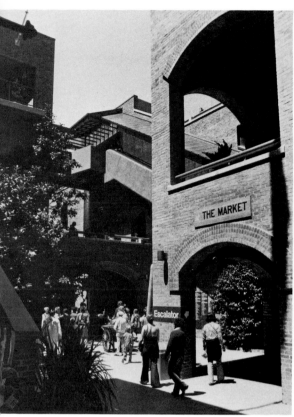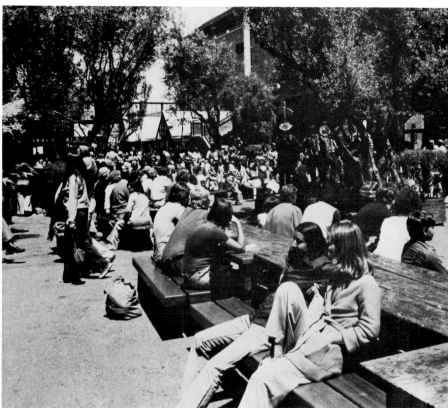

The Cannery Shopping Center, San Francisco. Joseph Esherick and Associates, Architects, 1968.

Numerous large-scale projects today which rely heavily on artificial interior environmental conditions are insensitive to energy conservation. The Galleria and Greenway Plaza shopping centers in Houston, Texas, represent typical case studies of extremely large-scale urban design interiors that, in spite of their interior architectural grandiosity, are energy insensitive and therefore unacceptable. *Energy* is at the heart of all development today. Because of that, the urban designer must "think modest." Designing modestly doesn't necessarily mean one cannot achieve "big" ideas, however. Great urban spaces can be designed with what is already there, through the use of minimal means. In order to do this, the urban designer must develop ways to promote immediate urban beauty and life through the use of these modest and minimal means.

Promoting Urban Beauty and Life

If the urban designer is to create an environment that is pleasant and relaxing for man, he (or she) should make it have human scale. An environment has human scale if it makes man feel grateful toward it. Such environments are built for man's basic needs. As man moves and stays in urban space, his needs can be seen as either "dynamic" or "static" movements. "Dynamic" refers to the movements man makes when he is at work; "static" to those he makes when he is performing static activities or relaxing.

In order to perform either type of movements, man must be able to perform his necessary biological functions: eating, sleeping, making love, urinating, and relaxing. With relaxation comes the need for entertainment; man must entertain himself.

All of these functions are performed differently in different societies according to certain ceremonials that vary from one culture and one life style to another. Some things urban designers can do in order to make man's everyday experience more appealing are the following:

1. Control signs, especially in downtown areas.
2. Apply fresh paint and neighborhood murals. Paint can perform miracles in neighborhoods, especially those adjacent to blighted districts. Community murals bring about participation and make community members achieve territorial attachments to the painted public space.[60] Programs of street or mural paintings can promote civic pride.

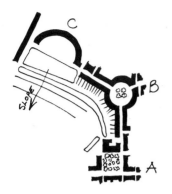

URBAN DESIGN RHYTHM: TIME SPACE EXPERIENCE: BATH

C

B

Slope

A

BATH. JOHN WOOD, THE ELDER & JOHN WOOD, JR.

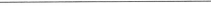

"LI'JNBAAN" - ROTTERDAM J.B. BAKEMA & VAN DER BROEK. (1942-43 DESIGNED), BUILT: 1946.

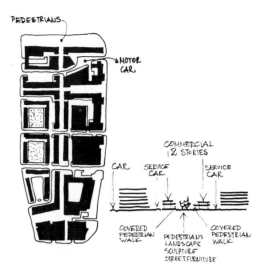

PEDESTRIANS

MOTOR CAR

COMMERCIAL 2 STORIES

CAR SERVICE CAR SERVICE CAR

COVERED PEDESTRIAN WALK PEDESTRIANS LANDSCAPE SCULPTURE STREET FURNITURE COVERED PEDESTRIAN WALK

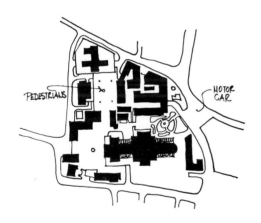

PEDESTRIANS MOTOR CAR

ST. PAUL'S - LONDON 1956
LORD WILLIAM HOLFORD - ARCHITECT.

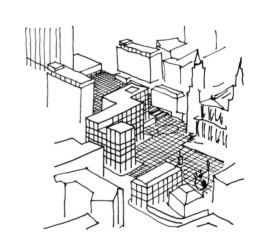

GHIRARDELLI SQUARE - SAN FRANCISCO

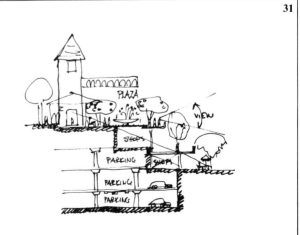

PLAZA

VIEW

SHOPS

PARKING

SHOPS

PARKING

PARKING

Figure 39. Urban design cases

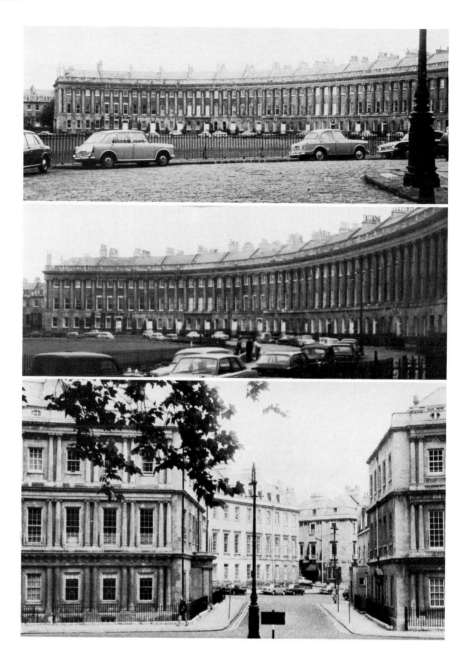

Along the major axis of the time-space urban design experience. Bath, England.

3. Plant trees and flowers; landscape.
4. Exploit existing buildings, respecting the "good" things that are inherited from the past.
5. Exploit strategic sidewalks and unused plazas for outdoor activities.
6. Strive for the institutionalization of a higher degree of community tolerance which will permit people to sell and buy, play, have music, etc., without police interference.
7. Use water whenever possible. Designers must realize the organizing quality of water, especially on calm days. Water has the power to give order to disorder, to calm even an aesthetic anarchy.

8. Invite community artists to exhibit on the streets, especially functional sculptures and sculptures that can be used by children. Make arrangements with museums and galleries to exhibit outdoors.
9. Provide flower boxes that are easy to rearrange.
10. Suggest incorporation of sound in buildings.
11. Select or design appropriate street furniture, flower pots, telephone booths, mailboxes.
12. Paint utility poles.
13. Concentrate posters on strategically selected poster walls. These walls may be unpleasant walls of decayed buildings.

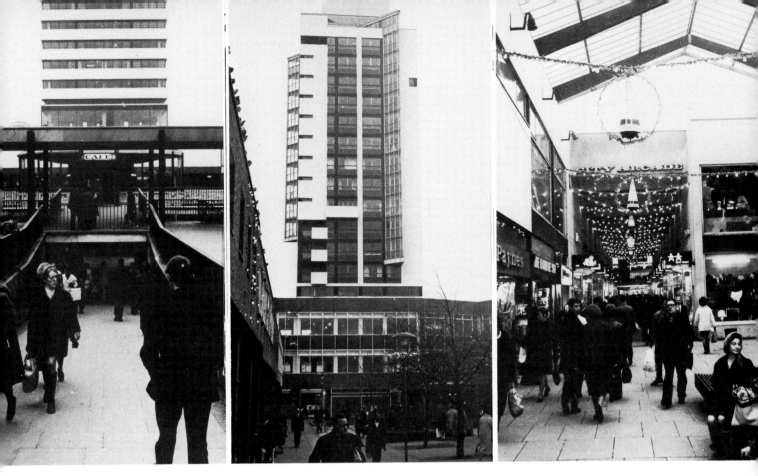

One of the first downtown redevelopment projects after World War II. Coventry Town Center.

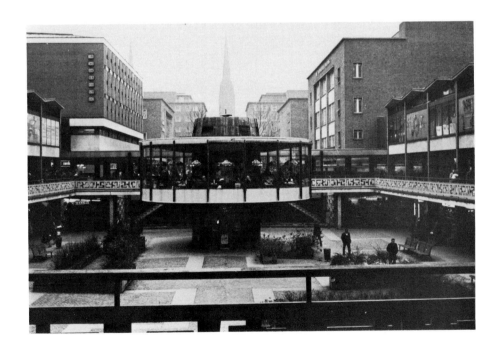

Coventry. Reconstruction of Town Center.

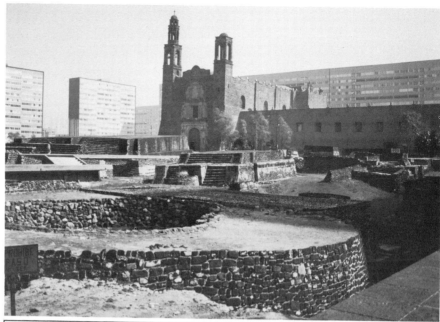

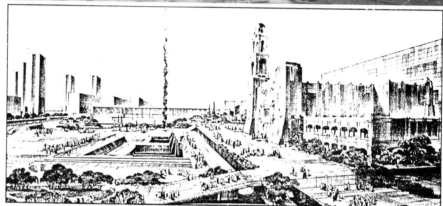

Plaza de las tres culturas, Mexico City.
Mario Pani and Associates, Architects.

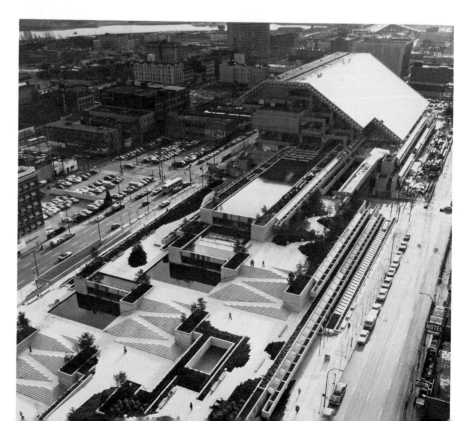

Robson Square, Vancouver.
Arthur Erickson, Architect.
(Photo courtesy of Arthur Erickson.)

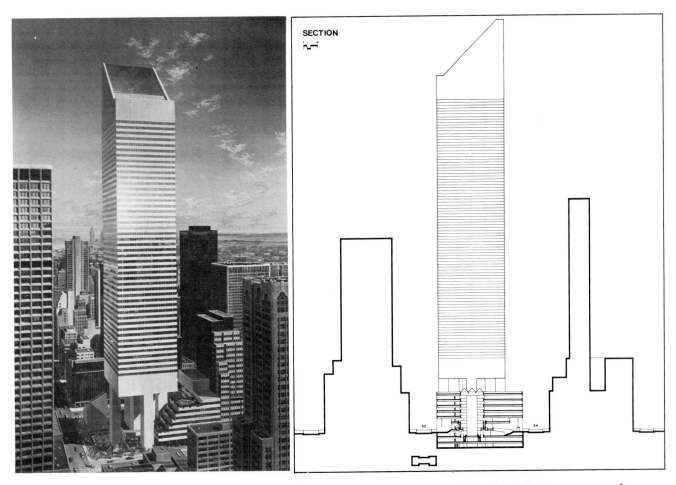

SECTION

Citycorp Center, New York City. A prototypical urban project in mid-Manhattan, New York. The building becomes part of the urban fabric through the integration of street level activities that interpenetrate the project. Rendering. Hugh Stubbins and Associates, Inc.: Architects/Planners, 1978. (Photos by Hugh Stubbins and Associates.)

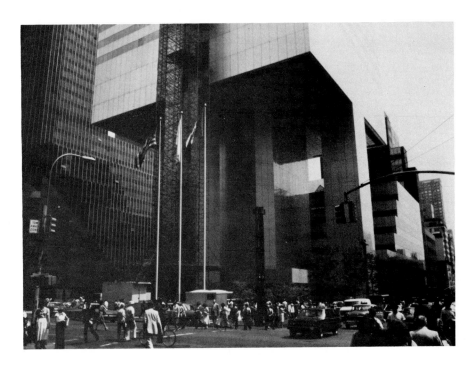

Citycorp Center, New York City. Hugh Stubbins and Associates, Architects.

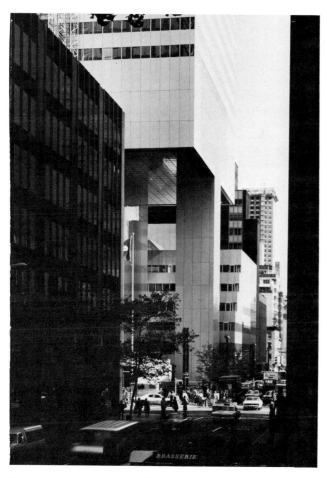

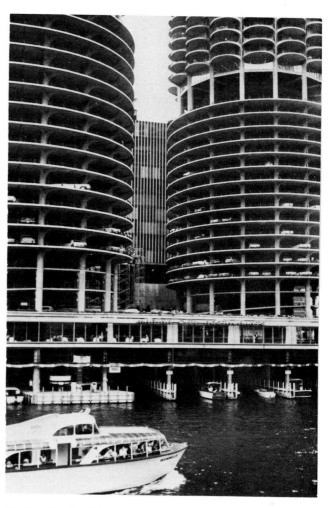

Street level articulation of Citycorp Center. The separation of street-related masses and tower. Hugh Stubbins and Associates, Architects. (Photo by Peter Aaron, ESTO.)

Marina City in Chicago. One of the earliest projects in the United States which responded to requirements of urban significance. The design is a result of integration of urban functions such as marina, recreation zone, parking for residents and visitors, residential, radio station. Bertrand Goldberg, Architect.

Water and a place to relax; elements that make man feel grateful towards his environment. A public fountain in Barcelona. A beach in Peñiscola, Spain.

Town Center, Skärholmen, Sweden.

Sculpture and water in public spaces can be used by children and enrich the life of the environment. Children playing with sculpture in Helsinki Finland.

Sculptural art in the outdoors can be used by children.

University of New Mexico campus.

Left, windows, flowers, light. Granada, Spain. *Right,* old and new in coexistence. Athens, Greece.

Paintings by art students on construction fence in San Sebastian, Spain.

Use of existing water bodies—waterfronts, lakes, canals, etc. Xochimilco gardens, painted boats on the canal. Xochimilco, Mexico.

Peasants selling their goods at the Saturday bazaar in the main Plaza of Tlaxiaco, Mexico.

Not a ruin; an abstract relief in urban landscape.
Toledo, Spain.

The architecture of each individual building is important for the enhancement of urban coherence and street relevance. Vocabulary of "mass" with historical allusions to the constructivist and color coding precedent of the Palace of Knossos. Athens, Greece. Nicos Theodosiou, Architect.

14. Paint existing buildings. Use supergraphics or otherwise. Ask artists to collaborate with citizens in the making of murals.
15. Organize parties and street festivals on frequent occasions.
16. Insure that there are sufficient numbers of benches for people's relaxation.

The list of practical recommendations could be endless depending on the designer's intuitiveness and "practical imagination."

There are, however, certain specific recommendations that are low-cost in their implementation, but require public official collaboration. These recommendations pertain to the "dynamic" elements of the urban landscape such as cars and people. Some "dynamic" ways to provide urban beauty are the following:

1. Paint busses. The red busses of London are good examples of moving elements of the urban landscape. They contrast with the prevailing grey and black color of the city and offer into the city a color of pleasantness.

2. Paint the systems of rapid transit with dynamic designs. Even the subways of New York become strong moving objects in the outdoors due to the graffitti that appeared on them during the early 1970s.
3. Organize temporary unconventional extravaganzas such as kite flying, car racing, one-color street permits (e.g., green and yellow cars only), etc.
4. Encourage outdoor contests of people's dressing appearances. People are the strongest moving element of urban design.
5. Encourage people's assemblies by allowing and promoting appropriate functions (e.g., street ceremonials, religious festivities, well-intended demonstrations, public debate).
6. Finally, but not least, permit public performances (concerts, theater, dance) in the outdoors, especially on the weekends.

Through the use of inexpensive
canvases for sun protection, this
street has become a distinctive
feature of the urban experience in
the center of Cordoba, Spain.

People in Tokyo.

Portobello Road. A neighborhood street on weekdays, an international shopping center on Saturdays. Notting Hill Gate, London.

"The city is the people." Square dancing in the cathedral plaza of Barcelona.

"Tolerance" in the streets of San Francisco. The key to the city's successful urban design.

Public debate in Hyde Park, London.

San Francisco. Transamerica Tower.

Embarcadero Center, San Francisco.

Cable car, San Francisco.

Fishermen's Wharf, San Francisco.

San Francisco sequences.

The environment must offer people a chance for self expression. "Sidewalk painter" in Paris (*left*). Primitive expression: Mexican driver sketching on the dirt of a truck stop parking lot (*right*).

All of the above suggestions regard the city as a theater, a characteristic of medieval cities. The city then was the stage for the performance of *the play of life*.[61] Different settings for this play should be selected by urban designers. These settings ought to be the natural resources: existing water, existing hills, existing spots of great vistas. Special events and activities of the play ought to take place on the "urban theater" set.

Great cities of the world today, such as London,[62] Paris, and New York, provide continuous settings for urban theater. The concept of the city as a theater is especially notable in San Francisco's urban design concept. The beloved San Francisco cable cars connect the sets of the downtown "commercial acts" with the sets of "amusement and recreation acts" by the Fishermen's Wharf. Then, pedestrian stroll takes the spectator from the wharf to The Cannery and then to Ghirardelli Square. The spectator becomes a participant. Buildings and activities planned through sensitive urban design provide the score for constantly changing "urban improvisations." Relaxation, human contact, and tolerance for expression make for the play of life in San Francisco!

San Francisco's example demonstrates that finally, but not least, urban sets ought to be supported by the functions that respond to man's basic needs. These functions—places to eat, sit, relax, make love, and places for man's biological comfort—should be the fundamental concerns of urban designers. It is pathetic that some of the most basic amenities, such as public lavatories, are almost totally absent from American cities. New York City has no public toilet system in its public outdoors. Paris on the other hand, is a very good example in that respect with specially designed *pissoirs*.

. . . The creation of "urban pride" should be the ultimate goal of urban design. When citizens are proud of the city or neighborhood in which they live, happiness prevails and life goes on in harmony.

The discipline of urban design remained relatively untouched from extremist theoretical disruptions, polemics and polarization. The Post-modern fuzzy, so evident in architecture, did not infiltrate into the theoretical anxieties of urban designers globally, inspite the efforts of several post-modern architectural historicists, both in America and Europe, who saw possible commissions in large scale urban design and came about with the promotion of what they presented as "contextualism." While Post-modernism lead architecture to the creation of individual buildings as set-design objects with historicist morphology, urban designers, with commissions from pre-post-modern years, were busy completing and supervising their projects of totality. The last decade, parallel to the rise of post-modernism in Architecture, witnessed (in silence) the completion or the maturity of several important urban design complexes and New Towns (i.e. The New Towns of France, the maturity of Toulouse-le-Mirail, University towns—especially in England, Sweden, Finland and Belgium, prototypical large scale housing developments such as the Byker Wall by Ralph Erskine in Newcastle Upon-Tyne in England etc.). All of these projects represent clear living testimonies of the strength of the comprehensivist (inclusivist) argument promoted by earlier architects of the century; in this sense they represent the thread of organic evolution toward the creation of appealing, non-oppressive, correct environments. The anonymity of earlier projects, such as the notorious Pruitt-Igoe in St. Louis, was criticized and alternative (correct) responses were found from within. The Byker wall has demonstrated the

possibility to achieve human architecture with identity and individuality even within a large scale superstructure. Good urban design has demonstrated that it is indeed possible to be "contextual," including "technology," that very important and significant part of todays' context usually left out by historicist "contextualists." Because of the above one could suggest that the architects who involved themselves with the urban design projects of this century were a lot more significant, from the standpoint of civilizational evolution, than those architects of individual buildings. There is indeed a potential for greater civilizational impact through urban design.

Notes

1. The definition employed here is heavily dependent on Sir Frederick Gibberd's notions on urban design. See Gibberd, 1953, p. 9.
2. Dr. Harry Anthony, lectures on urban design, Columbia University, Fall, 1966. Also, Gibberd, 1953, p. 9.
3. Gutheim.
4. Tankel, 1969.
5. Bacon, 1974, p. 23.
6. Halprin, 1972, p. 7.
7. For elaboration refer to Halprin, 1973, general reference.
8. The role of urban designers and their attitudes toward spatial and physical determinism are fundamental. "Those who shape the environment shape man himself." This statement goes back to original notions Winston Churchill had about man's houses. He stated: "We shape our houses and our houses shape us." Refer to Bertaux in W. R. Ewald's *Environment and Change*, p. 14.
9. Refer to basic references: Gibberd, 1953; Von Hertzen and Spreiregen, 1973; Bacon, 1974; Halprin, 1972; and Lynch, 1973.
10. Dr. Harry Anthony, op. cit.
11. For elaboration on the concept of "time" in urban design, refer to Lynch, 1972.
12. Jacobs, 1970, p. 46.
13. Ibid., p. 3.
14. Typical cases to be studied in that respect are the capitals of numerous Greek islands. These island towns were built in hinterland locations, away from the sight of invader pirates.
15. The author is referring here to urban design advocating protection from the atom bomb as well as to urban design responsive to protection from crime. Refer to Newman, *Defensible Space*.
16. *The Decentralist,* 1942; Duff, 1961; and Antoniades, 1971, Appendix 3.
17. Refer to Mumford, *History of Utopias*. Also Rasmussen, 1969, p. 21.
18. Doxiadis, 1972, p. 20.
19. Refer to Aristotle, *Politics*.
20. Rasmussen, 1969, p. 20.
21. Some of these bearers of authority were the actual town builders. A good account on this issue is provided by Rasmussen, 1969, pp. 20–27.
22. General reference, Mumford, *The City in History*.
23. Doxiadis, op. cit., p. 20. Also Travlos, 1955.
24. Ibid., p. 5.
25. "Radii from the vantage point determined the position of three corners of each important building, so that a three-quarter view of each was visible." See Doxiadis, ibid., p. 5.
26. See Troedsson, 1959, for general information on the dynamics of the growth of cities during the Middle Ages. Also Mumford, 1966.
27. For general information on medieval towns refer to Pirenne, 1952.
28. Current urban design vocabulary on the typology of voids, solids, and intersections has been developed through the study of medieval examples. For typical case studies see *Architecture d'Aujourdhui, 1962;* Chazimichalis, 1973, p. 26; and sketches in Japanese National Tourist Agency materials.
29. Zucker, 1970, p. 77.
30. Rasmussen, op. cit., p. 27.
31. Benevolo, 1967, pp. 14, 16.
32. Peets, 1968, p. 152.
33. Terminology credited to Kevin Lynch. Refer to Lynch, 1963, p. 2.
34. For detailed account on the subject refer to Benevolo, op. cit., p. 1.
35. Basic reference on these issues are the works of F. Engles. He makes reference to certain medical reports that point out the unhygenic conditions of slum environments. Also refer to Engles, F., "The Housing Question" in Benevolo, op. cit., pp. 75, 83.
36. Choay, 1969, pp. 32, 97.
37. Ibid., p. 57.
38. Ibid., p. 105.
39. Howard, 1970, general reference.
40. Geddes, 1971, p. xxix.
41. "Advocacy planning" theory and methodology developed by Paul Davidoff in mid-60s did not give credit to Geddes. See Davidoff, 1965.
42. Geddes, op. cit., p. xxix.
43. For general reference, see Stein, 1971.
44. Tunnard, 1967, p. 90.
45. For summary of the physical proposals, refer to Reiner, T., and Antoniades, 1971, table. Also basic reference: Le Corbusier, 1947, Introduction, referring to issues of reconstruction. Also Goodman, 1960.
46. For urban design proposals of Le Corbusier, refer to le Corbusier, 1971.
47. Newman, 1972, general reference.
48. This is demonstrated by most research on urban design as well as by some of the leading publications in the field. Basic example is the study of E. Bacon, presented in his book *Design of Cities*. See Bacon, 1974.
49. The physical design for Letchworth developed by Unwin was highly influenced by the ideas of Camillo Sitte, which were by no means advanced. For evidence on argument, refer to Choay, 1969, p. 106; and for influences on, refer to Choay, 1969, p. 108.
50. Stein, 1971, general reference.
51. General reference in Antoniades, 1971.
52. For the story of Hook, refer to Greater London Council, 1965.
53. For Tapiola, refer to Von Hertzen and Spreiregen, 1973.
54. *Architecture d'Aujourdhui,* 1962.

55. For the story of Chandigarh's design, fees paid to Le Corbusier, and time devoted to design, refer to Evenson, 1966.

56. Le Corbusier had stigmatized Camillo Sitte as an apologist "for the donkey's way." See Choay, 1969, p. 106.

57. No special references will be made, because comments made in discussion that follows are based on the writer's personal experience after visits to the mentioned projects.

58. Barnett, 1974, p. 45. Also Costonis, 1974.

59. Transfer Development Rights. See Barnet, 1974.

60. Sommer, 1974.

61. Huizinga, *Homo Ludens,* 1962.

62. See, for instance, Rasmussen, 1974 (2).

Selected Readings

Gibberd: *Town Design*
Goodman, Paul and Percival: *Communitas*
Huizinga: *Homo Ludens*
Lynch, Kevin: *The Image of the City*

16
Urban Planning

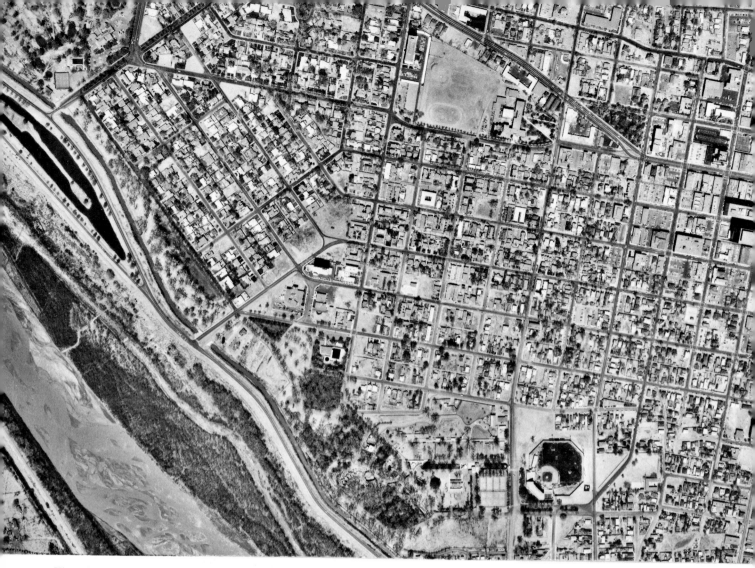

The urban planners' milieu. Aerial view of typical American town. (Albuquerque, New Mexico.)

Urban planning is a sphere of environmental design that is more comprehensive than urban design and architecture. As the term suggests, urban planning deals with concerns of the urban environment. Urban planning has been called different names on different occasions and in different places. It has been called "planning," "comprehensive planning,"[1] "town planning," "city planning," "structure planning," and finally here, "urban planning." The professionals who perform this aspect of environmental design in the United States prefer to call themselves *planners*; in Europe, especially in France, they call themselves *urbanists*. As you may have guessed, the lack of agreement in the terms reflects indecisiveness and ambiguity in the conception of this design profession. Yet others might suggest that this lack of agreement reflects the dynamism of a profession in evolution.

Urban planning concerns itself with many facets of the urban environment. Therefore, it is a field for many professionals, each possessing a basic specialization on a

certain facet, and beyond that, possessing a comprehensive understanding of the interrelationships of the various facets involved. As it will be argued later, the "urban planner" is not a solitary professional. The "urban planner" is a *group* of individuals with different basic specializations, but with a common vocabulary. Because of this common vocabulary, the members of the group are able to communicate among themselves. According to this, "urban planners" may be conceived as a round table. Each member of the round table is concerned with a certain issue; they coordinate their arguments and put them together in an interrelated way. Their conclusions, as a whole, represent the work of the "table" on the planning of the urban environment under scrutiny.[2] A member of the table (say the representative of "transportation" interests) may be a group of people, a transportation planning consultant, an individual, or a firm. There will be no planning, though, if a member of the table presents a solution on its particular area of concern as *the* solution to the urban problem. The solution must evolve as a result

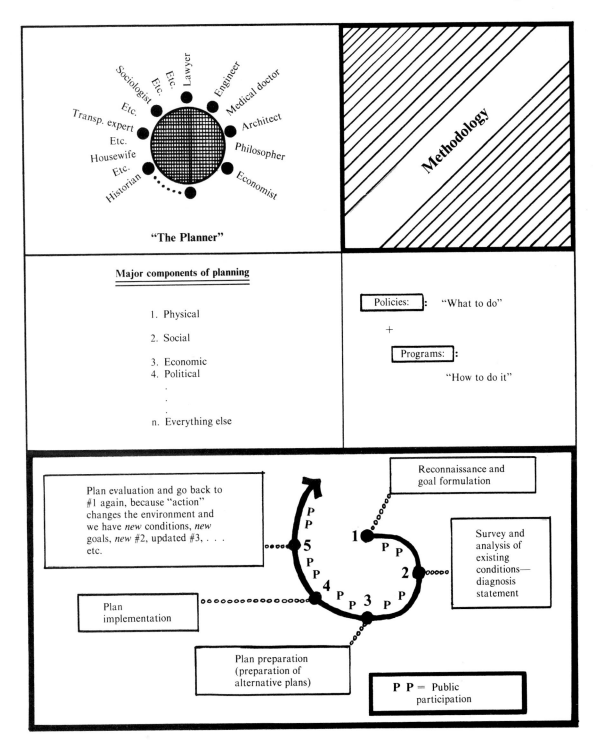

Figure 40. Planner and planning methodology

of the interrelationships and coordination of *all* facets involved, in a comprehensive way. This is why the terminology of "comprehensive planning" is more binding in terms of professional conceptualization.[3]

With this introduction in mind, we may now define urban planning as follows:

"Urban planning is intelligent *forethought* for the development of an urban community as a *whole,* in a functional, physically appealing, socially balanced, equitable, and economically feasible way. This must happen according to the goals and objectives of the said community."[4]

In order to perform the tasks of planning appropriately, the urban planner (that is, all the members of the round table as a whole) must follow a "fit" methodology.[5] It will be "fit" if it has evolved out of the circumstantial needs of the community and if it respects the structure and capacities of the planning group. Not every town can afford to support a large number of planners with as many subspecializations as possible. Because of this reality, the methodologies followed in urban planning vary. There are occasions when the "table" is short of planners of a specific concern. There are occasions when planner-sociologists are not available, but when there is an abundance of physical planners. If that is the case, the methodology will very likely be biased toward physical planning. On other occasions, it may be thought that the urban problem is due to one urban issue rather than another. If, for instance, there is widespread belief supported by politicians that the issue is, say, economic, it is to be expected that the methodology thought fit for the investigation for a solution of the situation will be an economic methodology.

Yet any methodology must consider the interrelationships that exist among the various facets, or components, of urban life. Any methodology must consider the type, nature, and complexity of the problem dealt with. There are "simple problems," "compound problems," "complex problems," and "metaproblems."[6] Each type of problem requires a different structure of the planning group. A "simple problem" requires the simplest structure; while a "metaproblem," where most parameters of the problem are unknown, requires a complex, diverse, research-oriented structure of the planning group. Determining the type of problem should be the first stop in deciding on the "fit methodology" and the "structure" of the planning group.

Unfortunately, this has not always happened in the evolution of urban planning. There have been times when the sociologists of urban planning groups have been more influential, as when certain prevailing social problems of

political significance have made politicians seek and endorse socially biased proposals. For instance, this happened during 1920–1925 in the United States, when the Chicago School of Sociology headed by McKenzie and Burgess promoted sociological biases.[7] Another bias toward sociological methodologies was experienced during the mid sixties; this was politically appropriate, as politicians gave priority to advice of sociologists[8] aimed at curbing riots and social unrest.

Urban planning methodologies biased toward economics developed during the 1930s, when the United States was facing unemployment and other economic handicaps due to the economic depression. Economists, headed by Homer Hoyt[9], offered solutions to urban problems by talking economic issues. Hoyt developed a methodology worked around the "economic base" theory; it suggested that the only healthy basis for urban growth and future urban planning is the "economic base of the master plan."[10] "Economic base," in short, was conceived to be the future economic potential of the community. If the community was to be financially healthy in the years to come, then all other things such as physical development would become feasible. Elegant economic methodologies for urban planning developed in England during the late 1960s. Their predominance was justified, as England was experiencing an economic decline accompanied by increasing unemployment. "Cost benefit analysis" became the prevailing urban planning methodology of the United Kingdom during that period.[11]

Right after World War II the urban planners who were closer to the interests of political determinism were the physical planners. Europe had been devastated by the war; cities had been destroyed through bombardment, and reconstruction was an urgent necessity. Architects and engineers evolved as physical planners. Most of the prototypical schemes for physical planning growth developed during this period. All of the influential architects in Europe concerned themselves with planning at the time. Le Corbusier finalized and greatly publicized his theories for physical development,[12] while Doxiadis evolved as an urban planner through his position as Greece's Minister of Reconstruction[13] right after World War II.

The urban planning of our time has evolved as a dilectic of the various planning biases which prevailed in the process of the twentieth century and were fit to political expediency. It is clear that biases will continue to exist. Planners should at least be aware of the dynamics that underlie the biases of the epoch and try their best to demand checks and balances for the prevailing methodology. Any methodology must consider the interrelationships that exist among the various components of urban life.

Any methodology, if it is to be constructive, must recommend *policies* and include *programs*.[14] Policies define the "what" or "what to do"; and programs provide the "how" or "how to do it."[15] There can be more than one "program" that might satisfy a "policy." The planner must recommend more than one program. Through the study of these alternative programs, he should recommend the optimum to the decision makers. A policy may be to "revitalize the downtown." Programs for this revitalization would suggest alternative ways of doing it; for example, tax incentives to businesses coming back to the downtown, provision of adequate parking facilities in the downtown, matching funds to encourage private business to expand, enhancement of police protection in the area, etc.

. . . Unless there is a well-articulated methodology, the task of planning will be impossible. Each methodology of planning should follow steps known by all planners of the group. The steps of a planning methodology are known as *the planning process*. The steps and components of each process vary according to the emphasis of the methodology.

For instance, a comprehensive planning process would be concerned about the theoretical and technological "ideal" and would most certainly emphasize the "synthetic" steps.

A "middle-range planning"[16] methodology fit for non-idealistic total approaches, on the other hand, would emphasize the "implementation" steps of its process. It would be concerned with the pragmatic implication of the proposals and with immediate implementation; "better to have five on hand than to wait for ten."[17]

Components of Planning

Considering only one aspect of urban life makes for biased planning. Yet even in the recent past we have seen such biases operate, though. It is essential that we remove as much bias as possible from the planning process. This can be accomplished through study.

The major aspects of life are the (1) physical, (2) social, (3) economic, (4) political, and (5) everything else (general). Planning, therefore, is concerned with all of these aspects. We refer to these aspects as the *components* of planning. Each component is an aggregate of subcomponents. The urban planner must become aware of the components and subcomponents. This awareness will constitute the basis for building the understanding of the other members of the planning group. The process of formally learning the details of issues pertaining to those components, questioning them, and refining them represents the inquiry of the planning studies. The major planning components and some of their basic subcomponents are summarized here.[18]

1. *Physical:*
 a. Land uses
 b. Transportation
 c. Community facilities

 Most of the concerns of "urban design" which were examined in the previous chapter belong to the physical component of planning.

2. *Social:*
 a. Education
 b. Health
 c. Safety
 d. Welfare

 Each of these affects, and is affected by all other components (physical, economic, political, etc.).

3. *Economic* or *Financial:*
 a. Economic base and employment characteristics
 b. Various governmental plans, regulations, and programs of economic activity; i.e., taxation and fiscal policies of the city.

4. *Political* (often referred to as administrative and governmental components):
 a. Local, state, and federal interrelationships
 b. Existing programs
 c. Legal and regulatory measures.

 The "political" represents the most pragmatic component of the planning process. This is exceptionally true in political systems where "political expediency" is important.

5. *Everything Else:* comprehensive component.

A Comprehensive Planning Process

There is undoubtedly a lot of debate among urban planners on the comprehensive planning process.[19] We are not going to resolve the various arguments here. This will come about through the further study of planning, and it will be the life task of those of you who eventually become more involved with planning or even become planners. The comprehensive planning process outlined below is one of the most traditional ones, and it has been used extensively by urban planners in the United States.[20]

1. Reconnaissance and goal formulation.
2. Survey and analysis of existing conditions (physical, social, economic, political, etc.)—Diagnosis.
3. Plan preparation (preparation of a number of alternative plans).
4. Plan implementation.
5. Plan evaluation and go back to #1 again, because "action" *changes* the environment; so we have *new* conditions, a need for *new* goals, new #2, updated #3, . . . , etc.

Pioneering multi-story housing in Paris in the effort to create "hygenic" street life by recessing top floors to let sun reach the street. Subsequent zoning ordinances, in Berlin and New York City were formulated on the above concept. Henri Sauvage, Architect.

The most debate concerning the validity of this specific methodology pertains to the first step, goal formulation. The argument is that goal formulation, as the first step of the process, comes too early; there are no facts available on which to base goals, and the goals may be totally irrelevant due to possible preconceptions. That argument is valid. In any event, there is a need to explain what each step of the process involves. We will offer that explanation to the reader and leave the argument of the ordering of the steps of the planning process to him as he develops his own professional methodology.

During the step of reconnaissance and goal formulation, urban planners first undertake the **reconnaissance;** that is, they move about the urban environment surveying most of its aspects, physical, social, economic, etc. They try to get a comprehensive impression of the total situation, and to experience and comprehend the reality of the problem. They keep notes and ask a lot of questions. They try to find out as much as possible in a manner similar to that of a tourist visiting a town of a foreign country for the first time. Many of the early observations are extremely worthwhile, and some of the solutions intuitively suggested by experienced urban planners later prove to be the due solutions. This is seen in many instances after indepth study of the existing conditions. For this reason, "intuitiveness" during the step of reconnaissance is very important.

The second part of step one is **goal formulation.** During this part the planners prepare a summary of goals which should include the aspirations of the community for future development. Whether the goals should be those of the community alone, those of the planners, or a combination of both has been an issue of considerable debate among the planners and critics of planning.[21] Urban planners have occasionally been accused of working toward achieving their own technocratic goals with little respect for the goals and aspirations of the community. This has unfortunately been true on many occasions. Debates over this issue have generated a number of other planning processes that emphasize citizens' participation in the goal formulation stage. Most important of those planning processes have been the advocacy planning[22] in the United States, and the citizens' participation[23] process of the United Kingdom as suggested by the Skefington committee. Countries with homogeneous makeup due to traditional evolution of values, or due to political directives, have "goals" set from above. In the case of some nations, methodologies such as "advocacy planning" are unthinkable at present. In many instances such methodologies are illegal.[24]

The second step of the planning process we discuss here is the easiest. It pertains to the systematic collection of information regarding all aspects of urban environment. During this step the planners **collect and analyze information** of physical, social, economic, demographic, and political natures. When all information has been collected and analyzed, the urban planners prepare a summary of "**diagnosis.**" That is, they make a formal statement of the things they have found to be wrong and that should be "cured" by all means. At this moment the urban planning team plays the role of the "physician" for the urban environment. The statement of diagnosis is most important, as it points out the disease.

After the diagnosis comes step number three. The urban planners have all information at hand; they know through their statement of diagnosis what they need to cure; and they then **prepare alternative plans,** that is, they prepare strategies for the "curing of the disease." A number of alternatives must be prepared, so that the decision makers will be aware of the options. The planners should make their recommendation as to the alternative they favor, and tell why. A tool for helping the decision makers select the optimum plan is the cost benefit analysis.[25] It analyzes each plan in terms of costs and benefits, that is, "who pays the cost and who gets the benefit," and tells the community which plan is more feasible from the economic (public interest) point of view. An elegant cost benefit analysis methodology for the use of urban planners was developed in England in the mid 1960s by Lichfield.

The adopted plan is referred to as the "master plan," "general plan,"[26] "comprehensive plan," "structure plan," or the "strategy plan."[27] It is general in nature without physical specificity. It is a written and graphic document that explains to the citizens what the goals and aspirations of the community are, and where the community will go in the years to come.

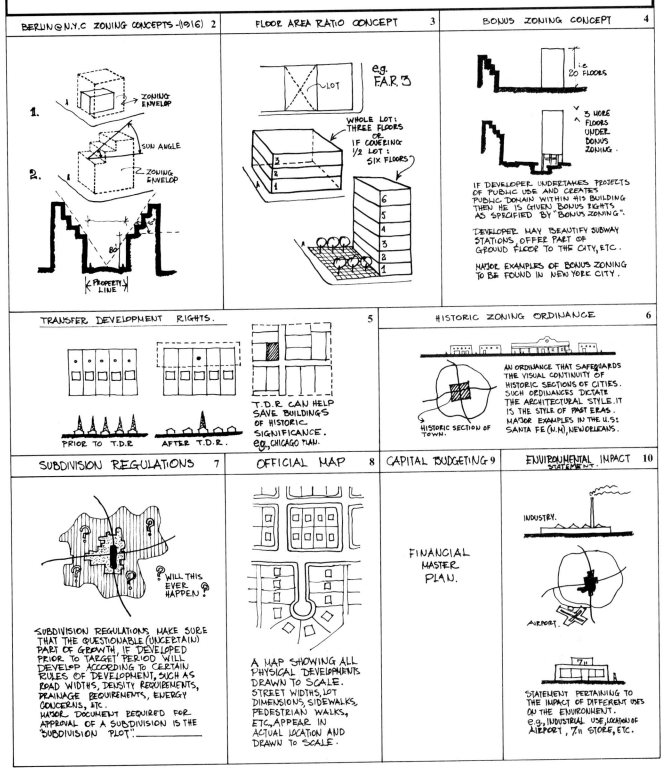

1

MASTER PLAN or GENERAL PLAN or COMPREHENSIVE PLAN or STRUCTURE PLAN, ETC. A COMPENDIUM OF WRITTEN + GRAPHIC DOCUMENTS.
MASTER PLAN: IS THE OFFICIAL STATEMENT OF A MUNICIPAL LEGISLATIVE BODY WHICH SETS FORTH ITS MAJOR POLICIES CONCERNING DESIRABLE FUTURE PHYSICAL DEVELOPMENT; THE PUBLISHED MASTER PLAN DOCUMENT MUST INCLUDE A SINGLE, UNIFIED GENERAL PHYSICAL DESIGN FOR THE COMMUNITY, AND IT MUST ATTEMPT TO CLARIFY THE RELATIONSHIPS BETWEEN PHYSICAL-DEVELOPMENT POLICIES AND SOCIAL AND ECONOMIC GOALS.*
THE MASTER PLAN IS A STATEMENT OF WILLFUL INTENTION.**
POLICIES : "WHAT TO DO"
PROGRAM : "HOW TO DO IT"

* KENT (SUBSTITUTING GENERAL PLAN FOR MASTER PLAN).1964.p.18
* Ibid. p.20

BERLIN @ N.Y.C ZONING CONCEPTS -(1916) 2

1.
2.
ZONING ENVELOP
SUN ANGLE
ZONING ENVELOP
45°
80'
PROPERTY LINE

FLOOR AREA RATIO CONCEPT 3

LOT
e.g. F.A.R 3
WHOLE LOT: THREE FLOORS or IF COVERING 1/2 LOT: SIX FLOORS

BONUS ZONING CONCEPT 4

i.e 20 FLOORS
3 MORE FLOORS UNDER BONUS ZONING.

IF DEVELOPER UNDERTAKES PROJECTS OF PUBLIC USE AND CREATES PUBLIC DOMAIN WITHIN HIS BUILDING THEN HE IS GIVEN BONUS RIGHTS AS SPECIFIED BY "BONUS ZONING".

DEVELOPER MAY BEAUTIFY SUBWAY STATIONS, OFFER PART OF GROUND FLOOR TO THE CITY, ETC.

MAJOR EXAMPLES OF BONUS ZONING TO BE FOUND IN NEW YORK CITY.

TRANSFER DEVELOPMENT RIGHTS. 5

PRIOR TO T.D.R. AFTER T.D.R.

T.D.R CAN HELP SAVE BUILDINGS OF HISTORIC SIGNIFICANCE. eg. CHICAGO PLAN.

HISTORIC ZONING ORDINANCE 6

HISTORIC SECTION OF TOWN.

AN ORDINANCE THAT SAFEGUARDS THE VISUAL CONTINUITY OF HISTORIC SECTIONS OF CITIES. SUCH ORDINANCES DICTATE THE ARCHITECTURAL STYLE. IT IS THE STYLE OF PAST ERAS. MAJOR EXAMPLES IN THE U.S: SANTA FE (N.M), NEW ORLEANS.

SUBDIVISION REGULATIONS 7

WILL THIS EVER HAPPEN?

SUBDIVISION REGULATIONS MAKE SURE THAT THE QUESTIONABLE (UNCERTAIN) PART OF GROWTH, IF DEVELOPED PRIOR TO TARGET PERIOD WILL DEVELOP ACCORDING TO CERTAIN RULES OF DEVELOPMENT, SUCH AS ROAD WIDTHS, DENSITY REQUIREMENTS, DRAINAGE REQUIREMENTS, ENERGY CONCERNS, ETC.
MAJOR DOCUMENT REQUIRED FOR APPROVAL OF A SUBDIVISION IS THE 'SUBDIVISION PLOT'.

OFFICIAL MAP 8

A MAP SHOWING ALL PHYSICAL DEVELOPMENTS DRAWN TO SCALE. STREET WIDTHS, LOT DIMENSIONS, SIDEWALKS, PEDESTRIAN WALKS, ETC., APPEAR IN ACTUAL LOCATION AND DRAWN TO SCALE.

CAPITAL BUDGETING 9

FINANCIAL MASTER PLAN.

ENVIRONMENTAL IMPACT STATEMENT. 10

INDUSTRY.

AIRPORT.

7-11

STATEMENT PERTAINING TO THE IMPACT OF DIFFERENT USES ON THE ENVIRONMENT. e.g., INDUSTRIAL USE, LOCATION OF AIRPORT, 7-11 STORE, ETC.

Figure 41. Planning measures of control

The moment a community adopts a master plan, in principle, is a happy moment of its history; its citizens then know what will happen to the community and to themselves in the years to come. The advantages of a community having a master plan are numerous and they are discussed extensively in the Selected Readings. The most important advantage of a master plan, in this writer's opinion, is the element of protection such a plan offers to the citizenry. Each citizen, after the plan becomes law, will know exactly where he stands within the intentions of the future growth of the community. He will know the future of his property and that of the properties adjacent to his. He can then plan for his own future and his personal interests accordingly. But a master plan is just a "wishful" document; it may never become reality if the trends for growth (or no growth) change due to unforecasted, yet possible, externalities. In order to make sure that the selected master plan becomes reality, it must first of all become *law.*

The details of making a plan law, that is, making sure it has legislative effect and thus will protect the citizens, are worked out during the **implementation** step of the planning process. The planners work out the necessary legal tools for that. These tools are often called "measures of control" or "regulatory" measures of planning. They are intended to secure "smooth" realization of the plan.

The tools of implementation vary from country to country, from planning process to planning process, and from one political system to another. The basic tools of plan implementation in the United States are four: (1) zoning, (2) subdivision regulations, (3) official map, and (4) capital budgeting. The first three are legislative documents presented in written statements as well as in graphic terms and diagrams. Written statements are needed, because they are more comprehensible in the courts.

In general, *zoning* deals with "land uses and the intensity of the uses."[28] Some of the physical concepts of zoning, as far as intensity of use is concerned, are floor area ratio, bonus zoning,[29] historic zoning ordinance, and a recent innovation in zoning consideration, the concept of transfer development rights.[30] In all, the zoning innovations idea is an incentive[31] for development, rather than a restriction. All innovations in zoning attempt to free the hands of physical designers and permit urban design schemes which will be aesthetically more pleasing as well as economically feasible.

Subdivision regulations make certain that the questionable (uncertain) parts of growth, if developed prior to the target date, will develop in accordance with certain standards; e.g., road widths, density requirements, drainage requirements, energy concerns, etc.[32]

The *official map* is the implementation tool that shows the exact location and scale of the existing development. All proposals of the master plan must respect the official map. As new parts of the urban environment are developed according to the general suggestions of the master plan, they are recorded on the official map immediately.

The *capital budgeting* is simply a financial master plan. It says how money will be spent and at what time, in order to make the proposals of the master plan reality.

In addition to the traditional four basic tools of implementation, the United States has recently developed an additional tool, the *environmental impact statement.*[33] This is a statement aimed at securing control over the issues of air, noise, and visual pollution; the conservation of energy; and the respectful use of scarce resources. Each physical development, prior to being carried out, must be given approval by a clearing agency called the Environmental Protection Agency. The permit is given on the basis of the environmental impact statement of the proposed specific project. It is unfortunate that environmental impact statements today are prepared in a routine manner. They are documents prepared to comply with bureaucratic demands and procedures; they are not in-depth studies of the environmental impact interrelationships.

In making a plan reality, one is confronted with public vs. private interests. It is extremely difficult in states of free enterprise to regulate growth where private interest is involved. In centralized economies, such as communistic ones, plans and developments are controlled with ease by the state. In the free world, control is difficult. The extreme and most difficult case for urban planning is observed in the United States. Yet, even in this country, plans can still be worked out and become reality, due to the concept and practices of "police power" and "eminent domain." Under the United States Constitution, each state has the authority to establish laws and ordinances for the *good* and *welfare* of its citizenry. This authority is known as the *police power.* An important aspect of police power is the power of *eminent domain.*[34] It is the authority of the government to take privately owned property in times of emergency or war, for the public good. The Fifth Amendment of the United States Constitution requires that *just compensation* be given to the deprived owner.

The last step of the planning process is, in fact, the beginning of a new cycle of the process, as the planning process works in a "spiral" rather than a "closed circle" way. As the proposals of the master plan begin to be realized, the step of plan **evaluation** begins (or should begin). The process starts all over again, from step number one (reconnaissance and goal formulation); because "action" *changes* the environment so that there are new conditions, *new* goals are needed, a *new* step number two has evolved, an up-dated master plan is needed (step number three), . . . , etc. Certain European countries have developed

substantial methodologies for the evaluation, feedback, and continuous operation of their planning processes. Candilis introduced the use of film for recording urban development and using this information as feedback for new decisions.[35] England has been concerned throughout history about involving the public in the planning process. Yet, even there, issues of "people's participation, and when vs. technocratic input by the planners, and how much" represent key concerns of planners.

Urban planning today is an environmental profession par excellence. Most of its members are keenly aware of the need to tackle the solutions to their problems by means of comprehensiveness and concern for the "interrelationships" involved. Most planners are highly conversant on general environmental issues. Many of the past critics of urban planning have been key contributors to the grounding and evolution of the profession in the comprehensive environmental context. Patrick Geddes can be regarded as a pioneer of contemporary planning. As early as 1910 he advocated the need to tackle the various problems of urban environments in comprehensive and interrelated ways. He also suggested the need for public participation and initiated the idea that the whole citizenry should get involved in the process of planning awareness. He believed this could happen through annual exhibitions focusing on the progress of planning in various municipalities.[36]

Yet planning, as we have already indicated, has not always been environmentally relevant; it occasionally has failed. This has occurred when its methodologies have focused on one-sided approaches that disregarded the wide spectrum of social, physical, economic, etc., interrelationships. We could say that the key enemy of environmentally relevant planning is one-sided planning, or the one-sided or biased urban planner who practices that way. Further investigation of planning issues and methodologies would be beyond the introductory scope of this inquiry. It is true that the best urban planning occurs in countries where freedom and social conscience work together. Any urban planner would point, without hesitation, to Great Britain and Scandinavia for urban planning prototypes.[37]

Notes

1. Most urban planners in the United States like to call themselves *planners*. *Comprehensive planning* is also a term familiar in the United States. It is the preferred terminology of the American Institute of Certified Planners. Terms such as town planning, city planning, and structure planning are used in England. The British have definite notions as to the use of their occasional terminology pertaining to planning. The term *structure planning* came from the notion of "structure" which was an advanced concept of the "master plan." The term is credited to Llewelyn Davies and appeared in the report of Milton Keynes' new town.

2. The concept of the urban planner as a "round table" was furthered by the author over a period of two years in the course "Planning Methods" at the University of New Mexico.
3. The term *comprehensive planning* is favored by the American Institute of Certified Planners.
4. This definition evolved out of officially accepted positions on planning by the American Institute of Certified Planners.
5. Methodology is referred to the way of "doing" planning.
6. For reference on types of problems, refer to A.I.P. booklet with readings for the A.I.P. examination.
7. The author has examined the process of planning biases in the course "Planning Methods" at the University of New Mexico. No specific references are provided here, because the research on this specific subject is still in progress; thus the statements here may be considered as early hypotheses.
8. This period of sociological supremacy gave birth to the "model cities program" established by the Department of Housing and Urban Development, the "advocacy planning" method (see Colboc, "Advocacy Planning"), and the process of "operation breakthrough." Basic references on above issues: *The Model Cities Program—A Summary of the Program*, HUD, 1965; Frieden, *Urban Planning and Social Policy;* Little, *Strategies for Shaping Model Cities;* Davidoff, *Planning Workbook;* and *The Social Responsibility of the Planner*, San Francisco A.I.P. national conference, prepared by P. Davidoff. The author was a collaborator in the preparation of the above position statement during the A.I.P. conference.
9. Refer to all writings by Homer Hoyt in *According to Hoyt*. Also refer to Hoyt, 1941.
10. Hoyt, 1963.
11. Major advocate of cost benefit analysis is Dr. N. Lichfield. Refer to Lichfield, 1962.
12. Le Corbusier's book, *Four Routes* especially concerned itself with planning problems as related to reconstruction. See Le Corbusier, 1947.
13. Doxiadis was the first Minister of Reconstruction in Greece right after World War II.
14. On "policies" and "programs" refer to Kent, 1964, pp. 20, 21. Also Altshuler, 1965.
15. According to Dr. Harry Anthony. Lectures in Urban Design. Columbia University. Fall 1966.
16. Term accredited to Altshuler, 1965.
17. A widely known Greek proverb explaining in simple words the essence of "middle-range planning" expectations.
18. This summary is based on the components and subcomponents of planning as understood by the American Institute of Certified Planners.
19. A recently published source on the comprehensive planning process is Cooke, 1976, p. 27.
20. First published in Goodman and Freund, 1968. Also adopted and taught by Dr. Harry Anthony, op. cit.
21. For general reference on "goals" in planning, see Altshuler, 1965.
22. Davidoff, op. cit. (on advocacy planning).
23. Skeffington report on public participation, H.M.S.O., 1969.
24. The reaction of one of the directors of the Ministry of Coordination in Greece, when discussing the need for advocacy planning for Greece, was that "such things" would be considered illegal. Christmas 1975. Writer's testimonial.
25. Lichfield, 1962.
26. Kent, 1964, p. 130.

27. "Structure" and "strategy plan" are terms used in England. They are favored by Lichfield.
28. Of the substantial bibliography on zoning, refer for introductory purposes and definitions to *Zoning in New York State.* Another valuable theoretical introductory reference: Pomeroy, 1950, whole paper.
29. Refer to Barnett, 1974, general reference; and Markus, 1972, p. 5.
30. Woodbury, 1975, p. 3; and Costonis, 1974.
31. Op. cit., p. 40. Also "Symposium: New Perceptions in Land Regulations," *J.A.I.P.,* January, 1975, p. 1.
32. Reference on subdivision regulations, in general.
33. Refer to Manual of Legislation on Environmental Impact Statement. Also refer to *Environmental Quality,* Sept. 1973 (general reference, the fourth annual report on environmental quality).
34. For further explanation of planning terms, refer to Charles Abrams, 1972.
35. See Antoniades, 1969.
36. Patrick Geddes, *Cities in Evolution,* 1971.
37. The central theme of planning is "equity." Urban planning therefore is concerned with the balance of the system of urban "equities." This social ingredient of this sphere of design has made it difficult for planners to operate in the Free World. For many years planners were given the negative attributes of sinister connotations. The United States is at present one of the most difficult places for the performance of successful planning. In any event, the energy crisis has made the public see the need for forethought and equity. It is possible that the years to come will bring better urban planning in the United States.

Selected Readings

Geddes: *Cities in Evolution*
Goodman, Paul and Percival: *Communitas*
Greater London Council: *Hook, the Planning of a New Town*
Kent: *The Urban General Plan*
Le Corbusier: *Four Routes*
McHarg: *Design with Nature*

17
Regional Planning

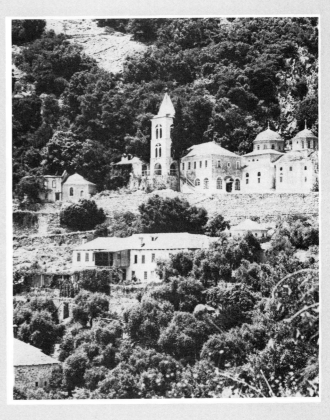

Regional planning is the broadest sphere of environmental design discussed in this inquiry. It is the most comprehensive and, therefore, the most general of all the design spheres. As the term implies, regional planning is planning for the *region*. Regional planners[1] study and analyze the "region" in depth, and they engage in intelligent forethought for its development as a whole. This intelligent forethought is done in such a way that: regional resources are not wasted; regional land uses are coordinated; regional characteristics are retained; regional wealth is used wisely; social, economic, and cultural wealth of the region evolve in a balanced way; and finally, the region exists in integrity within the range of potential competition that exists or might develop with other regions in the future.

Regional planning is a part of *national planning*,[2] generally an economic and industrial planning, undertaken by a country guided by "period plans."[3] Urban planning was conceived as the "intelligent forethought of a table" whose members speak the same language; and the same holds true for regional planning. The difference with the regional "planning table" is that the experts occupying its seats are more general in their concerns and less specific on small-scale issues. The prevailing professionals of a regional planning table (regional planning team) are economists, industrial location experts, geographers, transportation engineers, landscape architects, energy conservationists, and local elected officials. Architects of specialized buildings usually join the table only when the design and construction of such specific regional nodes as airports, electrical plants, and buildings of regional significance are being discussed. As we have seen already, the role of the traditional architect diminishes as the environmental design sphere becomes more comprehensive. The region, however, has a tremendous impact on "architecture." This issue is examined later in this chapter.

Landscape architects play a substantial role in regional planning. Many of the most sensitive regional land use plans have been prepared by regional planners whose basic training was landscape architecture. Regional planning in the nineteenth-century United States was largely performed by landscape architects. A notable example in this respect was landscape architect Frederick Law Olmsted, who initiated ideas for preservation of the natural resources of regions and for the creation of national parks, and advocated the adoption of coordinated regional outdoor schemes (regional outdoor corridors).[4]

In 1932 an outstanding regional planning era in the United States began. All projects undertaken by the Tennessee Valley Authority were based on *regional interdependencies*. The "electrification of America" program and construction of new communities took place during this epic period of regional planning. This was the period of the "New Deal" founded by the Roosevelt Administration.

Regional planning of national significance is currently taking place in Japan. This is one of the few industrialized nations where regions still retain their local characteristics, natural resources are conserved, the environment of the regional outdoors is absolutely nonpolluted, and technological progress manages to go hand in hand with the preservation of cultural values and regional identities.[5]

Imbalances between urban and rural development[6] can only be investigated and coordinated through regional planning. The trend toward excessive urban centralization, as observed in "developing" countries, can only be stopped and reversed through an understanding of regional dynamics and meaningful regional planning. It is necessary to focus on an equitable redistribution of regional resources, an in-depth understanding of the scarcity of resources, and an awakening of "regional conscience." Some of the most successful cases of regional planning of the past have focused on the above principles. As it may be easily understood, regional planning is implemented more easily in countries where there are advanced concepts of equitability and fairness with regard to resources and their distribution.

What Is a Region?

So far we have been talking about regional planning in a way that assumes we agree on what is meant by *region*. An inhabitant of Athens, Greece, for instance, would probably describe his region as the geographic area defined by the surrounding mountains (Parnis, Hymitos, Penteli) and edged by the Saronic Gulf. For a New Yorker who uses the subway every day going back and forth from his upper Manhattan residence to his lower Manhattan office, the region is the route of the subway trip, perhaps Times Square a few times a month, etc.; in short, his "region" is "the city," as he would probably tell you. The Athenian and the New Yorker have different concepts of the term "region"; "region" means different things to them. The same is true for different governments; and unfortunately, the same is true for various regional planners. Region has different meanings for different people. Interpretations pertaining to the conceptualization and definition of the region are fundamental for successful regional planning. The basic interpretations of "region" are the following:

1. *Geographical Interpretation.*[5] It defines region by means of physical boundaries such as mountain ranges, valleys, seashores, etc.
2. *Economic Interpretation.*[6] It considers only the economic base. It defines region by certain interrelationships of well-identified economic activities that bring economic prosperity to a particular population.

3. *Political or Administrative Interpretation:*[7] Regions are often defined "politically" by relatively arbitrary markings on a map that consider only the population size of an electorate, with no concern whatsoever for issues of homogeneity, balance, geography, culture. Other times regions are defined more responsibly for purposes of administrative convenience.

4. *Cultural Interpretation:* It defines a region by considering the homogeneity of the population. The criteria of homogeneity are language, customs, religion, ethnic background, etc. Anthropologists favor the cultural conceptualization of regions.

5. *Researcher's Interpretations:* These are often arbitrary interpretations for the purpose of research abstractions.[8] Regional definitions and regional dynamics are very often abstracted for the sake of investigation models' "elegance."

As one can see, there is no comprehensive interpretation of *region*. For the introductory purposes of this inquiry, however, the following will serve as a starting point

Region is an idea. . . . Region is the geographic area where a population with common ties spends its days and nights. . . . A region is in peace and prosperity within itself when it is in harmony with the external world. Successful regions are self-sustaining and self-sufficient. In these regions the "natural" and the "man-made" exist in harmonious balance; that is, the natural laws and ecology support the harmonious existence of human "growth" and "human ecology," and vice versa. Good planning for a region is found when there is balance between the natural and human habitat, when adaptation is taking place. There are cases where "hostile regions" (e.g., deserts, ice) have been brought to human standards and humans have been conditioned to survive and produce in those environments. Regions are the geographic areas where people feel the highest degree of "topophilia."

Regionalism

Topophilia is the love one feels for his place (region), and it has been the key characteristic of the regionalist movement in history. Geographic areas where people share the same love for place and the same regionalistic ideas can be safely defined as regions for regional planning purposes. *Regionalism* is a movement that attempts to transfer authority from a central government to local administrative units and emphasizes *self-sufficiency* and *cultural identity* of the provinces (regions).[9] More has been written on the "regionalist" movements in France during the twelfth and eighteenth centuries than on similar movements in any other country.[10]

Numerous new towns (the Bishopic towns) were built in France during the first regional movement (twelfth century),[11] and the dynamics of the second French regional movement (eighteenth century) were so strong that they led to the French Revolution. Regionalism survives at the doorstep of "nationalism." We can say that regionalism is a well-conceived form of nationalism,[12] and that healthy regionalism is the safeguard of national balance and welfare. Two countries other than France that experienced turmoil due to regional competition were Germany and Spain.[13] Regionalism is healthy when it is based on logic, study of the available resources, and planning. If it is based on sentimental feelings alone, it may lead to nationalism. It is possible that this nationalism may be ill-conceived, taking the form of hysterical love of one's country based upon no realistic criteria. This type of nationalism should be rejected for regional planning purposes.

A good attempt for regionalism in recent history can be studied in the United States. Each state can be conceived as a region, politically defined.

The greatest difficulty of regional planning rests with the definition and interpretation of the region. The theoriticians of regional planning point out the difficulty of the task.[14] Yet, unless a region is defined properly on the basis of the planning objectives,[15] and unless interrelated subsystems of the region are identified and studied, there is no way that planning for the balance of the whole system can take place.

The Study of Regions

Elements of Regional Study

The theory of a design field as vast as regional planning is vast also. Contrary to that, the applied references on the subject are few, especially those references fit for introductory purposes. A work that speaks about methods and applied techniques of regional planning is McHarg's *Design with Nature.* McHarg advocates that regional planners should design with nature, not contrary to it. At this time McHarg's basic premise and methodology seem very promising, as they are extremely comprehensive.

Other methodologies currently in existence eliminate many of the components of the problem in order to avoid complexities and make the solution methodologically easier. A key methodology used in the past and still in use in many countries, especially in England, is the cost benefit analysis initiated and developed by Dr. Nathaniel Lichfield. The regional components are isolated and, through an assignment of monetary values to the pros and the cons of each proposed scheme, a solution is reached. The optimum solution is usually the least expensive one for the target period. But, as Lichfield has accepted, most of the components are intangible, and therefore, no monetary values can be assigned to them. This leads the method to the use of a scoring system for the purposes of evaluation.

In view of these difficulties, the comprehensive methodology of McHarg seems more promising, even though it may appear more empirical. It can evaluate many more environmental factors than the cost benefit analysis of Lichfield, which uses a combination of mathematics and empirical evaluation. McHarg proposes[16] that, in order to design with nature, regional planners must be totally aware of the various ecological processes of natural habitat (plant, animal, human), that they identify in depth the existing natural reality of the region, and that they record these realities in a series of overlays and never develop on lands that are necessary to the ecological balance. McHarg's overlays, when considered in a composite way, may produce the regional scheme of developable vs. non-developable land. Development should take place only on developable lands.

The elements that any regional study needs to consider and coordinate are the Physical (natural and man-made), the Social, the Economic, the Cultural, and the Political.

Physical Elements: (a) *Natural:* lakes, mountain ranges, seacoasts, rivers, plains, forests, agricultural lands, underground resources (b) *Man-made:* urban settlements, communication routes, public works of regional significance (electrification plants, dams, airports, industry, etc.)

Social Elements: population characteristics, demography, all related facets of statistics

Economic Elements: primary, secondary, and tertiary industry; economic base of the region

Cultural Elements: customs, life styles, language, degree of homogeneity, level of connotations, degree of topophilia

Political Elements:

1. Form of local government and its attitudes toward regional planning. Optimum form of local government must be primary consideration of any regional planning scheme.[17]
2. Types of regional governments:
 a. State governments
 b. Specially established regional governments to carry out regional planning. These governments are appointed by the elected government; e.g., New York State Development Corporation.
 c. Authorities. These are specially established regional governments doing regional planning for just one element of regional significance; e.g., New York Port Authority, Bay Area Rapid Transit Authority in San Francisco, Tennessee Valley Authority–1932.

1932 was the beginning of an outstanding Regional Planning era in the United States. All projects undertaken by the T.V.A. were based on regional interdependencies. The "electrification of america" and construction of new communities took place during this epic period for regional planning. This was the period of the "New Deal" founded by the Roosevelt Administration.

Regional planning of national significance is currently taking place in Japan. This is one of the few industrialized nations where regions still retain their local characteristics, natural resources are conserved, the environment of the regional outdoors is absolutely nonpolluted, and where technological progress manages to go hand in hand with the preservation of cultural values and regional identities.[18]

Regional Imbalances: Centralization vs. Decentralization

The imbalances between urban and rural development[19] can only be checked out and coordinated through regional planning. The trend toward excess urban centralization, as observed in "nondeveloped countries," can only be stopped and reversed through an understanding of regional dynamics and meaningful regional planning focusing on: equitable redistribution of regional resources, an in-depth understanding of the scarcity of resources, and an awakening of "regional conscience." Some of the most successful cases of regional planning of the past have focused on the above principles. As it may be easily understood, regional planning is implemented more easily in countries where there are advanced concepts of equitability and fairness with regard to resources and their distribution.

Historical Implications

Regional environments of the habitable world are composed of urban and rural milieus. In the past these milieus occurred in laissez-faire ways. Yet even during the "primitive" times, when "the rules of the jungle" prevailed in the development of urban settlements, certain regional patterns emerged characterizing the logic of free regional competition. Historic overviews of laissez-faire regional developments took place during the nineteenth century and four basic patterns of urban settlement were found. Later theories were based on these findings:

1. Within the observed regions certain urban settlements emerged as more important than others. As these important settlements were found to be centrally located, they were called *central places.*[20] The reason for their growth was their accessibility to the people who used them.

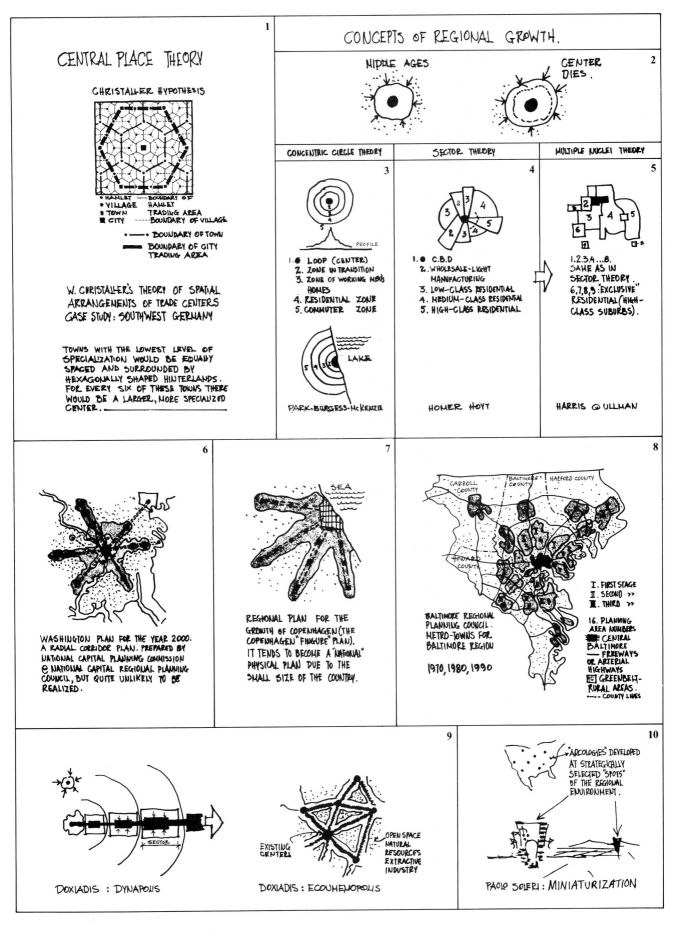

Figure 42. Regional concepts and theories

381

2. Certain settlements (cities) were concerned with linking their areas (regions) to the outside world; these settlements were the harbors of the regions.[21] They were significant economic elements of the region, and they possessed significant cultural diversity and a variety of life styles. As a rule, they were the most liberal urban settlements of the early regions, as they were in tangent with the external world, and trade requires tolerance and liberalism for its achievement.

3. Other settlements of tertiary significance developed around highly localized physical resources.[22]

4. Certain other settlements developed strictly due to accidental circumstances. This was the case with Detroit.[23] The reason for this town's growth was that it was the location of a "bar" where several friends gathered and eventually decided to get involved with the motor car industry.

Theories

A summary of the most important regional location theories follows.

1. Central Place Theory, or the W. Christaller Hypothesis. This is a theory on the spatial arrangement of trade centers. Christaller used southern Germany for his case study. He found that towns with the lowest level of specialization were equally spaced and surrounded by hexagonally shaped hinterlands. For every six of these towns there was a larger, more specialized urban settlement.[24]

2. August Lösch developed Christaller's theory further, but his "refinement" produced a more complicated interpretation.[25] Lösch's book, *The Economics of Location,* is an outstanding reference; it is extremely inspiring for the regional planner.

3. Concentric Circle Theory[26] of Urban Growth (Burgess Chicago School of Sociology). This theory concerns itself with the urban environment. It suggests that the environment grows in circles. These circles are the loop (center), the zone in transition, the zone of working men's homes, the residential zone, and the commuter zone.

4. Sector Theory.[27] This was developed by Homer Hoyt. He suggested the same typology of zones found in the concentric circles theory. However, only the loop (center) is in the center; the other zones develop in sectors, not in concentric circles.

5. The Multiple Nuclei Theory. This was first suggested by McKenzie and expanded by Ulmann. It demonstrates no apparent concentric order. Zones locate according to laws of supply and demand. Environmental competition takes place along lines of accessibility.[28]

6. Doxiadis' Concept of Ecoumenopolis.[29] This is an evolution of the "sector" theory combined with linear growth. Numerous regions of developing countries have been planned to grow according to Doxiadis' theories. Doxiadis' theory is not based on the study and findings of reality; it is, on the contrary, a synthetic suggestion.

7. Miniaturization Theory of Paolo Soleri.[30] This is an architect's vision of regional development based on high-density *arcologies* (architectural ecologies) at strategic spots of the region combined with maximum conservation of regional resources and energy.

Case Studies

In addition to the above theoretical abstractions, there are several outstanding regional plans available which can serve as case studies for regional planners. Among these plans, the most important ones are the following:

1. Greater London Plan,[31] prepared by Sir Patrick Abercrombie in 1944. It recommended that Greater London should grow mainly through a process of physical decentralization. Growth would come about by means of decentralization of industries and construction of self-contained, self-sufficient new towns. The story of the growth of London's region (Greater London) has been occasionally written, and the bibliography on the subject is the bulkiest in regional planning. Plans for the growth of Greater London are currently carried out by the Greater London Council (GLC), which is the largest regional planning agency in the world.

2. The Washington Regional Plan. A radial corridor plan for the coordinated growth of the Washington, D.C., region for the year 2000. An abstract-pattern constellation is characteristic of this regional plan.

3. The Baltimore Plan, conceived to develop in three stages; 1970, 1980, and 1990. The plan is for an aggregate of towns spread throughout the region, following no specific geometric pattern.

4. The "Fingure Plan" of Copenhagen, Denmark. Its concept is similar to the constellation concept of the plan for Washington, D.C. It is only half a constellation, however, due to the proximity of the sea.

5. The Regional Plan for Stockholm. This is another constellation developing along the lines of rapid transit.

6. The Plan for the Linear Expansion of Paris. Linear development along rapid transit lines characterizes this plan.

A study of the above cases suggests that in the implementation of any regional plan, the *most important determinant is the political system, the form of government.*

Unless there is a favorable political climate, and unless there is a proper governmental agency to undertake the plan, there is no chance for successful implementation.

The correlation between regional planning and form of government will be studied primarily in the cases of England, Sweden, the Netherlands, Israel, U.S.S.R., the Latin American countries, and the U.S.A. The first thing to be examined in the study of regional paradigms is the attitudes of nations toward centralization and decentralization in their physical, economic, and political interpretations. The study of centralization vs. decentralization is referred to as the study of *urban dialectics*.[32] If an *imbalance* is found between urban and rural settlements, then one is probably faced with a case of physical centralization and poor regional development. The advantages of centralization *and* decentralization must be studied, and the regional planning scheme must work toward the optimization of both systems. Let us see how this *balance* between centralization and decentralization has been achieved in various countries.[33]

Great Britain

Controlled regional growth was achieved through planned decentralization. Uncontrolled forms of decentralization, such as sprawl, scatter, and low densities which are generally found in the United States, were totally avoided.[34]

Sweden

Decentralization of Stockholm took place along the channels of rapid transit. Sites for the future growth and development of new towns were purchased by the Swedish government 50 years ahead of time. Rapid transit came first and urban development followed. This proved to be an outstanding way to control orderly regional growth and to avoid the sprawl caused by the motor car.[35]

The Netherlands

Regional planning became national planning in this case. Serious planning represents an issue of life and death for the whole population of this country. Planning at this scale is accepted and understood by all. The saying, "God created the earth and the Dutch created Holland," is not an unfounded statement. . . . But the people had to work together. The Dutch created their coordinated region by creating the sites for growth first; they did it by claiming the sea. When people claim the sea, they must be extremely careful about what they are doing.[36]

Israel

Regional planning in Israel involves the extensive construction of new towns[37] and the classification thereof for purposes of national defense. Regional planning is part of the total "defense" planning, and the whole population is involved. The Netherlands and Israel represent the top examples today for the study of "regional conscience," which can be considered the top prerequisite for successful regional planning.

U.S.S.R. (Totalitarian to the Left)

Eight hundred new towns were developed in the U.S.S.R. between 1926 and 1963.[38] Some towns were renewed, others were renovated, and a good many others were built as new. Regional planning, as far as economic and physical development goes, is accepted and performed as a matter of course. The quality of the physical urban environment has not been successful yet.[39] Good cases of regional planning within the Soviet Bloc are those of Poland and individualistic Yugoslavia.

Latin America (Totalitarian to the Right)

Regional planning undertakings in numerous Latin American countries emphasize economic and technological developments.[40] The study often reveals biased regional decisions aiming at the interests of ruling groups and external alliances. "Regional planning" is usually directed by government technocrats and foreign experts. This type of planning, although astonishingly expedient,[41] is regional exploitation rather than regional development.

U.S.A.

The free market economy, with its inherent competition and private ownership, makes regional planning in the United States an academic concern rather than a vital undertaking. The "urban dialectics" at present seem to be in a trend from "decentralization" to "centralization"; but the needed "big" thinking and the ability to implement "big" regional schemes are nonexistent. People involved with planning believe there is need for regional planning to be given priority, and that it is absolutely imperative for environmental design professionals to recognize the urgency for that kind of planning in the United States. It is true that regional planning in this country has experienced periods of sparkling concern. It is unfortunate that such periods did not last (e.g., the New Deal), and that the advocates of regional planning and the planners were regarded with suspicion and their profession was given leftish connotations. The environmental and energy issues of today are giving the United States the opportunity to reconsider its attitudes toward regional planning. Although there are certain minor positive exceptions at present (San Francisco Bay Area Rapid Transit, Twin Cities Regional Plan, New York State Development Corporation), the general attitude toward regional planning has not changed. Political interests and big private enterprise have not yet found the means for coping with the

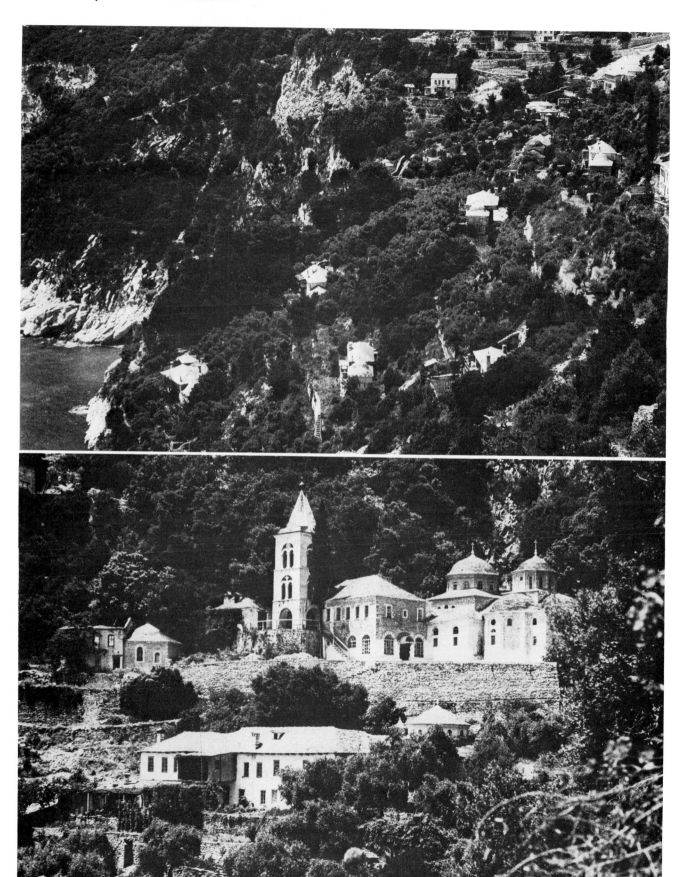

Most preindustrial architecture was the product of architectural regionalism. Unity through the exploitation of regional dynamics (climate, materials, techniques) in the ascetic village of Kafsokalyvia, Mount Athos, Greece.

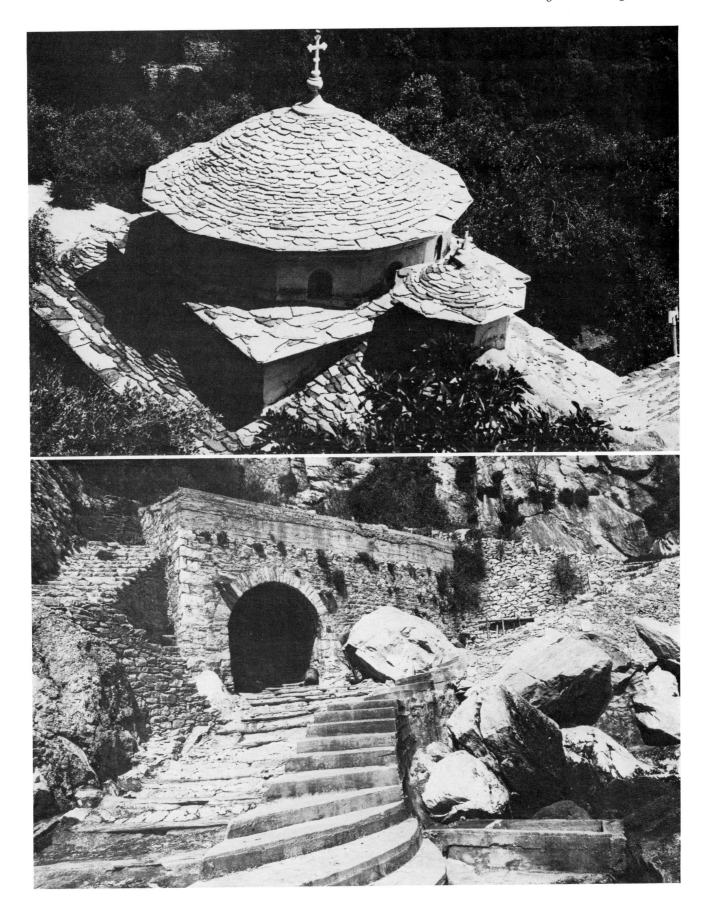

Regionalism as experienced in traditional examples has created works of unity and undeniable craftsmanship. Chapel and dome of monastic residence in Kafsokalyvia, Mount Athos, Greece, *above*. Boat-house in same ascetic village, *below*.

Contemporary regionalism based on the use of local materials and immitation of traditional forms. Such regionalism is easily doomed to failure (i.e. bottom left) due to the inherent handicaps of the process of imitation.

vital issues that are involved. It is unfortunate that the country that possesses the greatest technological potential and trains a great number of regional planners in its schools is unable in reality to cope with its own regional environmental problems. . . .

. . . Thus one could conclude that the key to successful regional planning is not to be found in the technocratic, know-how, quantitative attitudes on regional planning; it is rather to be found in the national value systems pertaining to planning. Perhaps the search for regional planning values should start with the study of the regionalist movement in France . . . then in England, the Scandinavian countries, Japan, and the Netherlands.

Regionalism and Architecture

There is a definite relationship between architecture and regionalism. Environmentally relevant architecture is sensitive to regional constraints and processes. Architecture that responds to the general dynamics of the region is a homogeneous architecture. Regional dynamics directly affecting architecture are climate, materials, construction techniques, life styles, and economy.

Regional influences, in time, create regional types of buildings. The meaning, texture, openings, color, treatment of glare, grouping of buildings, architectural sections of buildings, and interior arrangements obey to the constraints of the environment. It takes hundreds of years for a culture to learn the regional constraints and to respond to them appropriately. Although most cultures have developed "correct" regional solutions in their buildings, there have been occcasions when the opposite has happened.[42] If an incorrect regional solution develops in regional architecture, there is danger that the mistake will be repeated for centuries.

Many regions of the world have very similar climates and materials; it is possible, therefore, to find strong resemblances among the various regional architectures. Massiveness, texture, continuity, and supremacy of solids over voids represent key similarities between Greek island and New Mexico Pueblo Indian architecture, for example. The problem of glare, social attitudes, and the availability of similar materials have created the fundamental similarities of these two "parallel environments." The main difference between the Greek island architecture and the New Mexico Indian architecture is the color of the stucco.

386

Top left, residence in Athens, Aris Constantinides, Architect. *Top right,* apartment house in Athens Greece, Dimitris and Suzana Antonakaki, Architects, 1977. *Bottom left,* apartment house in Athens Greece, Doxiades and Associates, Architects, 1962. *Bottom right,* low cost housing in Albuquerque, New Mexico. Roger Barker, Architect, 1969.

La Luz; Albuquerque, New Mexico. Regional architecture by architect Antoine Predock.

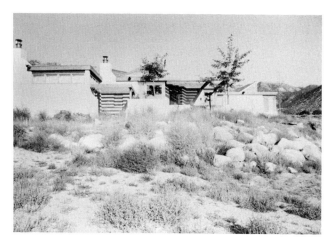

Solar House by the foothills of Sandia Mountain in Albuquerque, New Mexico. Edward Mazria, Architect. (Photo by Wayne Parker.)

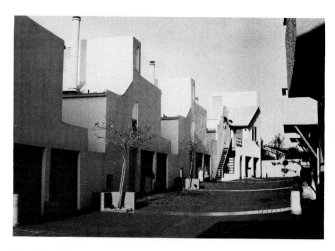

Condominium complex in San Diego California. Rob Wellington Quigly, Architect.

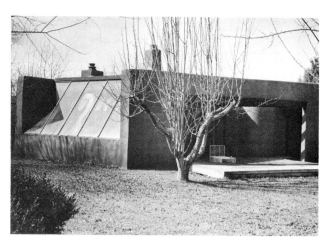

Solar guest house in Corrales, Albuquerque, New Mexico.

House in Corrales, Albuquerque, New Mexico.

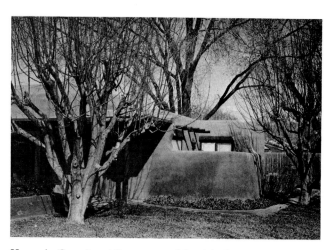

House in Corrales, Albuquerque, New Mexico.

Meticulous response to regional constraints (materials, climate, etc.) can produce pleasing results through articulate expression. Individual residence in Athens, Greece. Dimitris and Suzana Antonakaki, Architects, 1982.

Housing in Helsinor by Jørn Utzon. Outstanding case of planned unit development along the principles of comprehensive architecture.

Regional architecture uses the materials of the area which promote individuality and identity of visual expression. Motel Marina in Tammisaari, Finland. Adlercreutz Erik and Aschan Nils-Hinrik, 1972.

Unity of materials and careful response to environmental constraints has created the unique visual identity of Sea Ranch in California. Charles Moore, William Turnbull, Architects.

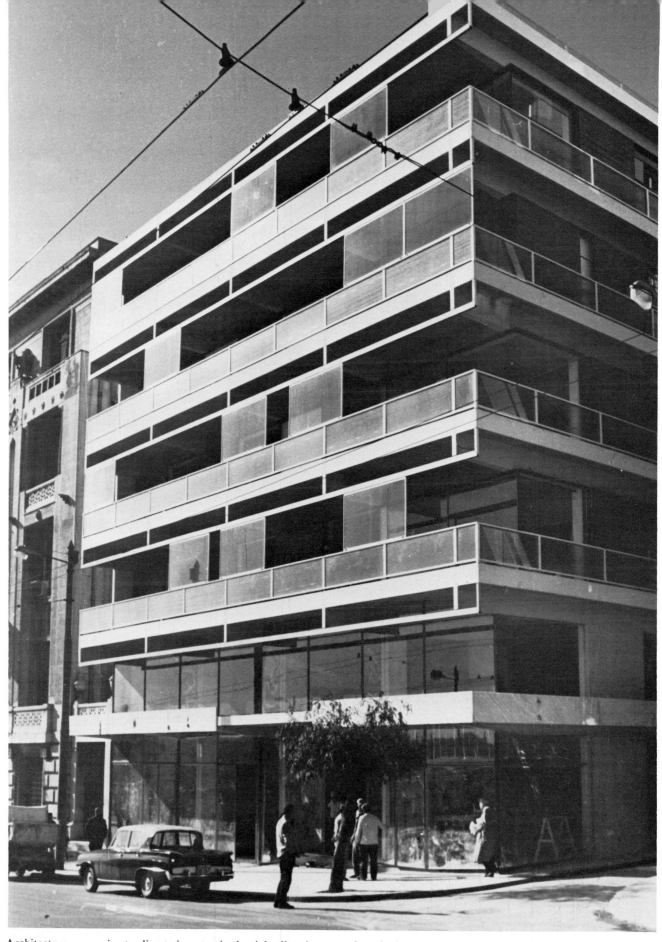

Architecture responsive to climate is a step in the right direction toward producing regional prototypes. Miesian vocabulary and "high tech" can produce regionally sensitive solutions if worked out appropriately. Building by Takis Zenetos in Athens, Greece, indicative of the possibility. (Photo courtesy of Takis Zenetos.)

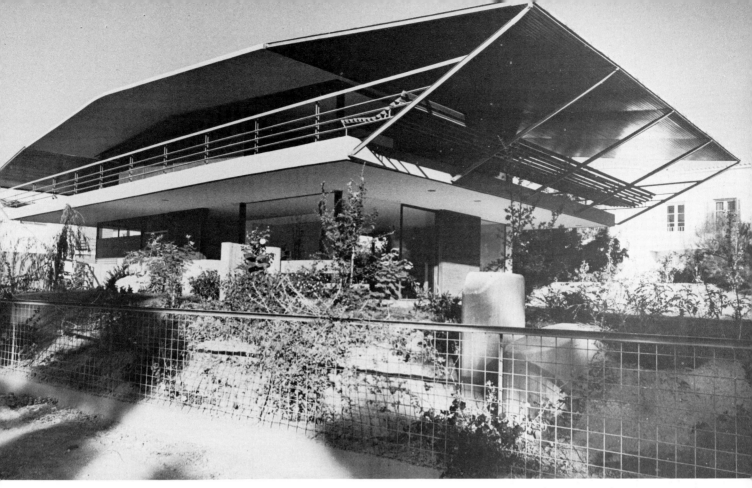

"High tech" and response to climate. Regionalism should not mean imitation of successful regional prototypes of the past. Residence in Glyfada, Greece. Takis Zenetos, Architect, 1964. (Photo courtesy of Takis Zenetos.)

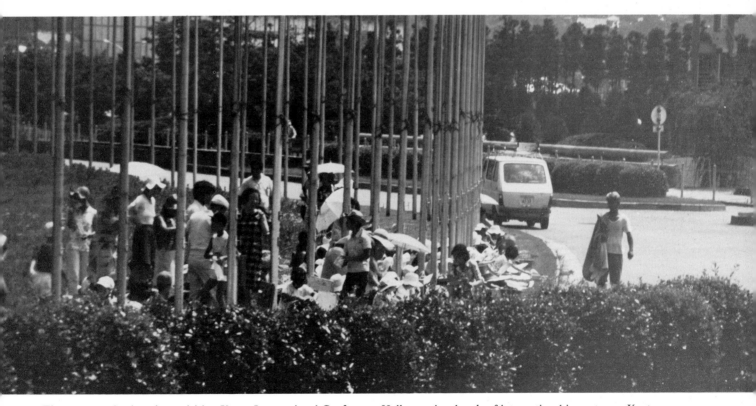

Elementary school students visiting Kyoto International Conference Hall, a regional node of international importance. Kyoto, Japan, 1966. Sachio Otani, Architect.

The "regional" architecture of
Reima Pietilä. Utilization of regional
materials in masterful combination.
Detail from apartment house in
Tapiola. Wood, concrete, and stucco
in joyful interplay. (Photo by
Constantine Xanthopoulos.)

Regional architecture is an energy-conserving architecture. It utilizes materials that are already there and does not consume energy to produce synthetic ones. In addition, such problems as ventilation, heat control, and summer cooling have often been solved through the use of appropriate architectural sections and orientation of the buildings. Modern architecture can learn a lot from the study of the various regional architectures of the world.

The issue of regionalism and architectural form is a sensitive one. Architects must study and learn the *principles* of regional architecture, not simply imitate its forms and textures unquestioningly.

The Need for Regional Conscience

Regional concepts can be difficult for adults to comprehend, as they relate large areas to "populations" rather than to individuals, and most adults have "set" attitudes toward individual rather than communal habits. Children are more receptive. As it is extremely important for each individual to develop a regional conscience in an educated manner, the best place to start is the elementary school.[43] These schools can become, among other things, the regional laboratories where young students will become aware of the vital issues confronted by their region and develop positive attitudes toward dealing with them. The facets and elements of the region could be presented through field trips in which the participation of teachers would be most important for on-site instruction. Japan, a country with a very small geographic territory but with a very large population, has achieved "miracles" in developing the necessary regional conscience through implementing regional education at the elementary school level. It is the author's opinion that Japan's example ought to be imitated, especially in the United States; its future citizens are going to *have* to deal with the vital problems of regional dynamics which at the present time are going uncontrolled and adding up to sprawl, energy waste, and anxiety.

Notes

1. Regional planners in the United States operate within the auspices of the American Institute of Certified Planners. The Institute is the national professional organization for both urban and regional planners. Because of that, there is no clear distinction between urban planners and regional planners. *A.I.P. Bulletin,* 1973, p. 1. Also refer to McLoughlin, 1969, a general introductory reference. Also Cullingworth, 1970; and Ash, 1969.
2. Because of this, regional planning is directly affected by the prevailing political system and philosophy. Regional planning is at home in socialistic countries. In the countries of the Free World, regional planning is affected by the political philosophy of the ruling party. Regional planning is in conflict with the issue of political expediency. There are certain countries where regional planning is vitally related to national planning. The Netherlands and Israel represent typical cases of this situation. Refer to Antoniades, 1971; and Spiegel, 1967, p. 21.
3. This term is used in the U.S.S.R. The period there is five years, and the plans are known as five-year plans.
4. Refer to Mumford, 1938, p. 308; and Taylor, 1964, p. 385.
5. There are conflicting views on the issue. The points made in the present study represent the personal evaluation of the writer.
6. Rodwin, 1970, p. xiii. For complete list of references on the points that follow, refer to Antoniades, 1971, pp. 18–22.
7. Refer to Taylor, 1964, p. 377.
8. For regional economists' concept of the region, refer to Brown, p. 27; "Areas that have some claim to be to the maximum extent self-contained."
9. The concept of the region for purposes of administrative convenience is credited to Charles Abrams. See Goodman, Paul and Percival, 1960, p. 104.
10. Sometimes regions have been defined on the basis of just one resource or of just one regional constraint. For instance, the "purchasing region" for Texas has been considered to be the area from New York City to Mexico City. Burton, 1968, p. 286.
11. Dickinson, 1952, p. 255.
12. Mumford, 1940, p. 359. This discussion assumes population size.
13. Antoniades, 1971, table (f), p. 41; also general reference, Troedsson, 1959.
14. Mumford, 1940, pp. 349–51. Also Antoniades, 1971, p. 47.
15. Mumford, 1940, p. 359.
16. Richardson, 1973, p. 6.
17. Richardson states: "Many hundreds of thousands of words have been written on this topic without coming to a fully satisfactory answer. We can say only that there is no unique definition, and that we may wish to define a region in different ways as the objectives of inquiry vary. . . ." Richardson, 1973, p. 6.
18. Ian McHarg, *Design with Nature,* general reference.
19. For optimum form of government in reference to planning, refer to Tinbergen, 1964. General reference.
20. Christaller, 1966, pp. 17, 66.
21. Taylor, 1964, p. 243.
22. Ibid., p. 301.
23. Abrams, 1969.
24. Christaller, op. cit., general reference.
25. Lösch, 1967. General reference.
26. For introductory summary, refer to Chapin, 1972, pp. 16–17.
27. Ibid., pp. 17–19.
28. For elaboration on summary, refer to Chapin, ibid., p. 19.
29. Doxiadis, 1968. *Ekistics.*
30. For introduction to the general theories of Paolo Soleri, refer to Soleri, 1973. On Arcology, see p. 41.
31. Abercrombie, 1944 and 1945.
32. Term first used by Antoniades. Refer to Antoniades, 1971, p. 41.
33. No specific references will be given pertaining to information that follows. Notes will pertain to suggestions for further reading.

34. Buchanan, 1972.
35. Swedish Information Bulletin.
36. Dutch Information Bulletin.
37. Spiegel, 1967, p. 22. Also refer to Sharon, 1976.
38. Shkvarikov, Haucke, and Smirnova, 1964, p. 307.
39. Fitch, 1961, pp. 279–80.
40. "Ciudad Guyana," in *Cities,* Scientific American Pub., 1967.
41. Oscar Niemeyer's opinion on the greatest achievement of Brasilia was: "We built Brasilia in only three years," in I.M. Goodovitch, 1967, p. 38.
42. Antoniades, 1971, general reference.
43. For further arguments, methods, and techniques regarding environmental and regional awareness and programs developed in this direction, refer to Educational Facilities Laboratories, 1974.

Selected Readings

Doxiadis: *Ekistics*
Goodman, Paul and Percival: *Communitas*
Lösch: *The Economics of Location*
McHarg: *Design with Nature*
McLoughlin: *Urban and Regional Planning*

18

Historic Preservation and Related Environmental Interventions

" . . . if, for the rest, it be asked us to specify what kind of amount of art, style, or other interest in a building, makes it worth protecting, we answer, anything which can be looked on as artistic, picturesque, historical, antique, or substantial: any work, in short, over which educated, artistic people would think it worthwhile to argue at all. Thus and thus only, shall we escape the reproach of our learning being turned into a share to us; thus and thus only can we protect our ancient buildings and hand them down instructive and venerable to those that come after us."

William Morris[1]

Historic preservation is one of the newest and most rapidly growing disciplines of environmental design in the United States. Preservation is one of several alternatives of environmental intervention through which environments of historic or other merit can be retained. Prominent among these alternatives are conservation, restoration, and adaptive use. Preservation and conservation are frequently considered simultaneously, so they are often confused or used as synonymous.[2] In spite of the definite distinction between the terms, *preservation* has dominated, and it is used to refer to the whole spectrum of subdisciplines and specializations that seek to keep up and retain meritorious environments.

The interest in keeping up and retaining meritorious environments, in a detailed or a comprehensive sense, is not new.[3] Yet the systematic approach and the emergence of the discipline have been recent, especially in the United States.

Preservation of the environment consists of isolated acts to preserve individual "buildings," in isolated (rural) or urban contexts, and also to those acts to preserve fragments of the urban continuum—whole cities even regions. In this sense, the discipline of historic preservation is one that applies to many environmental domains. As such, it is bound to be a discipline all by itself, not a subdiscipline of any one of the disciplines already discussed. It is, however, closely related and interdependent with all of them. We could say that "this new discipline" is a most refined one regarding civilization: it concerns itself with the continuity of civilization, the values and physical testimonials of the past. Such testimonials are an important factor for the development of community pride and identity in any part of the world.

The environmental and historic preservationist is, perhaps, the most "Renaissance person" among the environmental designers of today. He or she must have expertise in as many environmental disciplines as possible and must be able to cooperate/collaborate with people of other environmental disciplines, as well as with craftsmen, artisans, and materials and scientific experts.[4] The historic preservationist must be a historian, an architect-urban designer-planner, an artist, a technician, a scientist, a philosopher, and a humanist. If the architects who give birth to new buildings were to be regarded as those average persons who create new life, the preservationists could be regarded exceptionally, as they perform roles similar to those of the physicians who save and prolong life. They must diagnose the disease, prescribe treatments for cure, often perform operations, preserve life, and above all, conserve health.[5]

In order to conserve and prolong the lives of historic environments we not only need to take physical care for their restoration and conservation, but also plan for their future life style and economic feasibility. In this sense, historic preservationists are also concerned with such aspects as assigning new, more efficient and economically viable uses to old "buildings" of significance through the processes and techniques of retrieval and recycling.[6] Directly related to the historic preservation intervention are the acts and practices of restoration, conservation and consolidation, reconstitution, adaptive use, reconstruction, and replication.[7] Although all of the above, or some of them, are occasionally necessary for the interventions that will preserve environments of historic merit, it is *preservation* that prevails as the all-inclusive term for the discipline. It is important at this point to state the accepted definitions for preservation and the associated historic intervention activities.

Preservation is understood to be "the static maintenance of an object in unaltered condition, anologous to that of a museum specimen in optimum surrounding."[8]
Conservation is understood to include maintenance of the object in time and assigning dynamic character to it through needed adaptations.[9]

As it can be seen from its definition, *conservation* is more inclusive and dynamic, yet it is *preservation* that has prevailed and which labels the dynamic discipline.

Restoration applies to acts of intervention through which buildings are returned to the physical condition in which they would have been at some previous stage of their morphological development.[10]

Conservation and consolidation refers to the process through which the actual fabric of the building is dealt with so as to ensure its continued structural integrity;[11] while *reconstitution* applies to the case in which a building "can be saved only by piece-by-piece reassembly either in situ or on a new site."[12]

The economic way in which old buildings are saved by adapting them to the requirements of new tenants is called *adaptive use.*[13] *Reconstruction* describes the act of re-creating buildings that have vanished from their original sites;[14] and, finally, *replication* describes the creation of an exact image of a still-standing building on a site removed from the prototype.[15]

The above terms suggest the multiplicity of possibilities for historic intervention which may be part of the various strategies for historic environmental preservation.

Large economic benefits are generally possible through interventions of well-planned, successful preservation. Yet the reasons for preservation are not economic or material alone. The spiritual benefits are most important, although

Coronado Hotel. The largest wood structure in the United States. A historic living landmark subject of preservation and sensitive expansion. San Diego, California.

Restoration of individual buildings. Oulu, Finland.

Preservation and recycling of individual buildings. Neo-classic buildings in Athens after clean up, painting and recycling of functional destination.

Restoration-recycling. Initially the building for the first modern Greek Parliament. (Boulanger, Architect) Now: Museum of War of Independence.

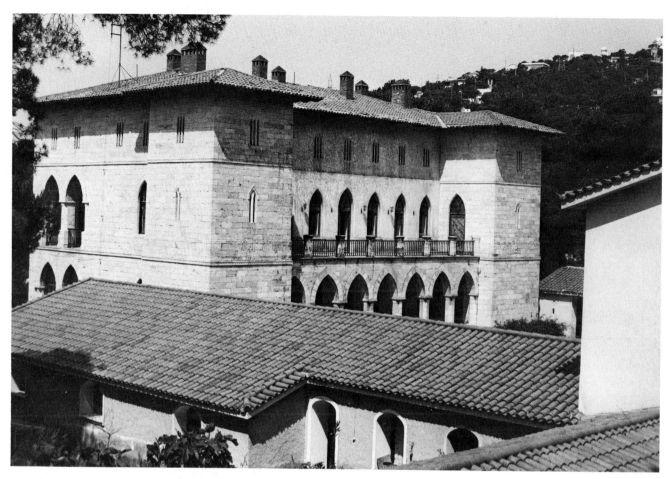

The Palace of Plakentia. A restored—recycled building of the 19th century. Kleanthis, Original Architect. Restoration Authority: Ministry of Culture and Civilization, Greece.

they are intangible. Focusing on old buildings alone we find out that their value to society is manifold. John Harvey has pointed out that there is an array of values:

1. Value of old buildings as expression of man's spirit.
2. Quality of permanance offered to an environment by old buildings.[16]
3. Value of "consonance"; that is, value due to the unique regional identities created in old buildings through the use of local materials (such regional identities stimulate people to travel).[17]
4. Value due to the "real value" of old buildings in strictly monetary terms (as it has been argued, old buildings generate enormous income through attracting tourists—"nobody visits" new towns for tourist purposes).
5. Old buildings represent capital investments of enormous size.[18]
6. Comfort, durability, fitness of the old as opposed to questionable performance of the new.[19]

The preservation and restoration of exceptional buildings may serve didactic[20] purposes, in that they can exhibit the qualitative spirit and the state of the art and architecture of the community. This has been understood since ancient times. Even the ancients preserved, restored, and recycled some of their exceptional buildings. Many of the still remaining historic buildings were built out of salvaged materials (i.e., the Pantheon of Rome[21]), and others were recycled not only once but many times. The most glorious example in this respect is probably the Parthenon. According to the poet Kostis Palamas, "The Temple" (the name he gave the Parthenon) was recycled several times:

—The Byzantine will turn the Temple Christian,
—The Frank will make it Catholic,
—The Moslem will force it to wear the Turban;
—Each race will plunder it with rage.[22]

Preservation through the process of "giving in". Historic Byzantine chapel is integrated (accommodated) through large cavity to new office building. Bus transportation terminal in Athens, Greece, 1970's.

Preservation through "giving in" Chapel of Haghia Dynamis in Athens, Greece. Co-existing with new building of Ministry of Education above. A good theoretical proposition with unsuccessful results in the above case. Chapel is compressed by the insensitive design of the new building above it.

Area Conservation in Tampere Finland. The Historic Zoning ordinance guarantees the retention of the character of the 19th century industrial district.

New Orleans, Louisiana. One of the most successful places for area preservation. Details and street furniture of the "French Quarter."

Area Preservation can be a living museum and be commercially successful. The case of "el Paseo" in Santa Barbara, California.

Successful cases of Historic preservation. The Historic District in St. Augustine, Florida.

The Canal Project in San Antonio, Texas. Comprehensive environmental conservation including landscaping, coordination of special uses (open-air theater, restaurants, etc.). Conservation of existing body of water. Local group with the help of architect, O'Neal Ford.

Preservation of interior space and original function turning old buildings of significance to living museums. Interior of typical private residence of the 17th century. Island of Patmos, Chora Patmou, Greece.

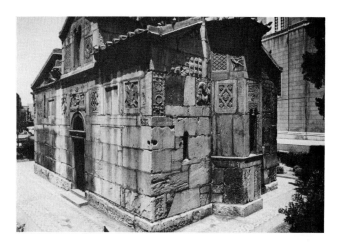

Use of salvage materials and recycling has been practiced consistently throughout history. The church of St. Eleftherios in Athens, Greece (10th century).

England is among the leaders in preservation. Integration of old and new, even if the old is in ruinous state. Area of the University of London.

Other old buildings have been retained until our time either due to forced recycling and conquest, or because of planning. The Hagia Sophia became a mosque, while almost all the historic monuments of today became, through planning, sites for visitation by tourists and sources of income for the locals.

Restoring and reviving the old have always been considered noble activities of mankind. This century has been rather active in acts of restoration and preservation associated with archaeological research and excavations. Extraordinary results have been produced in many parts of the world. One of the most worthy such cases, yet almost totally neglected by the literature on the subject, is the case of the Palace of Knossos. The protagonist in this effort was the British Sir Arthur Evans. Early in the twentieth century his crew of architects, archaeologists, and other technicians performed, under his direction and sponsorship, one of the miracles of archaeological resurrections, restoring and preserving for the generations to come an example of one of the most environmentally sensitive architectures of all times.[23]

Furthermore, preservation may address itself to many buildings or groups of buildings which although not necessarily exceptional in themselves may be necessary for maintaining the texture and continuity of the particular urban fabric.[24] Such environmental intervention is called *general preservation.* Europe offers a great number of examples of general preservation. Major thriving towns such as Rome, Paris, Vienna, Stockholm, Copenhagen, Helsinki, Prague, and Warsaw provide numerous cases for the study of this possibility. Whole sections of these towns have been planned on the basis of the principles of general preservation, and they present some of the best cases in which the new coexists in harmonious and respectful coexistence with the old.[25]

Area preservation refers to the preservation of rural or urban communities of general architectural, cultural, or aesthetic merit. This kind of preservation has been extremely important in retaining the quality and character of villages and historic towns in many parts of the world. The majority of Greek islands, many of the Italian hilltowns, and towns in Central and Northern Europe such as Rothenburg in Germany and Tammissari (now Ekenäs) in Finland owe their existence to practices of "area preservation" and the concept of "historic districts,"[26] elsewhere called "traditional settlements."[27] Area preservation is achieved through enforcement of strong controls such as historic zoning ordinances,[28] morphological and material standards, and strictness in the process of building permit issuance. Adverse as it may sound, area preservation was one of the achievements of Mussolini in Italy and its colonies (1911–1943). The present condition of many sections of Rome, especially those visited by tourists (i.e. monumental access to St. Peters Square, the district of the Colosseum, the area by the Campidoglio, etc.) is a result of preservation programs decided instantly by the dictator with the stroke of a pen.[29] The "Castello" of Tripoli in Libya and the old section of the town of Rhodes in Greece, both of which were Mussolini's colonies, were caringly preserved, displaying the high level of competence and expertise developed by the architects of the regime.[30] The old section of the town of Rhodes is one of the largest and most successful examples of area preservation ever performed and one which is living and thriving, visited daily by great numbers of tourists.

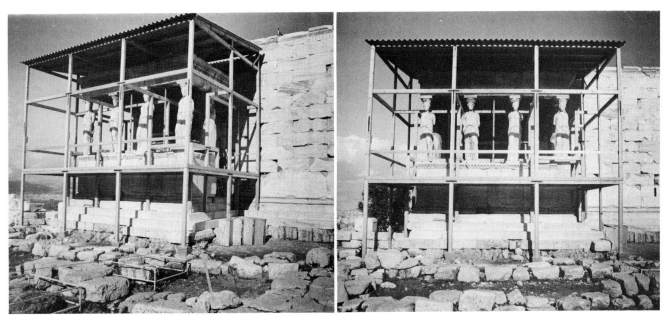

Archaeological preservation. The Caryatids of the Erechtheion in the process of being preserved.

Preservation through retention of facades of older buildings: a difficult challenge that requires exceptional design sensitivity in successful realization.

Jesse Owen Stadium with School of Architecture incorporated underneath. A case of superb recycling and efficiency ingenuity. University of Oklahoma at Norman.

Historic preservation at the urban scale. The case of Tammissari (now Ekenäs) in Finland.

Successful area preservation pays attention to the minutest environmental details. Mirror by the window at house in Tammissari (now Ekenäs) in Finland.

Santa Barbara, County Court House, William Mooser, 1929.

Restored old residence from the park "Kulturen" in Lund, Sweden.

Richness of texture as achieved through the use of salvage materials, conservation and recycling. The Acropolis of Athens from the neighborhood of Plaka in the late sixties.

Preservation of the landscape or the regional environment aims at maintaining the spirit and physical quality of the place, the landscape or the region. Such preservation is guaranteed through conformity to environmental standards, protection of the natural environment, and controls regarding private exploitation and insensitive use. Excellent examples of this type of preservation are found in the National Parks in the United States and the immense regions of Lapland in northern Sweden and Norway.[31]

Preservation of the outdoors can also be of smaller scale as rural or urban open space. The canal project in San Antonio, Texas, is one of the best such cases in the United States, the result of the effort of a local preservation group in association with the architect, O'Neal Ford. Sweden, however, is the most advanced country in this respect. Many of its towns have well-preserved parks where the preservation efforts retain not only the flora but samples of reconstructed old villages and archetypal buildings. The parks of Skansen in Stockholm and Kulturen in Lund are among the best known.

Adaptive use is a type of preservation with significant financial potential. It guarantees dynamic, non-museum-like prolongation of life for structures. Adaptive use is perhaps the most promising form of preservation in instances where private interests enter into the field of preservation.[32]

There are many good examples of adaptive use, especially in the United States where the element of financial feasibility for private enterprise is most crucial. The National Building Museum in Washington, D.C., represents, perhaps, the most representative and symbolic case study. Other exceptional cases include projects such as Ghirardelli Square in San Francisco and the Quincy Market in Boston, which we have discussed, as well as the preservation and adaptive use of large areas of historic significance such as those in New Orleans, Galveston, San Diego, etc.

"KIMO" Theater in Albuquerque, New Mexico. A case of preservation within the downtown areas of American cities which is extremely difficult to achieve due to the high cost of land in American downtowns.

An important issue concerning the recycling, adaptive use, and preservation of old buildings has to do with the fate of the plan of the old building.[33] Should the plan be retained? Should the plan be altered to meet the new functional requirements? There are two schools of thought regarding these issues. The one is headed by the authority of Cesare Brandi who believes that a historic building is not preserved unless all the aspects of its existence are preserved, including the plan. Brandi believes in what he termed "the preservation of historic wholesomeness."[34] In this case it is expected that the new functions will have to adjust themselves, be "massaged," into a plan that served other functions before. In a way, this school supports an attitude of functional adjustability into a preexisting form which is not too different from that of many "formalist" architects, who believe in the supremacy of form and accommodate the function to the form in one way or another.

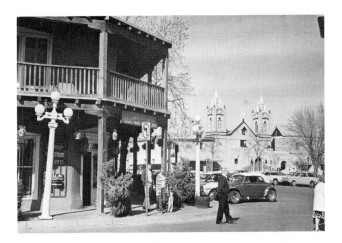

The "Old Town," Albuquerque, New Mexico. Preserved areas of historic significance are significant sources of income. They enhance tourism and anchor the cultural activities of the town.

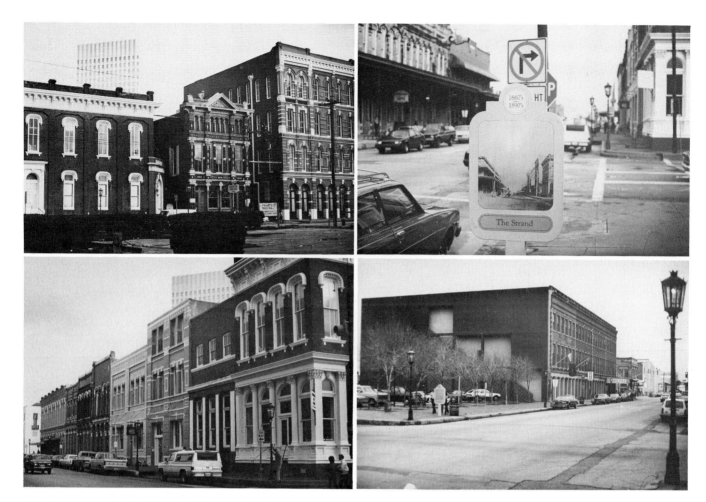

Historic preservation in Galveston, Texas.

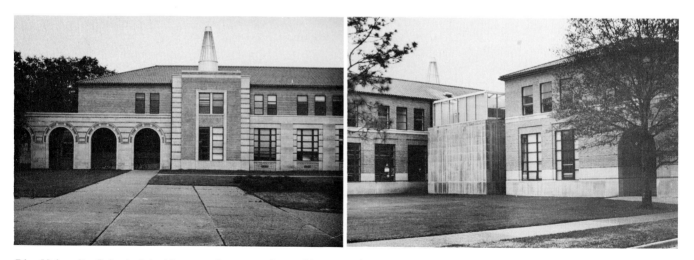

Rice University, School of Architecture. An extremely sensitive case of recycling, expansion and integration with the old through the vocabulary of today's materials and space making language. James Stirling, Michael Wilford, Architects, 1981.

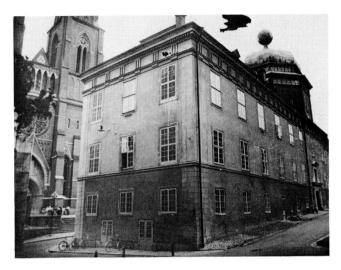

Historic preservation as a tradition. Mathematics building, Uppsala, Sweden.

The Linnaeus Museum, initially Linnaeus House, a typical example of sensitive Swedish historic preservation. Uppsala, Sweden.

Tool House, from the orangery in Linnaeus garden, Uppsala, Sweden. A case of preservation where all the details are kept to their initial status, i.e. the false windows, painted on the wall.

The Castello in Tripoli. One of the many cases of historic preservation and restoration undertaken by the Italians during the 1920's and 1930's. Brasini and Pelegrini, Architects.

The second school, generally represented by American theoreticians and demonstrated in the majority of practice, believes that it is more fit with the times to alter the plan and the interior space of the building so as to properly and efficiently accommodate the new functions. New technologies and stronger structural combinations can permit manipulation of the interior space so as to better serve its current use.

Although a charming, romantic aura prevails in the interiors of historic buildings restored on the basis of the principles of the Brandi school, it is perhaps more fitting with the urgent needs for preservation to be more lenient

in the approach and side with the second school. In this case more businesses and institutions will find preservation economically feasible, and more old buildings will be recycled. The goal should be to retain the historic grain of our towns by keeping the street sequences, the scale, and the texture intact. This would certainly be preferable to losing the battle over details and having the old buildings torn down in the process.

Finally, we come to the last case for preservation; that of furnishing historic buildings for didactic or exhibition purposes.[35] The buildings preserved for didactic purposes

The Old Town of Rhodes, Greece. An extraordinary case of historic preservation and restoration by the Italian team of Pietro Lojacono, R. Pettraco and Hermes Balducci, 1928–1936.

The Castello in the Old Town of Rhodes, Greece. One of the earliest cases of restoration and historic preservation. Pietro Lojacono, Architect, 1928.

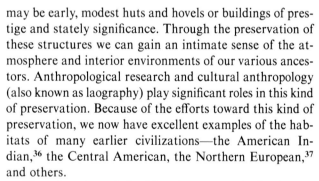

may be early, modest huts and hovels or buildings of prestige and stately significance. Through the preservation of these structures we can gain an intimate sense of the atmosphere and interior environments of our various ancestors. Anthropological research and cultural anthropology (also known as laography) play significant roles in this kind of preservation. Because of the efforts toward this kind of preservation, we now have excellent examples of the habitats of many earlier civilizations—the American Indian,[36] the Central American, the Northern European,[37] and others.

The education of the historic preservationist is very unique and multifaceted. Because of the archaeological nature of early preservation efforts, countries with archaeological wealth have taken the lead in furthering the concerns for preservation, developing expertise, and even establishing schools with comprehensive curricula in historic preservation. Italy and Greece have pioneered in this respect, although Italy seems to have achieved better results in the education of preservationists. The schools of architecture in Venice, Florence, and Rome are vanguards in the field, while the Greek Archaeological Society, in association with the schools of architecture in Athens and Thessaloniki and within the auspices of the Ministry of Culture and Civilization, has recently been performing pioneering work.[38]

Other countries such as France, England, and Czechoslovakia have also been exemplary. Works there have been singled out by American scholars and educators on preservation as working prototypes.

The first program for university education in historic preservation in the United States was initiated by James Marston Fitch at Columbia University in the early 1960s.[39]

It is not surprising that the man to make the call for and play such an important role in historic preservation was Fitch; he has been, in a sense, the most "Renaissance" of the few Renaissance men of our times. He was an architectural historian whose inquiring and infinite concern for the environment have shaped the interests and concerns of recent architecture. It was Fitch who called the attention of architects to environmental psychology considerations. He further inquired and called for energy-conscious design—design that responds to climate, local materials, and general environmental constraints; and it was he who ultimately synthesized all of these concerns into the primary advocacy for the recycling of old buildings and historic preservation. In a sense, Fitch was the motivating force behind much of what good architects, environmentalists, and historic preservationists have been doing today, at least in the United States.[40] It is unfortunate that the advocates of serious causes are rarely given their due credit while they are alive; and it is unfortunate for architecture that other personalities, advocates, and theoreticians of fads collect wreaths of glorification daily.

The establishment of the program at Columbia University was followed by other programs around the country, and together, these schools have furthered the cause of education for historic preservation.

The "Renaissance" quality of the historic preservationist is fostered by a well-rounded education and training in the field.[41] Studies in art history and the history of architecture are as important as those in philosophy, history

in general, and those that constitute one's background of expertise in architecture or other environmental field. The abilities to sketch and to use contemporary techniques[42] (such as photogrammetry) for the measuring and recording of buildings are as important as the knowledge of chemistry, materials, and economics. Schools of architecture are outstanding places for curricula of historic preservation, because many of the skills needed for the work can be cultivated there. Some European schools have been extraordinary depositories for the recording of historic environments. The chairs of morphology are usually engaged in the measuring and recording of old buildings as a means of teaching their students the relationships between form and its determining parameters (i.e., function, structural constraints, materials). It was not incidental that some of the first historic preservationists in Europe were professors of morphology in schools of architecture. Legendary in this respect have been Greek professors such as Anastasios Orlandos,[43] Panagiotis Michelis, Charalambos Bouras, and Nicolaos Moutsopoulos; all of these engaged through their respective "chairs" in the recording and measuring of old buildings, efforts which helped enormously in the efforts of actual preservation. One could say that much of the preserved classical and Byzantine heritage in Greece owes its preservation to the efforts of these people and the measured drawings of their students. There is much lacking in schools where morphology is not taught and where the discipline of measured drawing has been eliminated.

In order to guarantee successful preservation there must be artisans, technicians, and craftspeople as well as generalist preservationists. It is unfortunate that the training of such craftspersons as masons, plasterers, cabinet makers, stained glass artists, etc., has been generally neglected[44] thus far in the United States. Other countries, however, such as Italy and France, as well as socialist countries of Eastern Europe, have developed programs for the training and hiring of craftspeople.[45] If the environment of the United States is to be preserved and if historic preservation is to be a part of it, then it is only logical that the present attitude toward the training of craftspeople will have to be changed. One would hope that those who see themselves as future historic preservationists will become working advocates for the training of craftspeople.

For some good time the people of this country have encouraged growth, mass-production, decentralization, energy consumption, and other developments of "progress." It is only logical to expect that we will come to accept universally the need for the reversal of the trend; that the pendulum will swing, and an appreciation for history will moderate the drive for "progress." Judging from recent facts, the trend is already being reversed. Historic preservation along with all the other sensitive, prudent, respectful, and energy-conscious environmental intervention acts are now well established, and they will flourish in time.

Notes

1. From Manifesto setting forth the principles of the Society for the Protection of Ancient Buildings, 1877. See also Harvey, 1972, p. 210. For more on Morris and preservation see Pevsner in Fawcett, 1976, pp. 52–53.
2. For history and further arguments on the understanding of terms see Harvey and Fitch, 1982.
3. See Pevsner op. cit.
4. For elaboration on the above see Fitch, 1982, p. 349; Whitehill, 1967, p. 31.
5. Harvey, op. cit., p. 12; for important reference regarding visual evidence of the deceases of old buildings see Insall, 1973, i.e., pp. 75–91.
6. Fitch, 1982, p. 29.
7. Ibid., p. 47.
8. Harvey, op. cit., p. 15.
9. Ibid., p. 15.
10. Fitch, op. cit., p. 46.
11. Ibid., p. 46.
12. Ibid., p. 46.
13. Ibid., p. 47.
14. Ibid., p. 47.
15. Ibid., p. 47.
16. Harvey, op. cit., p. 18.
17. Ibid., p. 18.
18. Ibid., p. 20.
19. Ibid., p. 20.
20. The didactic benefits of preservation are clearly stated in the Manifesto of William Morris, op. cit.
21. Risebero, 1979, p. 11.
22. Palamas *The King's Flute,* see also in Maskaleris 1972, pp. 88, 89.
23. The all-inclusive environmental relevance of the Palace of Knossos has not been dealt before. It is fundamental, beyond the surface of mere formal or decorative consideration. This work deserves to become a prototype of Environmentally sound architecture. For reference information see Marinatos 1960, Graham 1962, Scully 1979 also initial publication by Sir Arthur Evans, 1921.
24. Ravenswaay, 1967, p. 20.
25. For world overview of historic preservation achievements see Fitch, 1982, pp. 361–91.
26. This term is used in the United States.
27. This term is used in Greece.
28. I.e., see case of Santa Fe, New Mexico.
29. Major reference of the subject Cederna 1979, pp. 248–253.
30. See Antoniades 1984.
31. The environmental preservation of Lapland is controlled by bilateral agreement. For open space preservation programs in the United States see Weaver, 1966, pp. 68–72.
32. See Fitch, op. cit., p. 165; Ravenswaay, 1967, p. 27; and Division for Historic Preservation, Office of, 1974, p. 15. For case studies on the economic feasibility of adaptive use see Anderson, Notter, Fine, Gold, Inc., 1978.
33. See in ICOMOS II, Monumento per 1 'Uomo, Padova, 1971.
34. See Cholevas Nicholas, "Epemvasis stin Architektonike Kleronomia tis Athenas" in *Archaeologia,* #6, Athens, Feb. 1983, p. 39.
35. Ravenswaay, ibid., p. 27.
36. As an example one may refer to the various cultural centers of Indian reservations where Indian houses have been restored and presented to the public; i.e., Gila Cultural Center, Gila, Arizona.

37. Typical cases are in Skansen (park) in Stockholm, and Kulturen (park) in Lund, Sweden.
38. It must be pointed out that although Greece pioneered in developing the groundwork infrastructure for the education of preservationists, she has only recently been able to implement widespread preservation policies for the environment as a whole. The adversity to it was perpetuated by political and economic interests counterproductive to all-inclusive preservation.
39. See Fitch, 1982, p. xi.
40. See Antoniades 1982 p. 178.
41. For more on the education of preservationists see Fitch, 1982, p. 349.
42. Many pioneering techniques and tools for scientific historic preservation have been reported in the *Journal of the American Society of Architectural Historians*.
43. Orlandos, the leading figure in these endeavors, was eventually honored with membership to the Academies of both Greece and France.
44. See Fitch, op. cit., p. 356.
45. Ibid., p. 358.

Selected Readings

Fitch, James Marston: *Historic Preservation*
Harvey, John: *Conservation of Buildings*

Epilogue

"If God held all truth in his right hand and in His left hand the lifelong pursuit of it, he would choose the left hand."

S. Kierkegaard[1]

It is certain that some readers will be impressed with particular environments and not impressed at all with others. Some people prefer "glitter" and immaculate furnishings in their surroundings; others do not. Some people prefer the homogeneous look of textural and elemental unity, while others seek total distinction of their ego, identity, and fragmentalized expression. These different preferences result from people's various cultural backgrounds; yet not all preferences are acceptable from the environmental standpoint. Although we cannot advocate that certain cultures are better or "higher" than others,[2] we can suggest that there are certain cultures that are more environmentally relevant than others at the present time. Environmental designers, therefore, need to develop a consistent environmental culture, as it offers the only hope for the survival of mankind.

The author's belief is that meaningful environmental design should seek "unity in diversity." *Diversity* permits freedom and tolerates personal differences; *unity* provides the common denominator of concern for environmental relevance. In order for individual environmental designers to achieve "unity in diversity," they must respond to the occasional circumstances of their problems.

In order to achieve the desirable ends of "unity in diversity," all persons involved in environmental design must be environmentally aware and must come to accept the environmental culture. In this book the author has attempted to address himself to all of these people—students, teachers, citizens, designers; people of different age groups, cultural backgrounds, and environmental preferences. Where does the inquiry leave *you*? Where do *you* have to go?

All of us are members of the citizen category and, as such, we are affected by all designs done by the designers. We are particularly affected by the spheres of environmental design whose scales of concern have long-range and social scope. As citizens we are affected by urban design, urban planning, regional planning. We are also affected by the architecture of individual buildings. Through their individual statements, they compose the collective image of the environment in which we live. . . . But as citizens we also can have an effect on our environment. We can have an effect if we care about it, if we become participants in the long-range environmental composition. If we become conscious of the fact that we constantly make design decisions either by selecting one product over another, by having our residence designed by one architect instead of another one, or by actively objecting to one urban design or planning scheme and favoring another alternative. In that sense, *all citizens who care are participants in the environmental design process.* Concerned citizens are environmental design decision makers.

Community involvement, participation in town hall meetings, and actual involvement with community projects will make one a better "citizen environmental designer." Adult citizens have one more task: they must become the primary environmental educators of the youth. The family must become the first environmental school. Environmental ethics should be taught at home and reinforced on appropriate occasions. Parents must prepare their children to pursue environmentally relevant lives and to face the environmental issues of the future.

Next to the family in importance comes the school. Formal environmental education must start there, and at the kindergarten level. Courses on environmental awareness and environmental facts must be taught throughout a student's education. The task of the environmental educators will be difficult. They must be qualified to speak "environment," but more than that, they must believe in the righteousness of what they teach. Each educator will have to discover for himself (or herself) the techniques of his teaching which are effective. He must be able to adjust to the needs of specific students. In order to do that, he must not only believe in his cause, but he must be a pleasant, likable person as well. As a teacher he will be part of his students' immediate surroundings. Authoritarianism of teachers creates oppressive environments for students. Such teaching attitudes must be eliminated. The environmental instructor must be an example of a serious but joyous human being, a believer in a cause, a citizen, and a communicator of ideas.

The college or university instructor must go beyond that. He (or she) must be able to answer more factual questions, and he must be professionally qualified in some specific environmental design discipline. His work must demonstrate his own actual attempts and his own contribution to shaping a balanced environment. Students respect such teachers; thus their instruction is more effective. As the years advance, environmental instructors will emerge from many different environmental disciplines. It will be natural that each one of these people will have a specific environmental discipline as the basis for his inquiry. However, it is very important that instructors never forget that they are teaching *environment,* and that they therefore make it very clear that the inquiry is one of *interrelationships.* They should emphasize that no decision should be made until it is considered within the general context of all possible environmental interrelationships, and that the factor underlying all decisions should be man and his harmonious coexistence with his surroundings.

The task of environmental design today appears to be immense. It won't be as difficult in the future. The multiplicity of environmental problems and the relative ignorance about our abilities to solve them won't be the case in the future. Tentative environmental vocabularies are already being developed. Many resource manuals are being prepared. Most of the facts of the separate environmental processes are already known through previous research. We need to put all of the existing research together. Only simple thinking is necessary, and elaborate models will be worked out. Then computers will prepare the specific factual answers for us.

This may sound optimistic for the future, but the author believes that current technological resources permit optimism. It is the present that is difficult, because it is the era of the beginning. Awakening, awareness, and the introduction of environmental instruction must come first. Families, schools, colleges, and universities must further the concern for responsible environmental education.

The last group of persons involved in environmental design to be addressed are the students. They deserve special attention, because they are perhaps the group that will most actively influence the environmental reality of the future. Many of them will become the actual environmental designers. Some will pursue careers in the disciplines examined in this book. Many of them perhaps haven't yet decided which discipline they'll enter. They perhaps want to get some help from this book in orienting themselves and making a selection. Should they stay with large-scale, or should they turn to small-scale? Should their focus be on architecture, interiors, or urban planning? This question will be touched on a little later, but first it is important to point out that it is an honorable and

respectable thing to want to become an environmental designer. Civilization needs this profession, and it can be a very rewarding life's work.

There have been people who have pursued careers in the various environmental design disciplines discussed in this book without demonstrating an understanding of the inherent interrelationships among the disciplines. These people have seen themselves as isolated professionals. Some of these individuals seem to have been so narrow-minded as to think their particular professions could provide the solutions to all problems. These people developed certain images for themselves. Many of these professional images, or stereotypes, still exist, and they are especially harmful. The image of the "gentleman architect" as well as the recent images of the "rebel advocate planner" and the "advocate architect" (blue jeans, beard, etc.) are pretty well-known. The same is true for the egotistical attitudes of many architects and the flamboyant attitudes of many interior designers and other environmental professionals. Equally well-known are the "arrogant" attitudes of many sociologists, as well as the inhibiting attitudes and eloquent speech of many elitist professions. These images are not only visual images but images of behavior and social status. The first thing one must do when dealing with these images or stereotypes is to try to look through them to the persons behind them and to the ideas the persons have.

One should not decide to become an architect (or not to) on the basis of these past images. It would not be wise to make oneself an imitation of a fashionable image. In order to become what you want to be, you must start by throwing out the old stereotypes and images of the profession in which you are interested. That is, if you want to become as good an architect as Frank Lloyd Wright was, you need to immediately remove the image you have created of yourself as a *Frank Lloyd Wright*. It will be necessary to study hard and see how Wright approached his discipline and why he became whatever he became. Through the study of Wright's circumstances, his image will gain meaning. His work will become clear. This study will teach you to look at the roots of your own problems and indicate to you that you ought to consider your own circumstances.

Here's a story to illustrate this point: Anthony Quinn, the famous movie actor, once wanted to become an architect. From the time he was a child, he had had a knack for drawing, and he admired Frank Lloyd Wright. He tried to see the old master and get his opinion about the course he should take in architecture. With his sketchbook in hand, young Quinn visited Wright. The old man greeted him. The youth wanted him to take a look at his sketches but Wright did not wish to see the sketchbook or the sketches. Anthony Quinn was a stutterer at the time, and Wright advised him that if he wanted to become an architect he ought to have an operation first to fix his voice.[3] . . . Quinn had the operation. But he never did use his new voice to speak to architectural clients, because he never became an architect. He served his fellow man, though, through another discipline by exploiting to the maximum his newly acquired inclination.

This instance is not to suggest that Quinn could not have perhaps become a good, or great, architect. It rather suggests that there are certain inherent requirements for each discipline. If not inclined or naturally gifted, one should put forth his best efforts to overcome any handicaps. To be able to speak well was, according to Wright, one of the prerequisites for an architect. We know, of course, that this is not necessarily true today. One of the major partners of a prominent Texas firm distinguished for its environmentally relevant schemes, suffered from the very handicap that Wright witnessed in Anthony Quinn. This partner was a most effective business promoter for his firm.

Someone who does not know you cannot tell you what kind of designer you should become, nor what suits your inclinations the best. Your instructor might give you guidance in making this decision. He will come to know you personally and he can probably advise you. Regardless of your decision, it must be based on your absolute belief that what you'll do, you'll do because you love it, because you select to serve it, not because of the image or the income it will create for you. You must "fall in spiritual love" with your profession, and if you are fortunate enough to make that happen, you'll have found the task of design that suits you the best.

Notes

1. Kierkegaard in Bretall, 1946, "Sickness Unto Death," pp. 341–365.
2. The author wholly agrees with Camus here. See Camus, 1968, p. 191.
3. Quinn, 1974, p. 212.

Bibliography

Aalto, Alvar. *Sketches*. MIT Press. Göran Schildt, editor, 1978.

Abercrombie, Sir P. *Greater London Plan*. London: H.M.S.O. 1944.

———. *The Greater London Plan*. London: H.M.S.O. 1945.

Abrams, Charles. "The Residential Construction Industry," in *The Structure of American Industry,* ed. by Walter Adams. New York: The Macmillan Company, 1969.

———. *The Language of Cities*. New York: Avon Books, 1972.

Ackerman, James S. "*Palladio*" Penguin Books, 1966.

Adams, William Howard "*Jefferson's Monticello*", Abbeville Press. New York, 1983.

Adelberg, T. Z., and Shelly, M. W. "Notes on Satisfactions in Shopping Centers," I, II, III, IV, in *Psychological Reports*. October, 1967.

A.I.A. Memo, March, 1976.

A.I.P. Examination Booklet.

Alexander, C. *Notes on the Synthesis of Form*. Cambridge, Massachusetts: Harvard University Press, 1964.

Alexander, Mary Leon. *Designing Interior Environment*. New York: Harcourt Brace Jovanovich, Inc., 1972.

Altshuler, Alan A. *The City Planning Process,* Ithaca. New York: Cornell University Press, 1965.

Ambasz, Emilio. *Italy, the New Domestic Landscape*. The Museum of Modern Art. New York, 1972.

American Institute of Architects. *Handbook of Professional Practice.*

American Institute of Architects. The Committee on Urban Design. *Checklist for Cities*. No date.

American Institute of Planners. The Board of Governors. *The Social Responsibility of the Planner*. Washington, D.C.: A.I.P. 1973.

Anderson, Notter, Fine, Gold Inc. "*Recycling Historic Railroad Stations: A Citizens Manual*" U.S. Department of Transportation. Washington, D.C., 1978.

Anthony, Harry A. Paper at the National Issues Conference on Conservation of Energy by Design. University of California, Riverside. October 2, 1973.

Antoniades, Anthony C. "Public Relations Stage of Planning Process." Discussion paper series #13. Town Planning Department, University of London, November, 1969.

———. "Traditional vs. Contemporary Elements in Architecture" in *New Mexico Architecture*. November–December, 1971.

———. *The Role of the New Towns in the Furtherance of Decentralization in Town Planning*. Unpublished M. Phil. thesis. University of London, December, 1971.

———. "Education of the Architect," *Symposia Colorado,* December 1972.

———. "Getting Back to the Roots," *Symposia Colorado,* April, 1972. Follow ups: August, 1973, November, 1973.

———. "Economics of Architectural Aesthetics: The Dallas-Fort Worth Case," research grant, University of Texas at Arlington, August, 1974, August, 1975.

————. "Ethics of Space," *Technodomica,* October, 1975.

————. "Recent Space," *A.I.A. Journal,* November, 1975.

————. "The Big Idea in Contemporary Japanese Architecture: From Le Corbusier to Tokyo Boogie Woogie," *Technodomica* (in Greek), December, 1975.

————. "Poems with Stones: The Enduring Spirit of Pikionis," *A + U,* Dec., 1975.

————. "Space in New Mexico Architecture as a Resource for an Energy Ethic," *New Mexico Architecture,* January–February, 1976.

————. "Sychroni Elliniké Architektoniké" (Contemporary Greek Architecture) in Greek, Athens, Anthropos and Choros editions Karagouni, 1979.

————. *"Mount Athos: Historic Precedent of Arcological Post-Modernism",* A + U, September, 1979.

————. "The Design Instructor as an Architectural Journalist" in proceedings of the 70th Annual Meeting of the ACSA 1982, in ACSA L'Hotel d'Architecture, Washington, D.C. 1982.

————. *"Architectural Road to the Deep North and Other Travel Sketches",* in A + U, September, 1981.

————. *"Italian Architecture in the Dodecanese: A Preliminary Assessment",* in *Journal of Architectural Education,* American Association of Collegiate Schools of Architecture, Volume 38, number 1, Washington D.C., Fall, 1984.

Antoniadi, E. *"Ekfrasis tis Agias Sophias".* Athens, 1907–1909.

"Architecture 1980. The Presence of the Past. Venice Biennale". Rizzoli, New York, 1980.

Architectural License Seminars. "Environmental Analysis," Los Angeles, 1974.

Architectural License Seminars, "Architectural Programming," Los Angeles, 1974.

Arnheim, Rudolf. *Art and Visual Perception* Berkeley, California: University of California Press, 1971.

————. *Visual Thinking.* Berkeley, California: University of California Press, 1971.

Ash, Maurice. *Regions of Tomorrow.* London: Evelyn, Adams, and MacKay, 1969.

Ashihara, Yoshinobu. *Exterior Design in Architecture.* New York: Van Nostrand Reinhold Company, 1970.

Bachelard, Gaston. *Poetics of Space.* Beacon Press, 1969.

Bacon, Edmund. *Design of Cities.* New York: The Viking Press, 1974.

Baker, Paul. *Integration of Abilities: Exercises for Creative Growth.* Trinity University Press, 1972.

Bandura, A., and Walters, R. *Social Learning and Personality Development.* New York: Holt, Rinehart & Winston, 1963.

Banham, Reyner. *Theory and Design in the First Machine Age.* London: The Architectural Press, 1967.

————. *The Architecture of the Well-Tempered Environment.* London: The Architectural Press, 1969.

Barker, R. G. *Ecological Psychology: Concepts and Methods for Studying the Environment of Human Behaviour.* Stanford University Press, 1968.

Barlow, Elizabeth. *Frederick Law Olmsted's New York.* New York, Washington, London: Praeger Publishers, 1972.

Barnett, Jonathan. *Urban Design as Public Policy.* New York: Architectural Record Books, 1974.

Bayer, Gropius, and I. Gropius. *Bauhaus 1919–1928.* Boston: Charles T. Branford Co., 1952.

Benevolo, Leonardo. *The Origins of Modern Town Planning.* Cambridge, Massachusetts: The M.I.T. Press, 1967.

Benevolo, Leonardo. *"The History of the City".* MIT Press, 1980.

Bertaux, Pierre. "The Future of Man," *Environment and Change,* ed. by W. R. Ewald.

Blake, Peter. *Frank Lloyd Wright: Architecture and Space.* Baltimore: Penguin Books, 1965.

————. *Form Follows Fiasco.* Boston: Little Brown and Co., 1977.

Blaser, Werner. *After Mies: Mies van der Rohe, Teaching and Principles.* New York, Van Nostrand Reinhold, 1977.

Boesiger, Willy. *Le Corbusier.* New York: Praeger, 1972.

Bonta, Juan Pablo. "Michelis," Reviews, *Journal of Aesthetics and Art Criticism,* Winter 1977.

Borissavliévitch. *Les Theories de l'Architecture.* Paris: Payot, 1926.

Boud, John. *Lighting Design in Buildings.* Stevenage, England: Peter Peregrinus Ltd., 1973.

Boudon, P. *Lived-in Architecture—Le Corbusier's Pessac Revisited.* M.I.T. Press, 1972.

Broundle, Kurt. *The Systems Approach to Building.* Associated Schools of Architecture learning package. University of Utah, 1974.

Bretall, Robert. *A Kierkegaard Anthology,* Princeton, New Jersey: Princeton University Press, 1946.

Brolin, Brent. *Failure of Modern Architecture,* New York: Van Nostrand Reinhold Company, 1976.

————. *Architecture in Context.* Van Nostrand Reinhold Company, 1980.

Brown, A. J. *The Framework of Regional Economics in the United Kingdom:* Cambridge University Press, 1972.

Brown, Frank. *"Roman Architecture."* George Braziller, 1967.

Bruenig, LeRoy C. *Apollinaire on Art.* New York: The Viking Press, 1972.

Buchanan, Colin. *The State of Britain.* London: Faber and Faber, 1972.

Building Systems Planning Manual. Menlo Park, California: Building Systems Information Clearing House, E.F.L., 1971.

Burton, I. "A restatement of the Dispersed City Hypothesis," *Annals of the Society of American Geographers,* September, 1968.

Bush-Brown, Albert. *Louis Sullivan.* New York: George Braziller, 1960.

Camus, Albert. *Lyrical and Critical Essays.* New York: Knopf, 1968.

Candela, Felix. "Understanding the Hyperbolic Paraboloid" in *New Structures.* Fisher, Robert, ed. New York: McGraw Hill, 1964.

Canter, D. V., ed. *Architectural Psychology: Proceedings of the Conference held at Dalandhui University of Strathelyde,* 28 February–March, 1969.

————. *Environmental Interaction.* New York: International Universities Press, 1976.

Carpenter, Philip L.; Walker, Theodore D.; and Lanpheaz, Frederick O. *Plants in the Landscape.* San Francisco: W. H. Freeman and Company, 1975.

Cartwright, Timothy J. "Problems, Solutions, and Strategies" in *Journal of the American Institute of Planners,* May 1973.

Caudill, William W. "Forces Shaping Architectural Practice" in *The Florida Architect.* November–December, 1975.

Cederna, Antonio *"Mussolini Urbanista",* Laterza, Roma-Bari, 1979.

Chapin, Stuart F., Jr. *Urban Land Use Planning.* Urbana, Illinois: University of Illinois Press, 1972.

Chazimichalis, C., and Polychroniadis, A. "Stadt Gestaltung" in *Bauen and Wohnen,* January, 1973.

Choay, Francoise. *Le Corbusier.* New York: George Braziller, 1960.

———. *The Modern City: Planning in the Nineteenth Century.* New York: George Braziller, 1969.

Choisy, A. *"L'Art de Batir chez les Byzantins",* 1883.

Cholevas, Nicholas. "Epemvasis stin Architectoniké Kleronomia tes Athénas" in *Archaeologia,* #6. Athens, February, 1983.

Christaller, Walter. *Central Places in Southern Germany.* Englewood Cliffs, New Jersey: Prentice-Hall, Inc., 1966.

Colboc, P. "Advocacy Planning" in *Architecture d'Aujourdhui,* 1971.

Collins, George. "Broadacre City: Wright's Utopia Reconsidered," in *Four Great Makers of Modern Architecture.* New York: Columbia University, A Da Capo Press, Reprint Edition, 1963.

Constantinides, Aris. *Dio Choria ap ti Mykono.* Athens. 1947.

———. *Ta Palia Athenaika Spitia.* Athens, 1950.

Cook, Jeffrey. "The Varied and Early Solar Energy Applications of Northern New Mexico" in *A.I.A. Journal,* August, 1974.

Cook, John, and Klotz, Heinrich. *Conversations with Architects.* Praeger Publishers, 1973.

Cooke, Thomas. "Guide to Planning Practice—A Process for Community Design" in *Practicing Planner,* February, 1976.

Corkill, P. A. "Preliminary Structural Design Chart" in *Architectural Structures* by Cowan, Henry. New York: American Elsevier, 1971.

Costonis, John J. *Space Adrift.* University of Illinois Press. Chicago, 1974.

Coulton, T. T. *Ancient Greek Architects at Work.* Cornell University Press, Ithaca, New York, 1977.

Cowan, Henry J. *An Historical Outline of Architectural Science.* Amsterdam, London, New York: Elsevier Publishers, 1966.

———. *Architectural Structures.* New York: American Elsevier, 1971.

Cullingworth, J. B. *Town and Country Planning in England and Wales.* London: George Allen Unwin Ltd., 1970.

Davidoff, Paul. "Advocacy and Pluralism in Planning" in *A.I.P. Journal,* November, 1965.

Davis, Llewelyn, *Milton Keyner-Structure Plan.*

Dawood, N. J. *The Koran,* translated by N. J. Dawood. Fourth Ed., Penguin Books, 1981.

DeZurcko, Edward. *Origins of Functionalist Theory.* New York: Columbia University Press, 1957.

Deasy, C. M. "People Patterns in the Blueprints" in *Human Behavior, the Magazine of Social Sciences,* August, 1973.

Dean, Andrea O. "Interiors as Architecture" in *A.I.A. Journal,* July, 1975.

Department of Housing and Urban Development. *Model Cities Program: A Summary of the Program.*

Despeycroux, J. "The Agadir Earthquake" in *Proceedings of the Second World Conference on Earthquake Engineering,* V. I, II, III. Science Council of Japan. Japan Society of Civil Engineers, Architectural Institute of Japan, Seismological Society of Japan, Tokyo and Kyoto, Japan, July 11–18, 1960.

Dickinson, R. E. *City, Region and Regionalism.* Routledge and Kegan Paul, Ltd. London, 1952.

Dietz, G. H. *Plastics for Architects and Builders.* Cambridge, Massachusetts, and London, England: The M.I.T. Press, 1969.

Division of Historic Preservation, Office of Parks and Recreation. *"Historic Resources Survey Manual."* New York, 1974.

Downey, Glanville. Byzantine Architects: Their Training and Methods in *"Medieval Architecture"* Volume Four, the Garland Library of the History of Art. Garland Publishing, Inc. New York and London, 1976.

Doxiadis, C. A. *Ekistics.* London: Hutchinson of London, 1968.

———. *Architectural Space in Ancient Greece.* Cambridge, Massachusetts: The M.I.T. Press, 1972.

Drexler, Arthur. *Ludwig Mies Van der Rohe.* New York: George Braziller.

Duff, A. C. *New Towns in England.* London: 1961.

Dutch Information Bulletin.

Eckardt, Wolf von "The Bauhaus in Weimar" in *Four Great Makers of Architecture.* New York: Columbia University, A Da Capo Press, Reprint Edition, 1963.

Eckbo, Garrett. "Landscape for Living" in *Architectural Record* with Duell, Sloan, and Pearce. New York. 1950.

———. *Home Landscape. The Art of Home Landscaping.* McGraw-Hill, 1978.

Educational Facilities Laboratories. *Learning for the Built Environment.* New York, 1974.

Eisenman, Peter. *Five Architects.* New York: Oxford University Press, 1975.

Energy Management. "County School Administrations Apply 'Cheaper-by-the-Dozen' Economics to HVAC Budgets" (advertisement) in *A.I.A. Journal.* September, 1975.

"Environmental Impact Statement-Writing Guidelines." *EPA.* Washington, D.C.

Environmental Quality—1973. The Fourth Annual Report of the Council on Environmental Quality. Washington, D.C.: U.S. Government Publications, 1973.

Evenson, Norma. *Chandigarh.* Berkeley University Press, 1966.

Eyck, Aldo Van. *"Rats Posts and Other Pests, or the Solid Teapot".* Annual discourse at the RIBA. *Forum,* Vol. 27, No. 3. July, 1981.

Fanelli, Giovanni. *"Brunelleschi".* Scala Books, 1980.

Ferebee, Ann. *A History of Design from the Victorian Era to the Present.* New York: Van Nostrand, 1970.

Fermor, Patrick Leigh. *Mani, Travels in the Southern Peloponnese.* London: John Murray (Publishers) Ltd., 1971.

Fido, Martin. *Oscar Wilde.* New York: The Viking Press, 1973.

Fischer, Robert E. *New Structures.* New York: McGraw-Hill, 1964.

Fitch, James Marston. *Walter Gropius.* New York: George Braziller, 1960.

———. *Architecture and the Aesthetics of Plenty.* New York: Columbia University Press, 1961.

———. "A Utopia Revisited" in *Columbia University Forum.* Fall, 1966.

———. "Experimental Basis for Aesthetic Decision" in *Annals of the New York Academy of Sciences,* 1965.

———. "The Future of Architecture" in *The Journal of Aesthetic Education.* Vol. 4, Number 1, January, 1970.

———. *The American Building.* Houghton Mifflin Company, 1971.

———. "The Aesthetic of Function" in *People and Buildings,* Gutman, Robert, ed. New York: Basic Books, 1972.

———. "The Control of the Luminous Environment" in *Cities,* Kingsley Davis, ed. Scientific American. San Francisco: W. H. Freeman and Company, 1973.

———. *"Historic Preservation".* McGraw-Hill, New York, 1982.

Fleig, Karl. *Alvar Aalto.* Praeger, 1971.

Fletcher, Banister, Sir. "*A History of Architecture*" Eighteenth Edition, Revised by J. C. Palmes. New York, Charles Scribner's Sons, 1975.

Four Great Makers of Modern Architecture. New York: Columbia University, Da Capo Press, 1970.

Frei, Otto, ed. *Tensile Structures.* Cambridge, Massachusetts: The M.I.T. Press, 1962.

Frieden, Bernard J., and Morris, Robert. *Urban Planning and Social Policy.* New York: Basic Books, Inc., 1968.

Friedmann, Arnold; Pile, John F.; and Wilson, Forrest. *Interior Design.* New York: Elsevier, 1974.

Furneaux, Robert Jordan. *Le Corbusier.* Westport, New York: Lawrence Hill and Company, 1972.

Gans, Herbert. *People and Plans: Essays on Urban Problems and Solutions.* New York: Basic Books, Inc., 1968.

———. "Social and Physical Planning for the Elimination of Urban Poverty" in *Urban Planning and Social Policy.* Frieden, J. B., and Morris, R., ed. New York: Basic Books, Inc., 1968.

Gardiner, Stephen. *Le Corbusier.* New York: Viking Press, 1975.

Gauldie, Sinclair. *Architecture.* London: Oxford University Press, 1972.

Gay, Peter. "Art: Its History and Psychological Significance." New York, Harper and Row, 1976.

Gebhard, David. *Schindler.* New York: The Viking Press, 1971.

Geddes, Patrick. *Cities in Evolution.* New York: Harper and Row, 1971.

Gibberd, Frederick. *Town Design.* New York: Reinhold. London: The Architectural Press, 1953.

Giedion, Sigfried. *Space, Time, and Architecture.* Cambridge, Massachusetts: Harvard University Press, 1967.

Goodman, Paul and Percival. *Communitas.* New York: Vintage Books, 1960.

Goodman, William, and Freund, Eric C., eds. *Principles and Practices of Town Planning.* Washington, D.C.: International City Managers Association, 1968.

Goodovitch, I. M. *Architecturology.* Tel Aviv: A. D. Publishing, Inc., 1967.

Greater London Council. *The Planning of a New Town.* London: 1965.

Grabar, Oleg. "*The Alhambra*". Harvard University Press, Cambridge, Massachusetts, 1978.

Graham, Walter James. "*The Palaces of Crete*". Princeton University Press, 1962.

Gropius, W. *The Scope of Total Architecture.* Toronto, Ontario: Collier Books, 1943.

———. *Apollo in the Democracy.* New York: McGraw-Hill, 1968.

———. *The New Architecture and the Bauhaus.* Cambridge, Massachusetts: The M.I.T. Press, 1974.

Gutheim, Frederick. *One Hundred Years of Architecture in America, 1857–1957.* New York, Reinhold Publishing Corp., 1957.

Hall, Ed. *The Hidden Dimension.* Doubleday-Anchor Books, 1969.

Halprin, Lawrence. *Cities.* Cambridge, Massachusetts: The M.I.T. Press, 1972.

———. *Notebooks 1959–1971.* Cambridge, Massachusetts: The M.I.T. Press, 1972.

———. *The RSVP Cycles.* New York: George Braziller, 1973.

Harling, Robert, Ed. *Modern Furniture and Decoration.* New York: Galahad Books, 1971.

Harvey, John. "*The Medieval Architect*". Wayland Publishers, London, 1972.

———. "*Conservation of Buildings*". University of Toronto Press, 1972.

Hasselman, Peter M. "The Architectural Potential of the Power Plant," in *A.I.A. Journal,* February, 1975.

Hazelton, Lesley. "The Responsibility of the Architect" in *ARIEL,* No. 36. Cultural and Scientific Relations Division/Ministry for Foreign Affairs, Jerusalem, 1974.

Hecker, Zvi. "Geometric Prefabbing" in *Progressive Architecture.* March, 1969.

———. "Polyhedric Architecture" in *Architectural Association Quarterly,* Vol. 4, No. 3.

Heinonen, Raija-Liisa. "Some Aspects of 1920s Classicism and the Emergence of Functionalism in Finland" in *Alvar Aalto,* New York, Rizzoli-an Academy Edition, 1978.

Hitchcock, Henry-Russell. "Walter Gropius" in *Modern Architecture International Exhibition,* Museum of Modern Art, New York, 1932.

———. *The International Style.* New York: Norton, 1966.

Hoage, John D. "*Western Islamic Architecture*". New York, George Braziller, 1963.

———. "*Islamic Architecture*". Harry N. Abram Publishers, New York, 1975.

Hopkinson, R. G., and Kay, J. D. *The Lighting of Buildings.* New York: Praeger, 1964.

Hopkinson, R. G., and Collins, J. B. *The Economics of Lighting.* London: McDonald Technical and Scientific, 1970.

Hoskins, Ed. "Environmental Psychology." Unpublished paper, University of New Mexico, Fall, 1971.

Hoyt, Homer. "Economic Background of Cities" in *Journal of Land and Public Utility Economics,* 1941.

———. "The Economic Background of a City is the Foundation of the Master Plan" in *According to Hoyt.* 1963. Also, in *National Real Estate Journal.* August, 1943.

Hubbard, Henry V., and Kimball, Theodora. *An Introduction to the Study of Landscape Design.* Boston: Hubbard Educational Trust, 1967.

Hughes, Helen MacGill. *Crowd and Man's Behavior.* Boston: Holbrook Press. 1972.

Huizinga. *The Waning of the Middle Ages.* New York: Doubleday, 1954.

———. *Homo Ludens.* Boston: Beacon Press, 1962.

Huxtable, Ada Louise. "Architecture in '71: Lively Confusion" in *The New York Times.* January 4, 1972.

———. "Deep in the Heart of Nowhere" in *The New York Times.* February 15, 1976.

———. "What's in a Wall?" in *The New York Times Magazine.* February 29, 1976.

Icomos, Ed. II. Monumento per l'Uomo. Padova, 1971.

Insall, Donald W. "*The Care of Old Buildings Today*". The Architectural Press. London, 1973.

Jacobs, Herbert. "How Big Was the Crowd?" Talk given at California Journalism Conference, Sacramento, February 24, 25, 1967. Also in Summer, 1969.

Jacobs, Jane. *The Economy of Cities.* London: Jonathan Cape, 1970.

Jacobus. "Introduction" in *James Stirling.* New York: Oxford University Press, 1975.

Japan National Tourist Agency, Tokyo, 1975.

Jencks, Charles, and Baird, G. *Meaning in Architecture.* New York: George Braziller, 1969.

Jencks, Charles. *Modern Movements in Architecture.* New York: Anchor Books, 1973.

———. *Le Corbusier and a Tragic View of Architecture.* Cambridge, Massachusetts: Harvard University Press, 1974.

———. *The Language of Post-Modern Architecture.* London: Academy Editions, 1978.

———. Interview with Charles Jencks in *"Archetype".* San Francisco, 1982.

Journal of Architectural Education, March, 1976.

Journal of the American Institute of Planners, "Symposium: New Perceptions in Land Regulation" in *A.I.P. Journal,* January, 1975.

Kahn, Louis Isadore. *Architecture.* New Orleans: Tulane University School of Architecture, 1972.

Kent, T. J., Jr. *The Urban General Plan.* San Francisco: Chandler Publ., 1964.

Keswig, Maggie. *Chinese Gardens.* London: Academy Editions, 1979.

Ketchum, Morris, Jr. "Recycling and Restoring Landmarks: An Architectural Challenge and Opportunity" in *A.I.A. Journal,* September, 1975.

Kittridge, A. Wing. *Bandelier.* Washington, D.C.: National Park Service, Historical Handbook Series, No. 23, 1955, reprint, 1961.

Kohler, Walter and Wamali, Luckhardt. *Lighting in Architecture.* New York: Reinhold Publishing Corporation, 1959.

Kostof, Spiro K. *"The Architect: Chapters in the History of the Profession".* ed. Spiro Kostof. Oxford University Press. New York, 1977.

Laine, Christian, K. "The Freeze of Architectural Thought" in *CRIT #4,* the Architectural Student Journal, Association of Student Chapters of the American Institute of Architects. Washington, D.C., 1978.

Lancaster, Osborn. *A Cartoon History of Architecture.* Boston: Houghton Mifflin, 1964.

———. *"A Cartoon History of Architecture".* Houghton Mifflin Company. Boston, 1964.

Larson, Leslie. *Lighting and Its Design.* New York: Whitney Library of Design, 1964.

Leach, Edmund. *Claude Levi-Strauss.* New York: The Viking Press, 1974.

Le Corbusier. *Four Routes.* London: Dennis, Ltd., 1947.

———. *Towards a New Architecture.* New York: Praeger, 1960 and 1972.

———. "A Talk to Students" in *Four Great Makers of Modern Architecture.*

———. *The Modulor.* Cambridge, Massachusetts: The M.I.T. Press, 1968.

———. *The City of Tomorrow.* Cambridge, Massachusetts: The M.I.T. Press, 1971.

———. *Le Corbusier,* 1958.

"Let's Invest in Conservation of Energy Instead of Waste," editorial in *A.I.A. Journal,* March, 1975.

Lichfield, N. *Cost Benefit Analysis in Urban Redevelopment.* University of California, Institute of Business and Economic Research, 1962.

Little, Arthur. *Strategies for Shaping Model Cities.*

Lösch, A. *The Economics of Location.* Yale University Press, 1967.

Lynch, Kevin. *The Image of the City.* Cambridge, Massachusetts: The M.I.T. Press, 1963.

———. *What Time Is This Place?* Cambridge, Massachusetts: The M.I.T. Press, 1972.

Lynes, J.A. *Principles of Natural Lighting.* Amsterdam, London. New York: Elsevier Publ., 1968.

McGuinness, J. William, and Stein, Benjamin. *Mechanical and Electrical Equipment of Buildings.* New York: John Wiley and Sons, Inc., 1971.

McHarg, Ian. *Design with Nature.* Garden City, New York: Doubleday-Natural History Press, 1971.

McIlhany, Sterling. *Art as Design: Design as Art.* New York: Van Nostrand Reinhold Company, 1970.

McLoughlin, Brian J. *Control and Urban Planning.* London: Faber and Faber, 1973.

———. *Urban and Regional Planning.* London: Faber and Faber, 1969.

McLuhan, Marshall. "The Invisible Environment" in *The Canadian Architect,* June 1, 1966.

McRae, Dick. "The Subtle Influences of the Environment," unpublished thesis, University of New Mexico, Fall, 1972.

McQuade, Walter. "The Enduring Work of a Great Finnish Architect" in *Fortune Magazine,* March, 1976.

Marinatos, S. *"Crete and Mycenae",* Harry N. Abrams. New York, 1960.

Markus, Marvin. "Urban Design Through Zoning" in *Planner's Notebook,* Volume 2, Number 5, October, 1972.

Maskaleris, Thanasis. *"Kostis Palamois",* Twayne Publishers, Inc., 1972.

Michelis, Panagiotis. *An Aesthetic Approach to Byzantine Art.* Batsford, 1955.

———. "Space-Time and Contemporary Architecture" in *Journal of Aesthetics and Art Criticism,* Vol. III, No. 2, December, 1949.

———. "Aesthetic Judgment" in *Rivista di Estetica,* Anno III, Fasc. III, Set.-Dic., 1958.

———. "Aesthetic Distance and the Charm of Contemporary Art" in *Journal of Aesthetic and Art Criticism,* Vol. XVIII, No. 1, September, 1954.

———. "Thought and Creation in Art" in *The Arts and Philosophy,* No. 3, Spring, 1962.

———. *L'esthetic de l'architecture du Beton-Arme,* Dunod, 1963.

———. *E Architektonike os Techni,* Athens, 1965.

———. "Form in Architecture: Imitation and Abstraction, Sign, Language, Symbol" in *Vision and Value Series,* Vol. 6, Gyozgy Kepes, ed. New York: Braziller, 1966.

———. "Humanism and Contemporary Art" in *Chronica Aesthitikis,* Vol. H, Athens, 1969.

———. "Philosophie et Art" in *Studi Internazionali di Filosofia,* III, Fall, 1971.

———. *Aesthitika Theorimata.* In Greek, Vol. I–1965, Vol. II–1971, Vol. III–1972.

———. "The Teaching of Aesthetic and Artistic Experience" in *The British Journal of Aesthetics,* Vol. 12, No. 1, Winter, 1972.

———. "L'esthétique de l'architecture." Klincksieck, Paris, 1974.

———. *"Haghia Sophia".* Athens, 1976.

Moliotis, Panos. "Development of the Design of Earthquake Resisting Structures in Greece" in *World Conference on Earthquake Engineering 1906–1956.* Dept. of Engineering, University Extension, University of California.

Mumford, L. *The Culture of Cities.* London: Secker and Warburg, 1940.

———. *History of Utopias.* New York, 1963.

———. *The City of History.* London: Secker and Warburg, 1966.

Naylor, Gilliam. *The Bauhaus.* London: Studio Vista, 1968.

Negreponte, Nicholas. *The Architecture Machine.* Cambridge, Massachusetts: The M.I.T. Press, 1970.

Nelson, Eames, Girard. Prost in *Design Quarterly 98/99,* Walker Art Center, 1975.

Nervi, Pier Luigi. "Is Architecture Moving Toward Unchangeable Forms?" in *Structure in Art and in Science.* Gyorgy Kepes, ed. New York: George Braziller, 1965.

———. "On the Design Process" in *Structure in Art and in Science.*

Neuman, Eckhard. *Bauhaus and Bauhaus People.* Van Nostrand Reinhold, 1970.

Neutra, Richard. *Survival through Design.* New York, Oxford University Press, 1954.

Newman, Oscar. *Defensible Space, Crime Prevention through Urban Design.* New York: Collier Books, 1973.

Newsletter of A.I.P. Urban Design Department, Vol. 1, No. 4, January 24, 1975.

Newton, Norman T. *Design on the Land, the Development of Landscape Architecture,* Cambridge, Massachusetts: The Belknap Press of Harvard University, 1971.

Norberg-Schulz, Christian. *Intentions in Architecture.* 1963, 1965.

———. *Meaning in Architecture.* Jencks, C., and Baird, G., eds., 1969.

———. *Existence, Space, and Architecture.* New York: Praeger, 1971.

Papanoutsos. *Aesthitiki.* Athens: Ikaros, 1964.

Pawley, Martin. "Introduction in *Le Corbusier.* New York: Simon and Schuster, 1970.

Peets, Elbert. *On the Art of Designing Cities,* Spreirengen, Paul, ed. Cambridge, Massachusetts: The M.I.T. Press, 1968.

Peña, William. *Problem Seeking.* Houston: Caudill Rowlett Scott, 1969.

Perin, C. *With Man in Mind: An Interdisciplinary Prospectus for Environmental Design.* Cambridge, Massachusetts: The M.I.T. Press, 1970.

Pevsner, Nikolaus. *Pioneers of Modern Design.* London: Penguin Books, 1972.

———. *Scrape and Anti-Scrape* in *"The Future of the Past",* Fawcett Jane, Editor. Whitney Library of Design, New York, 1976.

———. The architecture of mannerism in *"Readings in Art History"* edited by Harold Spencer, Volume II. "The Renaissance to the Present", Second Edition. Scribner, New York, 1976.

Phelps, Robert. *Professional Secrets: An Autobiography of Jean Cocteau.* New York: Harper, Colophon Books, 1970.

Pirenne, Henri. *Medieval Cities.* Trenton, N.J.: Princeton University Press, 1952.

Pomeroy, Hugh R. Seminar on American planning. April 22–23, 1950. Department of City and Regional Planning, University of North Carolina.

Pommer, Richard. "The New Architectural Supremacists," in *Artforum,* October, 1976.

Popular Science, "Now You Can Buy Your Solar Heating Equipment for Your House." March, 1975.

Porphyrios, Demetri. *"Sources of Modern Eclecticism",* Academy Editions/St. Martin's Press, London, 1982.

Princeton University. *Planning Workbook.* Princeton, N.J.: Princeton University Press, 1971.

Progressive Architecture. "Interior Volume" and "Exterior Volume." June, 1965.

Quinn, Anthony. *The Original Sin.* Bantam, New York, 1974.

Rapp, Robert. "Space Structures in Steel."

Rasmussen, Steen, Eiler. *Towns and Buildings.* Cambridge, Massachusetts: The M.I.T. Press, 1969.

———. *Experiencing Architecture.* Cambridge: The M.I.T. Press, 1974.

———. *London: The Unique City.* Cambridge: The M.I.T. Press, 1974.

Ravensbury, Charles Von. Planning for Preservation in *"Historic Preservation Tomorrow",* National Trust for Historic Preservation. Colonial Williamsburg, 1967.

Reps, John W. *"Town Planning in Frontier America",* Princeton University Press, 1969.

———. *"Cities of the American West",* Princeton University Press, 1979.

———. *"The Making of Urban America".* Princeton University Press, 1965.

Richard, Chafee. The Teaching of Architecture at the Ecole des Beaux-Arts in Drexler Arthur, *"The Architecture of the Ecole de Beaux-Arts",* edited by Arthur Drexler. M.I.T. Press, 1977.

Richardson, Harry W. *Regional Growth Theory.* New York: John Wiley and Sons, 1973.

Risebero, Bill. *"The Story of Western Architecture".* Charles Scribner's Sons, New York, 1979.

Ritsos, Yannis. "Stones-Bones-Roots" in *Anti,* Papoutsakis, ed. Athens, July 19, 1975.

Rodwin, L. *Nations and Cities.* Boston: Houghton Mifflin Company, 1970.

Rowe, Colin and Robert Slutzky. "Transparency: Literal and Phenomenal" in Yale *Perspecta #8.* (no date).

Rowe, Colin. "Neoclassicism and Modern Architecture" in "The Mathematics of the Ideal Villa," M.I.T. Press, 1976.

Rudofsky, Bernard. *Architecture Without Architects.* New York: Doubleday and Company, 1964.

———. *Streets for People.* Doubleday, New York, 1969.

Ruskin, J. *The Seven Lamps of Architecture.* London: Dent, 1907.

Russell, Bertrand. *Introduction to Mathematical Philosophy.* G. Allen & Unwin Ltd. London (Macmillan Co.: New York), 1919.

Rykwert, Joseph. *"On Adam's House in Paradise".* MIT Press, Cambridge Mass., 1981.

Safdie, Moshe. *Beyond Habitat.* Cambridge: The M.I.T. Press, 1970.

Salvadori, Mario, and Heller, Robert. *Structure in Architecture.* Englewood Cliffs, N.J.: Prentice-Hall, 1963.

Salvadori, Mario. "Thin Shells" in Fisher, Robert E., *New Structures.* New York: McGraw-Hill, 1964.

Sartre, Jean Paul. *Essays in Aesthetics.* New York: Philosophical Library, 1963.

Schildt, Göran. *Alvar Aalto: The Early Years.* New York, Rizzoli, 1984.

Schmid, Thomas, and Testa, Carlo. *Systems Building.* New York: Praeger Publishers, 1969.

Science Council of Japan. "Proceedings of the Second World Conference on Earthquake Engineering," Gakujutsu Bunken, Vol. II, 1960.

Scientific American Publications. "Ciudad Guyana" in *Cities.* Penguin Books, 1967.

Scott, G. *The Architecture of Humanism: A Study in the History of Taste.* New York: Doubleday, 1954.

Scully, Vincent, Jr. *Frank Lloyd Wright.* New York: George Braziller, 1969.

———. *American Architecture and Urbanism.* New York: Praeger, 1971.

———. *Modern Architecture.* New York: George Braziller, 1974.

American Houses: Thomas Jefferson to Frank Lloyd Wright in *"The Rise of An American Architecture"* ed. Edgar Kaufmann, Jr. Praeger Publishers, New York, 1970.

————. *"The Earth, The Temple and The Gods",* Yale University Press, 1979.

Sharon, Arieh. *Kibbutz and Bauhaus.* Stuttgart: Kramer and Massada, 1976.

Shkvarikov, V.; Hancke, M.; and Smirnova, O. "The Building of New Towns in U.S.S.R." in *Ekistics,* Athens, November, 1969.

Simonds, John Ormsbee. *Landscape Architecture.* New York, Toronto, London: McGraw-Hill, Inc., 1961.

Simpson, Otto George Von. *"The Gothic Cathedral: Origins of Gothic Architecture and the Medieval Concept of Order".* Princeton University Press, 1974.

Skeffington Report on Public Participation. London: H.M.S.O., 1969.

Skinner, B. F., and Holland, James Gordon. *The Analysis of Behavior: A Program for Self-Instruction.* New York: McGraw-Hill, 1961.

Smith, Ray. *Supermannerism.* New York: E. P. Dutton 1977.

Smith College Museum of Art. *"Speaking a New Classicism: American Architecture Now"* Northampton, Massachusetts, 1981.

Soleri, Paolo. *Matter Becoming Spirit.* Garden City, New York: Anchor Press, 1973.

Sommer, R. *Personal Space: The Behavioral Basis of Design.* Englewood Cliffs, New Jersey: Prentice-Hall, 1969.

————. *Design Awareness.* San Francisco: Rinehart Press, 1972.

————. *Street Art.* Links: New York, 1975.

Speer, Albert. *Inside the Third Reich.* New York: The MacMillan Company, 1970.

Spiegel, Erika. *New Towns in Israel.* New York: Praeger Publishers, 1967.

Stefany, John E. "Environmental Education in Florida Schools," in *A.I.A. Journal,* September, 1976.

Stein, Clarence. *Toward New Towns for America.* Cambridge: The M.I.T. Press, 1971.

Stierlin, Henri. *"Encyclopedia of World Architecture".* Van Nostrand Reinhold Company, New York, 1983.

Sullivan, Louis H. *The Autobiography of an Idea.* New York: Dover Publishers, 1956.

Swedish Information Bulletin.

Tankel, Stanley B. "The Importance of Open Space in the Urban Pattern," in *Cities and Space,* Lowdon Wingo, Jr. ed. Resources for the Future, Inc. Baltimore: The John Hopkins Press, 1969.

Taylor, Griffith. *Urban Geography.* London: Methuen and Co., Ltd., 1964.

The Decentralist, Vol. I, No. 1, January, 1942.

Theil, Paul A. *New Mexico, Dancing-Ground of the Sun.* Santa fe: Historical Society of New Mexico and School of American Research, 1954.

"Thomas Jefferson, Architect" New York, Da Capo Press, 1968.

Thompson, D'Arcy. *On Growth and Form.* Cambridge University Press, 1942.

Thorndike, Joseph J. *"The Magnificent Builders and Their Dream Houses".* American Heritage Publishing Co., Inc. New York.

Tiggeruean, Stanley. *"The California Condition".* The La Jolla Museum of Contemporary Art, 1983.

Tinbergen, J. *Central Planning.* New Haven: Yale University Press, 1964.

Tobey, George B., Jr. *A History of Landscape Architecture, the Relationship of People to Environment.* New York: American Elsevier Publishing Co., 1973.

Travlos, I. Title transliterated in *Poleodomike Exelixis ton Athenon.* Doctoral dissertation. University of Athens, 1955.

Troedsson, C. B. *The Growth of the Western City during the Middle Ages.* Transactions of Chalmers University of Technology, 1967. Göthenburg, Sweden, No. 127 (Avd. Arkitektur 2), 1959.

Tunnard, Christopher and Pushkarev, Boris. *Man-Made America: Chaos or Control?* Yale University Press, 1967.

Twombly, Robert C. *Frank Lloyd Wright.* New York: Harper and Row, 1973.

Tzonis, Alexander. *Towards a Non-oppressive Environment.* New York: i. Press, Inc., George Braziller, 1972.

Uniform Building Code. International Conference of Building Officials, Whittier, California, 1973 edition.

Utudjian, Edouard. *Armenian Architecture 4th to 17th Century.* Albert Morance, Paris, 1968.

Vassiliades, D. *Odiporia stis morfes ke to ifos tou Ellinikou chorou.* Athens, 1973.

Vassiliou. J. "Angkor" Albért Morancé. Paris, 1971.

Venturi, Robert. *Complexity and Contradiction in Architecture.* New York: Museum of Modern Art, 1968.

Von Hertzen, Heikki, and Spreiregen, Paul D. *Building a New Town.* Cambridge: The M.I.T. Press, 1973.

Warhol, Andy. "Secrets of My Life" in *New York Magazine,* March 31, 1974.

Weaver, C. Robert. *"Preserving Historic America"* Dept. of Housing and Urban Development, 1966.

White, Edward T. *Introduction to Architectural Programming.* Tucson: Architectural Media, 1972.

————. *Concept Sourcebook: A Vocabulary of Architectural forms.* Tucson: Architectural Media, 1975.

Whitehill, Walter Muir. Education and Training for Restoration Work in *"Historic Preservation Tomorrow".* National Trust for Historic Preservation, Colonial Williamsburg, 1967.

Whitehill, Walter Muir and Nichols, Frederick Doveton. *"Palladio in America".* Mila: Electa Editrice, 1976.

Whiton, Sherrill. *Interior Design and Decoration.* Philadelphia: Lippincott Company, 1974.

Wingler, Hans. *The Bauhaus.* Cambridge: The M.I.T. Press, 1969.

Wolf, Peter. *Evolving City.*

————. *The Future of the City.* New York: Whitney Library of Design, 1974.

Woodbury, Steven R. "Transfer Development Rights: A New Tool for Planners" in *Journal of the American Institute of Planners,* January, 1975.

Wong, Wucius. *Principles of Two-Dimensional Design.*

Wrede, Stewart. *The Architecture of Erik Gunnar Asplund.* The MIT Press, 1980.

Wright, Frank Lloyd. *The Natural House.* New York: Mentor Books, 1954.

————. *A Testament.* New York: Horizon Press, 1957.

————. *The Living City.* New York: Horizon Press, 1958.

————. *An Organic Architecture.* Cambridge: The M.I.T. Press, 1970.

Yi-Fu-Tuan. *Topophilia.* Englewood Cliffs, New Jersey: Prentice Hall, Inc., 1974.

Zevi, Bruno. *Architecture as Space.* New York: Horizon Press, 1957.

————. *The Modern Language of Architecture.* University of Washington Press, 1978.

Zoning in New York State. State of New York, Department of Commerce, Albany, New York, 1964.

Zucker, Paul. *Town and Square.* Cambridge: The M.I.T. Press, 1970.

Index